FROM THE THIRD EYE

THE EVERGREEN REVIEW FILM READER

FROM THE THIRD EYE

Edited by Ed Halter and Barney Rosset

THE EVERGREEN REVIEW FILM READER

Additional research by Matt Peterson

Seven Stories Press
New York · Oakland · London

A Seven Stories Press First Edition

All images were obtained from the personal collection of Barney Rosset (now the Barney Rosset papers at the Rare Book and Manuscript Library of Columbia University Libraries), with the following exceptions:

p. 10: Image of Barney Rosset courtesy of Astrid Myers
p. 70: Drawing courtesy of Jonas Mekas and Anthology Film Archives
p. 156: Image of *Mister Freedom* poster courtesy of Harvard Film Archive
p. 171: Image of *The Man Who Lies* poster courtesy of Harvard Film Archive

Seven Stories Press
140 Watts Street
New York, NY 10013
sevenstories.com

Library of Congress Cataloging-in-Publication Data

Names: Halter, Ed editor. | Rosset, Barney editor.
Title: From the third eye : the Evergreen review film reader / edited by Ed
 Halter and Barney Rosset ; additional research by Matt Peterson.
Other titles: Evergreen review.
Description: Seven Stories Press first edition. | New York : Seven Stories
 Press, 2017. | Includes bibliographical references and index.
Identifiers: LCCN 2017047397| ISBN 9781609806156 (pbk.) | ISBN 9781609806163
 (ebook)
Subjects: LCSH: Motion pictures--Reviews.
Classification: LCC PN1995 .F78453 2017 | DDC 791.43/75--dc23
LC record available at https://lccn.loc.gov/2017047397

Book design by Sam Ashby

Printed in the United States of America

9 8 7 6 5 4 3 2 1

CONTENTS

Opposite: Banner for the Grove Press International Film Festival flying over the Evergreen Theater's marquee on East 11th Street in Manhattan

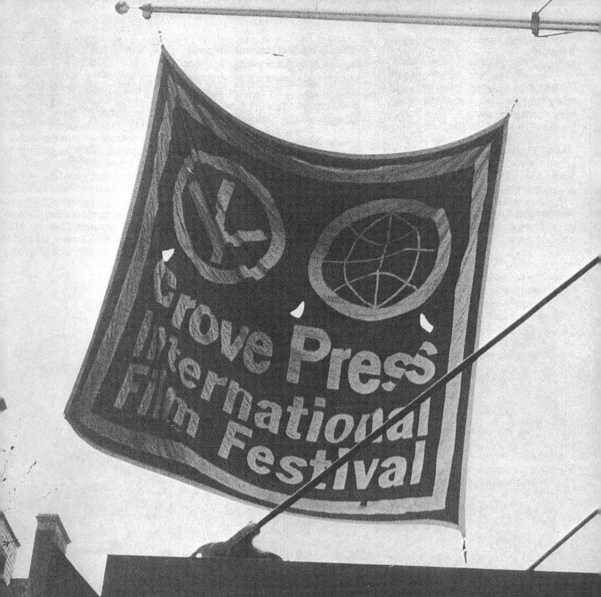

No. 5
$1.00

↓EVERGREEN REVIEW

THE CASE OF JAMES DEAN
By EDGAR MORIN

BECKETT JASPERS

ARTAUD RUMAKER

TUTUOLA H. D.

And others

Introduction

Ed Halter

Published by Grove Press from the late 1950s to the early 1970s, *Evergreen Review* is remembered as one of most important and influential journals of radical thought and politics, produced during the heyday of the American counterculture. Under the direction of Barney Rosset, Grove and *Evergreen* helped change the course of American publishing. Grove and Rosset grew famous for a long string of legal battles against censorship, fighting successfully to distribute banned books like D.H. Lawrence's *Lady Chatterley's Lover*, Henry Miller's *Tropic of Cancer*, and William S. Burroughs's *Naked Lunch*, and promoting international authors like Samuel Beckett, Marguerite Duras, and Jean Genet to American readers.

But *Evergreen*'s substantial contribution to the literature of cinema has been largely overlooked, and Grove's decisive role in the development of film culture has been nearly forgotten. During a turning point in film history—when the primacy of Hollywood was challenged by television and the music industry, international directors, and the American underground—*Evergreen* ran over a hundred essays and interviews about cinema. During this same period, Grove also branched out from traditional book and magazine publishing to become a groundbreaking film distributor, releasing new films from some of the era's most important international directors. One of its titles, the Swedish import *I Am Curious (Yellow)*, had a profound impact on the role of government censorship in motion picture exhibition, creating far-reaching changes in the American film industry as a whole.

Evergreen published the bulk of its film writing from 1967 to 1972; these same years saw some of the most tumultuous political events of the latter half of the 20th century. As society unraveled, then found new shape, *Evergreen* rode a bubble whose buoyant currency was the utopian dream of revolution. Vigorous, smart, and politically engaged, *Evergreen*'s articles about cinema read like documents from not just another time, but another world: an alternate universe in which Jane Fonda and Dennis Hopper are the only movie stars worth mentioning, directors cite Mao Tse-tung and Eldridge Cleaver as primary influences, film festival soirees end in police raids, and sexual explicitness is seen as an act of political rebellion.

Opposite: The first piece of writing on cinema to appear in the pages of *Evergreen Review* was "The Case of James Dean" by French filmmaker and philosopher Edgar Morin, featured on the cover of *Evergreen* No. 5, Summer 1958. The article was excerpted from Morin's study *The Stars: An Account of the Star-System in Motion Pictures*, published by Grove in 1960.

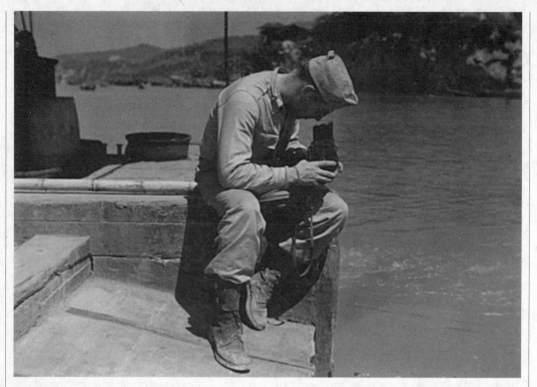

Rosset stationed in China with the US Army Signal Corps, 1942

"I was a filmmaker first. I think in images, not words."
— Barney Rosset

Born in Chicago in 1922 to a Russian Jewish father and Irish Catholic mother, Rosset developed a taste for an incendiary combination of art and politics at an early age. Though his father, a prominent banker, was politically conservative, young Rosset attended the private but progressive Francis Parker School, where he studied the Oedipus complex and read André Malraux. Extracurricular activities included anti-war lectures by teachers and political action by students. "I remember picketing *Gone with the Wind* when it came to town for being anti-Negro," Rosset later recalled.[1] Future cinematographer Haskell

Wexler was a close friend, graduating in the same class; Rosset and Wexler even served as co-captains of the school's football team. With Wexler, Rosset's first act of publishing was a mimeographed, hand-distributed broadsheet titled *The Anti-Everything*. Other classmates included Joseph Strick, later an influential film producer, and Joan Mitchell, who would become a major Abstract-Expressionist painter and Rosset's first wife; Rosset and Mitchell reportedly saw *Citizen Kane* on their first date in high school.

As a freshman at Swarthmore in 1941, Rosset submitted an essay on Henry Miller's *Tropic of Cancer*, not realizing the book was officially banned in the US until he bought an illegal, under-the-counter copy at New York's Gotham Book Mart. A restless youth, he transferred first to the University of Chicago, then the University of California, Los Angeles (UCLA) to study film. Only months later, he enrolled in the Army, and was sent to a Paramount studio in Queens, New York (now Kaufman Astoria Studios) that had been converted to a training school for the Army Signal Corps. Hollywood directors John Huston and Frank Capra were two of his instructors.

1 Unless otherwise noted, quotes from Rosset are taken from a series of audio-recorded interviews conducted by me (Ed Halter) between 2001 and 2003, while working with Rosset on the earliest versions of this collection.

Eventually Rosset was transferred to China, where he served as a second lieutenant of the Motion Picture Division. "I was the head of a unit for an area almost as big as the United States. [Documentarian] Ricky Leacock was in my unit, except we never saw each other because the Japanese were in between us," Rosset remembered.

Back in New York City after the war, Rosset formed the production company Target Films in 1947, largely with family funds. One of its first titles was a short documentary on street gambling, *Card Tricks*, made with Wexler, but soon Rosset would tackle a much bigger project. A mutual friend had introduced him to Leo Hurwitz, a seasoned leftist filmmaker who had made *Native Land* with Paul Strand, an early civil rights film narrated by Paul Robeson. In addition, Hurwitz and Strand had shot Pare Lorentz's celebrated New Deal–era documentary *The Plow That Broke the Plains*.

Rosset brought on Hurwitz to direct and edit the feature-length documentary *Strange Victory*, about the failures of post-WWII civil rights in the US. An ambitious compilation of wartime archival footage—including elements from Soviet and captured German archives—the completed film was billed as "the first exposé of racial persecution in America." Upon its opening at the Ambassador Theater in September 1948, *Strange Victory* was received warmly by the press; Rosset even received a personal letter of praise from W.E.B. Du Bois. But its critical tone was at odds with postwar optimism—not to mention rising anti-leftist sentiment against the film industry—and it attracted only meager American audiences. When Rosset traveled to Europe with the film, it played the Venice Film Festival and later

won prizes at festivals in Karlovy Vary and Marienbad. A Czechoslovakian film agency purchased *Strange Victory* for $3000, but this amount put barely a dent in its $80,000 production cost. Eventually, Rosset decided to unload the film and take a tax loss. "I finally sold it for one dollar to the Stanley Theatre, which was communist," he recalled. "And even they never showed it. They bumped it for something about the Pope." Hurwitz, in turn, became blacklisted in the film and television industries as a Communist sympathizer, at least in part due to his involvement with *Strange Victory*, and had to work under an assumed name for a decade.[2]

By the end of 1948, Rosset had enrolled in the New School for Social Research to complete his college degree. His bachelor's thesis was a screenplay adaptation of Alain-Fournier's 1913 novel of brooding adolescence, *The Wanderer (Le Grand Meaulnes)*. In the introduction to his script, typewritten on onionskin paper, Rosset declared his intention to explore "the relation of the film to the dream state,"[3] no doubt influenced by similar oneiric themes seen in contemporary experimental cinema of the time. Before Rosset submitted the script for his degree, he exchanged a series of letters with Alain-Fournier's estate, seeking to acquire rights to produce the novel as a motion picture. The author's heiress, however, would allow him to invest in the production only, demanding that she reserve the right to choose the film's producer, director, music, and more. Rosset declined, and the project was abandoned.[4]

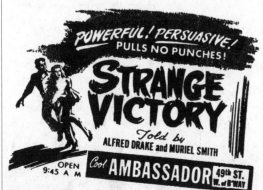

Original advertising image for *Strange Victory*

2 Rosset long remained proud of *Strange Victory*, even as it fell into obscurity. But the film has, over time, earned its place in the history of radical cinema. Prints of *Strange Victory* are held at two of the most important film collections in the world, at the Museum of Modern Art, New York and the Cinémathèque Française, and a restored version was released to theaters in 2016. Significantly, it was included by director Jean-Pierre Gorin in his 2007 series *The Way of the Termite* at the Austrian Film Museum in Vienna, a groundbreaking and discerning survey of essay films that traveled internationally; in the series' program notes, *Strange Victory* is lauded as "an epic poem of language, light and shadow." (Program notes archived online at https://www.filmmuseum.at/en/film_program/scope?schienen_id=1215680368485).

3 Barney Rosset, *The Wanderer* (bachelor's thesis, The New School for Social Research, 1951), 1.

4 During the 1950s, the first decade of Rosset's involvement with Grove Press, his activity in cinema seems to have been minimal. In 1951, for the Council

* * *

In 1951, tipped off by friends that a small publishing firm was available for sale, Rosset laid down $3000 for a failing entity called Grove Press, named for the West Village street where its founders' offices had been. The company's only assets upon purchase were unsold copies of the three books it had published; Rosset says he hand-carried the entirety of Grove's stock, in three suitcases, back to his apartment. In the next five years, Grove under Rosset grew into one of the most important publishers of contemporary literature in translation, introducing to American readers many of the writers Grove became famous, and infamous, for publishing.[5]

Founded in 1957 by Barney Rosset as a subsidiary of Grove Press, *Evergreen Review* began as a paperback-sized journal, switching to magazine format by 1964. In its first decade, *Evergreen* focused primarily on contemporary literature, and ran only a handful of articles on film, the earliest being "The Case of James Dean" by French filmmaker and philosopher Edgar Morin, in *Evergreen* #5 of Summer 1958, and musicologist André Hodeir's review of Alain Resnais's *Hiroshima Mon Amour* (1959), in *Evergreen* #12 of 1960. But by the mid-1960s, as Grove expanded its operations into film, theater, and other activities, and thus grew into a miniature, leftist version of the media conglomerates of later decades, *Evergreen Review* began devoting a major portion of its editorial content to cinema.

The first step in this expansion came in 1963, when Rosset established a new Grove subsidiary called Evergreen Theater, Inc., created "to originate and produce

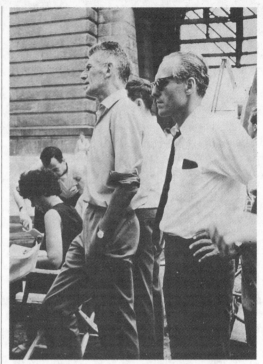

Samuel Beckett and Rosset on the set of Beckett's *Film*

motion pictures by prominent contemporary European writers and playwrights," according to its first press release.[6] Evergreen Theater's team consisted of Grove editors Richard Seaver and Fred Jordan, Grove legal counsel Edward de Grazia, and theater director Alan Schneider, who had directed *Waiting for Godot* and had recently scored a Broadway hit with *Who's Afraid of Virginia Woolf?* The new company would be headed by Rosset, who described its goals:

> Grove's entry into the motion picture field is a logical extension of our activity as publisher of the leading contemporary playwrights and novelists. It coincides with two important developments in the world of literature and film which tend to bring the two closer together: First, the growing interest among many important writers in the film as a means of artistic expression and, second, a growing world-wide audience for creative films which emphasizes the shift of the creative role toward the writer.[7]

of Living Theater, he prepared preliminary notes for a never-realized "dramatic film script on the American theater"; his research included visiting classes taught by Stella Adler and Sanford Meisner. In 1954, filmmaker Maya Deren invited Rosset to serve on the board of directors of the Creative Film Foundation, an organization formed to grant awards and funding to other independent filmmakers; other members of the board included writer Parker Tyler and exhibitor Amos Vogel, both of whom would later appear in the pages of *Evergreen*.

5 A comprehensive history of Grove can be found in S.E. Gontarski's "The Life and Times of Grove Press," published as the introduction to *The Grove Press Reader, 1951–2001*, ed. S.E. Gontarski (New York: Grove Press, 2001), xi–xxxix.

6 Grove Press, undated press release [*c.* 1963].

7 This quote appears in the press release "First Public Showing of Beckett's *Film* to be at 2 International Film Festivals," issued by Grove in 1965, but may have originated in earlier press materials.

Rosset's concept was indeed timely. In the wake of Hollywood's postwar decline, foreign films had taken on a new reputation in America for both artistic achievement and erotic explicitness. Not a few recent imports were by directors who had formerly worked as writers, playwrights, and journalists: Godard's *Breathless* (1960), Antonioni's *L'Avventura* (1960), Fellini's *La Dolce Vita* (1960), Truffaut's *Shoot the Piano Player* (1960) and *Jules and Jim* (1962), and Chris Marker's *La Jetée* (1962), for example. Films like these helped American urban intellectuals and university students cultivate a cinephilia both analogous to and overlapping with Grove's established literary following. The link between literary and cinematic art was underscored by the newly popularized notion of the *auteur*, which came into fashion among American film critics along with Nouvelle Vague directors who had fostered the notion. To Rosset, it must have seemed clear that the categorical divisions between authors, directors, and playwrights were becoming irrelevant; Grove would help push this development even further.

Soon after its creation, Evergreen Theater entered into a development deal with a company called Four Star Television to produce original scripts by Grove-allied writers. Cofounded by actors Dick Powell, David Niven, Charles Boyer, and Joel McCrea, Four Star had been the leading supplier of original productions (or "telefilms") for the growing networks, outpacing even the major Hollywood studios. Four Star specialized in anthology shows like *Four Star Playhouse* and *Dick Powell's Zane Grey Theatre*, as well as western series like *The Rifleman*, but its output had dropped dramatically following Powell's death in early 1963. In his memoir, Grove editor Richard Seaver remembers that Four Star approached Rosset on the strength of the success of Grove's playwrights, most notably Samuel Beckett, Harold Pinter, Eugène Ionesco, and Jean Genet. "Barney was in sixth heaven," Seaver writes. "The thought of edging his way back into film delighted him."[8]

In the fall of 1963, Evergreen Theater secured story treatments from five writers: Beckett, Ionesco, Pinter, Alain Robbe-Grillet, and Marguerite Duras. Requests were also made to Genet, Günter Grass, and Ingeborg Bachmann, all of whom ultimately declined. (Grass and Bachmann were the only two authors who had not previously been published by Grove.) Genet refused the proposal on artistic grounds, Rosset recounts:

> Genet was then and later a Grove author, but that did not keep him from angrily (though with a wonderfully comic effect) dismissing our proposal. Using the room's TV set as a prop, Genet explained to us—or at least to himself—that the little people on the screen were not really there. He proved this by walking to the back of the set. Where were they? He wanted "real actors."[9]

In a September 1963 article in the *New York Times*, Rosset gave hints about the nature of the scripts. Harold Pinter's story "might be described as a triangle set in an English basement … Ionesco's work, like his *Rhinoceros*, satirizes conformity by combining spy-thriller and comedy effects into one adventure." Duras's was "a love story set in a rural French town that uses the stream-of-consciousness effects of *Hiroshima* [*Mon Amour*]," while Robbe-Grillet's was "an unusual adventure set in a Caribbean locale." The Beckett, Ionesco, and Pinter films were planned as a feature-length anthology, with different directors for each segment. "I don't know which of these properties will be done first," Rosset is quoted as saying. "At the moment it looks as though the Beckett-Ionesco-Pinter trilogy, which is slated to be made in Ireland and France this spring, will be it. But it is all subject to change."[10]

These plans would indeed change. In the summer of 1964, the team shot the Beckett script, called *Film*, in New York, with Schneider as director. A minimalist narrative centered around a lone urban protagonist, it deals, as Beckett put it, with "a man trying to escape from perception of all kinds—from all

8 Richard Seaver, *The Tender Hour of Twilight: Paris in the '50s, New York in the '60s: A Memoir of Publishing's Golden Age* (New York: Farrar, Straus and Giroux, 2012), 318.

9 Barney Rosset, "On Samuel Beckett's *Film*," *Tin House*, No. 6 (Winter 2000), reposted on the Samuel Beckett On-Line Resources and Links website at http://www.samuel-beckett.net/lostnfound2.html.

10 A.H. Wheeler, "Pictures and People: International Projects in Prospect—Of Romy Schneider—Addenda," *New York Times*, September 8, 1963, X9.

perceivers, even divine perceivers … but he can't escape from self-perception. It is an idea from Bishop Berkeley, the Irish philosopher and idealist. 'To be is to be perceived'—'*Esse est percipi*'—The man who desires to cease to be must cease to be perceived. If being is being perceived, to cease being is to cease being perceived."[11]

Beckett traveled to New York for the production—his first and only time visiting the city. Rosset hired Boris Kaufman as cinematographer; the brother of visionary Soviet director Dziga Vertov, Kaufman was known to Rosset for his work with Jean Vigo on *Zero for Conduct* and *L'Atalante* (two of Rosset's favorite films) and had by then lensed major Hollywood productions like *On the Waterfront*. *Film*'s editor was Sidney Meyers, an old acquaintance of Rosset's who directed 1948's *The Quiet One*, a groundbreaking look at Harlem through a child's eyes, and, with Joseph Strick, the 1960 independent feature *The Savage Eye*. Zero Mostel was originally cast as *Film*'s protagonist, but became unavailable, so Schneider had flown to Hollywood to sign Buster Keaton for the role. Keaton accepted; it would be one of his final big-screen appearances prior to his death in 1966. The production took place in Lower Manhattan; writing after the fact, Schneider declared that Beckett remained in control of the film throughout: "With every new wavelet of contemporary cinema turning directors, in effect, into authors, it took the surprising author of *Film*, playwright Samuel Beckett, to become, not too surprisingly, its real director."[12] *Film* went on to premiere at the 1965 Venice Film Festival, made its US debut at the third New York Film Festival that fall, and then toured numerous international festivals. It won awards at Venice, Oberhausen, and a number of other cities.

Duras, Robbe-Grillet, Pinter, and Ionesco also completed screenplays for Evergreen Theater. At one point, Haskell Wexler was set to direct *Frank's Return*, the Robbe-Grillet script, but that project never came to fruition.

Both Duras's and Robbe-Grillet's scripts, however, became the basis for future works. Duras's script, bearing the working title *Lol Blair*, seems to have evolved into her novel *Le Ravissement de Lol V. Stein*, published by Grove in 1966. Robbe-Grillet, Rosset believes, incorporated elements of his script into later writings. Pinter's script, *The Compartment*, was later expanded by the playwright into a BBC television drama entitled *The Basement*, produced without Rosset in 1967. Ionesco's screenplay, *The Hard-Boiled Egg*, remained unrealized until 2006, when Rosset commissioned filmmaker James Fotopoulos to create a film using digital video and computer-generated animations.[13]

As Evergreen Theater pursued new directions in film, Rosset simultaneously sought increased attention for *Evergreen Review*. The goal, said Rosset, was "more distribution, more readers, more advertising."[14] In spring of 1964, *Evergreen* relaunched as a glossy, magazine-sized journal with four-color cover art and an increased run of 21,000. The new *Evergreen* took a little extra time to get into readers' hands, however. Thanks to a series of nude art photographs and a poem that included the line "Fuck the USA," the first two issues were seized at the printers by the Nassau County Vice Squad. The police action was later overturned by courts, and *Evergreen*'s new glossy format would help the journal reach a wider readership than ever before.[15]

* * *

11 This derives from an interview by film scholar Kenneth Brownlow, quoted in Barney Rosset, "Beginning to End: Publishing and Producing Beckett," in *A Companion to Samuel Beckett*, ed. S.E. Gontarski (Chichester, UK: Wiley-Blackwell, 2010), 55.

12 Alan Schneider, "On Directing *Film*," *Film by Samuel Beckett* (New York: Grove Press, 1969), 63.

13 Fotopoulos's *The Hard-Boiled Egg* premiered at the Museum of Modern Art, New York in May 2006, in a program presented by Rosset that included Jean Genet's *Un Chant d'amour*, Beckett's *Film*, and then-recently discovered outtakes from *Film*'s production. Fotopoulos and Rosset also co-directed an experimental video production, *working title (Shattered)* (2006), that eventually incorporated elements of Rosset's autobiography, his dream journals, and footage the publisher shot on trips to Thailand. Paul Cullum interviewed Fotopoulos and Rosset about their collaborations for the article "Samuel Beckett is Ready for His Close-Up," *New York Times*, December 4, 2005, http://www.nytimes.com/2005/12/04/movies/MoviesFeatures/samuel-beckett-is-ready-for-his-closeup.html.

14 Barney Rosset (interviewed by Ken Jordan), "The Art of Publishing, No. 2," *Paris Review*, Issue 145 (Winter 1997), 198.

15 According to Seaver, circulation for *Evergreen* nearly doubled after the switch to a "*Playboy*-sized" format. See *The Tender Hour of Twilight*, 367.

After Beckett's *Film*, the importance of cinema at Grove soon grew substantially. In January 1967, Grove announced the acquisition of the Cinema 16 Film Library, a property of Amos Vogel's famed film society Cinema 16, which had ceased regular programming in 1963 but continued in name as a nontheatrical distributor, mainly to universities. Purchased for around $50,000, the Library consisted of two hundred shorts and experimental works, including films by Georges Franju, Stan Brakhage, Carmen D'Avino, Peter Weiss, Agnès Varda, Kenneth Anger, and Michelangelo Antonioni. Grove, a longtime supporter of literary experimentation, now had the added distinction of distributing many of the finest works of the cinematic avant-garde.

The acquisition had pragmatic aspects as well. Grove's press release about the purchase declared that

> the Cinema 16 Film Library will serve as the basis for a new audio-visual program which Grove is developing … A major area of expansion for Grove films will be in the educational market, Mr. Rosset said. The Cinema 16 Library will be augmented with new films of quality, including avant-garde films and important works of modern drama, of which Grove is the leading publisher. Among the films to be added immediately are Eugène Ionesco's *The Lesson*, recently shown on Channel 13 in New York, and Samuel Beckett's *Film*, an international prize winner.[16]

In addition, a *New York Times* article on the deal reported Rosset as saying that "he thought that films from the Cinema 16 Library and new ones [like Beckett's *Film*] would, when shown in university communities, aid the sale of book copies of screenplays that Grove Press publishes. The publisher said another consideration in the film venture was that 'many of our best authors are making films and we want to keep in touch with them.'"[17]

Several other acquisitions that year rounded out Grove's burgeoning multimedia enterprise. Grove also bought the Mid-Century Book Club, increasing the reach of its 50,000-strong Evergreen Book Club, created for subscribers to *Evergreen Review*, by over 50 percent. The company purchased *Showcard*, an Off-Broadway theater playbill, renaming it *Evergreen Showcard*, and took out a ten-year lease on the Renata Theater at 53 East 11th Street in Greenwich Village. Grove moved its growing offices into the theater's building, then reopened the space as the Evergreen Theater, a venue for plays and films. Its first production, Michael McClure's *The Beard*, a one-act fantasy about Billy the Kid and Jean Harlow, opened that fall, featuring a light-show prelude performed with film strips and slide projections. Many, though not all, of the Theater's offerings were Grove properties; one of its most notable non-Grove bookings was a five-week run of Andy Warhol's feature *I, A Man*.

Grove became a public corporation in 1967; it first sold stock on the market that summer. Once a tiny operation, its staff began to grow to meet the demands of its many expanding interests. The company would employ over three hundred people by the late '60s. Edith Zornow, then producer of educational films for Channel 13 in New York, was hired to head a new Grove Press Film Division. Her background would be useful for Grove's interest in getting films into the educational market, which Rosset always considered Grove's primary and most reliable market for all its offerings.

Around this time, Grove began theatrically booking features in commercial theaters as well. The first slate included a handful of literary-related titles (Alain Robbe-Grillet's *L'Immortelle*, Norman Mailer's *Beyond the Law*, and Mary Ellen Bute's *Passages from Finnegans Wake*), documentaries (Allan King's *Warrendale*, Frank Simon's *The Queen*, and Frederick Wiseman's *Titicut Follies*), and international cinema (Jean-Luc Godard's *Weekend*). When two of its features—*Beyond the Law* and *Weekend*—screened at the sixth New York Film Festival in September 1968, Grove kicked up some attention as a film company by hosting a party at the event. As Rosset remembered it:

> We had a party for Godard and Norman Mailer at the Film Festival … at a big kind of nightclub they had at that time, for dancing or whatever. We rented the nightclub

16 Grove Press, "Grove Press Announces Two Major Acquisitions: Cinema 16 Film Library and Mid-Century Book Society," press release, January 10, 1967.

17 Harry Gilroy, "Grove Press Buys 2 Other Concerns," *New York Times*, January 5, 1967, 35.

across the street. Amos [Vogel] sent out the invitations. And you couldn't get in unless he clicked you off. So three really tough guys showed up. "We're getting in." "Oh no no, you're not on the list." "We're going *in*." Then they come charging into the party. They were left-wing hoodlums of that time. I'm standing at the door—the next thing I know, I'm on the floor and my glasses are rolling around. And I say, "What are you doing?" And they say, "Oh you guys are all conservatives," or some such horseshit. And I say, "Look at the walls!" I had put Brecht posters all over the place. They went, they looked, they said, "We're sorry," and they left. But Godard never showed up, and Norman Mailer hit his wife at the party—I mean slugged her.

The anarchic violence at Rosset's film festival party echoes events from earlier that year in July, when Rosset hosted Mailer at his estate in East Hampton, Long Island, which the writer used to shoot scenes for his film *Maidstone*. The production itself became a major press event: in his report for *Esquire*, James Toback noted encountering other journalists there from *New York* magazine, the *New York Times*, *Look*, *Life*, and other outlets.[18] Writing for *New York*, Sally Beauman described the setting at Rosset's place as "a surrealistic Buckingham Palace garden party [with] five camera crews and a steadily growing number of guests. A table has been set up under one of the trees, and it is laden with ice and cases of vodka, gin and Scotch. It's hot, and by two o'clock there's been a lot of drinking, but no filming."[19] The motley gang assembled included actors ranging from Rip Torn to Andy Warhol's Factory regular Ultra Violet, poets Paul Carroll and Michael McClure, prizefighter José Torres, documentarians D.A. Pennebaker and Richard Leacock—working as cameramen for Mailer's film—and various other members of the publishing, theater, and movie scenes, as well as some of Rosset's tony Long Island neighbors. Under Mailer's largely improvised direction, Beauman reported, the production proved chaotic:

> They go on filming late—until seven-thirty when the light is fading ... The Rossets' garden looks as if it had been the set for *La Dolce Vita*: bottles and people are scattered all over the lawn, one of the sound assistants is being quietly sick in the bushes, and an actor, drunk with exhilarating overthrow of inhibition, as well, perhaps, as the vodka, has waded into the middle of the swimming pool, minus bathing trunks, and refuses to come out ... The Rossets discover that Hervé [Villechaize] the dwarf, who cannot swim, is unconscious in their swimming pool. [Later,] happily, it's discovered that the problem is not the amount of water Hervé has swallowed, but the amount of alcohol.[20]

The Mailer episodes provide explosive examples of the confluence of literature and cinema that Rosset sought to orchestrate through Grove. "We intend to open our doors wide to movie people because we feel the barriers are now down between film and literature, with so many of our own writers, like Harold Pinter, Samuel Beckett, Marguerite Duras and Alain Robbe-Grillet, directly involved in moviemaking," Rosset told the *New York Times* in 1967, on the occasion of the theatrical release of Bute's *Passages from Finnegans Wake*.[21] If the lines between authors and filmmakers were breaking down, then so, too, might the distinctions between publishing houses and film companies.

In mid-1968, Grove Press issued its annual report for 1967 to its shareholders. Designed like an issue of *Evergreen Review*, the document celebrates Grove's entry into motion pictures as a major new initiative for the company, during a time when the company was seeing booming book sales as well.

18 Toback's December 1968 account, originally entitled "At Play in the Fields of the Bored," was excerpted and republished as introduction to *Maidstone*'s screenplay in *Maidstone: A Mystery* (New York: New American Library, 1971). Toback himself is today known as a screenwriter and director. His article re-edited and intercut excerpts from two other behind-the-scenes reports of the shoot, Sally Beauman's "Norman Mailer, Filmmaker," originally written for *New York* magazine's August 19, 1968 issue, and J. Anthony Lukas's *New York Times* piece from July 23, 1968, "Norman Mailer Enlists His Private Army to Act in Film."

19 *Maidstone: A Mystery*, 12.

20 *Maidstone: A Mystery*, 15–16. This episode features prominently in one of the very few extended studies of Rosset's involvement with cinema, an unpublished undergraduate thesis by Rachel Whitaker written in 2008 at Harvard University, "Beyond Books: Film Production and Distribution at the Grove Press Publishing House."

21 Howard Thompson, "Grove to Release New Joyce Movie," *New York Times*, September 14, 1967, 55.

In the past year, the company had begun theatrical distribution of feature films with *Passages from Finnegans Wake*, and was preparing the San Francisco release of Frank Simon's *The Queen*, a feature documentary on drag pageants that Grove had also invested in as producer; its Evergreen Theater was regularly screening "a fare of unusual films from our own film division";[22] and most importantly, films were being marketed through the company's college division in tandem with paperbacks, targeting university film societies, campus events groups, and classroom rentals.

"There were many other areas in which we branched out last year," the report states, "all part of an idea to develop Grove into a new kind of communications center of the sixties."[23] Throughout the celebratory 1967 annual report, it's clear that Grove wasn't simply aiming to make more money for its shareholders. Under Rosset, the company was radically reimagining the very nature of publishing in response to an age increasingly determined not just by the word, but the image.

* * *

For most of the 1960s, none of Grove's movie releases made any considerable amount of money. Like *Evergreen Review* itself, Grove's cinematic concerns were long viewed as loss-leaders, meant to attract more readers to their main business of selling books.[24] But one feature film brought far more attention—and income—to the Film Division than Rosset could ever have bargained for. While attending the Frankfurt Book Fair in October 1967, Rosset read a report in the Manchester *Guardian* about a Swedish movie called *I Am Curious (Yellow)*. Instinctively convinced the film was perfect for Grove, he flew directly to Sweden and purchased the US rights on the spot for $100,000—at the time, a generous sum. Directed by Vilgot Sjöman, a protégé of Ingmar Bergman, the film centers on Lena, a young female journalist played by Lena Nyman, on her journey of political awakening. Incorporating documentary footage and street interviews, the film analyzes class struggle and women's rights in Sweden through Lena's eyes. The film also includes some brief, softcore sex scenes, linking sexual liberation with political liberation.

Though hardly explicit by today's standards, *I Am Curious (Yellow)* drew scandal the moment it hit the US; at the airport, the print was seized by US Customs officials on charges of obscenity. Rosset immediately saw a parallel with his earlier battles over print censorship. In a prepared statement, he declared that *Curious* "may win for the film industry the same freedom afforded literature in the *Lady Chatterley's Lover* case."[25] Rosset's prediction was ultimately correct, though it took over a year's worth of federal and local court cases. As it had with *Chatterley* and *Naked Lunch*, Grove brought on notable star witnesses for the defense of *Curious* at its district court jury trial against US Customs, including Norman Mailer and film critics Stanley Kauffmann, John Simon, and Hollis Alpert. The jury found the film obscene and therefore unexhibitable. But in an almost unprecedented move, the ruling was later reversed by the US Court of Appeals, who declared that the film was not obscene under the Supreme Court's definition of the term, thus allowing the film to be distributed without legal barriers.

When *Curious* subsequently opened in New York in March 1969, at Evergreen Theater and the Cinema Rendezvous on West 57th Street, it was greeted with massive local and national press attention. Virtually every critic in America felt obligated to weigh in on *Curious*, but many journalists and op-ed pieces incorrectly claimed that the film included scenes of hardcore sex.[26] In the *New York Times*, Vincent Canby noted that *Curious* didn't show anything more explicit than did a number of Andy Warhol and Paul Morrissey's recent films, which played without legal

22 Grove Press, "1967 Annual Report," 2.

23 Ibid.

24 See Seaver, *The Tender Hour of Twilight*, 255.

25 "Grove to Fight U.S. Film Seizure," *Publishers Weekly*, February 5, 1968, 46.

26 For a bibliography of contemporary responses to *I Am Curious (Yellow)*, see Edward de Grazia and Roger K. Newman, *Banned Films: Movies, Censors & the First Amendment* (New York: R.R. Bowker, 1982), 297–98; for an academic study of the film's reception, see Kevin Heffernan, "Prurient (Dis)Interest: The American Release and Reception of *I Am Curious (Yellow)*," *Sex Scene: Media and the Sexual Revolution*, ed. Eric Schaefer (Durham, North Carolina: Duke University Press, 2014), 105–25.

uproar. Warhol's movies, though, did not need to pass muster with US Customs.[27] "When I attended the Rendezvous in the early afternoon, the crowds were large, mostly middle-aged and ruly," Canby wrote. "This week's landmark film doesn't seem to be unhinging the populace." *The New York Post* noted that crowds stood outside for over half an hour to see the film on its opening days. "Women constituted about 15 per cent of the afternoon audience. Only half of them were escorted," the *Post* reported. "The men ran the gamut of the population: an off-duty police officer, an insurance executive on a lunch hour, a stockbroker who first read about the film in the Wall St. Journal, a hooky-playing chemicals salesman and two roofers who said they would *never* let their wives see the movie."[28]

In its own marketing, Grove downplayed *Curious*'s sex appeal with simple, text-heavy print ads featuring only Nyman's face—though all ads contained the warning that "ADMISSION IS RESTRICTED TO ADULTS." As theaters benefited from around-the-block queues for many weeks, the phenomenon became its own selling point. That summer, ads for *I Am Curious* read, "350,000 New Yorkers have seen 'I Am Curious (Yellow).' How about you?" By the end of the year, Grove ran advertisements that bore the tagline "How to See 'I Am Curious (Yellow)' Without Standing on Line," and included a coupon that could be clipped and mailed to reserve a seat at the downtown Evergreen Theater.

Booking *Curious* became a careful matter for Grove; it was the first major national release it distributed. After successful runs in New York and Washington, Grove reportedly asked for $50,000 cash guarantees, paid in advance, for runs in Chicago and Philadelphia—an unprecedented sum for an art film, according to coverage at the time by *Variety.*[29] The industry journal also reported that theater owners were jockeying to book what had become known as "I Am Curious (Money)" due to its "cornucopia-like returns in New York."[30] As the film's distribution widened, the film was booked on a standard percentage deal in some locales; in other places, Grove rented out theaters—a practice known as "four-walling" in the business, which would become a popular practice of independent film distributors and film festivals in later decades. In Minneapolis, Grove even purchased a movie house outright just to show *Curious*, then sold the property when the run finished. Since state and city governments could still attempt to block screenings, an innovative strategy was devised whereby Grove hired local civil rights lawyers in each market, promising a percentage of *Curious*'s profits from the area in question. The plan largely worked: Grove won most of the dozens of cases that arose, while avoiding the enormous legal costs that had almost crushed the company following its *Lady Chatterley* case. *Curious* went on to pull in $6 million, coming only about a million and half away from toppling *La Dolce Vita* as the highest grossing foreign release of its day.

I Am Curious was not the only significant legal tussle over film for Grove. In September 1967, Rosset and other Grove staffers met with Frederick Wiseman regarding his first film, *Titicut Follies*, which depicts harrowing conditions at the Bridgewater State Hospital in Massachusetts, and which had already been scheduled to premiere at the upcoming New York Film Festival. The film hadn't sat well with Commonwealth authorities, who filed papers attempting to ban its screenings in Massachusetts and New York only a day before Rosset and Wiseman met. As a back-and-forth continued in the courts, *Titicut* still screened at the film festival, and Grove followed up with decent runs at Cinema

27 Vincent Canby, "I Am Curious (Yes)," *New York Times*, March 23, 1969, D1.

28 Judy Michaelson, "The Curious Line up for 'I Am Curious'," *New York Post*, March 12, 1969, 46.

29 Kent Carroll, "Grove Asks Cash, Ahead, $50,000," *Variety*, April 9, 1969, 5.

30 Morry Roth, "What Price All That Erotica?," *Variety*, April 9, 1969, 5.

Button worn by protesters in the events leading up to the occupation of Grove's offices in 1970

Flyer advertising a program of psychedelic short films available for booking, Grove Press Film Division, late 1960s

Rendezvous and the Carnegie Hall Cinema through the fall, booked under the aegis of a newly-formed corporation, the Titicut Follies Distributing Co. By November, however, Grove canceled plans to expand the film nationally due to the ongoing legal action.[31] After a 1969 court decree was modified to allow noncommercial exhibition of *Titicut*, Grove switched to exclusively nontheatrical distribution of Wiseman's film, selling over a hundred prints of *Titicut* to universities and libraries.[32] Wiseman, however, disputed Grove's financial accounting, filing his own complaint against the company in 1972,[33] and self-distributed the film in 1977 once his rights reverted. Ultimately, *Titicut Follies* remained banned from distribution to the general public until 1991.

"It's so foolish," Rosset told the *New York Times Magazine* in 1968, responding to the ongoing struggle over *Titicut*. "There's clearly an overriding public good in showing what conditions are like in such institutions. The film doesn't even say it's anyone's fault. We thought the authorities would say, 'You're right, conditions are terrible, but we don't have the money to correct them'—which is probably true. Instead of fighting the exposure, they could have used it to get the money. Censorship is always foolish."[34]

* * *

Aided by the massive attention—and income—from *Curious*, film went into full swing at Grove. By the end of 1969, its Film Division was handling over four hundred titles, mostly short films. Grove's film catalog would

31 Thomas W. Benson and Carolyn Anderson, *Reality Fictions: The Films of Frederick Wiseman* (Carbondale and Edwardsville: Southern Illinois University Press, 1989), 49–55.

32 Ibid., 90.

33 "Fred Wiseman vs. Grove Re 'Titicut'," *Daily Variety*, March 2, 1972, 3.

34 Gerald Jonas, "The Story of Grove," *New York Times Magazine*, January 21, 1968, 59.

eventually include titles by some of the most adventurous directors of the time—William Klein's *Mr. Freedom* and his Muhammad Ali documentary *Float Like a Butterfly, Sting Like a Bee*; Alain Robbe-Grillet's *L'Immortelle* and *The Man Who Lies*; Nagisa Oshima's *Death by Hanging* and *Diary of a Shinjuku Thief*; Godard's *Weekend*; Dušan Makavejev's *Innocence Unprotected*; Susan Sontag's *Duet for Cannibals*; Robert Downey's *No More Excuses* and *Chafed Elbows*; and Věra Chytilová's *Something Different*. These films reflected both the political sensibilities and formal innovations of Grove's authors. Editor Fred Jordan noted, years later, that a shared interest in the "distortion of narrative structure" could be found across Grove's literary and cinematic offerings: "That was the whole point of experimental writing, experimental filmmaking," he recalled, "changing the way the story was told."[35]

Evergreen switched to a monthly format in 1968, and much of the increased space was filled with writing about cinema. Beginning in early 1969, *Evergreen* began running exclusive translations from *Cahiers du cinéma*, including interviews with Ingmar Bergman, John Cassavetes, Jacques Demy, Roman Polanski, Glauber Rocha, and Miklós Jancsó. Regular reports on film were filed by future Hollywood screenwriter L.M. Kit Carson, critic Nat Hentoff, and counterculture journalist Dotson Rader. In the book division, too, film became a new focus, as Grove published a series of photo-illustrated screenplays from Bergman, Antonioni, Beckett, Godard, Kurosawa, and Truffaut (indispensable for the growing numbers of college film courses in the days before VCRs),[36] as well as Parker Tyler's *Underground Film: A Critical History*, one of the first book-length studies on American experimental film.

Around this time, the company created numerous advertising flyers and specialized catalogs on themes that might resonate with the college market. For example, a flyer for "Women Filmmakers" recommends an eighty-eight-minute program that includes Maya Deren's *Meshes of the Afternoon*, Carolee Schneemann's *Fuses*, and Agnès Varda's *L'Opéra-Mouffe*; a brief catalog of Grove's films on "Sexual Experience" includes films by Stan Brakhage, Gunvor Nelson, James Broughton, and Will Hindle; and a flyer simply entitled "From the Liberated Underground" lists Jean Genet's *Un Chant d'amour*, Kenneth Anger's *Scorpio Rising*, and the Cockettes's drag spoof *Tricia's Wedding*—a coded signal to the nascent Gay Liberation crowd. In other promotional materials, Grove touts films from the People's Republic of China, films for "Afro-American Studies," and a psychedelic package entitled "The 24 Frame Per Second Mind Excursion."

Amos Vogel, long allied with Rosset and Grove, joined the company in 1969 as "film consultant" and film editor of *Evergreen Review*, where he was hired to "be in charge of an expanded film section, with special emphasis on contemporary cinema and translations from international film magazines." Vogel's public statement about the hire poetically expresses the historical moment at which Grove then seemed poised:

> I have joined Grove because I believe it has the potential to become a major force for modern cinema in America. This movement—encompassing Godard as well as Brakhage, the avant-garde and the independents, the young political filmmakers as well as the explorers of a new esthetic—requires new patterns of distribution, exhibition, production and publicity, a willingness to utilize new technological tools and an openness to the 'sub-version' of established, already ossified norms and techniques. Grove's resources and well-known predilection for modernity, unorthodoxy and artistic freedom provide this possibility. I should like to help realize it.[37]

Vogel was sent to international festivals to acquire new films, bankrolled on the booming cash-flow from *Curious*. According to

35 Author interview with Fred Jordan, March 26, 2016.

36 Grove pioneered the illustrated screenplay as a publishing format, and their designs included many innovative strategies for translating unconventional films to the printed page. See Loren Glass, "Booking Film," in *Counter-Culture Colophon: Grove Press, the Evergreen Review, and the Incorporation of the Avant-Garde* (Stanford, California: Stanford University Press, 2013), 173–91 and Mark Betz, "Little Books," *Inventing Film Studies*, eds. Lee Grieveson and Haidee Wasson (Durham, North Carolina: Duke University Press, 2008), 319–50.

37 Grove Press, "Amos Vogel Named Film Consultant to Grove Press and Film Editor of *Evergreen Review*," press release, undated [1969].

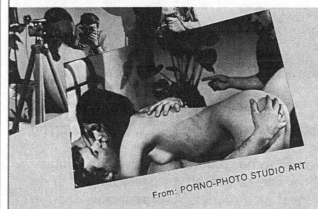
Page from Evergreen Club mailer, late 1960s

Rosset, Vogel and Grove editor Fred Jordan were tracked by both the FBI and Czech secret police while abroad; nevertheless, Vogel managed to acquire films by young Eastern European directors like Jaromil Jireš.

Another major project undertaken by Vogel was the Grove Press International Film Festival, which screened twelve Grove-distributed features at three New York venues in March 1970, accompanied by a program guide designed like an issue of *Evergreen Review*, with articles and interviews written by *Evergreen* contributors. The event included Ousmane Sembène's *Mandabi*, Oshima's *Boy*, Glauber Rocha's *Antonio das Mortes*, and Duras's *Destroy, She Said*. The Festival kicked off an innovative distribution plan: all titles would be available simultaneously for theatrical release at arthouses as well as non-theatrical showings at universities and secondary schools. (*Mandabi*, for example, was distributed to New York public high schools as a tool for teaching about contemporary Africa, accompanied by a twenty-three-page discussion guide and bibliography for educators.) The event garnered healthy attention in the trades; the *New York Times* noted that

conceivably, if New Line, Grove (with its current Grove Press International Film Festival of 12 films), Janus and other distributors can succeed in finding a public for films that would probably collapse in regular theaters, it will provide further impetus for the production of the kind of films that the major producers simply are not geared to handle.[38]

For the growing 8mm home market, Evergreen Club began selling 8mm reduction prints of films, ranging from Charlie Chaplin shorts, to experimental works by Stan Brakhage and Stan VanDerBeek, to vintage hardcore pornography and a handful of original hardcore short films shot by Kent Carroll in Denmark. Films by revered artists like Brakhage were sold alongside retro smut silents in Evergreen Club's cheeky "adults only" catalogs, years before the home video revolution would bring sexually explicit films into consumers' homes.[39]

Selling 8mm home versions of films through Evergreen Club may have led Rosset to pursue a speculative plan that was years ahead of its time: a home video version of *Evergreen Review*. Companies like Motorola, Sony, and CBS were then busy developing separate home video systems for the consumer market. Rosset saw a new opportunity opening up and compiled a 16mm prototype of "Evergreen Cinema" which he screened at a number of college campuses.[40] In a front-page article entitled "'Evergreen' Vidmag for Cassettes Piloted, with All the No-Nos for TV," *Variety* saw Rosset's idea as potentially revolutionary, bringing films to viewers in their homes, where community censors presumably would not be able to follow:

Nielsenless, sponsorless, networkless, stationless and blipless programming for the home bijou is in the works. Such massive unburdening of the tube portends limitless horizons. Adult tv. Polemic tv. Obscene tv. Unpatriotic tv … try to imagine CBS News' "60 Minutes" or NBC News' "First Tuesday" [with] the radical lib of Godard instead of the double-think of Stan Stunning on the nightly news.[41]

As the introduction to an unusually lurid profile of Rosset in *Life*, writer Albert

38 Vincent Canby, "What Godard Hath Wrought," *New York Times*, March 29, 1970, 77.

39 In an extended analysis of Evergreen Club's efforts, scholar Erika Balsom reads in these catalogs an "almost utopian wager that art and erotica might find common ground." Grove, she argues, participated in "an inchoate moment before the consolidation of the adult film industry when it remained possible to straddle categories that have since ossified in such a manner so as to often render them mutually exclusive." Erika Balsom, *After Uniqueness: A History of Film and Video Art in Circulation* (New York: Columbia University Press, 2017), 67.

40 When I was working with Rosset, he was very keen to find this reel, but as of this writing it hasn't been located. The Grove Press Records, Special Collections Research Center, Syracuse University Libraries hold an undated memo from the company listing the following lineup:

EVERGREEN CINEMA, VOL 1, No. 1
1. 3.145
2. Evergreen Cinema Titles
3. In This Issue:
4. BLACK TV [by Aldo Tambellini]
5. PAINT
6. T HOME (substituted for Hampton Beaches)
7. THANK YOU MASK MAN [by Jeffrey Hall]
8. Maidstone sequence
9. DARLING PLAYINGS (silent-will be sound)
10. MR. FREEDOM [by William Klein]
11. FUNERAL OF JAN PALACH
12. Logo

41 Bill Greeley, "'Evergreen' Vidmag for Cassettes Piloted, with All the No-Nos for TV," *Variety*, December 2, 1970, 1, 43.

Goldman imagined the publisher's zeal for innovation in rhapsodic terms:

> His theory goes something like this: The movie industry! Mohair tycoons worrying about films that cost millions, worrying about moral-ratings codes, worrying about how to please everybody. It's time to scale the movies down to human proportions. The moving picture camera today is just a very expensive typewriter. A Hollywood director can go home, like the young writer used to go home from the ad agency, and knock out a very good movie for $50,000. It's possible to take that movie and squeeze it into a cassette videotape the size of a book. And then one evening, when the kids are in bed, you can slip that cassette into your TV set and, without getting dressed or driving the car, you can watch *Tropic of Cancer* or *Story of O* right in your own living room—where the censor can't go.[42]

While Goldman stressed the anti-censorship angle of video distribution, there were more pragmatic financial incentives as well. In some of *Variety*'s coverage of this project, Rosset referred to the prototype as a "cinemagazine" with a single "editorial viewpoint" that could be distributed as a 35mm theatrical release, a 16mm nontheatrical release, or 8mm home versions, with "video tape cassettes as a more distant possibility."[43] Elsewhere, he focused more on the coming future of "videotape to be played in the home over existing tv sets," stating that he had been encouraged by the development of quarter-inch tape in Japan (the format that would eventually be used as VHS). "His idea is to make 'specialized' product directly on the tape cheaply enough so that a profit could be realized after selling only a few thousand reels."[44] Thus Rosset's "cinemagazine" would have not only brought an editorial sensibility to the moving image, but also reduced the costs of film distribution to the point that they could approach that of book and magazine publishing.

* * *

While the Film Division increased its distribution offerings, *Evergreen Review* continued to publish substantial pieces on film, with particularly active coverage from the years 1967 to 1973. In keeping with Grove's role in forging new directions in cinema, *Evergreen*'s writing never reads like armchair reflection or fawning fandom. Rather, it feels fully engaged in both the creation and critique of an insurgent cinematic counterculture, in its overarching vision of a society renewed through revolutionary ideas. There are no typical reports from Cannes or the Oscars; one instead reads about visits to Warhol's Factory, erotic film festivals in San Francisco and Copenhagen, and the sets of porn productions. But while *Evergreen* generally endorsed the liberation of Eros (and the erotics of liberation), there was little cheerleading. Rather, a wearily sarcastic tone runs through these "notes from the underground" (the title of *Evergreen*'s front-of-the-book column), evincing a supportive but semi-skeptical curmugeonism designed to prick the counterculture's inflated self-image. At the premiere of Charles Henri Ford's *Johnny Minotaur* at the Bleecker Street Cinema—an erotic film shot on Crete with naked, barely-pubescent local boys—journalist Tom Seligson noted the assortment of attendees: novelists Sol Yurick and Hortense Calisher, Warhol stars Holly Woodlawn and Jackie Curtis, German prince Egon von Fürstenberg, actress Sylvia Miles, and Patricia Buckley, wife of the era's most prominent conservative intellectual. "There's a quiet desperation to *Johnny Minotaur*, apparent not only in its hedonism and indiscriminate search for satisfaction," Seligson observed, noting the strange sight of the German prince smoking angel dust. "The underground, rebelling for the last fifteen years against the sterility and hypocrisy of straight culture, suddenly seemed terribly weak and flaccid. And, like one of the interviewers in Ford's film who yawned while watching a love scene between two boys, it seemed cynical and bored."[45]

The "you-are-there" mode of documentary reporting was one of *Evergreen*'s most

42 Albert Goldman, "The Old Smut Peddler," *Life*, August 29, 1969, 49.

43 "Rosset to 'Compile' Odd-Lengthies," *Variety*, September 17, 1969, 5.

44 "Grove's Rosset: All Censors Wrong, Valenti is Encouraging Vigilantes: Forsees Vidtape Feed to Homes," *Variety*, September 17, 1969, 25.

45 Tom Seligson, "Perverse Chic," featured in this volume, as are all other film articles mentioned below.

distinctive features. The reports read like mini-movies themselves, made not with cameras but tapped out on IBM typewriters, creating virtual time capsules of the micro-politics and emotional feel of the contemporaneous film scene.[46] In other articles, Amos Vogel lambasted H. Rap Brown for shilling Paramount's Uptight. (Later author of Film as a Subversive Art, Vogel had little time for capitulation to mere market forces.) Beat novelist Seymour Krim sheepishly struggled with his own sexism in the face of Jane Fonda's radical celebrity, and Sara Davidson (one of only two women who wrote about film for Evergreen) noted that the odd educational porn films of sexologists Phyllis and Eberhard Kronhausen, while theoretically liberatory, also caused her to lose her appetite. Evergreen—a magazine that never shied away from publishing erotic photography or selling itself as the unofficial voice of the underground—was also suffused with critiques of pseudo-radical pleasure-seeking and the marketing of political movements, even as its own pages ran ads from record companies and other publishers marketing their wares to the Now Generation.

Evergreen was just as impassioned, but less ironic, in its coverage of politics and cinema. Novelist Julius Lester riffed on black Americans seeing African culture depicted in Ousmane Sembène's Mandabi, Tom Seligson compared Hollywood images of Native Americans with real-life trips to reservations, and Nat Hentoff called for documentarians to turn their cameras onto the everyday middle-class as a form of self-critique. (Hentoff, who would later become one of the Left's most important political essayists though his column in the Village Voice, provided often agitative film pieces for Evergreen. In his back-of-the-book column, he frequently reviewed films by reviewing the reviews of other film critics.)

In interviews with directors from Europe, South America, and Asia, the discussion was as much about struggles for revolution as it was about cinematography. The challenge that international cinema and American independents posed to Hollywood ran through interviews with American filmmakers like Arthur Penn, Dennis Hopper, John Cassavetes, and the makers of Woodstock. The tone is urgent, the mood one of steely determination, and the question is whether these young turks will be absorbed by the old system, change it from within, or simply create their own, politicized industry outside of Hollywood.

While cultivating the best writers of the '60s generation, Evergreen also incorporated perspectives from members of the avant-garde who came of age in earlier years. Poet and critic Parker Tyler wrote the first of his many Evergreen articles in 1967, an essay on Andy Warhol's early Factory films, and contributed many essays on film and other topics throughout Evergreen's run. Insider politics were as much fair game as mainstream politics. Amos Vogel courted a bit of film-world sensation in the June 1967 issue with a critique of the New American Cinema, an emergent independent scene centered around New York journalist, filmmaker, and impresario Jonas Mekas. Called "13 Confusions," its incendiary tone was answered by a collection of responses from Mekas, Tyler, filmmaker Gregory Markopoulos, theater manager Dan Talbot (later founder of arthouse distributor New Yorker Films), critic Richard Schickel, and scholar Annette Michelson.

* * *

Though the Grove Press International Film Festival was considered a critical success, its subsequent booking strategy garnered meager results. At least partially responsible was the fact that Grove soon became embroiled in a tumultuous political struggle from within. While Grove's warehouse staff was unionized, its editorial staff—like that of other publishers at the time—was not. On April 8, 1970, several Grove employees took out union cards at a rally by the Publishing Employees Organizing Committee of the Fur, Leather, and Machine Workers' Joint Board. In the following week, nine of them were fired from Grove, including editor Robin Morgan, today known as a groundbreaking feminist activist.[47] On April 13, while Rosset

46 In this regard, Evergreen often engaged in a mode later named by writer Tom Wolfe with his 1973 anthology The New Journalism.

47 Among other actions, Morgan edited the anthology Sisterhood is Powerful, published later that year by Random House; the book has been credited with helping jump-start a wider movement for Women's

was in Europe, Morgan returned with nine other women (who were not former employees) and occupied Grove's executive offices, wearing buttons that read "We Are Furious (Yellow)." Flyers listed demands for "no more business as usual for Grove Press and *Evergreen* Magazine," charging Rosset with making money off leftist politics and sexist erotica. *Evergreen* was denounced as "hypocritical radicalism" and "anti-women propaganda." One salvo appeared to specifically target *I Am Curious (Yellow)*:

> No more peddling of Grove movies that offer nudity as "sexual liberation" but present women as "hung-up" and men as "liberated," and that force women to act out their bestialized oppression while the whole world is watching, making Rosset rich![48]

Another leaflet from the occupation states that "Grove Press and its subsidiaries Evergreen Review, Grove Films, and other corporate enterprises have earned millions off the basic theme of humiliating, degrading, and dehumanizing women through sado-masochistic literature, pornographic films, and oppressive and exploitative practices against its own female employees," and demanded that "all publication of books and magazines, and all distribution of films, that degrade women must be stopped immediately."

The notion of political radicals trying to shut down what was probably the most far-reaching leftist media enterprise of its day is, of course, rife with the complex ironies of its historical moment. The feminists who took over Grove's building in part protested the financial success of *I Am Curious (Yellow)*, a film they viewed as exploitative of women, but Rosset argued, years later, that "that film was a very serious film about women's rights." To be sure, at least some of the erotic art and literature published by Grove and *Evergreen* was, in fact, by women: Marguerite Duras, Phyllis Kronhausen, Mary Ellen Mark, and Betty Dodson, to name only a notable few. From today's vantage point, however, it's clear that *Evergreen* as a whole was decidedly geared towards the (largely)

heterosexual[49] male reader: throughout its run, the majority of its writers were men, and after its switch to magazine format, it frequently featured a four-color cover image of a beautiful, often scantily-clad woman to entice customers.

After police took away the feminist occupiers, Grove's lawyers defended them in court. When Rosset conceded to allow a vote at Grove whether to unionize, Grove employees ultimately voted against unionization. But ongoing actions against Grove during this time took their toll. "We couldn't do business," Rosset recalled. "The company came to a dead halt. All day long we were on the street with emergency calls, fire alarms, bomb threats, so that we were going in and out of the building. There was no business. It was just gone. Many people were fired or left." For years, Rosset long harbored suspicions that the action was, at least in part, instigated by outside forces, much as the CIA had fomented dissent within other leftist groups of the period. Morgan, however, chronicled the event as a "strategic success" that would prove to be "the first such militant move taken in the current feminist wave."[50]

Grove did not, however, shy away from its vision of radical film. Only days after the feminist occupation, Jean-Luc Godard and Jean-Pierre Gorin arrived at Grove's offices. As the "Dziga Vertov Group," the pair had made *Pravda* and *British Sounds* (retitled as *See You at Mao*), two radically experimental features that Grove had paid $6000 to distribute stateside. With a production agreement from Grove—reportedly a five-picture deal with an investment of $25,000 per film—the

Liberation in the US and beyond.

48 Copies of the original fliers are held at the Grove Press Records, Special Collections Research Center, Syracuse University Libraries.

49 Though male-dominated, *Evergreen*'s writing is far from exclusively heterosexual; its vision of sexual liberation included a strikingly open discussion of homosexuality as part of the counterculture, years before Stonewall. Parker Tyler especially wrote from a queer perspective, as did Dotson Rader, who would obliquely chronicle his life as a male hustler in his 1971 novel *Gov't Inspected Meat and Other Fun Summer Things*. In many ways this attitude would follow from Grove's offerings in literature, which included homoerotic works by Genet, Yukio Mishima, John Rechy, and William S. Burroughs. Grove Film Division carried many early and important gay films, most notably *Funeral Parade of Roses, Scorpio Rising, The Queen, Tricia's Wedding*, and *Un Chant d'amour*.

50 Robin Morgan, "On Violence and Feminist Basic Training," *Going Too Far: The Personal Chronicle of a Feminist* (New York: Random House, 1977), 132–33.

pair were working on two other Dziga Vertov Group projects.[51] Grove seemed eager to promote Godard as one of their own. Along with Grove staffer Kent Carroll—who had joined Grove to oversee film matters after a stint as a reporter for *Variety*—Godard and Gorin embarked on a US college tour with *See You at Mao*. *Evergreen* ran an interview with the pair by Carroll, along with a new translation of revolutionary Soviet filmmaker Dziga Vertov's "We: A Manifesto." Part of this tour formed the basis for Ralph Thanhauser's documentary *Godard in America*, which Grove Films also distributed. But according to Carroll, the French Marxist didn't quite mesh with either Rosset's vision or the campus culture of the time. "You got turnouts because of who he was, and it was a new film and he was going to talk, and so we'd fill up an auditorium. But by and large, response wasn't good," Carroll recalls. "I knew a lot of people through Grove who were politically committed in one form or another. But that kind of ideological European politics was foreign to most Americans."[52]

Following this period of Grove's unrest, one of the ongoing *Curious* cases went to the Supreme Court. In a case against Maryland (the only state which then still had its own censorship board), the Supreme Court issued a deadlock 4–4 verdict in the spring of 1971, thereby upholding the lower court's ban on the film. Justice William Douglas abstained from voting, having discovered that his publisher sold an excerpt from his book to *Evergreen Review*. Though the Court's decision was not technically a victory, by then the issue had already been settled in the eyes of the public. *I Am Curious (Yellow)* had become a national topic of discussion, and its record-breaking box-office earnings helped knock down the barriers to the theatrical distribution of sexually explicit films. Grove's legal counsel Edward de Grazia later wrote that the film's case "was widely considered to have broken the grip of governmental interference with the depiction of sexual love-making on the screen."[53]

But by this point, Grove and *Evergreen* were falling into financial decline—in part due to its reinvestment of too much of *Curious*'s box-office revenue into expensive new motion-picture initiatives; in its 1969 Annual Report, the company stated it had offered advances to filmmakers on twenty foreign feature-film projects in the past year.[54] "*I Am Curious (Yellow)* was a big success," Rosset explained. "Because we made a lot of money, I went and bought a lot of foreign films—which were no longer viable because all the art theaters had closed down, overnight, in 1970. They had started showing X-rated porno films. There had been a big market for foreign films in this country, and suddenly it was gone. *I Am Curious (Yellow)* played, that was the end. We killed our own market."[55] Indeed, by the early '70s, the former Evergreen Theater had been renamed the Soho Cinema and, under new ownership, shifted to a program of gay porn. In retrospect, some staffers (Rosset included) felt that Grove devoted too many resources on the risky move into film, and not enough on their core business of publishing books.

* * *

Despite waning financial prospects, Grove's Film Division had gained a reputation as one of the most important collections of cinema. In 1972, the American Film Institute in Washington, DC presented a week-long retrospective of films from Grove at the Kennedy Center; Rosset was the first independent distributor to be honored by the AFI. In 1973, the newly formed Pacific Film Archive at Berkeley ran an even more comprehensive retro, citing Rosset's achievements "in the most challenging areas of independent filmmaking—the American underground, the political cinema of Europe and the Third World, and the cinema of personal expression in Eastern Europe."[56]

One of the films on view at the PFA's retrospective was a Rosset–Godard "collaboration" that has probably been rarely screened

51 Financial figures are noted in Richard Brody, *Everything is Cinema: The Working Life of Jean-Luc Godard* (New York: Henry Holt, 2009), 354–55.

52 Author interview with Kent Carroll, July 23, 2002.

53 De Grazia and Newman, *Banned Films*, 299.

54 Grove Press, "1969 Annual Report," 2.

55 Rosset interviewed by Jordan, "Art of Publishing, No. 2," 212.

56 Exhibition catalog, "A Tribute to Grove Press: Films of Protest and Personal Expression," May 18–25, 1973, Pacific Film Archive, Berkeley, California.

since. In 1971, Godard and Gorin delivered one of their Dziga Vertov features, entitled *Vladimir and Rosa*, into which Grove had invested $25,000. The project had originally been planned as an adaptation of Marx's *18th Brumaire of Louis Bonaparte*. Godard later told Rosset the film would be a political fantasy about Vladimir Lenin meeting Rosa Luxemburg during the Paris rebellions of 1968, yet the final product turned out to be a fictionalized rendering of the Chicago Seven trial, with French actors playing characters based on Bobby Seale, William Kunstler, Jerry Rubin, and Abbie Hoffman. Disappointed, Rosset invited Rubin and Hoffman to watch *Vladimir and Rosa* with him at Evergreen's offices. "The film was a travesty," Rosset recalled, "and they ranted and insulted it from the first word on. They were so snide. I think they were hopped up on LSD, but I don't know." At that moment, Haskell Wexler happened to stop by. Rosset took advantage of the opportunity and had Wexler's crew shoot Portapak video footage of Rubin and Hoffman mocking Godard's film, and later spliced excerpts into the print of *Vladimir and Rosa*. The new film, called *Vladimir and Rosa and Jerry and Abbie*, was screened with the original at the PFA retrospective.

Evergreen's final issues came out in 1973, as the American counterculture it chronicled began to splinter into the more fractured politics of the '70s.[57] And as the erotic revolutionary ideals of the previous decade gave way to depoliticized Hollywood stabs at X-rated entertainment, one of *Evergreen's* final issues of the era marked the transition. In 1973, an entire special issue was devoted exclusively to a single film, Bernardo Bertolucci's *Last Tango in Paris*, starring Marlon Brando. The film had not yet hit US theaters, but was already causing a critical ruckus for its reportedly explicit sexual content. The issue assembled a formidable roster: alongside *Evergreen* regulars Dotson Rader, Parker Tyler, and Nat Hentoff, it featured contributions from literary figures Norman Mailer, Alberto Moravia, and Fernando Arrabal.

When the film's distributor, United Artists, refused to issue press photos prior to *Last Tango's* release, Kent Carroll asked a projectionist he knew in Paris to clip frames from a print of the film. Carroll's girlfriend at the time was an airline flight attendant; she hid the stolen images in her clothing and brought them back to *Evergreen's* offices, where they were used to illustrate the special *Last Tango* issue.

With its theatrical bookings basically shut down by 1971, Grove became almost exclusively an educational and nontheatrical distributor. The Film Division continued to acquire titles for these purposes: some late additions of the 1970s included Toshio Matsumoto's *Funeral Parade of Roses*, Gerard Damiano's X-rated *The Devil in Miss Jones*, and Michael Beckham and Allan Segal's exposé *The Rise and Fall of the CIA*. The Grove Press archives at Syracuse University include a few choice examples of film booking correspondence from the 1970s. In 1972, the Columbus Gay Activists Alliance in Ohio rented *Tricia's Wedding* and *The Queen* for two screenings, and wrote in later to request a reduction in their invoice since "we were only able to have one showing because of the riot on the OSU campus that night." In 1974, a chapter of the Phi Kappa Tau fraternity in Minnesota attempted to host a screening of *The Devil in Miss Jones*, but had to move the event off-campus. "There is a good-sized bar outside of the city limits that will let us put the movie on there," a handwritten letter from a fraternity member states. "He has done stuff like having strippers and can get away with it."

In the mid-1970s, Grove outsourced its film bookings to the company Films Inc., taking itself out of active operations in film distribution. In 1979, according to archived correspondence in the Syracuse archives, Rosset and Francis Ford Coppola discussed plans for Coppola's company to acquire equity in Grove in exchange for a percentage of the profits from *Apocalypse Now*, a deal that never materialized. As Grove continued to lose money, Rosset finally sold the company to two investors for around $2 million, hoping to improve its prospects, but after the contract was signed, the new owners quickly dismissed him from the company he had built. Rosset retained control of *Evergreen*,

57 A single revival issue of *Evergreen Review* was released in the '80s; Rosset revived the journal as an online publication in the late '90s, which was maintained up to his death in 2012. In 2015, publishers O/R Books announced that they would be reviving *Evergreen Review* as a new publication, working with Rosset's estate.

which he had hoped to revive, but the film collection seems to have been abandoned by both parties. Some prints returned to their original producers; many eventually ended up at the Harvard Film Archive in Massachusetts, where they remain.

Postscript

In 2001, I was living in the East Village in Manhattan and looking for odd jobs after being let go from an Internet startup that had lost its venture capital funding in the dot-com crash. Outside of a day job, I was running an often chaotic, six-year-old underground film festival that relied largely on corporate sponsorship for its funding, and writing occasional film criticism for a local weekly. A colleague introduced me to Barney Rosset, who was then living with his wife Astrid in a loft only blocks away from my apartment. Barney was in his late seventies at that time, still publishing books through his relatively modest Foxrock imprint and occasionally speaking to scholars and journalists, most frequently, it seemed, about his longtime relationship with Samuel Beckett. He hired me to help him scan old issues of *Evergreen* so he could sell them as e-books online. While going through his personal collection of *Evergreen* issues, I noticed how substantial and wide-ranging its writing on film had been, covering everything from Hollywood releases to the cinematic avant-garde, all packaged in a keenly-designed magazine that clearly intended itself for the widest possible readership, despite its decidedly countercultural vibe.

Impressed by this trove, I asked Barney if he had ever thought about doing a collection of film writing from *Evergreen*. No, he said, but we should. Before I knew it, a contract was drawn up, and I was working with him regularly to compile the volume, tediously scanning each page myself in order to create digital versions of the articles.

As the work continued, it quickly became clear that this project wasn't just about the writing in *Evergreen*—the topic of cinema energized Barney immensely. He soon suggested that the introduction to the book should go beyond the magazine itself to tell the untold story of his involvement in film, from his early days of producing *Strange Victory* through the intense years that followed the *I Am Curious (Yellow)* phenomenon. We recorded several conversations on these topics, and he gave me free rein to look through his private papers. At the time, Barney maintained a massive collection of his own correspondence and materials from the Grove days at his loft.[58] You could say that he lived within his own archive, and as I worked he seemed to rearrange its contents every few weeks, never satisfied with how it was cataloged. We watched old VHS tapes of *Mr. Freedom* and *Thanos and Despina*, two of his favorite Grove titles; I asked him questions about yellowing Grove flyers and film catalogs, trying to piece together the story from his vibrant but episodic memories. He had told the story of his life to people so many times that he had developed a rich repertoire of stories, and while the information contained therein was fascinating, it was at times difficult to get beyond his stock recollections.

The main body of the collection was finished relatively quickly, with most of the time spent digitizing its contents. Then work on the introduction seemed to take over the project, as he requested several substantial rewrites over many months. Though the events he discussed had taken place decades ago, his emotions about the feminist takeover of Grove's offices and the subsequent demise of the company in the early '70s remained volatile, and at one point he told me that the Grove story should be completely scrapped from the introduction, leaving only reference to *Evergreen*'s film writing itself. I wrote a second introduction, hewing to these parameters. Somewhere along the line, Foxrock apparently lost its relationship with its distributor, and the project stalled indefinitely.

Barney engaged me with a number of film-related projects. I introduced him to the filmmaker James Fotopoulos, whom he hired to finally realize Ionesco's script of the *Hard-Boiled Egg*. Rummaging through their apartment, Barney and Astrid discovered a number of film prints: footage he shot as a young man, vintage silent pornography, Genet's *Un Chant d'amour*, and, even more

58 Most of these personal papers were donated to Columbia University after his death, where they are held in the school's Rare Book and Manuscript Library.

remarkably, unseen outtakes from the shoot-ing of Beckett's *Film*. I remember one partic-ularly pleasant evening when I brought over my 16mm projector, and Barney, Astrid, and I drank cocktails while I projected his footage from the 1940s and some old porn loops.

Barney and I spoke much less after 2007. I had moved further away to south Brooklyn, begun other projects, and only reconnect-ed with Astrid after Barney's death in 2012. Seven Stories Press eventually got word of the manuscript, however, and together we began the work of finally bringing *From the Third Eye* to press. Going back to the book's original introduction, I expanded its story with new research at archives and by con-sulting essays and books about Grove's his-tory that had been published during the inter-vening years.[59]

Over a decade and a half after beginning this project with Barney, the full story of his important contributions to film culture can fi-nally be told. Anyone who works with film as a creative medium today holds a debt to the battles he fought, and we all benefit from the legacy of his vision: our collective liberation through the unfettered circulation of words and images.

Many thanks to Astrid Myers for helping see this project through; to Veronica Liu and Dan Simon at Seven Stories for their patience and care; to Joseph Lieberman and Carolyn Lazard for pro-duction assistance; to the Special Collections Research Center of Syracuse University Libraries, the Rare Book and Manuscript Library of Columbia University Libraries, the Film-Makers' Cooperative, the Harvard Film Archive, the New York Public Library for the Performing Arts, and Anthology Film Archives for access to their collections; and to many others who pro-vided advice, contacts, and feedback, including Hilton Als, Erika Balsom, Thomas Beard, Kent Carroll, Michael Chaiken, Paul Chan, Paul Cronin, Andrew Durbin, James Fotopoulos, Kendra Gaeta, Michael Galinsky, Sam Green, Robert Haller, Jytte Jensen, Fred and Ken Jordan, Tom Kearney, Nellie Killian, Alex Kitnick, Laris Kreslins, Andrew Lampert, Dennis Lim, Jonas Mekas, Andrea Morgan, Jake Perlin, Elisabeth Subrin, Amos and Marcia Vogel, and Christopher Wilcha.

59 In 2016, as the manuscript for *From the Third Eye* was being finalized, O/R Books was simultaneously preparing the manuscript of Rosset's long-awaited autobiography, which he had been working on for years before his death. During discussions with As-trid at that time, it became clear that large parts of the original introduction I had written while working with Barney had become, uncredited, a chapter in his own book. How exactly that material came to be there may ultimately remain a mystery, but it made me recall one of the last times I saw him, sometime around 2007. At that meeting, he pulled out an an-notated copy of my original, longer introduction. To my surprise, Barney told me that he admired the essay—after rejecting it earlier—and asked if I'd be willing to work with him to adapt the chapter for his memoirs by changing it to the first person. It was such a strange idea that I didn't know quite what to say. However, we never followed up, and as I moved on to other projects, we stopped meeting regularly, and eventually fell out of touch. We may never know how Barney got from asking me to revise that intro-duction to inserting large parts of it into his autobi-ography. He was often difficult to work with, given to changing his plans and opinions, but he was also incredibly generous with his time and advice. While other writers might bristle at having their work recy-cled in such a fashion, for me it's a strange kind of honor, and a weird souvenir of an intense but forma-tive time in my life spent working with him.

No. 6, Autumn 1958

THE ANGRY YOUNG FILM MAKERS

Amos Vogel

In Brussels, in the spring of 1958: a huge, glimmering, high-priced, chromium-plated concoction of artificialities, the World's Fair, in which the world's governments propagandistically project antiseptic and idealized self-images. The revelations of national character are present; but they are unintentional.

The U.S.S.R. and the U.S. pavilions: the deadly earnestness, the massive mediocrity of the Russian effort; the flippant sophistication, the open, democratic purposelessness of the American. To ascend to the Russian pavilion, one must mount an imposing row of stairs—(as Man Ray puts it, similar to the Aztec pyramids, which the victim is forced to ascend—only to be sacrificed at the top). The American pavilion: at ground level, behind a charming and incongruous lagoon, its many glass doors wide and invitingly open; while at the Russian pavilion, only 2 or 3 of the doors are open at any one time, the others forbiddingly and inexplicably closed. The American pavilion: an ornate message from a rich planet in outer space, delivered at the wrong wave length: "Look how happy and rich we are," with no means of space transportation offered to the earth-bound Europeans to arrive

at similar bliss. The Russian pavilion: "Look what hard-working, backward peasants we are"—solemnity, puritanism, pompousness, the stuffy odor of bureaucratism and a truly spectacular display of mid-Victorian *kitsch* in its art and interior decor sections: the ornate lamps with the glass beads, the rugs, the colored glass animals, the horrendous cups and saucers with the flowers. A wall to wall painting, stupendous in size, of a young girl walking through the fields with a bouquet in her arms, entitled, of course, "Spring." The usual paintings of happy workers parading through the streets, perhaps to celebrate Nagy's execution. In the American pavilion, the subtle satire of Steinberg's murals, totally lost on all but the European sophisticates; and the emaciated, sterile, coldly beautiful models walking down a ramp into an ethereal indoor pool that has the visitors transfixed. "Atmospheric" differences between the two giants are clearly noticeable; the sheer and deadly "weight," the authoritarian whiff of the Russians, and the free, disordered casualness of the Americans, modern, sunlit, but quite cool and inaccessible except to the native-born. There is humor and some

30

self-deprecation here; there is none in the Russian pavilion. The Russians relate to the Europeans, if only in a perverse way: "This is what you, too, could be like, if only—," while the Americans lack any ideological message except to say "This is who we are." And the ugly barrenness of the American soda fountain type "restaurant"—complete with slow service and 65¢ milk shakes, is perhaps the exact counterpart of the plush, mid-19th century Russian restaurant, in which a complaint concerning the loudness of their "Muzak" system is met with a terrifying symbolic statement, pronounced in measured voice by the headwaiter: "The level-of-the-music-is-not-controlled-by-us-only-the-center-can-change-it ..."

In Brussels, in the spring of 1958: an unruly red wig slithers across a table, envelops a glass, sips the liquid it contains through a straw and then crushes it in an octopus-like grip. A troupe of restlessly agitated abstract forms, scratched onto film without the intervention of a camera, nervously pulsates to the rhythms of African tribal chants. An occult ritual moves hypnotically across three screens, while the producer sprinkles incense across the front of the theatre. A series of harrowing documentary shots of concentration camps are set to the strains of a popular rock and roll ballad. And a reverent religious procession, led by a bearded priest, suddenly moves into 2-step and then into spasmodic reverse motion, heading into nothingness.

Such is an indication of the range of the International Experimental Film Festival held this spring in Brussels in conjunction with the World's Fair under the auspices of the Belgian Cinémathèque. Spurred on by the totally unexpected promise of $15,000 in prizes (donated by Gevaert and SIBIS), the international experimental film movement, glorious and impoverished stepchild of a huge industry, responded by spewing forth 400 entries, from 1 to 80 minutes in length, of which 130 were found worthy of final consideration by the pre-screening jury.

Among these 130 final contestants are synthetic sound experiments, poetic, expressionist, dadaist, surrealist, symbolist works, abstract color animations, hand-drawn films, films shot in negative color, with *musique concrete*, or sound tracks produced optically without musical instruments, films made with the oscillograph, experiments with light, prisms and distortion lenses.

For an entire week, an enthusiastic audience of critics, intellectuals, film nuts, and film makers watched these experiments parade across the screen at the rate of 9 hours per day, applauding, hooting, whistling, while an illustrious international jury tried determinedly to keep eyes open to the films and ears closed to the noise around them.

On the jury were, unexpectedly, Grierson, legendary ideologue of documentary; McLaren, the eminent animator, in danger of becoming a saint in his own lifetime, dazedly observing a parade of imitators of his own style; Oertel, producer of *Michelangelo*; Varèse, the noted contemporary composer; Man Ray, link to the classic postwar I avant-garde; Alexeyeff, producer of the unparalleled *Night on Bald Mountain*; Pierre Prévert, director of *Oh Leonard* and *Voyage Surprise*. Ensconced (expenses paid) and strangely out of place at one of Brussels' luxury hotels, they argued for hours after each of the exhausting screenings, only to be confronted with yet another 20 aural and visual attacks on the audience the morning after.

For "attacks" these films are most decidedly. Far removed from the innocuous placebos served up by the commercial theatres to passive consumers of mass culture, these poverty-stricken little films literally aim to explode the filmic frame itself. They explore in technique, treatment, style and form, the limits of the cinematic medium, revealing both its and their own potential and limitations.

Crude, exuberant, antidiplomatic, highly original or highly derivative, they display the vitality, the uncompromising violence, the unorderedness and anarchic freedom of youth. Unhampered by considerations of box-office or worldly success, they attack the (to them) false gods of puritanism, commerce, religion, mass culture and conformity, often missing the mark, yet at least aware of its existence. At times precious and jejune, they nevertheless attempt to hew to values far removed from those of the marketplace and to emulate, in their own field, the best creative efforts of the avant-garde in other media. Theirs is the desperate, last-ditch sincerity of the stepchildren and outcasts, with nothing to lose and hence a willingness to

say it all.

Of the 130 titles shown, 50 came from the U.S., 20 from France, 12 from England, 9 from Germany, 7 from Poland; but surprisingly enough, unusual films were also entered by such countries as Sweden, Argentina, Israel, Japan, Austria and Yugoslavia. Quite apart from having the largest number of entries, the Americans also walked off with 6 out of 11 prizes. While this pre-eminence of the U.S. is noteworthy, the real revelation of the festival was the existence of a contemporary avant-garde in Poland.

From amongst the morass of so-called "socialist realism" of the East—the most sterile and conservative artistic tendency of our day—comes, not one lone experiment (that in itself would have been sensational), but an entire school, an avant-garde movement. The Polish October that brought Gomułka to power expressed itself also in the cinema. Seven films were entered, produced and paid for by the state film monopoly Film Polski, in 35mm, and in color, representing surrealism, dadaism, abstract art, poetic and expressionist techniques. To be sure, there are derivative and jejune elements (apparently every new avant-garde movement needs to go through similar stages without being acquainted with the works of other countries); to be sure, the welcome state subsidy works both ways and may be withheld on the morrow just as it was granted yesterday (Poland's limited artistic freedoms are today once more in jeopardy); the fact remains that behind the Iron Curtain there exists, at least in one country, a youth exposed to and responsive to contemporary art, slowly groping its way amidst dictatorial ukases to a greater freedom of expression.

The two best Polish works deservedly won prizes: *Dom*, the Grand Prix; *Two Men and a Chest*, a Bronze Medal. This writer would have reversed the awards.

Dom (The House) defies description. It is a work clearly in the surrealist and dadaist tradition, derivative, but thoroughly refreshing, thoroughly "free," combining cutouts, live action, drawings. In it, the "red wig" makes its triumphant entry; in it, the compulsive restatements, so effectively used by the "classic" postwar I Western avant-garde, appear to full advantage; a man enters a room, backwards, and places his hat on a rack; this action is repeated almost ten times. Directed

by Walerian Borowczyk and Jan Lenica, the film, in the words of the jury, "shows an attempt to make use of the possibilities inherent in cinematographic art, which is a purely visual art."

Two Men and a Chest (by Roman Polanski) succeeds, by means of brilliant images and a truly poetic conception, in the impossible: to blend what superficially appears as a light and fantastic comedy with a social comment of the most profound severity. Two men emerge from the sea with a dilapidated wardrobe, symbolic of a mysterious treasure. They attempt to interest organized society in it, but to no avail. While they lightheartedly pursue their task (accompanied by a lilting jazz accompaniment), hooligans, pickpockets, murderers and drunks crowd the edges of the frame. Society has no room for ambiguous and possibly dangerous treasures, and prefers to pursue its own set and corrupt ways; and appropriate conclusions are drawn by the two protagonists in a brilliant and provocative ending to a memorable work.

No other East European country had entries, except Yugoslavia, which sent an unusual art film based on the woodcuts of a noted Yugoslav artist portraying the last minutes in a man's life. Very well-substantiated rumor has it that the Russians entered ten documentaries in the mistaken notion that they were "experimentals."

Of the remaining prizes (all of the prize-winning films, including the Polish ones, will be shown by Cinema 16 this season), 6 were garnered by the Americans, the Second Prize of the festival ($5,000) falling to Len Lye's *Free Radicals*. With beautiful and exemplary economy of means, this long-neglected precursor of McLaren and UPA, undoubtedly one of the most original living talents in his field, creates a perfectly controlled work that surpasses in its simplicity and form most of the other, more elaborate works shown at the festival. The abstract designs are directly engraved on plain black leader film in a "direct" film technique without the intervention of a camera. As the jury put it, "'Direct' film animation gives an image of extreme kinetic tension. The imagery of *Free Radicals* exploits this. A 'Free Radical' is a fundamental particle of matter which contains the energy of all chemical change, very much like a compressed spring before

release. The film gives an artistically symbolic portrayal of fundamental energy."

There was also a special award by the selection jury to "all of the films of Stan Brakhage," one of the most talented and radical of the young American experimenters, whose originality and filmic explorations have finally brought him to his most extreme and most controversial work, the 50-minute color film *Anticipation of the Night*, which created a near riot in Brussels; and Bronze Medals were awarded to Francis Thompson's semi-abstract fantasy of New York from dawn to dusk, *N.Y., N.Y.,* a dazzling and stunning display of cinematic trickery and ingenuity, leading to some of the most breathtakingly poetic images of the city ever captured on film (this also won the Award of Exceptional Merit at the 1958 Creative Film Foundation Competition in the U.S.); to Hilary Harris' *Highway*, a restless and overpowering visualization of the American "road," set to rock-and-roll and photographed mostly from vehicles moving at high speed; to Hy Hirsh's *Gyromorphosis*, an "animation" of Nieuwenhuys' constructivist sculptures, with jazz; and finally, the special "L'Age D'Or" Award presented by the Belgian film critics to Kenneth Anger's study in black magic, *Inauguration of the Pleasure Dome*, an ornate re-creation of occult rituals in the best traditions of decadent art.

The three remaining prize winners came from Israel (Yoram Gross' *Chansons sans paroles*, an animation of newspaper sheets and match sticks); from the Argentine (Rodolfo Kuhn's *Symphony in No B-flat*); and from France (Agnès Varda's *L'Opéra-mouffe*).

Symphony in No B-flat, a mordant little satire, takes place the day after an atomic bomb has been dropped. Mutations have been created; two choir boys officiating at a wedding get married to each other instead; and memory has been erased, compelling young people to go to school once more to relearn the emotions of love.

L'Opéra-mouffe, winner of the International Federation of Film Societies Award, is a film of haunting and profound originality, with a love sequence of such erotic fervor as to send the censorious screaming to the exits. It is a poetic documentary "in depth" of an impoverished section of Paris, with vivid and often terrifying images of the poor, the anxious, the old, the children, the lovers—and, as a framing theme, obsessional in power, images of pregnancy and fertility.

But there were other films of interest, which may well have deserved prizes too.

There was the work of the bold Herbert Vesely, *Nicht mehr fliehen* (No More Fleeing), winner of the highest 1957 Creative Film Foundation Award; a beautifully photographed and hypnotic paraphrase on mankind's atomic cul-de-sac, with two ambiguous travelers trapped in a desolate landscape that suddenly erupts in violence; followed by Vesely's newest, *Prelude*, a poetically conceived impression of a pause during a ballet rehearsal, with dancers and theatre personnel grouped in casual and evocative incidents.

There was Hultén–Nordenström's *A Day in Town* (winner of the 1958 Creative Film Foundation Award for exceptional merit), a wild, dadaist explosion that starts as a typical FitzPatrick travelogue of Stockholm and ends in the city's total destruction by fire and dynamite in one of the most hilarious and anarchic film experiments on record.

There was Maya Deren's celestial ballet, *The Very Eye of Night*, a mysterious and mystical transformation of space and human forms, photographed mostly in negative; *Nice Time*, Goretta and Tanner's somber account of the empty and heartbreaking pleasures of Piccadilly by night; Christopher Young's *Subject Lesson* (Creative Film Foundation Winner 1957), symbolic tracing of the development of man's consciousness, with startling juxtapositions of familiar objects and incongruous backgrounds; VanDerBeek's *What, Who, How,* a comedy of "the unexpected that lies beneath the real," a surrealist mélange of paper cutouts, with country houses, young men, terrible animals, jewelry emerging from the heads of beautiful New York models.

There were several original animation efforts: Pintoff's and Whitney's painless and charming introductions to the abstract film, *Performing Painter* and *Blues Pattern*, made for UPA; Pintoff's *Flebus*, a cartoon with a theme not usually dealt with in entertainment productions; John Hubley's *The Adventures of Asterisk*, a highly original attempt to deal with the concepts and values of modern art purely visually (produced in

cooperation with the Guggenheim Museum and James Johnson Sweeney); Richard Williams' surprising *The Little Island*, one of the "discoveries" of the festival, an animated morality play, visualizing (without a single word spoken) atomic war, neutralism, power politics, moral crusades—and doing so with both humor and foreboding; there was the exuberance and utter charm of Carmen D'Avino's work, displayed in *The Big "O"* and *Motif* (1957 Creative Film Foundation Award); the impish and sophisticated visual puns and sallies of the highly original Robert Breer (*Cats, Jamestown Baloos* and *A Man and His Dog Out for Air*).

Shirley Clarke's *Moment in Love* is a poetic love ballet, choreographed by Anna Sokolow; Willard Maas' and Ben Moore's *Narcissus*, a re-creation of the classic myth in modern terms (Creative Film Foundation Award 1957).

Five other films deserve special mention. Two from France: Jean Dasque's spoof, *Cinesumac*, a very unusual portrayal of a "sound" from the time it escapes from a singer's gaping mouth (in close-up, with both tonsils showing) to the time it is captured on a film strip; and Jean-Daniel Pollet's *Pourvu qu'on ait l'ivresse*, which in its cold-blooded and pitiful portrayal of an adolescent dance-hall as a sexual jungle leaves the similar *Marty* sequence at the post. From Spain, *La Gran Siguriya* (by José Val del Omar), a dark, explosive, somber, cruel and unpredictable work of the deepest passion, which in its best sections combines the heightened realism of Buñuel's *Land without Bread* with the surrealism of his *Un Chien Andalou*. From Sweden, Peter Weiss' *According to Law* (embroiled with censorship laws in several countries), an unsentimental yet passionate, poetic yet factual investigation of a Swedish prison and its inmates. Finally, from Mexico, Carlos Toussaint's *La Canción de Jean Richepin*. Asked by his beloved to bring his mother's heart for her dog, a hopeless lover tears it out, stumbles with it, lets it fall. Rolling across the floor, the heart gasps out: "Are you hurt, my son?"

Polyvision, Circarama, the Czech experiment and "Impressions of Speed" deserve mention as four experiments in screen and projection techniques. Polyvision, connected with the name of the French film pioneer

Abel Gance, consists of the projection of 3 images upon one huge cinemascope-type screen; no attempt is made to join the 3 images as in Cinerama; in fact, different actions proceed on each of the 3 panels and at times only the center one is utilized; the effect, at least as shown at the festival, must be considered a failure artistically. It does not blend into one visual experience, and we are reminded jarringly of the mechanical contrivance employed. This time we are taken not on one rollercoaster ride as in Cinerama, but on three simultaneously. The effect is totally self-defeating; the human eye simply cannot correlate these three disparate images into one joined subretinal experience.

Circarama, Walt Disney's totally unexpected (to this observer) success: a 360-degree film, projected onto joined screens spanning the entire circumference of a circular theatre, in the center of which the audience stands. The film was photographed by 12 cameras mounted in circular fashion on one truck, reproducing one "continuous" image on 12 film strips, spanning 360 degrees. The effect is startling, stunning; you are "in the midst" of Times Square, "surrounded by" Times Square (complete with stereophonic sound); and even the blatant patriotism of the images, complete with Statue of Liberty and the Grand Canyon, cannot obliterate the physio-psychological impact.

In the Czech pavilion, an intimate, small "theatre" features about 8 or 9 discontinuous screens, placed at various heights and angles and at some distance apart. The audience is seated on low, irregularly placed divans. Some of the screens tilt upward from the floor, others are placed at varying depths. The film—a record of a music and dance festival in Prague—proceeds on all, most, or only one panel and consists of separate film strips, ingeniously synchronized to provide an encompassing visual-poetic whole. It succeeds, in part; the assembled experimental film makers watch in awe, hoping for similar state subsidies in their own countries, one may presume.

"Impressions of Speed": in a special pavilion, a thoroughly engrossing experiment, for only 25 spectators at a time: the audience is seated as if in the cab of a simulated railroad engine, with a full view of the landscape not only in front but also on both sides of the

train; a continuous all-encompassing image is projected through the simulated windows; stereophonic sound is used; the landscape flashes by, in perfect synchronization and in color, the total impression so vivid as to approach the actual experience. The jury is stumped: Has this film left behind the "illusion of art" and become "reality" itself?

Not many of the films shown at the festival can lay claim to greatness or completeness; and far less complimentary comments must be made regarding the majority of the other films shown and not mentioned in this article; for, much too often, freshness takes the place of originality, technique substitutes for meaning, form for content. Embarrassment is caused by purely derivative works, and by the adolescent preciousness of some of the others. But when all is said and done, there remains a feeling of vitality and promise, of scope and sincerity. To find even 25 unusual works among 130 is not too poor a percentage.

What binds these disparate and diverse works together? It is not merely their daring (at least as compared to the creations of the commercial cinema); it is primarily their emphasis on film as a *VISUAL* medium. This is a self-evident truth which today is being trampled to death in the mad scramble for wider screens and a more total approximation of reality, with the camera reduced to the level of a recording instrument. The contemporary cinema, more often than not, is literary in origin and form, tightly bound to (or rather emasculated by) a naturalistic sound track, dialogue and wide screens which have practically succeeded in destroying the true heart of cinematic art, the image, and its creative ordering into sequences of associative and hypnotic power via montage (editing). These experimental films restore the visual to the cinema. They remember Eisenstein, not Shakespeare. The sound track is utilized as a subsidiary component or as a creative counterpoint to the image, and not as a substitute for visual action and filmic progression (as occurs, for example, in such contemporary creations as *The Long Hot Summer* which is not a film but a literary artifact and can be reasonably well followed with eyes shut).

Duplicating, if decades late, contemporary art's break with realism and naturalism, they attempt to introduce into the film medium nonrealist storytelling, stream-of-consciousness, imagist, or symbolist techniques, surrealism, dada or, more modestly, poetic continuity and semi-abstract animation. If, in Hans Richter's words, the contemporary commercial cinema represents 19th-century realist art, theirs is a desperate effort to break through to the 20th century, regardless of the incubus of the five million dollar mass market creations of Hollywood. In these poverty-stricken works, there is an effort at pushing film to its limits, technically, thematically and aesthetically.

Thematically, the search for "self" continues to predominate—and why not? The exploration and documentation of the soul is every whit as valid as that of the outer world. It is only through the understanding and mastery of both inner and outer realities that we can hope to control our environment and thereby our own fates. In the majority of these films, the "self" is explored either directly (via symbolist, poetic, expressionist techniques) or as it expresses itself in art (abstractions, collages, automatic painting). In the former, it is either the adjustment of the self to society and its values, or its self-realization and self-knowledge that matters. In the latter, it is the free flow of artistic imagination, the magic of artistic creation. Both are "relevant" to the social situation, notwithstanding the common accusations of preciousness, of ivory towerishness, often leveled against these films. Problems of alienation and atomization of the individual, problems of sex and love, problems of adjustment and conformity are eminently social in character. The works of the modern artist, even in their most abstract and nonrepresentational forms, are but a filtering and refraction of reality through the very contemporary subconscious of its maker.

In the narrower sense, direct social relevance is found in the ideological films shown at the festival, the "political" works, such as the antibourgeois spirit found in *A Day in Town, Cuckoo Waltz, What, Who, How*, the sharp social satire of *Life Is Beautiful* and *Symphony in No B-flat*, the social critique of *According to Law, Two Men and a Chest, Nice Time* and *No More Fleeing*.

They display a preoccupation with the H-bomb, with totalitarianism, mass culture, concentration camps, commercialism, and

bureaucratism. In all, there is a concern for the body politic, an attitude of commitment. For the makers of these films, in truth, are the Angry Young Men of the contemporary cinema. They may not express their anger in the "approved" realistic and naturalistic traditions of the early (and still uncompromised) documentary movement of the thirties or the works of the British Free Cinema movement of the middle fifties—but the anger is there, expressed in the vocabularies and often oblique techniques of contemporary art. Paralleling the Angry Young Men and the Beat Generation, their anger remains on a subpolitical plane; it is an expression of generalized anguish and tension vis-à-vis organized society, not a call to action.

Perhaps the most "experimental" episode of the festival was the reception for the film makers given by the president of Gevaert (roughly, the European counterpart of Eastman-Kodak). It was held at his château, an authentic anachronism complete with moat, with 22 servants feeding champagne and sumptuous dainties to the "Hungry Young Men" of all nations. Candelabras, period furniture and woodwork, the high ceilings of European aristocracy blended into an incongruous and unforgettable whole, with the flaming West European Communist film maker, the pale Polish intellectual, the restless American outsider, the young fellow in fatigue jacket with only ten cents and a thoroughly original film to his name. A more experimental gathering Gevaert never did see. Finally, inebriated and exhausted, thoroughly corrupted by continental bourgeois munificence, the film makers were herded into special buses and driven thirty miles through the silent Belgian night back to the reality of their dingy rooms.

For the reality and future of the film avant-garde, as always, is precarious, its problems profound and continuing. The fundamental obstacle, of course, resides in these courageous artists' working in possibly the most expensive existing art medium. Even the relatively paltry sums involved in experimental productions are far higher than the out-of-pocket expenses of the aspiring painter, the young writer or poet. The "tools" of cinematic art are too expensive.

Now that the festival is over, the question remains: how will future productions be financed? The assembled film makers, needless to say, were deeply impressed by the fact that the Polish films were completely financed by the state; and, while it is true that such official munificence carries its own dangers of political control over the artist, it seems very attractive to people who have nothing to lose. Likewise, certain German experimentals have been partly subsidized by state or local governments out of the proceeds of the commercial film industry, and a similar method of financing has been used by the important British Film Institute's Experimental Production Committee. Yet, this state financing or subsidy cannot be hoped for in the U.S. in the foreseeable future. In the present climate of opinion, any production of surrealist films under Mr. Eisenhower's aegis would be considered "creeping socialism." Nor, it should be added, can such films expect to find any more favor under an administration headed by that sensible, well-ordered antidadaist and tortured standard-bearer of the semi-liberal phrase, Mr. Stevenson.

There remain private sources and here the work of the Creative Film Foundation opens unusual opportunities. Organized a few years back by a group of leading intellectuals and artists in several fields of endeavor (under the guidance of the energetic Maya Deren), the foundation exists to further the production and appreciation of works exploring the creative potential of the film medium. It has only recently been granted official nonprofit status by the government and is now approaching the large foundations for support. If such is forthcoming, grants will be offered to individual filmmakers.

There remains the exhibition and distribution of experimental films. In America, it was Miss Deren on the East Coast and Frank Stauffacher's Art in Cinema society on the West Coast which pioneered the public showing of experimental films, shortly followed by Cinema 16 which, over the past 12 years, has provided continuity and stability to the movement, enabling it to show all contemporary experimental works of interest. It has also established the most comprehensive library of the avant-garde for distribution to film societies, art museums, schools and interested individuals. This distribution is continuously growing (unlike the distribution of documentary and other types of films, which seem to

suffer more profoundly from the impact of TV); yet, neither exhibition nor distribution have so far solved the financial problem of the avant-garde. The income remains—so far—too limited.

The result has been a lack of continuity in the movement, a passing from its ranks of its most talented members, only to be replaced, in each generation, by newcomers, who start afresh, from a low and derivative plane (as shown in the works of some of the new young West Coast film makers at Brussels). On the other hand, some of the "greats" of the movement are unable to continue their work. Peterson, the surrealist, has not made a film in years. Anger moved to Paris. Harrington is fashioning a Hollywood career. Broughton has left the movement, disillusioned. To continue, a filmmaker must be able to keep production costs minimal (this determines choice of subject matter and treatment) or he must have independent means.

Ultimately, the fate of this movement is tied to the fate of the cinema as a whole, to the fate of all art in a commercial society. The values of mass culture dominate in all media, but in none as much as in the medium of "family entertainment"—the cinema. The art of the moving image (already surely buffeted by the introduction of sound, the development of the large screens, the rise of television) may never be able to develop its full potential and may possibly be referred to by future generations as the art that never was. If so, perhaps the historians of tomorrow will fish out from a rusty time capsule some of the dilapidated, courageous films of this festival and exclaim: "Here, gentlemen, is a little example of what might have been."

No. 14, September/October 1960

JAZZ ON A SUMMER'S DAY

Jerry Tallmer

A fellow I know once had a terrible idea for a new magazine which mercifully died aborning, and in that time when he was running around everywhere to see about it, a second acquaintance one day mused aloud in my presence: "I dunno. Suppose I'd come to you 25 years ago and said *I have this great idea for this magazine, every month we'll reprint digests of selected articles from all other magazines;* what would have you said? You'd have said *Enhhhhh!* and thought I was out of my mind." The first fellow's idea was not even as good as that one, however, and it is the second fellow and his remark which I suddenly find myself remembering as I seek some defining approach-path to Bert Stern's "Jazz on a Summer's Day," an oddly unclassified color film of feature length now (April) in its third or fourth week of a modestly successful double-header premiere at New York's Fifth Avenue Cinema and 55th Street Playhouse. Because if somebody had come along a couple of years ago to say: *I've this great idea for this movie, we'll just go up to Newport to shoot the Newport Jazz Festival and make a movie of it*—what would you have thought? If you'd been at all jazzhip or

moviehip or simple commonsense hip you'd have thought *Enhhhhh!* and turned to the jokes to see how the beavers were making out in Mark Trail. But young Mr. Stern, on his first try (from a topflight position in the slick, still world of advertising photography) has made himself a quite lovely movie which doesn't in the slightest—well, only in the slightest—resemble the *Reader's Digest* or anything else about jazz anyone ever tried and failed to put on film. Though almost diametrically antipathetical in every other aspect to Jack Gelber's revolutionary off-Broadway play, "The Connection," it yet shares with "The Connection" this notable distinction: of being the first in its particular field to multiply a different medium against the jazz medium without the *x* inevitably standing for some degree of rape, discreet or violent. Further than that, and where it most differs from "The Connection," it is a work suffused in tenderness, in the ordinary uncomplicated joyousness of sitting around and getting beautifully muzzy on beer as these guys blow these horns through the bright midday and the long afternoon and the soft enfolding evening of a rich little green little

seaside town so far out of this world as to exist perhaps only in the now distant and disintegrate mind's eye of the late Commodore Vanderbilt; if, for the musicians, as for us, life remains—is no farther off, with all its indignity and grind, than tomorrow's departure from Rhode Island, tonight's walk home from the movie theater—then that's another problem. Meanwhile it is forever a sun-soaked summer's noon, the camp chairs still half empty, the crowd desultorily trickling in, and in an absurdly nocturnal and floozyish and smart-as-blazes black dress and white kid gloves and huge black-and-white picture hat, a trim smiling she-devil named Anita O'Day is fastidiously picking her path under the open sky to the steps, the bandstand, the mike, the first sprung-bedspring break into "Sweet Georgia Brown," and oh yes, life is very much worth living. All but the last 10 minutes of the picture—where the editing goes both lax and opportunistic in giving too much time, and two too many numbers, to the latter-day, or institutional, Louis Armstrong—make life much worth living. The finest thing I can think to say about Mr. Stern's movie is that, those 10 minutes aside, it leaves you wishing that if you were ever to do a film of your own, it might be as steady-eyed and loose-limbed and loving as this one.

On the basis of interviews which have been published since the opening, what Bert Stern appears to have brought with him to Newport was an educated love of photography, a layman's love of movies—this is his first—and no more than, say, Robert Oppenheimer's knowledge of jazz. "Jazz on a Summer's Day" would not have been nearly so true nor evocative if any of these circumstances had been otherwise. His professionalism made him know he could trust his cameras and film; his amateurism drove him to trust what he saw with his eyes and heard with his ears—the most difficult of trusts to come by for most "old hands" in the systematized arts. Because he trusted his film he refused to assist it or improve on it (as Hollywood congenitally "improves" on it) with filters; as a result the strength and purity of Stern's color has knocked every New York critic out of his seat. (Nor was the developing lab allowed to do any "improving" except with one tiny sailboats-in-the-sunset sequence which now jumps from the screen in a weird vivid

rust-orange that Stern himself would just as soon forget about.) Because he trusted his eyes he so aimed and held his cameras as to "go after," zero in on, ferret out, what in each case seemed to be the root physical (or psychic-physical) source of the music being produced; and then he had the insight and stubborn courage to keep his lenses trained there for incredibly long exposures that have the ultimate impact on the spectator, not of tedium, but of thrilling revelation. Thus for the first time in or out of a movie theatre I learn that Miss O'Day pistons her jazz up from the thorax to the rear of the mouth-chamber and then, in an endless irreverent cascade of tiny high-pressure explosions, down past the bridge of the nose and out through nostrils worked like trumpet valves and flared always with the most sophisticated sort of inner and outer amusement. That Dinah Washington, after she gets rolling, does it from her belly and breasts, and in substantial part from her broad-beamed but well-pivoted behind; that Gerry Mulligan blows his saxophone straight from his shoulders and only from his shoulders, putting into it all the inexhaustible cojones and stunning jungle-cat grace of Ray Robinson in his prime; the same for drummer Chico Hamilton, not just in his merciless ingoing physical drive but in what seems to me almost the virility in compositional structuring of a Mozart; and for each of the others there is some similar central power plant to which Stern's responsible cameras have miraculously penetrated.

The method was of course expensive, maybe criminally expensive: of a total shooting of 130,000 feet only 9,000 ended up in the movie houses (not bad as Hollywood ratios go, but very bad as compared with swift intuitive craftsmen like Maya Deren, whose gross-to-net, for all the element of abstract "accident," will rarely exceed 3 to 1; still, a jazz festival cannot be as pre-planned as a film by Miss Deren). On the other hand, the cutting and editing of "Summer's Day" are, with the single already mentioned exception, nothing less than brilliant. I do not mean merely in cutting from one musician or instrument to another or from one group to the next; I mean in cutting back and forth between the first complete movie that Stern shot at Newport and the second complete movie that Stern shot at Newport, for the

fact of the matter is that there were two, and that it is the two films conjoined in organic union which gives the total product its gauze of beauty; which lifts it from sheer reporting to creative artistry. But before we get to this there are a few things yet to be said about the camera work and editing in the jazz film proper.

There is, for instance, something to be said about the way that great right-profile shot of Anita O'Day, the one that reveals both her method of making music and her whole zotzy philosophy of life, is held away from the movie audience until the precise instant the singer finally reaches the slight pause at the end of her long cool mannerist introduction to "Sweet Georgia Brown," and then hits the first hot jaunty note of the famous chorus; meanwhile the camera has swept idly back and forth over the waiting ranks of mostly empty seats, and then with long shots to some of the earliest-arriving listeners, and then close in to some of their more interesting faces, and then back to Miss O'Day in medium front shots, and back to the faces and chairs, and back to the singer from far away on the neutral side; by now you have the exact feel of what it must be like to be there under that crazy white sun, bravely inaugurating the proceedings before acres of empty camp chairs at an hour no self-respecting night owl would consider other than indecent; she has ventured out into the sun and the suspended noon and all this unreal Newport bit, and now, having reached the end of her almost Oriental embroidery on the introduction to "Georgia Brown," she lifts her handsome chin and grins under the big floppy black hat and the blue eyes twinkle dangerously as she sucks the air into her throat and then her nose, and then *wham!* she hits it and *wham!* the camera hits it, flush on the beat, and stays there and stays there and stays there and stays there and we're off and running in Rhode Island this wide-open blue-white afternoon. Is there an analogy with a skillful performance of the act of love? I intend one. I believe Mr. Stern did too.

Or then there's the camera (a different camera) that introduces us to Dinah Washington by way of something for which the only explanation is that it must have so fascinated the camera man (there were three; I don't know which one) that he simply

couldn't lift his viewer off it. It is the big bouncy baby-pink bow unblinkingly at the V of the pelvis of the ornate evening gown into which Miss Washington has stuffed herself to jiggle, then mince, then finally belt out the song most appositely entitled "All of Me." Her entire section of the film is a sort of iris-out from a long-sustained initial traveling close-up of the bouncing pink bow, and if every other foot of the movie weren't stamped, as I have said, by love, Mr. Stern might here be open to a charge of unnecessarily cruel wit. But in context it is an enjoyment shared *with* the singer, not against her, just as Mr. Stern's cameras share all the immense mirth and vitality, some minutes later, of a fantastic 300-pound shout-singer named Big Maybelle. And he keeps in the movie at the end of Maybelle's turn a wonderful secret 30 seconds in which, as she makes it toward the wings, all her underlying little-girl pride and bashfulness is nakedly, and most winningly, exposed. I found actual callousness only once in the film, where it focused and then refocused for the silent ridicule on one of those standard vacant physiognomies of Girl Onlooker with Drooling Popsicle. Or perhaps, at that, she was a hired performer; Mr. Stern has admitted to having enlisted some.

Let us come now to the sub-movie within this movie—the one Mr. Stern invented, rather than recorded. It is a rambling free-form mood poem of time and place, of being young enough to swim and dance and sail boats and drive jalopies and go to jazz festivals, and being old enough to go up to the bedroom to practice Bach on the cello (Nathan Gershman of Chico Hamilton's quintet) while the kids romp and shout the afternoon away on the lawns below. It has no story, this other movie, merely a bunch of associated vignettes, and these are woven with great delicacy into the far more precisioned documentary fabric of the main film. What ties the vignettes together (except for the interlude of Bach) is the happy if distinctly unmodern intrusions on the sound track of a Dixieland combo of college boys from Yale University. Many of the scenes are straight simple shots of a yacht race out on Newport Bay. Others are unexplained fragments of jitterbugging, beer-drinking, quiet necking as the afternoon gradually darkens to evening, all the while the Festival rolls along. There is

one heartstopping instant constructed out of nothing more than watching one of the Yale boys, standing on a seashore rock at sunset, make a vibrant Dixieland trumpet march out of "Maryland, My Maryland," to hurl back into the teeth of the darkening waves. From there we cut to the yachts returning home and from there back to the bandstand for Louis Armstrong. Night thickens and the air is rich with nostalgia; an excess of Armstrong's mugging will dissipate it, but for that one imperishable moment in time we hung there at the true climax of this warmly conceived, sweetly executed motion picture and once more knew what it was to believe in the eternal bold youth of everything.

P.S.: The Newport Jazz Festival which was the subject (in a manner of speaking) of Bert Stern's movie has come to its end with the 7th annual event on the week-end of July 1–4, 1960, when the rich little green little smug little seaside town suddenly found itself invaded by 12,000 screaming-wild straw-hatted Eastern Seaboard college "boys" who tore the joint apart with beer cans and whiskey bottles and fire hoses and an envenomed curiosity to take part in the sex orgies, one supposes, of those other visitors to the Festival, the beatniks. We all know that Jazz Festivals are always attended exclusively by beatniks. As a result, there will be no more Newport Jazz Festivals—ever. All of which merely demonstrates that there is more than one kind of eternal bold youth, and that art—for Mr. Stern's film is a work of art—once again proves itself far better than life. And more timeless.

THE MAGIC BOX

Jerry Tallmer

Television for the millions is just about fifteen years old. In its time, in this country, it has contributed to the fragmentation and ruination of baseball, boxing, parlor games, Joseph McCarthy, Richard Nixon, Frank Costello, and Adlai Stevenson. It has tried very hard to ruin the drama, but without success. Television and drama are water and oil; they simply do not mix despite the several allowable (*Miracle Worker*, *Twelve Angry Men*) or unallowable (*Marty*, etc.) plays or films transplanted in starvation season from the potato fields of videoland.

The terrible thing about television drama is its quick fade-away; it is impossible to keep in mind even the "best" TV script, production, performance for more than a few weeks, if that. As I write it is something like a month since I saw Julie Harris do *something* exceptional on television—for Miss Harris is of course almost always exceptional—but what the devil was it? Ibsen, I think. No, that was last year. Here there should be a space; to indicate a long pause during which I truly try to remember, and cannot remember. Yet I, like you, can marvelously well remember nearly everything that Julie Harris did for us

in various Broadway dramas good and bad, and most notably in a play called *Member of the Wedding* which is now ten years distant since I first saw it on stage and then, a couple of years later, as a film.

In fifteen years of watching television with erratic regularity, I have seen one moment of drama—apart from politics, investigations, etc.—which still sticks in my head. And it was not pre-packaged as such; it was almost an accident. The week that Dylan Thomas died, Alistair Cooke came on with an impromptu postscript at the conclusion of that Sunday's *Omnibus* program. With his customary urbanity he told us that a great poet had just died and that we would now hear the voice of Dylan Thomas reading, "Do Not Go Gentle into That Good Night." Mr. Cooke bowed off, and on the screen they showed us a still photo of the poet from the jacket of one of his books. They held it there as that voice which was the voice of Thomas read its poem, and then as it neared the end of the poem they slowly backed the camera away from the photo to make the man seem to draw farther and farther away from *us*, and as it retreated it became smaller and smaller

until finally it dwindled into a pinhole of light and then the pinhole winked out into complete darkness and the poem ended. It was—well, it was the way to do it.

Nor do movies work for me on television, not even the great ones which my generation has been going back to for years in their native habitat. All the juice had inexplicably spilled out of *The Bank Dick* when I caught it on television; ditto the Marx brothers in *Duck Soup*, a picture which you would expect could survive *any* catastrophe. I have spent years analyzing this curious problem and have come up with the simplest of answers: the smallness of the television screen must defeat every cinematic purpose of every frame of every motion picture ever made. That which is created for a screen thirty feet wide is just too antlike and flimflam on a screen twenty-one inches narrow. Movies must be larger than life, literally, or be nothing. Also the great dark womb of the theater is lost when you turn instead to the midget screen in your living room or bedroom. This womb is equally as important, though different, at a legitimate theater—even at a huge junky musical, even in the tiniest off-Broadway bandbox. Essential to the ambience of the "womb"—with its bright portal somewhere out there before you—is (1) the absence of any interruptions except the traditional ones, and (2) the heightening of awareness and tension through the coexistence of fellow participants on all sides. It is impossible to substitute for this in terms of Uncle Willie going off to take a beer or a leak during the commercials. Last season *The Play of the Week* introduced the revolutionary new idea of two intervals per program of sixty seconds of absolute silence; it gave everybody the heebie-jeebies and has since been dropped. One of the things that took all the starch out of *Duck Soup* on TV was the nil and void of audience laughter at all the places (about three million of them) an audience would shake the theater apart in a movie house; the Marx brothers spent a lifetime learning how to put those laughs in, and television lifts its little finger and instantaneously wipes them out.

When it comes to "live" (or taped) TV dramatic fare, most of these ailments are terminal. I am not talking about the quality of the scripts, *i.e.*, the "TV originals"; everybody knows that situation, and each of us has his own rich storehouse of memories. (Shall one ever forget *People Kill People, Sometimes?* Can there ever be anything to top *Cool Wind Over the Living?*) No, I am talking about the built-in technical and operational characteristics of the medium, up against which the stoutest hearts may hurl themselves—and crack.

The definitive test of television as a home theater was in this, its approximately fifteenth year, in the week of April 3–8, 1961. In that week the drama presented seven times on the program called *The Play of the Week* was Samuel Beckett's *Waiting for Godot*.

Here we had, in extrinsic characteristics, the perfect play for television. *Godot* has only four characters, one of whom, Lucky, is utterly silent throughout 99 percent of the play; except for his single brief, mad outburst he tells his story through visual effects and mime. (There is a fifth and minor character, a small boy, who has about six "sides" and twenty words toward the ends of both acts of *Godot*.) The dialogue from first to last is as economical, as pruned, as poetically compact as any in the drama of our century. We know that the play has (except for American drama and television critics) a universal appeal, that it is being produced and hailed around the globe as a masterpiece which somehow speaks of the human condition to every unfatted brain everywhere—of what was, is now, and may likely always be in a universe seemingly forgotten by God and bereft of reason or justice. Furthermore, for all its verbal power, *Godot* is also a highly visual comedy of two old tramps on a lost landscape with their hats, their shoes, their belts, and the naked tree. At the root—at one of its roots—it is old-fashioned vaudeville, and vaudeville happens to be the entertainment form with which TV has always been most successful (the "variety" show as put together by Steve Allen, Ed Sullivan, Dinah Shore, and dozens of others). Finally, one would have imagined (before seeing it) that *Godot*, with its few characters and sparse, telling dialogue, would have lent itself to the kind of careful pacing and abundance of close-ups we have not seen on television since the earliest Chayefsky dramas. One would have imagined. But one neglects to remember that the early technique got tedious after the first five years and had to be

abandoned; also one neglects to remember that you cannot create the mood for *Godot* without the width and depth and conventions of the living stage (blue background "cyc," etc.) through which to evoke a barrenness of infinity; this of course returns us instanter to the primary and insoluble problems of scale on the miniature screen.

When *Godot* was announced for *The Play of the Week*, it sounded promising, exciting. The director was to be Alan Schneider, a director of Beckett's plays off Broadway (*Endgame*, *Krapp's Last Tape*, the Miami production of *Godot*), and a personal friend and ardent admirer of the playwright. It is Schneider's belief, and he is right, that Beckett is unmatched in our era as a "pure artist." The cast was to consist of Burgess Meredith and Zero Mostel, two actors whose entire careers have been distinguished by unusual subtleties and sensitivities, as Didi and Gogo; and from the original Broadway (Herbert Berghof) production, Kurt Kasznar and Alvin Epstein as Pozzo and Lucky. These two had come closest in that Broadway production to Beckett's intent, and the memory of Epstein's devastated Lucky still thrills those who remember it.

So what happened? The production on television was an abortion, an abomination, a bomb. It was, in the first instance, at least for me—some have disagreed—almost totally incomprehensible. Everything was rushed and jumbled and shouted, shouted, shouted; not one of its lines seemed to me to travel to target or to travel anywhere. Mostel merely repeated the coarse, overbearing characterization of his current Broadway performance in *Rhinoceros* (where it is appropriate), making Bert Lahr, who had brilliantly perverted the role of Gogo into something of his own and not of Beckett's on Broadway, appear in retrospect as an avant-garde genius. Meredith became heavy, loud, cryptic, menacing, and again as coarse. Kasznar more or less stuck with his original portrayal, and stood out in the video production, but the camera and that damn screen always made him either too near or too far, too large or too small, too omnipresent or unimportant; also his make-up had become Lear's, not Pozzo's, which makes little if any sense to me. Worst and most shocking of all was Epstein's Lucky, which had degenerated overnight (or with the passage of years) into a mannered overly-obvious miming in the style of the Yiddish theater or of ancient silent movies; I assume the actor (and director) thought he now had to be *ultra* visual, and slowed down a bit, (the only thing that was slowed down—disastrously), and hammed.

But where the director could not, I think, be blamed was with a crisis yet more clearly imposed on him by the nature of the medium: this may be termed the crisis of the rope. There are considerable sections of the play in which Lucky and Pozzo must appear on opposite ends of a long rope that begins around Lucky's neck and ends in Pozzo's hand. In the "real" theater this rope may very often be allowed to extend the full horizontal width of the stage, and beyond it into the wings. It is a fantastically striking device, and Beckett is a fantastically knowing playwright (his stage directions are the best and most theatrically brilliant since Chekhov's). Now reduce everything down to twenty-one inches. I found myself thinking of poor Alan Schneider as he must have sat staring with horror at that bloody monitor: how to get that rope in and be visible, and the people, and their words, and the relationships, and the meaning? Ultimately he "solved" it by either pushing the rope very close in on close-up, with the characters out of focus behind it, or by altering the direction of the rope from across the camera to *away* from it—back into the depths of the "stage," or screen. In a review of the production in the *Village Voice*, Martin Williams was quick to spot Schneider's "odd, ineffectual staging—front-to-back, away from the camera." The reason, not mentioned by Mr. Williams, was the rope. And without the rope there is no *Godot*, and with the rope extending toward the rear, and with the awkward, unrelated "blocking" this would impose on any production, there is no *Godot* we can understand. But we could not have understood in any event a *Godot* which is stamped solely by speed and anger. If *Godot* is anything it is a drama, not of anger, but of compassion—and, I persist in thinking, of hope. On television, no hope, just haste. Hasty squirrels in a lunatic squirrel cage. The result, only too predictable, in the New York press, was absolute and splenetic stupidity.

I could not close without some quoting from the ignominious reviews that appeared

that week in the television columns of the *New York Times* and *New York Herald Tribune*. All the old idiocies were reiterated, as if no progress or enlightenment whatsoever had occurred (which it has, even among drama critics) since the Broadway premiere of three or four years ago. And everything was put exactly arsy-versy: the play was attacked, the production (moderately) praised. Jack Gould in the *Times*: "*Waiting for Godot* is lugubrious and unintelligible ... painful redundancy ... determined incoherence ... Burgess Meredith captures, on a number of occasions, a wisp of the poetic delicacy that is required ... Alvin Epstein [gives] an exceedingly good performance." Sid Bakal in the *Herald Tribune*: "... babbles endlessly, flails around hopelessly ... Nothing happened and Godot never showed up which makes him a smart chap indeed ... Zero Mostel and Burgess Meredith ... deliver their lines with an enthusiasm denoting they might even understand their pointless dialogue."

They did not, Mr. Bakal. They should have. Whatever it meant to each of them—more yet, to Mr. Schneider—they should have tried to understand.

The fault is not in Beckett, gentlemen. The fault is in the magic little box, the priceless invention, that can give us the man in the street, yes, the shaping and shaking of governments, yes, the insides of our leaders and despoilers, yes, and endless, endless hours of mental self-abuse against our boredom—but nothing in the dramatic arts on a great scale and a true one, ever.

No. 46, April 1967

Dragtime and Drugtime; or, Film à la Warhol

Parker Tyler

Dragtime

Pop Art is a cultural misnomer. It was really studio phenomena that went Pop, by way of comic strip drawing and advertising layout, so that "Pop Art" became a commercial article patronized by a section of the sophisticates who go in for art collecting. If we hope to do justice to a distinguished art world personality such as the Andy Warhol who makes films, we must abandon all the film-poetry cant of the Underground cultists and look at his work and its motives in a much more realistic light. Warhol, at first letting it out to friends that he wished to make "bad films," served fair enough warning of his own. Granting nobody consciously wants to do or be "bad" (why should bland, nice Andy Warhol want to do anything or anybody harm?), he must have meant he planned to make films that were "bad" *as films* but "good" as almost anything else, including the fun-potential based on the success of Pop.

In 1963, when Warhol first set up his sentinel camera, it wasn't original to ignore the hard-won title of "art" that had been historically attached to film. It was already a confirmed, and in fact celebrated, habit of the new American avant-garde to practise an art-economy motivated to some extent by the economy of production costs. For many years, *Cinéma Vérité* and the *Nouvelle Vague* of France had been impressing film fans over the world with the virtue of informal manners, uncomplicated photography, spontaneous fancy, and texts taken unpretentiously from contemporary life. For all I know, the *Nouvelle Vague* to Warhol was only a name. However, he was brought along to a private screening at the office of *Film Culture* by Charles Henri Ford, whom I had asked to attend. Getting there a heavy load of the current Underground style of reeling around on the reel, Warhol also seemed to get the idea that nothing was easier than to make an impression with the medium of film. Film, after all, was even more untouched by human hands than the technical means Warhol employed for his graphic works. His intuition turned out to be very shrewd. His first films, *Sleep*, *Eat*, *Kiss*, and *Haircut*, aroused the fervor of the dominant New York Underground film group, whose magazine,

Film Culture, proceeded at once to give him its Sixth Independent Film Award.

Pop is a cult of the ready-made reprocessed for the uses of camp entertainment. Its parody idiom stretches from the puritanically strict to the bohemianly brash. A lot of rough stuff in the home-movie style (played, as in *Flaming Creatures*, for pathos camp rather than camp laughs) was then available as models. Yet, in an instinctive gesture, Warhol chose to exploit a minimal rather than a maximal animacy, and to limit his subject matter accordingly. His first move, metaphorically speaking, was to nail the feet of his camera to the floor. He might have decided that the camera was at least as talented as Gertrude Stein and deserved every single second of its liberal say-so. The consequent unedited footage was as fetishistic as *musique concrète* except that, as *cinéma concret*, its silence, for a while, was unbroken. He himself knew nothing about the film camera, was probably frightened of its famous pyrotechnics, and so began by treating film as if it were a tentative extension of his still portrait variations, such as the multiple Marilyn Monroes.

It seemed to work wonderfully with the unaided image of a sleeping man. Here was a living organism in which unconsciousness is the more spectacular in that, when wide awake, man is, without a rival, the most intelligent among the animals. True, his reputation has seriously declined in this century, but in the six-and-a-half hours which Warhol devoted to this specimen breathing blissfully along, man as such tends to regain a certain appealing, even monumental, innocence. God knows who, in the eyes of the general audience, the sleeping man is, but he proves that an adult can sleep like a baby; and not just any baby, but a Pop baby.

The *precieux* among cult connoisseurs were not slow to stress the exquisiteness of displaying the simplest, most ordinary happenings at an unvaried pace, to unprecedented lengths of time, and from a viewpoint with the fixity of a voyeur's if without the voyeur's dividend; the aspect of the early subject matter is prim, not scandalous. Other spectators, more permanently and loyally acclimated to the variety and skills of the film art, found Warhol's dragtime film much more replete with nullness than with nuance. Nevertheless, we must note, nuance had

appeared with some real success in the filmmaker's Pop paintings.

The multiple Marilyn Monroes show the actress's head in poster colors via the Warhol simplified-photography method, but each of these images is subtly varied so that we get very much what, if it were transposed to film, would be a series of frames cut from a film sequence in which colored lights had been passed around Marilyn's head. As Allan Kaprow once pointed out, the subject's facial expression varies from unit to unit so that a fluently moody Marilyn is created. Such an effect (Warhol repeated it more dramatically with variations on Jacqueline Kennedy's head) is indeed "human" when compared with the static rows of those poker-faced soup cans. Later, Warhol converted the red-and-white Campbell's Soup color scheme into arbitrary "psychedelic" spectra, related to the fluent kaleidoscope of his Velvet Underground projector.

Whatever value, market or aesthetic, may be placed on Warhol's Pop paintings, they do not demand the passive attention of a fixed (that is, seated) spectator in a film theater. This is what makes the viewing time required for his films into a drag exquisitely nuanced or excruciatingly redundant. Once you take an attitude, it's not hard to decide which of these responses is yours. But suppose you don't find it easy to take an attitude, to judge the thirty-three minute *Haircut* after three minutes or the forty-five minute *Eat* after five or ten minutes? Suppose a sort of hypnotism emanates from the screen so that you begin to feel rather like a rabbit being fascinated by a snake? The "freeze" is not only on the subject, and the camera swallowing it, but on your own morally committed attention.

I am analyzing a likely spectator response. After all, it's the ritual habit of a filmgoer to enter, sit down, and relax. Does any filmgoer avoid this habituation? Film-seeing implies the most passive psychological state of all the visual arts because the theater seat itself is habit forming, and because while watching plays, on the contrary, one shares a certain tension with the live performers. Stage actors themselves speak of rapport with the audience: a feeling that cannot exist for film actors. The very decision to applaud is incubated from the first in the theatergoer and stimulates his attention. Both mind and

eye, in the theater, feeling more responsible to the spectacle as a living thing, are the more alert. On the other hand, deep within the principle of film action (and thus film time) is something "not living": a self-starting independent mechanism, a kind of *perpetuum mobile*, that relieves the watcher of his maximal mental cooperation.

A part of Warhol's negotiable charm as a modern entertainer is his work as applied art-naiveté. There is something both perverse and violent about pasting the camera eye on a limited field of vision, with limited action inside it, and asking the spectator to paste his eye over that, and just wait. The ensuing charm, I should say, is more than a trifle masochistic. But take the contrary view. A high pulse exists in the modern temper (I mean everybody's temper) for elective affinity with occupations that dissociate themselves from the ugly spectacle of war, and lesser lethal agents, as forms of cutthroat competition. The very peacefulness of just watching a man eat a mushroom (even though, as if on purpose, he takes forty-five minutes to bite, masticate, and swallow it all) has its exclusive charm: an exclusive charm that makes it easy for the watcher to feel both chic and restful. The idea of peace, I mean, is directly related to the ultra-passivity of the pre-conditioned, relaxing filmgoer.

Obviously, too, the chic feeling relates to the Pop ambience of the vulgar made precious through parody. The Pop cult is a cult of reassuringly minimal irony; the more it blows up actual scale beyond natural proportions, the less room there is for bothersome irony. Warhol, incidentally, liked to give his early films "art projection" (magnified 16mm) on ordinary interior walls. A pair of kissers then look like an animated mural, billboard size. If overwhelming reality *must* invade our privacy and peace, let it be screened, at least, at the door, and only amusing versions allowed in. As we know so well, certain scales in Pop painting, especially murals, simply giganticize the scale of advertising art, often literally as large as, or larger than, life. Warhol's first film gambit was to giganticize with *time* instead of *space*. Doing it with time (in the film house there is no inevitable sense of the actual physical magnification) made it necessary for him to choose subjects just as obvious and commonplace as those of his paintings.

For many years now there has been a school of film thought of which film à la Warhol is Pop parody. Its theory may be conveniently termed (in the late Siegfried Kracauer's phrase) "the redemption of physical reality." This school believes that the true function of film was not to produce and maintain a new art form, but to provide a super-investigation of mere physical reality. To struggle with this theory on the basis of whether art *is* a mirror, and film a *representational art*, would waste time in this place. Warhol's (probably unconscious) parody of "the redemption of physical reality" makes such an aesthetic argument pointless. The living organic world we see in *Sleep*, *Eat*, *Haircut*, and *Kiss* has a visually implosive force whose burden we must bear or else heave off. Warhol's point is exactly that what we see should reveal nothing new in proportion to the quantity of time required to watch it; indeed, his object might be to portray a deliberate "vicious circle": a closed process with no progress whatever, only an "endless" self-engrossment.

Inevitably, all mental interest and visual attention are governed by an economy that establishes a self-sustaining rhythm. Experimentally, Warhol matched the pulse beat of the camera and the respiration of a sleeping man (the mastication of an eating man, the osculation of erotic couples, etc.) with the pulse beat of the spectator's available interest. If these don't match in the film house, the spectator's boredom will take over. At the same time, the filmmaker's strategy was to make a direct appeal in line with the automation atmosphere of the film. The temptation for the watcher (the preconditioned individual I mentioned above) is to be automated along with the camera's automation as this is rhythmically adjusted to the basic physical drives of eating and kissing. It is "good" to eat. It is just as good, or better, to kiss. How could either occupation make a *bad* film? Such commonplace activities are universal and thus very easy to "identify" with. The film, Warhol plainly says, is no "better" or "worse" than what it records. Result: the plastic medium that creates "filmic interest" and "film art" becomes the victim of another Pop put-down.

That a number of filmmakers in the

Underground movement, as well as a brace of art connoisseurs, fell prostrate before the Warhol Pop film tells us something tangible about the current state of the American avant-garde in film and elsewhere. Dragtime (the superficial tempo of Warhol's primitive films) might be said to have more than a mite to do with drugtime and the magic beauties of an expanded time assisted (as it is in *The Chelsea Girls*) with overt psychedelic decor. Theoretically, the Warhol devotees suppose that a definite beauty exists in his reductio ad "least" absurdum of progress in objects.

The same reduction seems less absurd if we expose it to a light to which it might seem to aspire. We know a great deal about the chemical change of witnessing organisms that much expands time-lapse as measured on the clock. The well-publicized "psychedelic experience" is all we need to be informed that the agent of such wondrous expansion is a variety of drugs, having a range of effects on time-awareness and the appearance of objects, but all peculiarly improving the rewards of sense perception. I recall how, as long ago as pre-WPA days, certain Village brahmins would speak of the marvelous thrill to be had from smoking marijuana. A cat would cross the room; that was all. And yet not only was this something that seemed to go on forever, but also it produced a fantastic sort of pleasure: a pleasure which looking at a cat crossing a room when one was in a normal state decidedly failed to produce. The later Warhol films suggest that he divined in the physical accumulation of screen time a potential hypnotic effect on watchers which nothing else but drugs could guarantee. I think that his primitive films can be called experiments in dragtime which logically predicated an innoculation of the unwinding reel with drugtime.

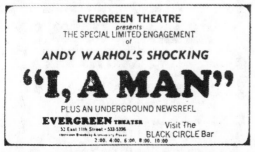

An advertisement for Andy Warhol's *I, A Man* that ran in the June 9, 1968 edition of the *New York Times*

Drugtime

Warhol was still a rather esoteric quantity as a filmmaker till his latest film, *The Chelsea Girls*, which climaxes his self-maneuver out of his original styleless style into something like profession-pretending filmmaking. The purity of the original eventless films was first modified by *Blow Job*, an erotic conceit that begins with the opening of a fly and ends with closing it. In between, with only the passive subject's face in the unswerving camera range, we are treated to a process which actually, since it leads to an orgasm, is also a progress with a readymade mounting interest. Here the psychological element of a *tiresome* progress, an *exhaustible* drive, was significantly, in fact fatally, hinted.

Even the sexual act is something in which a boredom-potential inheres. At the same time, sex has an indispensable organic suspense: the climax may be irritatingly or profitably postponed; the very physical labor may unaccountably grow wearisome; still the great end, psychologically and physiologically, stays in view. Referring *Blow Job* to the preliminary sexual activity of kissing, one notes that *Kiss*, which lasts fifty minutes and holds numerous pairs of kissers, does not fail to show signs of tiring its subjects and forcing them to fresh prodigies of osculative style to justify, it seems, the camera time being spent on them. Here already was a flagrant "impurity." The human subjects involuntarily betrayed that a sort of theater was present, a "show" which felt obliged to sustain the "interest."

Hitherto, Warhol's subjects notably seemed indifferent to being watched, to (so to speak) having to perform anything with a "program" or a "script." For all that suspense or expectation is involved, *Haircut* or *Eat* might be totally outside time in a vacuum like that of far space. When, for example, we are asked by *Empire* to watch a famous landmark ("the world's tallest") standing quite motionless, with the camera equally unmoving, while the sun is allowed to take all of eight hours to go down and come up, we are being asked to submit ourselves to an endurance test; that is, to the opposite of an entertainment form … unless (which is, I think, the point) it should occur to us that this

quantitative time, spreading out its minutes in a morgue, is merely the abstract proposition for a much more entertaining, specifically psychedelic, time. The latter provides a dramatically decisive change not in the object, but in the one viewing it. *Drugtime is the other pole of dragtime.* However unconsciously, Warhol began playing with this interpolar tension as if it were a new toy (which in a way, being a camera, it was!). His social milieu already contained these same two polarities and their vibrating rapport. Another ready-made subject awaited his Pop ministrations.

Narcotizing is very close to Narcissizing. The only distinction is that with drugs, the gazer's own image is not the object of fascination; rather it is the image of the world transmuted by a chemical change in the gazer's perceptive faculties. Narcissus' image *has become* the world and the resultant rhythm of merged awareness is, exactly, drugtime. It is the time of sublimated leisure: *all the time in the world.* Warhol's *Vinyl,* his first film with "progressive" social action, came along as a documentation of people in the mixed throes of narcotizing and narcissizing; also for the first time, there were credits for the title, the idea-man and the leads; otherwise, as usual, the film was titleless. A group of young men, watched by a motionless female odalisque, are got up in a way to suggest exotic Leather Boys while their behavior (sado-masochistic according to the shadowy script) suggests the dazed performers of an impromptu, faltering charade. We are witnessing a snail-paced fantasy in which familiar homosexual sadism, enhanced by drugtime, is putting on some kind of an act. Warhol still holds up a still, small mirror to nature, but now nature, by all the signs, is narcotized narcissism.

One hears that Warhol's productions have a way of being group-groomed. Logically, then, his function became a parody of the Hollywood "genius" producer who decides everything and delegates the execution to others. However valuable another's contribution, the Warhol label is the only thing featured. A curious accident took place in the next film, *My Hustler,* aligning it with the objective hazard of the Surrealists. Not only does this film fall apart into two sections of very unequal aesthetic caliber, but the accident seems to have been caused by the studied inattentiveness to form typical of Warhol's *cinéma concret.* A rather flossy homosexual, with a handsome, freshly picked hustler as a guest at his beach cottage, is in a tizzy that a marauding male or female will grab him away during his lone sunbath on the sand; this is the gist of the clumsy screen sequences, badly framed, casually intercut, amateurishly acted, indistinct in sound and altogether home-movieish, that comprise the first section. The second section is a small miracle, not the less miraculous for seeming just as ad libbed and "unprofessional" as the first; once more, the camera is without so much as a tremor to disturb its voyeurish solitude.

A dark-haired hustler, an old-pro, has appeared at the beach cottage and has evidently decided, on his own, to help initiate the blond, a newcomer to the trade. Cozily

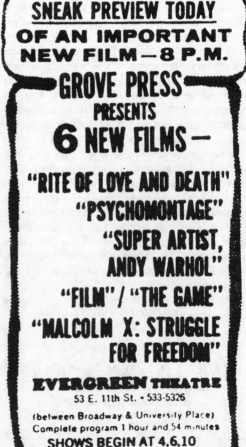

An advertisement for films at the Evergreen Theater that ran in the April 16, 1968 edition of the *New York Times*

flank by flank in the cottage's tiny bathroom, the pair engage in some beautifully deft verbal sparring. The hush that can sound like an interminable desert of silence in Warhol's films is here as precisioned into tense pauses as the most carefully crafted dramaturgy. One has a notion the directorial genius that makes everything in this true-life put-on look utterly right is a real objective hazard; I suspect it was due simply to the perfect understanding between the two performers as to just what was involved. Adagio, sotto voce, it leads into a veiled proposition from the old-pro—tactically prolonged through an endless shave and wash-up—that the blond, in return for the other's invaluable list of tried customers, must first render up his body to the old-pro himself. The charade idea is built into the readymade material, which is as sober in tone, as ordinary in rhythm, as the action of *Haircut*. Here, too, is the old faint-away stop: tantalizing because we don't find out if the wary neophyte accepts the proposition or even if he's faking his alleged puzzlement over what the proposition really is.

Then came the expanded-keyhole variations of *The Chelsea Girls* suite, which, as I write, has just been promoted to art-theater status. Some confusion among fluttered commentators has been created about whether the film is "dead serious" or a horrendous "put-on." Whichever it is, they like it as much as if it were a homemade *La Dolce Vita*, which is what it is. The fact should have wider currency that nothing can be so "dead serious" as a "put-on" by Warhol Super Stars. Super Star is a category which some of his actors claim and to which all have the legitimate right to aspire. Fame, sheer fame, has a way of stirring up its favorites and would-be favorites with the force of, at least, amphetamine. The whole cast of *The Chelsea Girls*, seen for 3 1/2 hours in a series of sometimes overlapping rooms, has the habit of loitering before the camera with looks half drug-dazed, half glamor-glutted, and for super-measure, more than half bold with nonchalance. Without nonchalance, they could hardly "perform." And sometimes—it is Warhol's big step toward "theater" and "story"—the actors here *do* perform.

Not only do the actors before Warhol's cameras seem, now, really involved with something, his camera itself is involved with what it sees. *All* tend to freak out. Intermittently, in contrast to some steady-eyed close-ups, the camera pointlessly starts zooming with the push-button ease of an addict launching on a rhythm kick. No longer is it a stand-in for the beautifully bland, impersonal, kind and so tolerant gaze of a transfixed watcher immune to boredom. Now it is as perambulant as some of the guests at a (supposed) Chelsea Hotel who pay each other cozy, more or less friendly, visits. The dragtime, with its monotonously circular non-progression, is much tightened, though still distance-going. The subject is, in fact, peepshows, and the show is, nearly always, intoxicated persons (even beer is one of the intoxicants) doing their stuff under bright lights with the dazzling intimation of coming publicity. It is for intransigent critics or in-group gossip to say whether the performers are really drug addicts, or just pretending to be. The inside myth is, I take it, that they are, and thus that Warhol's camera has grown daringly, shockingly candid.

The truly shocking thing, in terms of the previous Warhol, is the new sort of violence: the violence of sadists and masochists freed into their desired domain by courtesy of a stimulant such as amphetamine or an hallucinogenic such as LSD. Yet, while there is a dedicatedly dreary scene in which a hustler lolls around in bed with his male patron, spitefully upstaging him, there are no wild orgies even approaching Sadian eroticism. Because of the pacifying effect of the drugs, apparently, the sadistic impulse, like the erotic impulse, is rerouted and held in a kind of narcissistic trance in which the monologue takes command. Here is narcotized narcissism in full, unimpeded, leisurely stride. As a sadistic bout, it seems best suited to Lesbian delusions of grandeur; for instance: the Amphetamine Amazon on the telephone and Hanoi Hanna in her straight-camp TV parody, during which, on the side, she persecutes two of her weaker mates. Not that cinematic skill or theatrical form have materially altered Warhol's primitively flat style. At best, *The Chelsea Girls* provides some scenes that, properly trimmed, would look like respectable *Cinéma Vérité*. But that is the limit of Warhol's homage to the film art, with the sole exception of a color sequence where his sliding Velvet Underground lights

51

project the interior of an addict's trance. This sequence has quality but within the context of *The Chelsea Girls* it is only another form of Olympian self-documentation.

Curiously enough, however, the "self" has become schizoid here: both in some of the actors and in the camera. Through most of the film two screens (or "rooms") exist side by side. Dragtime/drugtime is itself a split plastic "personality" and this is reflected in the alternate aspects of a character seen simultaneously in different psycho-physiological states in different rooms. Crudely handled as the device is, it is intrinsically interesting, especially as to its possibilities. Warhol's invasion of hallucination as promoted by drugs poses a procedural dilemma for his future film making. The formal restrictions super-exploited by his primitive style (the dragtime) imply an almost puritanical detachment from life: reality's fabulous deadpan dream. Now he has chosen to grapple with that peculiar collective secession from normally rational society that implements drugs to achieve its isolation. He has not tried to use hallucination as a device of creative film making; rather he has shown, almost exclusively, the *outsides* of those seeking hallucination as means of rescue from sober, everyday reality. Has this "behaviorism" of hallucinated subjects always been Warhol's Underground motive? Did he always intuit the psychic tension between dragtime and drugtime and gradually begin manipulating it?

This seems certain: The anti-heroic film marathons he calls *Sleep, Eat, Haircut, Kiss,* and *Empire* can be conceived by dedicated audiences *as if* they were drugtime—that is, as inexplicable wonders of eventfulness. As I say, Warhol has translated into quantitative minutes on the screen the magical *durée* inducible in watchers by marijuana and other drugs. Psychologically it is possible for quite sober persons to grasp the physiological principle lodged in drug-taking and transpose its consequences, in terms of visual perception, to some film *objectively laid out like a "trip."* Hence the primitive Warhol films might function as dialectic antitheses, demonstrating how what is excruciatingly tiresome and commonplace cries out for the right conversion-formula in the witness—not the intermediate witness, the camera, but the final witness, the audience. Warhol may have moved in some mysterious way his wonders to perform—those wonders so filmic and yet not filmic!

Opposite: Advertisement for Grove Press Film Division that ran in *Evergreen Review* No. 61, December 1968

Grove Press presents another four-letter word

"Film"

(the other one, of course, was "book")

No. 46, April 1967

SOMEDAY WHAT YOU REALLY ARE IS GOING TO CATCH UP WITH YOU

I JUST HOPE IT ISN'T TOO LATE

OR

**Don't be a fool!
Once a romance is dead...
it can never
come to life again**

A MERCILESS EXPOSE OF DRIVING PASSIONS AND WASTED LIVES
BY MICHAEL O'DONOGHUE

STARRING

LESLIE HOWARD

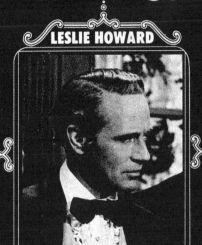

as the winsome neurosurgeon
who preferred to operate
in the dark!

CLARK GABLE

as the debonair biplane ace who
won every dogfight, yet got shot
down in the bedroom!

VIVIEN LEIGH

as the girl from the
wrong side of the tracks
who came across!

Vivien Leigh: I felt so terribly alone.
Leslie Howard: I love you.
Vivien Leigh: And I love you. You don't know how much.
Leslie Howard: I didn't know anyone could love anyone as much as I love you.
Vivien Leigh: Do you really mean that?
Leslie Howard: Every word of it.
Vivien Leigh: How beautiful the moon is tonight. The night seems magical, doesn't it, darling?
Leslie Howard: Why, you're . . . trembling.
Vivien Leigh: Hold me close, darling. Closer! Closer! Don't ever let me go.
Leslie Howard: We've been living a lie.
Vivien Leigh: It's not me you hate. It's yourself.
Leslie Howard: Does it really matter?
Vivien Leigh: I never thought it would and now it does.
Leslie Howard: Why?

(Violins suddenly sound a haunting refrain. The lovers stare silently into the darkness, their eyes glistening with awe and wonder.)

Vivien Leigh: We couldn't help it. We just fell in love.
Leslie Howard: Look Kathy, I know how you feel but you've got to snap out of it.
Vivien Leigh: Leave me alone! Leave me alone!
Leslie Howard: You've got to eat something.
Vivien Leigh: I just happen to be in love with you.
Leslie Howard: Gee, I think you're swell too.
Vivien Leigh: You can't fool me and you can't fool yourself.
Leslie Howard: You have spirit. I like that.

(Clark Gable enters makes a telephone call.)

Clark Gable: Hello. Hello. Oh, nothing. I just wanted to hear your voice again.
Vivien Leigh: You have no idea, Robert, how much I hate you.
Clark Gable: I've got to talk to you. It's terribly important.
Vivien Leigh: Would you mind taking me home? I have a splitting headache.

Leslie Howard: You are an angel.
Vivien Leigh: How do I look?
Leslie Howard: Beautiful.
Clark Gable: Wait, Phyllis! Don't hang up! Don't . . . (He slowly hangs up.)
Leslie Howard: (Preparing to leave.) May I take a rain check?
Vivien Leigh: Every time you walk out that door, I'm afraid you're not coming back.
Leslie Howard: Don't do anything you'll regret, Beth, I'm warning you. (Exits.)
Vivien Leigh: Goodbye, my love.
Clark Gable: I need you, Niki. I never knew how much.
Vivien Leigh: It's no good. It just doesn't seem to be working out.
Clark Gable: You're wonderful. I didn't have sense enough to see it until now.
Vivien Leigh: Perhaps it's just as well if we don't see each other again.
Clark Gable: It's no use kidding myself. I'm really stuck on you.
Vivien Leigh: Maybe someday you'll understand.
Clark Gable: Bonnie . . . You can't go on acting as if we were strangers. You know how I feel about you.
Vivien Leigh: It's all over, Don! It was over two years ago! Now please leave me alone.
Clark Gable: The moment I saw you, Bonnie . . . it started all over again for me! Nothing . . . no one . . . seemed to matter anymore . . . but you!
Vivien Leigh: Don't be a fool! Once a romance is dead . . . it can never come to life again.

(Violins suddenly etc. . . . awe and wonder.)

Clark Gable: You're everything I ever wanted.
Vivien Leigh: What difference does it make as long as we're together?
Clark Gable: I want to love someone and be loved in return.
Vivien Leigh: I wish I didn't love you so much.
Clark Gable: How long can this go on? Until we are ashamed to look at each other?
Vivien Leigh: Jeff, you've made me the happiest woman in the world.
Clark Gable: No happier than you've made me, my darling Abby.
Vivien Leigh: I've never been so happy in my entire life.
Clark Gable: I love you.
Vivien Leigh: If you really loved me you wouldn't say a thing like that.
Clark Gable: I've been playing a part for you. But I'm not going to play it any longer.

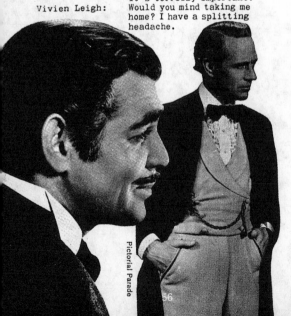

Vivien Leigh:	I suppose I've behaved outrageously.
Clark Gable:	So it would seem.
Vivien Leigh:	Face up to the truth! Face up to yourself!
Clark Gable:	I'm lost.
Vivien Leigh:	Harold, you're never lost. You always know exactly where you are. But where am I?
Clark Gable:	I'm sorry. It isn't that I haven't tried.
Vivien Leigh:	I know.

(Violins suddenly etc....awe and wonder.)

Clark Gable:	If you think I'm going to come chasing after you, you're wrong.
Vivien Leigh:	Do you know where you're going?
Clark Gable:	Maybe with somebody like you, I would. (Exits.)

(Enter Leslie Howard.)

Leslie Howard:	Once you let him go, you'll never get him back.
Vivien Leigh:	I knew you couldn't stay away...not after all we meant to each other.
Leslie Howard:	I love you. So very much.
Vivien Leigh:	I worried about you, dear, while you were away.
Leslie Howard:	Oh, don't worry about me.
Vivien Leigh:	Promise you'll never go away again.
Leslie Howard:	I promise.
Vivien Leigh:	Do you love me?
Leslie Howard:	I'd be pretty dumb not to, wouldn't I?
Vivien Leigh:	If you loved me, you wouldn't let me go to Norman. You wouldn't want me to.
Leslie Howard:	Why must it end like this?
Vivien Leigh:	Because it's happened. I'm in love!
Leslie Howard:	Yes, but honey...
Vivien Leigh:	Oh, Greg. Larry doesn't mean a thing to you. I've loved you all the time. I've been too blind to see things clearly.
...rk Gable:	(Entering.) We all make mistakes in life. That's how we grow up.
...en Leigh:	What is it, Tom?
...rk Gable:	It's about you and me, Dotty.
...lie Leigh:	Let's just call it quits.
...slie Howard:	You're like a kitten. Soft. Warm.
Clark Gable:	I was crazy letting you go.
...ien Leigh:	Darling, it's not our fault. We didn't mean to fall in love.
...Howard:	Maybe we didn't try hard enough not to.
...Gable:	You're everything I dreamed Anna. A beautiful angel After Father died, Mother and I...
...ble:	Come back. Please come back.
...oward:	She's found somebody new.
...ble:	It's time you woke up.
...eigh:	Tell me you love me. Please tell me you love me.

Leslie Howard:	I love you, sugar.
Clark Gable:	It's no good, Helen. It isn't right.
Vivien Leigh:	The important thing is we'll be together.
Leslie Howard:	We'll be together from now on.
Clark Gable:	I want you to know there's never been anyone else.
Leslie Howard:	You really don't see, do you Edward?
Clark Gable:	This is my own problem. I want to solve it my own way.
Leslie Howard:	You can't solve problems by giving in to them.
Vivien Leigh:	I'm sorry for hurting you the way I did, Roy. Please forgive me.
Leslie Howard:	I understand. Take care of yourself. You're precious to me.
Vivien Leigh:	I've been such a little fool, such a little heel.
Clark Gable:	I don't want anybody's pity.
Vivien Leigh:	When I was a little girl, I used to tell my doll...
Leslie Howard:	You're different from any woman I've ever known.
Clark Gable:	I'll never forgive you for ruining my life.
Leslie Howard:	Love! What do you know of love? Just because your heart was broken you think you have the right to break mine.
Clark Gable:	You may not know me as well as you think you do.
Leslie Howard:	That may work both ways.
Vivien Leigh:	You know, there's never been anyone but you.
Leslie Howard:	Of course. I've known all along.
Vivien Leigh:	Oh, darling. You're so marvelous.
Clark Gable:	You're not going to destroy me! I won't let you destroy me!
Leslie Howard:	I'll stay, if you think you can learn to love me.
Vivien Leigh:	I'm learning already.
Leslie Howard:	What a pupil!
Vivien Leigh:	Chris, this is goodbye.
Clark Gable:	Someday, what you really are is going to catch up with you. I just hope it isn't too late. (Exits.)
Vivien Leigh:	We shouldn't mourn for the past.
Leslie Howard:	Sometimes, Tony, it's more beautiful than the future.
Vi... Leigh:	(To audience.) I knew, as his lips met mine, that there would be other nights, other kisses... this was the wonderful love both of us had yearned for.. now, there would be no more waiting

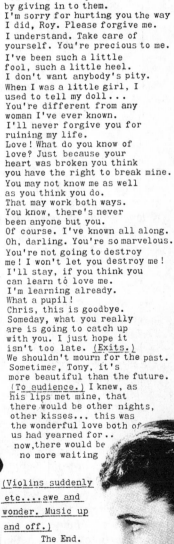
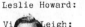

(Violins suddenly etc....awe and wonder. Music up and off.)

The End.

13 CONFUSIONS

Amos Vogel

This critical look at the present state of film-making in the U.S. by a pioneering figure in the American avant-garde cinema opens a debate which Evergreen *will continue in its next issue with replies to Amos Vogel's provocative statement.*
—THE EDITORS

After two decades of obscurity, poverty, ignorant rejection, and dogged persistence, the American film avant-garde suffers today, for the first time in its history, from an ominous new ailment: over-attention without understanding, over-acceptance without discrimination. Crime of crimes, it has become fashionable. Its gurus and artists are in danger of becoming the avant-garde establishment; its growing fame hides only imperfectly an inner weakness. The following observations, aimed at the removal of confusions, represent a criticism from within, fully cognizant of the movement's many achievements.

These lie not merely in the many talents and works it has discovered and championed, but in its continuing creative "desecration" of the medium, leaving nothing undisturbed, taking nothing for granted. In the hands of the movement's foremost practitioners, film is sacked, atomized, caressed, and possessed in a frenzy of passionate love; neither emulsion, exposure, lighting, film speeds, developing, nor rules of editing, camera movement, composition, or sound are safe from the onslaught of these poetic experimentalists who have irrevocably invaded the medium. While most commercial films can safely be followed with one's eyes closed, these works force spectators to open them wide, thereby rendering them defenseless against the magic powers of the medium.

The American avant-garde is part of a strong international trend toward a more visually-oriented, freer, more personal cinema. This movement expresses a revolt against the ossifications of institutions and the conservatism of the old. It represents a cinema of passion. By restoring the primacy of the visual element, this movement brings us face to face with the essence of the medium, the profound and inexplicable mystery of the image.

Thematically, stylistically, and ideologically, the films belonging to this tendency reflect and prefigure an era of social change,

disorientation, and decline, and are suffused with an existentialist humanism devoid of certainty or illusion. Liberated from nineteenth-century art, they increasingly displace realistic narrative structures, clearly defined plots, and well-delineated characters by visual ambiguity and poetic complexity, exploring ideas and forms vertically instead of illustrating events horizontally. There are strong influences of surrealism, neo-dadaism, pop art, the "absurd" theater and the theater of cruelty, Robbe-Grillet and the new novel. Textbook rules of filmmaking have been abandoned. Editing is explosive, elliptic, unpredictable; camera movements fluid, frequent, and free; time and space are telescoped, destroyed, or obliterated; memory, reality, and illusion fused, until, in a flash of revelation, we realize that the totality of these uncertainties and discontinuities reflects nothing less than the modern world view in philosophy, science, art, and politics. These questioning, white-hot filmmakers—themselves anguished configurations of the anxieties and limited wisdoms they portray—are the committed artists of the sixties, the true explorers of our day.

But the American avant-garde seems to have arrived at a crossroads. On the one hand, the seeds planted by Frank Stauffacher's "Art in Cinema" series and Maya Deren's screenings in the forties, as well as Cinema 16's programs, 1947–1963, have been transformed into a full-blown, highly visible movement. There are unceasing, voluminous productions; new exhibition outlets; schools, art centers, and civic groups clamoring for the "underground"; discothèques and coffee-houses utilizing film-oriented mixed-media techniques; mass circulation magazines and television providing widespread publicity. This new stage remains the undeniable achievement of Jonas Mekas and the New American Cinema Group.

On the other hand, however, there now exists a certain wariness concerning the movement, even among its friends and supporters. Too many of the films are unsatisfactory, even with the greatest of efforts at a sympathetic magnification of their small virtues. In film circles it is no secret that, after all the growth and publicity, audiences at the Film-Makers' Cinematheque in New York are leveling off. To this must be added the paradox of voluminous productivity and little new talent; the growing credibility gap between the movement's house organs and observed filmic quality; the absence, despite new and laudable attempts, of any real resolution to the crucial distribution and exhibition problem. As the faint odor of trouble becomes more noticeable, the evangelical ardor of the movement's leaders becomes more insistent, the manifestos and exorcisms less circumspect.

To begin the process of an informed critique of the American avant-garde (and more specifically, the ideology and style of the New American Cinema tendency within it) is an act of the highest and most necessary loyalty to the movement. The time has come to rescue it from the blind rejection of commercial reviewers and the blind acceptance of its own apostles, both posing as critics and neither subjecting it to dispassionate, informed analysis.

1. CONFUSING TIMES SQUARE WITH MANHATTAN

The New American Cinema (NAC) and the American Film Avant-Garde are *not* synonymous. The NAC group is the dominant, but not the only, factor within the American independent film movement today. Because of its vociferousness and quantity of production, it impresses its values and style on the entire movement, and is frequently and erroneously equated with it. This leads to the convenient omission of Bruce Baillie and the Canyon Cinema Cooperative, other West Coast filmmakers, George Manupelli and Richard Myers in the Midwest, Hilary Harris, Carmen D'Avino, Francis Thompson, Len Lye, and others in New York.

2. CONFUSING A PRODUCERS' COOPERATIVE WITH A SCHOOL

The New American Cinema is neither ideologically, stylistically, nor otherwise a unified movement or tendency. In its manifestoes, it elevates eclectic estheticism and undifferentiated enthusiasm into a principle, instead of admitting that the group—ranging the spectrum from Anger to Breer to Warhol to Brakhage—is an economic and not an esthetic unit.

3. CONFUSING HISTORICAL CONTINUITY WITH IMMACULATE CONCEPTION

It is necessary to situate the NAC within history—the past, the present, the speculative future. As to the past, the American film avant-garde has its roots in the European surrealist and expressionist avant-garde of the twenties and the American experimentalists of the forties and fifties. The current NAC leaders, for obvious and indefensible reasons, prefer to draw a veil of silence and disregard over this past, thereby contributing to the provincialism of its adherents. It is only recently and because of internal criticism of the kind perpetrated here in public that a few of the works or writings of the "fore-runners" have begun to appear on some Cinematheque programs or in *Film Culture*. Nevertheless, it is safe to say that the crucial importance of such filmmakers as Sidney Peterson, the Whitney Brothers, Ralph Steiner, Oskar Fischinger, Watson–Webber, Maya Deren, Curtis Harrington, and James Broughton remains unknown or unanalyzed trivia in the ideological development of the new generation. To see a resemblance to a certain type of history rewriting is not entirely out-of-place. It evinces the customary narrowness and demagoguery, but is fortunately unaccompanied by effective control over the information media. One shudders at what might happen if some of our present-day proponents of total liberty became Commissars of *Film Culture*.

As to the present, the NAC is undeniably and inevitably part of the world-wide movement toward a more visual cinema, despite all their protestations to the contrary. It is impossible to remain neutral when confronted with the astonishing provincialism of the NAC's ideologues in dismissing, disregarding, or exorcising Antonioni, Godard, Resnais, Skolimowski, Bellocchio, and Lester; and magnifying, as their field of vision narrows, every object in it, until pygmies loom like giants.

The NAC will transcend its present dilemmas only by carefully studying the techniques and achievements of these experimenters; and by fully acknowledging that this international "pro-visual" movement is neither an exclusive club nor a dogmatic sect, but includes both Emshwiller and Antonioni, VanDerBeek and Godard. No film or filmmaker can be read out of this movement by papal decree.

Jonas Mekas' statement at the recent Museum of Modern Art "New Cinema" symposium ("Old cinema, even when it is successful, is horrible; New Cinema, even when it fails, is beautiful") is provocative and untenable. Bertolucci's *Before the Revolution*, Rivette's *Paris Belongs to Us*, Dreyer's *Gertrud*, Skolimowski's *Walkover*, Schorm's *Courage for Every Day*, Teshigahara's *Woman in the Dunes*, Rocha's *Black God, White Devil*, Jancsó's *The Round-Up*, Paradjhanov's *Shadows of Forgotten Ancestors*, Antonioni from *L'Avventura* to *Blowup*, Resnais from *Hiroshima* to *La Guerre est finie*, Godard from *Breathless* to whatever his latest—*all of these created within what Mekas calls the "old" cinema*—are avant-garde works. They are not merely more important than the failures, but often even the successes of the independent avant-garde. Some day soon an interesting discussion will be begun as to the relative degree of experimentation, achievement, subversion, political or artistic daring in these works on the one hand, and the NAC films on the other. In any case, the creations of these so-called "commercial" directors can be disregarded only by hopeless dogmatists.

4. CONFUSING FREEDOM WITH FORMLESSNESS

Lack, failure, and disregard of *form* is the overriding weakness of today's avant-garde. Current tendencies in all the arts toward improvisation, fluidity, and chance are mistaken for a total absence of form; they disregard the fact that it is precisely the achieved works of this kind that reveal an inner structure and logic.

This inner coherence is "felt" rather than explicable. It is totally lacking in so many current efforts, which could equally well go on for fifteen minutes or fifty, and in which the succession or duration of shots remain totally irrelevant or mutable in terms of the total construct of the work. They lack surprise, mystery, and that inexorable form and flow which are the characteristics of all great art.

Film, both as a plastic and time art, involves considerations of tempo, length,

progression, editing, camera positioning. These considerations, even in experimental works, are not and can never be suspended. They operate quite independently of the artist's announced intentions on the deepest psychological levels and determine the work's value as art. A strong sense of form, structure, and tempo, regardless of their specific and differing esthetic commitments, is inevitably present in the best works of the American avant-garde movement.

5. CONFUSING CONTENT WITH QUALITY

Thematic liberation is no guarantee of quality. Nor is the use of five simultaneously operating projectors, extreme nudity, unexceptionable anti-Vietnam sentiments, hand-held cameras, portrayals of transvestism. Said Cocteau ironically, when first confronted with Cinemascope: "The next time I write a poem, I shall use a larger piece of paper."

6. CONFUSING NON-SELECTIVITY WITH ART

The NAC's proudly proclaimed policy of showing, distributing, and praising every scrap of film is self-defeating. Every new person who gets a camera and thereupon "completes" a "work," immediately obtains a public showing and distribution. In this manner several hundred titles are added to the yearly "oeuvre" of the American avant-garde. Under the circumstances, it is easier to discover epigones of Brakhage than new Brakhages.

It may be essential to show every single film to filmmakers at internal, workshop screenings so that they can see each other's work; it is suicidal if this is done with general audiences. Given the present volume and level of "production"—miles of new films—this gluts the market and inundates the viewer in a morass of mediocrity or worse. Sooner or later, the audience refuses to accept the frequent ratio of five minutes of promising footage to two hours of tedium. Unable to judge the works in advance or to rely on somebody else's judgment (since no selection takes place), they ultimately decide to stay away or to stop renting films, their frustrated interest supplanted by hostile irritation. How could they have known, amidst the welter of unknown new productions and a total absence of critical writing, that *Metanomen, Lost in Cuddihy, Oh Dem Watermelons* and *Relativity* were most eminently worth seeing and four hundred other recent films were not?

There is therefore a need for a new showcase for the avant-garde, not under the control of one faction within the movement, however important, but presenting the best new avant-garde films, as carefully selected by a group of avant-garde—including NAC—critics and writers. Selectivity is a function of taste and of proper growth.

Any criticism of this method of selection as an impermissible "directing" of public taste is hypocritical. First, wherever there is exhibition, there is prior exercise of judgment. Second, if anything, this criticism applies to the present system of control by one faction.

7. CONFUSING GOOD WITH BAD

It is time for the NAC to admit that there is such a thing as a bad avant-garde film; that in fact there are more bad avant-garde films than good ones; that at least half of the films presently exhibited or distributed are bad; that one must be able to point out why some are bad or why others are good; and that to do so, it is necessary to establish critical standards and to develop critical writing and taste.

It is time to admit that not all that is good is avant-garde; that not all that is avant-garde is good; and that even a good avant-garde filmmaker can make a bad film.

Ultimately, there is only good and bad art, within the framework of one's particular value system. Our real interest in avant-garde art resides not in its being avant-garde, but in its implicit promise of quality as against the exhaustion of the commercial cinema. There is nothing inherently superior or automatically supportable in the concept of avant-garde cinema as against the old cinema, unless it proves its superiority in practice.

8. CONFUSING PROPAGANDISTS WITH CRITICS

It is quite correct to say that publicists and propagandists were eminently essential to

create this so often unjustly maligned and disregarded movement. No one will deny their success in contributing to the creation and visibility of the movement.

In the process, however, they have imperceptibly blurred all distinction between propaganda and criticism, until their "reviews" and house organs have begun to resemble the literary vanity presses, with an appropriately hallucinatory inflection.

Today, when the avant-garde is entering a dangerous new stage, analysis must take precedence over publicity, and the two must be clearly distinguished from each other.

Publicists are hyperbolical, particularly where the client's products are concerned. For this reason, the following formulations, continually posing as critical evaluations in published articles and essays, should properly be labeled publicity or advertising copy: "A work of beauty," "a beautiful work," "it is beautiful." Particular care must be taken with such phrases as "One of the ..." (i.e., "This is one of the most beautiful works of the American avant-garde.") Finally, the continuous procession, week after week, of new masters, geniuses, and giants quickly becomes an object of suspicion or ridicule.

We need proponents, not fetishists, of avant-garde cinema. We must rigorously insist on the same standards of judgment for avant-garde films as those we apply to any other work of art. This concern with standards must not be equated with authoritarian strictures regarding style or content. On the contrary, it is when we coddle the experimenters with misplaced tolerance, when we talk of achievement where there are only attempts, of attempts where there is nothing, of retrospectives after two years of production, that we profoundly weaken the movement.

9. CONFUSING PUBLICITY WITH ACHIEVEMENT

Publicity is no proof of quality; large-scale attention by the mass media is no guarantee of achievement. It merely denotes that the avant-garde film has reached the level of a marketable commodity; it has become copy. This is because the avant-garde's aggressively anti-establishment stance expresses itself frequently in well-advertised taboo subjects (eroticism, "deviations," drugs); charmingly offbeat acts and disturbances; publicizable new techniques (mixed media, "creative" tedium); and interesting visual gestures of a vaguely oppositional nature.

Since this limited radicalism is, by virtue of nonselective programming, drowned in endless reams of innocuous films, it is the more easily subsumed by the establishment, which, by publicizing it, robs the underground of its cult appeal while simultaneously deriding it ideologically. In this sense, the latitude granted to these isolated showcases to exhibit whatever they wish implies that they serve as a safety valve for the draining off of radical impulses and that the avant-garde, at the very moment of its acceptance by the establishment, is faced with the possibility of imminent emasculation or absorption.

10. CONFUSING ONE SWALLOW WITH A SUMMER

The commercial success of a single film, *The Chelsea Girls*, must not blind us to the realization that the distribution and exhibition problems of the avant-garde remain unresolved. The reviews and word-of-mouth publicity regarding this film's presumed depravity and sexual daring automatically provide a ready-made audience for it. No pejorative comment is intended; the saleability of sex in a sexually repressed society is inevitable.

11. CONFUSING ONE GENERATION WITH ANOTHER

It is a significant comment on the stagnation of the American avant-garde that most of those who are by common consent considered today's best directors are members of the middle generation first seen at Cinema 16: Anger, Brakhage, Breer, Clarke, Conner, D'Avino, Emshwiller, Frank, Harris, Markopoulos, Menken, Maas, Rice, VanDerBeek. Of the younger generation, among the few to approach the above in promise or interest are Warhol, Bruce Baillie, Peter Goldman and possibly Tony Conrad and Sheldon Rochlin.

Amidst the welter of new works and new directors, there will undeniably be found new talents and, in this sense, the present explosion of filmmaking is to be welcomed.

But after more than six years of this activity, it is today equally legitimate to speculate as to the paucity of significant new talents and to wonder, when they do arise, about the influence of unquestioning acceptance and the dismissal of world cinema on their later development.

To this must be added the threatening or already accomplished exhaustion of some of the middle generation talents and their inability to progress beyond earlier achievement.

12. CONFUSING LITERARY WITH VISUAL CRITICS

The movement needs not merely critics as such; it needs visually-oriented critics. Most of the current reviewers and critics come out of a literary or journalistic tradition. Their commitments are to clear narratives, realism or naturalism, noble and identifiable sentiments, with the visuals serving as illustrations of an underlying literary thesis. This is criticism oriented toward sociology, literature, psychology, not toward the visual essence of cinema.

Art critics and historians such as Amberg, Arnheim, Hauser, Langer, Panofsky, Read, Richter, Schapiro, and Tyler have always concerned themselves with the esthetics of film; and the recent incursion of new art critics and historians into film criticism (Battcock, Cohen, Geldzahler, Kepes, Kirby, Meyer, Michelson, O'Doherty, Sontag) is therefore to be welcomed and encouraged. Visually oriented, their special sensibilities and commitments, their openness to the techniques and philosophy of modern art could contribute significantly to the elaboration of an esthetic for a visual cinema. This must include an investigation of the differences between film and the other plastic arts (the element of time, the illusionary portrayal of motion and reality on a two-dimensional surface, the use of sound, the cinema as a palace of dreams). These "filmic" characteristics, at least in the case of happenings, environments, and mixed-media works, are now, in any case, becoming more closely related to the other arts.

The NAC could do worse than to concern itself with these questions and to study the writings of these critics, as well as the works of Balázs, Nilsen, Cocteau, Eisenstein, Pudovkin.

13. CONFUSING POPES WITH FREE MEN

Ultimately, the growing ability to "see" implies the ability to see oneself. Growth occurs through mistakes recognized as such, criticism realized as valid, the exposure of the self to new and alien influences, interaction with a hostile yet fructifying world. Blind adulation and hermeticism are the enemies of growth and lead to the repetition of what has already been achieved; the rise of epigones and mediocrities; the progressive narrowing of vision and the cumulative deterioration of taste. What the American avant-garde is confronted with is sectarianism parading as freedom, flattery as criticism, sterile eclecticism as artistic philosophy, anti-intellectual know-nothingness as liberation. Dogmas, myths, and popes are inevitable stages in human pre-history; a higher stage will be reached when they are superseded by men of free will.

No. 48, August 1967

The New American Cinema: Five Replies to Amos Vogel

Daniel Talbot, Parker Tyler, Annette Michelson, Richard Schickel, and Gregory J. Markopoulos

In the last issue of Evergreen, *Amos Vogel presented a thirteen-point indictment of The New American Cinema charging the movement with indiscriminate critical standards, self-flattery, sectarianism, and a dogmatic approach to the development of the avant-garde film. A leading filmmaker, three critics, and a film exhibitor here continue the debate with their answers to Vogel's provocative statement.*

A Quarrel Over Strategy!
by Daniel Talbot

To discuss, point by point, Amos Vogel's "13 confusions" would require much more space than my given allotment. So we'll stick to the basic argument, to wit, that the indiscriminate programming and buckshot missionary proselytizing of the New American Cinema (the Stakhanovite arm of the American avant-garde) is at this moment in danger of becoming its worst enemy by substituting random enthusiasm for disciplined criticism and by theatre programming at the

Film-Maker's Cinematheque by the yard instead of informed pattern.

I don't like the tone of Amos' article. Argument by manifesto, exhortation, and the call to arms for "a new showcase for the avant-garde" just does not fit our situation. I don't know the answer to the problem myself.

Amos mentions films by Bertolucci, Dreyer, Skolimowski, Teshigahara, Resnais, Godard, Antonioni: "Some day soon an interesting discussion will be begun as to the relative degree of experimentation, achievement, subversion, political or artistic daring in these works on the one hand, and the New American Cinema films on the other." *The equivalent of these European directors has never existed here.* I doubt that they ever will. Assuming that an American could make a film like *Before the Revolution* or *L'Avventura*, he would have his head handed to him by critics and audiences for even being so presumptuous. It seems to be O.K. for Europeans to make this art, but there is something mysteriously unexplainable about the American scene that absolutely prohibits our filmmakers from doing similar art. (This is a big discussion in itself.) There

64

must be over 10,000 itchy Americans who are possessed out of their skulls with the ambition to make a *Jules and Jim* or a *Breathless*. Why hasn't it happened? For the very reason that Orson Welles has just become a French citizen. Our artists, I'm about to suggest, are not so much artists as circus performers, freewheeling cocksmen, all wailing their asses off for Mom. I'm not sure that the result is always art. Sometimes it is, sometimes it is not. Whatever it is, it certainly is capturing the imaginations of a huge young audience. Program directors and critics are not always necessary to preserve the virginity of the Movement. Audience capacity for bullshit in America is awesomely big. The worst that will happen is that the new underground cages will fold. It certainly won't stop our acrobats from performing. I, for one, do not look forward to that day—it may even be here now—when committees, critics, and distributors will contour the market action in Red Guard fashion. As publicists, polemicists, and hosts for the American avant-garde both Vogel and Jonas Mekas have more than paid their dues. So far as I can see their quarrel has to do with strategy, an argument more suitable for *Film Daily* than *Evergreen Review*. Enfin, I may not have what it takes to join the Underground but I can assure you that I have an absorbing curiosity about all its work. I'm perfectly willing to take my chances at any underground hall. It's simple enough to walk out on *drek*. That's what our whole life is all about once you leave the front door in our society. There just aren't that many options. But, please, don't program me.

Thirteen True Confessions?
by Gregory J. Markopoulos

Having read Amos Vogel's article, "13 Confusions," I consider several other titles which might have sufficed: "Absolution from Guilt," or "13 True Confessions."

I sincerely question Vogel's approach, concern, and understanding both of the needs of the filmmaker, today and yesterday; and, too, his knowledge of the film in the United States today, the New American Cinema. Particularly when he tends to use such noble academic phrases which refer to textbooks of filmmaking abandoned, the limited wisdom of filmmakers, the seeds planted by Frank Stauffacher's *Art in Cinema* and the late Maya Deren's screenings, the selectivity function, taste and proper growth, extreme nudity, and the use of names such as Panofsky and Arnheim.

Few, if any of the filmmakers he speaks of, have ever used textbooks or abandoned textbooks of filmmaking. Those commercially or academically oriented filmmakers that do use textbooks present those films which type them as sterile: from New York University to Poland. Nor do I know of any filmmaker who is not constantly aware of his limitations. Limitation from which Art may emanate is one of the powerful forces of the New American Cinema movement. This as opposed to the aura of glamour or professionalism imposed again in schools which purport to teach the film. As for the seeds planted in the forties by *Art in Cinema*, and the late Maya Deren, I would hazard to say that these were more seeds of discontent than anything else. How often films were not shown because the organizers of these film showings (and distributors) felt or imagined that certain films were inferior or simply did not meet immediate demands. This dare not be even suggested of the New American Cinema. And extreme nudity! The very statement proposes the private censorship of the commercial distributor. Finally, the naïve suggestion of Vogel to return to the critics of the film is ludicrous. For how many of the so-called critics of the film are in reality critics of the film. Is it not more true that individuals who have taken a curious interest in the film know very little about the medium. That such critics of the film have hardly ever inspected a foot of celluloid in a viewer, let alone understood the vital intricacies, the chaos that is film creation. That, further, such film critics are merely imposing and diverting personal theories concerning the art of painting or the art of writing to a medium wholly foreign to them or to their individual tastes.

In brief, therefore, Vogel's apparent herculean effort to save the public and the filmmaker has little or no foundation. What the movement of the New American Cinema has accomplished and continues to accomplish was never dreamed, attempted, or even casually understood by former cliques of the

avant-garde: twenties, thirties, forties. What the New American Cinema has become is a PRESENCE, a teacher. As in the sciences, the experimental (Vogel's *the bad*) works, and the finished works (Vogel's *the good*) teach the New American Film spectator how to understand the film as film. Such *communication* has never before taken place in any of the other arts at such a rapid and remarkable pace.

Fashion or Passion: The NAC and the Avant-Garde by Parker Tyler

It is natural I should agree with Amos Vogel's strongly put "*13 Confusions*" in your June issue. I have committed myself already to some of the points in his energetic, well-aimed indictment of current forces in the American avant-garde film. Vogel has the true courage of "anti" critics by coming out against the "fashionable." He writes that for the avant-garde to be fashionable, as is the central trend of the movement he criticizes, the New American Cinema is a "crime of crimes." This, I fear, is utopian reasoning—I wish it *were* a crime of crimes. "Passion" is Vogel's term for the wayward urge of many filmmakers whose works help breed the confusions he lists. That term is flattering. Obsession, addiction, delusion of grandeur would more closely define the urge in question.

Granting, however, that members of the NAC would accept the defining term, passion (a "frenzy of passionate love," Vogel further specifies), the truth is that, whatever it's called, it functions as the arch excuse for every possible offense against film form, against grace and precision of style, against significant and mature reference to human experience. In the twenties, there was no danger of confusing Flaming Youth with the Dadaists and Surrealists; today, there's much danger of confusing teenie-boppers with the NAC, depending on whose film you're watching.

Vogel properly cites Neo-Dada and Pop influences as shaping the quasi-aesthetics of the NAC. Insofar as Pop means cute vulgarity and cleverly simple-minded manipulation of faddish modernism, I suppose the NAC does try to capitalize on its recent art precursors. But the important angle is that the new filmic avant-garde's connection with its own precursors of the forties and early fifties is more chronological than ideological, more economic than artistic. As for economics, as Vogel virtually says, the NAC's chief contribution to the avant-garde movement is socio-economic organization and printed publicity. Thus his article is perfectly right about the present movement's disunity with its artistic past as well as with its present ranks.

Automatically, the NAC ideology translates aesthetic revolution into stepped-up "moral outrage" as if the main object of assault should be, not "bad" filmmaking or "commercial" filmmaking, but the film industry's old Hays Code psychology of prudish suppression of subject matter. This is absurd on the face of it: the Hays Code and its successor capitulated to the rising tide of free expression in books, painting, and films long before the gurus and gushers of the NAC went into action. Anyway, the NAC's naïve "outrages" against bourgeois prudery and hypocrisy have been made in concert with the more advanced European films, which to date have displayed much more creditable performances in, for example, erotic candor than the equivalents the NAC has been able to muster.

It should be remembered that Vogel is aiming at an overaggressive and pretentious trend in the NAC that actually can be isolated from the avant-garde movement as a whole. Certain elements have "taken over" temporarily entirely through organizational tactics. The task of serious critical observers, who have a more *genuine* "passion" for film, is to use Vogel's tables of value as a platform for weeding out the inflated pretenders and mere addicts of the NAC from serious underground surfacers with something to say in their cameras.

A Film Is Not a Painting by Richard Schickel

I could not agree more with Amos Vogel's specific strictures against the avant-garde—its

lack of perspective about even its own history, its failure to establish sensible critical standards for its own work, let alone that of other cinematic traditions, its slightly paranoid tone when it addresses itself to the larger world, and so on. His piece seems to me a particularly valuable corrective in that he writes as a known sympathizer with the avant-garde style and psychology; one may therefore hope that he will be listened to as those of us who are outsiders will not be.

There is, however, an implicit assumption in his article, as well as in almost all the writing and talking about avant-garde cinema, which ought to be subjected to serious debate. Mr. Vogel speaks off-handedly of "the primacy of the visual element" in films as if we were all in agreement about *that*, anyway; then registers his pleasure over the "incursions" of "visually oriented" critics, with "their special sensibilities and commitments, their openness to the techniques and philosophy of modern art"; and ends up making me a little impatient. I do not believe the visual qualities of a film should automatically be accorded "primacy" in our consideration of it and I am quite certain that the art critics, who have done so much to bring "the other plastic arts" to their present state of anarchy should be kept as far from film as possible.

I am not attempting to downgrade a film's visual elements in favor of its literary elements and I understand that the polemic emphasis on the visual by all filmmakers (not just the avant-gardists) is largely a response to decades of popular criticism by literarily-oriented critics. I am only suggesting what seems to me obvious—that movies are not, never have been, and never should be a "pure" medium—purely visual or purely literary. The best films strike a rough balance between these two forces. Indeed, they do more than that—they intertwine them in such a way that they are inseparable. Antonioni's imagery, for example, would be wasted were it not employed in the service of plot, characterization and, most important, philosophy. On the other hand, these last are immeasurably enriched by the metaphorical aptness and the almost tactile quality of his visualizations.

A film, to put it bluntly, is simply not a painting. It is—well, a film. It comes in long, thin strips, which implies the necessity of organizing it lineally and sequentially to borrow a term from Our Canadian Cousin. You look at it in a darkened room, whereas you look at paintings in the light, which implies different psychological sets for both artist and audience. All of which implies to me that art critics will probably end up being as wrong about films in their way as literary critics are in theirs.

Indeed, the art critics are, at this point, more dangerous to the avant-garde cinema than any other group. What it needs is not less emphasis on meaning, if I may be permitted an unfashionable word, but more. One understands that there is a cost factor here—that the proper development of subtle meanings through characterization, plot, etc., requires more film, more settings and set-ups, more actors, more time, and therefore more money. But these are not insuperable obstacles. They might even be seen as challenges to the independent creator of limited means. He need only think before he shoots—which is not a bad idea for any artist.

Mr. Vogel rightly suggests that "thematic liberation is no guarantee of quality." I'm beginning to think it is almost always a guarantee of the opposite. Having exhausted the possibility of holding our attention purely through visual experiments (most of which can now be seen in TV commercials every night) and having reached the point where the latest sensation is the anti-technique of Warhol, the avant-gardists have, in fact, been forced back to the hated realm of non-visual ideas, where their competency is, shall we say, limited? At best they give us such unexceptional generalities as Mr. Vogel mentions and avoid the dramatically specific. At worst, they give us a gamey sexual sensationalism that is no different in its intent than Hollywood's slightly better-draped explorations of the same ground. Titillation is titillation, no matter how you cut your film.

It may be that we are witnessing "the exhaustion of the commercial cinema," but at the moment the avant-garde looks pretty pooped itself, no matter how many eager youths are racing through the streets with aero-flexes on their shoulders, no matter how many dentists and their wives are making the trek in from Queens looking for a cheap turn-on at the Film-Makers' Cinematheque. The way to better health lies back up the stairs

and through the door marked "meaning." Even dreams are rationally explicable, however subtle and difficult the task of deciphering them, however bemused we sometimes are by their purely visual elements. Let the avant-garde become the analysts of our mass fantasies. Or let them go to the analysts.

The Camera as Fountain Pen by Annette Michelson

One must begin with some sober recognition of the fact that "confusions" are arising at a time when cinema is not merely gaining recognition as an art form, but is in some ways superceding other forms. In so doing, it inherits, distorts, and uses their achievements and aspirations. When Alexandre Astruc, writing in the euphoric prescience of post-Liberation Paris, spoke of "the camera-as-fountain-pen," he had in mind, of course, that absolute intimacy and authority which have characterized the modernist aesthetic at its most rigorous. Seeking to liberate film from the constraints of Industry and the Academy, he nevertheless—and quite naturally for a Frenchman—retained the notion of literary composition as paradigm of artistic sovereignty. His phrase has come, however, to characterize, in a sense both deeper and more extensive than was at that time apparent, a succeeding generation's relationship to the medium.

In this country where one may buy cameras at the drugstore counter, the camera is supplanting the fountain pen for many people, especially, the young. Filmmaking tends, on the whole, to appropriate the aesthetic and strategies of other, older art forms; consequently, its history is at least in part a chronicle of cultural lags, contradictions—and confusions. The origins and transcendence of the contradictions are of far greater interest than the politics of film circles. Vogel's strictures constitute, on the whole, a classical chapter in the history of most modern movements. The confusions of "historical continuity with immaculate conception," "freedom with formlessness," among others, echo the charges of sectarianism, historical distortion,

lack of critical discrimination, and responsibility leveled at Surrealism, for example. Of course they are grounded in fact, but they bear further examination.

I. For many artists in this country, the camera is replacing not only the fountain pen, but the brush as well. Here is another instance of the manner in which cinema has appropriated the aesthetics of a previous form and period—in this case, as I have elsewhere argued, those of action painting. For those among us who have been concerned over the last decade with contemporary painting, sculpture, and critical method, this particular appropriation has highly debatable implications. That heavy burden of social and personal redemption which the American avant-gardist tends to impose upon his art is augmented by the moralistic repertory of existentialist-inflected options which informed the orthodoxy of "Action painting." Painters, sculptors, and their critics these last few years have been involved in a kind of chastening reappraisal of the rhetoric which passed for the thought of action painting, a critical review of its assumptions and metaphors, their contradictions and constraints. One could hope that filmmakers and their critics might profit by the experience; one understands, however, that their ontogeny is condemned, as it were, to recapitulate a philogeny—that historical and aesthetic confusions and contradictions have to be painfully and even wastefully experienced before they can be transcended. This seems to be the nature of things in our country. Like all movements which are "redemptive" (and Surrealism—a prime influence, though only one—provides a clear precedent in this respect), New American Cinema operates within the framework of a fundamental ambiguity as to its own aesthetic aims and purposes, an ambiguity compounded by other factors.

II. If the camera is to replace the fountain pen, one must perhaps redefine one's notions of the role and function of such institutions as the Cinematheque. This can, I believe, be seen as developing in a manner analogous to that of the literary review; and the NAC should accordingly be viewed as something comparable to a publisher rather than to an exhibitor in the traditional sense. The

Cinematheque's seemingly over-inclusive and indiscriminate programming reflects the extraordinary increase of independent production of film in this country. In the face of this, it has obviously had to revise its notion of function. Read through twenty years or so of *Les Temps modernes* or *Partisan Review* and you will find little you would care to pantheonize. Yet it is largely that which is dispensable, tentative, unsuccessful, ephemeral, or merely topical which has intensified their interest, insured their continuity, their continuous relevance. It is in this sense that the Cinematheque, for a generation of "authors," becomes a "publisher." Vogel is quite right in asking for some sort of selectively organized showcase. It is needed, however, in addition to, not in replacement of, one like the present Cinematheque in which those who care more than casually about film can see almost all that is being done—both good and bad—in which artists can expose their uncertainties to view and in which spectators and critics can feed their curiosity and addiction—to the point of satiety, if necessary.

III. Mekas' condemnation of "Old Cinema" in favor of New demands to be taken seriously, though not literally. The distinction is of capital importance. His polemically inspired rejection of European film again recapitulates the American painter's declaration of independence from a European tradition. What Mekas has been doing quite admirably in his customary hyperbolic style is battering away at the assumption that a corporate capitalist economy is necessary to sustain filmmaking. That economy and its middle-class culture have, of course, done so—though in Europe at great cost and most precariously, particularly in France and Italy. They have also produced that fusion of really radical visual intelligences and powerful intellects which characterizes the major filmmakers like Resnais, Bresson, Godard, and Antonioni. In this country, the disaffection between American intellectuals and artists has been chronic. Our intellectuals are largely absorbed by the Academy and our artists have been bred, most particularly these last twenty years, in an atmosphere of provincialism. Even the most sympathetic, kind, gifted of our critics, like Farber and the late James Agee, though men of special insight, are shallow when compared with the best critics and theoreticians of the Continent. American filmmakers have evolved for the most part in a climate of abdication from the radicalism of the political and aesthetic commitments of the pre-war period. The cold war atmosphere and that philistinism which characterized the "integrated" intellectual of the late forties and fifties were interrelated. The work of Godard, Bresson, and Resnais presupposes a culture animated by some sort of permanent radical commitment, not abrogated in the name of "adjustment," "authenticity," or "integration," but rigorously maintained and renewed. The laxness of critical standards is endemic in this country, but the dithyrambs of *The Voice* have to be understood as a reaction to the arrogant mediocrity of *The Times*. A generation of young people for whom the camera is a fountain pen will find or produce their own Bazins.

No. 49, October 1967

Amos Vogel Trying to Walk on a Tightrope of the New American Cinema
by Jonas Mekas

This unpublished illustration from filmmaker Jonas Mekas was received too late for publication alongside other responses to Amos Vogel's "13 Confusions" that were printed in *Evergreen Review* No. 48. However, *Evergreen* No. 49 reproduced the bottom-most section of Mekas's drawing in its "Letters to the Editor" department.

Chappaqua

Lawrence Shainberg

No. 50, December 1967

Some art wants biography more than criticism in response to it, and *Chappaqua*, Conrad Rooks' film about drug addiction, may be the quintessence of the genre. Particularly in America, artists have been around for years who forge their work out of a terrible desperation that locates their ego at the center of every word, image, or frame they use. Mailer creates Mailer more than his books, Henry Miller announces himself as his only character, and Rooks—though it is stretching a point to put him in that class—hasn't made a movie as such but a pained mosaic diary of his own self-absorption and his attempts to escape it. *Chappaqua* is a scattered, anarchic collage in which scenes shift rapidly and without transition from India to Central Park, from a London gambling casino to a Northern Cheyenne peyote rite in Montana, and the moods shift so inexplicably between tragic and comic and maudlin romance that the viewer feels like a basketball in a game with too many players and no referee. The ideas are simplistic, the acting is lousy, and there is no sign of insight into any of its characters. What makes the film interesting, in spite of these deficiencies, is that it could not

have been made anywhere on earth except America, nor at any time but this decade. Like many American artists before him, but with more bravado and grandiosity, Rooks lays himself on the line in his film. He doesn't offer us art but himself-in-art, and so it is with Rooks himself, not objective critical evaluations, that you must begin when you look at the film—with Rooks, with the way he made the film, and with the demands he made on the medium he used.

That, at least, is where I began. I had heard for years the odyssean stories of the film-in-progress, but the first time I met him was at the Venice Film Festival, 1966, where he was showing the film in public for the first time. He was sitting in one of the town's more exotic outdoor restaurants and he was talking about hallucinogens—how they would save us from our destinies. There were four empty wine bottles on the table and a dozen empty dishes. The afternoon was hot and the dull melancholy that comes from eating and drinking too much too early had settled on everyone but him, for he had drunk water while we had drunk the wine he'd bought us, and he hadn't once stopped talking, and the

talk had done wonders for his metabolism. "I mean the Pilgrims found an hallucinogenic world in America when they came and they destroyed it. Now the drugs will bring it back. They will give us a world with no separation between past, present, and future. They will give us back reality."

Someone interrupted to ask about Timothy Leary and this made him angry. "One of the reasons I made this film was to show Leary where it's at! What right does he have talking about this? You know who taught Leary what he knows about the Sacred Mushroom? Me. Me and Harry Smith. I did a special report for him when he first started doing his experiments. Leary doesn't know anything. He's just using this to get attention."

From Tim Leary and Harry Smith he drifted on to the American Indian, then the Indian Indian. This led to a discussion of Hinduism and Tantric Yoga, the use of which, he said, had given him "the strength to survive the superhuman demands this film made on me." He was just going into yoga more deeply when the woman interrupted him.

"Excuse me. Are you Mr. Rooks?" She was a portly English lady in silk foulard blouse. "Well, I wanted you to know how much I enjoyed your film. My husband and I saw it last night at the Palazzo and we've been talking about it all morning. Trouble is, it was too good! I'm thinking of getting myself some heroin this afternoon!"

Rooks was silent for a minute when he turned back to the table. Then an enormous smile came over his face, and he said: "Well, I guess that's what it's all about, isn't it?"

This was the day after *Chappaqua*, "un film di Conrad Rooks," had been shown in competition at the festival. The critics, almost unanimously, had panned it, calling the film "a childish self-indulgence," a "pointless voyage through the dead-end worlds of drug addiction and self-absorption," but there was no sign of any dint in the boundless egotism that had made *Chappaqua* happen. And why should there be? Wasn't he still the most interviewed man in Venice? Weren't reporters even now doing a piece for French television? What had Conrad Rooks to fear? Critics? "Screw them," he said. "They're paid off anyway. I'll take the film to Rome and hire my own."

* * *

Somewhere along U.S. Highway 62 in northern Kansas a motorist will be informed by a spindly grey metal sign that he is ENTERING ROOKS COUNTY. The name refers to some eighty-six square miles and to a man named Noah Rooks who was the first white man to settle in the state, as well as the descendant of a preacher named Samuel Rooks, who landed in Virginia in 1622. There are records of Rookses in the Revolutionary War and—on both sides—in the Civil War, and for his part in the latter a man named Thomas Rooks was given a large chunk of land in Grundy County, Missouri. It was on this land, unlike his uncles and cousins who had gone to Kansas, that Albert Rooks, Thomas' son, eventually settled in the 1870's. He raised some of the best carriage horses and workhorses in the Midwest and gradually accumulated a massive spread of land, maybe eight or ten thousand acres and getting larger, until the automobile came and took the bottom out of it all. Albert Rooks had to start selling land to support himself and when his sons were old enough they had to go to work. But the Rooks pioneering tradition had not been stunted by the automobile, only redirected, and so of Albert Rooks' five children, four—in professions as disparate as beer distribution and cattle breeding—became millionaires. The most successful of the four was Russell Rooks, who went to work as a stock clerk for Avon Products, Inc. when he was nineteen and, during the 1930's, came up with a plan called "City Sales" which revolutionized the famous Avon sales program and allowed the company, for the first time, to move into large metropolitan areas. The idea worked and became a significant factor in the meteoric successes Avon was to achieve in the forties and fifties. In 1962 Russell Rooks was rewarded with the presidency of Avon, by then the largest cosmetics company in the world. He was fifty-seven, and he died a month after he took office.

On a June morning in 1963 a car pulled up beside the Rooks County sign and the oldest son of Russell Rooks leapt out. He was bearded and had not bathed for longer than he or his two traveling companions cared to figure. His hair had not been cut or washed for more than four months, and it hung in

matted strands over his shoulders. This was Conrad Rooks, and what he wanted to do with the sign was steal it.

Yet the theft must not be altogether clandestine. Rooks was beat, and slightly disconnected at the time, but he was not one to let a significant event disappear unrecorded. There were three 16mm cameras in the back of his car and with one of them Harry Walker Staff, his colleague at the time, immortalized the theft. Now the footage would be sent back to New York, processed, and stored in Rooks' studio in Carnegie Hall.

At that time Rooks knew almost nothing about filmmaking, by his own admission. He was twenty-eight, depressed, and looking for some action. "I had done some work with Sheldon Rochlin, and he had taught me more or less how to use a camera, but I knew nothing about film and nothing about sound either. I had a Nagra [tape recorder] but didn't know how to use it." Harry Staff had suggested the trip. "I'd heard of these people in east Tennessee called the Melungeons," Staff remembers. "They were shipwrecked Portuguese sailors who'd intermarried with Cherokee women and moved inland. What interested me—and Connie—was the unique, almost Elizabethan English they spoke. I told Connie about them and the next day we rented a car and pulled out." They signed out the car for six days and came back to New York five months—and twelve thousand miles—later. After Tennessee they went to Florida, Alabama, Mississippi, Arkansas, Kansas, Wyoming, and Montana. In Mississippi the Schwerner crisis was just breaking, and Staff and Rooks, along with Chris Gray, their soundman, were put in jail in Natchez when the police found them having lunch in a Negro section. This was when Staff first discovered the quality about Rooks he admires most—his nerve. "We came out of the restaurant, and there were four cops around the car. Rooks had the camera with him, and as this big cop started jawing us out, Connie filmed him, shifting the camera from his face to his pistol holster, and back again." Staff was also discovering how Rooks' nerve increased and decreased with the group's distance from Avon installations. "As soon as I saw him coming on with the cops, I'd know we weren't far from one. I got so I could hit it every time." They finally left Mississippi

with a police escort to the border, and in Arkansas their troubles continued. Winthrop Rockefeller was campaigning for governor, and both Rooks and Staff knew him from New York. But neither the group's untidiness nor their New York license plates sat too well with the Rockefeller camp, and some of the candidate's boys suggested they get out of town. They complied, but not before culling some footage out of a rally where Staff, an excellent improviser in his own right, embarrassed Rockefeller by greeting him openly and effusively. They then headed for Kansas, where they spent time with Rooks' relatives, particularly his Uncle Archy, who has the Schlitz beer distributorship in the Midwest.

It was Archy Rooks who mentioned to them the Custer battlefield in northern Montana, and when they left Kansas, they headed in that direction. In Lame Deer, Montana, on the Northern Cheyenne Reservation, they had a flat tire, and while it was being fixed, Rooks wandered off to explore the town. "I went into the general store and began talking with the owner. He was impressed with how much I knew about Indian art and he put me onto the peyote rites. They let us in that night and we were the first people ever to film them." This was neither the beginning of his interest in the American Indian nor his first experience with peyote, but it was the first time he participated in a peyote rite and the first time he sensed its cinematic possibilities.

The filming went on for four years and the collection of documentary and autobiographical film in the Carnegie Hall studio became monumental. Eventually, Rooks gave up 16mm for 35 and hired Robert Frank, of *Pull My Daisy*, as cameraman. He hired Ornette Coleman to write and record a score, at a total cost of nearly $20,000, and then, when his cinematic idea moved Eastward, he replaced Coleman's music with an original score by Ravi Shankar. He persuaded William Burroughs to make his acting debut in the film as a quintessentially evil dope pusher, and he got Allen Ginsberg and Peter Orlovsky to chant the mantra for his camera by the reservoir in Central Park. By this time the film had become completely autobiographical and Conrad Rooks had made the most quixotic of all his choices. Since the film was not about some imagined character but about

himself, there was, he figured, only one person who could play the lead. If Conrad Rooks made a film about himself, Conrad Rooks—already his own writer, director, producer, and financier (to the extent of nearly a million dollars)—must play himself in it.

In the end there were nearly three hundred hours of film. Four editors failed with the footage before editor Kenout Peltier came up with a cut that worked. In spite of the critics, it worked well enough for the Venice jury. Rooks was awarded Second Prize (best film by a new director) and a special citation for "use of sound track and photography."

* * *

The French television director said we'd better hustle. We'd been together half a day, and all he'd gotten was a few minutes of Rooks sprawled on the back seat of a motorboat, reading his reviews. Now he wanted something at an outdoor café, and as we walked, Rooks continued talking. He asked about his friends in the States—he hadn't been in New York for over a year and for each person he had a prescription—what they were doing wrong, what they ought to do, what they did best. As one of his ex-girlfriends said, "Connie has two sorts of relationships with people—either you're his guru or his student." So the friends broke down into these categories. One who elicited an unequivocal guru response was Allen Ginsberg, to whom Rooks said he owed "most everything." He'd met Ginsberg in his early twenties and sent him copies of the poems he was writing, and Ginsberg had responded with criticism and spiritual advice. "He wrote me: 'You must be prepared to stand naked—remember that you won't need anything else!' Now I've done it," Rooks said. "It was the hardest thing in the world, but you've got to do it. This film was therapy for me. I stood naked before the world and now I have nothing to fear. I've liberated myself, and the film will liberate anyone who watches it and understands."

He was also anxious for news of the Swami, *his* Swami, Satchidananda, who now lives in the East Village and conducts regular religious services. Rooks explained that he'd met the Swami in Ceylon (where at one time Rooks owned an island off the north coast) and became his disciple, receiving instruction in yoga and meditation. When he found out the Swami wanted to go around the world, he gave him the ticket and paid all his expenses. After his trip, the Swami came to live with him in Paris where, says Rooks, he has been an enormous help to him. When there was some disagreement between Rooks and his ex-wife over alimony payments, he sent the Swami to Greece to talk with her, and when he was looking for a school for his son, it was the Swami who visited those under consideration and finally decided which was best. Last year the Swami decided to come to the States, and Rooks encouraged him. "He had to come to New York. For a spiritual leader, America is the true virgin land."

We walked in silence for a minute, but then I asked a question that set him on a wilder tack: Were there any feelers yet from the distributors?

Rooks turned to me angrily. "Why I need them? I'll distribute the film myself! Man, I'll lease my own theaters!" But mightn't this get expensive? "I'm a millionaire. Don't talk to me about expensive." He went on to detail his ideas on distribution. The first screening of the film would be at Carnegie Hall, a benefit for the Northern Cheyennes. "After that I'll head across country. I'm getting a special Volkswagen bus outfitted with a high-fidelity system, and I'll head out with the film. I'll take Allen and Peter and the Fugs with me, and get others to fly in and meet us. James Brown maybe, maybe Ornette. The Swami will have to be there. We'll hit the college towns and rent the gym and show the film for two bucks a head. Then we'll throw a terrific party. The way the bus will be fixed up, I'll be able to go into PAPA'S GOT A BRAND NEW BAG like that."

He snapped his fingers in the Venice air to show me what he meant.

* * *

Rooks was born in Kansas City in 1934. For the first eight years of his life he moved with his family as his father's assignments moved, but when Russell Rooks became an Avon vice-president, the family settled in Chappaqua, New York (thus the film's title). His childhood wasn't the classic rich boy's childhood by any means. The family wasn't that wealthy yet, and they had moved around

too much to establish any of the social connections one usually associates with money. It was in Chappaqua that the normal abnormality might have begun, but Rooks' destiny had little room for anything normal. A serious illness hospitalized him and led to three operations in the next two years. He missed school and there began for him an alienation from his peers that has never let up. During this time, too, the relationship between Russell Rooks and his wife was beginning to disintegrate. The family hardly saw him before ten at night, and he was gone by the time they woke up in the morning. When his parents finally separated, Conrad was in the hospital for his final operation.

He chose to stay with his father after the divorce, and from this point his life changed radically. There were prep schools, and, when his grades fell, there were psychiatrists. "They said I was a master con man, an expert salesman, as long as I was selling myself. Later on their diagnoses got more specific. They said I was a paranoid schizophrenic. Delusions of grandeur, they said, and I guess they were right."

During the next few years Rooks attended, and was thrown out of, St. Andrew's, Dwight, Taft (where at fifteen he threw a black-tie champagne party to celebrate his dismissal), and Graham-Eckes schools. He had also begun to drink, and by the time he was sixteen he was, by his own evaluation, an alcoholic, "the worst sort, hanging out in the worst dives in New York, waking up mornings in my own vomit. I weighed 250 pounds (Rooks is 5'9") and all of it pure fat." When he came out of his stupor those mornings, he used often to stagger off to his father's Park Avenue apartment for a bath and a bed. Russell Rooks knew what was happening, knew even that drugs were involved along with alcohol, but he lacked the rapport with his son which might have helped him one way, or the psychological insight which might have helped in another. Conrad's brother, Wayne, an ex-rock-and-roll-singer, remembers their father as desperate to help but bewildered. "He lived by the Golden Rule and that was it. He was liberal with us, maybe too liberal, and the most generous man I ever knew. He got exasperated, but he never lost his temper with Connie. The worst thing I remember him doing was throwing cologne on him some mornings to get him out of bed."

Rooks says the drinking started when he was thirteen and working on one of his uncle's beer trucks. "It was summer and when it got hot we drank and that was it." Wherever it started, it got more serious as time went on, and, as a sort of companion enterprise, he began forging his father's name on checks and charge accounts and, in general, using the family money and name to support his activities. "I used money to build an image of what I thought I was. You know, we'd go into the Stork Club and I'd introduce myself as Russell Rooks, and they'd lay down the carpet. I used money mostly to impress girls—which meant, of course, that I only got a certain kind of girl."

He was also beginning to experiment with drugs—"just pot at first, but I moved on to demerol and then to coke and horse ... just sniffing ... I didn't shoot horse until much later ..." When he was sixteen his father called him into his office at Avon and said he'd heard he'd been "playing around with marijuana." Rooks denied it. "Well, it's your business what you do," his father replied. "I just wanted you to know they're after you. If you continue they'll get you." Two weeks later Rooks and two companions were arrested with an ounce of pot on them. Russell Rooks, though he was furious when he learned of the arrest, testified for his son in court and helped to get his one-year sentence suspended. "Soon after that," says Rooks, "the chief lawyer at Avon called me down to tell me I was hurting the company image. Jesus, I was stoned while we were talking. I told him, 'Man, half the sons of half the people up here are smoking pot. The only reason you don't hear about it is their fathers are on the board and my old man is just an executive.'"

Soon after the arrest, Rooks moved in with some relatives in California, enrolled in Carmel High School and went into a relatively sane period. He attended school regularly, played a lot of tennis (he was good enough to play in some of the lesser tournaments), and got into shape. He continued drinking, but not so heavily. After graduating from high school, he enrolled in the Marines ("... just to prove I could do it ...") but was discharged after a year with a bad knee. Once again he returned to New York, and once again the combination of the city's temptations and

being Russell Rooks' son overwhelmed him. The drinking was heavier than ever now and he began to get serious about drugs. "I was in trouble constantly, half out of my mind most of the time."

He was living in the New York Athletic Club at this time and often raised money, he remembers, "by tipping every porter in the place ... I'd sign for a five-dollar tip, and they'd give me four-dollar kickback. I could raise about seventy bucks in an hour."

For a couple of years he did almost nothing. Then, when he was twenty-one, he met a man named Barry Mahon, who suggested that, if Rooks could get the money together, they could make a film. Rooks raised some $15,000 from relatives and, with Mahon directing, they made two Forty-second Street type films, *White Slavery* and *Girls Incorporated*. The latter is still playing the circuit, under titles that change every year, and has made, Rooks says, more money than any other film of the type. "Of course, I didn't get a penny back. They had set up the partnership so I didn't have a chance."

This wasn't the first or the last time Rooks was conned, and he remembers it, like the others, without remorse. "Sure you get conned when you have money, but you always get something in exchange. Mahon, for example, taught me a lot about production." Money was becoming a problem, however, particularly as he began to have more and more friends who had none. If he gave it away, he would be damned for being patronizing, and if he kept it, he'd have suffered more—not only from others' accusations of selfishness, but from his own guilt. But Rooks says he handled the problem. "Over the years I've given away a tremendous amount of money, maybe half a million, but I always got something in return. You have to demand something in return—labor, not love—or else people will hate you. That's the genius of this film, that I devised a means of giving money away which was satisfactory to me and to others. Even if it fails, I've gotten this from it, and gotten myself a career."

The first thing the Frenchman asked at the outdoor café was how Rooks was fixed for money now. Rooks, getting bored with the interview, replied that he was broke. "If I don't sell this film, I've got to go to work." He gave me a wink.

"How old were you when you started using drugs?"

"Around three," replied Rooks, merely suggesting the wink this time, "but I didn't become an addict until a couple of years later."

He was leaning against a railing, the Grand Canal behind him, and, since his features and bearing are almost too American to be believed, the incongruity was striking. All through the festival he wore a Stetson tilted just right over his eyes, Levis, and a Levi jacket. He has light blond hair, long in back and almost Ivy League short in front, and the elegance and directness of glance of a man who belongs to his world and feels justified in being there. It is hardly the sort of face one would expect the auteur of a self-conscious, alienated film like *Chappaqua* to have.

The interview with the Frenchman grew more ridiculous as it went on. Rooks was asked what advice he had for young filmmakers, and he, who in his one film had made every conceivable mistake, replied without hesitation: "They should use Arriflex and hand-held. By all means, don't mix color and black and white. And stay under thirty days for your shooting."

And "What," the interviewer asked, "do you think of a sense of humor?"

"Humor is the most important thing in the world. As soon as you realize you're dying, you can begin to laugh at things. There is no reason to live without humor. My next film, I hope, will be entirely humorous."

After we'd left the café, I asked him if he really had plans for a "next film," and he said, "Sure, I'm gonna make a Western with Harry Smith."

You have to know Harry Smith to appreciate the ludicrousness of this. Smith made animated films—which he painted frame by frame in his bathtub and showed on homemade projectors up to fifteen years ago, but hasn't made anything since. He is an acknowledged genius among a certain circle in New York and an acknowledged eccentric among a wider circle. He is considered one of the great experts on string games, Black Magic, and Indian Lore. Rooks himself hired Smith as an editor in 1963, left for Europe, and gave him the key to the Carnegie Hall studio. When he returned he found bills for $5,000, mostly for an enormous sandpile Smith had constructed in the studio. "Sand was everywhere,"

Rooks recalls. "The goddamn pile was forty feet long with film strips poking out all over. Smith said he was setting up to film a peyote vision. I asked him what he had done on my film since I'd left and he said, 'Nothing.' 'What do you plan to do?' 'Nothing,' he said. 'All right,' I said, 'You're fired.'"

During his twenties the descent continued. He met and married Zina Rachevsky, but the relationship was tempestuous from the beginning and grew more difficult as time went on.

"During this time," he says, "I got in a bag I had never seen before, a drug scene that drove both of us crazy." A son, Alexander, was born in 1959, and Rooks who, in spite of his dissipation, had enough conventional ambition to expect he ought to be a good father, found in the child a new source of guilt. At this time, too, he began suffering from delirium tremens and found drugs the only thing that stopped them.

There were some good things happening. He had met Smith, who taught him a great deal about the American Indian and encouraged his interests in both cinema and the hallucinogens. "Harry was like a computer," he says. "Whatever I wanted to know I programmed through his brain." Smith introduced Rooks to peyote, and the first trip proved momentous for him, the beginning, he feels, of the revelation which would eventually turn him away from self-destruction.

He had also begun correspondences with Leary and Ginsberg and William Burroughs. Burroughs has become a central figure in his life and once, says Rooks, "he spent four months teaching me his literary techniques." Nowadays Rooks never travels without an enormous pair of scissors. He works regularly at his cut-ups and hopes they someday add up to an autobiographical novel.

Rooks was traveling constantly at this time. He went to the West Indies regularly, to Europe many times, and finally, with Zina and the baby, on a six-month trip to the Far East. He described this trip in a letter to Leary:

> The irony was that I went to the East— India, Ceylon, Burma, Thailand, Cambodia, Vietnam, China, and Japan—expecting a guru to come out of a cloud of mist of antiquity and lay the great mysteries concerning man at my feet. Instead, I spent most of my time in the Orient spiraling in precisely the opposite direction of my goal. I unknowingly allowed myself to travel almost completely along the level of the senses using food, alcohol, and opiates to excess.

The trip—and Rooks—reached their nadir in Bangkok where he spent six weeks constantly stoned on opium. Finally, he managed to get to Hong Kong where he used all but $300 of his money to send his wife and child home. He had decided not to write his father for more money, but then he found an opium connection and spent the three hundred. "Within three weeks I was in a hospital, hemorrhaging. There went my conviction. I called the old man and he sent me money for the flight home."

If he was looking for the shock that would get him once and for all to the bottom, he found it in his father's death. After Hong Kong he had tried once again, and unsuccessfully, to live with his wife. He was drinking more heavily than ever and taking a tremendous amount of drugs when Russell Rooks became President of Avon. Rooks says his father didn't want the job. "He knew it would kill him, and he was right." Russell Rooks had no history of heart trouble when the coronary hit him. He was still working his twelve-hour

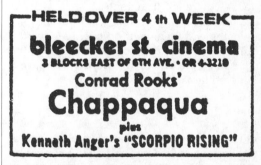

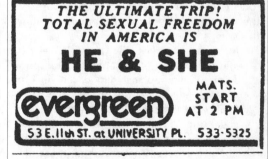

Advertisement for an extended run of *Chappaqua* at Grove's Bleecker Street Cinema and a run of Matt Cimber's sexploitation documentary *He & She* at the Evergreen Theater, from the *New York Times*, November 22, 1970

day and hadn't yet brought himself to take anything longer than a three-week vacation. He was planning his first trip to Europe when he died.

Three weeks later, Conrad Rooks entered the Klinik Hirslanden in Zürich, Switzerland, to take a sleep cure for his alcoholism. He was out cold for thirty days, and when he awoke he was clean.

* * *

We did the next scene in San Marco. With the cameras and tripods and soundbooms, along with Rooks in his cowboy get-up and the three striking women he'd brought along, we attracted a sizable crowd. After a bit of formal interviewing, the director asked Rooks if he felt like "turning on." Without a word he seized the microphone and, whipping the cord about like a pro, inveighed against the crowd. "Look at you, you idiots! Standing there staring at me like you're in some god-damn zoo ... what are you waiting for? You think something exciting's going to happen? You think I've got something interesting to say? Well, let me tell you all of this is nothing but bullshit! Bullshit! Do you hear? And look—you're still listening!"

He went on in this vein for several minutes and then, as if on cue, he gave the mike back to the director, walked over to the sidewalk café where we were waiting, and ordered himself some ice cream.

* * *

Rooks emerged from the hospital purged of his various addictions, and all the energy he had spent in that direction suddenly turned toward evangelical ends. The brochure on the film, which Rooks wrote himself, puts it this way:

> In order to offset the possible relapse into addiction, Rooks began to work on a semi-autobiographical film based on one of his poems called Chappaqua; the poem dealt with the process of maturation, the sadness of leaving one's youth and home, the death of a loved one. As work on the film progressed, Rooks became more and more convinced that the film medium was the most effective and dramatic way of getting at international drug addicts, and

especially the most vulnerable of them, the teenagers.

But it took some time for the vision to crystallize. During the trips with Sheldon Rochlin and Harry Staff, his goal had been documentary. Staff says that at the beginning Rooks' idea was to make a film about a "young guy who had written this poem and was traveling around the country reading it to people ... then we got into the trouble in Mississippi, and he decided it was going to be about the police in the South, and then, by the time we got to Montana, it was about the Indians." Robert Frank, perhaps the only one who has seen all the footage Rooks took on these trips, describes it as a "monumental waste of film—there are long stretches of Rooks holding a microphone, nothing else, and then endless shots of things like car trunks and roadsigns."

Rooks met Frank through Harry Smith and invited him to come to Paris, where he had rented the fifteenth-century chateau which was to be a hospital in the film. He had hired a Hollywood camera crew (Eugene Shuftan, who did The Hustler) and a French production crew that numbered well over a hundred. He wanted Frank as a still photographer, for publicity, and Frank recalls their first meeting in Paris like this: "He'd sent me a ticket, and directions to go to this hotel, but when I got there, there was no sign of him. I waited for two days and then, on the third morning, I was awakened by a terrific screaming in the room next door. I went on the terrace and there he was, on the adjoining balcony, standing on his head, chanting the mantra. The screaming I'd heard was from a tape recording of Rooks reading from his poetry. There were fifty people in the street below, staring up at him. When he saw me, Rooks rolled over onto his feet and gave me hell. 'Goddamn it,' he said, 'where's your camera? What the hell did I hire you for?'"

Miraculously, Rooks and Frank established an effective working relationship. Shuftan was bewildered by Rooks and so, within two days, Frank became the film's chief photographer. Rooks says Frank "taught me everything I know about films," and Frank, like Staff and almost everyone else who worked on the film, remembers the job as one of the great adventures of his life. "I mean, there was insanity all the time, but

he had the money to finance it as well as this unlimited belief in himself. It was this most of all that kept him going, because everyone else, including me, thought he would never finish this film or anything else."

The filming at the chateau was characteristic of Rooks' methods throughout the film. He'd hired Jean-Louis Barrault to play a doctor and, though Barrault was getting $1,000 a day, Rooks showed up two hours late the first day, and then disappeared into his dressing room for another hour. When he emerged, he had no idea what was going to happen, but there was a pool table in the chateau, and Rooks suggested he and Barrault might have a game. For the next two hours they played pool and walked around the chateau while Frank followed them with the camera. They were using a color film which, from initial cost to printing, costs about $400 for a four-minute roll. Frank, who was making his own film at the time and sweating out each minute on an impossible budget, says he got physically ill at the sight of so much film being wasted. The next day Rooks again disappeared into his dressing room and this time, when he came out, announced he wanted a helicopter. Within an hour they had one for him and with it they got some of the best footage in the film—Rooks dancing on the parapet of the chateau. As Frank hovered above him in the helicopter, Rooks suddenly got deliriously high on the whole scene and began to climb even higher. Finally, he reached the tip of the spire that rose from the chateau, some four hundred feet above ground, and began to wave his arms frenetically at the camera. This footage is the finale in *Chappaqua* and depicts the addict's euphoric escape from his addiction.

We had to rush back to the Lido because Rooks had arranged a special screening of the film. Gregory Corso was coming and bringing some of his friends. On the boat he relaxed and talked freely. Nothing could have pleased him more than his performance at San Marco, for he sees himself—with obvious justification—as part of the American showman's tradition, which, as he put it, has led so many American poets and artists to "sell themselves as much as their work. Performance!" he cried. "That's where it's at. *Chappaqua* is part of the whole spectrum ... Harry Smith, Ginsberg, Corso ... you have to

sell yourself now. You stand naked. You cure yourself and others are cured by watching you. You can do anything if you're willing to be a showman."

An American friend of Rooks' sat down with us, and this caused an immediate change in him. He sometimes seems to get confused about the different roles he wants to play, and this makes his conversations almost impossible to follow. When I asked him to elaborate on this showman idea, he paused for a minute, eyed his friend, and gave this answer: "All patterns in a culture you see are built on thought. Einstein's Theory of Relativity made it possible to split the atom ... well ... what I mean is all of us are formed by an image of ourselves that is constructed from our cultural influences. In America this means the movies. The masses have created themselves in the image of the movie stars: John Wayne, Humphrey Bogart, Brando. These have made the archetype of the time. Once someone matches the archetype, we say they have star projection. But if ever they should reveal they aren't the gods we think they are, the image will be destroyed. That is the battleground a showman has to fight on. And it is exactly parallel to the battlegrounds of Greek mythology." He turned to his friend, "Do you follow me?"

"Yes," the friend said. "Absolutely."

"Ginsberg," he continued, "is the greatest showman in the world. He grows out of the Jewish tradition of the Messiah, but my own is different. I come out of the tradition of the Buddha. The Buddha, you know, was just a prince who renounced his father's throne. Do you follow?"

* * *

During the next three years Rooks and his ever-changing crew filmed in Lame Deer three times; in India at the famous Kumbh Mela religious gathering, which occurs every twelve years, lasts thirty days, and attracts up to fifteen million people; a discotheque in Lower Manhattan; Buttercup Powell's Soul Food restaurant in Paris; Redwood National Park in northern Oregon; Kingston, Jamaica; Mérida, Yucatán; Mexico City; a gambling casino in London; Stonehenge, England; Central Park; a Holy Roller Temple in Savannah, Georgia; and an Air France plane en route from Paris

to New York. In the course of these travels Rooks was buried by the Holy Roller preacher in Georgia, made love to a girl in New York with a (16mm) camera tied around his waist, and prayed beside the Ganges. He was killed at least twice: by Burroughs (tommy-gunned) in a New York garage, and in a motorcycle accident on the Henry Hudson Parkway. He also sniffed cocaine, smoked a considerable amount of marijuana, took LSD and peyote, killed Burroughs (in the next scene), killed a girl, Dracula-style, in the gambling casino, danced in at least ten different places, and wrote a letter to his mother about a film he planned to make. Not one of these trips, not one of the scenes, had been planned more than three days in advance. Not a single moment of the film was based on a single line of script. "We had to learn to take advantage of the accident," he says. "That's why Robert was the only one I could work with. We worked twenty-four hours a day for long stretches and then we did nothing for a while and then we went to work again. The accident—that was the thing." His brochure put it this way: "Frank realized that Rooks worked out of panic: panic contrived to realize the flow from his psyche which must give birth to the drama; that it was this innate fear which gave Rooks the power to create ... Frank trained Rooks in techniques of action filming very akin to Jackson Pollock's technique in modern art."

Frank remembers other aspects of the "panic." "At the gambling casino, we had a very elaborate scene to do. He had invited half the potheads and junkies in England to the place. He planned to rape a girl in a pile of money on one of the crap tables, but he balked at the last minute and we did the Dracula scene instead. He grabbed her and tore into her neck. Then there was to be an orgy when the girl was eaten, but in the middle of this Rooks got angry at me because I was filming the others too much and ignoring him. He turned and walked out of the room. A minute later he came back and said it was all over. He opened up a suitcase filled with pound notes and started paying everybody off. He didn't speak to me for three days."

Another orgy failed, this one in the chateau. The crew returned one evening with fifteen Paris friends, including five beautiful women, records of Indian music, and two cases of liquor. Rooks, as usual, disappeared. As one of the girls recalls, "Robert set up some suggestive scenes, nothing exciting, but when Conrad came out, he was furious. He said Robert was wasting film, that his job was to film him, not us. 'All right,' Robert said, 'what do you want to do?' 'We'll do me with the girls in the bathroom,' he said, and so we went in there and set it up two girls on each side of Conrad—I had my head on his shoulder—and him in the middle in this incredible Indian costume."

Frank says he started to film the scene, though "it was obviously ridiculous, nothing moving, like Hollywood costume junk. Finally, one of the girls started giggling and everyone, including Rooks, realized it was absurd. He got up and walked away, but suddenly he turned and stared at me. I turned the camera on him and filmed him for about fifteen seconds, and I got him as I never had before—just staring into the camera; angry, and terribly frightened. Then he walked away.

"Those fifteen seconds—I saw them in the rushes, and they were maybe the best of all the footage. They're cut out of the version he showed in Venice."

* * *

"My stroke of genius," Rooks said, "was to build the film on a foundation of American Indian mythology. That allowed me to tap the collective unconscious, which is the first thing any work of art must do."

Rooks said he first got interested in the Indians when he found arrowheads in his backyard in Westchester. "I looked up all the books in the library but they told me nothing. Which isn't surprising. The white man is terrified of these people, and the terror is built on guilt. No race has ever been persecuted as they have. There were thirty million Indians in this country when the white man arrived. Now there are seven million and the race is not ten years from vanishing."

The boat had left the freeway and entered the canal. The engines were turned down as the captain carefully negotiated the channel, which was narrow and had several low overhanging bridges. In the distance we could see the rear of the Hotel Excelsior, the social headquarters of the Venice Festival.

He began to talk again about the

"collective unconscious" and this led him into a discussion of Ornette Coleman's music, and of how film, like music, is a system of tonal relationships. He said he wanted in *Chappaqua* to tell a story "with color as well as acting and pictures. Movies, you know, are nothing but the control of light through a manipulation of dots. Some time during the filming of *Chappaqua* I realized I was making a pointillist canvas. If you know how to do it you can make a film as rhythmic as a Japanese screen painting."

The boat nosed up to the Excelsior pier. There were Festival people standing around, and a photographer snapped his picture as he climbed out. He seemed not to notice. He was excited by what he'd said, and, pounding his fist into his palm, he cried: "That's what all of us are after—Ornette, Burroughs, Allen—it's what we all want … to tap that unconscious stream!"

At the door of the Excelsior an Italian photographer stopped us to ask if he would pose the following morning—for the cover of an Italian teen-age magazine.

The story of any of Rooks' trips has odyssean proportions. The Paris trip and the filming at the chateau are full of events like the yoga session on the balcony, and the second trip to Lame Deer was even wilder. On his first visit to the peyote rites, Rooks had prayed that he would get his son back from his ex-wife, who had won custody in the divorce proceedings. Now he had Alexander again and he asked the Indians to arrange another rite, this time specifically for the child "in order to set him on the right track." Since he wanted to film the entire affair, he arranged to take Frank and Ornette Coleman, who was then writing the music. The day before they left, Rooks and Frank were walking down Sixth Avenue in New York when they spotted Moondog, the blind composer who, in one of the world's greatest Viking costumes, begs on the corner of Fifty-fifth Street. Rooks decided instantly that he wanted Moondog with them on the trip and asked him how much he wanted. Moondog said $200 and Rooks wrote him a check on the spot. The next day the five of them flew to Billings, Montana, and the following day they drove on to Lame Deer, where they made contact with Rooks' friend, Jasper Red Hat. The rite went off beautifully. The Indians consumed

their usual amount of peyote and began their prayers—long recitations in which a person will tell an intimate story from his own life. It all lasted seventeen hours and ought to have made magnificent footage, but unfortunately the crew had partaken with the Indians, and the film was a disaster.

The trip that concluded in Oregon was the most bizarre. Rooks telegraphed Frank from Paris that they were going to film in Chicago. Two days later Rooks arrived in New York. The first day he had lunch with Harold Hayes, the editor of *Esquire*, and told him of his need for a "really beautiful woman." (Brochure: "He conceived the role of Water Woman, Female American, Child Woman, naïve, unobtainable, the void of the mirror …") Hayes told Rooks of Paula Pritchett, who had a big spread in that month's *Esquire*, and Rooks immediately set about contacting her. That same day he met with a former publicity assistant who told him of her recent visit to Jamaica. She was particularly excited about an old house she had stayed in, and she sold Rooks on it too. Two days later, Chicago forgotten, he and Frank and Miss Pritchett left for Kingston.

At the airport in Kingston, Rooks startled his companions by making reservations to leave within five days. "I didn't know it then," says Frank, "but he had seen this magazine on the plane which had a big story on the ruins in Yucatán. Which wasn't surprising. Whenever we arrived in a new place Conrad always made reservations to leave before he did anything else."

They were so pressed for time in Jamaica that Rooks was unable before they left to clear their footage with customs. At the last minute he gave all of it to an airport porter, with $50 and instructions to send it on to New York. The footage was never seen again.

In Mexico, Frank found a magazine in the hotel. There was a story on the redwoods, with huge color photographs. He showed it to Rooks, who looked at it intently for a minute, then handed it back. "That's next," he said.

First, however, they flew to Los Angeles, because Rooks said he needed rest before he could work again. They sat around the Beverly Hills Hotel, Rooks telephoning Paris several times a day from poolside, until Frank and Miss Pritchett began to get restless. On

the morning of the third day Rooks decided he was ready. The only way they could get to the redwoods was via San Francisco, where they had to take a private plane. When they finally got to the park, there were maybe thirty minutes of daylight left for filming. They used it, got a miniscule amount of footage, and headed back to New York the same evening.

But the day's frenzy had riled nerves. Rooks and Frank had an argument at the conclusion of which Rooks fired his photographer—for the fifth time. "You may be a great photographer," he said, "but you'll never work for me again."

Frank did not hear from him for six weeks, but then the inevitable telegram arrived:

Need you seven days work India Ceylon two final collages equipment Paris rent zoom bring stock two 400 feet or hi speed color two normal neg color usatine will arrange payment film discuss your salary here ... meet me 19th Hotel Tajmahal Bombay no later urgent Ravi Shankar you I attending mass meeting 20th Central India will cable ticketing airline Conrad

* * *

Four months after his Venice triumph, Rooks brought *Chappaqua* to New York for a series of private screenings. What audiences saw was an extremely ambiguous document whose subject often seemed to be confusion itself, a nonsequential blast of disparate imagery on the one hand and an extremely conventional film on the other. It failed far more often than it worked, but interested even those who hated it. *Chappaqua* is a mosaic of visions and daydreams and memories of an American childhood and ideas that run the gamut from Hinduism to Jung to William Burroughs. It is magnificently photographed—Frank has never done better work—accompanied by an exquisite, lyrical score by Shankar, and edited in collage patterns which seemingly disavow any interest in narrative. The mosaic, however, is held together by a banal plot: Rooks, called Russell Harwick in the film, goes off to a hospital to be treated for his addiction, has a deluge of visions there, escapes back to his pot connection in Paris, returns, has more visions, and

finally leaves in two different ways: elegantly and quietly in a limousine and hysterically in the helicopter. The conclusion, like the entire film, is noncommittal, straddling a fence between some of the most antagonistic ideas that have ever occurred to man. It is unclear whether Harwick will return to drugs. He neither disavows nor re-embraces the ecstatic dream he brought with him to the hospital, so the film seems simultaneously to condemn drugs and eulogize the visions they bring. Not that this in itself is a deficiency. It is difficult to imagine any honest contemporary film which would not be ambiguous in its conclusions. The trouble with *Chappaqua* is that it is not a vision of ambivalence but an ambivalent vision. From beginning to end, at the very core of its structure, it is inconclusive. Harwick is bent on his own destruction, but we know nothing more about his self-hate at the end of the film than we did at the beginning. Indeed, we know nothing more about anyone in the film. No one has changed in any way, no one has intrigued us, no one has hurt us. The inconclusiveness shows itself most in the tone, which shifts so radically and so often that it undercuts the film's spontaneity and most of the emotional rapport it creates with its audience. Although the visions, particularly those that take off on American gangster films or the sequences from the peyote rites, occasionally rise to a high level of visual insight, and break the film out of the subjective bag that inhibits it so often, the scenes with Miss Pritchett, she and Rooks strolling dreamily among the redwoods, or those with the Swami, sitting in a picture-postcard setting before a wall of turgidly colored flowers, reach a level of schmaltz that even a daytime television director would envy. If you could laugh at these scenes, they'd be tolerable, but the way Rooks has set you up, you can't, and that's a disaster. In general, whenever *Chappaqua* needs acting to support its photography, or dialogue, or any sort of narrative bridge, the entire apparatus chokes and falters like an automobile on its last drop of gas.

Movies, though, are a unique art form, the only one which can survive on movement alone, and Rooks understands this well. Whenever he gets in trouble, he simply cuts and moves on. We leap from one of the girl's maudlin smiles to India with such staggering

incongruence that the smile is forgotten, from a ludicrous, stilted exchange between Barrault and Rooks to a jazzy scene of Rooks roaring down the highway on a BMW. Bad scenes are left behind like thirty-second stops by the subway, and ultimately, when the film ends, it is movement alone, and none of the stops, that we remember. The fact that the whole thing is laid in the so-called psychedelic framework adds another rationalization. As anyone knows these days, once you call a work of art psychedelic, you effectively defend it from all critical discourse. A lot of people will love *Chappaqua,* and many who don't will forgive it, simply because it is laid on a foundation where esthetic discipline seems mostly irrelevant and filmed in the medium that is the most seductive of them all. For this reviewer, however, it wasn't quite seductive enough, but, figuratively and literally, rather like one of those trips that travel agents arrange—a day in London, an hour in Paris, ten minutes of free time in India. Like those trips, *Chappaqua* won't tell you much about the places you visit, but somewhere in it there's a hell of a message about your point of departure.

Turning the Camera into the Audience

Nat Hentoff

The more encapsulated we become, the more we see of other tribal enclaves. With hand-held camera, through "natural" sound, television and film teams increasingly stimulate our appetites to be voyeurs of "the real." Not only invisible, but impregnably at home or among strangers in a theater, we overhear in *Black Natchez* what blacks really say to each other when they think we're not around. You want to hang out with Bob Dylan and his picaresque familiars? Donn Pennebaker takes you along into private rooms in *Don't Look Back*. How about a search-and-destroy mission before bed? Tune in the eleven o'clock news.

McLuhan appears to be right. If it's "involvement" you're after, you've got to see and hear. Man, there's hardly any place we can't go to find out where other tribes are at. Homes for disturbed children, the President's office on a day of crisis, the last hours of a man on his way to the electric chair, that other country of the aged from which there is no return (except for us). No doors or walls can keep us out. And best of all, we don't even have to say good-bye.

But when are the cameras going to turn on *us*? When are we going to see ourselves, I mean really see ourselves through someone else's lens? My point is that cinéma vérité has just begun its explorations. So far, the truth-collectors have made it easy for the moyen middle-class viewer—he who looks, nods, maybe gets bugged for a while, maybe even feels tears, as I did watching the now widely distributed *Like a Beautiful Child*, an organizing film made by John Schultz and Don Hunstein for New York's Local 1199 of the Hospital Workers. OK, so I cried. And the next time I'll see a member of 1199 is when she comes in to change my sheets if I'm ever in a hospital again.

Where McLuhan comes up short and simplistic is his failure to recognize that as our outer environment becomes more and more "charged with audio-visual messages," these proliferating nonlinear stimuli can all the more easily facilitate the illusion—but not the experience of "depth" involvement. Just by being and growing advanced communications technology does not inexorably, magically lead us to fathom our own reality. In fact, by heightening the ways in which we are diverted, these messages can keep us

hidden from ourselves until our last reaction to anything.

What I am proposing is that workers in cinéma vérité—social cinema, as some call it—do much more than add to the messages we get from places where we'll never be other than invisible. Instead, look into many more kinds of life styles than those of the maimed, the militant, the restlessly renowned. Look into *our* life styles.

Consider, for example, what happens in this country to our children, those who are not "disturbed" in a clinical sense. I've seen many documentaries on education, but none that comes close to exposing the nerve of fear that is endemic to most classrooms in which the "advantaged" children of the middle-class are systematically stripped of their sense of wonder, their spontaneity, their reaching out to experience. The dictum in all but a few schools that everyone must learn the same things at the same pace is annealed to the holiness of grades to create a pervasive anxiety which shreds the real interests of the young and eventually turns most of them into the dead souls that make this country come closer and closer to being the undertaker of the world. No number of books by Neill and Goodman and John Holt can make this slow killing of the young as fully immediate in its ritualistic horror as films could.

And conversely, much more can be shown than is available now of those schools where learning is pleasure, where children learn at least as much from each other as from their teachers, where individuality is nurtured, not curbed as being disruptive. And why can't there be long-term film projects through which children, both the dying and those being given room to live, can be returned to in five or ten years after we've first seen them? After we've seen our children in them, and ourselves.

Another area of cinéma vérité which has been only marginally explored is the self-portrait. Shirley Clarke's two-hour *Portrait of Jason* takes us voyeurs into the coruscating netherworld of a male Negro prostitute. But turn the camera into the audience and let us see and listen to a judge of the criminal court, a surgeon, an art director for an advertising agency, a *New York Times* editor, a writer trying to be both relevant and solvent, a union official, a welfare caseworker, a Reform Democrat, a woman past forty trying to remember what it was she thought life was about. Let us look into the slight but chronic acts of prostitution and perhaps even some fulfillments of our *semblables*, those from whom we are not nearly so distant as we are from Jason and Bob Dylan and the man a meal away from the electric chair.

What do we know, moreover, of death in this country? What do we think about death? *The War Game* stunned us into thinking, briefly, about apocalyptic atomic death. But we submerge our intimations of ordinary, individual, actual death. I don't propose to sketch a scenario here, but a film about the ways in which we pretend that death, especially our death, is not real—and the consequences of that reckless fantasy—could excavate feelings and compressed desires that might begin to affect the priorities of some lives.

I should note here that I am not contending reality is necessarily more deeply probed in "fact" than in "fiction" films. As in writing, quite the contrary is true much of the time. No sociological study I've seen approaches the depth and accuracy of *Last Exit to Brooklyn*'s distillation of how brutalizing and vulnerable life can be among those who can only prey on each other. Similarly, I learned more from Arthur Penn's *Bonnie and Clyde* about the idiomatic rhythms of American violence and our delicious ambivalency to it than from any documentary I've seen on the subject. But I stick to "fact" film in these projections because the best of its makers have developed an integrity of language that can, in its way, reveal much more than it already has of who we are.

Take violence. Arthur Penn is right: "The trouble with violence in most films is that it is not violent enough. A war film that doesn't show the real horrors of war—bodies being torn apart and arms being shot off—really glorifies war." Bearing him out, whether they are consciously trying to glorify war or not, are network television executives who carefully measure the degree and amount of violence they'll allow to be shown in battle reports. But even if we were to see relentlessly undiluted cinéma vérité sections of war, there is a great deal we are not shown of the violence in us in our natural civilian habitats. The violence of language, gesture,

face-set in any ordinary day on any city street. The high, and growing, incidence of men and women on those streets, consumed by the need and inability to let violence out, walking, fiercely uptight, like mobile land mines. The violence, in eye-bulging intent, if only intermittently in execution, of parents toward their children. And not only parents in the lower- and under-class. The ghettos are dangerous, we say, as if we were at peace where we are. Barely suppressed rage is as pervasive in our cities and their steadily more squeezed together environs as auto exhaust fumes; but to keep ourselves tentatively sane, we act as if all feral creatures were behind bars or in the "disadvantaged" hunting grounds.

Tom Wolfe begins a piece in *New York* magazine about an anthropologist visiting New York, but the name of the city is interchangeable: "I just spent two days with Edward T. Hall, an anthropologist, watching thousands of my fellow New Yorkers short-circuiting themselves into hot little twitching death balls with jolts of their own adrenalin. Dr. Hall says it is overcrowding

that does it. Overcrowding gets the adrenalin going, and the adrenalin gets them hyped up. And here they are, hyped up, turning bilious, nephritic, queer, autistic, sadistic, barren, batty, sloppy, hot-in-the-pants, chancred-on-the-flankers, leering, puling, numb—the usual in New York, in other words, and God knows what else. Dr. Hall has the theory that overcrowding has already thrown New York into a state of behavioral sink. Behavioral sink is a term from ecology, which is the study of how animals relate to their environment. Among animals, the sink winds up with a 'population collapse' or 'massive die-off.' ... It got to be easy to look at New Yorkers as animals, especially looking down from some place like a balcony at Grand Central at the rush hour Friday afternoon. The floor was filled with the poor white humans, running around, dodging, blinking their eyes, making a sound like a pen full of starling or rats or something."

As graphically evocative as Wolfe is, it would take a camera to really get into that behavioral sink. And not only in the streets or at Grand Central. There are the diverse pens of offices, huge stores, schools, high-rise

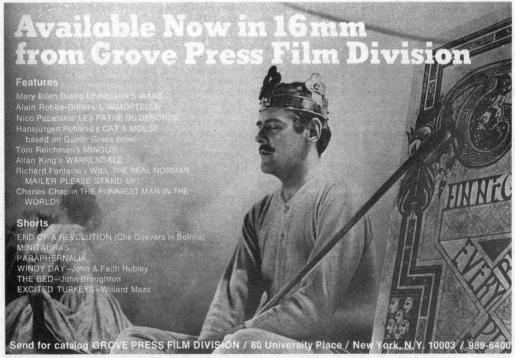

Advertisement for Grove Press Film Division, featuring an image from Mary Ellen Bute's *Passages from Finnegans Wake*, that ran in the magazine *Film Comment*, Fall 1968

apartment houses (luxury and otherwise). While there is rhetoric, there is no mass, desperately urgent outcry to humanize the cities because we are no longer able to fully see ourselves as we live and work in them. A swarm of film-makers, extracting the murderous essences of cities, could do more to reverse the slide into population collapse than any number of surveys by urbanists and pleas by such otherwise persuasive political figures as John Lindsay.

Nor do we see ourselves as we take our pleasures. The instant transmogrification of a crowd into a lusting mob, blessedly released from civilization, at pro football games or boxing matches. Or more subtly, turn the camera on us as, vicariously ennobled in blood, we watch films of violence in the luminous cause of national independence—Pontecorvo's *The Battle of Algiers*, for instance. And move the cinéma vérité eye into our bars for a film on the different ways in which the night is held off by class, by neighborhood. The different mating styles, too. The different ways in which we struggle against the quicksand of boredom in honkie and black refuges, in hippie coffee houses.

Nor need the social cinema limit itself to our pens by day and our grottoes by night. There are those who do their thing and dig it, actually dig being. The kind of lawyer that Conrad Lynn, whose clients are black revolutionaries and draft-resisters, is. Or in a quite different, but self-fulfilling way, that Edward Bennett Williams is. Others who take joy in their skills—certain artisans, certain journalists, certain architects, certain teachers, and even, I've seen them, certain dentists. They are the saved. How do they do it? How do some find and sustain relevance, relevance to themselves?

So far, much of cinéma vérité, through the kinds of subjects it has largely focused on, has actually reinforced our distance from those who are not like us and our distance from ourselves. The "truth" we ingest about those other tribes is like the "truth" we keep learning from all the media about the ghettos. It is inoperative. It may affect us transiently, but harrowing as some of it may be, it leaves us as we were. It leaves us passively entertained, knowing in so much richer detail all about them we care to, and waiting for the next encapsulated trip somewhere else.

But if the cameras are turned at us, going to see *that* kind of cinéma vérité may begin to resemble what it was like hearing Lenny Bruce. We were his act; he was our mirror; and he made us look—bizarrely, shockingly real in our nakedness—into that mirror. Most of all, Lenny wanted to make films. He never really got started, but if you begin to conceive what those Bruce films might have been like, you can recognize the distance cinéma vérité has to go before it make its audiences visible to themselves.

No. 53, April 1968

Norman Mailer's
Wild 90

Lita Eliscu

Norman Mailer's made a film. Norman-Mailer-has-made-a-film? What the hell for, I thought. (I was irritated.) Norman playing with—and for—movie cameras: the new parlor game. This moves you into a new profession besides, and still no fear of anyone thinking you don't trust your future as writer. And if you have a friend named D.A. Pennebaker (what kind of name is that for someone to have, anyway?), who knows, you might get some real Dick Lester kind of shots. Norman's last novel is done in classic, mainlining DJ style, leaning heavily on cinematic effects ... so why not have a movie, based on what goes on in your mind just before you drop off (no, baby, I said *drop* off). After all, there it all is: light/sound/action with your head as executive producer and director. And if your mind is named Norman, how can you miss?

I looked again at the ad. *Wild 90* starring Norman Mailer, some friends, José Torres—oh, OK, got it. We are gonna get a pre-game-time insight, head projection time: five minutes; screen time: oh, say ninety minutes. This will be a right-before-bedtime-kiss-off. Maybe even structured. We are going to see Norman making like George Plimpton making it like Norman would have *if he* had fought Archie Moore. All those intellectuals, nothing but Our Gang revisited (remember Spanky?). I have always wanted to know what a real smart-ass thinks about off-duty when he isn't interviewing himself. Epiphany: I am jealous. I am trying so hard to talk myself into this cocky sophisticated "position," when I have already bought my ticket and have no desire to get a refund. I am jealous right then because he has made a home movie, Norman and Friends At Play in the Fields, and the screen set (one) is a grungy, gummy room with a great albeit unseen view of the 59th St. Bridge. This is not Warhol home movies: color-Plus and the aesthetic bitchiness, determination, and pills to shoot twenty-five hours of film; this is Norman not even pretending he has an artistic excuse, but just having fun. And he gets audiences to come see the side show.

So I watch what is up there on the dinky screen. Black and white, the color of a *Daily News* centerfold photo, three months old. The sound track sounds as though my sister's kid sent away for Real Sound Equipment, kids!

Just $3.95 and this coupon! and then donated the whole bag to Norman. I pay attention long enough to establish a semi-possible interpretation of the action, but when Norman talks, or mutters, the sound is totally unintelligible, so I switch gears to let my subconscious receive messages subliminally while I ponder the scene. A thought creeps by: perhaps he means to be this non-understandable, just as though there is a Gardol plate between us. If this were not N. Mailer, would I not think of this lousy sound as a verbal cue to the dream-state quality, a reaffirmation of the fuzziness in all our heads? His intellectuality is proclaimed so stereo-loud in so many other ways, it is impossible he would allow his brilliance undermined, unless on purpose. His character is a gangster, a sort of Jewish mother's boy-Mafioso who talkslikedis wenne talkssoze ukin unnerstanim atall. But his preoccupation with words—here is the real Norman. In a fifteen-minute piece, he remonstrates with one of his cousins, the guinea asshole (whose name in the movie I can't remember, if he has a name). Norman tells him never to call Mickey a cocksucker again. (I'm not too sure if the other cousin's name is Mickey, but everyone calls Norman "Fritz," and at least Mickey does not sound like Fritz.) The guinea asshole says it was an expression, like motherfucker, or, I suppose, like guinea asshole. While Fritz should see the logic, Norman-baby points out that Mickey spent eight years in prison for not ratting on his friends and despite subsequent nutsiness from this, he is entitled to respect from a guinea asshole. Only someone who spends time creating characters would realize that cocksucking, in Italian culture, is a highly frowned upon activity implying as it does a loss of masculinity almost paralyzing in its enormity. Two points in the chivalric Norman Code which says call a man by his true name.

There is a plot and I don't think it is too much to give it away for free. Norman and his cousins are holed up in this warehouse, trying to outwait and outwit the police. That's right, the ad does not lie. They are there for twenty-one days and a night; another day, another night; another night; another night; and maybe another night, I forget. The refinements of this outline are of course dictated by the Mailer soul and body: cunt, lack of; fighters; ability relative to one's own. Now I lock my lips and throw away the key.

Most of the shape and content is indisputably the work of Mailer, but not in the orthodox sense of making a film. The script is largely the result of what goes on up there, hardly a cause. Norman is king of the mountain, or better, he is that little boy who, mysteriously enough, is somehow always unanimously considered the Ringleader. When the film opens, everyone is a little overbearing, too strident, emphatically playing a role. Swinging into the game gradually, they come round to a full acceptance of the reality they have worked out, and then they live within this framework totally, for the rest of those ninety minutes of time. Sensibilities mesh and the obviousness of the whole malarkey just shines through that worn velvet, so that it seems right to have them screaming "Watch Out!" to Jimmy Zapp when he goes to save Gloria Glorious—like kids, they believe, finally, in the reality they have created themselves, when they come to realize that they are exploring that Congo between myth-making and "reality," on whose boundaries we all live while trying not to let the myths dominate the horizon.

Much of the funniness of the film is the result of the obvious amateurishness. Even D.A. Pennebaker cannot stop grinning in his walk-on, as he looks around at the ridiculous set. You laugh from annoyance when a particularly funny dirty joke (or particularly dirty, funny joke) is so garbled that you cannot hear the punch line. But the funniness in the film is a gentle humor which gradually permeates the whole screen. This is not, after all, a college underground experiment. The rough edges of bowled-over, cool wit are missing, the overattempts to please both the audience and themselves. These are grownups—funny, intelligent men who had some film, some time, and plenty of egos. For most of ninety minutes, they exhibit a common belief in a fantasy they create themselves and do not mind showing to audiences.

Sometimes, not everybody is as finely attuned to the improvisational air as they all might be. Mickey's younger cousin pays a nighttime visit, bringing another bottle of wine. Looking at Fritz in the corner, he says, "What's that you're drinkin', poison?" Fritz tells him to shuttup, get out, and he's a

no-nothing (or know-nothing) punk. The two engage in a "'Yeah?' 'Yeah.' session." Time for exit; no go. There is very little tension, more a sense of panic as it becomes clear the cousin is too taken by the camera to leave under his own power, so Norman and Mickey combine to push him out the door, out of camera range, at least. A different test of supremacy occurs with the sudden entrance of a German shepherd, José Torres, and his manager. The addition of three good props and Norman practically outshines Jonathan Winters. First, the dog. Intermittently, Norman stops mumbling at everyone (including his reflection in the mirror) in order to really growl and snarl. With all this road practice, he figures the dog as an even match and gets down on his hands and knees for a fair fight. It ends in a draw only because Norman gives the dog points. In the back of the shepherd's mind, you sense, is that this could be a case of man bites dog and he is at that stage in his career where he doesn't want to risk his face. The one with the silk ascot and hat (which he removes reluctantly after some nasty urging from Fritz) turns out to be the manager ... He introduces José Torres as a young fighter on his way up and would Fritz condescend to offer an opinion on this boy's future. The looks on faces, at this point, run from simple distrust on the dog's through no-shit disbelief on Norman's. José mainly giggles. Grudgingly, Norman agrees to spar with said young fighter. Guess who fights with his palms out and laughs for most of the two-minute round. Suspense is introduced for the first and last time: will Norman allow himself to win or not? José is obviously not too sure what is supposed to happen. Twenty-five years from now, when some college senior does his thesis on Norman Mailer, *A Startling Example of Ego in Conflict*, will this film be included in the bibliography?

The final scenes are the best for many reasons, not least because the problem of cunt, lack of, is satisfactorily resolved. The three leads are beginning to tire of one another and the introduction of females revitalizes the whole improvisation. It is not fair to say what happens near the end of the film, but think back to all those great gangster movies, and the gun molls, and then try to cross-breed Bette Davis with Mrs. Adam Clayton Powell, and this gets you openers. This part of gun moll *extraordinaire* is played by Mrs. Norman Mailer, and her professionalism in this sea of amateurs makes her stand out like Esther Williams doing a guest appearance at the high school aqua-nette performance.

The two introductory shorts remain irrelevant, naturally, until the conclusion of Mailer's film, which is why I refrained from any reference to them until now. In an incredible color short, Zal Yanovsky gives a pop-op view of love, sex, and ego. Zal is seen (and sees himself) in countless shots as a tee-nie-idol. This is followed by a slow-motion treatment of the-closer-she-gets, the-better, etcetera, starring Zal and willing girl, together with a cast of thousands, in the spring-time-fresh, mentholated countryside grass. The witty-wise flipness of these two shorts contrasts strangely with the man-woman situation presented in Mailer's fantasy, a world more hard-bitten, vulgar, and stark, and yet much more romanticized and sentimental, after the fashion of *Lassie, Come Home* or Wallace Beery in some version of *Riders of the Purple Sage*. Mailer, after all, while a contemporary and current writer, has his roots back there in that literary underground which idolized action, and whose heroes were named Sugar Ray, Lou Nova; Hemingway was not then referred to as Papa. Love was not a shot of two birds flying in perfect unison, or a building like the Astor Hotel crumbling in a mighty crash. Love was something for adults, and in the movies it was mushy.

The second short also serves to locate more precisely Mailer's film both spatially and temporally. In black and white, it is a slapsticking harty-har-har of an ostensibly famous marimba band, popular in the 1940's. The women wear black frowzy organza gowns, the sound is rinky-dink, and the humor is pure Katzenjammer Kids. Coming right after a short produced by people who don't even know who Krazy Kat is, the sharp time-gap becomes even more pronounced. In retrospect, Mailer has never seemed more vulnerable than in this silly, fictional fantasy which does not try to hide emotions in a thick screen of sound effects, color, and hip-a-dip wit. After all, Norman Mailer is no longer a boy, or boy-genius. His film, home-made and -produced as it is, is the work of adult artists, and one must believe him when he

says, "Any workout which does not involve a certain minimum of danger or responsibility does not improve the body (or artistic consciousness)—it just wears it out."

Each time I breathe in, to say something about the validity of this film as cinema, Norman grins back from the mirror he keeps looking in throughout the movie. He knows: this is a Supreme Mix Production whose immediate pedigree may read by Norman Mailer out of His Mind, but it goes further back, and the records are lost. The loose, almost nonconscious use of film and camera techniques, let alone the blatant disregard for audience ears, may be a faint but mocking homage paid to the origins of underground dada films, with a side salute to the home movies mania of the 1950's, as Donn

Pennebaker's camera makes great sweeping shots across the room like when Daddy tries to get Baby beetling it across the living room floor. The language, however, is pure Mailer consciousness, reveling in and revealing his feelings about sex, and is not subject to the regressive fantasy limits of the 1940's version of the movies. This is not a Polaroid Excalibur trained on the kid, and this is not a finger to a whole industry. This is just Norman's first film. Remember his first novel?

Advertisement for three Grove Press films that ran in the October 25, 1968 edition of the *New York Times*

Warhol's
Nude Restaurant

Stefan S. Brecht

This is a movie shown in a movie house. This being the case, its primary effect is that of a departure from the genre, non-conformity with the genre's conventions. You watch a movie being made (the camera is rolling) and/or/but you are practically told: "We are not making a movie." This negative reference is not characteristic of underground movies generally: they come on as new movies, defying Hollywood. It is a dadaist provocation of the audience, frustrating its urge for an audio-visual fix.

Next, there is a pretense that somebody modern, who wouldn't dream of living without a movie camera around any more than without tape recorders, etc., in the course of everyday living, routinely and without special purpose, though playfully, makes these movies, shoots what he and his friends happen to be doing, almost as a part of doing it (it's his "thing")—that this movie was part of the footage, he having been somehow induced to release it. Just as he likes to fool around with his camera, give a bit of structure to the day, his friends like to kind of play games, not impersonations exactly, but posing in adopted attitudes. Naturally this lends itself to being photographed. Naturally a person who doesn't like not to make movies would hang out with such people. One senses that these people have one party after another. They and he play these games all the time. It's what they are apt to be doing at any time any day. It's what they do.

There are such people of course, always have been, a real leisure class, though a demimonde. To that extent the pretense is plausible (and the movie decadent). This sort of life—life as a party—in fact tends to polarize into posing and observation, so that the introduction of cameras and sound recording equipment does not really change it, is just a way of being more modern about it.

This pretense is consistent with that primary effect. Something like it is, in fact, called for to create it. If they are not making a movie, what are they doing? But the pretense goes a little beyond that dadaist effect. It carries the suggestion that we all ought to be filming ourselves: formally acknowledge and externalize our social self-awareness—be self-consciously self-conscious, and not one by one but in groups—make our own movies of ourselves, instead of going to watch

movies made by others of others about ourselves. Socialize the movie industry! Appropriate the means of communication! Under the aspect of this suggestion, that pretense is a deceit rather than a deception.

But the pretense is phony for, notwithstanding it, a movie has been made. Essentially: a woman's plaint that she has found male heterosexuality to be sadism, delivered against a background of rough trade, in an enforced competitive duet with the fey *non sequiturs* of a middle-aged homosexual boy effortlessly contributing the role of uninterested listener. Viva divagates over her life (sexual "experiences" and "relationships," her dad's pimping), a clanging monotone out of a pure-contoured face over which few expressions pass. The face is posed over two small round breasts, emblems of femininity. There is a body, the camera does not dwell on it, a dry-skinned structure. Soft breasts, a harsh voice, a beautiful face. The large eyes move for the camera. She seems a nice person, a classic bitch's blind. We don't see her arse: this is pornography—though a bathtub sequence with a laughing, limp-dicked male and a nibbling kissing scene stir the crotch.

Ingrid, a "pig," appears briefly.

Apart from their genitals, which they carry in a black bag, the actors are in the nude. They look censored.

They do not act, the camera does not film, the cutter did not make a movie out of the footage. So the action—whether the bitchery between Taylor Mead and Viva, the funny idea of a bit of bar life in a nudist bar without a liquor license, or Viva's story—is not a line but spongy tissue, and the movie is neither shallow nor profound but flat: in the surface on which it is projected, and in the nature of the photography, which nature it proclaims is its reality. The actors don't move much—they sit (Viva stands, she serves) and pose. The camera switches from one face or other bit of epiderm to another, making you aware of its whir and swivel. The film presents itself as film, not as film of something. The action is that of the camera, not that of the actors (let alone of characters portrayed or impersonated).

The theme of female demand and dissatisfaction is thus made to compete for your attention with the enterprise of making a movie about such (though not with any "camera work," "treatment of a theme," "personality of a director") a movie, not even this movie. Obviously, of course, and however, Warhol was not about to shoot just anything: most likely he was out to get Viva. She seems to be under the illusion of being "some kind of a star." You couldn't say she was anything but the star. She's also being a good sport.

She is not a good storyteller. A queer etiquette obliges people to be blasé non-serious. Non-seriousness is not the same as unseriousness. In a quiet way these people are serious about themselves, which is why they cannot permit themselves to be serious, but which is incompatible with unseriousness. Thus, for instance, levity is out. Mead, an excellent comedian, is studiedly unfunny in word and gesture, humor being the poignancy of concern. Viva's stories are interminable. She is terribly boring. Of course, the on and on from time to time adds up to being funny, but I would suspect it would be underestimating this gang to think that it was a governing purpose of theirs to be funny. They are really quite serious, though not about anything. And then, the telling of a good story in a nonfilm would be incongruous.

Mead's dialogue with the war resister is a draw: the resister comes on slow but steady; the camera lovingly on his acne'd face, he delivers his challenge to Mead's moral position, Mead swerves, sideswipes it. One is free to admire the young fellow's integrity or Mead's commitment to himself ("personal rights"): the general public will be spared disgust with both by not going to see the movie. All in all, perhaps, Vietnam is brought up in this decadent frolic as apology for its cult of boredom.

To an admirer of Jean-Luc Godard, perhaps thinking of a scene in *Masculin/Féminin*, that dialogue seemed every bit as good as things in Godard. But such qualitative comparison seems to me to insinuate a nonexisting identity of genre. Godard's camera operates on fictions (symbolic representations): Warhol's records staged events. There is an inner relation between the active handling— of Godard's camera, creative interpretation of acted action directed by him, and a symbolic reference to a larger social reality; another one between the simple foci of Warhol's camera on the poses of his poised creatures and the absence of reference. The resemblance of genres is delusive. The cavalier way Godard

treats his story with his cameras and sound recording equipment implements that story's tragic play on life; whereas Warhol's informal recording of his naturally histrionic (narcissist and exhibitionist) friends, the off-hand capture of glacial poses, expresses his and his friends' common strenuous unconcern with (I quote on their behalf) "the society." Of course, Warhol's address to the audience is finally direct, whereas Godard's is the traditionally oblique one à travers the art object.

Mead and the resister are really fighting for their lives—and right before you. The contained desperation that Warhol exhibits is his own.

At the 10 p.m. performance on West 44th Street only a few men, looking like business men, attended, watching the self-consciously unconcerned naked figures, listening to the desperately harsh, "bright" voice delivering the monologue.

Cartoon by John Kristofori from *Evergreen Review* No. 53, April 1968

No. 56, July 1968

Vietnam Déjã Vu: A Film Review of Godard's *La Chinoise*

Lita Eliscu

It doesn't always pay to go to the cheap(er) movies in town. Everyone wants to be paid what he can get: maybe the audience will even think it was Worth It …

La Chinoise is a movie about boredom, a movie about that time of life when there is difficulty finding the reality of the reflection rather than the reflection of the reality—as one of the serious young French students of Leninism-Marxism points out. All these serious, etc. people are forever exclaiming such statements. They write them on the beautiful white walls of the apartment they stay in for the summer (the apartment belongs to one of the girl's parents); they write witty sayings: "One must counteract vague words with clear ideas"; they keep their short-wave radio set (part of a beautiful hi-fi stereo) tuned to Radio Peking; and, oh yes, tea is served while the virtues of discipline are extolled. The bookshelved living room rigorously defends their austerity—only one book is featured: the Red Book of Mao. Of course, the whole room is filled with copies.

In France, the children are weaned on wine and then grow to appreciate milk; somewhat similarly, they also start out with the fullpowered zeal of an old-time radical warhorse and only then mellow into that famous gallic dry irony. Eh bien, M. Jean-Luc Godard has created a film which sometimes sighs over this fact, sometimes wheezes, always smiles sardonically and sympathetically. Faced with the ultimate ennui of the subject—only Eskimo parents still have any reverence for childhood—Godard has used the intellectual approach of cubist art in order to reveal the multifaceted passion and rigor of the bourgeois students of France. It really is not *his* fault if all this emotion is boring to anyone but these teenage comrades.

Or is it …? The techniques used are brilliant—collage effects, using people, the furniture, fake props and word-covered, newspapered walls to achieve a truly marvelous depth on a two-dimensional piece of film. The words are reminiscent of Matisse paintings, where words and letters also curlicue across the surface. A "take-board" flashes and snaps in front of the actors' faces; the actors talk to the cameramen, and sometimes directly into the camera, which is visible and even audible as it whirrs. The reality of the reflection, to be sure. An actor, the boyfriend

of the girl whose apartment they all stay at, is really an actor. He tells the camera, "Yes, I am an actor. But I do not do this because I am acting, but because I am sincere." Because we all are actors, non?

This film makes one want to break into the same dry humor known only to those capable of breaking into French. Perspective is all, and literateness has never before been so requisite. This is a picture to be read, although not through visual imagery so much as by use of the whole head which must perceive and then inform. And enjoy, if education is amusing.

Here is a quintet of French students—the old-new breed—one of whom is nineteen years, eight months, fourteen days, eight minutes, and twenty seconds old at one point during the film. It is this girl, Veronique, whose family owns the apartment. They also "own some factories" much to her initial loss in this world of rigorous discipline. (But it works out—she redeems herself, as they say.) The camera watches patiently, munching an apple like that Central Park coach horse over there, while the generation gap is reenacted. Boring? Of course. Tedious? Of course. Minimal art is at work here: less is more. The eyes are forced to reexamine the film itself for some glimmer of freshness, interest, power. Technique is all. The images (as the film promises in its opening shot with words written on the wall) are clear. The warning has been given. Words are used mainly for decorative purposes, or for cross-purposes, as when two actors talk and the subtitles become an impossibly contradictory means of understanding what is being said. (As a matter of fact, the same bland repetitiveness is consciously threading its way through this review, mais oui, in an effort to reproduce the effect of the movie.)

Because the words of the movie are belied, yet ultimately true. "In everything we need sincerity and violence." This film counterbalances this truth with total cool; the inertia of distant omniscient perspective. The other side of the goddamn apple tree, ladies and gentlemen, for that's what happens once you are knowledged: intimations of immortality and a need for sincerity and violence become reflections of the reality only.

The realities of life: sex, power, fear, hunger, will to live—these are negligible and are replaced with an all-consuming desire to right the world. "If an action is not just, it is wrong." But what is the motivation, the aesthetic of justice involved? There are three deaths in *La Chinoise*, all of them unnecessary and almost gratuitous à la Gide. One of the boys in this summer cell is Russian, Serge Kirilov. He kills himself. Veronique, in an extension of a debate—Terrorist Action, the Need For—kills two men. Number One is A Mistake—she has read the room number upside down in the registry. Number Two is a Russian named Shokolhov, "or is it Sholokhov?" she asks. Anyway, she immediately returns to the building, enters the correct room (No. 23, not 32) and shoots the right man, thence stepping out on the balcony to give a triumphant "all-clear" wave to the boy waiting below in the little green sports car.

Kirilov's death provokes the camera into cutting to a shot of springtime-lovely, too-blue, true-blue sky. The shooting of the other Russian dissolves into that happy arm wave. Right before these events, one of the students recounts the story about the Egyptian children, do you know it ...? Well then, the Egyptians decided that their language was the language of the gods. In order to prove it, they took some very young babies and put them in a house by themselves, apart from all other human beings. Of course, if Egyptian was the language of the gods, the children would, of course, learn it. So about fourteen years later, they came to pick them up again, and found that the children were baa-ing, like sheep. They had not realized that next to this isolated house was a sheepfold ...

Veronique's ability to kill two people, and her subsequent performance, is only a Bonnie-and-Clyde extension, a sensitive reaction to her environment, *our* environment. Death has become a bore, too, these days; only assassinations can grab a headline for even a day or so.

Then home comes not the parents, but the older cousin of Veronique, who looks in distaste at the walls and red books, exclaims that all must be cleaned up before *they* get home ... and clear out the kids and the philosophies. The walls are again pristine fresh whitewashed, and the shutters stand clear. Books of all reflections and realities line the walls. Veronique's voice, "... and I realize

I have taken but the very first step of a long march."

The trailer short is called *You're Nobody 'Til Somebody Loves You*. It stars the wedding of Timothy Leary and Monti Rock III singing the title song at the wedding party afterward—"You may possess/The world and its gold/But gold won't bring you happiness/When you're growin' old ..." The children of *La Chinoise* don't want gold, but they don't want happiness either. They want justice. "I love you" becomes a lesson, cruel but effective, taught to Guillaume by Veronique. She says, "I don't love you any longer," while the hi-fi plays a properly woeful song. Guillaume demands an explanation, then begs for one, and Veronique sweetly explains that contrary to his just-stated opinion, one can work on two fronts simultaneously: he has just listened to both the music *and* her words. This is perhaps the only sequence in the film where the words, or implied emotion of anybody, have any visible effect on another person. Naturally. This is the only scene where someone speaks his thought to anyone else and is not either quoting Mao, listening to a (groovy, 1950's style) rock-and-roll record called *Mao, Mao*, or attempting to correct someone's impure incorrect Leninism-Marxism. Where there is such a sequence put in, of course, like that one curved line in a rigid Cubist painting—that one souvenir of nature—where there is such a memory, no matter how faint, then there is hope.

There is a great temptation simply to string together certain phrases which appear in the movie—on walls, in mouths, and elsewhere. Such a pearl choker is dazzling, but dangerous in its hypocrisy and moonlike refusal to reveal the other side. It is easier to end with just one more quote, said by one young Françoise to another: "Reality has perhaps not yet appeared to anyone." And let both relevance and conclusion be a private matter ...

In true, inimitably Godard fashion, his subject matter *is* a direct reflection of at least some of the reality surrounding us. *But*, it is not a personal reflection, only a distillate. Godard never puts himself on the screen; in schizophrenic fashion, he is able to divorce his perceptions from his sensibilities and reveal only the former, intellectualized ideas. Godard always has an epilogue, like this last paragraph, a Brechtian hangover to ensure the dissociation, the distance necessary to any admiration of his art, which consists only of his technique. Perhaps technique is all anyway.

The Edge

Lita Eliscu

Who would think of killing the President of the United States? No, seriously ...

Exactly. Times have changed; that is no longer an even absurdly funny comment. Robert Kramer has made a movie that is aware of the reality and cannot be absurdly funny. It could have been absurdly, ridiculously, painfully serious. Somewhere after the title shots, unfortunately, *The Edge* slips off and becomes simply absurd, ridiculous, and painfully pompous. Dramatic seriousness is a dangerous province, only to be trespassed by the wise and funny people of this world.

The movie is about a group of people who do indeed live on the edge, the periphery, of society. One of them, Dan, has decided to assassinate the President. Just for the record, that's Danial Rainer—twenty-eight, single, early civil rights associations, extensive left-wing activities, Appalachia (REF: DR-1023-s). There are thirteen people involved, and Dan is the one who decides he really should do this. There is yet one more candidate for the part of Judas—all depending on your point of view. There is Max Laing—twenty-seven, single, hospital orderly, no known political affiliations. Max is the fink who stool-pigeons to the authorities, although I won't tell if it is before or after; and that's the sad part of the movie—it doesn't really matter and no one really seems to care. The whole movie is played through a fog, a physically visual fog, because of less-than-top-quality lighting, but much more annoyingly, through a fog of incomprehensibility (and I don't mean the soundtrack). None of these people ever existed or ever will. They are just not human; their reactions belie them time after time. They even have their own system of breathing which requires pause-for-effect sighs, far from refreshing.

I give credit to the filmmakers for trying to deal with this problem and even some of the complexity of possible consequences. In the words of Richard Kern, "Nowadays it's called action if you merely say what you believe." That is not enough. The attempt was made but it failed, and there you are, trying to find a reason to award a laurel and not even finding enough reason for a pine cone.

Many of the scenes might have worked if only there had been less sloppy thinking; if anything is fuzzy and not in the center of the matter, it is the thought directing the whole movie. Showing a hospital orderly coldly applying electroshock therapy to a mental patient does not by itself symbolize the sadistic strain of America; especially not when that same hospital orderly is the rat-fink of the picture. After all, this is America, and no matter who he is revealing as an assassin, he still is a fink. Somewhere there is an objective correlative for *The Edge*, but it has not yet made its way to film.

Mr. Kramer, however, has been doing work of a different and better quality with The Newsreel. This group of filmmakers all have some political background as well as cinematic training. They have been making those shorts—documentaries averaging seven to seventeen minutes in length, covering the Jeannette Rankin Brigade's march on Washington, an interview with those four sailors who deserted, and other such topical "newsreel"-worthy features. Current, finished products can be seen around locally, in New York, and will soon be shown all over as more theater distributors get smart. The Newsreel fills a definite void, not the one left by the old-style, same-name, black-and-white shorts, but a void left by the mass blackout in all mass-media coverage, even prior to the announcement of the credibility gap.

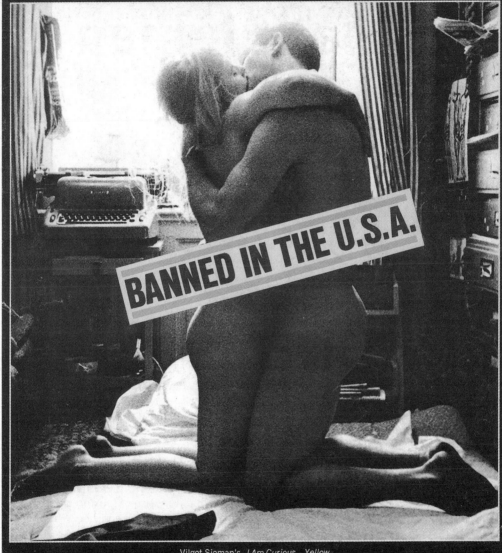

evergreen

EVERGREEN REVIEW NO. 56 JULY 1968 / ONE DOLLAR

BANNED IN THE U.S.A.

Vilgot Sjoman's *I Am Curious—Yellow*

Cover of *Evergreen Review* No. 56, July 1968

No. 56, July 1968

Sex and Politics: An Interview with Vilgot Sjöman

John Lahr

Question: I Am Curious *seemed to be a cinematic* Tristram Shandy, *in the sense that it used the conventions of the film against itself; the attitudes toward sex, position of camera, putting the director in the film itself, etc. What were the ideas (social, sexual, cinematic) that you were working against?*

Answer: I had made four films, the last being *My Sister, My Love*, which, I felt, had led me into a dead-end. With *My Sister, My Love* I was trying to do a well-made play, translated into cinematic terms.

Q: *You mean with a logical coherence?*

A: Yes. Sort of beautiful lines and structure, in the period style that Bergman had invented for Swedish film. How do you deal with modern problems in costume? You have the *Seventh Seal* and others like it. So *My Sister, My Love* was really an exercise in his school. Although I think that the film had some feeling and emotions which were personal and not Bergman's, it was that school and that tradition I had to break out of. With its completion I felt freed, but I thought, "My God, what am

I going to do now?" And I answered: "Try all kinds of things." You're not going to do a well-made movie; the most important thing is that it somehow stay alive. It could be awkward or a failure, but I had to try. These two versions of *I Am Curious* were experiment. I tried to get away from the old techniques.

Q: *What were some of these new techniques you discovered with* I Am Curious?

A: One which was new to me was the interview. I approached a minister of trade. While filming him I put in a fictive situation, with me (as the interviewer) looking at Lena. This gave it another dimension. For me the important word was "play"—play with reality, don't just depict it. I discovered another new technique with Lena in a discussion with the Russian poet Yevtushenko. I interviewed him to get shots but found the interview was no good. It didn't really boil down to the important things. So what I did was shoot three separate sequences: one of Lena, one of Yevtushenko, and one of the interpreter. In the film I combine these three—Yevtushenko's was the actual interview; the sequences with

Lena and the interpreter were staged. But somehow you discover that you can work with the camera and edit and cut in a funny sort of way. I hadn't realized that before.

Q: *This idea may be new to Swedish films, but doesn't Fellini bring himself and the crew into his films?*

A: Yes, and the funny thing is that Bergman has a hint of it in *Persona*. He made that film in 1966 and I made *I Am Curious* in 1966. We didn't know what the other was doing since we were not in contact at that time. Of course, you can see from the film that I've seen many Godard films; also you can see that I am very fond of *8½*. I wanted to do my version of it. *8½* is a self-portrait, but Fellini didn't really *portray* the director himself. Mastroianni's is a very bad part. He's a sort of empty space; he has no action. There's a lot of reflection of what is going on around him all the time which is beautifully done. But Mastroianni is looking at people all the time. He's rarely involved. Now, what could I do that Fellini had not done before? Oh, I could play the part myself. But I wanted to avoid casting myself in the role of commentator on the action (the kind of thing you get so often); I should be involved in it. That's how the love triangle with the other two actors evolved.

Q: *It is interesting from a critical point of view that while it is an old film axiom that the audience sits where the camera sits, this is the first time that the director's response is brought to the front of the camera and is not simply behind it. It thus becomes an entity unto itself. The reality off the screen is moved onto it. From your diary, I take it that you did not start the film with the idea that you would be in it.*

A: No, this came out of the cinéma vérité situation. I found that it's not very easy when you go out with a camera, trying to catch what's going on, to keep the illusion of an ordinary story. The crew, the cameramen, and the people around the set are very easily involved in the film situation. We got into complications when we actually had to deal with reality, instead of merely constructing it in a studio.

Q: *You're dealing with chance?*

A: Yes. For example, Martin Luther King was in Stockholm when I was about to begin the picture, and I thought: "My God, I'm going to have a nonviolent theme in this film. I'll interview him." But how to do it? Lena? No. She can't speak English that well and she's not an experienced interviewer. Besides, she was at drama school and couldn't get away. So I had to do it myself, and then see how it could be used afterward. So I thought I should be in the story some way. And then Lena came up with the idea that there should be a relationship between us. *She* brought that up. I was shocked and then I got adjusted to the idea and pursued it further than she had expected.

Q: *You predicted in your diary that some people are going to think this film is outrageously sexy. The Customs Office of the United States has obviously felt that way. Yet your instincts were puritanical and the improvisations brought out artistic ideas that you would not have considered initially ...*

A: That's true. I had a feeling of awkwardness about the love scenes I had made in previous films. I felt that if I was ever going to do a sex scene that had some value I had better get in touch with some people who are interested in doing this. So there wouldn't be the usual emotional, psychological hurdles.

Q: *What in particular made you dissatisfied with the way sex was presented on the screen?*

A: Firstly, you have the general pattern of American/French/Italian films and how they deal with sex. In an American film you have a kiss and a fade-out in the neighborhood of a bed. What the Swedish tradition has done is to extend that idea. You have them in bed, you have them covered with sheets so you can't see the genitals or the breasts. And then you devise camera angles to avoid exposing any of these things. I felt that I was very inhibited while doing traditional sex scenes, full of clichés. Of course you can handle the clichés well. Some people do. I think Bergman has done it excellently in *The Silence*. He doesn't show very much in his pictures; he's really handling it in the same way Fellini does in *La Dolce Vita*. In the orgy ending of that film nothing is really shown, yet you

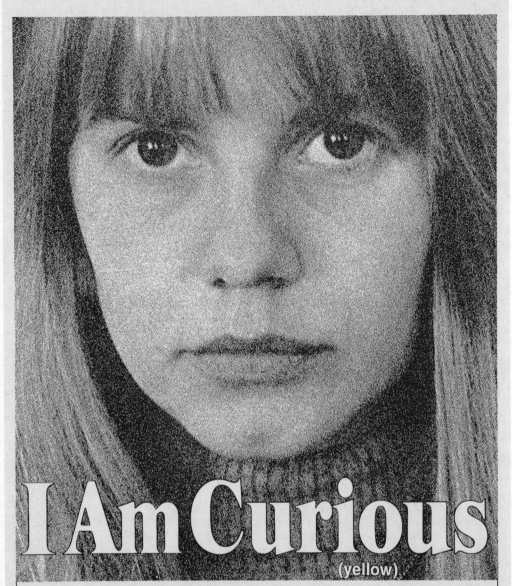

I Am Curious
(yellow).

Vilgot Sjöman's complete and uncut *I Am Curious (Yellow)* is "a landmark likely to permanently shatter many of our last remaining movie conventions," says William Wolf of Cue Magazine. The Evergreen Film presented by Grove Press stars Lena Nyman and is a Sandrews Production. ADMISSION IS RESTRICTED TO ADULTS.

Poster for the 1969 American release of *I Am Curious (Yellow)*

get a tremendous feeling of flesh. I thought, "If I'm going to do any kind of love scene it cannot be one of these stock situations. You have to break through these clichés if you are to do anything of value."

Q: *How did the actors respond to this themselves? Lena mentions in her diary certain recriminations about having to do these things, and yet what is amazing in the film is how spontaneous and attractive they make the sex scenes. Evidently, the refusal of previous films to confront sex implied an ugliness.*

A: A lot of people would say that it is not attractive. You can see that you can affect the audience in different ways with the same images. I was scared in my first four films, but with *I Am Curious* I knew what situations I wanted for the actors, but I didn't know what kind of love scenes we were going to invent. When I picked the actors, I didn't realize that they were thinking along the same lines. Since I didn't present a complete script but worked the whole thing out day by day in discussion, there were few problems, compared to what one might expect. They both had a sense of comedy in them which made it easier. If you were completely serious about sex, you'd have complete tension.

Q: *In the first sex scene in Lena's room, what is interesting is that you have them groping around the room with their pants down around their ankles. This adds another dimension to sex. Did they get this by improvising?*

A: When we talked about how to do that scene, I suggested we go to the room we were going to use. I asked Börje, "If you were going to approach this girl, how would you do it?" Well, they tried various things—against the wall, for example. It didn't work. What next? I suggested that her room was so cluttered she has no place to go to bed with her lover and that they have to make love on a mattress on the floor. They invented one thing after another. This was really the way to work, to present a problem to the actors and with their help write the scene on the spot and film it the next day.

Q: *The fact that you have a part in your film and are also filming it raises a question which you yourself mention in the diary, the question of voyeurism.*

A: The camera and voyeurism are closely related to each other, but there are very few cinematic instances where the theme of the camera as voyeur has been developed. When I made my first love scene in my first film, I suddenly felt like a voyeur. I hadn't thought of that before. This is part of the director's profession. I told Bergman about this experience and he said, "Yes, you certainly are a voyeur. And you have a big camera which is catching it for you so that you can look at it over and over again."

Voyeurism has to do with the director and the crew, but it has something to do with the audience, too. They are going into a closed room to watch other people. This is the whole tradition of movies. You don't usually think of it in those terms, but, my God, if you are a girl of eleven and you watch the hero and heroine in close-up kissing each other, that's voyeurism. What I've been doing is trying to bring this theme to the surface, open it up for discussion and illustrate it. I discovered that this was one of the main themes of the film while making it. So the title *I Am Curious* came quite naturally; it is another way of saying "I Am a Voyeur."

Q: *That's interesting. I thought the title referred to Lena's voracious inquisitiveness about life?*

A: Lena is voyeuristic about society as well as about sex.

Q: *I am very interested in the relationship you see between the sexual impulse and the social one. Despite Lena's interest in nonviolence, her love-making was fundamentally violent.*

A: In *I Am Curious* I have covered many aspects of sex. It ends with violence, but people tend to forget that it begins with humor and tenderness. Lena and Börje have a nice time the first time they meet and on the balcony of the King's Palace. The violence comes later in the countryside, but this is the thing that people tend to recall when they think of the film.

Q: *You speak of Lena and Börje having a "nice time" in their first meeting. Yet the actual physical involvement between man and woman is violent—the clutching, the movement of the body, etc. It is not peaceful, it is not passive. It seems to me that one of the ironies of Lena's involvement is that she wants to explore sex, which she sees as something potentially peaceful, but which turns out to be violent. She wants the world to be peaceful, but it isn't. And she can't understand it.*

A: Your main point is correct, but I don't agree that their embracing in the first scene is violent. They are eager, but there is no violence in it. I would like to add about that first scene (and this goes for most of the scenes) that I have tried to avoid portraying intercourse with a climax, which is what they usually try to do in Swedish movies. They attempt to depict how it feels to have actual intercourse and orgasm. What I did was to pick situations which focus on what is more interesting— the preparation or what comes after. In the case of the floor sequence in Lena's room, you never actually see them doing anything. They are preparing to make love and the fun comes from an idea which is left out of all other films, namely, how they get their clothes off. In other films, you have a fade-out or the couple are suddenly in bed without any explanation. I thought that the trouble with clothes—with getting them off—is part of the human experience.

Now to the question of violence and nonviolence. I was trying to introduce a Utopian idea about nonviolence: Sweden changing its military defense into one of nonviolence. I also planned that Lena should be a follower of Martin Luther King and the Movement. Then I started to embellish that theme, and suddenly discovered that the girl was surrounded with symbols of aggression. She had knives in her closet, and a rifle. This is really a strange adherent of nonviolence! Earlier I would have said that such objects were illogical, irrational in terms of Lena's character. But I said, "No, there may be something to it." She has a rifle and wants to use it, so let her use it.

In one sequence in the countryside, she takes a rifle from an altar where she has a picture of Martin Luther King (the symbol of nonviolence in Sweden is a broken rifle).

She gets it, loads it, and fires it at Börje because she's angry and disappointed with him. While making the film, I found that this too was one of the important themes, that violence and nonviolence are interrelated. The main situation in *I Am Curious* is that Lena discovers that she has so much hatred in herself that she cannot adhere to nonviolence, to the teachings of Martin Luther King. This is a moment of self-recognition. She can't stand what she learns about herself. She cannot work anymore. The next step, of course, would be to say, "I have to do something about this, and stick to my ideas." But she is a child and becomes so bewildered and horrified at the contradictions she finds in herself that she starts crying and consoles herself by stuffing herself on pastries. Suddenly there is a voice over the TV announcing that Sweden has done just the thing that Lena has been working for, that is, changed to a nonviolent defense. The idea is often greater than the person involved. She fails, but the idea lives on.

What I'm doing in the film is depicting the contradictions of nonviolence. On the one hand you want both yourself and your society to be nonviolent, and on the other, it opens up the question of what should be done about the whole world. There are two themes in the film. One is about class society: people high up using people from the lower echelons of society. Then you have the nonviolent theme. What's happening around the world? These two themes clash and collide. You have to use force and violence if you want to break down privileged societies, class societies. So the idea of creating a classless society without violence clashes fiercely with the idea of an open society, where people can move around freely.

Q: *In the film, occasionally words like SABOTAGE, FRATERNIZATION, and NONCOOPERATION are flashed on the screen. You say in your diary that these are nonviolent terms. But sabotage is hardly nonviolent.*

A: If you build a nonviolent defense, the main object is not to have people killed. Then you use all kinds of methods. There is great disagreement among nonviolent supporters as to what methods to use. Without trying to be destructive and aggressive, you use another

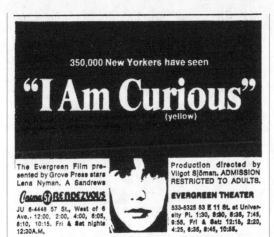

Advertisement for *I Am Curious (Yellow)* that ran in the December 5, 1969 edition of the *New York Times*

kind of "violence." Sabotage in the film is factory sabotage which is not violent in the sense that it is not intended to kill people.

Q: *Was it effective?*

A: I wanted people to hear the terms. You have a big audience, and if one out of twenty-five people gets interested in the idea, then it is effective.

Q: *In your diary, you describe your conflict about whether or not to bring propaganda into the film. Why were you undecided about this?*

A: The discussion in Sweden has shown that a lot of people are very bewildered by the film; they don't feel the left-wing thrust in it. I'm surprised about that. They feel there is a lot of ambivalence in the way I presented almost all the themes. In doing propaganda, ambiguity is not an asset. Propaganda should be very clear, straightforward, and say just one thing. I disagree with that. I think the idea of making propaganda in a straightforward manner is banal. I think you can present propaganda with all life's ambiguities. If I had said, "Look, now we are going to introduce nonviolence into Sweden, and this is how it's going to be done," that would have been artless. I think people will remember more my way. I don't believe in presenting an idea without its contrary arguments.

Q: *How did the Swedish audience respond to sex in* I Am Curious? *Were they shocked, upset, or confused?*

A: You get all kinds of reactions. There are the people who say, "My God, this was a relief. Finally a bit of reality. This was good and healthy." Then you have the other element, saying, "This was the dirtiest thing I've ever seen. That man is destructive." Then they write anonymous letters threatening to kill me or have Lena and me burned.

Q: *What about the image of a much more liberal Swedish audience?*

A: The discussion of sex is more open in our country than in America. It's easier to be more open in a little country of seven million people which is very homogeneous compared to your country. I really wanted to portray Sweden in the late sixties in my film. I wanted to puzzle a foreign audience with it, saying, at once, that it is both very active and open, and still you find a lot of sex difficulties.

Q: *Conservatism?*

A: Yes. Lena's story is filled with these kinds of contradictions. She is fighting hypocrisy but she still has problems. In the beginning of the film, she states clearly that she has

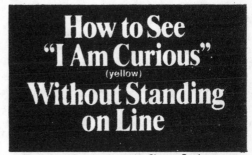

Advertisement for *I Am Curious (Yellow)* that ran in the May 18, 1969 edition of the *New York Times*

had twenty-three lovers. She says it casually, proudly. Near the end of the film, we get an insight into her. She says that she didn't enjoy the first nineteen at all. There you have an interesting piece of reality. To me it was very important that we have both things in the film.

Q: *What you're doing in film parallels much of the approach of various theater groups— the Living Theatre, the Open Theater, etc. They too are moving toward abandoning the script, creating a new relationship of playwright to play, and involving the actor/ director/writer in a dynamic improvisational situation. Invariably in improvisation, autobiography becomes the source of the content, doesn't it?*

A: That's very true. It's quite natural when you work with two actors that you go to their experiences. I'm asking them, "What type of boy is this? What type of profession does he have?" Then Börje starts thinking about this and he suggests a profession which is close to his imagination. He picks things from his own experience the same way a writer does.

Q: *Do you think that this method of working reflects a life-style for the people involved? The trust, the involvement are themselves an extension of a classless, communal idea, aren't they?*

A: This is the beautiful socialist idea that you're devoting yourself to the other person, giving up the struggle for attention. But all the time you find there are clashes between personalities and egos. The problem then arises, if you don't have anyone in control, these clashes will go on endlessly. There is a need for a leader, but then you are back in the authoritarian tradition of older film and theatrical conventions.

Q: *Do you think this irony comes into your film at all?*

A: In the end, I think I tried at least to do a piece of it. You'll recall they have a disinfection treatment for scabies. I portray the director being very content because he has invented a situation which is humiliating for the actors. They are exposed. This is his re-

venge on Börje and Lena for falling in love. As Melina Mercouri was leaving after seeing the film, she looked at me and said: "You fascists! I know you ..." meaning, I suppose, that there is always something of a lust for dictatorship in directors.

Q: *Your film relies heavily on documentary techniques. Even in filming sex, your camera isn't sneaking around trying to shoot at an erotic angle. Sex it portrayed straightforwardly.*

A: That was an important decision for the photographer, and for the actors. Yet if we were going to break away from the old clichés, we had to say: this is what people look like; now put the camera on them and don't use tricks.

Q: *It astounded me that the actors, with you watching them, with the camera watching them, could get excited. That's a difficult thing to do, isn't it?*

A: Yes, this is only possible with a small crew where you know each other well. All the members of the crew were between twenty and thirty, me being the oldest. They felt happy; they made a lot of jokes. We were like boy scouts on an adventure. We felt that there was some big dragon to be slain.

Q: *What are your feelings about American censorship?*

A: To me, personally, the present situation is ironic. In 1956 I was here on a fellowship, and as a writer and novelist interested in movies, I decided to study the relationship between the writer and the movie industry. I was sent to UCLA, and one of my major interests became the Hollywood production code: how it developed, where it came from; how you were able to say in this country that you didn't have censorship when in fact you did. When I returned to Sweden, I set out to write a book on Hollywood. It took me four years to complete—it was almost a dissertation by that time! At the end of that period, I think I understood the strange cooperation in America between money and morals and how that affected films. And why the Hollywood code was wrong for religious, artistic, and

psychological reasons. At that point I wasn't involved in making films myself. As soon as I began, I ran into censorship problems. And here I am again, confronting the same old bugbear.

Q: *Would you say that* I Am Curious *is pornographic?*

A: No. Pornography titillates. It points at one thing, sex, to the exclusion of the rest of the picture. The people are not human beings in pornography. Usually you get to know very little about them. This combination of titillation and isolation belongs to pornography, but not to my film. I was not very concerned (nor were Lena and Börje) when we made the film with whether we were going to excite the audience or not. Our main interest was to add to the knowledge of human behavior in an artistic way.

Q: *The question of nudity in films also raises the questions of the actor's response to a sense of shame, loss of freedom, etc. Did that affect your production?*

A: There were surprisingly few problems while making the film, but there has been a boomerang effect. You present the film and then you begin to get other reactions.

Q: *Society makes you feel ashamed?*

A: It takes a sense of moral security that what you're doing is OK and has its own validity. The pressure comes afterward, not while you're making the film. That is really the most difficult anxiety because you tend to hide from yourself that you are affected by the criticism.

Q: *Have you started planning your next film?*

A: I just have a few ideas.

Q: *Will you be working again with Lena Nyman?*

A: I don't know. For two years we've been working closely together and it was a great experience for both of us. I think now we should develop ourselves on different lines and with others.

Q: *What aspects of Swedish society were you analyzing?*

A: What I feel I'm portraying is a kind of opening up of closed doors in Swedish society. What the film stresses, partly, is sex. But it is a very young and immature kind of sex. They are exploring each other's bodies, curious to see how they work. I imagine that when Lena interviews her boys, she has a secret code for the sex value of the experience. Some of the scenes, like when they make love under water or in the tree, are clearly parody. I'm showing the new freedom of the sixties. As you know, we are now permissive about pornography, to a great extent. I am referring to that, while making fun of the technical excesses. You can certainly feel that in the countryside scenes. I believe you should do away with hypocrisy, but that still leaves room for parody.

Q: *The improvisation in the film merges in a strange way with psychodrama to the extent that you are externalizing private fantasies. The film is the process of learning about yourself. Did you feel that the actors or you learned something new about the world in this experimental situation?*

A: I became aware of a lot of things and certainly Lena did too. It's a very political thing. You become aware of contradictions in yourself. Things which were clear become blurred, things which were vague come into focus. Making a film is really exploring yourself at the same time. But when you get knowledge of yourself, how do you handle it, what do you do with it?

Q: *Make another film?*

A: I'll be very curious to see what I do next. That will tell me something about what the results of the first experience were.

Q: *The film, then, becomes almost a private journal? Not merely a social history, but an emotional one?*

A: Yes, some people complain about that, maintaining it's too personal and difficult for an audience to follow. But I do believe that I've done a portrait of contemporary Sweden. You could say that I have been mixing

up Sweden with myself. This kind of mixing may be a fruitful approach.

Q: *Why the two versions of I Am Curious?*

A: Originally we were just gathering material, filming stories. We ended up with a tremendous amount of footage. I thought I should do one straight story, but that would have been a four-hour film. So I decided to make two films, the second telling the same story all over again—the story of Börje, Lena, and me making a film. But I have different material in each film, portraying different aspects of Swedish society. The Blue film deals with the state, Church, prison camps, and other things. My intention is to meld the two. You have a yellow pattern and a blue one. If you lay one on the other, you get a fuller picture. Yellow and blue are the Swedish colors. I want the two films to be regarded as a whole. I hope people, if they are interested, will see both.

Q: *If I Am Curious is allowed into the United States, will one version be shown or both?*

A: Grove Press has an option on the Blue version, and as soon as there is a chance of getting the Yellow one through, both will appear here.

The Sixth New York Film Festival

No. 61, December 1968

Sidney Bernard

Will the sixth New York Film Festival (Philharmonic Hall, September 17–28) be the last? Two posters at the New Yorker Bookshop underscored this question. One—the official poster—was a kind of Op Art congeries of lines and announcement of dates and place. It went for $5.50. The second—got out by the Up Against the Wall angries—showed a baleful theatrical death's mask, and bore the message: Stop the Lincoln Center Film Festival. The latter reflected the sentiments of a small but determined group of film underground called the Newsreel. Their goal was disruption, and they ran sharply worded polemics in the *East Village Other*, the *New York Free Press*, and the *Village Voice* for weeks before the opening. Basically the charge was that Lincoln Center was a cultural imperialism and that the festival underwrote a kind of elitism of film aesthetics that ignored real life issues such as Vietnam and Mayor Daley's Chicago.

The disruption never came off. It appeared that a split developed in the angries' ranks. Congruent with and perhaps feeding that split was the feeling among others that the elitism charge was not a closed book, and that the festival, in any case, was able to claim films by Godard and Bertolucci and several Czech directors whose content was closer to life than to elitism. Still the disruption threat worked to the extent that it put a pall of uneasy conscience and polemical rumbling over the festival. On the surface, the festival moved along easily, the public part checking out with a record number of fifteen SROs. Close to thirty full-length films were shown. But the pall of uneasiness was never wholly absent.

One example was the phalanx of thirty or forty cops from the 20th Precinct who had been called in opening night in case the Up Against the Wallers opted at the last moment to do their thing. They could have saved itself the overtime. A handful of film revolutionaries did show up and neatly outflanked the cops to the rim of the plaza fountain, where they poured several boxes of detergent that activated the jetting fountain into pretty cascades of bubbles. When the opening night crowd made their exit, by which time the bubble showers had been spent, many stood around and wondered aloud where the action was. The mood among them was in a way capricious—not inappropriate as a coda

to Czech director Jiří Menzel's *Capricious Summer*, which opened the festival. It was as if the festival directors—who for the first time canceled an opening night gala and thus removed what some called a "provocation"—had deprived the audience of that small bonus of confrontation, and maybe even of police overreaction, that a gala might have produced.

Things went smoothly almost to the wire, with a two-a-day succession for press and public of new films and a trio of retrospectives. (Ophüls' 1955 *Lola Montès* took honors among the latter.) The general level of response, in both press and public screenings, was more drift than high-tide excitement. Jean-Luc Godard caused the biggest tide. His 1967 film, *Weekend*, which is an apocalypse of blood and gore, in color, cartoony and mimetic, as devastating a score against bourgeois—in this case, Parisian—life as you are going to find, brought on a clamor of cheers and boos, the cheers having it in a ratio of about five to one. *Weekend* was shown one day before the close, and may well have served as an incubator, or at least as an irritant, for the one flurry of violence that surfaced. The setting for the violence was—how else to put it?—a sneak gala that was quietly and well-nigh surreptitiously planned.

The time was around midnight, Saturday, after the showing of the closing film; the place, Philharmonic Hall's glass-enclosed promenade, to the rear of the orchestra. Private cops and plainclothesmen had stopped up all of the several possible infiltration routes. After the public audience was ushered out, the gala invitees had to go through two checkpoints to get to the promenade. Small red-colored invitations had been issued, and it was a safe bet that no potential stink-bomb thrower could get past the cops short of levitating. The affair itself was pretty austere. There were trays of cocktail wedges, quick refills of New York State champagne, a Latin-American combo for dancing. Plus an aura of in-ness, that aura of rubbing shoulders with directors, stars from the films, and assorted members of the culturati.

Aside from some words about the security, coming from foreign guests mainly, things moved along in a kind of plastic calm. But the mood changed rather suddenly. Two of Andy Warhol's factory people—actor Allen

Midgette and superstar Viva—were dancing away to a *bossa nova* crescendo, and to their own banshee cries. Midgette started to strip off his clothes, and Viva was unloosing her already very loose garment. Soon the crowd moved in around the couple, shedding a layer or two of their own plastic as they watched. Enter three of the cops. They laid rough hands on the couple, and dragged them inside the orchestra's glass enclosure. But Midgette and Viva would have none of it, and they resisted with karate fury all the way, to loud cheers from many of the guests. One young man, a short husky Italian filmmaker, who was dressed in immaculate semi-formal blue, started to beat a tattoo on the glass enclosure. He was yelling over and over, "Abbasso the pigs ..." The incident came and went in a short span, with no arrests, two thrown out, no serious injury, and a sense of outrage. (A passing outrage.) The security circuit had been shorted by an overload of cops.

A Way of Life: An Interview with John Cassavetes

André S. Labarthe

After Shadows *(and an interview that appeared in number 119 of* Cahiers du cinéma*),* Too Late Blues *(and his unfortunate experience in Hollywood), and* A Child Is Waiting, *we did not hear much about John Cassavetes, except that he had embarked on a career as an actor, in Hollywood and in Italy. But Cassavetes had been preparing, producing, and filming* Faces *for three years, in 16mm, entirely on his own. The film was shown at the recent Venice Film Festival: it is one of the most important films to come from the American film world.*

CASSAVETES: Making a film in America about America is an especially difficult thing because the country itself is very complicated. The fact that there are a great many ways to live in America—each very different from the others—must never be lost sight of. The diversity of people and the way that they behave is very great, even if there are a few constants, such as the admiration of physical courage and the taste for competition. Even if he is content to be a spectator of other people's courage, it is very important for the American man to be able to say of his neighbor: "This guy is—or is not—courageous." That is why sports are very important in the life of the American man: when you're in "business," you spend your life behind a desk that is a sort of fortress for you, whereas you must really show your physical courage on the playing field ... Along with this constant, the importance given to physical courage, there is also, of course, for us Americans, the taste for, the need for competition: competition, rivalry are the only cultural values we have. But America is a large country, in which geographical conditions vary a great deal: people don't live the same way in the seaports as they do in the plains or the mountains. And besides the extreme diversity of the geographical conditions, the cultural environment and traditions differ a great deal from one place to another. It's America from one end to the other, but here it will be rather German, there Swedish, Italian, or French. In this country there is no common national base: the differences between the people who live here, even if they get together to form a larger community, are never abolished or forgotten ...

That is why it is difficult to make films

dealing with America. It is difficult to treat America's social problems today, even though they are plain to be seen. In fact, we Americans know nothing about Americans. And seven, or twenty, or a thousand lives would not be enough to read all the books, to go through all the libraries. In America, people are particularly aware of this powerlessness, this lack of knowledge. Lots of Americans know that there are many things in their country that aren't going right, and yet they don't know what or why. The complexity of the Negro problem has gotten beyond even the militant whites and blacks.

Question: *Yet we have the impression that* Faces, *for example, gives a true picture of a certain class of average Americans ...*

Answer: When I make a film—and this is especially true of *Shadows* and my latest film, *Faces*, which we worked on for more than three years—I am more interested in the people who work with me than I am in the film itself, than I am in filmmaking. For me, making a film is something that involves all those who participate in it. I never think of myself as a director (in fact, I think I'm one of the worst directors): I don't count, I don't do anything. I am responsible for the film only insofar as all those participating in the film want to express themselves in it, and feel that their participation in the film is essential to themselves first of all. In all honesty, *Faces* would never have been finished if everyone had gotten interested in the directing problems rather than in the human problems. Films are not very important to me. People are more important.

The people I work with and I are searching for a sort of personal truth, the revelation of what we really are, with no pretenses. We have to put up a fight each day to remain healthy, to stop criticizing ourselves. That is why, when we work on a story—even an outright melodrama, even the simplest and most banal story—we don't understand it as long as it doesn't have a lived meaning for us: it's no good unless and until we are personally committed to the story. It is necessary to commit yourself to the people that you film, the characters you've chosen. When I began to work on a film—*Shadows*—in 1958, I didn't have the least idea that this was

so. All I knew was that lots of people made films and that it didn't seem too difficult. So probably there was some way to make films that people would be happy to work on, that would let actors express everything that was important to them. *Shadows* is a frightening film because it goes further than many other films. It is a film about young people, and you can say more things about them than you can about older people, since young people themselves want to express themselves absolutely, and continually run the risk of losing themselves, even of being killed. Young people like or dislike things and persons with no two ways about it; they always talk in terms of absolutes. On the other hand, it isn't easy to talk about middle-aged people, who change from one minute to the other according to their mood, their state of health, their memories, what happened to them ten years ago, or what will happen to them in ten years more, when they're dying ...

Q: *How did you get the idea of filming* Shadows?

A: At the time, I had a studio that lots of people used to come to. I had set this studio up because I had lots of friends who worked as actors. But after I had rented the studio for a year, none of these friends came to work there, because my idea was that people in the profession would help out with the work, that producers would come and take a look, in short, that it wouldn't be like the usual sort of school for actors ... Then one day I put an ad in the *New York Times*, saying that anybody who wanted to work as an actor could come to this studio. The next day the studio was full of amateurs, people off the streets, pickpockets, lawyers, bankers, policemen, students who had come there to work ...

Q: *It's been said that you raised the money you needed to film* Shadows *from these people.*

A: Yes, in a sense: we had a radio program during which we talked about movies, about films that should be made ... One day somebody said: "It'd be marvelous if we could make such and such a film and have people come to see it ..." Jean Shepherd announced this during his daily 1 A.M. show,

"Jean Shepherd's Night People's Story." I said: "OK, let's make a film like that." Jean asked his listeners to each send a dollar. And that same day $2,000 in one-dollar bills came to our studio in the mail. We began the film then, improvising completely: nothing ever less resembled a film—as you think of one ordinarily—than what we were doing. We simply filmed a series of scenes taking place in a Negro family in New York. And the actors we used during the four months of filming were wonderful. We began shooting without having the slightest idea of what had to be done or what the film would be like. We had no idea at all. We didn't know a thing about technique: all we did was begin shooting. And once we'd begun, we would never have been able to finish if all the people who participated in the film hadn't discovered one absolutely fundamental thing: that being an artist is nothing other than the desire, the insane wish to express yourself completely, absolutely. The only talent that I might have is to get you to express yourself the way *you* want to, not the way I want you to! When I'm working on a film, I forbid myself to have any opinions, and what's more, I really don't have any. I just wanted to record what people said, film what they did, intervening as little as possible, or, in any case, trying never to film inside them, so to speak.

Technique, direction are only a sort of prostitution that doesn't interest me in the least. Making a film, that is to say, telling the story of a man, of a woman, of two or more people, in less than two hours or in at least two hours, is a terrifying business that deserves far more than the mechanical cleverness of a prostitute. Not that certain elements of technique don't enter into the picture, especially when it's a question of condensing. But people prefer that you condense; they find it quite natural for life to be condensed in films. And then you discover that people prefer that because they've already caught on to what you wanted to say and are ahead of you. So that there's a sort of competition between them and you, and you try to shake them up rather than please them: you show them that you know what they're going to say, so as to be more honest than they can imagine ... All that takes time, you can't do this in a day. It can take a year, two years. It took me two years to write *Faces*.

That's why *Too Late Blues* is an incomplete film. It was shot in six weeks, and the script was written in one weekend. The studio people liked and accepted the first thing I did. I intended to change quite a few things, to add things, but I had no experience at all in the tactics to follow in Hollywood studios. That's why the film lost out. Later, I realized that I had to fight the studio system, which I did, and I haven't lost out in the films I've made since then. *Faces* is a film that I liked making, because I like to see things being done. It's a film that is in a sense unique: I know that no one else but me could have made it, because I committed myself so deeply to it, because it's such a part of my life ...

Q: *There are many relationships between* Shadows *and* Faces: *part of the film crew is the same for the two films ...*

A: We were all a little bit older, a little bit more mature ... but sometimes it's good to go back to where you started. At the beginning of *Faces*, as with *Shadows*, we didn't have very much to say. But after three years, we had lots of things to say ... My wife Gena, who was in the film, was pregnant while we were shooting—which made things more difficult. One of the other actresses was pregnant, too. Between the end of the shooting and the day we began cutting, Lynn Carlin had two children. Lots of things happened during this film ...

At the beginning I had written a first draft that was two hundred and fifty pages long, and that wasn't even half the film ... Then we decided to film everything, even if the film lasted ten hours. We were happy to be shooting this film; we shot for six full months. So *Faces* became more than a film: it became a way of life, a film against the authorities and the powers that prevent people from expressing themselves the way they want to, something that can't be done in America, that can't be done without money. We had only ten thousand dollars when we started, and the film cost almost two hundred thousand. To get the money, I played parts in five films during these three years: I became an actor in order to finance the films that I wanted to make. Many people made sacrifices for this film: one man, for example,

didn't see his wife for a year and a half ... But now we can do as we please: offer it to a university, destroy it ... The idea is that the three hundred persons who participated in some way or other in *Faces* made the film, made something exist out of nothing, thanks to their determination, without equipment, without technical knowledge—there was just one technician. We made millions of mistakes, but it was exciting.

Q: *What is your relationship to underground film?*

A: To tell the truth, I don't know what underground films are. In its time and in its own way, *Shadows* was a sort of underground film, a sort of "new wave" film ... In fact, all these filmmakers are people who are just trying to express themselves; the labels come afterward. If your films have no chance of being shown everywhere, if you don't have enough money, you show them in basements; then they're underground films.

I believe this: there are only individuals. It doesn't really matter what you call them. Two films of two different individuals will never resemble each other. Each man's mind is unique. When you make a film you aren't part of a movement. You want to make a film, *this* film, a personal and individual one, and you do, with the help of your friends.

Lola in LA: An Interview with Jacques Demy

Michel Delahaye

The fact that Jacques Demy was shooting a film in Hollywood was the main reason for our trip to America.

The film is called Model Shop, and it continues the story of Lola, as previously recounted in Demy's Lola.

Jacques Demy calls his film "a kind of loveless love story." Demy in Hollywood? That won't change much, certain people will say (thinking perhaps of The Umbrellas of Cherbourg and The Young Ladies of Rochefort, and recalling that he was already making American-type movies while still in France). Doubtless, they'll anticipate a sort of grandiose return to nostalgic things.

But this is really not true. First of all, Demy's films have never pretended to imitate an American model. These films (which, moreover, had a long French tradition behind them) were in fact so French, that we had seldom heard our language spoken with such veracity in a movie.

If Model Shop is profoundly American (but in a different sort of way), it is because Demy, in his quest for Lola, happened to find along the way an America that soon became the essential object of his quest. Thus he opened his film to all the winds and currents of America today, especially to everything that is unique about the state of California, whose largest city, Los Angeles, is a place most people do not know well, or know only superficially.

Los Angeles is a city that Demy has visited, loved, and understood, especially its people—and it was his wish to remain as close as possible to people that implied a way of shooting far removed, both in technique and spirit, from the ponderous machinery of the studios. In this sense also, the film is non-Hollywood, even though American, and doubtless American because it is non-Hollywood, for it is a truism that what is being done in Hollywood today has almost ceased being American and ceased to be cinema—but that is another story.

Here, then, is a film that should be doubly precious to us, both because it allows us to rediscover ourselves and our cinema, and because it permits us to rediscover America through Demy's kind, penetrating, and original way of looking at it—to have a fresh look at this country which too many positive or negative (but also passionate, if not downright neurotic) clichés too often prevent us from seeing very well.
—Michel Delahaye

Question: *What are the circumstances that allowed you to make a film in the United States?*

Answer: It was largely because of Columbia Pictures' executive Jerry Ayres. I met him when I came here to receive the Academy Award for *The Umbrellas of Cherbourg*. He called me the next day to ask me to come and see him at Columbia. I expected the meeting to be somewhat cold and formal, but he simply wanted to talk to me about the film, to ask me what had made a film such as that possible. We have been good friends ever since, and we have continued to write each other.

Then I came back here last year for the San Francisco festival, and I saw him again. I spoke to him of a vague plan I had in mind, and told him that I was very much tempted to make the film I was planning in Los Angeles. He said: "Wonderful! Let's make a deal with Columbia." And in a week it was all arranged. The surprising thing is that Columbia signed a contract with me without my even having a scenario, which is extremely rare. They thus signed me up as scenarist, producer, and director. I accepted this contract as director-producer so as to have more freedom, for it allows me to have direct contact with the studio without having to go through a producer, which does away with any kind of intermediary and gives me all the freedom I want at every stage of the production.

So all this happened very fast, without any major problems, and with only a few conditions attached. That is to say, for example, that in return for the complete freedom I was given, I guaranteed that I would make an inexpensive film on a very small budget. It's what is called a "below the line" film here. It's a $500,000 film, not including actors' salaries, which would correspond in France (taking into consideration the standard of living here, which gives people about two and a half times as high a salary as in France) to a film of 120 million francs—including color, naturally. We agreed on this, and there have been no difficulties.

And, naturally, among the things I got and insisted on getting was the right to the "final cut," which is very rare here, for they lag a little bit behind us in this respect. If I had merely been the director, I don't know whether I would have been given this right, but as producer-director I could have it.

Q: *In view of this, and since there is so often trouble getting this famous final cut, why aren't there more directors who become producers?*

A: Because it's also a responsibility. Because the whole thing falls on your shoulders if you're a producer. You have to do the whole thing right, from beginning to end, including the financing. You have to give full guarantees regarding the work schedule, and so forth.

In my case, I had begun by asking Columbia for all the freedom I wanted, and it was they who offered me this contract as scenarist-producer-director, so as to make sure I would have it.

Q: *There is also the fact that they accepted the film without a scenario. One can't help wondering in this case, too, why that isn't done more often.*

A: I think it's because in my case two factors entered in. First, the success of *Umbrellas*, which gave them a certain confidence in me, and then the fact that I was letting them in on a very inexpensive production. The whole film can be wrapped up for about a million dollars, including publicity. This is very cheap for Hollywood, for today the most modest film, the smallest little thing shot on a set, costs around two million dollars.

Q: *What is curious is that generally they aren't all that interested in films with small budgets.*

A: There, too, what entered in was a certain snobbery, their feeling that they were doing the right thing.

For they have come to realize in America that European films have a certain audience, and even a real future at the box office. This was at a time when quite a few Hollywood films were flopping. For example, *Belle de Jour* is doing extremely well right now. Last year it was *Blow Up*, and there was also the Czech film, *Closely Watched Trains*, which was a huge success. I could give you ten other examples like it.

Q: *As for the cost of shooting, there has been another problem, I think—the fact that a budget such as the one you set up has been almost doubled because of conditions that have to do with technical matters, unions, and other restrictions under which shooting is now being done here.*

A: Yes, it's a film that should have been much cheaper, but they haven't reached that stage in Hollywood yet. Because the unions are so powerful that they require a minimum film crew of forty here, for one example. There are a bunch of other absurdities that I rebelled against. For example, you have a makeup man who's there to make up faces (and can go down as far as the neck), but if you must make up a shoulder, you have to call in another makeup man who is called the "body makeup man," whose work begins at the neck.

In my film there's a scene in which Anouk Aimée doesn't have any clothes on. They told me: "In that case you'll have a body makeup man." I said: "No, nothing doing, her body will stay the way it is, because body makeup is always terrible, so in a word, I don't want any body makeup man." That caused all sorts of trouble, but they ended up not forcing a body makeup man on me when I didn't need to make bodies up. But if I had needed one, I would have had to put up with one.

I could cite a dozen examples of this sort, in which the union intervenes to force people on you that you could get along without. I can understand that, in part: Their point of view is that a maximum number of people ought to have work, but I can't defend this point of view when it works against the freedom of cinema, a kind of free cinema, that is, I and quite a few others want to create.

It's all part of the system. The point of view of the studios and the unions is this: You have to give work to as many people as possible, which increases the budget, but the American market is so enormous that you can permit yourself to have an enormous budget—so it's a vicious circle.

Let's take a large company that employs two thousand persons on its permanent staff. To amortize this, the general overhead, and all the rest of it, they have to go in for huge productions. The company has to make a ten-million-dollar film every year (so as to bring money in every year), and so big stars are necessary (for the star system still exists, and nothing can be done about it—it is still king). Well, big stars mean big budgets. And that's another vicious circle. But there is this enormous market that guarantees them distribution, a market that must be fed, that feeds them, and permits them to feed their people all year round. Things go round and round that way. Except that in the midst of all this, they're beginning to produce a few small-budget films.

In fact, the future in Hollywood, when all is said and done, is the Underground cinema. It's all those people who are shooting 16mm film. There are more and more of them now, and they're completely free, like Andy Warhol.

Q: *But faced with the failures of the system, and faced with the Underground cinema, haven't the people in the studios had to think of reforming at least some of their methods?*

A: Of course, the studios, the producers, have all been upset about the situation. They've all said to themselves that films cost too much, that there has been too much time wasted, too much money, too much energy, that the unions' demands were too tough, and so on. And they found the solution by saying to themselves: Well, we'll go make our films in Europe—in Italy, in Spain—or in England, because you can employ fewer people there, you can pay them less, and so on. But the result is that this makes for a bastard cinema that is neither European nor American, and one which aggravates the problems of European and American film industries in the bargain.

Q: *This bastard cinema is created right in Hollywood too, insofar as the young film-makers who have come here the last few years seem to be trying to make a vaguely "European" sort of film that is only a parody of what they've swiped from Europe, and at the same time a parody of everything good that Hollywood ever made in the past.*

A: Yes, for since they come from another generation, they have or have had a desire at a certain moment to do something else. But in the end they gave in and obeyed the

laws of the old system. They've never tried to rebel against it, nor even to improve it, and I don't really think they want to. In the case, for example, of Stuart Rosenberg, Norman Jewison, Curtis Harrington, and other young guys who made their first film two years or so ago, none of them really wants to change the system. I think that that's what the real trouble is—they've accepted everything, the laws of the studio and its conditions. It's only the free-lancers, the independents, who do anything interesting, those working in 16mm always. It's a bastion, and practically impregnable. And as long as the young people of this so-called "New Wave" in Hollywood don't have the courage to say, No, this can't be, we want to make personal films, with a certain point of view, with a certain perspective; as long as they don't go that far, nothing will ever change.

Q: *Aside from that, the concept of a personal film must in any case—for good reasons or bad—be rather foreign to people in Hollywood.*

A: It absolutely doesn't exist. Just as the notion of style totally escapes them. Style, or cinematic language (which is dear to Bresson, Resnais, Godard, and has always interested me, too) are notions that are completely foreign to them. But I am speaking here of people in the studios, for you obviously find others who for their part have thought about this. I know that people like George Cukor or John Ford are perfectly aware of the way that they handle film.

Q: *What is the real reason for the studios' insistence on reserving the right to do the cutting themselves, when there are so many directors who demand this right?*

A: Remember that Hollywood is an industry, that the studios are organized like factories, and that the product that comes out of them is a manufactured one. Therefore the task of judging the quality of a product cannot be left to one single person. Whether it's the length of a scene or a shot—and with all the more reason—when it's a question of editing, it would not be reasonable to leave it up to one individual to decide. It must be left in the hands of a number of people.

In any case, I was lucky enough to have a certain reputation here, thanks to *Umbrellas*, but if I hadn't had that, I would never have obtained the right to the final cut.

Q: *How does it happen that certain companies are less set in their ways than others?*

A: Because they are often headed by the sons of the old bosses, or by people who are younger. At United Artists, there's David Picker, who took over from his uncle, if I'm not mistaken, and is thirty-seven years old. He knows the problems and tries to face up to them. At Columbia there's Jerry Ayres, who is very young, and there's also Stanley Schneider, who's around forty. At Paramount, there's Bob Evans. And it seems to me that at Fox, Zanuck's son has taken over the management of the studios. This is a very recent phenomenon, for these people have been placed in their present positions in the last two years.

Q: *How does the film crew function during shooting, both as individuals and as professionals? Are they more precise or faster than in France, for instance?*

A: They're all very, very professional. This has already been said, but I'll say it again because it's true, and it's very important. The actors and actresses, for example, are always on location at the exact time they should be, and know their lines perfectly. And they generally know how to do everything you ask them to do. It's really a very great satisfaction to work with American actors. It was all the more pleasant for me because I also had to work with Anouk, who wasn't really professional at all. She would arrive late, and wouldn't know her lines. But that's perhaps part of her charm, even though it costs a great deal. All the others, though, men and women, were absolutely irreproachable.

As for the technicians, it was exactly the same thing. They too were very professional. But with American technicians you mustn't improvise. They have to be told in advance, otherwise they're lost. So you have to tell them at least a week in advance if you need a traveling shot or a flash bulb on the camera. Because if you ask them the last minute, it takes half a day to get it. And that's the other aspect: The system's like a heavy machine

that takes a long time to get moving.

Aside from that, when they have the materiel, everything is perfect. The sound, for instance, is always simply amazing. I've never seen the like in France. They work with a Nagra. And I've had up to six microphones in a room, with two or three boom-men. And different sorts of microphones, according to how you want to cover the lines and the sounds. And the sound is impeccable everywhere. I never had a chance to have two boom-men in France, and I've never seen more than two microphones used. Moreover, you don't even have time to see them installed; everything is done very quickly and very precisely. And everyone is very calm. Nothing like French film crews. And they're friendly, smiling, relaxed. And, finally, even though the machine sometimes seems ponderous, the people are freer, because they each have one specific thing to do and they do it well. There are four of them on sound, for example, where there would be two in France. But the four of them do an eight times better job.

Q: *What pleasant or unpleasant surprises have you had with the technical equipment? As a whole it seems to be a little bit on the outmoded side.*

A: Yes, it's quite disappointing. The camera, for instance, is still a dreadful Mitchell without a reflex viewer, which I detest. The cameramen are clever, but even the cleverest cameraman makes mistakes in parallax correction. You can't frame the image precisely—you can't get a precise shot. And I finally caught on why. In most American films, aside from Welles', there's no movement. You stay where you are, and there's hardly even a panoramic shot. You can also see how American films are set up: field and depth-of-focus, and that's all. So they haven't felt the need for a reflex camera.

Q: *There must be some here, though.*

A: There's one in Hollywood, a Mitchell. They got it this year. I rented it. But since the film was held up, it got rented out somewhere else, and I couldn't have it.

Besides this camera, they have the Arriflex. They don't have the Caméflex because they had lots of trouble with it when it came out ten years ago.

Q: *The cutting tables look like they came out of a museum.*

A: It's scandalous, because they date from the very earliest days in Hollywood. All this materiel was bought by the studios forty years ago—it's old as their rules and regulations—and since it belongs to them, they see no reason to buy something else so long as it continues to function. No reason to buy other cameras, other cutting tables, or other electrical equipment. But there was an exception on this latter point, because I made them buy quartz lights for my film. Nobody in Hollywood used them. In fact, I'm to meet Hitchcock, who's heard of them and would like to know how they work.

I had them buy these lights so as to film a natural set inside a house, because they have only big floodlights. Quartz lights are very small and can be placed in any corner of a ceiling, but they still have large old-fashioned studio floodlights which are ten times bigger for the same candlepower. And there's absolutely no way to use them in natural interiors.

In any case, when I had the quartz lights brought in, there was general astonishment. This is curious, for in France they've been used for the last ten years. Anyway, I got the lights thanks to Michel Hugo, the cameraman. He's French, but he wasn't familiar with this technique, for he's been here for the last twelve years (he left the French film world long before the so-called "New Wave"). So he looked around, and finally found a company that made this sort of light—for advertising, as I remember. But since they'd never been used in the studio, we had to talk the purchase over. They didn't understand. They kept saying: "But you have all the equipment you'll be wanting here." I had to demonstrate to them that this equipment couldn't be used in a little house in Venice.

You see, they seldom shoot on natural sets. First of all, they don't know how to, and second, they don't see why they should, since they have a studio that belongs to them that doesn't cost them anything and has to be used, just as all the people they employ have to be put to work. Moreover, it's much more comfortable in the studio.

Q: *But, on the other hand, there seems to be a whole collection of cranes.*

A: Yes, they have everything that's needed. Little ones, middle-sized ones, big ones. I was thunderstruck when they showed me the Chapmans: twenty enormous, brand-new cranes. Unfortunately, I couldn't use them on the film.

I'll probably have to put up a fight for new cutting tables, for they're really a catastrophe. They're the first moviolas—they're noisy, you can't see anything on them—but they're the ones they've been working with since the earliest days of Hollywood. They may very well call touching memories to mind, but as far as working on them goes, it's dreadful.

There isn't a single modern cutting table in Hollywood. There's no Steenbeck, there are no Italian tables. There's one in San Francisco that John Korty sent to Europe for. He's the only person who has one of them.

Q: *On the other hand, I've noticed that the camera stand is a fine Italian Elemack. Are there many of them here?*

A: Yes, but it's a recent thing. On the other hand, they don't have any stands with a gyroscopic head that allows the level of the camera to be changed during a scene. That simply doesn't exist here. So I had several scenes where the framing is off because I couldn't change the level.

All this, on the technical plane, is really *amateurism*. I can't get over the fact that an industry like the one here, which stakes millions and millions of dollars on its films, still works the way it did back in Charlie Chaplin's day.

I know, of course, that technique alone doesn't determine the quality of a film, and often it is meaningless, but all the same when you want to change the level in a panoramic shot and you can't, and yet you have buildings whichever way you look, you can't conclude that the situation is entirely as it should be.

Q: *Are there other examples of films that have been shot like yours, in natural settings, by other companies?*

A: I don't know. I don't think so. This isn't done in the big companies.

When I talked of filming in real houses, in the streets with the Arriflex, they were rather taken aback. To them filming with an Arriflex is just playing around. The smallness of it is suspect. This is another prejudice that costs them dearly.

So with a few rare exceptions, they almost never shoot in the city outside the studio. They simply use transparencies. What is filmed in the streets, however, are TV advertising films. So perhaps a new school will be born from the advertising film, thanks to those who will have learned to shoot in real houses and make *cinéma vérité* films.

For advertising films are *cinéma vérité*. They interview the man in the street to find out what he thinks of a product. In the last analysis this is where new things in cinema are coming from. In any case, this might well be the source of new techniques and new styles.

Q: *And television?*

A: Television is very classic, almost conservative. They often simply adopt Hollywood's classic technique for the shooting script. Aside from that, the whole television phenomenon here is something absolutely marvelous—it's exciting, fascinating. Something we could talk about for hours.

Q: *How about your own film? What struck me when I saw* Model Shop *is that it was really the sequel—and in the spirit—of* Lola, *and at the same time it is as American as* Lola *was French. But perhaps you weren't conscious of that when you made the film.*

A: It all happened this way: I left France at a moment when I was a little tired because nothing was happening in Paris or anywhere else. Everything seemed a little dull and dreary to me. Then there were the events of last May, the students' and workers' strikes, and I really regretted not having been there, because even from far away it seemed fantastically interesting. Of course, I can't say how I could have participated in it, but when you're far away and something like that happens back home, you really feel you're missing something. But when I left Paris

things were really dead, and from a purely personal standpoint I felt as if I were turning around in circles, not to speak of the difficulty of making a film. I felt ill, I was suffering horribly because of my own limitations.

By coming here, I encountered things, problems, that seemed interesting and important to me—this whole business of young people, the hippies, the reactions to the war in Vietnam, the Negroes—the whole mixed-up American scene with all its problems. And I was completely fascinated, captivated by this kind of ferment. And the fact that I'd changed worlds, changed languages, opened my mind and gave me a new enthusiasm that I'd partly lost before. It's illusory, perhaps, but I was a little tired of the whole world I'd been in before (including, moreover, the world of *Lola*). I had the feeling that I was marking time.

Coming here, I forgot about some of this, and I tried to make a fresh start. I really made the film in that frame of mind—trying to discover something. That's why I could have called it *Los Angeles '68*.

My own personal world isn't important at all. I made my film a sequel to *Lola* because there was suddenly the possibility of doing so. But above everything else this film is a documentary on what Los Angeles was like in 1968, with the problems of young people, what certain young Americans have to face up to, and so on. All that seemed so interesting to me that I tried to forget myself and be the sort of guy who's just come here with a fresh eye and tries to speak of something that is new to him and appears to him to be fantastically interesting.

This experience really decided things for me: I had the feeling that I had gotten musty in France. You're struck by something when you get off the boat from France—the freedom of expression here in the press, on the radio, on television. You really have to see it to believe it. When you think of all the things you can say about Vietnam, about education, about American politics, it's really amazing to a Frenchman. People talk about contraception as readily as about Vietnam, and in terms that would be unacceptable on French television.

Q: *So it's on television, rather than in films, that America now expresses herself, not to mention, of course, the Underground.*

A: Apparently. Of all the films I've seen here in America, perhaps the most interesting one is that film of Warhol's, *Bike Boy*, which is really remarkable, whatever other opinion you have about Warhol's tastes. This film is really personal, and in America, once you leave the Underground, that's something exceptional.

I think that from the moment Warhol arrived and got shown, something was accomplished. He expresses himself, he's seen, he's heard. Of course, it's on Sunset Boulevard at the 16mm *cinémathèque* in a theater with eighty or a hundred seats. And it's probably the same thing in San Francisco, Chicago, New York. But perhaps there's not even that in Dallas. Of course, this isn't a great deal, but it's enough to make this sort of cinema exist, and the essential thing was for it to exist. What also counts are the universities, with a new audience, a new generation, which show many films and form a sort of parallel circuit. The future of the cinema perhaps lies there.

Aside from that, it is obvious that the people in the Underground form a completely marginal group, but their own line of reasoning is responsible for that: They refuse to be integrated. Their personality makes them stay in their corner and not try to have a real distribution. And I've come around to understanding them: If I were American, that's what I'd do.

How could they envisage establishing another system? Or overthrowing the Hollywood system? There have been certain independents who have gotten together to try to form their own distribution network, but so far they haven't been able to. So now their tactic is to continue as best they can, to be there, to exist.

American cinema was fine when it came to action, to simplicity, and even their reflections on life were always true, human, simple. What happened? They didn't manage to evolve. They simply noticed that Hollywood films were failures more and more often, and that European films, on the other hand, were successes more and more often. So they attributed this success, not to the simplicity or the truth or the freedom of these films (for basically that was the real reason for their

success), but, instead, to a certain intellectualism that, moreover, they had an absolutely flabbergasting notion of.

So they said to themselves—the young generation—the Rosenbergs, the Jewisons, and others, as well as a certain number of producers: We're going to make problem films, too. But everything was false from the very start, and the result was that they fell into intellectualism in the worst sense of the word, for the problems were taken up in an idiotic sort of way, not really dealt with at all, and the result is ridiculous.

Only the free-lancers can revive American cinema: those of the Underground, the independents, the New York outfit, Shirley Clarke, or Juleen Compton, if she continues to make films here—in short, all those who have really understood something and are working to get people to see it. They are the only ones who can create and implement new ideas.

This is the position of the Underground: They don't want to integrate with Hollywood, for they have the impression that if they did, it would be the end of them. Is it because of their egos that they talk so much? In any case, they have both a sort of pride and a great sense of insecurity. And perhaps their fear of being eaten up alive comes from the fact that they feel too weak, afraid that if they confront the system, they won't be strong enough to resist it and will get eaten up by it instead of changing it. I've often spoken with directors. I've often said to them: But why don't you get together to protest, to get things your way, why don't you declare: This is the end of it, we don't want to do this and that, we're going to do what we feel like doing. It's not a question of putting up with the system, it's up to you to make the first move and to do something else. But they say: No, the system is too strong, we wouldn't get anywhere!

I try to explain to them that before 1959 we also had a system that wasn't viable, and that we did our best to replace it with something else and make the films we wanted to make. The result isn't perfect, naturally, but the fact remains that these films exist and that quite a few young people were able to make films after we came along, something that wasn't even conceivable before 1959.

They have a few publications here in which they can express their opinions. I tell them: Why don't you get together and say what you have to say in them, and go on from there to do what you have to do? In any event, you're the cinema of tomorrow, so go to it! But something isn't right. They don't dare. A sort of timidity too, and perhaps at the same time they're afraid of not always remaining as pure as they are now. Perhaps there's also a little too much respect for the dollar in their hatred of it or their fear of it.

In their eyes I'm someone who is getting devoured by the system. They've all told me that—the people in the Underground, directors, reporters: "What! You're making a film in Hollywood! Aren't you afraid of being devoured by the system? You'll see. They'll own you body and soul ..." I said to them: "Of course not, there's no reason, I fail to see why I'd be devoured. In any case, I don't use the system to serve *them*, but to serve *my* ends—namely, the film I want to make. I profit from their organization, their method, their technique, eliminating or ignoring everything I don't like, and I apply all that to my method. But of course the minute the system rears its head, I refuse, I don't need it, it doesn't interest me, I wouldn't know what to do with it, so I have no reason to accept it. If I feel that I can discuss things, I talk, and if I feel that it isn't worth the bother, then I drop the subject and pretend I'm deaf. So I don't see how they'd devour me."

But I've never gotten them to admit that. I think that basically they're not so sure of themselves, and that they're perhaps afraid they'll succumb to the dollars.

It's insane how important dollars are here. If you tell an American that you don't give a damn about money and want to live as you please, he considers you abnormal. That's why the rebellion of the young is of such importance—it's also a rebellion against the dollar.

Translated by Helen R. Lane

No. 67, June 1969

THE DAY RAP BROWN BECAME A PRESS AGENT FOR PARAMOUNT

Amos Vogel

Operating within a context of absolute pow-
erlessness and absolute relevance, radicals
in America today inexorably find themselves
confronted by situations of absurd hilarity
and farcical tragedy. Cast by mass media,
legal suppression, and their own followers
as mythological figures, the leaders at times
tend to levels of bedragglement and absurdi-
ty which, to faithful, clear-eyed sympathizers,
reveal their humanity and touching fallibility.

Thus, we have all had violent and accu-
rate visions of Rap Brown hounded across
state lines on trumped-up charges, harassed
by one authority after another, prevented
from revolutionary functioning by arrests,
excessive bail, subpoenas, limitations on
movement—a lonely, uncompromised fig-
ure, an early victim of a not-so-incipient
police state, worthy of both compassion and,
even more, respect. We have conceived of
him as a romantic, unapproachable figure,
holed up with friends or fellow revolutionists
in cold-water flats and night-lit motels, plan-
ning, with equally beautiful and right-think-
ing blacks, the next moves in a desperate
struggle for power.

And so it was a shattering surprise to

confront him, one recent rainy Saturday
morning, on the bare stage of the decaying
Loew's Sheridan at Seventh and Greenwich
Avenues in the glare of union-controlled
spotlights, as a voluntary and undoubtedly
unpaid press agent for Paramount Pictures.
What, ultimately, does Hollywood have to
fear from television if it can command the
heroic figures of the radical Left?

The situation was a typical double con,
with both Establishment and Left convinced
that they were outmaneuvering each other:
a not-so-private preview and discussion of
Paramount's tribute to the Black Revolution,
Uptight, a vehicle designed for both cultur-
al enlightenment and the black market. The
audience consisted of young black militants,
white liberals, and a third element that was to
provide a fitting climax to this bizarre event.

The film was the first American work in
twenty years by that veteran of ersatz radi-
calism, Jules Dassin, indefatigable fighter
for right causes dressed up as simplistic
sentimentalities, blacklisted for years, po-
litical expatriate, now respectable again.
Forever aspiring to harness his inherent lim-
itations to appropriate social issues, Dassin

has produced in *Uptight* a thundering array of clichés, an utterly banal cartoon of the complexities of black power ideology, a catastrophic tribute to the apparently inevitable corruption of legitimate causes by the exigencies of mass-market production.

The real Hollywood conspiracy is not imposed from above, but oozes from the social situation, finding its very willing victims not only among audiences, but among directors and writers (in this case, the respectable black novelist Julian Mayfield—*The Hit* and *The Long Night*—and Ruby Dee) who present the film industry with what they themselves consider "far-out" subject matter, "relevant" to a social issue, and, therefore, profitable.

One can sense the motivations of the principals: Dassin's unquestionable need to make a social contribution which, because of its timeliness, could also interest Hollywood; the undeniable honesty of the black writers of the film; the probable initial hesitancy of the production company to risk capital on an explosive social issue and its subsequent willingness to go along, convinced by the impeccable qualifications of the artists and by a realization that there indeed exists a market for this kind of left-wing meshugah. "The businessmen who invest money in films," says John Skow in his article on *Uptight* in the *Saturday Evening Post*, "have decided that there are enough angry black people and scared white people to fill a lot of theaters."

One can also speculate on the daring of Paramount's publicity department conceiving the idea of a post-screening symposium starring Rap Brown, then their astonishment when he accepted the assignment (presumably convincing them that everyone, but everyone, can be bought: the squares with money, the idealists by appeals to their ideology).

An updated version of John Ford's *The Informer*, *Uptight* is a fatuous transposition of the Irish liberation struggle to the present-day American black power movement. To establish a spurious authenticity, it opens with particularly offensive intercutting of newsreel shots of Martin Luther King's funeral with the vulgar artifacts of the first scenes of the film proper. Tank, played by Julian Mayfield, a former union militant and now a weak member of a black action group, is unable to carry through an arms robbery for the cause, is ostracized, and betrays his best friend for a $1,000 reward. Driven by remorse, he lets himself be captured and ultimately executed by the black militants who had passed a death sentence on him.

One can see why the portrayal of a black power organization as a group existing proudly outside society (robbing for ideological reasons and meting out extra-legal justice without retribution) would be superficially attractive to black militants. But this advantage is gained at the cost of cheap moralizing and the attempted resuscitation of a dated gangster plot as significant social statement. There is the ever-loyal, all-suffering girlfriend; the "remorse" sequence played out against somber urban landscapes ("It's the city that has done this to me," he moans) and the furnaces of the steel mill, where the informer, long ago, achieved his great victories as a labor leader ("I gave you twenty beautiful years and you don't remember nothin'!"). And there is that great, inevitable sequence where his best friend, on the run from the cops because of Tank's denunciation, might still make his escape. There is just one more thing he must do: Visit His Dying Mom, with predictably dire results. There is Kyle, conservative Negro leader, who wears a tie, has white confederates, and favors nonviolence; we know what side *he* will be on in the final conflict.

But what is most painful is the predictability of the film and one's growing realization that old-fashioned sentimentality and even more old-fashioned cinematic techniques are here applied to an explosive social problem in an essentially exploitative fashion. Has a single film ever shown more heavy breathing to denote tension, more large-scale sweating to denote fright, more heavy-handed symbolism in practically every scene, more melodramatic turning away from whomever one talks to "for emphasis," more elephantine zoom shots to drive home already perfectly obvious points?

The actors are stereotyped puppets; they do not move, they are manipulated in rigid, artificial congruence with a creaky thesis that never comes to life. Reminiscent of the worst aspects of Eisenstein's otherwise brilliant type-casting, their characteristics are telegraphed by appearance and surroundings (the official black stool pigeon for the police

is portrayed as a homosexual); they never develop or reveal, they simply expound. The sentiments expressed may be largely acceptable in a sociological tract; in dramatic or cinematic terms, they die aborning.

The most typical sequence takes place in an amusement arcade, where, during Tank's desperate journey to remorse, he is observed at target practice by a group of disgusting, unbelievable "bad" whites—drunken bourgeois revelers who make fun of him and themselves. Their vulgarities are played out to the accompaniment of a raucous soundtrack, against distorting mirrors—Dassin's heavy-handed comment on the Decline Of Civilization In The West. Richard Schickel, in *Life* magazine, is right when he says: "The fact that two of the Negro actors involved in this fiasco receive screen-writing credits only demonstrates that whites have no monopoly on *corrupt* art."

The discussion that followed the screening was a perfect set-up for a kill. In front of the curtain appeared an implausible Paramount representative, dressed for the occasion in some sort of dilapidated jacket (his version of what hippies or hippie sympathizers look like) to introduce the MC, a black lady whose name no one in the audience seemed to know, but whom he described as "a leading cultural figure." This well-dressed lady immediately and consistently antagonized the audience with her British upper-class accent, no more irrelevant under the circumstances than the rest of the proceedings. She, in turn, was followed by the ever-smiling Ossie Davis, Julian Mayfield, writer and star of the film, Rap Brown, in jaunty white cap, and, finally, a pale, fatigued, and worried-looking Dassin. One wondered why Rap had appeared at the Fillmore East *Guardian* benefit a few weeks earlier with his obligatory on-stage bodyguards, presumably to protect himself from assassination by a sympathetic audience, but participated in the Sheridan discussion without them. Is he unaware that assassinations can be carried out without guns, and even with the consent of the victim?

The floor was thrown open to questions and Rap immediately emerged as the chief spokesman. While this film "certainly did not go as far as it should," it had a "positive meaning" for blacks; we all had to learn that in a revolution certain people would have to be "dealt with"; that those who opposed this did not understand the concept of total revolution; that nonviolence had to be rejected. Unencumbered by his customary dark glasses (to stress that he was among friends?), Rap acted the benevolent, friendly pedagogue, patiently explaining realities to the less understanding souls who criticized both the conception and execution of the film. Mayfield began to intervene; a member of the Newsreel, the radical film cooperative, stated that they had brought a projector and were prepared to screen a documentary of the Black Panther movement "to show where it's really at." Rap repeated that Tank, having failed to carry out revolutionary orders, had to be eliminated, raising visions of recalcitrant followers so quietly done away with that not even the bourgeois press had heard about it. He concluded by calling *Uptight* the equivalent, for blacks, of Pontecorvo's *The Battle of Algiers*, to hoots and applause from the audience. The lady MC asked for more questions, pronouncing the word *ahsk*, which provoked rising laughter from an audience unaccustomed to British gentilities among the rough violences of the black power movement. Ossie Davis remained silent; Dassin intervened once, feebly.

While all this was going on—for not more than ten or fifteen minutes—various representatives of the Newsreel made it unmistakably clear to knowledgeable observers that they were about to out-coup both Rap and Paramount by a truly revolutionary act. This suddenly surfaced with the appearance of a 16mm film image on the Sheridan curtain, accompanied by poor sound: the long threatened projection of the Black Panther film. Apparently their activists had been sitting in the center balcony with a carefully hidden projector plugged into one of the theater's wall outlets. As the discussion proceeded simultaneously with the 16mm sound film, Rap holding forth unaware, and the various protagonists on stage casting worried glances at the curtain behind them, the situation assumed surrealistic proportions. The management turned off the lights, stopping the film as well; chaos followed when the lights went on again, and a Sheridan representative announced that the fire department would not allow 16mm projection (a patent untruth, since 16mm film is nonflammable).

The lady MC pleaded with the audience, and the Newsreel revolutionists clamored for the opening of the curtain. A few moments later, the Establishment obligingly surrendered to this revolutionary onslaught, the curtain opened to applause, and we were treated to conventional interviews with Eldridge Cleaver, Huey Newton, and other Black Panthers. The speakers left in hurried confusion, casting glances at the screen, unable to cope. When the film was over, the Newsreel announced its availability to interested parties and provided a telephone number.

But there were more thrills to come. As the audience left the theater, it was handed a questionnaire, tailored to what someone obviously had determined to be the interests and needs of the young:

The movie Uptight *dealt with a theme of social significance. For aid in selecting future potential movies we would like to get attitudes of important moviegoers such as yourself on a variety of our social customs and mores. For each statement below, indicate whether or not you agree:*

It is permissible to break the law for a worthwhile cause.

Pot is not as harmful as alcohol.

Although war is hell, it is sometimes necessary in order to preserve democracy.

Premarital relations are okay among couples going steady.

After this bang-up beginning, there was a noticeable slump in the subsequent true-false questions, but matters picked up at the end:

Our country is going to hell.

Movies today are good entertainment.

We should get out of Vietnam, period.

Considering the probable responses, we can be sure that Hollywood films will never be the same again.

So what is wrong with Rap being a press agent for Paramount? Was it not Lenin who said we should utilize our opponents and enjoy whatever means are at hand to advance the cause? The answer, of course, rests with the final part of Lenin's statement. Does sentimentality, second-rate agit-prop, simplistic sloganeering advance the cause? Does it perhaps provide a momentary emotional release (for blacks) of justified anger and hate, a deliciously titillating feeling that even *we* (newly powerful) have now been recognized by Hollywood? But does the movement need Hollywood's validation? Can the ideology of nonviolence be disposed of by pontifical, brief exchange between two stock characters, one transparently portrayed—in good old movie style—as good, the other as bad?

To achieve its goals, the black movement in this country will require, as do all revolutionary movements, finesse, subtlety, close attention to evolving realities, the most sophisticated responses to complex, ever-changing tactical needs and strategic considerations. One's concern at Rap's apparent acceptance of this simple-minded film stems not from doubts about his abilities as a film critic, but as a political leader. One somehow doubts that Malcolm X would have lent himself to this particular task.

The black movement also requires and will inevitably create its own works of art. It is in the process of doing so in the theater, but no film has done it justice, neither *Uptight* nor the Newsreel documentary.

It is necessary to recognize that *Uptight* is a thoroughly safe, ultimately innocuous film, but that *The Battle of Algiers*, with its utter, inherent truthfulness, its relentless, unnerving probing of moral questions in the midst of violence, is a truly subversive work. Great art is a shattering, blinding, liberating experience; bad art makes for bad politics. The truths of black freedom cannot be advanced by clichés, half-truths, sentimentality, and banality.

And yet, Rap's acceptance of *Uptight* (already duplicated by black movie audiences) must also be recognized, in sadness and deference, as a symbol of profound desperation and monstrous agony. Since it is we who caused the desperation and agony and permit it to continue, we can only with some embarrassment pontificate at those who, drowning, clutch at straws.

Solanas:
Film as a
Political Essay

Louis Marcorelles

The political film has its patent of nobility in the history of film. In the forefront is Eisenstein (all his silent films), then Leni Riefenstahl (*The Triumph of the Will*, 1935), and Frank Capra (*Prelude to War*, 1942). Dziga Vertov should also be mentioned, and to a lesser degree, King Vidor. The best works produced in this vein owe their particular quality to the cutting, whose principles had been laid down as early as the silent film and were clearly defined by Soviet filmmakers, among them Eisenstein and Vertov. Neither Leni Riefenstahl, with Walter Ruttmann as an intermediary, nor Frank Capra, backed by the analytical genius of William Hornbeck, ever really departed from these principles; at the very most, the considerable role played by dialogue beginning with Leni Riefenstahl may be noted: the weight of the words, the encompassing sound, recorded live, balance or correct pure action. In 1939, Frank Capra, in *Mr. Smith Goes to Washington*, was to play with infinite virtuosity on a whole range of sound effects, which by itself was an illustration of a certain conception of American democracy (the astonishing senators portrayed by Harry Carey, Claude Rains, Edward Arnold, H.B. Warner, Porter Hall, and the young James Stewart).

With the development of techniques of recording directly from life, that is to say, primarily since the advent of light synchronized cameras, before the tape recorder and the mini-cassette were perfected, the sound track, for the first time in the history of film, proved to be, if not the equal of the image, at least possessed of potentialities that were almost equal. At the same time that it rediscovered its natural function—the one it had in the beginning—cutting and editing had to be redefined. Gratuitous visual symbolism could not prevail exclusively, and sound, dialogue, and the general acoustics of the film be considered as a complementary element, a mere useful tool. With guilty consciences relegated to the night of time, filmmakers could speak freely, confront ideology in its living state (Leacock) or its lived state (Perrault).

Limiting oneself to the political film, the intentionally political film—for every film is political—it became possible to envisage, at the very outer limits of film, the existence of an "essay," in every sense of that word, written directly for the screen, without literary or

dramatic or plastic mediation. This is what Fernando Solanas, with the collaboration of Octavio Getino, has tried to do, and has succeeded in doing, in his monumental *La hora de los hornos* (*The Hour of the Braziers*).[1]

It is difficult to pin down Solanas' and Gettino's work precisely since they wanted it to be an "open" work, to use the fashionable expression, which is here anything but a mere stylish phrase. The film is addressed to militants, the situation changes, the film identifies itself with the need to act, and could never be considered a finished product. This very notion of being "finished" is totally alien to the film, for history is never finished. At most one can try to observe the changes that are taking place. In its original version at Pesaro, in June 1968, the film lasted four hours and twenty minutes, being divided into three separate and distinct parts, lasting respectively 95, 120, and 45 minutes, the final section being able to be expanded indefinitely by documentation, letters, testimony gathered after each showing. The subtitle of the film, "Notes and Testimonials Concerning Neo-colonialism, Violence, and Liberation," serves to indicate the overall plan.

The first part, the one which is best known in Europe and which wrongly tends to give a somewhat limited, if not distorted, idea of the work *in toto*, is called "Violence and Liberation." Essentially a tract, *agitprop*, to use the old Soviet term, a flying trapeze exercise, manipulation par excellence, its aim is to wake the Latin American spectator from his lethargy; it is addressed just as much to workers and peasants as it is to intellectuals. In thirteen "notes" varying in length, Solanas analyzes one after the other the history, geography, and economy of the country, day-to-day violence (poorly paid workers, the constant presence of the police, the latifundia, disease), the port city (Buenos Aires), the oligarchy (the rural aristocracy and its dreams of grandeur, its nostalgia for the past, for Europe), the system (denunciation of the agrarian oligarchy and the industrial upper middle class), the political violence (Latin America everywhere the victim of coups d'état), the neo-racism (inherited from colonialism and perpetuated by neo-colonialism), dependency (neo-colonial exploitation inseparable from underdevelopment, its logical consequence), the violence of the culture (the national concomitant of economic violence in a continent that is illiterate, the culture imported from Europe, outside of its natural context, merely serving to perpetuate oppression), the models (development of the preceding idea), the ideological war (everything perpetuates the culture based on European or American models, both for the young and for the "chosen few"), and finally, the choices (a shot of Che Guevara, dead at Camiri, which is held for five minutes).

The second part, the most masterful of the three, which was cut to pieces at the express wish of the filmmakers after the violent criticism it encountered in Europe on the part of all those who instantly identified Perón with Franco or Mussolini, is intended as an "Act for Liberation," and is in turn divided into two parts of unequal length, the first, "A Chronicle of Peronism" (1945–55), being the real detonator of the film, and the second, "The Resistance" (1955–66), which is more complex, being the logical conclusion of the first, a new series of notes, thirteen of them to be found in the present modified version.

Solanas, as opera buff and a musician himself, goes back to the style of the opening part of the film, an overture, in almost the musical sense of the word: short phrases in large letters that are so many invitations to action. Dziga Vertov had also used the intercalated title to good advantage, combining the plastic effect with the dynamic effect, modifying the size of the letter when the film's threat or its passionate drive comes to the fore. Solanas, a partisan of the simple linear word, merely restores the chain of words as they are spoken, as will become even more evident later when, in the purest style of the animated film, he puts phrases on the screen letter by letter, as if they were being written out by an invisible typewriter.

Just after this introduction, "a few lights go on in the house," while Solanas' voice, which continues to be heard from the screen which has now gone black, invites the audience to consider the film as an *act*,

1 The literal meaning in English of *La hora de los hornos* is *The Hour of the Braziers*. It refers to the braziers lighted by the Indians seen by the first European navigators along the Latin American coast (they were also found along Cape Horn). The expression appears in a sentence by José Martí, which Che Guevara cited: "It is The Hour of the Braziers, and all that need to be seen is their light."

and to consider themselves as protagonists of the action. A calico banner proclaims in enormous letters: EVERY SPECTATOR IS A COWARD OR A TRAITOR (FRANTZ FANON). At the end of his discourse in the film, a minute of silence is observed "in honor of Che Guevara and all the patriots who have fallen in the struggle for the liberation of Latin America." After this minute of silence, the projection begins again, and the marvelous documents on the overthrow of Peronism explode—there is no other word—on the screen.

From Perón's takeover on October 17, 1945, to his self-exile ten years later under pressure from the army, a page of history *filmed live* comes to life again before our eyes, brilliantly illustrated by impressive newsreels which are the source of the profound discomfort, if not of the often unfair attacks, of European spectators who have seen the complete version. I say unfair, because, *without passing judgment on the content* (I do not have enough information to do so), it seemed quite obvious to me that Solanas and Getino were in no way asking us to commune with the ecstatic mass of *descamisados* ("shirtless ones") swarming around their leader, but rather were presenting evidence, as they themselves stated, of the first appearance on the stage of history of the Argentinian masses *as masses*. The whole film hinges upon this, and becomes probably the greatest historical film ever made. The fact that it survives being cut into ribbons, plus the reflection that follows (for the tone of the film, after this shocking opening, will change completely, turning more and more toward active meditation, patient, implacable explanation) is sufficient proof of Solanas' talent.

From this flood of shocking images, images which this time are not manipulated but crude, with both the sound and the picture filling the theatre to the point of crushing the spectator, we shall choose to remember, even more than the embarrassing passage in which Evita Perón speaks to the crowd with her usual fervor of a cheap plaster Madonna, the scene in which the army, on June 16, 1955, bombards the government palace and the center of the city while the crowd fills the streets—images of naked power, of stark repression brought to bear against what obviously was the will of the people. On August 31, 1955, Perón speaks to the crowd gathered in the Plaza de Mayo for the last time and announces his intention of remaining in power. A few days later the army deposes him, and immediately thereafter the bourgeoisie and the clergy joyfully parade through Buenos Aires. All trace of Peronism is erased: books are burned.

There is no doubt that Solanas here obtains the shock effect that can set off a whole chain of thought about the need to put Peronism in proper perspective, about the overly facile identification of Peronism with European Fascism and therefore with absolute evil. In Cuba, at least, justice has been dealt these simplistic views in various theoretical writings. The masses loyal to Perón have undergone their first baptism of fire, their first act of awareness. From this point on the struggle will be carried on by the labor unions and the underground.

* * *

But it would be unfair to ask Solanas and Getino to be absolutely objective, to act as if they were observing events from Sirius. They are playing their cards straight when they cruelly stigmatize the speeches of Communist and Progressive Democrat deputies allied in the Democratic Union, which in 1945 called upon the people to denounce Peronist Nazi-Fascism, at the time of the sacred alliance among the Allies of World War II, the forerunner of what was later to become peaceful coexistence. The second part, "Resistance," in thirteen notes and testimonials, logically develops the forceful main theme of the opening section, the value of Peronism as the masses' first experience, and illustrates by concrete examples the day-to-day struggle by members of the movement with a totally new class consciousness.

We thus follow the evolution of Peronism between 1955, the date when Perón fell, and 1966, the date when *La hora de los hornos* was filmed. One after the other, labor leaders, students, writers, journalists bear witness to the need for political commitment, which has no sense unless mediated by the positive side of Peronism. At work in the factories, men and women militants describe the battle they are waging, the strikes, the occupation

of factories, the relations with the power structure. The myth of "spontaneity" suddenly rears its head, a spontaneity that has allowed the disoriented Peronist masses to survive, to find other immediate solutions in order to continue the fight. This spontaneity is no longer enough.

The last note, an introduction to the debate, serves as a transition to the third section, "Violence and Liberation." We are bludgeoned with the most brutal images of the film in the space of a few minutes: Angel Taborda, whom we have previously seen fighting labor's battles, is beaten by policemen in civilian clothes, and dragged through the dust unconscious; the great strike of Tucumán is accompanied by the chant "Father, where is God?" A leader of the Peronist youth group presents the alternative: from now on *military action* is called for, since political action is of no use in a democracy that does not exist. The house lights go on, and a discussion period with the audience begins.

The third and last part, "Violence and Liberation," is shorter, more subversive, more committed—if that is possible. An old militant from Patagonia describes the oppression Argentinians once endured at the hands of the English colonizers. A militant's first letter is read. At what is perhaps a crucial moment in the film, Julio Troxler, a militant labor union official who has gone underground, explains how he once escaped summary execution when Perón fell, how he was caught and tortured, why he continues to fight. We had read these things, but we had never seen and heard them simultaneously. A second letter speaks of the political commitment of the intellectual. Just as, among other changes made in the film after Pesaro, the second section introduced discussion between three students, the written testimonial of a priest who is an apostle of revolutionary violence is evoked a little later. The voices of the two filmmakers alternate. Solanas is more grandiloquent and Getino more passionate. Solanas stresses the need for revolutionary *praxis*, a term that has come more to the fore since Pesaro. Then there is another letter: "Latin America will be the Vietnam of the next ten years." Peaceful coexistence is impossible; the struggle must be begun here and now. The film ends in a lyrical nightmare, with the ever-present police and violence which have lent their rhythm to the whole film, in a song called "Violence and Liberation," with music and words by Solanas, calling for armed struggle.

* * *

Will people talk of a madman? Either *La hora de los hornos* is an aberration, an hallucination of Latin American intellectuals, or it is a deliberate revolutionary act on the part of its makers. I don't know what the outcome of the struggle will be on the battlefield. In the theatre, *there is a revolution*: we cannot remain neutral, we are forced to react, to project ourselves into a precise problem, to which we cannot begin to respond unless we make an almost scientific—or structural, if you will—analysis of the film, and I have only sketched the bare outlines of such an analysis. From today on, however, the history of Argentina, because of this conjunction of objective eyewitness accounts, newsreels, interviews made in the heat of battle, and of the subjectivity of two committed filmmakers, speaking to us live, in dialogue or written words, is no longer—for me at least, and I believe this will be true of every spectator who feels somewhat responsible—the unknown factor described in history texts.

If Solanas' film were not sufficient proof, his responsibility would also reside in this effort of his to restructure his work with the passage of time, on the basis of the experience he has acquired from contact with others since the film was first shown. The somewhat crude presentation of Peronism has taken on nuances; a new introduction to the second section will perhaps some day come our way if circumstances permit. A "work in progress" if ever there was one, the film intersects other experiences which are perhaps less militant but no less political, such as Fernand Dansereau's *Saint-Jérôme* in Canada and other efforts in France. Its dialectic is based on living and lived witness, which is the incarnation of ideology. A simple intermediary medium, it solves nothing. It shows the dialectical movement of a given situation. An analysis in depth would distinguish between what was contributed by the live filming and more classical means, such as music, which dominate this lyrical

film; it would contrast sequences filmed live with sequences which are often remarkable montages based on the music. Without exaggerating its meaning, *La hora de los hornos* could be defined as a succession of themes and variations on revolution: the maximum commitment of the artist allies itself with the most subtle sense of balance.

Despite doddering, senile criticism, it is important that a work that forces us to redefine our relationship to film be distributed as widely as possible.

Translated by Helen R. Lane

EASY RIDER:
A VERY AMERICAN THING
—AN INTERVIEW WITH
DENNIS HOPPER

L.M. Kit Carson

Dennis Hopper, co-author, director, and co-star of the Columbia film Easy Rider, *was interviewed by L.M. Kit Carson immediately after the first press screening in New York City last summer. The following is an edited transcript of that conversation.*

Question: *How did this film start? With what? With whom?*

Answer: It started with Peter [Fonda] calling me on the telephone, saying he had an idea for a movie about two guys who smuggle cocaine, sell it, go across the country for Mardi Gras and get killed by a couple of duck-hunters because they have long hair. "Do you think it can make a movie?" And I said, "Yeh. I think it can make a great movie."

Q: *At what point did Terry Southern come into it?*

A: Terry Southern was an old friend of mine. I asked if we could use his name to get money; then, would he help us with it. He said, "Sure, I like the idea." So we got some cameras and people together, ran down and shot Mardi Gras first; then began the rest of the movie a month later.

Q: *Why'd you shoot on a split and backwards schedule like that?*

A: We wanted to use the real Mardi Gras and scheduled to shoot it. But Peter had gotten the wrong dates for Mardi Gras—we thought it was a month away. Suddenly we learned it was a week away. So we shot Mardi Gras without a script, without anything—with just what I had in my mind. I knew generally what I wanted the acid trip to be, and what I wanted from Mardi Gras.

Q: *How many days did it take to shoot Mardi Gras?*

A: We had five days at Mardi Gras. The acid trip was shot on two different days—half of one day, the whole of another day. This was fast, but I'd learned to squeeze, learned to work fast from television—how to move quickly and utilize your time.

Q: *Did you do anything to the Mardi Gras*

film-stock? Some sections seem to be off-tone, or in high contrast.

A: Some of that footage has stains on it, but those were stains that came on the film. And one day it was raining and another day not—so, different light. But I believe what Cocteau said: "Ninety-eight percent of all creation is accident, one percent intellect, and one percent logic." I believe that: you must keep *free* for things to happen, for the accident—and then learn how to use the accident.

Q: *Were you satisfied with the acid trip footage?*

A: Yeh. But everyone else was confused. It was a mess at Mardi Gras. I took over the camera myself at one point. Fifteen men threatened to walk out. It was a classic mess. And there was this great question then whether I would go on directing the movie after that. Nobody understood what the hell I'd shot in 16mm. Everybody was asking, "Well, what is the acid trip sequence like?" So I held back from editing that footage until the last, saying: "Nobody'll be able to unravel this part of the film but me, so they can't finish the film without me." We shot as much film at Mardi Gras as we shot for the whole rest of the movie.

Q: *And this Mardi Gras footage convinced Columbia to give you the money for the movie?*

A: No, we had the money before. Got the money from a very complete story outline which we had dialogued with a tape recorder. Then after Mardi Gras, I drove back across country to California from New Orleans, spotting locations for the other sequences along the way. Then I came to New York. Peter was here with Terry, and we sat down and wrote the script in two weeks because I needed at least a week and a half to complete casting. Then we started shooting. I wanted the pressure kept up like this because the quicker we worked, the more it rushed Columbia. We moved so fast at the beginning that the studio couldn't absorb everything that was going on; it was hard for them to question us when they couldn't even keep track. And this worked. Finally the studio just sort of had to

lay back and let go.

See, I believe that if you're going to do something you have to learn how to protect yourself. "You should protect yourself from the braggarts because they'll find the advantage which you expect, and they *will* find that advantage. Take an example from what will happen to me."—The Gospel According to St. Thomas, found in 1946, printed in 1959, which a lot of the picture is based upon. This was Doubting Thomas' *Sayings of Christ*. A lot of the acid trip was based on it: Peter talking to his mother, telling her how much he hates her—it says in St. Thomas: "If you do not hate your mother and father in the same way I hate mine, you shall not be worthy of being a disciple." Now I take that doctrine as evolution: wanting to one-up your father, your mother. And, in a strange way, you have to resent them to go on. Most people don't resent their mother and father, and they fall in the same traps, like Jack in the movie—he can't get out from under them, he can't evolve. Thomas' Christ also says: "I only ask one thing: don't lie and don't do what you hate." That's the only moral judgment he sets up. He says, "If you want to kill a powerful man, just take the sword in your hand and thrust it through the wall of your house to see if you have the thrust. If you do, then go and slay him." It's a very revolutionary, *evolutionary*—which I like better—evolutionary document. It talks about how things *go on*, continue.

Q: *You shot in Los Angeles first after New Orleans?*

A: We were in Los Angeles for three weeks. We shot the commune, which was the only set we built, up on Topanga Canyon outside the city. Then shot the interior of the whorehouse—which is really the inside of a friend's home. Then we shot four weeks cross-country. Whole movie: seven weeks including a week at Mardi Gras.

Q: *Elaborate on the way you handled the non-actors in the Southern café scene. It looked to me like the people in the booths had script-cards on the table in front of them—they would refer to the cards, then look up and speak a line.*

A: Yeh, well, they weren't. They kept looking down because they were supposed to be playing dominoes. I never gave them the script. How I worked them? First of all, there was a man who preceded us into towns like that and got together people he thought would be right for the roles. I came into one village—Morganza, Louisiana—and looked at the people he'd chosen. I didn't care for them. And I saw a group of men standing over beside us doing the kind of joking that they guys in the café were to do. I said, "*Those* are the people I want." He said, "Well I don't know whether I can get them." And I said, "Those are the people I want." So he went over and asked them, and to his surprise they were more than happy to do it. Then I told these men that we had raped, killed a girl right outside of town; and there was nothing they could say about us in this scene that would be too nasty—I mean, they could say *anything* they wanted about us. (And they were pretty set in this frame of mind anyway.) All right. Then I gave them specific topics, things that were covered in the script: talk about long hair, is-it-a-boy-is-it-a-girl, the teeth I'm wearing around my neck, or Peter's black leather pants, or the sunglasses. Then I set up the camera in such a way that I could stop them: "Don't say that"; and isolate: "You say something about this." And the girls: I got them to flirting with one idea—they wanted a ride on the motorcycle. Because I wanted to get them outside. And because this flirting would aggravate the guys even more. So at first I just let them go at it, work their real feelings out. After watching a bit of this, I gave some definite lines: "Check the flag on that bike. Must be a bunch of Yankee queers." "You name it, I'll throw rocks at it." Those were lines from the script. But basically the scene, improvised and all, plays according to the *intention* of the café scene written in the script.

Q: *How long did this scene take to shoot?*

A: We shot it in half a day.

Q: *In regard to those café people: do you feel guilty of any indecency done to them?*

A: Do I feel that because of this film there's harm done to them personally?

Q: *Do you feel you violated them in any way?*

A: No, I don't believe that—well, you've got to understand that I believe that anything that is a creative act can be justified.

Q: *Murder included?*

A: Well, not quite that far, but almost. I don't know whether I violated them. But then we all violate. Still, there's an area in me where I hope I didn't hurt them because I happen to like those people. I didn't mean them any harm.

On the other hand, I know that if I'd come in there actually traveling across country alone, or if me, Peter, and Jack Nicholson had walked into that restaurant without a movie company behind us and those men had been sitting in there, we'd have been in a lot of trouble.

That's true—I know. I was in the Civil Rights March with King from Selma to Montgomery—it was crazy. There was one guy standing on the side of the road pissing on us. I mean, there he was with his cock in his hand pissing on nuns and priests, all over. And he was calling us white trash. Pissing on nuns and priests and rabbis and Protestants and all religious people in their uniforms, and on us—and calling us white trash. Crazy, you know: how can a man be pissing on people and calling *them* white trash? It doesn't make sense.

And I know that this time the only thing that stopped trouble was the fact that we were making a movie. And suddenly I could relate to these people as their director and they could relate to me.

Q: *Do you connect yourself to any actively political people today?*

A: I don't think anyone intelligent connects himself to anyone political today. The last time I mixed with politics was when I got kicked out of a SNCC meeting in the South because they were going into black power, and all the whites had to get out. Which was all right; they were right. They were going to take care of their people, and we should take care of our people—because our people were in just as much a mess as their people. Unfortunately, it's harder to take care of

whites because a great mass of them don't think we have any real problems. When SDS went out to Newark a couple of years ago to the poor whites, the people said: "What are you trying to help us for? We're cool." And at the moment I don't think there's going to be any serious change in this attitude—most of us think, "I'm cool. He's the trouble." Until we have some sort of war. It'll have to be some kind of war because a lot of things need changing.

I think the movie says this—I mean, it creates this dangerous atmosphere. I know when we were making the movie, we could feel this: the whole country seemed to be burning up—Negroes, hippies, students. The country was on fire. And I meant to work this feeling into the symbols in the movie, like Peter's bike—Captain America's Great Chrome Bike—that beautiful machine covered with stars and stripes in America. I'm not sure that people understand, but that bike with all the money in the gas tank is America and we've got all our money in a gas tank—and that any moment we can be shot off it—BOOM—explosion—that's the end. We go up in flames. I mean, at the start of the movie, Peter and I do a very American thing—we commit a crime, we go for the easy money. We go for the easy money and then we're free. That's one of the big problems with the country right now: everybody's going for the easy money. I think Americans basically feel the criminal way is all right *if you don't get caught*; crime pays, *if* you get away with it. Not just obvious, simple crimes, but big corporations committing corporate crimes—swindling on their income tax, freezing funds abroad.

Q: *Are you saying that Peter in the movie represents America?*

A: Yeh. But more than that. Me and Peter are the Squire and his Knight, Sancho Panza and Don Quixote, also Billy the Kid and Wyatt Earp, *also* Captain America, the comic book hero, and his sidekick Bucky. I'm saying that Peter, as Captain America, is the Slightly Tarnished Lawman, is the sensitive, off-in-the-stars, the Great White Liberal who keeps saying, "Everything's going to work out," but doesn't do anything to help it work out. He goes to the commune, hears the people have been eating dead horses off the side of the road—does he break any of that fifty thousand out of his gas tank? What does he do? Nothing. "Hey, they're going to make it." Hey, the Negroes, the Indians, the Mexicans are going to make it. What does he do? He rides a couple of the girls over to another place because he's eating their food. *He does nothing.*

Finally he realizes this when he says, "We blew it." "We blew it" means to me that they could have spent that energy in something other than smuggling cocaine, could have done something other than help the society destroy itself.

Q: *All right. But I wonder whether this disfavor you've just explained toward Captain America comes across in the movie. I've seen the movie four times, and only the last time did I begin to pick up some ambivalence toward Captain America in the commune sequence. I'm asking you as a filmmaker, could you have made it more clear how you wanted us to feel about Captain America—just done it in that one sequence which, I think, is very crucial? Because when Captain America says, "They're going to make it," a lot of people get confused: "Does Hopper really believe that? That's bullshit. But sounds like he believes it."*

A: I don't think it comes through. I think Peter comes off as simply a Super Hero, or Super Anti-Hero. Bucky doesn't believe they're going to make it. Bucky says, "Hey man, they're not going to grow anything here. This is *sand."*

Q: *Right, but you give Captain America the last line: "They're going to make it."*

A: Yeh. Doesn't Captain America always have the last line? "Go to Vietnam." I go to Vietnam. I don't question Captain America. I may be bitchy or carry on, but Captain America always has the last line. That's the way things are.

Q: *What do you think the moral effect of your film is going to be—for instance, what will happen when the scene in which Jack Nicholson smokes pot is shown at the Majestic Theatre in Dallas, Texas?*

A: I don't know. You do something and you do it for a lot of different reasons. I look at that scene on several levels. First, it's dishonest if those two guys on motorcycles don't smoke grass. It'd be ridiculous, unrealistic. You can't make a movie about these characters in the late 1960s and not have them turn on. And if they have a guy like Jack Nicholson around, they're going to turn him on. That's all, it's that simple, no propaganda intended. But the *main* reason I used pot in that scene was to give me a humorous handle for the Venusian speech—which I consider a very serious piece of work, heavy propaganda.

Q: *It succeeds as both.*

A: What I'm saying is, without that device of humor, people would get uptight, say, "Wh-what's he saying?" And this way nobody says, "What's he saying?" I've never had anybody say, "What are you saying in that scene?" And what we're saying is either an incredible lot of nonsense or an incredible lot of not-nonsense. So we made it funny, as in the Victorian period or other periods of oppression, when you wanted to say something hard to take, you always dressed it up as a folk ballad or a humorous little ditty that was sung in a tavern somewhere.

To get back to the moral effect of the scene—the only time a reaction really hit me, really hurt me: in Cannes, Omar Sharif's nineteen-year-old daughter came up—she'd never turned on before—and said that after the film she turned on. I said, "Oh, how'd you like it?" She said, "It didn't do anything for me." I said, "It's probably very difficult for anyone as frivolous as you to feel anything anyway." Because it hurt me, man. Because I didn't make that movie for her to use it as an excuse to turn on—I don't want any nineteen-year-old to go get high just because they see the movie. Look, I've been smoking grass for seventeen years—there've been bummers and good times. All in all, I'm glad I did it because smoking gave me some insight, some paranoia, some self-searching I wouldn't have had otherwise. But not everybody can handle it. And I did not make this movie to turn everybody in the country on to grass. I already assumed everybody was turned on or about to be turned on—without my movie.

Q: *You're prepared for some very righteous people to come raging up and saying, "What the hell are you trying to do?"*

A: Yeh, well I've had that. Right. In Cannes, we held a press conference after the film and UPI or one of those news services got up and said, "Why are you making a movie like this? Don't you realize how bad this is for the country? We have enough problems without you doing this terrible movie, etc." Then a young communist said, "Why did you make a movie for three hundred and seventy thousand dollars? Why didn't you make a 16mm or 8mm movie and give that money to the Cause? Why are you copping out, putting commercial music to this movie? Blah-blah." And I said, "You're only kidding yourself. If you make a propaganda film, art film, any film you feel has something to say—you *can* work small and show it to people who think like you already, dress like you, wear their hair like you, and you can all sit in a little room somewhere and look at your movie over and over. *Great*. But if you want to reach a large mass of people at this point in history, you *have* to deal with the people who are going to *release* your picture." And I also told the kid, "Hey, all I know is how to make movies. I don't know anything else. It took me fifteen years to raise three hundred and seventy thousand dollars. I'm not going to give it to the Cause—I am the Cause."

Q: *How long did it take to edit?*

A: A solid year, working the whole time.

Q: *Did you always have the music?*

A: I put the music with the film pretty much from the top of the editing.

Q: *How did you come to the stanzaic structure for the movie?*

A: I believe that you start a movie very slow, very slowly drag people in up to a certain point. Then, just as they get a little restless, you start socking it to them. This makes me favor the episodic structure, like music—something that moves along with short breaks in it: you keep giving people something new, keep building pressure. Then you

cut off, relax, go for a ride.

Q: *Did you have different movies at different points along that year?*

A: We had the same film all along, but in different versions: 240-minute, 220-minute, 180-minute, 160-minute, and finally 94-minute.

Basically it was my discipline problem. I loved the 220-minute version because you got the real feeling for the Ride—very hypnotic, very beautiful, like in *2001*. One of the things I liked in *2001* was the hypnotic feeling of movement. We had that at one time with the bikes. You really felt like you crossed country, in the same way Antonioni makes you feel you're walking around with a character in his movies—suddenly he creates in you the same boring, edgy sense of time that his character is suffering from.

But how many people were going to sit for three hours and forty minutes of bike-riding and dig it? So it came down to the fact that I wanted to communicate, I wanted to reach as many people as possible. It was important for me to reach a mass of people. And I decided the 94-minute version would do that best.

Q: *Why the flash-cutting device early in the movie—boom, boom, boom and into a new scene?*

A: I'm very given to the idea of light transmitting thought. The light-energy bouncing on the screen like that, the six-frame hypnotic flash hitting you, pushing you into the next scene is better, much better than dissolving one image over another and going out of one into another—that's terribly romantic and sentimental to me. And I think that now's not a time for that. There are no superimpositions in the film, no dissolves, we don't have time for that now—now just direct-cut it. This is all a problem of control, of me controlling myself. Originally I had a lot of flash-forwards all through the film. For example, in an earlier version, on that first morning when Peter looks up at the sun flaring through the rafters, I had him flash forward to a lot of things: Mardi Gras, Jack Nicholson, the stranger on the road, the commune. Very abstract, quick flashes. Finally I cut this down to just one

flash: his death-flash in the whorehouse.

Q: *Why did you reject these other flashes?*

A: Because I think that one took care of it. Using other flashes—that's for another movie maybe.

Q: *Jack Nicholson's character seems written and directed to be fuller than the other characters.*

A: Right. You run into Jack Nicholson and the whole picture changes. He's the only one constructed to be three-dimensional, the only character whose background and present situation are developed. You're told a lot about Jack: his father's powerful, he played football in school, he's a lawyer for the ACLU, he's poisoning himself with alcohol, he sees flying saucers. You learn an awful lot about him.

You asked earlier if Peter represented America. No, actually Jack is America: he's Trapped America, killing himself. As far as the other people go, you don't know much about them, just basics: Luke Askew is hitchhiking to the commune: why? where's he from? what's he doing? Not important. You get no background on the two hookers. You don't know what the commune is really into. Obviously I wanted you to get closest to Jack. All you know about Captain America and Billy is that they sell cocaine, smoke grass, ride bikes. You don't know they were trick bike-riders who worked traveling carnival shows, rodeos, and so on. You don't know that Captain America and Billy originally made their lives jumping bikes through flames, etc. At one time, this rodeo stuff was the first scene in the movie. But I finally decided not to do it that way. To explain all that is disturbing to me. I hate to *explain* who everyone is at great length. You see, in the kind of TV shows and movies I've done for the past fifteen years, everything's explained. I mean, *everything*. I mean: even if some kid has ten lines, you know who his father, mother, uncle, brother are; and you know his dog died when he was three and that's why he's a race-car driver. Right?

Now I'm no longer interested in telling you all that. I hope that if you watch the characters, just watch them, you can understand all you need.

Q: *You don't mind that Captain America and Billy seem two-dimensional?*

A: All I wanted was for you to be comfortable with Captain America and Billy, just so you wouldn't mind crossing the country with them. And somewhere I gradually wanted you to sort of like them—not necessarily identify too closely with them, but accept them enough so you could lose them in the end.

Q: *The end shook me up quite a bit, probably because it seems so accidental.*

A: Not so accidental really. I believe that if Billy hadn't shot the finger to the guys in the truck, there wouldn't have been that existential moment when the guy decided to pull the trigger. It was action-reaction operating when they killed me. They killed Peter because they just didn't know what else to do—it was too complicated for them to work it out any other way. But I'm not denouncing the South in this ending: I say it was action provoking reaction. Businessmen have come up to me after the movie: "I like your movie, but I'm not the guys in the truck. You're saying I'm the guys in the truck." I'm not saying that. The guys in the truck and the guys on the motorcycles are both the same: criminals, victims of the climate of the country today.

Q: *So instead of the helicopter shot at the end, you could just as well have driven off with the two guys in the truck.*

A: Yeh, well, not yet. That may come in the 1970s.

PARTICIPATORY TELEVISION

Nat Hentoff

Television continues to strengthen its ranking as the medium most people rely on for news and the medium they are most inclined to believe.
—Walter D. Scott,
Chairman of the Board, NBC

... One basic assumption underlying the First Amendment's protection of speech is that "the widest possible dissemination of information from diverse and antagonistic sources is essential to the welfare of the public ..." Associated Press *v.* United States, *326 U.S. 1, 20 (1945).*
—Nicholas Johnson, FCC

What may puzzle the lay observer is the enormous energies and resources which the broadcasting industry has invested in trying to question accessibility to the airways by the average citizen.
—Jack Gould, *New York Times*

Yes, television is the quickest—and often the most powerful—means of persuasion. And yes, television does *not*, to say the least, provide "the widest possible dissemination of information from diverse and antagonistic sources." As Jack Gould has emphasized: "Television, to be blunt about it, is basically a medium with a mind closed to the swiftly moving currents of tomorrow. The networks have erected an electronic wall around the status quo."

Where is the television time for regular commentary by the Black Panthers, by the various wings of SDS, by Mexican-Americans, by Puerto Ricans, by poor whites—by you? On what station can black students present their own documentaries on their schools? Or white students? Or radical teachers? Or nonradical teachers?

Well, you see, this kind of programming just doesn't seem "suitable" to management. And television management is small and concentrated—and often quite distant. In the eleven largest cities of this country, not a single network-affiliated VHF (very high frequency) station is independently and locally owned. All of them are owned by the networks, newspapers, or multiple station owners.

For a more general picture of television's "independence": of the 496 commercial

stations around the country, 160 are hooked up one way or another with newspapers. And there are 44 communities in which the only local paper controls the only local television station.

The folks who decide on programming for the commercial stations, urban and rural, already know what the Black Panthers and dissident students are all about. They've been "informed" by the newspapers who pay the salaries of many of them. That's all been covered, friend. No need to preempt Lucy for anything like *that*.

A few of the "educational" television stations are somewhat more open to "diverse and antagonistic sources" of information. But not too diverse, and certainly not too antagonistic. And in any case, just as on commercial outlets, the station or the network decides who is to be heard and in what context.

That—along with concentration of ownership—is the essence of American television as an undemocratic activity. Jack Gould has put this very clearly: "The test of a communications medium, especially one dependent on survival through use of air waves that are public property, is a willingness and commitment to make its facilities available *to persons other than employees under its direct supervision.*"

Do you know of any station in this country with such willingness and commitment? Oh, a few UHF (ultra high frequency) stations occasionally make tentative moves in that direction, but there, too, the power to decide and control is the station's.

By contrast, as FCC member Nicholas Johnson has pointed out in *TV Guide*, "In Holland, any group that can get 15,000 persons to support its list of proposed programs is awarded free time on the Dutch Television Network for a monthly program. There is even an organization for tiny and often eccentric splinter groups without 15,000 supporters. If a similar experiment were conducted in this country, groups interested in electronic music, drag racing, handicrafts, camping, as well as the League of Women Voters, the National Association for the Advancement of Colored People, local school boards, theatre and drama associations, the Young Republicans (and who knows, even the Smothers Brothers), could obtain television time to broadcast programs prepared under their supervision."

But this won't happen here unless the extraordinary technological possibilities now beginning to become available through cable television are made accessible to the "average citizen." Present cable systems have the capacity to relay at least twenty separate channels to a home connected to the system. That number can eventually rise to fifty, and probably more. In addition, since these channels are distributed over a wired hookup from a central control point, a simple switching process can direct individual channels to specific small neighborhoods. Watts or Greenwich Village—or even smaller subdivisions—could have their own channels. Also, because reception is so much clearer on cable television, it's likely that as many as ninety percent of American homes will be hooked into a cable system within a decade.

The conditions, then, for decentralization of television are at hand. But, specifically, how can this be accomplished? And how much will it cost?

Television can be democratized, as the American Civil Liberties Union makes clear in a presentation to the FCC, by requiring cable television companies, "as a condition of franchising, ... to provide separate and individual channels by geographic units of any reasonable size down to a thousand or fewer households." And these local units could then be hooked up regionally and nationally with other groups with similar interests and concerns. Watts and Bedford-Stuyvesant could share ideas and information. So could high school students in Los Angeles and New York.

It's easy to do. Cable television is like the telephone system with its 20,000 local "exchanges." The various geographic units that are possible in cable television can, as the ACLU has noted, "be interconnected in an unlimited variety of patterns." As for the cost, the ACLU proposes that cable television operate as "a common carrier, leasing channel time to all those who desire it at uniform, fair, and reasonable rates with the operator of the facility having no control over the intelligence which is carried through his channels." If these fees are carefully regulated by the FCC, there is no reason why the television screen cannot become as accessible to "the average citizen" as long-distance telephone service. And for those who can't afford any fees at all,

Cartoon by Jean-Jacques Sempé, *Evergreen Review* No. 61, December 1968

the service should be made available without cost. These are *public* airwaves, right?

Nor need the price of equipment—cameras, lights, etc.—be prohibitive. Equipment can be rented. But why shouldn't it be obtained permanently, through government grants, for education, for job training, for community involvement in its own affairs? And why shouldn't some of it be given to local communities by the commercial stations and networks which have been prospering so long and so well from "free" television? Giving equipment will not only improve the "image" of commercial stations and networks but will also result in tax credits. (The ideal corporate gesture: a profitable benison.)

The potential ramifications of bringing democracy to television can just barely be conceived at present. Consider the learning possibilities, on all kinds of levels. From individual neighborhoods with access to their own channels—and with connections outside—there will emerge thousands of black, Puerto Rican, and Mexican-American commentators, reporters, engineers, lighting directors, and administrators. These, along with whites of the underclass (why not an Appalachian channel?), could not otherwise become active *participants* in television in such a short time.

Certainly many will then choose to make more money by working on the commercial stations which, by the way, will no longer be able to claim a paucity of "qualified" television professionals among the poor. Many others of the new professionals, however, will prefer to remain where they are, sharpening their techniques and their capacity for action on the basis of the knowledge they're acquiring by informing themselves as well as others.

And this knowledge will spread and grow in individual communities and through intercity hookups. Blacks, for example, no longer limited to Huntley-Brinkley-Cronkite priorities for television news, will be finding—and thereby making—their own news. Let us suppose, for one instance, that a percentage of a

particular neighborhood is not yet sufficiently aroused by the state of its schools to change them. And let us suppose another segment, though aware, feels impotent in terms of making those changes. A neighborhood channel would *show* the schools in detail to the first group. And it might have Rhody McCoy give a series of talks with film clips to the second group about ways to get community control of schools and about the educational directions Ocean Hill-Brownsville was able to start exploring even when under siege.

This, and so much more, could happen on cable television in a stunning liberation of the medium for all manner of groups and neighborhoods. Decentralization of television is not only technically and economically possible *now*, but it's also entirely desirable in terms of any organic definition of what democracy ought to and can be.

So what's in the way? The commercial broadcasters and the owners of cable systems. The latter would like to use as many as possible of their twenty, or fifty, channels per city to make money. Much more money than can be made by charging "common carrier" fees. Meanwhile, owners of present commercial stations and networks want as little competition as possible. They can't any longer hold back cable television but they are intent on preventing cable systems from linking themselves together into competing networks. And they certainly don't want hundreds, eventually thousands, of thoroughly independent neighborhood channels chipping off audience percentages and—much worse—making these local citizens highly skeptical about anything they see on commercial television, the news in particular.

Accordingly, commercial station owners and holders of cable system franchises are trying to come to an agreement among themselves which will keep the "electronic wall around the status quo" from being breached. This past June, for example, a cartel arrangement was almost sealed. The cable people would have agreed not to interconnect their facilities to form networks. In return, local cable systems would have been allowed a greater quantity and variety of time to sell than they now are allotted. Also part of the agreement would have been a limitation of the number of channels in each city. The proposal foundered. Partly, I suspect, because

Jack Gould exposed it in the *Times* as a plan which "would put the force of law behind a package understanding on ground rules for competition, and allow those already in the business to decide what constitutes adequate television service for the public."

Those already in the business will, of course, keep trying to prevent the "average citizen" from having access to television in any other way than as a passive consumer. They have strong allies in Congress. But they can be defeated.

Such liberals as exist in Congress who do not own stock in newspaper-broadcasting combines ought to be filled in by interested constituents on the need to keep cable television open to all the citizenry. And more effective as a source of counterpower against the broadcasting industry would be a national alliance to bring democracy to television. This is a clear, palpable issue around which could be organized those most directly and urgently concerned with breaking down that electronic wall—blacks, Puerto Ricans, Mexicans, students, radicals, liberals, Buckley conservatives, good government groups, the kind of labor unions being led by César Chávez and Leon Davis of the Hospital Workers' 1199. The list can go on and on. This alliance, once it gains some momentum, could bring real pressure for open television.

In the meantime, since individual citizens so seldom write to the FCC, even your single cymbal note of support can have weight. Particularly if you write to Nicholas Johnson, an authentic populist from Texas, the one man on the FCC most committed to the First Amendment and to actualizing democracy. His address is: Federal Communications Commission, Washington, DC 20554.

Johnson, in a concurring opinion, when the FCC dismissed the United Federation of Teachers' charges against WBAI-FM (and Julius Lester), wrote: "If truly free speech is to flourish in broadcasting, and if individual citizens are to be given rights of access to the media to exercise their First Amendment freedoms to any meaningful extent, then it is apparent to all that the public must seek its First Amendment champions among other than industry spokesmen."

And where else must it seek if not in itself?

ROCHA'S FILM AS CARNIVAL

Frieda Grafe

To Glauber Rocha, his country—Brazil—is a land entranced, alienated from itself by its mysticism and lack of consciousness. "Brazil is one big carnival and this carnival must be eradicated."

Antonio das Mortes is the killer in Rocha's second film, *Black God, White Devil*. He has hired himself out to the Church and wealthy landowners who want him to kill off the *beatos* and the *cangaceiros*: the *beatos*, religious sects who have abandoned all hope of a better life on earth and whose only hope is in the afterlife; the *cangaceiros*, at best guerrillas who actively strive to bring about social justice—they rob the rich to help the poor. Though the misery of these people torments him, he knows the revolution will come some day and, when it does, it will owe nothing to the black God or the white Devil, which is why he can kill both groups; so says Antonio to the blind storyteller in *Black God, White Devil*. In *Antonio*, a rich man once again calls on him to fight his old enemies. In the meantime the *cangaceiros* and *beatos* have joined forces, and Antonio—the "dragon of terror," the "matador of the *cangaceiros*"—refuses to accept money for the job. The rich man doesn't like this: he doesn't trust a hired killer who isn't bound to him by cash. And, in fact, instead of killing the rebels, Antonio joins them.

The film begins with the showdown. The setting is the barren *sertão*—the poorest, bleakest region of Brazil. Before Antonio makes his entrance, we hear the crackling fire of his rifle. Then a mortally wounded *cangaceiro* staggers into the picture; he staggers and dies endlessly—through more than half of the frame. In the course of the film, Antonio wounds him with his machete, in single combat. At the start, images do not follow in the sequence of the narrative. An entrance from the right is followed by an entrance from the left. The sounds preceding the images before the images appear are important; the roar of the gun, the horrible screaming of the wounded man, his staggering—these come only after we have seen Antonio's determined stride. Antonio is a giant of a man in a dark-green cape, a purple scarf around his neck, his face—above all, his eyes—concealed by an enormous felt hat under which hangs his long, glistening, black hair. He is sinister, he is somber, he is mute.

Only once does he break out of his silence, when, in a spirit of enthusiastic camaraderie, he tells about his fight against the *canga-ceiros* and about the great Lampião who was his mirror image.

Then, too, only the wealthy landowner, a corrupt politician, their friends and underlings, and the village school teacher express themselves in ordinary language. The others use dance, song, combat, or an ecstatic, poetic form of speech. This apparently frightens those in power, since when the big machete fight—which is also a dance in rhythm to songs, a drama played out in deadly earnest—between the *cangaceiro* and Antonio takes place, the rich man screams for the people to stop their singing. Song and dance lift the oppressed in a rhythm unlike that of their poverty-stricken lives, transporting them into an ecstasy whose arguments in the language of their oppressors—i.e., the language of law—can no longer reach them.

Antonio is threatening, mute. He has not yet come to the language Marx called "practical consciousness." He uses the language of those in power only reluctantly. Antonio is the revolutionary of the Third World, a man with no bourgeois upbringing to stand between him and the road to revolution. He is like the *sertão* itself, a region still untouched by capitalism and the middle class. Antonio's road leads from feudalism straight to revolution. The detour he takes by killing for the oppressors leaves him uprooted and, thus, for the first time, prepared to help his people. His progress is that of a man in the process of becoming a revolutionary.

Antonio's development from the killer of the first film to the avenger of the second closely parallels that of Rocha's development from a more narrative, bourgeois style to a revolutionary esthetic that expresses itself in a transcendent, poetic language, rough and disjointed, exploding with violence. In *Black God, White Devil*, violence was still represented, narrated. The film's extravagant (from a realistic point of view) violence cannot bear repetition. Being stylized, however, it creates the distance which permits events to become symbols, signs, ideas. In the machete fight between the *cangaceiro* and Antonio, it is the length of Antonio's violet scarf that determines the greatest distance between the two since each clenches one end of the

scarf between his teeth. Distance appears as image. This rejection of realism, of mimesis, of art as a mirror is, at the same time, a step toward a unified art in which performance and life coincide, as in the danced uprising of the insurgents. As a result, Rocha's film is much closer to theater, to spectacle, than to narration.

Rocha's film is carnival. The Russian literary critic Michail Bachtin holds that "the carnivalesque" is a genre containing all those elements which are repressed by the official culture: an anti-theological but not anti-mythical genre, a genre created by and for the common people, a genre that flourished on the fringes of Western culture during the course of history in folk games and celebrations, in the mystery plays of the Middle Ages, and in certain popular prose pieces; a play which knows no stage and which, being played out like a game, becomes an activity in which the actor is, simultaneously, a spectator; the participant loses his sense of identity, doubles to become the subject of the play and an object within the game. The author becomes anonymous. He creates and observes himself creating; he is both man and mask.

The *romanceiros*, a folk genre dating back to medieval Portugal, served Rocha as a starting point for his films. He did not invent a story, in the usual sense of the word, so much as a language—a language whose relation to its model is his real creation. He made free use of the legends and myths of the *sertão* that are said to be as plentiful as those of the American West and, like them, are based on historical fact. Rocha's film is no one-man invention, but an act of sharing and participating in property common to all. With regard to certain technical devices, his films show an almost aggressive acquisitiveness, a tendency to appropriate others' innovations. Rocha speaks of the use he makes of other directors' films: "For me, influences are tools that make my work easier." To make use of others' inventions, to use them for one's own ends, Bachtin describes as characteristic of the carnivalesque, which is a dialogue with preexisting texts, no final product, but a dynamic colloquy between two vital structures: each text is built up as a mosaic of quotations; each text represents an absorption and transformation of another

text. This constant referral to the other text is, at the same time, the only legitimate way for the author to proceed—by participating in the story, in history. "Plagiarism is necessary," writes Ducasse-Lautréamont in his *Chants de Maldoror*. Rocha originally wanted to title his *Terra em Transe* "Maldoror." But for those who find these instances too superficial, two other comments by Rocha: "In making *Black God, White Devil* I started out with a poetic text. Its basis was a metaphoric language." And about *Terra em Transe*: "I agree with Sartre—politics and poetry, that's too much for one man."

Rocha's films are revolutionary because of their message, and the destruction of traditional esthetics is an integral part of the message they carry. Destroying that esthetic, they also destroy the ideology which stands behind it. The guerrilla cinema, the cinema of violence Rocha advocates, which takes its means and materials where it finds them and improvises when necessary, is no primitive cinema as the cultural imperialists would like to think. It is subversive because it shows the disintegration of certain dramatic structures. And it is self-destructive, like Antonio, who kills both the *beatos* and the *cangaceiros* and who is, in himself, both. Self-destruction is essential, says Rocha, because in his country it is the only way to overcome powerlessness, impotence.

Rocha's longing to bring rationalism and consciousness to his country seems somewhat questionable, however, since it is to be feared that these words and the concepts that underlie them would bring with them the very things which the carnival calls into question: word-worship and, with it, an art which is once again reduced to a mere representation of life.

Translated by Jon Swan

Opposite: Advertisement for Grove Press Film Division that ran in *Evergreen Review* No. 80, July 1970

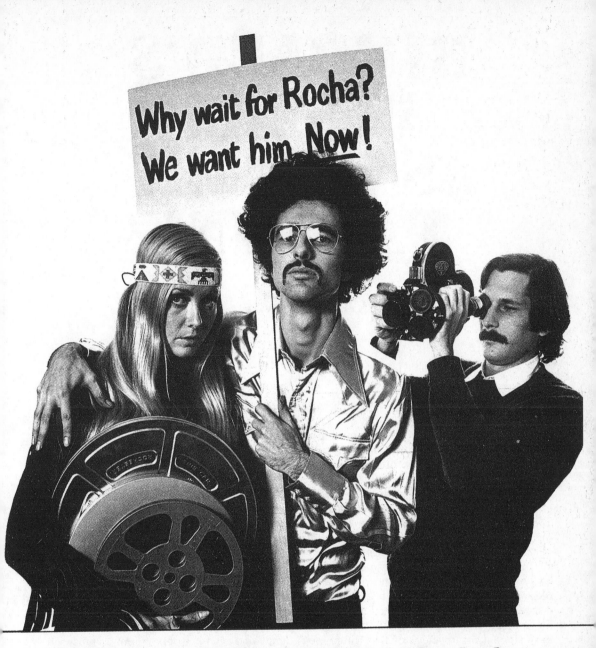

Bring Grove's Film Festival to Antioch or Ann Arbor, Oberlin, you name it!

Now you can have your own film festival, right on your own campus. With films that have won awards in Cannes, Venice and Berlin, and have brought audiences to their feet at the New York and San Francisco Film Festivals. Films like Glauber Rocha's *Antonio das Mortes* from Brazil, Evald Schorm's *The End of a Priest* from Czechoslovakia, Marguerite Duras' *Destroy, She Said* from France, Zelimir Zilnik's *Early Works* from Yugoslavia, Ousmane Sembene's *Mandabi* from Senegal, Nagisa Oshima's *Boy* from Japan, Miklós Jancsó's *Winter Wind* from Hungary. These are the films of the revolutionary new filmmakers from Europe, Africa, South America and Asia just about to have their U.S. première in the Grove Press Film Festival you'll hear more about in the months to come. They are all part of the Grove Press Film Festival Library you can now rent for your campus 16mm film club, your local film society— Take a look at the column on the left for more information. Grove Press Film Division, **214 Mercer St. New York 10012**

No. 74, January 1970

RIMBAUD'S DESERT AS SEEN BY PASOLINI

Wallace Fowlie

Pier Paolo Pasolini is both author and director of the film *Teorema* (1968). The title "theorem" is justified in the rigorous working out of a problem which the film reveals. It is a term used mathematically as well as mystically. The full title might well be given as *The Theorem According to Pasolini*, to complement the title of his earlier film, *The Gospel According to Saint Matthew*. *Oedipus*, another film of Pasolini's, is the supreme example of a mathematical demonstration of fate as the machine of the gods which explodes at a given moment and annihilates a man. As the triangle was used in the Middle Ages to designate the mystery of the Trinity, so the theorem was used by sixteenth-century French poets to represent the mystery of the Redemption: *Théorèmes sur le sacré mystère de notre rédemption* by Jean de La Ceppède, for example.

A theorem is a vision. *Teorema* is a vision presented in the form of a demonstration. Starting with the image of a handsome young Visitor reading Rimbaud, lines extend that touch and alter each member of a wealthy Milanese family. At first only the cover of the book is visible, but those spectators who know the iconography of Rimbaud recognize the sketch by the poet's friend Ernest Delahaye: Rimbaud with hair combed back "in the style of Parnassian poets." Later in the film the Visitor reads out loud to two members of the family the last few lines of Rimbaud's text *Les Déserts de l'amour*. By this time in the film, the two key themes have been lucidly established as the desert and love.

There are multiple derivations here: the spiritual meaning of Rimbaud's desert of love, and a familiar plot in pornographic literature in which a young man, either a visitor to a family or a member of the family, seduces in one varied scene after another every member of the family, including servants. This is the plot of Guillaume Apollinaire's pornographic story *Les Exploits d'un jeune Don Juan* and it is the general plot of *Teorema*. Although the accusation of pornography or at least eroticism will be leveled at Pasolini, the tone of his film, its beauty, and its meaning make it into a contemporary work of mysticism that draws upon sexuality and the desert of Exodus, of Jeremiah, and of Rimbaud.

Who is this intruder, whom we will call

the Visitor? His arrival is announced by a telegram, and his departure is announced by another telegram when the family is seated around the dining room table. Much of the film transpires between the two telegrams, which are mysterious signs, or commands, coming from the outside. Terence Stamp, who plays the Visitor, is quite literally a foreigner to this Italian family. He speaks very little and the few Italian words he utters may be dubbed. He is the "guest" whose origin is never made clear, although his function is closely related to that of redeemer, of doctor, of a divine emissary who will bring about a cure or at least a change in the lives of those he encounters.

One thinks of Eliot's *Cocktail Party* and the doctor, both psychoanalyst and miracle worker, who first mingles with the guests and later interviews each one separately. In the same way we see the Visitor in *Teorema* first in a gathering of young people, students from the *liceo*, relaxing after school. He is casually introduced to the family in the film and to the spectators in the theater. A girl asks the daughter of the family, "Who is that boy?" (Terence Stamp looks more Nordic than Latin.) She asks the question in English, and the answer, in English, is, "A boy." The meaning of *Teorema* depends on what interpretation is given the role of the Visitor. He bears no specific name.

The first member of the family to emerge with any degree of clarity is the young son, Pietro, age seventeen or eighteen, a charming, gracious fellow, affable and at ease with others. He is an athlete and has an easygoing relationship with his friends. His real interest is painting. In one scene he is looking at a book of reproductions of modern art. At the end of the film he has left his family to work alone in a studio, where he appears seriously disturbed as he goes about painting. We see him pouring paint from a can onto a canvas, and we see him urinating onto a blue canvas placed on the floor. Pietro is a redhead, and his physical resemblance to van Gogh is quite striking. This resemblance is all the more marked in his final scene of madness.

The Visitor's first important scene is with Pietro. It follows a soirée. The two fellows enter Pietro's bedroom where there are two beds. The boys undress and Pietro appears more self-conscious than the Visitor. The younger boy leaves his jockey-shorts on and hops into bed where, under the covers, he removes his shorts and puts on his pajamas. Natural and unabashed in all his movements and behavior, the Visitor takes everything off and we see him naked as he gets into his bed. He lies on his back, pulls the covers up to his chest, settles his head into the pillow and closes his eyes. As they are getting into bed, each boy says *buona notte* to the other. There is almost no conversation. The scene is a picture of a growing tension in Pietro and the balanced naturalness in the older boy. The son is handsome in a boyish way, and the Visitor is beautiful as an angel ought to be. The expression on his face is always angelic, as it had been in Stamp's earlier role of Billy Budd.

Pietro tosses about on his bed, unable to sleep. He starts to get up a few times, finally does, and stealthily approaches the other bed. He reaches down, takes hold of the bed covers with his two hands, and slowly turns them down. At that moment the Visitor opens his eyes and looks straight at Pietro. There is no surprise or fear in his eyes. But the young boy is terrified. He drops the covers and throws himself sobbing onto his own bed. Without hesitation, the Visitor gets out of his bed and sits down on the other bed. All we see is the side of his naked body and his arm patting the shoulders of his friend. His sympathy and his understanding are immediate. The shot is brief, but it is clear he is trying to say, "Don't be upset. I understand your desires. I like you. We can be close ..."

Later in the film, when the father is wandering about the house at daybreak, he opens the door of the boys' room and sees them sleeping together in the same bed. An almost imperceptible expression of understanding and acceptance crosses his face. The psychological problems with which *Teorema* is concerned are expounded not by speech but by means of facial expression, by the ever so slight expressions which are actually clear articulations. Only in one scene does Pietro speak at any length with the Visitor, just after the Visitor's departure is announced. He speaks then, not in the language of his age, but in a serious philosophical language, saying, "You have revealed to me the self I have tried to hide. I tried to believe the daily self, the social-athletic self, was real. Now I know

it isn't, and I don't know what is to become of me ..."

The maid in the family, the shy peasant girl Emilia, played by Laura Betti, is more moved by the presence of the Visitor than all the others. Twice we see her receive and sign for a telegram, the first one announcing the arrival of the Visitor, the second calling him away. The young lad delivering the telegram dances about between the entrance to the estate and the door, a caper that is half demonic, half angelic. He teases Emilia, pleads for a kiss, but she is impervious to his charms. In the first instance she is waiting for the revelation and in the second she has seen it: the Visitor, representing felicity.

Emilia's first big scene is on the lawn. Pasolini uses the vast lawn as a graphic means of showing the tragic distance between human beings. There is only a seeming peacefulness on the lawn. Invisible lines stretch out between the estranged figures— Emilia and the Visitor at first—to form the design of a theorem. The lawn spreads out like the desert that is shown after each sequence. The desert is the classical symbol of dryness and repentance, culminating in the final episode where, for the first time, one of the characters is seen walking over it. But the lawn and the desert are the same endless space where two human beings cannot meet.

Emilia is raking leaves on the lawn in her first scene and, at some distance from her, closer to the house, the Visitor sits reading a book, his legs spread far apart. If we accept the truth of the camera, Emilia is looking not at the Visitor's face but at his crotch. The theme of the bulging male crotch, insistently reiterated by Pasolini's camera, is a major clue to the film. When ashes fall from the cigarette the Visitor is smoking onto one of his thighs, Emilia rushes over to him, kneels down, and brushes the ashes away. He smiles faintly, a smile composed of surprise and knowledge. Her hand has almost caressed his crotch.

When Emilia's longing for the boy reaches a peak, she runs across the lawn into the kitchen and attempts suicide with gas. The Visitor knows what is happening and follows Emilia into the kitchen, interrupting the suicide attempt. He drags the young woman to her room, stretches her out on her bed, and then, as if to pacify and cure her, stretches out on her body as the prelude to intercourse.

When the Visitor leaves the house—this is a culminating moment in the life of each character—Emilia becomes a saint. She returns to her farm, refuses to eat anything except boiled nettles, heals a sick child, is seen suspended in the sky, and, at the end, with the help of an old woman who understands the way of martyrs, is covered with dirt in a ditch, close to a bulldozer. Only her eyes are left uncovered. Her tears make a pool beside her head. All the classic elements of sainthood are included in the Emilia sequence. Thanks to the seduction-cure of the Visitor, she enters into another kind of life.

Silvana Mangano, remembered for her beauty and for her role in *Bitter Rice*, and still beautiful in the Italian masklike style, plays the part of the wife, Lucia. Until the arrival of the young Visitor, she has been the impeccably dressed, chaste, bourgeois wife. She describes herself in precisely those words to the Visitor. Obviously bored with her existence, she spends much of her time in her room, changing clothes and perfecting her makeup.

She too, like Emilia, is sexually aroused by the physical proximity of the Visitor. One morning when the children are at school and her husband at the factory, she hears him racing with a dog through a wooded swamp close to the house. She takes off her clothes and throws them from the porch to the ground a floor below. She stretches out naked on the porch and waits for the stranger. He comes, with the dog at his heels, and calls out "Lucia!" "*Sono qui,*" Lucia answers, and he goes up the stairs to the porch. Again, when he looks at Lucia, he shows very little surprise, almost as if he had controlled the scene. And again, his smile is an extraordinary combination of innocence and ambiguousness. He makes love to her, in a totally simple, chaste way, because love is a sacrament in this film.

This act has the effect of liberating Lucia from the sterility of her marriage. But the temptation to pure carnality is strong in her, and she offers herself first to a student, and then to one of two young men she picks up in her car. This final act is humiliating and degrading. To take her, the boy pushes her ahead of him into a ditch near a church outside the city. Later we see her returning to the church. This last experience seems to be one

of repentance and illumination. Only temporarily was she the apostate from love.

Odetta, the daughter, appears in an early scene. As she is leaving school she is approached by a fellow student who makes a mild pass at her. She runs away from him. The only male who counts in her life is her father, Paolo. During her father's illness she watches the Visitor practice a strange kind of therapy on him. The older man is in bed. The Visitor pulls down the covers (just as Pietro one night had pulled the covers from the Visitor). He then sits on the bed and places Paolo's legs one on each shoulder. A curious posture—Paolo wearing pajamas and the Visitor fully clothed—until one realizes that it is a position for sodomy. Again the eyes speak. An intense kind of understanding passes between the two men as Odetta watches. She knows her father is being cured and turns toward the Visitor in gratitude.

This gratitude then turns to love, of the most intense and hopeless kind. The second scene of Paolo's cure is on the lawn. The convalescent is in a chair and is drawn to the Visitor, who is reading Rimbaud. This time he reads out loud. Odetta runs into the house—an action reminiscent of Emilia's—in order to get her camera. She then photographs both men, but concentrates on the Visitor. The young man playfully assumes comic poses, which are also sexual poses in which he exhibits himself.

This lawn scene is followed by one in Odetta's room where she shows pictures and mementos of the past to the Visitor, and then offers herself to him. She sits on the floor between the boy's legs and then turns her head slightly and rests it on his crotch. On turning about and facing him, she opens her dress to show him her breasts. He caresses her face. Soon after the Visitor leaves the house, Odetta enters a state of paralysis. One of her fists remains tightly closed. Her entire body is benumbed and she is unable to speak. She is finally taken away by hospital aides.

Anne Wiazemsky, the young actress who plays Odetta, and the wife of Jean-Luc Godard, rarely alters her facial expression. (This seems to be true of every role I have seen her play.) Her eyes are intense and sad. She articulates very little. Her sadness is almost the expression of sulking. It is the look of a girl suffering from psychic depression and

admirably suited to the role of Odetta. She is a young girl—too heavy for her age—who looks ungainly when she runs. Five actors are seen running in *Teorema*—the telegram boy, Emilia, Odetta, Pietro, and the Visitor—and thereby trace on the lawn or along the Po the lines of a theorem.

Paolo is the figure in the film who has gone deepest into the desert, deepest into the desolation of himself. The opening sequence shows the desert of the factory, a vast uninhabited expanse, seen at the end of the day when the workers have left. It prefigures the empty, deserted, colorless routine of existence in the home. Paolo is driven away from the factory in his car by a chauffeur. Then gradually we see flashes of the real desert in between the succeeding episodes of the "theorem." Insistently the desolation of the heart is reiterated in pictures of the windswept desert.

Paolo and his wife in bed are the picture of the estranged couple, of the wife who does not want to make love and of the husband who suffers from violent dreams and who stretches out on his wife in a sterile effort to make love and resume a sensual relationship. In the scenes of convalescence Paolo never appears with Lucia. In two scenes, in his bedroom and on the lawn, he is with Odetta and the Visitor. In both of these scenes, the Visitor propositions Paolo by silent gestures and poses a sensual release.

Then comes the significant scene when Paolo and the Visitor, a pseudo-father and pseudo-son, drive away from the house, and instead of going to the factory, stop by the Po River, in an uninhabited section of the city. Laughing, the Visitor runs along a path by the river to a secluded, swampy area. Paolo follows him. When he catches up, he sees the boy stretched out on his back, waiting. This kind of scene of lovemaking in a deserted place is an often repeated theme.

Paolo, the father figure, is the strongest symbol of the desert. After the desertlike factory, with its vast empty spaces, we see Paolo in the desert of his king-sized bed where, close to Lucia, he cannot consummate the sexual act. Then we see the desert of his illness when he is attracted to the Visitor. These scenes culminate in the riverbank scene, in which there is a return to the warmth of human closeness.

This leads to the father's decision to sell the factory and give it to the workers. We see him wandering through the railroad station, which greatly resembles the factory. He passes track after track and comes to the center of the station. There, outside the men's room, he looks at a young fellow sitting on a bench. The boy, although heavier set, resembles the Visitor who has by now left the family. This resemblance may be the reason why the father is unable not to look at him. The camera focuses on the faded blue jeans and the crotch of the boy, the reincarnation of the Visitor. The fellow obviously believes he is being propositioned by the man, and after rubbing his crotch slightly as a sign, be gets up and goes into the men's room.

But the struggle in the father is over. He slowly undresses in the middle of the station as a few people gather around him. At the end of the sequence we see only his bare legs and feet as he begins to walk off. Then the camera moves to the desert. At a great distance, Paolo appears, naked, half walking and half running with difficulty because of the sand and the wind and his exhaustion. He is now naked to his fate. The camera follows him in his slow progress across the desert, and we think of the running figures on the well-kept lawn of the large house. A piercing cry from Paolo ends the film. It is a Saint John the Baptist cry in the desert, where there is no one to hear him.

Of all the protagonists, the struggle is most intense in Paolo. But the same struggle takes place in Pietro, Odetta, Emilia, and Lucia and the Visitor is the force precipitating it. And in each case, the struggle is made real by a sexual encounter that is interpreted by Pasolini as pure, as an act that is innocent and necessary.

The love—momentary as it is—that the Visitor shows for the three women and two men *is* the action in the film. Each of the five characters looks to the Visitor for sexual fulfillment and receives it. Thus each of the five lives is, momentarily, removed from the desert. But each returns to the desert after the departure of the Visitor: Emilia to martyrdom; Lucia to a new sense of religious life, barren of human contacts; Odetta to the total solipsism of physical and mental paralysis; Pietro to the creation of art (which will be an upsetting experience at first because it is so closely associated with the Visitor); Paolo to the real desert of another existence, cutting himself off from everything human—family, factory, love, habitation, clothes.

The film is the work of a poet. Rimbaud's prose poem *Les Déserts de l'amour* provides a clue to *Teorema*. The text is studied silently by the Visitor as he reads to himself, and in one scene with Odetta and Paolo, he reads a few sentences from the end of the poem out loud. They are two sentences about the visitation of a being or angel who entered the daily life of the poet, manifested kindness, and then left forever. This is the summation point of the film.

The contemporary interpretation of such a visitation would be sexual. The title *Teorema* seems to demonstrate the logicality of sex. All of the sequences are complex in meaning. The beauty of the colors in each scene—the trees and the shade of the trees, the play of light, the varying shades of green and brown—as well as the sensitiveness of each of the love scenes, is the cinematographer's attempt to express something for which there is no pure verbal equivalent in the film.

Each of the major scenes is a confession, and the Visitor is the priest listening to the confession. The sexual act he performs with each is the absolution, the forgiveness, the chance of beginning again, the momentary cure. Sex in *Teorema* represents a nonverbalized concept of love. It is gratuitous and angelic. Sex is a visitation. The role of Terence Stamp is comparable to that of Oedipus and Jesus in Pasolini's two earlier films, and to the role of the son in his most recent film, *Porcile*, or *Pigpen* (1969).

The Visitor-teacher uses sex as a mode of psychotherapy in order to reduce the emotional anxiety in each of his patients. He appears intelligent and detached and without guilt. In his sexuality he is offering a new innocence to each lonely, frustrated, and sad member of the family. This supernatural Visitor comes in order to break down the sterility of men and women. The offer he makes of his sex is both natural and sacred.

In Exodus, the Chosen People reach the Promised Land by way of the desert. The prophet Jeremiah speaks of God's love for Israel and Israel's love for God. Midway in the film the narrator recites a short passage

from Jeremiah (20:7) about the daily derision the lover feels in others: "Everyone mocketh me." At the end of the film, naked Paolo crosses the desert as if he were following the column of fire.

Rimbaud himself seems to be speaking in *Les Déserts de l'amour*. In several passages the poet could easily be the boy reading in *Teorema*, the mysterious Guest who sees in retrospect what the film is revealing: "It is a Woman I saw in the City ... I saw her in my bed, completely mine ... it was the family house ... she, a worldly woman, was offering herself ... I went into the endless city. O weariness! ... Finally I went to a place full of dust."

As in *Teorema*, Rimbaud's dream is a series of hallucinations, mingling rustic and urban scenes, that transcribe a great spiritual effort. The prose poems (*Les Illuminations* as well as *Les Déserts de l'amour*) and the film narrate a defeat. In Rimbaud, it is the awkwardness of a youth and his inferiority complex in the presence of a worldly woman; in *Teorema*, it is the opposite: the inability of the members of the family to sustain the revelation of the Visitor. The country house, the city, the desert, the factory, the station, are places that stretch out interminably, as in a dream where the protagonist crossing them can never reach the end.

There is more sadness than anguish in *Teorema*, and this is also true of Rimbaud's prose poems. The *Théorèmes* of Jean de La Ceppède contain the sum of Christian doctrine. Like them, the sequences in *Teorema* are pictures, highly colored and concrete, each one depicting a change from the boredom of routine to a physical adventure that propels each character into a desert where spiritual fulfillment may be reached.

MISTER FREEDOM: AN INTERVIEW WITH WILLIAM KLEIN

Abraham Segal

Question: *I saw* Mister Freedom *in Paris and I had the impression that the audience reacted very well, that people are receptive to what's said and shown in the film.*

Answer: It's funny, but I rediscovered the film, what its intentions were, in commercial movie houses after having, more or less, let it get away from me in private showings.

Q: *Because if you judge by the reaction of certain critics ...*

A: Well, everybody knows what critics are like. I was very conscious of this in America with the film *Far from Vietnam*. There were critics who went stark raving mad and launched into political explanations on the level of a concierge in a fit of rage.

I noticed that certain people are shocked by the film's vulgarity, and others by its violence. They're shocked by the vulgarity and the violence in a film—a Punch and Judy film, a graffiti film—but they don't seem shocked by the vulgarity of a Johnson or a Rusk announcing for the 2600th time that "We are waiting for a gesture of reciprocity

from Hanoi." If that isn't the most abominable vulgarity, what is?

The film isn't nearly as bad as the reality, a reality where people talk like missionaries and drop three million tons of bombs on a little country that hasn't done anything to them.

It's vulgar and grotesque bad faith when Americans boast of having stopped the bombings in the North ... It's a good deal for them—they lost lots of planes in the North ... Now they're dropping all their bombs on the South—which was already getting four-fifths of them.

What can you call behavior like that?

There's no exaggeration in the film, to my mind. On the contrary ...

Mister Freedom is an American folk hero, if you like, the American hero of American films. He's John Wayne, Burt Lancaster ... John Abbey! You find the face that Americans put on in films. The guy who wants to do the right thing, who even gets conscience-stricken, the guy who tortures himself, who asks himself questions. This anguish is a big performance they put on. In his speech in San Antonio, Johnson said, "Every night before I

go to bed, I rack my brain, I ask myself: 'Have I done enough for peace?' I pray each night that people will understand that violence is useless, that people want peace all over the world."

But to me Mister Freedom isn't touching. I find him ridiculous and I emphasize this, when he begins to have doubts, by a super-syrupy music. There's music by Stephen Foster in the background: "Old Black Joe." The sentimentalism of spirituals written by whites, a mixture of a bad conscience and tears about the lot of the blacks.

I think I've brought out very strongly how grotesque Mister Freedom's dialogue and his attacks of conscience are. And he's completely crushed when Marie-Madeleine's kid calls him a fascist ... he even gets stigmata.

Q: *I think the denunciation is even more forceful in that he has a human face. A ridiculous one, a grotesque one, but a human one. If Mister Freedom were simply the ...*

A: ... the evil robot, yes of course.

Q: *Your film is openly political, but this doesn't prevent it from winning public approval.*

A: Which proves, perhaps, that I was right to use our folk imagery, because films like *Far from Vietnam* didn't go over very well. How can you get people to go to a film and want to talk about it, discuss it, when they come out? I made a film that's a kind of booby trap. People may come to see adventure, fistfights, and ...

Q: *I don't think so. They're aware that it's about politics.*

A: It's obvious that you have to put on a mask in order to talk about politics in a commercial movie house in France or anywhere else. I put on a mask when I make this sort of film. You try to fool the distributor with stills of fights, of bare breasts, and so on ... but I must say the distributor doesn't go along that easily! What can be done?

In Cuba the film industry is in fine shape. There are directors there like Santiago Álvarez and the directors of the national cinema, Alfredo Guevara and Saul Yenin—very capable men who know a lot about film. They want to do films and television programs that not only answer the needs of the country but are also quality productions. And they manage to. But can this be done anywhere else besides Cuba?

Q: *The spectator doesn't have much trouble recognizing the reality behind the masks.*

A: When he hears Mister Freedom saying, "I'm ready to go anywhere to discuss peace with anyone," it seems to me that the next time he hears Johnson or Nixon say that he'll burst out laughing or choke with rage.

People in France aren't that familiar with certain of these formulas, but in the United States people will recognize them right away.

Q: *Here, on the other hand, the audience was very receptive to the meeting with Super Frenchman.*

A: Yes, but there were things that were censored. Super Frenchman says: "I prefer my dictatorship to that of the people, of Freedom, of Moujikman, of Red Chinaman." They asked me to take this sentence out. I suggested that the word "dictatorship" be replaced by "democracy." They said that that was very insidious, but they couldn't object to the word "democracy."

Q: *There's a certain vagueness surrounding the reasons for Mister Freedom's failure. Was it because of a trick pulled by a French girl, a "Red" agent, as Claude Julien tried to lead us to believe?*

A: No. It's quite clear in the film that Mister Freedom's defeat isn't due to dirty tricks on the part of Marie-Madeleine—she's a kind of double-agent Delilah—but rather to a popular uprising, which catches the [Communist] Party as much by surprise as the one in Czechoslovakia. And Mister Freedom's defeat is a local thing, and not clear-cut. The struggle continues, as they say.

Q: *But the intervention of the Anti-Freedom commandos is very important.*

A: When I began the film a year ago, I couldn't imagine what form a popular uprising might take in France. So I thought of a front with

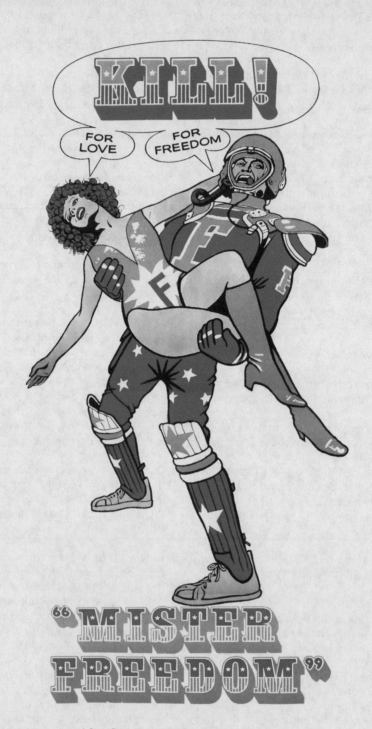

A Grove Press International Film Festival Presentation
Starring Donald Pleasance, Delphine Seyrig and John Abbey ■ Film by William Klein – An O.P.E.R.A., Paris Film

Poster for *Mister Freedom* created for the Grove International Film Festival, March 1970

ties to the Russians (like the Cubans, for example), which at a given moment would break off with them and act independently.

The stylization creates problems for some people. Rightly or wrongly, I used a comic-strip style. A few Marxist-Leninists have reproached me for having represented seven hundred million Chinese in the form of a dragon. They think it's a caricature. It's all right to caricature the enemy, but not your friends. But the basic style of the film is that of a carnival puppet show, and it would have been stacking the cards if all the characters hadn't been carnival-like.

Even in the Chinese and Vietnamese mime plays *everyone* is masked and made-up.

The Anti-Freedom commandos wear a sort of uniform. If you really wanted to depict a popular movement in France, that's not the way you'd go about it.

In any case, it's not a film about the May revolution—as certain people think—but rather a fable about a little country pitting itself against imperialism.

The Anti-Freedom commandos want to change over to direct action. They break with the Russian who wants to make a deal with Mister Freedom.

Q: *Nonetheless, Marie-Madeleine is an ambiguous person.*

A: There are several conventions people may have some trouble accepting and perhaps I'm wrong to use them. I don't know. Mister Freedom is something like a sheriff, or a James Bond. So certain film conventions are taken for granted, and exaggerated to the point of being absurd. The spectator must react in a Pavlovian sort of way, and then be brought back to reality or awakened by breaks in the tone so that he *sees himself* reacting. Marie-Madeleine is one of these mechanisms. But I thought it was clear when and how I put a stick in the wheels of the mechanism.

Q: *At certain moments the spectator finds a direct correlation between the characters in this fable and particular political personalities. But we can also tell ourselves that once the convention of the circus is accepted, we're free to put any face we please behind the mask, and therefore it's possible to interpret your intentions differently.*

A: There's a particular person behind most of the masks, or else the particular behavior of a certain country, a particular politics.

Mister Freedom is all the Westmorelands, the MacArthurs, the pin-up boys of the war. Doctor Freedom represents the system and its leaders—the Trumans, the Johnsons, the Nixons, and the Kennedys.

Almost all of Mister Freedom's dialogue is made up of sentences from Rusk, Johnson, McNamara. The ambassador is Lodge–Harriman. Moujik talks like Khrushchev. The Chinese Dragon gives out warnings like the 2000th solemn warning broadcast by Peking Information, and so on.

Q: *Red Chinaman is the only one not to have a human face.*

A: That's what the Marxist-Leninists have said. But the others aren't any more human. De Gaulle is an inflated bladder. There are ministers who are pinball machines. And Mister Freedom himself is a doll, he comes unjointed, he falls to pieces.

They're clichés, they're folk images, popular prints. So in this gallery of images, China is a dragon. In order to illustrate this, I looked around for a dragon like the ones you see at popular festivals in China, as well as in Chinatown in New York, but I couldn't find one, so I designed an inflatable dragon. The biggest and the least expensive one possible, because you mustn't forget that the film cost relatively little. It was made for $270,000 in two complete versions, French and English, and when you think of all the sets and costumes … And it was shot very fast—six weeks isn't very long for this sort of film. But naturally it took lots of preparation and tinkering.

Translated by Helen R. Lane

Grove International Film Festival Catalog, Spring 1970

Destroy, She Said: An Interview with Marguerite Duras

Jacques Rivette & Jean Narboni

Question: *It seems you want more and more to give successive forms to each of the things—let's not use the word "stories"— that you write ... for instance,* The Square, *which had several versions, or* La Musica, *which also had several forms, or* L'Amante anglaise. *This corresponds to ...*

Answer: To the desire that I always have to tear what has gone before to pieces. *Destroy, She Said* is a fragmented book from the novelistic point of view. I don't think there are any sentences in it. And there are directions that are mindful of screen plays: "sunshine," "seventh day," "heat," "intense light," "twilight"—do you see what I mean? I would like the material that is to be read to be as free as possible of style. I can't read novels at all any more. Because of the sentences.

Q: *When you wrote these stage directions, was the idea of a film lingering in your mind? Or was it simply because you could only write in this form?*

A: I had no idea of a film, but I did have the idea of a book ... of a book that could be either read or acted or filmed or, I always add, simply thrown away.

Q: *In any case, you had theater in mind somehow ...*

A: Yes, yes, Claude Régy was to stage it, but I made the film first, I couldn't help it ... I believe it necessary to create things that are more and more timesaving, that can be read quickly, that give the reader a more important role. There are ten ways to read *Destroy, She Said*; that's what I wanted. And ten ways to see it, too. But, you know, it's a book I hardly know at all. I know the film better than the book; I wrote the book very quickly. There was a good scenario, called "The Chaise Longue," which we tried to film; but it came out of a certain kind of psychology, maybe a searching one, but psychology nonetheless; and Stein wasn't in it ...

Q: *Did the scenario come before the writing of the book?*

A: "The Chaise Longue," yes. There were only three characters. Still, as a story it was

obviously classical. When I found Stein, the scenario wasn't any good at all any more, and we threw the whole thing out that same day.

Q: *I was struck by an interesting contrast between film and book. The directions for the characters are very brief in the book, but a number of acts and gestures in the book are omitted from the film. In the end, the film is a kind of mechanical process that is exactly the opposite of the one whereby a bad filmmaker who adapts a book keeps the events, the facts, the physical acts, and leaves out everything which would seem, on the contrary, to belong to the writing itself. And here one has the impression that you took out everything that would seem to stem directly from "cinema," and that you kept what would seem to belong to the realm of literature.*

A: That is correct; I had a feeling that this was so. Are you thinking of any special gesture?

Q: *I'm thinking of several: the moment, for example, when Stein strokes Alissa's legs. The only part of this passage that is left in the film is the conversation.*

A: It so happens that during rehearsals I realized that it was impossible, because of Michel Lonsdale, who is gigantic. He was too important, if you like, sitting there at Alissa's feet, close to her legs. I had to keep him away from the other two, so that they wouldn't be completely overwhelmed. So it was really for practical reasons that I came to omit this gesture. I worked on the possibility of keeping this gesture for a long time. I wasn't able to do so, and I'm sorry.

Q: *But there were rehearsals that took place before ...*

A: They were at my house. For a month and a half.

Q: *Did you rehearse everything before shooting?*

A: Yes.

Q: *But wasn't it also true that Stein at that point was too much on the same plane as* the other characters? *Or was it just this one gesture that was impossible?*

A: Oh, it's very hard to say why it was impossible. It wasn't possible; it obviously wasn't possible. Or else it would have been necessary for him not to say anything. It was a choice of either the gesture or the dialogue. I think it was because of Michel's size. What did you think of him in the film?

Q: *He is magnificent. He is always a very great actor, but here he is even more of one; it's really great to see him finally being used ...*

A: This was the first time. The first time he has ever been used like that ...

Q: *And did the other actors come to mind immediately? This is one of the things that make the film really impressive: the choice of the five actors, the way they harmonize. And I personally was flabbergasted when Gélin was used.*

A: I thought of Gélin almost immediately. The hardest one to find was Max Thor: Garcin.

Q: Destroy, She Said *is made up structurally of people watching each other at different levels. For example, someone is watching the tennis court and is watched by someone else, who in turn is observed by a third party, and the narrator, or whatever plays a narrative role, more or less takes up these stories and sees what these watching eyes see ...*

A: You see a narrator? ... It is the camera.

Q: *Does it exist as a watching eye?*

A: Yes, in the film.

Q: *Perhaps the expression "watching eye" is not the right one. Let's say, then, a last determining factor, a last court of appeal.*

A: As if someone wanted to tie the whole thing together?

Q: *No, it is not something static, but a watching function, so to speak.*

A: But this watching function can also be

called identification with the character. Do you agree with that? With the sacred law that Sartre laid down in an article answering Mauriac, I believe, about twenty years ago, in which he said that one could identify only with one person. To reach the other characters it is necessary, therefore, to do so through the character with which one identifies: if there are A, B, C—A being the spectator and the character with whom one identifies, one must go through him in order to reach B and C.

Q: *Yes. Sartre accused Mauriac of taking himself for God and dominating all the characters.*

A: That's right. But this is a law that has applied to spectacles for centuries now. And to novels, too. I attempted to break this law; I don't know whether I succeeded. There is no primacy of one character over another in *Destroy, She Said*. There is a gliding from one character to another. Why? I think it's because they're all the same. These three characters, I believe, are completely interchangeable. So I went about things in such a way that the camera is never conclusive with regards to the way one of them acts or the words that another speaks. What one of the men says could also be said by the other. What the other says, the third person, Alissa, might say as well. The men are slightly different from Alissa, it is true, since she doesn't speak of the men, whereas the men speak of her. She never judges. She never goes on to think in generalities.

Q: *That is to say that you confronted the risk that the camera might become God ...*

A: This is a nineteenth-century prejudice that still holds sway in filmmaking ...

Q: *You refused this sort of closure that always makes the camera enclose a space or imprison a character by making it assume multiple roles, in the same way that the characters are interchangeable throughout the film.*

A: Yes, that's it, that is what I tried to do.

Q: *This is strikingly evident from the very first shots, shots that I saw in the beginning as*

representing the watching eye of a character and then in the end, within the very movement of the shot, focusing from the outside on this very character whose eyes the spectator thought he was seeing through.

A: In my script, moreover, there are many directions that point to what you are saying: "So and so is seen watching someone else."

Q: *This was in the book, too, but it was indicated by other means—the means of the book.*

A: But it is the relation between the people that isn't right, perhaps, in *Destroy, She Said*.

Q: *In any case it is a film in which the spectator is obliged to pay close attention to the way in which the camera behaves toward the characters. And for that very reason it is fundamentally different from* La Musica, *where the camera had a much more traditional role in relation to the characters.*

A: From the point of view of the camera, I'm not sure quite what I did; you're teaching me things ... When I planned it, it seemed to me that that was what had to be done, but I did so almost without thinking it out beforehand.

Q: *There is one passage where the difference between the book and the film is quite striking: the first long dialogue—or perhaps the very first dialogue of all—between Alissa and Elisabeth. In the book this is interrupted by the gaze and the words, the commentary of Max Thor and Stein, and which in the film, on the contrary, is continuous, though the spectator may think that this continuous gaze of the camera corresponds to the point of view of the men, or of one of the two men, on the two women.*

A: Yes, that posed a problem. If the men had been shown watching the women, Alissa would have known that she was being watched. And she would have been a bit more cagey with Elisabeth Alione; knowing that she was being watched, and acting as if she were not being watched. I could not bear the least suggestion of caginess on Alissa's part ... The men are behind a bay window ... There are voices offscreen during the

dialogue between the two women. During the dialogue, there is: "In the bedroom Alissa has no certain age." "It is the void that she is looking at …" And then I wanted the two women to be alone. It's a long scene. No, it isn't too long: I cut a little bit of it … This long stretch of time … Dull. Banal. Dirty and gray … would have obviously been broken up. You can imagine how hard I had to fight to keep this scene this long. Many people said to me: "It's impossible; they exchange nothing but banalities." But that's exactly the point …

Q: *But was it for practical or other reasons that there are a number of shifts of scene from the book to the film? Scenes which, for instance, took place in the book in the main dining room of the hotel take place outside in the film, or vice versa.*

A: It was because we had only one room to shoot in, one room and a little adjoining room.

Q: *You, in fact, didn't have a room representing the main dining room of the hotel?*

A: Yes, but we finally replaced it with a terrace. We didn't have a hotel building. Someone had loaned us the grounds, and an old converted stable …

Q: *So it's for purely practical reasons that you shifted various scenes.*

A: Yes, yes. But there were two possibilities—outside or inside—for all the scenes.

Q: *But did you intentionally change from inside scenes to outside ones, or on the contrary …*

A: This was done deliberately, and what is more, I couldn't do anything else because the weather was bad. I took the scene of Alissa's arrival with her husband out of doors, for example, because I had filmed the preceding scene indoors since the weather was bad … the scene with the letter.

Q: *The card-playing scene, too?*

A: Yes, and then, too, there were some scenes that in any case could only be indoors: there

are two of them. Because the dialogue would have gotten lost outside, it seems to me.

Q: *This is obvious in the case of the second long scene between the two women, which was also indoors in the book, but not in a bedroom, as I remember.*

A: It was in Elisabeth Alione's bedroom. No, it was in the dining room. They both act well in this scene.

Q: *And all through the film. The card game is a very extraordinary moment. What Catherine Sellers does in this scene is really tightrope-walking. But it is beautiful, because you aren't aware that it's tightrope-walking.*

A: It was awesome. Really awesome. Because at the same time there is the way she handles the cards, which changes little by little. She completely forgets everything she knows in a few seconds. But she really did this all by herself: no one can lay down rules for a thing like that. She played cards all by herself at home; she didn't know how to hold a card before the film.

Q: *I had the feeling that the playing of the hands of the three other players around her was very precise, very closely controlled.*

A: We focused on their hands: the camera came in close and once their hands were in the film frame they were free, except for Stein, who had to stay in the foreground with his cards. So inevitably he was constantly in front of the camera, rooted to the spot … We rehearsed the card game spot for a month. And at the end of the month I realized that it was completely useless to see the others, that their hands alone were enough …

Q: *To get back to the question of the role of the camera that we were discussing a moment ago, there is another moment that struck me, but this time it's a passage that's been cut up, the scene—the next to the last scene, if one can divide the film into scenes—of the five characters around the table where there is an overall shot that recurs from time to time and punctuates the sequence, and closeups of the five of them. What especially impressed me was that the closeup of Daniel Gélin is*

from a point of view that seemed to me to be clearly that of Elisabeth, from the very way in which people's gazes are oriented ...

A: Yes. That is to say, all the other angles have been abandoned; this gave us some trouble, as a matter of fact, during the montage. We abandoned all the other angles in favor of the one that passes through Elisabeth. The scene where they eat together caused me so much trouble ... I abandoned one angle completely because from the other side of the window that is in view, from the broad grassy plot, there was a window with bars over it. I could not shift the angle; that is to say, this window with bars over it would have reminded the audience of a mental institution. I didn't want that. So I had a white curtain hung up. But this white curtain was worse than nothing at all because it gave the impression that there was another room, that Gélin, as seen in the angle of the window, was suddenly elsewhere. So removing those two angles resulted in there being only one angle in the end.

Q: *But this is where the role you would like the viewer of the film to take begins—to install Elisabeth in the camera's place, and situate even the absence of Elisabeth there, so that the same angle, the same diagonal, continues to run toward Gélin. I had the impression that there was this sort of line linking Bernard Alione and Elisabeth that became even more powerful precisely when Elisabeth is supposed to be on the grounds of the hotel ...*

A: It's a sort of line of force, since Gélin resorts to Elisabeth in order to know what is happening. He often says: "What is happening?" and looks to his wife to tell him what is going on ...

Q: *Yes, and at the same time, it's not as if he were judged by her, but still were more than looked at, more than merely observed. It's as if this angle, which has to do with Gélin, made her suddenly see him as if she had never seen him before ... She discovers him through the medium of the three others. And the role of the camera emphasizes this fact strongly.*

A: She is already inside the dialectic, in a sort of natural dialectic that she has either found anew or discovered ... But there are two characters who belong entirely to me, and two characters who do not belong to me in the film. I don't know whether this is noticeable. Alissa and Stein are completely familiar to me, whereas Thor and Elisabeth are characters outside myself.

Q: *Thor is the most opaque character.*

A: He's asleep ... Thor is in a sort of catharsis: he is in this state when he meets Stein, and at the end of the book and the end of the film he still is; they are identical. In the end Thor asks Stein only three questions—and it is all over. After that he talks like Stein. As early as the meal they eat together he talks like Stein. They are interchangeable ... They are equally indecent. I wanted their indecency to be absolute; I don't know whether I succeeded in showing it to be so. Immodesty and indecency. But natural. This was what was hardest to get out of the actors. But they managed in the end. Garcin is an adorably humble person, you know. As he had had very different roles in the theater, he was ready to do anything to change. All five of them are absolutely marvelous. Shall we talk about the ending?

Q: *Was the ending of the book as noisy for you as the last shot in the film?*

A: No.

Q: *In the book there is a brief notation having to do with the importance of the music whereas in the last shot of the film the sound effects are very important.*

A: And the poses are different too; in the book Alissa was lying on top of Stein, as if on a plot of ground, a piece of land. She was stretched out on Stein's physical body. This was not possible in the film. A change was necessary because of the image. Because Stein was then completely immobilized by Alissa's body. And the music—in order for the whole thing to take on meaning ... The music stands for revolution. I had to murder it up to the very end ... if it had suddenly been very pure and very carefully decanted ...

Q: *One feels that the music is a struggle ...*

A: I would have liked to distort it even more, but I didn't find any way of doing so. The noise is a piano. It's a Pleyel concert grand. The scene takes place in a salon in the middle of the hotel grounds, with the windows open and the piano open, and we let the piano lid fall. During the montage the attack of the notes was cut off, and all the harmonics are heard. This is the noise on the sound track. Michael, the sound engineer, and I did it together one evening. But the mixing of the noise on the last reel was rather funny, because the engineer couldn't bring himself to ruin the music. He simply couldn't. I spent twenty minutes urging him to go to it. I gave him superb music and I told him: "Spoil it." He couldn't. And I said to him: "No, go ahead! Go ahead!" Finally he got desperate and did a thorough job of it ... Don't you want to talk about the political side of the film? Can I read you what I say in the trailer? I'm going to read it. Someone asks me the question: "Where are we?" "In a hotel, for example." "Could it be some other place?" "Yes. It is up to the viewer to choose." "Don't we ever know what time it is?" "No, it is either nighttime or daytime." "What's the weather like?" "It's a cold summer." "Is there anything sentimental about it?" "No." "Anything intellectual?" "Perhaps." "Are there any bit players?" "They have been eliminated. The word 'hotel' is said, and that ought to be enough to represent a hotel." "Is it a political film?" "Yes, very much so." "Is it a film where politics are never spoken of?" "That's right. Never." "I'm completely lost now ... what do you mean by 'capital destruction'?" "The destruction of someone as a person." "As opposed to what?" "To the unknown. That the communist world of tomorrow will be." "What else?" "The destruction of every power ..." I'm perhaps going to change that a little ... "the destruction of all police. Intellectual police. Religious police. Communist police." "What else?" "The destruction of memory." "What else?" "The destruction of judgment." "What else?" "I am in favor of ... closing schools and universities, of ignorance ..." I added the word "obligatory," but this would amount to decreeing something. I go on: "I'm in favor of closing schools and universities. Of ignorance. Of falling in line with the humblest coolie and starting over again." "Of falling in line with madness?" "Perhaps. A madman is

a person whose essential prejudice has been destroyed: the limits of the self." "Are they mad?" "They may be in today's outmoded system of classification. Communist man of the year 2069, who will be the absolute master of his freedom, of his generosity, would be taken for a madman today and put behind bars." "Why a German Jew?" "Please understand: we are all German Jews, we are all strangers. This is a slogan from the May revolution. We are all strangers to your State, to your society, to your shady deals." "What is the forest?" "It is also Freud." "You say that it is classified as a historical monument?" "That is quite correct. Freud and Marx are already pigeonholed by culture ..." "Well, I'm going to ... Is it a film that expresses hope?" "Yes. Revolutionary hope. But at the level of the individual, of inner life. Without which ... look around you. it is completely useless to make revolutions." That's how it reads. So I'm out gunning for an entire part, a whole sector of the public ...

Q: *Do you really think that wiping the slate clean is the only ...*

A: What other means do you have of catching up with the rest of humanity? What other way do you have of reaching absolute zero? I went to Cuba a while ago. I spoke with students, I talked with people at the university. They said to me: "Should we read Montaigne? And Rabelais? We don't have them here." What would you have answered? Even if I had said no, I still would have been posing as an authority. I said: "I have no opinion." So then. We won't soon see the end of this state of affairs. And it doesn't matter that we won't. It is not because there is no solution that things are in a mess. May was a success. It was a failure that was infinitely more successful than any success at the level of political action.

Q: *What disturbs me is the fact that people don't want to think about the work that the person must do, work that your will sets before you at the zero point. I believe there is no escaping the work one has to do on oneself, by oneself.*

A: But is this work in the strict sense? You know that work was invented in the

nineteenth century ...

Q: *No, I'm speaking of a kind at work ...*

A: Inside the self?

Q: *Inside and outside: an interaction, in fact, between one's action on what for convenience's sake is called the outside and then the return at one's outer action back into oneself ...*

A: But one can't escape this. And this action is always irreplaceable; it always remains strictly personal. No one can ever put himself in the place ...

Q: *That is exactly why it seems indispensable to me for this zero point to be lived precisely as work, and not as something to which one would abandon oneself. Because the moment one abandons oneself to it, there is the danger of purely and simply remaining there, of getting bogged down ...*

A: Good enough. And after that?

Q: *And after that being duped. Being duped in one way or another.*

A; Yes. But I much prefer being duped like that.

Q: *But when I say duped, I don't mean being carted off to an insane asylum. I mean duped because one has gotten caught up in a myth that is just as alienating as the old myths.*

A: Yes, but then one would be responsible for one's own alienation. These young people don't want to do anything. Nothing at all. They want to be bums. I have a son who doesn't want to do anything. He says straight out: I don't want to do anything. He wrote me one day saying: "Be carefree parents; don't feel responsible for my adolescence any more; I dont want to be a success at anything in my life; that doesn't interest me. I'll never do anything." ... Don't get the idea that things were easy for me before I arrived at the point where I said to my son: "Do what you want to." I had to do a fantastic amount of work on myself. Moreover, I believe I wouldn't have written *Destroy, She Said* if I hadn't had this

child. He's wild. He's impossible, but he has found something ... something that's outside of all the rules. A freedom. He enjoys the use of his freedom. He possesses it. This is extremely rare ... But since we've gotten far away from the film ...

Q: *Not all that far ...*

A: Were you perhaps shocked by the violence? By the way Bernard Alione was attacked during the meal? I cut some of the violence out ...

Q: *On the contrary, I found this scene very powerful and very true to life, all the more so in that it was a very difficult scene to do and the character played by Gélin might have been rejected early on and relegated to a sort of position as an outsider that would have been comfortable for the others, for the spectator, for the film, and for the director too ...*

A: He isn't lost, is he?

Q: *No. I was afraid, during the beginning of the scene, that it would become a real ...*

A: A trial? That was the danger ...

Q: *And to be truthful, I was more than relieved at the precise moment it became clear that he too could be "saved"—that isn't the proper word ...*

A: Changed.

Q: *Yes, that's it.*

A: He asks to stay. One day.

Q: *And we realize he can be loved ...*

A: That's right.

Q: *And that moment is the point at greatest intensity in your film, and after it ...*

A: To me it's the moment ... yes, there's no doubt that it's the one that's most important. "We could love you, too." When they tell him that, they are being absolutely sincere. Aggression had to be prevented. They are indiscreet. They are immodest. But they don't

attack Bernard Alione. I don't know, though, if that's the way it appears in the film ... I didn't have them eat, you see. That may interest you. Because Bernard Alione would have been the only one eating. As in the book. He would have been ridiculous simply because he was eating, whereas eating is something that everybody does, both people who are asses and people who are not. So I eliminated this false ridiculousness ... I replaced certain things. When Stein asks Gélin: "What sort of work do you do?" for example. Before, in the book, he answered: "I'm in canned goods." Now he answers: "I'm a real-estate promoter." I thought "canned goods" was too easy a way to ridicule him ... It has something touching about it, and something naïve too.

Q: *And the sort of haste on the part of Elisabeth, who finally almost goads Bernard into leaving just when he's been asked outright to stay—do you intend this to be interpreted as a still greater distance from people, perhaps, than that of her husband, or a panicked reaction on the part of someone who feels close to ...*

A: This is the last time she panics. After this her panic disappears. The last death-throes, if you like. Before she kills her former life. When they say to her, "You vomited," it's her life that she's vomited out. She doesn't know this. All she knows is that it was gratifying. Elisabeth expresses herself in this movement. She leaves to protect her "interests," interests that she then vomits up.

Q: *I find the film quite a bit more complex than the book. In the book one has somewhat the impression which one loses in the film—that Stein is something of a dispenser of wisdom.*

A: He says one thing about there being no need to suffer any more that illustrates what you are saying: "It's not worth it to suffer, Alissa, not ever again, not anybody, it's not worth it." This is more or less what Bakunin said: "The people are ready ... They are beginning to understand that they are in no way obliged to suffer" ... For Philippe Boyer, in *La Quinzaine littéraire*, Stein is the one who "speaks the desire of Thor," and who is going to allow him to go beyond modesty, the

rules of the outside world, the world of order. For him Alissa is "the one who destroys and who brings on madness in all its power." Many people have said that the characters in *Destroy, She Said* are mutants. That Stein, especially, is a mutant. I more or less agree.

Q: *What struck me most was a sort of passage from numbness, in the full sense of the word ...*

A: A hippie numbness, almost ...

Q: *... to a waking state.*

A: In Stein? Or in everybody?

Q: *In all the characters. It is a film on a state of drowsiness, with escapes, with arousals from this state of numbness ...*

A: That pleases me a great deal. I was very frightened while I was writing it. I was fear itself.

Q: *The word "destroy" comes much later in the film than in the book. And the film has: "She said: 'Destroy.'"*

A: This caused lots of misunderstandings. Because, when Thor and Alissa said it, when it was said as one person to another, between just the two of them, people thought that it was a reference to an erotic intimacy that did not concern the others. In the film the word is said in public. I take it to be a slogan.

Q: *In the film Alissa acts by coming closer, by making contacts, even at a distance, by ...*

A: Tropisms ... Nobody can bear her except Stein. She is not made for living and yet she is alive.

Q: *She is discomfort, in the strongest sense ...*

A: Yes. She is anxiety itself. Live anxiety. Live innocence with no recourse to speech. I can't talk about a character; I tell myself that the actors are going to read the thing, and say: "See, she prefers Alissa to Stein ..." No, Stein is the character most like a brother to me ... Would you like us to talk about conditions while shooting? The film was shot

in fourteen days, after a month and a half of rehearsals, and it cost $44,000. I don't know whether that will interest your readers.

Q: *The $44,000 covered everything?*

A: I don't know. I couldn't have done it without those rehearsals. But don't get the idea that sequence-shots are shots that don't cost very much. I'm afraid that's what people will say.

Q: *What's economical, often, is to cut.*

A: Not necessarily. No. Just imagine: I have a hundred and thirty-six shots, but a good sixty of them weren't used. The closeups of the meal. But I realized *after* shooting, during the rough cut, that what was interesting was the impact, for instance, during the card game, of the other characters' words on Bernard Alione. It wasn't the others saying "we're German Jews," it was Bernard Alione reacting to this. Or rather having it thrown at him. Then we cut down drastically on the number of closeups in general. But in fourteen days ... Just imagine: we sometimes shot closeups one after the other, without even numbering them—if you can imagine that. It could have been dangerous. But it didn't matter. One must let oneself go.

Q: *What do you mean "let oneself go"?*

A: Oh, I let myself drift along. Because I had used a certain emptiness in me as a starting point of the book. I can't justify that now. After the fact. There are things that are very obscure which aren't clear to me at all, even now, in the film. But I want to leave it like that. It doesn't interest me to clear this up. For example, the direction all through the scene of Alissa arriving. The whole symbolism, when she says: "Where is the forest? Is it dangerous?" and then Thor says to her: "How do you know?" and she looks at him and says: "I'm looking at it, I see it ..." Afterwards, a long time afterwards, I was able to justify this to myself, but at the moment it was completely instinctive. The forest at that moment was a danger that Thor had incurred. For he was attracted by Elisabeth Alione. And Alissa's attitude was already a reassurance: "Don't be afraid," her husband said reassuringly. And I

became aware of this long after I had directed the scene. When I saw the film, I said: "Well, that was exactly right."

Q: *Where does the shot with the words "I didn't know that Alissa was mad" come in exactly?*

A: She leaves the table. There's a worm's-eye view of her. And the voice of Stein offscreen saying: "You didn't tell me that Alissa was mad." Then Stein is seen, after he has spoken; then Thor says: "I didn't know." And after Thor, Stein says offscreen: "The woman I looked for for so long is Alissa Thor." This is the only time that Alissa is called by her married name, to clearly indicate that Stein is in no way bothered by the fact that Alissa is married ... Did you think that the two men were her lovers?

Q: *It's a question that never occurred to me.*

A: I don't know myself ...

Q: *The hair scene intrigued me ...*

A: It's very obscure to me. She cuts her hair ... it's a bizarre gesture. This is one of the most obscure points, and I can't describe it. I know that it is sacrificial ... Were you afraid when you saw *Destroy, She Said?*

Q: *Yes. Fear, as a matter of fact, that the film would stop being uncomfortable.*

A: I've been told that it's a frightening film. It frightens me ... But it represents a break with everything that I've written for films: the couple ... It doesn't interest me any more at all now to do what I've already done before. I'd like to make another film on a text that I'm writing. It's called: "Gringo's Someone Who Talks."

Q: *Will it be written for the screen?*

A: No. Another one of those famous hybrid texts ... And it would be a little like *Destroy, She Said* as well, that is to say, a sort of superexposition of certain things—and the intrusion of the unreal, but not a voluntary one. That is to say that when it happens I leave it in. I don't try to pass it off as realism.

Q: *I wouldn't use the word "unreal."*

A: I nonetheless believe that that word isn't far off. But when I say the word "superexposition," does it mean anything to you? And if I use the word "unreality," you don't see. How about if I use the word "surreality"?

Q: *Yes, I'd understand that better, except that "surrealism" has the same connotations.*

A: Hyper-reality. Yes. But where are we? This film … is not psychological in any way. We're not in the realm of psychology.

Q: *We're, rather, in the realm of the tactile.*

A: Yes, that suits me fine … That cuts me off from everything else in a strange sort of way … But as for *Destroy, She Said* I was really quite comfortable. Even though I was afraid. And at the same time, completely free. But frightened to death of being free …

Translated by Helen R. Lane

Grove International Film Festival Catalog, Spring 1970

The Man Who Lies: An Interview with Alain Robbe-Grillet

Tom & Helen Bishop

Question: *For me,* The Man Who Lies *is a film in the making. A film which creates itself and which the spectator must construct for himself. Do you agree?*

Answer: Yes. "Must construct for himself ..." That depends on what you mean. These are not pieces of a puzzle which the spectator can arrange according to his own taste. There is no image which each viewer finds in himself by giving a particular orientation to the different pieces of the puzzle. I don't think so. They are in the order in which they are supposed to be, if you like. That is already an important thing. The form might appear to be a little disjointed in relation to traditional narration. This is something that I have said before and which I say again. This is an open film, a film in which each viewer must enter and find his own way but nevertheless without moving things about. They are in their proper place, and this place is already a path in a labyrinth at the end of which one must find the minotaur. Each one finds his own way but one cannot displace the walls of the labyrinth.

Q: *If everything is in its place there are still many different approaches. You propose different ways, don't you? One can follow them or not follow them?*

A: There are different ways but there is a character who himself is already trying to follow them. There is someone who is already trying to tell his own story and who is moving ahead on a particular path, then he runs into a wall, then he gives up, then he explores another path, etc. Just what did you mean by this participation of the spectator you were talking about at the beginning?

Q: *I meant that, for instance, in your novels, as well as in other important novels of our period, the reader must also work along with the author to reconstruct the meaning of the novel.*

A: Yes, that's true.

Q: *For instance, compared to the novels of Balzac or to the films of the 1940s?*

A: Yes, that's true for novels. It's also true for films. If I was a little bit reticent when you expressed that idea at the beginning it is because there is a contemporary trend toward "participation," whether it be of the spectator or of chance, in which the work, film, novel, or whatever, only appears to be a series of pieces where one can change the order of reading them or the general arrangement of the pieces. For instance, in modern music there are compositions by Iannis Xenakis and other composers where the musicians group things according to dice and decide on the orientation given the performance of the piece through the numbers given by the dice. The same is true for literature. There was the book of a minor writer of the "new novel group" whose name is Saporta in which the pages were not numbered and where each reader had to put the pages in the order which he felt to be best. Michel Butor had a similar idea and he wrote his "Faust" libretto in collaboration with Henri Pousseur. The performance is dictated by the reactions of the public.

Q: *In other words, then, this is not what you were trying to do at all?*

A: No. In fact I discussed this very subject a few months ago. The Hamburg Opera brought together three people whom they wanted to work together and who were perfectly well disposed in principle to collaborate. These three people were the designer, Nicolas Schöffer, the creator of cybernetic sculptures, mobiles, and so on; the composer Pierre Henry; and the novelist-librettist was myself. At the very start of our discussions we hit on a snag which concerned a very important point, as far as I was concerned. Schöffer wanted to have the public intervene in the development of the opera—of the work—and I was completely opposed because for me the work is open to the spectator. He must participate in it, must recreate it himself, but recreate it as it is. In other words, not to upset the order of the pages of the book, not to change the orientation of the story line in the opera, and so on. If I stress this point it is because there are now two opposing schools, the one which wants chance or the public to intervene—which are really the same thing—and the other which

allows the author full liberty to dispose of the orientation of his works more or less in the classical sense.

Q: *Would you call that the difference between structured and non-structured works?*

A: Yes, that is exactly it. As a matter of fact, the result of these works left to chance or to the decisions of the public is often an absence of structure. Whereas, on the contrary, in a film like *The Man Who Lies*, as well as in the book *La Maison de rendez-vous*, a novel I wrote more or less at the same time, all the parts are carefully arranged to interact exactly the way they are exposed.

Q: *After that, it is up to the spectator to find the meaning: in other words, you do not impose any meaning.*

A: Meaning? I'm not sure that's the word. I'm not sure there is one. I don't know if the spectator should find one.

Q: *In any case, you do not impose any meaning yourself.*

A: No. There is someone who speaks, there is someone who is trying to speak. In *The Man Who Lies*, that someone is Don Juan, the Don Giovanni of the 18th century who was the first man to have chosen his own word against the word of God. Before Don Juan, God had been the guarantor of truth; Man, in order to be truthful, had to conform to the word of God. Don Juan is the man who affirms that his own word is truth and that there is no other truth than his own word and, even more, that there is no God. From this point of view *The Man Who Lies* is almost a continuous parody of a certain number of Don Juan myths right down to the commander's handshake, the commander who is the Doctor Muller who appears at the end of the picture. Trintignant crumbling under his handshake is exactly like Don Giovanni when the statue of the Commendatore shakes his hand. From this point of view the title, *The Man Who Lies*, is somewhat ironic since, after all, he cannot lie because there is no truth. As there is no God there is no truth and as there is no truth exterior to Man, Man creates his own truth through his word and

that is what my protagonist is all about. He is a man who needs to be believed. If people believe him, he will exist but he is not at all searching for some truth outside of himself which might have escaped him. He is a man who speaks, a man who fabulates. From the very beginning of the film he appears in an atmosphere which is as unrealistic as possible. He is neatly dressed in a suit and tie in the midst of a forest completely surrounded by the German Army in tattered uniforms. He thinks he is persecuted by these people who really don't seem to be running after him. They seem to be running in the forest after something and he himself seems pursued by something. And at that particular moment he tries to speak. He tries to speak, he tries to prove that he exists. He tries to say who he is and he makes a point of affirming his name. "My name is Boris Varisa," as if he were hanging on desperately to this name until that moment where, ironically, he leans on the gravestone where the name Boris Varisa is written, as if he were already dead in fact. And of course the three women he finds in this chateau are also taken from the Don Juan legend. He must seduce them but the seduction is also accomplished with a word. This is really the problem of the modern novelist, of the modern filmmaker as opposed to the 19th-century novelist whose fiction could fall back on fact. Balzac could always claim that what I said was true. All you have to do is look. That's the way it is in the world. Go look at the printers and you will see that the printers I describe are true to life. They are just like the ones you meet in the street. And when Balzac described journalists or bankers or more or less shady hotel keepers it was always in keeping with the reality he had studied or claimed to have studied objectively. The modern novelist is someone who affirms that there is nothing other than what he says. He is precisely in the position of Don Juan and in the position of Trintignant in this film, a position which in the final analysis—and this brings us back to what you were saying before—is also that of the spectator. The spectator who knows that there is no truth outside of himself and that consequently it is he himself who must invent the film he is watching since this film is nothing without him. It is a film which seems to represent a reality exterior to himself but which is actually nothing other than himself, the spectator.

Q: *Yes. And in that sense, then, the film is like* La Maison de rendez-vous *which, as you were saying, dates from the same period. I personally feel that* La Maison de rendez-vous *is one of the most important works in your own development. There would seem to be a parallel that could be made between the novel which creates itself through the words of the narrator or narrators who attempt to say, to speak, in* La Maison de rendez-vous, *and the narrator of the film or rather the protagonist, who is also trying, in different ways, to find his own truth to say what he is.*

A: That's right, yet a difference which is immediately evident is that the central character of *The Man Who Lies*, that is, Trintignant, has a much higher degree of complexity than the narrators of *La Maison de rendez-vous*. Narration is much more diffuse in *La Maison de rendez-vous*. Here, however, there is this character who speaks and who comes to grips only with ghosts. They are ghosts which he creates himself. First of all there is his own double who strangely enough has the face of young Kafka, this character whom he calls Jean and who in fact is himself. There is this particular kind of ambiguity which we find in all tales of the resistance; ambiguity of traitor and hero. He is either a traitor or a hero and the other one is what remains, that is the hero or the traitor. But they are more or less the same character and, besides, both have the same voice. In the French version of the film they are dubbed by the same voice and I hope that the same procedure will be followed in foreign versions. In short, it is like a ghost of himself that pursues him constantly.

Q: *Which allows you, at the end of the film, to underline this identity?*

A: Yes.

Q: *It seemed to me that at the end the two identities tended to merge.*

A: Yes. There is even an overlapping of the two faces and the character played by Trintignant sees himself again pursued by his double and he goes back into the forest

Poster for *The Man Who Lies* created for the Grove International Film Festival, March 1970

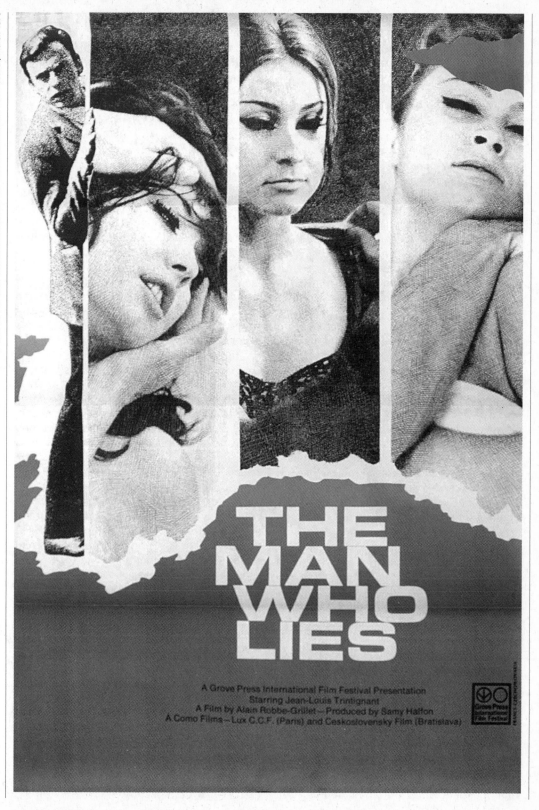

where he will again be pursued by the same soldiers and so on, but it is really his double that pursues him and he is himself in pursuit of his double as if he were desperately trying to stick two halves together.

Q: *What is the function of the other characters?*

A: The three women are themselves only ghosts which he creates. And the characters he finds in the café or at the inn are already telling the story. They are also like ghosts. He is very much alone, lost in a labyrinth, in a world of ghosts which he tries to give a degree of reality to because, through his own words, he will create a reality for himself and at the same time for the world. In a certain manner of speaking the film is his failure since he doesn't manage to do it but at the same time it is a moment of victory, but a victory which always ends in defeat. At the beginning he speaks rather intelligibly, relating almost believable things but without any conviction. It is a bit weak and then, little by little, as the film develops, what he relates becomes increasingly mad, increasingly hysterical and yet at the same time he says it with more conviction and with a kind of passion as if it were really becoming true. There is an obvious contradiction here which the spectator feels in the form of a disappointment each time a sequence begins, every time a story takes shape. It is cut sharply by Trintignant by a splendid movement of his hands.

Q: *You know it is strange. You have spoken about your main character in terms of Trintignant, that is, you don't speak about him in terms of Boris but in terms of Trintignant: Is it inconceivable for you to think of the character without referring to the actor who plays him?*

A: The film was written for Trintignant. I had worked with Trintignant in *Trans-Europ Express*, and I felt like making a film for him and this film was written entirely for him and almost with him and at one point when I was having financial problems Trintignant suddenly became a famous actor, had multiplied by ten. The producer of the film felt that his price had become excessive for this kind of experimental film and I thought for a while that Trintignant's agent was not going to come to an agreement with my producer. I think that I would have given up on this film and not made it because Trintignant really is the central character.

Q: *The women in the film don't seem to believe his story either. When a seduction scene begins we believe in it, we expect it, we almost hope for it, but the women don't seem to be involved or believe in it themselves.*

A: No. They can't believe in it because what he says is incoherent. He claims that he knew Jean very well, this man who was the husband of one of the women and the brother of the other and yet he recognizes no one in the house. All these people who have been there for a long time. He doesn't recognize the old caretaker, he does not recognize the father himself. He asks who he is. He doesn't know the place. It is quite obvious that he has never been there before.

Q: *But, however, something struck me as strange. There was a moment of ambiguity in his relationship to the women for the women themselves didn't really seem to believe in it. In view of the complicity that exists among the three women I wondered whether there was not a rejection of the male as well as a rejection of the character himself.*

A: Yes, you are right, but that introduced a completely different point of view about the film. This story is the story of a man who isn't there. There is someone who has gone and there are three women who live together in a more or less narcissistic or even lesbian manner. It is as if the three of them loved one another through the man who isn't there. With the man having gone they organized their world so well without a man since there were only old men around that they actually had an instinctive reaction to exclude him at the moment that he reappears. If you want to consider the plot from a realistic point of view you can wonder what would happen at the end of the film between the women and the man who came back since all they can do now is to reject him and to continue their game of blind man's bluff and at the same time we have trouble imagining that this man who was present everywhere through

his portrait and his photographs in every room of the chateau could now live there like a real character. These three women can only live with ghosts because they are ghosts themselves.

Q: *Aren't we now discussing literary allusions other than Don Juan?*

A: Yes, particularly to Boris Godounov. My main character is called Boris. Boris Godounov was the usurper of a czar who reigned after having assassinated a child that should have been the real czar and he was pursued, psychologically, by the ghost of the czarevitch he had killed and who finally gets the upper hand. Because someone else assumes the role of the czarevitch and succeeds in dethroning him and in taking his place.

Q: *Did you deliberately look for this dimension and this possible identification of Boris Varisa with Boris Godounov?*

A: He is clearly a part of it. There is especially an important hallucination scene which is almost copied from Pushkin's scene. It doesn't have to be identifiable in an absolute manner. I think of it rather as an ironic illusion because, naturally, the story of Boris Godounov is quite different since in Pushkin's mind there was a truth. He either was a murderer or he was not, whereas here that isn't the case. He invented the notion that he was the murderer.

Q: *Have you been particularly fascinated by the character of Boris Godounov?*

A: Let's say I have been fascinated by the characters of mad kings. Of course there is Boris Godounov but there is also Macbeth. There is Pirandello's Henry IV and there is a whole tradition in the theater of the mad king which is very important now because someone who is mad is someone who does not know the same truth as other people. Someone who is king is a man who by that very fact imposes his truth on other people. The mad king is a character who is very disturbing in a metaphysical way because what he says is true since he is the king and what he says is false since he is mad. There is another famous

one, Erik XIV of Strindberg ... And all these characters made a great impression on me in my readings. *The Man Who Lies* is full of allusions to mad kings. This king, by the way, Czar Boris, is similar to the one we find in *La Maison de rendez-vous*. The person who knocks with his cane on the floor above. He is Czar Boris, Boris Godounov, etc. By the way, the allusions to *La Maison de rendez-vous* are quite numerous in *The Man Who Lies*. There is Jean, who is naturally an allusion to *The Voyeur*.

Q: *I found that very surprising.*

A: And then there are also all the dead heroes whose names are written on the gravestones. They are all the heroes of my novels. There is Matthias, the hero of *The Voyeur*. There is Manneret, the hero of *La Maison de rendez-vous*; as if this village were entirely inhabited by the characters of my novels.

Q: *Since you mentioned Pirandello's* Henry IV, *I would like to ask you something that is of particular interest to me. It seems to me that there is a sort of Pirandellian game of reality and truth and of multiple personality in some of your works such as* La Maison de rendez-vous, Trans-Europ Express, *and* The Man Who Lies. *Do you think that you were influenced by Pirandello?*

A: Yes, I certainly have been but I do think that there is a rather important difference, namely, that the Pirandellian games of truth are psychological games. They are more or less variations on the theme of "right you are if you think you are." That's what Pirandello is all about. Every person has a different view of the situation, everyone lives the same story in a different manner and I think that it takes place in the world whose dimensions are the same as those of my works. Certain works of Pirandello have, in fact, turned out to be very important for me. *Six Characters in Search of an Author*, for instance. There is a direct quotation of Pirandello in *The Man Who Lies*. It is a very difficult quotation to identify for the spectator. When Trintignant wakes up in the maid's room after having spent a fitful night with her and then the father arrives with the caretaker to throw him out, there is something very special about

the scene. I don't know if you noticed it but one can constantly hear noises which are not the noises of the scene itself and if you listen carefully you notice that they are the noises of a theater. Moreover, you eventually hear the applause.

Q: *Yes, you had already used that technique in* La Maison de rendez-vous, *where applause from the audience in a theater comments on the action going on elsewhere.*

A: Yes, but this time I really superimposed on the scene, as background sound, a recording made in a real theater and the play that was being performed in this theater, it was the Théâtre de France, was a play by Pirandello. During the whole scene in *The Man Who Lies* you hear the reactions of the spectators, you hear the laughter, you hear the noises of the seats, the murmurs of the theater crowd at the Pirandello play, in other words, all the noises at the same time.

Q: *Now let's get back to the three women. Several times during the course of the film these three women play blind man's bluff with each other. Does this represent something akin to what Bruce Morrissette calls "an objective correlative," a way of guiding the spectator who may be a little bit lost himself?*

A: Yes, one might say that, but I really did it more for esthetic reasons. I felt like seeing girls blindfolded for esthetic reasons. By the way, I used that technique again in the film I am finishing right now. The theme of the blindfold, of the covered eyes, runs right through this film. One can certainly see an objective correlative but yet it might seem to be overly metaphoric.

Q: *What role does eroticism have for you in the cinema?*

A: It plays a very important role for me but less in the more recent films. *Trans-Europ Express* is the only one that enjoyed a long career as an erotic picture. That's probably the reason for its success. Not for me, of course.

Q: *It is a beautiful film on a very different level.*

A: Perhaps, but I think it did well because of that. People reacted well to the nude girls in chains. I must say that, for me, eroticism in the cinema is a very important matter. Speaking of myself as a spectator I am very, very often, let's say more than half the time, motivated by erotic reasons when I go to see a film. Perhaps because I am interested in a particular actress or perhaps in some particular type of scene and if I take a very close look at my contacts with the cinema I must acknowledge the truth of what Freud proclaimed a long time ago, namely that contact with a film is under all circumstances an erotic contact. That contact with art in general is more or less always probably an erotic contact but that this is particularly clear in the case of the art of the film, that there is an erotic type of contact with this big screen in front of which we are lost in the crowd of spectators but where we are, in fact, alone. Any closeup of a face on the screen even without any sexual allusion is always erotic and I think that one must not neglect this. That one must see it, show it, say it, and to take it into consideration as one of the most significant elements of the cinema.

Q: *I would like to go on with this matter of eroticism in films. There is a subjectivity to the nature of fantasies in your films and I wonder whether it is while writing a scenario that you deliberately or unconsciously, perhaps, find a vehicle for your particular fantasies.*

A: Well, you might even ask that question in a more chronological way. Why did I begin to write and why did I begin to make films? I was an engineer. I had a profession which I found fascinating, which provided me with status and money and suddenly I began to write strange things that no one was interested in at the time. A psychoanalyst or a psychiatrist might be interested in that transformation. There is something in that which is not quite right and in fact I have often wondered whether there is not something in this transformation of an engineer into a writer which might have something to do with the kind of revelation of his sexual peculiarities, to put it in general and delicate terms. This peculiarity which on the one hand set him apart and on the other hand really moved

him to affirm himself with other people in terms of the one who really knows what the truth is. I am convinced that my work as a writer and as a maker of film is very closely linked to my erotic life.

Q: *Your novels seem to bear that out as much as your films.*

A: I frankly think this is true for any creative person and when the critics carry on about an erotic invasion in modern art and all that, then that is just bullshit because that is what people write for, that is what people have always written for. When Flaubert began to write it was certainly for erotic reasons. Well, nowadays, people simply say it more openly. They are more aware of it. If anyone had told Lewis Carroll that he wrote for erotic reasons he would have been very upset and very indignant and yet today it is perfectly clear to everyone. If our contemporary period has been so invaded as people like to say by this eroticism it is simply that now artists have realized that there is no longer any reason to camouflage it, that, on the contrary, they had to study this eroticism and in all fairness they had to underline it. As far as I am concerned, what is really immoral is to hide behind alibis. For instance, to hide behind a moral alibi, even a moralizing alibi, in order to make a film on prostitution or slavery or Nazi sadism … A film which will really seek a public interested not at all in this struggle against the Nazis but in sadism. I think that our era is much more honest in that it does away with these puritanical alibis.

Q: *Can you tell me about the film that you have just finished? What is it about? What is it called?*

A: I have just finished shooting, but for me the editing is extremely important and very long and I am still in the midst of it. The film is called *Eden and Afterwards*, and it was shot partly in a studio in Czechoslovakia, on location in Czechoslovakia, and in Tunisia. It is difficult for me to speak about it. I can talk with ease about works once they are finished because I can have a somewhat removed critical point of view about them. Right now I am still in the middle of this one. As far as creating a film while shooting it is concerned,

I went further with this one because I refused to write a scenario ahead of time. The producer agreed to let me shoot with a very vague outline for the beginning of the film, for the Czech part. The scenes which were shot then called for other scenes which we shot subsequently, and so on. It was a fascinating experience for me, especially because I had the help of three collaborators who really participated in this film with enthusiasm. The first was the cameraman who shot *The Man Who Lies*, Igor Luther, and who, I think, will have a great career as a cameraman. He shot this new film in color whereas *The Man Who Lies* is in black and white. Next, a Tunisian production assistant named Férid Boughedir, who really participated in the process of creation on a day-to-day basis. And for the first time an actress. With Trintignant I'd had a really creative and fascinating collaboration but this had never happened with an actress before. It was Jacques Doniol-Valcroze in *L'Immortelle*, Trintignant in *Trans-Europ Express* and *The Man Who Lies*, and since this last film has the erotic importance for me that I was talking about a while ago, it was a very new and exciting experience for me to have this creative collaboration with a girl. Her name is Catherine Jourdan and she is an actress you'll hear a good deal more about in the future because she really participated in the film with an intensity that can be called creative and which was a marvelous thing for me.

Q: *In a film shot without a rigid scenario, does real life tend to play a greater role?*

A: Let me answer you indirectly by telling you an anecdote that concerns *The Man Who Lies*, and which has to do with the truth of lies. It is a story that interested me a great deal. There were things invented and even deliberately invented to be laughable which became true during and after the film. The film was shot at a time when all scenarios had to be submitted to the Central Committee of the Communist Party of Slovakia. This is again the procedure now, but during the spring of Prague's liberalism, scenarios were free. However, my film was shot before this period of liberalism and scenarios still had to be submitted to the Central Committee and despite the fact that the Communist Party of Slovakia was full of good will towards me there were certain

details which were considered to be shocking from the point of historical accuracy. The first was that there are no longer any Czech aristocratic families who keep domestics and then the Central Committee felt that no son of an aristocrat in a communist state ever participated in the liberation of his country. That was impossible. And often there were some very precise details. At one point one sees a German officer dressed in Wehrmacht uniform who reads a newspaper and this newspaper is *Pravda*. Not the Russian *Pravda* in Cyrillic but *Pravda* in Roman letters, the organ of the Communist Party of Slovakia, in other words, a Czech newspaper and not a Russian one. The party inspector pointed out to me that *Pravda* did not appear during the occupation, the German occupation, and therefore no German officer could read it. I said, "Okay, let's have him read *Le Monde* if you prefer," but finally I let it stand because I found it extremely amusing that this minor detail was so ambiguous since it was obviously a lie. This German officer can only be a lie since he is reading a newspaper which was not in existence during the war and yet at the same time the word *Pravda* means "truth" in Slovak and in other Slavic languages, thus it is the word truth which is the proof of the lie. That is already quite amusing. The film opened in Bratislava in one of the large movie houses of the city on the very day Soviet troops and their "allies" entered the city and on the poster of *The Man Who Lies*, the title, of course, written in Czech, they had added the name Brezhnev. Brezhnev, "the man who lies," and all the scenes of occupation brought on roars of approval from the many students who went to see the film and, in particular, the scene of the German officer reading *Pravda* because there were East German officers in the city wearing the same uniform reading *Pravda*. Thus this lie had become the truth. As to the chateau in which we did the shooting, it is a real chateau in which there was a real Baroness who had remained there with a servant who had not left her.

Q: *I supposed, though, that the Baroness and her servant were less beautiful than their counterparts in the film.*

A: The Baroness was about 75 years old and her servant was also an old woman and they remained on in this completely dilapidated chateau. When I returned to France and the film was shown I met a Hungarian nobleman who lives in Paris and who told me that he had been raised in this chateau. He asked me whether I knew the old Baroness and I had said that I had seen her every day during the shooting and he asked me whether I knew why she was there. I said no, I didn't know. Because it seems that all the Hungarian aristocrats had left Slovakia long ago. They all had palaces in Vienna or things like that and the only one that was left was that old Baroness. What was she doing there?

Q: *She was waiting for her son?*

A: She was waiting for her brother who had disappeared in 1917 on the Russian front. She has been waiting for him ever since because she is sure that he will come back. And every time someone comes into that chateau where only ghosts enter she thinks that it is her brother coming back.

Q: *One last question. It seems to me that for some time now you have been attracted more and more by the notion of cartoon strips. Do you think this is true?*

A: Yes. You are right to say that I have been attracted by the notion and not by the cartoon strips themselves because, as a matter of fact, I almost always have been very disappointed by the cartoons I have come across. Cartoons for children are always very disappointing and cartoons supposedly for adults which are more or less erotic are interesting in principle but in practice turn out to be very disappointing. But it is true that the notion of cartoons does interest me. Of course there are some exceptions. There is one that I saw recently which called *Valentina*, which you must know. There are a lot of things in it which I find fascinating on the mixture of dream and reality and I have a project for doing a cartoon one day together with a cartoonist.

Q: *Is it the two-dimensional element of cartoons which attracts you?*

A: Yes. It certainly is. After all, a cartoon makes no pretense at any depth. It is very interesting from that point of view.

Do They or Don't They? Why It Matters So Much

Parker Tyler

There used to be a day when the love plot of a movie reached a supreme crisis. This was when the lovers were "compromised" by being forced through sheer circumstance to spend an unsupervised night together. Once, I remember, there was a cave or something from which they had to be rescued; the fact that they came out alive and physically unscathed (so to speak) did not guarantee that the lady was still a virgin. On the contrary, both were under a shadow in their community, and would continue to be, unless they were legally joined forthwith. One of the strongest reasons for my movie-going habit when I was an adolescent may be expressed by the formula, "Will They or Won't They?" Will they or won't they, that is, finally get together in bed? Personally I never cared if it was a legal thing, though I, as a member of society, fully realized that so far as the movies went (USA style), the fact that the lovers had consummated the sexual act wasn't understood at the end unless certification by church or state was in normal prospect. The suspended certainty of physical conjugation, and only that, was what kept me in my seat through many a banal plot till the ultimate fade-out.

Now that being adolescent is an autobiographic memory, I can declare myself witness to the gradual, if radical, change in movie mores from "Will They or Won't They?" to "Do They or Don't They?" to "Sure they do, you sap!—only you can't expect them to do it before the camera since there's a law against it" to our time's much more licensed "Are They or Aren't They?"—when so obviously they are going through the peripheral motions. I refer, in case your memory needs jogging, to the new brand of skin flick in which screwing *au naturel* is ostensibly performed in full view of the camera—it's what your eyes tell you, and it's what, for the purposes of fiction, you're supposed to believe of the naughty nudie films lately turned porno skin flicks. The aforementioned "law," in other words, has been suspended with official cognizance, being limited as of now to prohibiting sight of the erect male organ and the reasonably certain consummation of sex characteristic of stag movies, i.e., optically confirmed entry of the erect member into this or that human aperture.

The point has become most poignant in off-Broadway theater in a play such as *Che!*, where it was alleged and unalleged

that actual coitus took place (at times anyway) amid the naked let's-pretend of sexual intercourse. Homosexuality too has ridden in on the overwhelming wave produced by the public's acceptance of honest nudity and the honest simulation, at least, of sexual acts. On the stage, one can't expect even consenting adults, hetero or homo, to work themselves up properly for the real thing before nightly audiences. As for the movies, it has been left to the underground to portray stag-movie sex and (more or less) get away with it.

It's odd how legal terminology tends to pop into the head while watching real sex performances on the screen. This is simply because such underground movies (like Warhol's *Blue Movie*) are not meant to be film fiction but cinéma vérité. Doing cinéma vérité, you couldn't expect the underground set to cheat, could you? No. Beyond a reasonable doubt that couple or that trio are really—to borrow a term from *Frank Fleet and His Electronic Sex Machine*—balling, or executing variations of same.

Now, moviegoer, does it *matter* to you whether a given pair on screen really achieves technical intercourse—oral/genital, anal/genital or genital/genital? Search your midriff *and* your heart. You ask the question automatically anyway when exposed to some realistic representation of fact or fiction; you *might* ask it consciously. Maybe you think a decision unimportant. The inner technicality may not matter as long as the optical image hits you right. To some of us film-and-theatergoers, I take leave to say, it really matters if only because it seems to matter to *others*—to the vérité people for instance and such an element must influence the style of the thing and modulate the way it's looked at. I think the issue pivots on a problem much older than that antediluvian "Will They or Won't They?" of my adolescent moviegoing days. The problem is that of form and content, purpose and result. In terms of today's artistic crisis, it's whether the let's-pretend of art is not, somehow, quite outmoded, put into permanent question by the pervasive ideal of the communication of fact as opposed to the communication of fiction. Conceivably the verdict might be: fiction doesn't communicate *enough*.

That verdict, to my mind, is awfully important. Not that all fiction-romancing would

then become fact-romancing or just fact. It wouldn't be, at first anyway, a question of labels or patent assumptions. It would, however, influence style in the making of film and theater works; ultimately, it might set up as all-powerful the already rapidly growing school of fact-fiction in the novel, the stage and the film. But rather than predict the future here, I'd like to examine further the elements of the situation, decide just what's involved, just what's at stake for all of us: entertainment lovers, art lovers, just-fact lovers, and (could I venture to add?) just lovers.

Take the new super-suggestive nudity. What exactly is achieved, for instance, by the most recent screen version of *Romeo and Juliet* by Franco Zeffirelli, where the lovers are not only the teenagers they were supposed to be, but are also shown ostensibly naked in bed—the upper half of Juliet anyway, and then all of Romeo from the back? I say "ostensibly" only because one must beware of the inherent trickery of theatrical illusion, all the more possible in film owing to its suddenly shifting angles (impossible in the theater) which allow for certain kinds of cheating; in this case, the actress playing Juliet may have worn something under the sheet and she may not even have been present to see Romeo's unadorned backside when he stands at the window: mere editing can effect such lightning-like deceptions. Furthermore Romeo here may have worn a phantom or optically invisible jockstrap (as did young Adam in John Huston's film version of *The Bible*) so that no one on the set might see his naked genitals.

This *Romeo and Juliet* achieved something, then, in the unalterable direction of sexual literalness. No fact-enlightened and reasonable person, regardless of age, ever doubted that Romeo and Juliet *did* have intercourse amid their transcendentally expressed sentiments. On stage or screen, representing that intercourse has depended on preliminary love-making and inference from the verbal text. No really sound work of art ever had any intention (unless as an aspect of plot suspense) of leaving the audience in doubt about whether intercourse actually takes place between two given lovers. At a certain point in the crucial love scene, whatever it was, intimation-of-sex takes over from demonstration-of-sex: at one point, a veil is

drawn in the form of somehow withdrawing from sight the crucial action. What's the value, then, of latter-day literalness, of more and more detail in the form of nudity and hot caressing? Well, esthetic enjoyment perhaps, and only that.

Such would seem Zeffirelli's purpose because his "morning after the night before" remains lyrical, has no touch of lewdness. Personally, I think the scene could have done with a touch *more* of literalness; not nudity as such, but *erotic involvement*, however signified. One notices that Romeo's eloquently adolescent behind is small tender for the sexual steam he is supposed by Shakespeare to have worked up over Juliet. My criticism is that Zeffirelli's scene is too much babes-in-the-wood … too goody-goody innocent, like the precoital swoon of rather shy, rather conventional teenagers; surely *all* grades of teenagers saw this new, much vaunted version of the play. So much for the *esthetics* of this particular sex occasion on film.

The vérité atmosphere of our newer cinema does not leave Zeffirelli's artistic contribution uninflected. It is bound to evoke the subject of theatrically representing sex in general. There was that memorable scene in *Gone with the Wind* which proved that even the American screen could get away with daring innuendo *if* the innuendo produced an honest laugh rather than a lascivious yawp. The odd part about this shot—the one where Scarlett, fresh from having spent the night with a brutally overwhelming Rhett, favors the camera "next morning" with a ladylike spasm of blissful recollection—is that the audience is said to have laughed out (I can't verify it) in surprised delight. I doubt that in 1970 more than scanty giggles do honor to this bit of standardly naïve signification. Vivien Leigh as Scarlett had done something natural, spontaneous and feminine enough to be accepted with articulate gratitude by a mainly middle-class audience. Everything, of course, had depended upon the style in which the actress did it. If audiences do still laugh outright at Scarlett's gesture, surely it's at the broad naïveté of a quite dead convention. Thus the laugh would be largely satiric, as it was not at all when the scene was originally shown; then, it had been directed at a sex joke that could be decently relished in the cozy darkness of a movie house.

But the film public, no matter how normally crepuscular it is on this side of the screen, has shown a growing taste for more and more sustained light in visible bedrooms, more and more footage of the represented action just at the point where, in the past, the usual veil has been drawn. Why so? It seems a bit foolish to ask it that curtly but the question is not exactly self-answering. If it were, one would have to conclude that footage of literal sex action means pornography, and we would be off on an argument which shows strong signs of being beside the point today. In brief: Why should not the behavior of human beings in sexual intercourse be as engagingly informative as that of human beings in social intercourse? Why shouldn't bed behavior be as commonly seeable as horseback riding or riding in autos—things which lovers have always done in films quite visibly?

I'd promptly answer, "Why not?" provided that precisely what happened in bed had some decisive meaning, would add to our understanding of character and situation. Reflect how many love scenes have started and stopped in moving autos, how many autos have *stopped* so that a couple could *start* necking—and then??? Well, commercial skin flicks have begun showing how far necking can progress. Ripped dresses, bared thighs, garters, undies, violent struggles with accompanying grunts, gasps, outcries: all sorts of marginal denudings with the only rare thing (rare no longer) the absolutely pants-less male … Matron or maiden or freelance, whatever the film she was in, showed signs of resistance when a certain point was reached; at times, embarrassed—one had to guess from the context whether this was because no pessary or condom was handy, or because she was faithful to husband or boyfriend, or believed fornication was a sin, or just didn't like the fellow enough. We live in a time, speaking as of 1970, when moral scruples as such have little apparent weight in such matters—the flesh is presumed to want its immemorial way and in the great preponderance of cases to get it, however reluctant the lady, or nowadays, the gentleman; for homosexuality also has shy maidens. See—you mean you haven't even *once?*—Sal Mineo's *Fortune and Men's Eyes.*

The impressive thing about our time

of underground sex-surfacing is that pornographic subject matter, decidedly underground in historic perspective, has come into the open even in seriously meant plays and films, and in many cases is direct, sober, and aboveboard. In short, it has risen to the full stature of, one might say, Erotica Unbound. Today's radical skin flicks—take for example *Russ Meyer's Vixen* and other of his films—feature straight comic-strip melodrama with all the surface appearance of lusty naked intercourse, which two or three years ago would have been left to the imagination by even the dirtiest-minded film meant for public consumption.

After a moment's thought, we can confidently say that to be pornographic in the old sense, all that many a recent or unrecent film (regardless of grade) had to do was to keep the camera grinding a few minutes more on the logical and inevitable action. If we cared to tabulate as achieved all the *insinuated* acts of fornication, adultery, rape and whatnot in films prior to 1970, we would have a hypothetic treasure chest of erotica millions of feet long. Legend says that on occasion some worldly director would go further than

insinuation with a pair of obliging actors, only the result was never handed down to the studio's film editor. Thus, that not-so-unreal treasure chest would, could you lay hands on it, yield probably a few thousand feet of precious, indubitable erotica.

Fortune and Men's Eyes is a perfect example of second-thoughtfulness turned liberal, sexy and tangibly consequential. It was hilarious to notice a female New York drama critic self-righteously waxing indignant over Mr. Mineo's alleged vulgarity, ineptitude and lewdness in getting very pretty young males to incarnate the homosexual melodrama of a boys' prison. Said drama critic was right in the abstract insofar as the play's tacit moral pattern became ludicrous the way Mineo conceived it, since his production is totally unconvincing as a realistic text taken from prison life. But if you actually see it—the offstage violent intercourse now onstage—you see (if you have all instinct for charisma) that Mineo has made it into a poem of homosexual erotica, illustrating what a lovely thing it is for the unwilling bottom-man in a conjugating male pair to turn into willing top-man through sheer heroism. The Smitty of

Cartoon by Tony Munzlinger from *Evergreen Review* No. 81, August 1970

Mineo's version is simply a typed homo-hero and his saga is as true of life outside prison as of life inside it.

Now for my basic question: Vixen or wolf, virgin or faggot, does it make any difference whether there's literal intercourse?—actual entry of organ into involved aperture? Mineo's boys give a stunning imitation of teenage rape of male by male, meaning (among other things) that the issue of sexual truth has been driven to its very lair, its final optical showdown. *Showdown*: there's no other word to express the dilemma which "Do They or Don't They?" now connotes. For its part, art limits itself, at discretion, to degrees of intimation, for by definition, art is a formal representation of life ("imitation"), not life itself. Esthetically, imitatively, intimation-of-sex could never reasonably be challenged by demonstration-of-sex: imitation of intercourse is all any *sane* esthete could ask even from the most realistic film or play. However the whole vérité movement, in its sexual aspect, is a force tending to turn mediumistic, esthetically valid imitation into a source of literal information. By the latter standard, one couldn't accept a moving photograph of intercourse without optical verification of phallic entry and enough footage to vindicate the plot's assumption of a reached climax.

Am I serious? Yes! And I'll expatiate on why. Take the Russ Meyer films. A very definite line is to be drawn between them and such films as *I Am Curious (Yellow)* and *Coming Apart*. Subtly, content as well as type of representation differ. *Coming Apart*, *Curious*, and *Vixen* show offbeat no less than onbeat sex: lesbian play, fellatio or cunnilingus, even masturbation (female using leg of male). Consider just what these forms of representation are and how far they go. In *Curious*, except for one well-aimed lunge by the hero, cunnilingus and the ensuing sixty-nine are portrayed by before-and-after notations. *Esthetic* or *legal* discretion?—can one tell? It is one of the wobbliest parts, artistically, of this very serious and interesting film; there is no more *inevitability* about the rationed visibility of this erotic incident than there is about the unrationed microphone interviews that overweight the rest of the film. The script might have opted for a little more sexual detail, or a little less. The nudity itself is not ornamental, nor for provocative show. But the insistent accumulation of interviews, despite their political content, end up being ornamental because they are so monotonous. On the other hand, the girl's bicycle ride, her dream, and the variety of intercourse situations are all superb, done with true artistic economy. I should say that all sexual representations in the theater are "artistic" if one is not impelled to wonder whether (I see I must repeat myself) the organ *actually* makes its supposed entry.

Yet I'm making an issue of precisely that supposition—or rather, I'm recognizing that the issue exists in the realm of the public's optical appetites. Somehow the issue of "seeing is believing" comes into unavoidable focus concerning sex. A difficulty I once stressed about a film of the forties, *Suspicion*, was the plot's peculiar dependence on a finally unclarified mystery: a woman's growing but unconfirmed suspicion that her husband plans to murder her. She finds reason to think he callously married her for her money but this is far from accounting for her obsessive fear of him. Soon, with no proper explanation, she's locking her bedroom door against him every night the bewildered husband becomes desperate. The "happy ending," when he manages to convince her her fear is imaginary, still leaves all vital points in the air. I argued that the lady's delusion could plausibly have been based on the simple factor that the fellow didn't give her satisfaction in bed. But, reluctant to admit the libidinal fiasco of the marriage, her vanity had succeeded in erecting over the repressed truth the false superstructure that he must be plotting to get rid of her. Our knowledge of the pair's actual intercourse would have exposed either the relevance or irrelevance of the wife's suspicion. But on *that* score the film has been mum.

The central point about sexual representation is that if character motives, to be clear and efficient, depend on something hidden from us, the action will remain a silly charade and we, the audience, have a legitimate complaint. The truth is, as carnally candid as are sexual incidents in that gloomy, groovy little movie, *Coming Apart*, the thing is an exhibitionistic charade. That's because, despite the recording device and the mirror of the analyst supervising his own clinical ordeal,

nothing said or happening tells us more than the fact that he is coming apart (at the mental seams) and that the cause has something— just *what* we never learn—to do with his sex life. He seems to be "withdrawing" from sex.

The reason could be repressed homo- sexuality, drug addiction, psychic impo- tence, one or two other equally tangible but concealed things. Such things would not have had to be literally demonstrated but they would have had to be (as in the case of *Suspicion*) properly hinted at so as to make sense of the overt action. The best we can do for the effort of *Coming Apart* at psycho-sex vérité is to assume that the hero (played with obliging puzzlement by Rip Torn) is a stand- in for the now dated and notably abstract Alienation Hero. In such a case, all the film's sex exhibition becomes rather humble por- no-erotica, incidentally convincing in Sally Kirkland's case, but never wholly persuasive as more than routine stag stuff, radically trimmed down the middle.

Russ Meyer's skin flick craftsmanship, transparently porny as it is, is quite different. Yet one pauses before concluding that the obviously more serious motives of *Coming Apart* are esthetically more apt than the glaringly explicit surfaces of Russ Meyer's nonchalant, blatant Vixen. In dozens of com- moner, cheaper skin flicks, the actors on the whole look awful in their amateurish affecta- tions of lust and sexual ecstasy. It is possible for a connoisseur of the absurd to find, for a few minutes, those same affectations fee- bly laughable—as laughable, I suppose, as the more legitimate and credible vision of Scarlett's testimony to Rhett Butler's brute love. All laughing aside, the actress playing the nymphomaniac vixen (free-form and forthright) is not half bad at seeming to enjoy the sexual calisthenics she has to perform. In the lesbian scene, where she all but rapes her house guest, there are some daintily carnal maneuvers that put equivalent maraudings in recent underground films to shame. The rest of the time she's frantically bouncing around, quite naked, on all convenient and willing virilities, including that of her at first reluctant brother. Regardless of actual entry, there is here no cheating about *ostensible* entry. Studio light or daylight, in water or on dry land, the summative optical image is as broad as a desert sun at noon.

Now the last thing I wish to seem here is really naïve or false-naïve. I recognize the score. Skin flicks are getting more and more bountiful of sex like it is: how it hap- pens when people are plain uninhibited. That being so, one can't deny that, despite the disguise of calculated plots (there's even racism and a benign resolution of same in *Vixen*), all such skin flicks are only strenuous simulations of peep shows rigged out with comic-strip melodrama. Peep shows are, let me iterate, naked information and their only "art" can be in clever cheating. This dis- crepancy—an *esthetic* discrepancy—would account for the fact that the audience in the 42nd Street movie house where I saw *Russ Meyer's Vixen* didn't show much gusto at the goings on, nor was the place full at an hour when it well could have been. Sitting around me were a number of male teenagers (all, I trust, over sixteen) in a state which I inferred was silent gluttony: all was taken in without notable demonstration. Yet somehow I sixth- sensed a vague, even tragic, disappointment in the air. I decided that, after all, *Vixen* is *not* a true stag show—it is only movie fiction. I was sensing the whole audience's disap- pointment that, despite the bell being raised, *Vixen* wasn't … well … vérité.

What, then, is it? It's a pseudo-documen- tary; that is, one fancied up and falsified by an arbitrary fictional dress: the *transvestite documentary*! If fact-fiction methods can be thus starkly compromised by conversion to visible sexual intercourse, how can fact-pre- ferring stage, TV and film watchers ever again be satisfied with the mere entertainment or mere art of honestly simulated erotica? The literal-information standpoint can make *Oh! Calcutta!* look and sound like an archaic set of smoking-car anecdotes. Stop and take some mental notes of things you've heard about the new sex movies—I mean about even the more serious ones. Haven't you heard speculation about "faking" about, for instance, whether the apparent heterosexual sodomizing in *I Am Curious (Yellow)* could have been real sodomizing? One can so easily hallucinate images of the actors doing it "for fake" before the camera and then "for real" without the camera. In fact, this is something the director of *Curious*, Vilgot Sjöman, ac- tually suggests by showing himself waiting around in the film to photograph his actors

while they're supposedly inside the cottage, nature-naked, having their rugged little ball.

It would seem, all these years, as if the public had been calling, however silently, for more and yet more candor. The candor has unquestionably arrived, re-arrived and re-re-arrived. I ask, with a certain yearning of my own, just what the implications of that arrival are, and I think of these dubious implications in terms of the communication mania that looks to its favored media for *facts* rather than *fictions*. It makes no difference that maybe the facts themselves are either advertent or inadvertent put-ons. It's just that they shouldn't *pretend* to be those futile things: fictions.

The film public always had a mythological yen to think of Elizabeth Taylor and Marilyn Monroe, and the glamour girls and boys in general, as really doing it, not just pretending to. The art of illusion—which is a redundancy, like saying the art of art—has suffered a severe disrepair in our age of dogged documentarism and computerized mountain ranges of fact. After all, the search for fact, if serious enough, might go so far as to measure the sincerity of a man's love by measuring the vibration of his orgasm by an electrical attachment. And if he doesn't register par, a woman might be able to divorce her husband on grounds of inadequate consummation or sue her lover for false representation ...

You see, then, what a paltry, token affair "actual entry," no matter how often or vividly photographed, might become in an impassioned search for literal truth in sexual representation! Do I sound slightly ironic? I mean every syllable of the irony. I deem it downright silly to view the new literalism in sexual representation as necessarily serving anything but honest porno joking and the great public occupation of getting vicarious sex thrills from palpable fictions. Why in the world should not sex, represented in artful entertainment or entertaining art, remain what it has always been in created works, whether on printed page or in a theatrical medium—a fiction, and a fiction that doesn't have to be fortified *by visible entry?*

We may have reached a point, we the public, as dangerous for comic-strip art as for higher art, as dubious for the health of morals as for the health of art works. Flesh, skin, the genitals—these are all very delicate and beautiful things and should be handled with the deftest care and respect even when employed for the most savage erotica. Remember, the criterion for esthetic validity is exact signification, not literal fact. A world of difference is in that distinction. And, for the record, I am for fun as well as for art (sometimes they're the same). Yet I think that what has come to be known, deceptively, as documenting the facts is traffic-jamming both fun and art. What really happened in *Coming Apart*? Primarily, it was the skin flick and its fun that literally, rather grimly, came apart in front of our eyes. If it comes to choosing, I prefer as spectacle the couple that tore off each other's swimsuits while in a pool (in a certain 42nd Street masterpiece of film-flam) and went to it as if they meant it. I enjoyed a few seconds of sheer esthetic illusion, delightfully sensual. Meanwhile, I hazard, 99 percent of the audience hoped against hope to glimpse—the McCoy.

Don't mistake the casual sarcasm. I am against the voyeur's gluttony and the naïve pretension of the vérité school's literal-information program. These are basically unbeautiful because they are basically unimaginative. Strenuous sex can be very beautiful when it's for real and actuated by true, deep impulse. I've been handling here the problems of fictional sex. I want to add that marvelous paeans to sex-how-it-is could go far beyond underground bedroom acts and the faked flicker of the custom-made skin models. Why shouldn't sex, any kind, be a lyric unto itself? It could provide the most exquisite patterns and rhythms, utterly realistic and exciting. Imagine a beautifully paced sex-ball of active bodies and a music of natural sounds! The field of flesh-turned-filmic-sex-fantasy remains virgin so far as exploitation by serious art goes. That—in case you've been in doubt about—my theme—is why it matters *so much*. There's also the *independent art* of erotica.

A curious and debatable exploitation of the new freedom of sexual representation has arisen in the recent release of a film made (the author never expected to live to see the day) from Henry Miller's *Tropic of Cancer*. The very odd part about this modern bible of sex slang and bohemian sexology (circa the thirties) is that the language of the original

book in all its once-banned licentiousness is given a lot of play—literally—while the screen shows only some faintly suggestive glimpses of the anatomic parts and sexual behavior so plainly being described on the soundtrack. A great breakthrough for the soundtrack! But a deplorable backtrack for the total progress of Erotica Unbound.

Maybe this happened because Paramount, the major company which put up the money for producer Carlo Ponti and director Joseph Strick to make the film, anticipated public tolerance toward overt linguistic sex but a residue of unbearable public shock (or legal taboo) toward overt physical sex; actually, we see much less crucial erotica in *Tropic of Cancer* than in dozens of recent movies. The optical medium of film, which for McLuhanites means visual massage, has had to settle, via Strick's new film, for verbal massage. That's not contemporary filmic cricket. What about that investigative flashlight in Henry Miller's hand and that visually investigated vagina in the novel? Henry, your colloquial literature has been super-honored by a film script, yet while being so, its human and visual substance has been super-castrated, so to speak, by an eye-operation. A great pity! I should think *all erotica* buffs ought to protest—and the film critics, too. Sight, in any honest art, should *couple with* not just *illustrate* sound: word, grunt, or slither.

Mandabi:
Confronting Africa

Julius Lester

Africa! The name conjures up only the vaguest images. The mere sound of Paris, London, and Rome evoke images of sweetness, light, and culture, if not of the height of civilization itself. Tell your friends that you just got back from Paris and your status is increased by their envy. Tell them that you just returned from Addis Ababa, Kampala, or Dakar, and they will try to manage an appreciative "Ooooh!," while trying to figure where you've been and what the hell you could've been doing there.

Africa! The white man called it the "Dark Continent," a phrase that was not so much descriptive of its inhabitants, but of the white man's state of mind. Africa! Naked savages, who had no written language, who believed in voodoo and witch doctors, who lived in jungles and carried spears. It was primitive and ignorant, so the white man came to bring light, a white liberal euphemism for colonialism, which is a white liberal political euphemism for thievery. ("When the white man came to Africa," Stokely Carmichael is fond of saying, "we had the land and they had the Bible. Now, we have the Bible and they have the land.")

For American blacks, Africa was a place to be ashamed of until recently. After all, where could we learn of Africa except from Tarzan movies in which Cheetah was made to show more intelligence than the natives. Some blacks hated themselves so much that they went to the movies and cheered for Tarzan to "kill them niggers!" Others went and laughed uncomfortably, not wanting to believe the reflection of themselves they saw on the screen, but not knowing how to counter it. And some of us never went, not wanting to be humiliated. (I've only seen one Tarzan movie and that was *Tarzan and the Nazis*, high camp at its highest. I must confess, however, that I rooted for the Nazis.)

A few blacks looked upon Africa as the homeland. Men like W.E.B. Du Bois and Leo Hansberry and J.A. Rogers knew that Africa had once been the site of great civilizations and was the center of learning in the ancient world. Marcus Garvey was the first to bring a positive consciousness of Africa to masses of American blacks. At best, however, it was difficult for any black to feel for Africa what an Irish-American, for example, felt for Ireland. What could we know of Africa? Few of us had

ever been there, nor did we live among people who had come from there and remembered it. And where the Irish-American could write and visit his cousin in County Cork, I only knew that, yes, somewhere in Africa, I had cousins and uncles and half-brothers and sisters, people whose blood I shared in the most personal way and I could never know them, for I did not know my name. Only that of my slave-owner. And even if I were able to locate them through some miracle of the gods, we could only stare at each other, unable to exchange one word. Unlike the young Jews of today who can repudiate Yiddish and Hebrew, I cannot repudiate what I never knew. Thus, I am effectively cut off from ever, ever, ever knowing my past. To feel that I have no country which will protect me is bad enough, but to feel that I have no past is, perhaps, the central crisis in the lives of all blacks who live outside Africa. Who am I? The only definite historical answer can be found on a bill of sale.

This is not to say that if I knew my historical past all problems would be solved. Perhaps I would be so ashamed of it that I would deny it, or so indifferent that I would let it slip away, or I might even find that I had no need of it. But I have no choice in the matter. My past was deliberately destroyed. Therefore, I must recreate what I can and create what I must. I must, in other words, create my historical self, because a man without a history exists to himself only in what others tell him. If I am to be a man, only I can tell myself who I am.

A change in the attitude of American blacks to Africa began in the late fifties. For many of us it began with the Mau Mau uprising in Kenya. I was a teenager then and had little idea of the political implications of what was happening in Kenya and in the papers of Nashville, Tennessee, all I learned was that black, ignorant savages were engaging in secret blood rites and swearing oaths and trying to kill white men, which was all the proof anybody needed that Africa was not ready to join the other civilized nations of the world (which had dropped atomic bombs on Japan, fire-bombed Dresden, napalmed Greece, and used germ warfare in Korea; no, Africa will never be as civilized as the West, I hope). That is what the papers wanted me to believe, but there is a vast difference between what a white man tells a black and what that black hears. What I heard was the first positive thing I'd ever heard about Africa. Niggers were killing white folks! Goddam! I fantasized about going to Africa and joining the Mau Mau. I could see myself drinking the blood of my brothers and swearing all kinds of oaths, tipping my spears with the deadly poison of strange roots and sending them hurtling into some cracker's chest. Thunk! Goddam! That it never occurred to me to throw some spears at the white people of Nashville (who were definitely not in short supply) is an indication of how futile I felt it was to fight here. We were outnumbered. But in Africa! In Africa! Wasn't no way we could lose. (Little did I know.) My fantasies were short-lived, for the Mau Mau were short-lived. Nonetheless, I had been awakened to an Africa that was trying to kick Tarzan's ass (though the disposition of Jane's remains in question) and that was enough. For the first time, I was not uncomfortable with the word "Africa."

In the late fifties and early sixties, the French and English colonies in Africa were given their independence and blacks in America began to take an interest in what happened there. Our present was no longer inhabited by savages who embarrassed us, but by United Nations diplomats and rulers of nations—Kenyatta, Nkrumah, Nyerere, Senghor (who, incidentally, wrote the story of *Mandabi*), Touré, Kaunda, and, always, the Adam Clayton Powell of Africa, the Lion of Judah, Haile Selassie of Ethiopia. (He was always the one positive black symbol in the pre–black power days of my youth—proud, defiant, flamboyant—and how I loved the stories about the two lions who walked unchained on the grounds of his palace, but had to be chained the day Princess Margaret came because she was afraid of them. Even now, when I know that he is nothing more than a repressive feudal lord, I still thank him for the positive black image he presented to me. He was the Lion of Judah and carried himself with such dignity and pride that you believed. After all, in 1200 AD Paris was a little country town, with wolves roaming through the streets after sunset. In 1200 AD, Ethiopia had been a nation for a millennium. Selassie traces his lineage back to the Queen of Sheba. God bless the Lion of Judah, tyrant though he be.)

In 1964, Malcolm visited Africa and, for the first time since Garvey, a link was built between Africa and its homeless children. In 1966, black power exploded in our minds and we were no longer Americans. We were Afro-Americans, African-Americans, Africans-in-Exile, Overseas Africans, and just plain blacks. We destroyed our slave owners' names and christened ourselves Askia, Chaka, Muhammud, Abdul, and Masai. We no longer brushed our hair down but combed it up. The women no longer had their curls straightened with hot irons, but shaped those curls into full, luxuriant crowns. We transformed brightly colored bolts of cloth into robes and turbans and daishikis (though we didn't take off our shades).

Africa, which had been a nightmare in our minds, became the material of which dreams are made. We began reading about the empires of Songhai, Mali, and Ghana, about the Yorubas and Ashanti, about Benin and other countries of ancient Africa. We had a past, one of which we could be proud, one that rivaled Europe in accomplishment and learning. (Did you know that iron was first discovered and used in Africa?) And when anthropologists could no longer avoid saying publicly that civilization had its beginnings in the African interior, we laughed with delight at the white man's discomfort and with contentment at finally being vindicated.

Some blacks contended that not only did Africa have a glorious past, it represented a superior civilization. LeRoi Jones changed his name to Ameer Baraka and became a Sufi Moslem priest. He said his prayers, bowing toward Mecca, and learned Arabic. To him and many blacks, the white man had existed only to reveal the depths of evil of which man was capable. Having done that, it was now time for him to pass from the face of the earth and let the Garden of Eden return. The very presence of the white man on the planet had become an unbearable insult to the rest of humanity.

Blacks began to visit Africa in the late sixties. The feeling began to grow that you had to go to the homeland, as the Moslem wants to see Mecca before he dies, and I know that I cannot die without once seeing the homeland, without standing on the shores of the Atlantic Ocean in West Africa from whence my ancestors set sail when they were transplanted across the world. (The ability to transplant hearts is really no great accomplishment. Blacks are the only people in the history of man to have been transplanted, en masse, from one continent to another. Two hundred million people taken bodily across the Atlantic Ocean; and it is their ancestors who now stretch from Tierra del Fuego through Central America, Mexico, the Caribbean, into the United States and Canada. And, as Charles Darwin has aptly pointed out, only the strong survive. We, whom you see everyday, are the direct descendants of Africa's strongest, the descendants of the only people transplant in the history of the world. And you ask why we're angry?)

Some who returned to the homeland have stayed. And it's no wonder. It must be amazing to be in a country and everywhere you look, black people, and everything to be done is being done by black people. You get on a plane and the pilot, co-pilot, and stewardesses are black. The airplane mechanics are black. You go into a bank, any bank, and the tellers and bank president are black (though the president is probably on the phone getting his orders from Paris or London). I cannot imagine what it must be like not to be subjected every day to white people. Not to have to explain, or be defensive, or watch out, 'cause this is one of them slick intellectual whiteys, or this is one of them sincere, well-meaning whiteys, or this is just a downright nigger-hating honky. To spend a whole day and not be put through any changes from white people! Wow! Not to have to wonder if that cab passed me because I'm black. In Africa, no problem. That cab passed me because the driver is a no-good bastard.

To be relieved of the burden which whites have made of my blackness. That is what Africa means to a lot of us. To have that burden lifted and just lay back and be my black self. I could be arrogant black if I wanted to, or stupid black, or nigger evil black, or exuberant black. I could change everyday for a while, just to see what all the different kinds of black felt like. After I went through that period I could just be me—black. But as long as I'm in the white world, part of me, if not all, has to be a white-folks-fighting black, which is tiresome, aggravating and should

MANDABI

90 MIN. COLOR RENTAL: $150 SALE: $750 ORDER #363

8

A film by
Ousmane Sembene

"Almost classic directness and simplicity."—*New York Times*

"A prodigious work . . . truly comparable to Satyajit Ray's first and greatest work, *Pather Panchali*. . . . One can give it a rating of superb."
—*New York Post*

"Momentously beautiful. . . . It's a simple, comic, heartbreaking and above all universal story."
—*Newsweek*

Mandabi was chosen Best Foreign Film at the 1970 Atlanta Film Festival. Just as Satyajit Ray's films opened the surprised eyes of the Western viewer to the world of the Indian village, so does this film from Senegal unlock for the first time the world of modern Africa—a civilization struggling to recapture its own rich heritage after a century of colonial tutelage and corruption. **Mandabi**, a story of classic simplicity about a man who receives a money order, tells how this dubious windfall threatens to destroy the traditional fabric of his life. Sembene's film is

unique not only because it marks the arrival of the first truly African filmmaker of international standing; it is also a deeply moving, witty, masterful portrayal of an ancient civilization in the throes of change, a warm, subtle comedy with a series of visual revelations about a world unknown to us. With Mamadou Guye, Ynousse N'Diaye, Issa Niang, Serigne N'Diayes. A Senegalese film in Wolof with English subtitles.

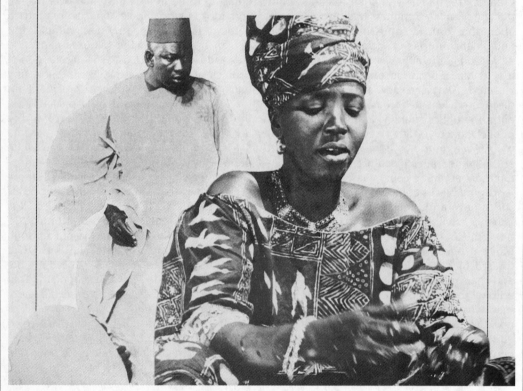

Page advertising *Mandabi* from the Grove Press Film Division distribution catalog, circa 1970

be downright unnecessary. Life is defined as a struggle with white people and that's not what I call living (though we do OK at it). To many American blacks, Africa means a new definition of life.

Others who have gone to Africa have had the disquieting experience of feeling that they had not come home, but merely to a foreign country. Richard Wright, in his book on Ghana, *Black Power*, felt that. He looked at Africans and wondered which one's great-grandfather had sold his into slavery. He loved Africa, but he was an alien there. To what degree can a transplanted, miscegenated African go home? The Africa which exists in our mind may have little relationship to the Africa we will see in our eyes. Indeed, blacks in America are in great danger of creating a mythology of Africa which will make it impossible to comprehend the reality. But we need that myth right now, that myth of empires whose streets were paved with gold. So many of us need to create a fantasy world to combat the white man's Golden Age of Greece fantasy and his Italian Renaissance fantasy and Age of Reason fantasy which we were forced to study in Western Civilization classes. ("I think; therefore I am," the teacher said, glowing as he read it. It summed up the best and worst of Western civilization. Thinking has nothing to do with being. I think; therefore I think. That's where that's at. The question is, how do you live?) So we have created in our minds an Africa which cannot live up to our fantasies, and for many of us, it is shattering to go to Nigeria and see "Bonanza" and "Cowboy in Africa" on television. We go to Africa and realize the cold realism of Fanon's words: "All the proofs of a wonderful Songhai civilization will not change the fact that today the Songhais are underfed and illiterate, thrown between sky and water with empty heads and empty eyes."

Africa does not exist merely as raw material for our fantasies. It exists in and of itself. When some of us realize that, we find that we are little more than Americans visiting Africa. In many instances, Africans look upon us as Americans. Black, yes, but black Americans. Others, however, such as Nkrumah, see us as another tribe, a far-flung tribe, captives of war, who are returning, and some of the masses share this feeling. A friend of mine visited a village in Ghana and when asked by the chief where she was from, replied, "The United States." He asked her to tell him about her country and when she finished, he looked at her in amazement. "We have heard stories about our people who were taken across the waters, but I did not believe them until today." And she was received as what she was—a member of the tribe who had come home.

Whether or not Africa becomes an actual homeland and not merely a psychic one depends on Africa and whether the consciousness of the African people will be tribal, national, or Pan-Africanist. Blacks in the West are Pan-Africans, because they have no home in the Western world. Thus, they feel a unity with all non-whites. But whether that feeling of unity will be reciprocated by Africa is a question for the future. The African has his tribe and his country. He does not feel the same urgent need to be a Pan-Africanist as the American black. Indeed, he is not as intensely anti-white, if he is anti-white at all. After all, it is his country and he is a majority in it. Israel gives automatic citizenship to any Jew (except black Jews from Chicago, it seems). Africa must one day confront the same issue. But, as of now, it has too many problems which are more immediate and pressing. It does not reject black Americans who come home; but it does not roll out the red carpet, either.

The black American in Africa confronts his blackness in a new way, for it is thrown into bas-relief, not by whiteness, but by the complexities of Africa. We think of Africa as if it were a unity. It is not. It is a continent (the second largest) of separate nations, artificial, white-man-made nations which were created by colonialism for the convenience of dividing up the spoils. The press defines Africa's problems in terms of tribalism. No. Nigeria was at war because it was only a nation in the eyes of Britain for the convenience of Britain. It is a country with Arabs in the north, Ibos in the west, and Christians in the central regions. The current Nigerian government was at war to make the country into a nation, trying to weld its disparate parts into some kind of whole, to get its various tribes and religions to live together under a central political authority. Whether or not Nigeria, or any other African nation, wants to accept the definition of nation imposed on it by

colonialism is almost a moot question. The complexities of international economics, as well as the presence of neo-colonialism on the continent, precludes any other course at the moment.

The concept of a nation as a political unit is very new in Africa. The basic unit has always been the tribe and one of the first problems of black African governments is how to get tribes and members of tribes to identify more with the nation than the tribe. An African is an abstraction. A Kikuyu is not. A Kenyan may or may not be an abstraction, depending on the political consciousness of the Kikuyu. Blackness has little or no meaning, except in those countries where whites either dominate or are close enough to spell a danger—Rhodesia, South Africa, Botswana, Southeast Africa, Zambia, Tanzania. Blackness as a concept with intrinsic values seems to rise in worth the closer its proximity to whiteness.

Thus, when the American black confronts Africa, he confronts a people who are struggling to know their identity, and their struggle is not a simple black-white question. In fact, it can be exceedingly complex, particularly if you live in one of the large cities. This is where the concepts of race and nation and tribe and religion exist and provide the context for the lives of the individuals. It is where Africa confronts its own cultural past and present, the vestiges of colonialism, and the actuality of neo-colonialism.

Dakar is the capital of Senegal. It is a city with slums which compare with the worst of Chicago's or Philadelphia's and, in 1967, it had the highest prices in the world, followed by Paris and New York. During colonialism, it was the center from which all of France's interests in Africa were looked after. It was the black Paris (as Hanoi was the Asian one). It was a well-to-do city then, because French soldiers put money into the economy; the civil servants and bureaucrats who looked after France's African interests from their desks in Dakar put money into the economy. When France granted Senegal its independence in 1960, it did not, of course, return the country to the state it had been in before France had come. It merely watched as the tri-color was lowered from flagpoles and smiled as the new flag ascended to flutter in the illusory winds of independence. France left the city of Dakar with 10,000 civil servants who presently drain $520 million a year from the economy, civil servants which France needed for its colonies but who are useless for Senegal. The industries in Dakar which had serviced all the colonies could now only service Senegal, and thus, they were a wasteful extravagance, as well as a source of lost revenues. And with independence, Senegalese markets contracted as the French closed their bases. The economy of the French federation had been to France's benefit. Senegal's chief crop was peanuts. It also supplied soldiers for the French Army (some 280,000 fought in World War I, as well as in Vietnam up to Dien Bien Phu). Because Senegal was part of a federation, its other needs were supplied by the other members of the federation. After independence, Senegal had to furnish all of its own needs, as did Mali, Guinea, Cameroon, and the other French colonies. (An attempt was made to restructure the federation after independence, but the political differences between the new countries, particularly Senegal, Mali, and Guinea, were too great.)

Senegal, like the rest of Africa, has not yet recovered from another experience it suffered at the hands of the West—the slave trade. Senghor considers the loss of 200 million people to be a worse catastrophe to Africa than colonialism. "What civilization," he asks, "would have been able to resist such a hemorrhage?" Imagine, if you can, the entire population of the United States being transported across the ocean to China. Perhaps that will give you some idea of the proportions of the African slave trade and its impact on Africa. (Two hundred million people. Count them and then maybe you'll understand why blacks are not sent into paroxysms of agony over six million Jews. When Jews and other whites become as indignant over 200 million black people taken from a continent, a significant number of whom did not survive the Middle Passage, and pound it into the heads of people as Hitler's attempted genocide has been impressed upon the world, then we will not feel insulted when Jews talk about the six million. When you cry for our 200 million, we will weep for your millions, who number more than six million in the centuries of pogroms Jews have suffered. For right now, I must remember the 200 million. Everyone else has forgotten,

or considers it of little or no consequence. I sincerely hope that you understand why my tears are reserved for black humanity.)

The slave trade, then colonialism, and now, neo-colonialism. The white man is no longer seen ruling Africa today, but he has merely learned the advantage of ruling from behind a black mask. The problems faced by the "emerging nations" (emerging from the predatory claws of the West) seem almost insurmountable. It is a wonder that there have not been more conflicts like Congo-Katanga, Nigeria-Biafra.

This is the political-economic environment against which many Africans must lead their lives today. French-speaking Africa has not had the violent upheavals of the former Belgian colony, the Congo, or of the former English colony, Kenya. Senegal, in particular, remains closely tied to France as it attempts to become a nation. It is a difficult process. There are many tribes, each speaking a different tongue. The schools, those which exist, are modeled after French ones. French is the official language. But it is spoken by less than ten percent of the population. How do you begin to educate the masses of people to the problems? How do you begin to explain to them the increasing complexity of their lives? This is not the place to even attempt an answer to those questions. Indeed, the questions are only raised to try to give some indication of the enormity of the problems to be dealt with. Perhaps the strangest part of it all is that while this situation exists, people are leading their lives each and every day and it is in those lives that one finds the actual history of the nation, in the individual lives of people who do some things and have a lot of things done to them as they traverse the space which stretches from birth to death.

Ibrahim Dieng is one of those people. He is sitting in a square in Dakar. His skin is black, a rich, luxurious black. He looks to be in his fifties, maybe sixties, and is having his head shaved with a straight razor. Behind him three black women walk slowly down the street, carrying bundles on their heads. Their long, colorful robes reveal nothing of their bodies, but the gentle sway of their large hips cannot be hidden. Indeed, it was not meant to be, for the robes emphasize the sensuality of their movements. Ibrahim does not notice. The barber places the straight razor inside Ibrahim's nostrils and swiftly, but gently, cleans the hair from them. Ibrahim does not flinch. When it is over, he picks at each nostril, sniffs, looks at himself in the small mirror, and without a word, pays the barber. Getting up, he walks away, stolidly and with great dignity.

As a person, Ibrahim is no better or worse than anybody else. He seems to take great pride in his physical person and, although he is somewhat rotund, he still manages to present a fine image to the world. He has good reason to. He has not been able to find a job for four years and has two wives (he is a Moslem) and seven children to support. But one would not know of his poverty watching him in the streets. He looks like a prosperous merchant. He has retained his self-respect.

At home his wives treat him not like a man who is unable to support them, but like a king who daily bestows upon them the riches of Solomon. He enters the house, sits on the bed, and one of the wives removes his sandals, pours water into a pan and washes his feet. After they are dried, his meal is brought to him and, in what has to be one of the great scenes in motion pictures, he proceeds to eat. The eating scenes of *Henry VIII*, *The Seventh Seal*, and *Tom Jones* pale by comparison. Here, there is no table laden with food, no drunken crowds of people, nor is the air heavy with sexuality. Here, there is one man, seated on the floor, his back against his bed. Between his legs is a large bowl of rice. He shovels the rice into his mouth with his hands, belches with great effort, runs his hands around the inside of the large bowl and shovels it in. Finally he finishes and one of his wives brings a bowl of water and he washes his hands and the inside of his mouth. Then he is brought fruit, which he devours quickly and greedily. Then he stretches out on his bed for a nap, and one of his wives massages his back and legs.

This is the prelude to the actual story, which is exquisite in its simplicity. Ibrahim receives a money order (*mandabi*) from his nephew who lives and works in Paris. Ibrahim tries to cash it. And it is there that the story begins, unfolding slowly and in painful detail. Those of us who have tried to cash a check at a bank where we didn't have an account or were not known realize as Ibrahim walks confidently into the post office that he will

not get the money order cashed. But Ibrahim is not schooled in the ways of "civilization" as we are. He does not know that to cash a money order is to subject one's being to an all-out assault by the forces of civilization.

He walks into the post office and goes over to a young black man seated behind a desk. Hesitantly he hands the letter to the young man and it is then that we realize that Ibrahim cannot read, that in Senegal one can get a job reading mail to those whose sons, nephews, brothers, and cousins have left and gone to Paris. The reader takes the letter and begins to read it to Ibrahim. Suddenly we hear, not the voice of the reader, but that of the nephew and on the screen we see a young black man, dressed in pants and a heavy sweater, a stocking cap on his hand, leaning his long-handled street-sweeper's broom against the wall of a building, entering and mailing the letter which Ibrahim is now listening to. Then we see the nephew leave, take his broom and return to the gutter and the Seine and those quaint little bridges arching it do not look so romantic seen from the gutter. The boy tells his uncle that he is saying his prayers each day and remaining true to the Moslem faith. He is homesick and hopes to return one day but, as Uncle Dieng knows, there is no work in Senegal. He has saved five thousand francs, which is to be divided between Ibrahim, the boy's mother, and the rest to be deposited in a bank for the boy for when he returns.

Ibrahim smiles shyly when he finishes listening to the letter, but it is obvious that he has understood little of what the boy was saying and feeling. The reader, who has obviously read many letters like this and might have written a few himself, demands his payment and is only partly-mollified when Ibrahim tells him he will pay as soon as he receives the money for the *mandabi*.

The reader watches closely as Ibrahim goes to the window to cash the money order. The clerk asks Ibrahim for his *carte d'identité*. Ibrahim, of course, does not have one and scarcely knows what it is. But he cannot get the money without it. The clerk tells him that the money order will be kept at the post office for two weeks, after which it will be returned to the sender.

Ibrahim starts to walk out of the post office when he is accosted by the reader, demanding his money. Insults are exchanged between the two, with Ibrahim using anger to cover his inability to understand why he should pay someone to read a letter to him. He stalks out of the post office, leaving the reader staring after him and, though one's sympathies are with Ibrahim, you wonder how many times this has happened to the reader.

Ibrahim goes off to get his *carte d'identité*. There are three clerks at the government office, three of Dakar's 10,000 unneeded civil servants. One is reading a magazine and discussing (in French) getting a loan from one of his fellow workers. The loan is finally agreed to, but with exorbitant interest. The clerk goes back to his magazine. Ibrahim stands at the window, uncertain what to do. The clerk reads. Ibrahim stands. The clerk reads some more. Ibrahim continues to stand until one of the other clerks calls attention to him. The window clerk looks up from his magazine and addresses Ibrahim in his own language with the rudeness which seems to be the one qualification for a job in a government bureaucracy. Ibrahim requests an identity card and is asked for the place and date of his birth. Ibrahim, of course, knows only that he was born "around 1900." "You must know the exact date and place of birth. Without it we cannot give you an identity card." But surely the young clerk has not been so French-fried that he does not realize that he is asking for information which Ibrahim could not possibly have. But there is nothing which links the clerk and Ibrahim except the color of their skin and that, it is becoming obvious, is not enough.

I had had my dreams of Africa. And although I am accustomed to being insulted and mistreated by blacks in positions of authority in this country, I still didn't want to believe that it would be the same in Africa. But Ibrahim goes from experience to experience as if he is wandering through some Dantesque hell. A nephew, a civil servant, arranges with a friend to get an identity card for Ibrahim and then, needing two photographs, Ibrahim goes to have his picture taken. He walks by a row of small photo shops, pretending to be merely looking at the photographs on display on placards outside, until a black man comes out and leads him inside one of the studios. Ibrahim gets his picture

taken for 500 francs—which he borrowed—and you have that sinking feeling that there probably wasn't even film in the camera. Ibrahim returns on three consecutive days to get his photos and he is finally told that the photos did not come out and to go away and forget about it. Ibrahim strikes the photographer, smashes his camera, and gets his nose bloodied in return.

It is at this point, perhaps, that you know that even if Ibrahim does get the money order cashed, it will make little difference. It will be scant compensation for all that has happened. Prior to the *mandabi*, Ibrahim was poor, but so were all of his neighbors. He was poor, but he had his self-respect and his dignity and, among his peers, he was an unquestionable equal. Now his friends wait outside the door to his yard waiting for him to come home with the money. They visit him with many smiles and beg for money, which Ibrahim, being a good fellow, promises. They come and beg for food, knowing that Ibrahim has been advanced many bushels of rice from the grocer, who also awaits the redemption of the *mandabi*. Ibrahim ceases to be simply Ibrahim, which was his only significance. Now he has greater significance. He is the *mandabi*. And it is only to his wives that he remains a human being. It is they who try and protect him from his friends and protect the *mandabi*, too, for they must feed the children with the money from it. One of them gives Ibrahim her necklace to pawn when he does not have the money to make one of the interminable trips downtown and it is perhaps one of the few moments in the film when Ibrahim seems to realize that his wives are more than personal body-servants.

Ibrahim is eventually cheated out of the money by a young black lawyer who promises to get it if Ibrahim signs a statement giving him permission to do so. We have seen the young lawyer earlier in the film promising another young black, who wants to buy Ibrahim's house, that he will get it for him. So when Ibrahim makes his mark on a piece of paper, we are uncertain if he is unknowingly signing away his house or merely giving permission to have the money order cashed. When Ibrahim returns to the home of the lawyer the next day to get his money, at long last, the lawyer tells him that he was robbed of the money, etc., etc., etc. It is Ibrahim who

has been robbed and he knows it, but there is nothing he can do but weep and wail and plead, unwilling to believe that all of this has happened to him and unable to understand why.

Ibrahim is the central character of the film and, if a film is supposed to have a hero, he is that, also. But he is a hero who does not act; he is acted upon. And the chief actor is only seen in the film in person once. As Ibrahim waits outside a government building, a white man, his wife, and child come out, pause at the top of the steps as the man reads a document, and then proceed down the steps and out of sight. The camera does not focus on them, but catches them out of the corner of the eye, as it were. Just a glimpse, but it is enough to be a violent shock. By the time they appear, you have adjusted yourself to the delightful (if you're black), strange (if you're white) experience of seeing nothing but blacks on the screen. Then, out of nowhere, white people! My God! But they do not look like the stereotyped colonialist, white suit and white hat. The man is young, casually dressed, and has a beard. He looks like a decent human being, but what is he doing in Africa? He can't be up to much good! And having been immersed in the sensuality of black skins, how pale and ugly these white people look, you almost utter aloud in disgust. But by that time, they are gone, as the camera goes inside the building.

The film focuses on Ibrahim, but white people are its subject. And we see them throughout the film. Ibrahim confronts them in the apartment of his nephew, the one who tries to arrange for him to get an identity card. Ibrahim looks and feels out of place in the small, sterile apartment, with its modern furniture and its modern inhabitants—a young man, suit and tie, and his son who is wearing short pants and sitting primly on the couch (which looks like it came off Third Avenue in Harlem, a dollar down and a dollar a week). The apartment has nothing to do with Senegal.

Ibrahim confronts them whenever he meets a young black, who talks to his friends in French and to Ibrahim in the native tongue. The use of two languages in the film (Wolof and French) is skillfully done, slipping in and out, making of Ibrahim now a participant, now an alien.

Western civilization appears when Ibrahim's wives are working in the yard and a man (black) comes along, selling brassieres. The wife looks them over carefully and, expecting the money order to be cashed, she takes a red one from its hook. No, no, beautiful woman! But thereafter, there is the small part of a red bra strap staining her black skin, as it goes over her shoulder and beneath her flowing robes to choke her breasts.

Most of the blacks in the film represent Western civilization to some degree. Only Ibrahim and his wives are the exceptions. And it is impossible to really hate them for they, too, are victims. They, too, are caught in the vise of a history they did not make. The grocer, who must decide every time someone walks in the store whether he can afford to let them have more food without having been paid for the food of the previous months. The young civil servants, educated into French culture and who now speak French among themselves because it is the language of "civilized" people. Pity the young reader at the post office, who can probably recite Racine, Corneille, and La Rochefoucauld from memory, who knows the rulers of France from the reign of Charlemagne, who has been made to see the height of civilization in the statuary of Notre-Dame instead of the minarets of the mosque. (For me, the most exciting scene of the film was the saying of prayers outside the mosque and the singing of the muezzin. It was Africa before the white man, eternal Africa, black Africa, Africa as Africa, and not Africa in its struggle for life against the West. In that scene I was part of the Africa of my forebears and felt an inexplicable communion with the faithful who knelt on the mats and bowed to the East.) Pity the reader for he has entered that world of double-consciousness, he has gained nothing except a knowledge of French and lost everything—himself.

The four women of the film are the most dynamic and vital people we meet. Ibrahim's two wives are gentle strength personified. They are young, much younger than Ibrahim, and between them there is an obvious love and affection. They are like sisters to each other. As wives they are obedient, attentive, and respectful. Ibrahim berates them for the slightest thing, but they never show resentment. They are aware of his faults and seek to protect him from them. When a neighbor comes to borrow rice, Ibrahim tells one of the wives to give away most of what they have. She protests and Ibrahim commands her to do as he says. The wife gives away only a fraction of the rice, claiming that it is all they have, knowing that the next day when Ibrahim sits down to fill his great belly, he will be grateful. And even if he is not, the wives are determined that the children will not starve. One of the most intense scenes of the film occurs when Ibrahim goes to the grocer to borrow money. The grocer refuses him, knowing that he has given Ibrahim many bushels of rice, that he gave him cash for his wife's necklace, which Ibrahim did not redeem, and he is wondering if there ever was a *mandabi*. Ibrahim pleads and the grocer becomes indignant and insulting. Ibrahim returns the anger and insults and a small fight breaks out. The grocer threatens to call the police, who will make Ibrahim pay what he owes, if not in cash then in property. The law can make him pay what he owes. The two wives push their way into the store through the crowd which has gathered and without hesitation they begin to insult, yell, and scream at the grocer. He backs away into a corner, pleading for Ibrahim "to get these women away from me." But they are there to protect Ibrahim and if he had not told them to go outside it is clear that they would have left only after they had wrecked the grocer's store. They are worth a film in themselves.

For those of us who have heard of polygamous relationships, this film affords the opportunity to observe one. However, is it something which a Westerner can understand? The polygamous relationship has a long history in Africa, pre-dating Mohammedanism, which perhaps adapted itself to what was already custom. While I loved the wives, I felt uncomfortable with their total loyalty and submissiveness. Their lives were lived through Ibrahim, it seemed. Were they thereby oppressed? Within my context, yes. But what about within theirs? Their context is one that I do not know and, to a great degree, cannot know. So I accepted them as they presented themselves, but hurting each time Ibrahim failed to give them the respect, love, and gratitude they deserved.

Ibrahim's sister is another strong figure. She is the mother of the nephew who has sent the money order and comes for her share.

While Ibrahim can intimidate his wives, he withers before his sister. She shows nothing but complete contempt for him, though she has an affection for his wives, who intercede between her and their husband when the tension reaches the breaking point.

The other black woman in the film is seen in the apartment of the lawyer, sitting on a couch, filing her nails. She wears a dress, speaks French, and if she is not a whore she might as well be from her manner and looks. She is only in the film for a minute at most, but it is enough to establish another point of contact with the film's subject matter—the white man.

There is another woman in the film—a naked white doll which belongs to Ibrahim's children. It is seen lying in the yard and on the porch. It is never shown just for itself (there are no phony close-ups in the film to make sure you don't miss a symbol). Each time you see the doll, it is an integral part of the scene. Indeed, the camera does not pay any attention to the doll. It is as if it were there and the camera caught it along with everything else, but wasn't aware of it. You are, though. Each time you glimpse it, it is like being slapped across the mouth. It is the most infuriating thing in the film.

No one in the film is an abstraction. These are people in a particular historical, social, and cultural situation. They are not wholly admirable. Nor wholly despicable. You can feel some degree of sympathy and empathy toward everyone.

We feel the world through Ibrahim. He is the white man's victim. Indeed, he is Africa in transition. An illiterate peasant without a *carté d'identité*. Yet, you don't pity him, because he does not pity himself. Instead, you feel his bewilderment, his frustration, and his sorrow. (After the fight with the photographer, he sits beneath a tree, his white robe spotted with his blood, the blood still dripping from his nose. You want to cry with him, not for him.) Even in the horrible scene near the end, when he gets on his knees and pleads over and over for the money he knows he will never get from the lawyer, you don't pity him. A poor man's most important possession is his self-respect and Ibrahim retains his.

He returns home from the lawyer's house and tells his wives that he has been cheated out of the money. He does not yet know that he will lose his home, too, but if he did not sign it away to the lawyer unknowingly, he will lose the house to the grocer to pay his debts. He has been defeated. Then, in the last scene, the postman, who has appeared twice before with the news about the *mandabi*, enters the yard and, learning the fate which has befallen Ibrahim, tells him that it does not have to be that way, that people do not have to be poor, that there is a way to fight. Ibrahim and his wives look at the postman in bewilderment, having little idea what he is talking about. And the film ends.

You are confused, Western viewer, veteran of Fellini, Godard, Truffaut, and Antonioni. The ending seems out of place, as if it were put on as an afterthought. It sounds almost as if it came out of Central Casting in Moscow. It comes so suddenly and we are not prepared for it. And perhaps that is the point. We were prepared for everything else, because Ibrahim's degrading experiences have been our own. But unlike Ibrahim, we have picked up revolutionary theories almost by osmosis. Whether we agree with them or not, we can engage in a political discussion just for the intellectual stimulation we get.

The postman is not a Greenwich Village or Harlem intellectual. He is a postman, a middle-aged man, who is probably not aware that Che and Mao ever existed. More than likely, he is a peasant like Ibrahim, but unlike Ibrahim, he went to school (probably a Roman Catholic mission school), became literate, and joined the postal service. As a postman he has a unique position in the life of the city, for his work brings him into contact with young intellectuals and the peasants, like Ibrahim. Unlike the intellectuals, however, he is able to be exposed to the new without losing his relation to the old. He hears things and sees things and somewhere in his daily moving in and out of both worlds (and one has the feeling that he lives, not in a Western-style apartment, but in Ibrahim's neighborhood), he begins to think about what he sees. And he begins to talk to different people. Eventually he concludes that there is a way out of the vise, that there is a way for Senegal to be its own master instead of France's victim. In the little that he says at the end of the film, it is unclear if he belongs to an organization—a secret organization that is making long-range plans. Perhaps, for

No. 56, July 1968

he speaks with the confidence and assurance which can only come from being a part of a group. He has his eyes open constantly for those who might be receptive to the new knowledge he has to bring. Thus, he speaks to Ibrahim.

Within the context of the film, it is not important that we know how Ibrahim responds. And Ibrahim's response is really not important. What is important is that another layer of consciousness within Senegal is revealed. Thus, in the figures of Ibrahim and the postman, we see a total Africa—the old which has been made a victim, and the victim beginning to fight back. That is enough.

It is good to see Africa honestly presented through the eyes of a black African. The film destroys the myths and fantasies which we involuntary exiles cannot help but create. We confront ourselves in a manner more intense than if we were actually there; thus, art fulfills its function. I came away from the confrontation with a deeper feeling for the motherland and more intense hatred for what had been done to it. Of course, hatred will not solve the problems of Ibrahim. Nonetheless, the hatred will be my energy, when my commitment finds itself a little tired.

I am not sure what the film can mean to whites. If they see it and get Tarzan out of their minds, that will be enough. Of course, many, if not most, will contend that the film could just as easily be about white people and that, in actuality, the film is proof of the commonness of man's experience (man's experience as produced and directed by Western civilization). *Mandabi* is universal, I can hear the liberals telling me. Of course it is, which is not the point at all. Nor does it have anything to do with the film. All too often people invoke the universality in art so they can avoid having to confront the particulars of life, of which art is merely an expression and interpretation. It is the particulars of *Mandabi* which make it a first-rate film. And *Mandabi* must be experienced in its particulars. This, of course, calls for honesty from the viewer.

I confronted myself in the film. I don't think it's impossible for whites to confront themselves in it also. I know it isn't. The film is, after all, about them. The question is, as it has always been, will they allow themselves to be confronted?

SEEING AMERICA FIRST WITH ANDY WARHOL

Dotson Rader

When I leave Andy Warhol, those occasions when I have been with him and he has been open, I go home and I have an urge to call him on the phone to find out if he is all right, if he made it home OK. I sometimes worry about him like I would worry about a child, but a bereaved child, who by some terror has been weakened irreparably and is vulnerable. You see, I hate to leave him. I want to stay the night in bed with him, to sleep with him to be certain that he makes it through to morning. For he is possessed of death. It is no longer unexpected.

One night this winter, Brigid Polk, Andy with one of his boys, and I had dinner together at a restaurant in the East 20s. Earlier, at his Factory, he had run his tape recorder and shot pictures of us with his Polaroid, and as we walked to the restaurant, about fifteen blocks from the factory, the tape machine went on recording our conversation. At the dinner table, Andy ate with one hand and with the other he held the mike awkwardly and recorded what we said. After dinner, he and Brigid took more Polaroid pictures of us.

In Brigid Polk's apartment there are thousands of Polaroid pictures of Andy and Gerard Malanga and Paul Morrissey and Joe D'Allesandro and other friends. There are pictures of them nude and making love, pictures of Gerard and Tom Hompertz under the shower, of Jane Fonda and Cecil Beaton, pictures of Andy's friends taken over many years in many places and many moods. Brigid has a Cock Book, Scar Book, and Tit Book where I and others have put our imprints, body markings—recording them like voices on tape. Brigid and Andy have tape recorders attached to their phones. They record each other's conversations and have transcripts typed up which they save. Photographs, tapes, scrap books, masses of trivia, documentation, evidence: what other possible motive for this than the attempt to cheat death by salvaging the exhaust of existence as immutable objects. As celluloid, a voice survives. And a tit remains in negative.

Andy once wanted to have a show about death in America—this was before the dyke tried to murder him—where he would display his Marilyn Monroe pictures (after her death) and his Elizabeth Taylor pictures (when he thought she was dying) and pictures of accident and riot.

He said that he made his Campbell soup cans and Brillo boxes because he liked the design and colors and because his rooms were empty and they filled the space interestingly. He also said that he filmed his movie *Lonesome Cowboys* because "everybody [his friends] could be in it together. They look nice together. They won't always be like that. They won't be together all the time. This way it doesn't change."

Now Andy Warhol's second film about Joe D'Allesandro, *Trash*, is soon to be released. It was directed by Paul Morrissey, and I think, on many grounds, that it is Warhol's best film. Certainly it is an important American film. I saw it at the Factory, with the cast assembled to view the rushes, and I was moved by it. For it is bleak, and it is without any sense of hope, and it is true, and it marks a change in the way in which Warhol sees America and, therefore, in a very real sense (since Warhol, like Mailer, often has the capacity to see us truly before we see ourselves) it signifies a change in ourselves.

In *Flesh*, Joe D'Allesandro's first film, Joe played a hustler who went out to raise bread for his chick's girlfriend who needed an abortion. And he hustled his ass to get it. He was young and handsome and charming and equal to life in *Flesh*.

Trash begins with D'Allesandro standing naked with Geri Miller kneeling before him, trying to blow him. But it is hopeless because D'Allesandro, the super-stud Mr. America, is now impotent, and on junk, and he is desperate and demeaned and dying. He is human waste, trash, and his life is populated like a pesthouse by victims who are so near the borders of death, toppling on the edge, that they have become immune to life. There is Holly Woodlawn, Joe's "woman," who looks and acts like an hysterical 1920s movie star gone bananas, out of luck and scheming insanely, and desperate for affection to the point of madness. And what she is hot for is Joe, her man. But Joe, like some faggot who fails to pass anymore, can't get it up. He is worn through by life, driven by drug sickness into silence. Holly lives on hope with a mute and an impotent, her man, the archloser phasing out on scag while she goes out of her gourd masturbating herself with a beer bottle. And in a scene with Raphael colors, like an episode in a dream, Joe tries to mount Holly's sister, Diana Durban, pregnant and big as a cow in the belly, but the rest of her emaciated, gaunt, passing, passing. And at another time, Joe is brought home by a young wife, a cake-eater, and is bathed and prepared, and later, on a bad trip, nearly dying, he is held by her in a room with colors like a cathedral while the camera photographs him from far above. A broken man. It is too obvious. The Pietà.

What does this have to do with Warhol, and with us?

It concerns Warhol because it is one more document created by his fascination with and terror of death, death which I suspect he senses in the objects (the people) he digs the most. And us, because, for the first time, Warhol appropriates what I think is the most acute symbol of the young man growing up in urban America today: the hustler as an impotent. Stripped, right? Utterly without effect. Useless. Objectified. And, finally, because Warhol has intuited what we are only beginning to suspect: that is, that America does not exist. Americans live as if they were uprooted, driven from home, and that back there, back home, the real America still exists. That once it was good for them, it was just; that this good and just country has been spoiled. It has been stolen. But for them, the remembrance of it continues. (It was only this year that I realized that I did not like America, but while not liking it, I was still stuck with it, as in a bad marriage.)

In *Trash*, even the remembrance is gone. America, like hell, has no past and it has no future, for it has no generation to survive us, and it has no hope. It is dying, and as it dies it becomes, like Joe himself, impotent and indifferent and unhandsome and desperate and grubby and coated with filth. It reaches the time where it no longer resembles itself. You go away from America and when you see your country again—as when you come to *Trash* and see Joe—very little remains of what was there that you dug. And you think, soon, America, they will take what remains, your name, and call you something else.

No. 80, July 1970

"It Could Only Happen in California"

Dotson Rader

During the last two years, in every major city in America, there has come a flood of exclusively "homophile" movies which run at gay theaters, like the Eros in Manhattan, before audiences composed primarily of aging voyeurs beating the meat in the back rows. The appearance of homosexual films on the market (I think it would be accurate to claim that homosexual films constitute a separate genre in themselves, creating their own conceits, dramatic rituals, etc.) coincides with the growth of organized homosexual lobbies, such as the Gay Liberation Front, which emphasize political street action rather than court appeals to guarantee homosexuals equal treatment for their community. Thus we have a remarkable situation in which homosexuals abandon the closet to battle police over the closing of the Stonewall Saloon, picket city hall against civil service discrimination, storm a police station outraged because the pigs have injured a youth in another bar raid. We are witness to the creation of exclusively homosexual hippie communes in San Francisco, and the publishing of the names of policemen who work as undercover agents in the entrapment of homosexuals.

All of which I find gutsy and commendable, particularly the latter since it has about it an appropriate irony. It has been the threat of disclosure which police have used to hassle homosexuals for generations. What the hell does some poor cop say to his wife when she learns that he has *volunteered* to wile away the night shift in the men's room of Grand Central? I was only taking orders? The pigs have it coming—let's admit it, the Vice Squad is, along with the Red Squad, the most indecent and dishonest and assuredly corrupt of police gangs.

The homosexual film industry (for that is what it has become—an industry with contract players, producers, an embryonic star system, a burgeoning network of gay theaters) is beginning to seek critical legitimacy, to self-consciously consider its product as *art* and as authentic socio-psychological documentation when, from the limited samples I have seen, homosexual films on the whole are little better than sexploitation vehicles, homemade movies, boy-boy beaver flicks. It is not promising and, as far as the socio-sexual pretense goes, it is literally softcore. Simulation. The boys don't get it up.

Los Angeles, as befits a city without a recognizable culture, is the production base for Pat Rocco's film company, Bizarre. Rocco is the Cecil B. DeMille of lavender Hollywood (the Ross Hunter is more to the point) and he has given the world such jewels as: *The Sailor and the Leather Stud, Big Muscle, Fanny's Hill, Groovy Guy, The Sailor Stud at Large, Yahoo, The Body, Strip-Strip, Sunny Boys, Big Bares, Magic in the Raw, Up, Up, and A-Wow!* and *Surprise Lover*. Not bad, considering the fact that he has been grinding them out for only two years, has had no previous experience with the medium (unless being a dancer on the Tennessee Ernie Ford Show counts), and runs a mail-order beefcake basket boy-boy book business on the side.

While in Los Angeles, I attended the premiere of Pat Rocco's latest epic, *Mondo Rocco*, at the Park-Miller Theater. The evening was interesting on several counts: it displayed members of the homosexual community in a public light—queens and Rocco-actors bounding awkwardly out of rented Cadillacs onto the red carpet under the marquee, mouthing incoherently into a microphone held by a small man looking uncomfortably like the checkout man at Food City, and nervously running his left hand over his hairpiece, as he and the film crew hired by Rocco recorded the event. It showed the queens finding heaven at least in going under the sky light to a real Hollywood premiere, as stars yet, tripping by a crowd of disbelieving locals, straight as hell, pressed behind the police ropes utterly spaced by seeing their local theater turned into a gay Grauman's Chinese overnight. One note: an actor arrived in typical Hollywood evening dress—wide fishnet bellbottoms, a fluorescent blue evening jacket, pampered blond hair, and, underneath all that fishnet, nothing but a gold jock cup and bare ass.

Mondo Rocco is four hours long. It consists of a series of short films, two of which are romantic, trite boy-meets-gayboy stories (the same sensibility which, in a different age, produced what were called "ladies pictures"); a passingly interesting short about a youth in prison who is almost raped by an aged inmate (who resembles the model in the Poligrip commercials—"It really holds my dentures! I can eat apples now!") but is saved in the nick of time by his hung and darkly handsome cellmate; a three-part female impersonator routine in which Judy Garland, Mae West, and Barbra Streisand are each in turn demolished; and finally, to give the whole sack of nuts some socially redeeming importance, we are treated to boring documentary sequences covering such earth-shaking events as a love-in in a park in Los Angeles, a gay power demonstration fed by Rev. Troy Perry, and a police raid on a bewildered male nude dancer in a sleazy suburban bar.

The four hours limp to a close with a little number called *The Kiss*. I was not ready for it. Picture this: two blond midwestern types, with a distinct imbecilic vacuity about the eyes, spy each other through Edenic foliage on the edge of a field of yellow grass. Their looks lock. Heavy breathing. Their hearts tremble. Pause. The plowboys move toward one another. They fall to their knees and in slow motion *crawl* naked through the long grass toward each other. Within touching distance, they *resist* temptation and instead of banging to it like normal human beings, they begin to run in everwidening circles around each other, staring idiotically at each other's faces, running faster, their members bobbing absurdly like shuttlecocks on a string. Finally they embrace and kiss while the Longines Symphonette Strings quiver dramatically. Good God.

To end this quickly: before the premiere I spent time talking with Mr. Rocco; I believe, despite the amateurishness and falsely lyrical nature of the story lines, despite the incompetence of the actors, I believe that Pat Rocco is truly, yes, Virginia, *truly, seriously* attempting to create a legitimate homosexual cinema. He actually *believes* the line he rattles off about his pictures having a Message. It could only happen in California. Thank God, only there.

No. 80, July 1970

Women's Lib: Save the Last Dance for Me

Tom Seligson

"Dotson Rader! You motherfucking Grove Press pig!" I was standing next to Dotson Rader at the May Day benefit party he organized to raise funds for Walter Teague's legal defense, and we were listening to the Stones belt out "Get Off of My Cloud," and watching, along with five hundred other people, a showing of Andy Warhol's *Blue Movie*, and I felt high, high from the Scotch and pot, and high, too, from the pulsating light show on the parachutes suspended overhead and the burning incense that permeated the hall, and the people, and the dancing, the hugging, the animated people who were so together. And I was telling Rader how successful his party was and how great the money raised at the door would be for Teague's defense and then, suddenly, the music stopped. I looked at the screen across the hall. The film too had stopped. Broken, or shut off. There was silence as the guests, still lost in the movie or the sound or something, didn't know how to react. No one knew what was happening. I turned to Rader for an explanation. And he didn't know either and he really looked funny, like a little boy dressed up by his mother at his first birthday party, clad in the sailor suit

sent to him by a boy he had met in Puerto Rico, the suit mailed wrapped in the sheet they had used on the beach. Rader walked quickly to the projection booth where both the film and the records were being run. And then he heard it. We all heard it.

"Rader! You pig! You bourgeois, sexist pig!" A short girl with dark hair and glasses, dressed in a green T-shirt and blue jeans, pointed at Rader and shrieked, her voice very shrill, "You pig! You faggot!" It blew Rader's mind, like it really spaced him out, to have some chick he never saw before call him a faggot like fascists do when they shout at the long-haired kids marching against the war—"You faggot!" He was stunned.

"What do you want?" blurred, one too many drinks in Rader, slow to respond. "What the fuck do you think you're doing?"

"You sailor faggot!" This delivered in unison by two girls to the rear of Rader—one in an army fatigue jacket, the other in leather coat and boots—hair wild, faces contorted, resembling harpies on the attack. Rader wheeled to confront them, and it was obvious that he was drunk and unable to understand why this was happening to him, why he was

being surrounded and insulted.

The answer came quickly. When Rader was about to reply, he was cut off by the sound of a shouting voice on the public address system and all the lights went out with the exception of one, a spotlight held by someone in the projection booth and directed on a girl standing on top of the booth. "Off the hip pigs!" she began, reading from a mimeographed sheet, copies of which were being passed out in the hall. "Right now, while this party is going on, tens of thousands are going to New Haven in support of the Black Panthers, thousands of US troops are invading Cambodia, and thousands of political people throughout the US are being shot, arrested, jailed and murdered—including, right here in New York City, hundreds of women caged in the Women's House of Detention."

Women's Liberation. The ladies had done it again, taken over the party, and I couldn't help thinking, what the fuck for? To them the idea of a party on the night of the New Haven Panther rally was a decadent bourgeois cop-out. But the party had been planned for months, a May Day party, a party to celebrate spring, friends, life, what freedom was left to us, and the Movement. And I knew that's what Rader had in mind. And his friends too. Sol Yurick, exhilarated, danced to Jimi Hendrix, and near him Holly Woodlawn, star of Warhol's *Trash*, hostess for the party, in drag, greeted everyone in her better-than-Marilyn breathy voice, while Robert La Tourneaux from *The Boys in the Band* looked pretty and Ed Wode, rebounding from his court defeat with *Che*, talked enthusiastically about his new play, *The Republic*. The underground was together again—warm, fraternal, affirming itself—and there to help one of its members.

Teague had come to Rader in the middle of March and they had decided on the party to raise bread for the appeal of Teague's conviction as a result of a protest against the South Vietnamese ambassador at NYU. As the guests arrived at the Old St. Peter's Parish House in Chelsea, they were blinded by floodlights and asked for a two-dollar donation. The money at the door was exclusively for Teague. It was collected by his people from the US Committee to Aid the NLF.

The liberated female, enjoying center stage, continued her rap. "Having had little to do with the arrangements of this party, the US Committee to Aid the National Liberation Front of South Vietnam denounces the people who planned this travesty. While this party was supposed to be for the benefit of the US Committee and political prisoners, it is in reality only an attempt to use the committee's name to mask the recent exposure of Grove Press with a 'left' disguise ... There is a new financial elite springing up in America, who, in the name of cultural revolution, make profits off the struggle of Vietnamese, black, and other Third World revolutionaries; who, in the name of sexual revolution, make profits off the bodies of women, portraying women as objects rather than people, encouraging prostitution and the oppression of women."

"BARNEY ROSSET IS A DEVIL!" yelled Sid Bernard, his voice heavy with sarcasm. With his wings of long gray hair neatly angulated off his head, and in his colorful ten-year-old tie, he looked elegant as he shouted at the female speaker, his clenched fist waving in the darkness.

The prepared rap continued, an attack on Rosset and Grove Press for making millions off leftist books and female workers at Grove. Rader, meanwhile, stood in front of the projection booth, trying to get in to talk to Teague as three burly members of Teague's committee, the same three who had been friendly two hours earlier while preparing the hall, now forcibly blocked him from the door. "I want to talk to Walter," Rader shouted at one of them.

"Get the hell out of here!" jabbing Rader in the chest. "You're a *pig*! A lackey for Grove Press!"

"This is my party. Why are you doing this to me? Why the hell are you doing this?"

"You're a culture vulture!" the doorkeeper shouted, and with that Rader went blank.

Turning from the door to look at his guests, some already leaving, others taking the development in stride, Rader hesitated, then went toward the control panel in the back room for the light and electricity switches. "I don't know what I expected to do," he said after the party, "I just felt I was being treated unfairly. I felt I was being used. I wanted to regain control. There's nothing wrong with that."

Right or wrong, Rader couldn't regain

control of his party. A tall boy with an NLF button on his shirt was guarding the switches. "Get the fuck away from here," he shouted at Rader, shoving him to the floor. Rader didn't even bother to argue. He returned to the main room, dazed, heavy in his step, nervously looking from one person to another. He looked lost and unsure of his friends.

"Others, such as Andy Warhol," continued the speaker, the only voice in the room of five hundred, "have nothing vital to contribute, no vision of change or of a new society, bringing only their ultimate boredom with life, creating valueless art which is incapable of relating to the pressing needs of people in this desperate society."

"ANDY WARHOL IS A DEVIL!" hollered Sid Bernard, grinning at Holly Woodlawn who was searching around in her head for a simply stunning exit line. "Oh, shit." That was the best she could do, and she threw her hands up à la Bette Davis and half swooned in the direction of Louis Abolafia who was twirling around the floor in a red cape trying to attract the attention of the *Daily News* photographers.

"Still others here have built their careers and fortunes on the life-styles and half-articulated needs of dissatisfied youth ... We have decided that a share of the proceeds of this party, which the culture vultures arranged to use as another rip-off in the form of favorable publicity, will be used instead as a contribution to the Women's Bail Fund for bailing women out of the Women's House of Detention. Women—whether they are Panthers or members of Women's Liberation, prostitutes or shoplifters—are all women who have been exploited, used, then trapped and jailed. It is only with exploitation's death that freedom's life can begin. We offer you a choice: either we and the Committee's friends will leave, or we will stay and show *Battle of Algiers*—a true revolutionary film! Which shall it be?"

The spotlight went off, and immediately the music and the film began. It was still Jimi Hendrix and the Stones throughout the room, but it was no longer the *Blue Movie* on the screen. Instead of Viva and her lover cavorting in bed and bath, nude and in color, it was the scenes of running Algerians and bursting machine guns, in unembellished black and white. Rader returned again to the

Images from Dotson Rader's May Day benefit party, 1970. From *Evergreen Review* No. 80, July 1970.

projection booth and this time Teague consented to speak to him. Moving over from where he had been holding the spotlight, he looked down at Rader. "Walter," said Rader, "you owe me an explanation."

"I don't owe you any explanation," said Walter. "All I owe you is an understanding."

"Why didn't you ask me, Walter? I would have let you show *Battle of Algiers*. Why didn't you ask me?"

"We took a vote, and the others said they couldn't trust you. We put it to a vote and we decided we just couldn't trust you."

"I'm your friend," said Rader. "A long

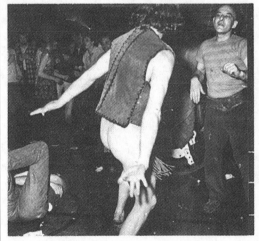

More shots from the ill-fated benefit. Dotson Rader, in sailor suit, receives a kiss from Warhol starlet Holly Woodlawn in the upper-left photo. From *Evergreen Review* No. 80, July 1970.

time I am your friend."

Walter hesitated, then said, "This is politics, and politics wins out over friendship. Politics is everything. You're a writer; you should know that."

I left Rader standing there talking up to Walter, and I got a drink and wandered around the hall, the people returning to life with the music and the lights, and I thought of all the writers at the party: of Sid Bernard, who has been at about every Movement demonstration for the last fifteen years, of Richard Lorber, another radical writer, and William Burroughs Jr., and more. The Movement

needed them. It needed its spokesmen, its publicists. To renounce them was to deny the Movement its basic strength. They, the writers and artists, deserved better than this.

When the Women's Liberation rap ended and the party was returned to itself, it became a different kind of party than before. While some of the guests left during the women's takeover, most stayed, and more kept coming—Tom Hedley from *Esquire*, and Peter Ward, a model, and Jackie Curtis at her glittering best. Once there was a knock on the back door and Andy Warhol apparently had come and gone. There was a new

enthusiasm. Boys started dancing with boys. Girls with girls. Others by themselves. And as I danced five records without stopping with a girl from Random House, I was reminded of high school dances when, as the time to leave approached and the last record began, we used to push ourselves into a near frenzy, desperate to use every ounce of our strength and become lost in the sound, afraid, yes, that this would be the last record at the last dance where we could abandon ourselves so completely, and there was this premonition of our aging beyond joy in the late hours of this May Day gathering, this fear that we would never be together like this again.

While Teague's "Politics is everything" was heard only by a few, it was felt by everyone at the party. A Movement party, given by a Movement figure. And it too was vulnerable. From now on, no party would be spared. The puritanism that Warhol's *Blue Movie* condemned, and which the liberated female defended, was hastily abandoned. Arnold Leo, an editor at Grove, having brought a couple who planned to undress but didn't, took off his own clothes. Baby Betty played on the seesaw in the middle of the room, and people began screwing upstairs in the ladies room and in the hall, and Rader kept running to the door to pacify the cops who came in to complain. Pot was passed around by people who hadn't exchanged a word, and bartenders, shirtless all night, began sweating profusely as the lines grew around them. One man, naked except for his underwear, fell onto a pile of plastic cups and cut himself. He got up and went right on dancing, waving his bloody hands in the air. "It's wild," said Sol Yurick. The wildness of desperation. Part of the underground, together but not for long, struggling, as it had against the censors, the yahoos, the pigs, and the straights, now protecting itself from its own. Like the couples embracing in the middle of the hall, holding on with fists rather than fingertips, oblivious to the swirling figures around them, the underground, denying the suspicion that it was dated, that in some terrible way it did not exist anymore.

A long-haired boy in a leather jacket kept coming up to me while I danced and asking me if I'd seen Burroughs. "I thought he'd be in one of the bathrooms shooting up, but I've looked everywhere, man, and I can't find him."

"Try that one over there," I said, stopping dancing and pointing to another bathroom. As I turned back to my partner whose flying hair blinded her to what I was doing, I noticed one of the boys in Teague's committee—the one who had barred Dotson Rader from the switch box—dancing frantically by himself. And behind him was Teague, smiling, and bending his knees to the music. The Stones were singing, loudly, but from far away, "It's all over now."

Have You Seen It All, Dennis Hopper?

L.M. Kit Carson

Tomas Milian, actor: "This is a miracle. No: can't talk about it. I just keep saying yes to Dennis. Not even understanding. I've had thirty leads in Italian movies—with Fellini, with Cocteau. But this feels like my first movie. Dennis scares me. I feel pure.

Real life: I don't give a shit about it. I just want to keep on here in Chinchero, stay under this time here, just keep on filming this movie, I hope Dennis never dies."

1. "People keep saying to me: 'Hopper, you're no genius. Orson Welles—that's a genius: made *Citizen Kane* when he was twenty-three years old.' *Well, man, I am too a genius*—only when I was twenty-three, they wouldn't let me make *Citizen Kane.*" Dennis Hopper hunches against the steering wheel of his dirty red Ford pickup truck, his scrawny legs jumping over and over from the gas pedal to the clutch-and-brake as we bounce and fishtail down the side of a small mountain in the Urubamba Valley in the southern Andes. The cold, imponderably sad Peruvian night rolls down after us, rolls past us. Hopper's grinning like a fox in this moonlight.

2. Thirty-seven movie actors are struggling to climb a rocky hill in the morning sun, to get to the top where a movie camera waits to shoot them. It's a pathless hill, almost straight up: Rod Cameron, Peter Fonda, Sylvia Miles, Jim Mitchum, etc. crawl along silently as insects, none of the usual repartee, keeping their thoughts to themselves (save them for "The Johnny Carson Show"). The actors are goofy in the thin air, their jaws hang open.

"A little pain. To climb here without hurting, a *gringo* would have to grow four hundred and seventy-three more veins in the sole of each foot and three extra lung cavities." Dennis Hopper says this several times, looking over his actors at the watery thunderclouds drifting in, Hopper drops into his drunk-cowboy drawl: "Lil' pain. Gonna hurt'cha. But tell ya one thang: down here'n these mountains, *nobody* gon' get away from makin' this here movie. Ain't no planes flyin' t'Palm Sprangs for th' weekend."

"You can't do THIS TO MEE ANN-Y-MORRE!" (one of the actors is cracking up a little, clinging to the rocks), "I'm an ACT-TTOR!! I-DON'T-HAVE-TO-DOO-THISS! I'M STOP-PING! I'M STOPPING NOWW!"

But, of course, nobody stops.

3. Suppose Dennis-Hopper-Shooting-*The-Last-Movie*-In-Peru is a living model of what American movie-making will be like in the 1970s. Then this diary of Peru, end of March 1970, is a diary from the future:

March 21, 197-

Very easy to get crazy now, here.

First: the whole countryside smells rotten: a thick, burnt, goaty smell pushes right into your nose as soon as you wake up in the morning.

Second: drugs are embarrassingly easy to get hold of. Not just the commonplace uppers and downers: hash, good Berkeley speed, marijuana, cocaine, bad French acid— but real un-doers: belladonna, ether. Tonight a journalist comes to my door, eyeballs rolling in his head like mercury, holds up a royal blue bottle with a washrag over its mouth:

"Want a hit?"

"Of what?"

"Ether." (shakes bottle) "It's legal here. Picked it up at the pharmacy cross the street."

"Um. Well, no thanks. I'm pretty ridiculous already."

Third: Fear. Fear's all over this place. Fear's in the three broad-shouldered men who meet me at the airport, flash badges, search me (trembling fingers feeling through my hair, they say: "Don't be scared, son. Don't make any quick moves."). Fear's in Peter Fonda packing to go back to LA: turning his pants, coat, socks inside out; shaking his suitcase in the air to make sure nobody's planted any drugs on him to set up a narcotics arrest at customs. Fear stumbles in around two A.M. with a bouncy, blubbering actress gasping and choking (snot in her long brown hair in her face) that the government's trying to force her to leave Peru—got four, five gash marks up her left wrist; but she's really all right, she's a big girl now. Ultimately, Fear's in Dennis Hopper. And I believe he likes it.

4. HUCK FINN IN PERU

"Hello, chickenshit," Hopper says to the assembled journalists outside his Cuzco room at five of seven A.M. (Hopper's room's empty today when he leaves: surprise—this means Hopper was alone last night. Now that's odd: Hopper's your classic loner desperately afraid of being alone.)

Shambling down the hotel stairs, Hopper spots some workmen tilting a low table over by the gaping lobby fireplace. "Broke that table last night." (snickers) "Sat there for two hours trying to talk some guy out of blackmailing me. Finally I just jumped up: UYAAH!" (jerks both hands above his head), "grabbed his hair, and BAM!, bounced his head off the tabletop. Look at that: glass tabletop three-quarters of an inch thick— cracked it right cross the middle." (clicks his cheek, nods his head) "Crazy fuckin' Dennis Hopper."

5. "Dig it: *If I could turn you on, if I could drive you out of your wretched mind.*" (Vincent Cresciman, a wire-haired Ray Bolgerish ex-Digger, now Hopper's assistant director, reads aloud the last sentence of R.D. Laing's *The Politics of Experience*. This kind of exchange is a beginning-of-the-day ritual with Vincent, while Hopper gets an oozey red "sunburn" make-up stuck on his face.) "*If I could tell you I would let you know. If I could tell you I would let you know.* R.D. Laing. Heavy Stuff." Vincent closes the paperback slowly, like it's the first book Gutenberg printed.

"Mmm," a stunt man agrees unsurely.

"If I could tell you I would let you know," repeats Hopper, rubbing the back of his hand against the putty ridges of scar tissue built on his cheek.

Vincent (urges): "Yeh."

Hopper (rises, his open, boyish face now completely torn up into a mask of scabs; open sores): "Well, man, that's a cop-out."

6. The sun's going down. László Kovács, the cinematographer, drives the crew to set up lights, angle reflectors, position the camera— racing the sun to get the last shot of the day in a small "jail" set built on some Inca ruins in the fourteen thousand foot high village of Chinchero. (Today's been bad: Hopper planned to shoot a scene between himself and Tomas Milian in the middle of 200–300 villagers in a Chinchero religious procession. Well, okay: 200–300 villagers showed up— squat, dignified Quechuan Indians; great. Then suddenly, the village priest who'd been

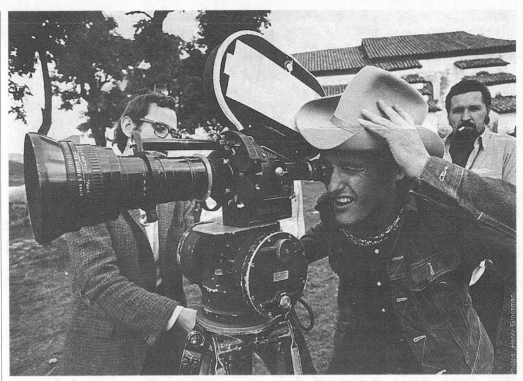

"Dennis Hopper on location in Peru with *The Last Movie*." From *Evergreen Review* No. 81, August 1970

paid to stage the procession disappeared, and the Indians refused to move. Botched. *The Last Movie* company broke for a tense lunch without a foot of film shot and half a day gone. At lunch, the priest sent word he'd come back if Hopper'd sneak him US one thousand more dollars. "Aha," said Hopper, tilting back his cowboy hat to admire the priest's corruption, "The old Machiavelli game. Well, tell *padre* NO—no more payola. The Renaissance is over." And Hopper began sucking on an orange, rethinking the scene, shifting it into the "jail"—no procession. By the way, at the end, as usual, the priest reaped the wages of his sin: the archbishop of Lima excommunicated him.)

Now the black plastic "wall" of the "jail" is tearing apart, shards of fleshy plastic ripping in the gusty oncoming night wind. It's a nagging sound: flap, rrriippp! flap-flap-flap, *rrripp*, flapflap—like some evil clock erratically counting off the rays of the sun as *The Last Movie* loses one precious day on a tight forty-eight-day shooting schedule. Sweating nervously in the cold, the crew begins to hate the sound—finally some of them climb the set and pull down the plastic. Meanwhile,

Hopper and Tomas Milian sit on the "jail" porch, read back and forth from the script, gulp straight Scotch from folding paper cups. Hopper leads Milian down into the scene eleven times, both of them getting drunker and drunker, voices lowering and lowering, turning the words around, throwing them, dropping them until they eat the words and the words really begin to come out of their mouths and not off the page. Abruptly, Hopper bobs up out of deep in the scene, stands up, goes into the "jail," cuts Milian off seconds away from his moment of truth with the scene: just emotional inches shy of feeling secure in his part. Milian slugs down more Scotch, stares at his shoes, shivering with anxiety.

Inside, Hopper wanders about, looks in the camera, stands on the spot László has lit, pulling on his bottom lip, his silver eyes blinking. There's utter silence. The sun's *really* going out now, the cold begins to rinse through everybody. Twenty-five men watch Hopper without a word: they watch $800,000 stand on Hopper's thirty-four-year-old risky, skinny shoulders.

(This has been the riskiest movie I've

been around: actors lost for three days in the mountains, horses falling on people, a stuntman mutiny, schizophrenic love/hate treatment of the movie company by the military government and the Peru communists, rain stopping the filming almost every day— Hopper *uses* this insecurity. Hopper courts risk, in his personal life, in his work: he tricks actors by starting the camera after the scene and filming them when they think no one's looking; he interrupts their dialogue with sudden questions from behind the camera (I've seen him goad actors into punching each other bloody, into breaking their hands)—in all of this, he's driving spikes into ordinary moments to crack them, and get inside them to the dangerous, real, uncontrolled meat.)

Suddenly Hopper's hand pops up, straight up.

"Hey c'mon, who tore down the plastic! Vincent?"

"It was noisy."

"Right! I want that noise! C'mon, Vincent, don't do things I don't know about. Now tie that stuff back up there!"

Hopper wheels and goes outside to get Milian. People clamber up the set, dragging the plastic back into the wind. Now Hopper and Milian get in place. Now Kovács rolls the camera, tilting and panning serenely, and against the desolate flapping plastic and the exiting sun, they shoot the staggering actors in one long seven-minute take. And it all works. Works like a dream.

7.

Bugs Darkness
 for Dennis Hopper
He (what!) requested
the funeral hymn
 to be
the end-theme
 from Loonytunes
 (duddle-luddle-la-da-da-da)!
"That's All, Folks!"
 put me in the ground.
—Billy Collins

8. They say that after Bob Dylan saw *Easy Rider* at a preview last May, he rushed out of the Rizzoli screening room (5th Avenue and 56th St.) and kept walking *very fast* all the way down to his house on Gramercy Park (Park Avenue and 20th St.). That's a distance of twenty-eight blocks or two miles; but Dylan just kept walking, forgot to catch a cab, didn't stop until he got inside his house and closed the door—he was that scared. Then he went to a phone and called Hopper: "Dennis, don't you understand what you're *projecting*, man? That's *death* you're projecting. Your death. My death. Our death. Do you *want* to do that?"

They don't say how Hopper responded; but I believe he said: "Yes."

9. We're standing around the bar in the fake "Longhorn Saloon" in Chinchero: Hopper, a bunch of funny-looking journalists, a cute girl-photographer-revolutionary in tight overalls, couple stuntmen. We're waiting for the sun to come out, and listening to Buck Wilkin sing his blues, *Have You Seen It All, Mirarjane?* from a tape recorder. It's a touching song; right now we're all grinning dumbly to ourselves being touched by the funky troubles of this funny girl Mirarjane as Buck moves into the chorus, breaking his voice down to a sob:

Have you seen it all?
And (fingering the real heart-chords)
Have you seen it all?
I mean: Have you seen it all?
(suddenly talking): Dennis Hopper?

Woodstock: An Interview with Michael Wadleigh and Bob Maurice

Kent Carroll

There are four Woodstocks: The place, as in artist's retreat and the sometime-residence of Bob Dylan and the Band; the event, as in the music festival cum sub-cultural phenomenon of last August; the nation, as in the symbolic territory which became very real to many alienated American youth; and the movie, as in Warner Bros. presents.

The film is important both as a commercial commodity and as entertainment—in producer Bob Maurice's words, "we made a musical with found materials."

The two filmmakers (Michael Wadleigh, director and cameraman, and Bob Maurice, producer) are significant, not simply because of an identity that places them outside the crumbling movie establishment, but rather because of the reasons for their commitment to film, the manner in which their well-chosen vocation is integral to their life-style, and the way they relate to the changing patterns of production and distribution of films in this country.

Woodstock, the film, opened in New York March 26 to enthusiastic reception by critics and patrons alike. The following interview took place two days later at a studio on West 80th Street where the original footage was assembled and cut before Wadleigh and Maurice moved to the Warner Bros. studio in Burbank for final editing, opticals, and mixing.

—Kent Carroll

Question: *D.A. Pennebaker's* Monterey Pop *proved that making a movie of a live, super-rock concert was a natural for a documentary filmmaker. How and why did you get the idea for* Woodstock?

Wadleigh: Bob and I had been talking about making rock revival films with all the fantastic performers of early rock and roll.

That sort of fell through, but on the way to that film, we began talking to people about a Woodstock film. Although I didn't really like the selection of musicians up there, the fact that it was going to be held on a farm interested me, and I believed that it would provide a basis not only for a social document but for the musical film I'd been wanting to make.

Q: *When did you discover you wanted to make films? What was your intent, and how*

did your involvement grow or change?

Wadleigh: In high school, I was involved with what we thought were political problems, like getting white lines painted along the sides of the road, and other more important things. Getting used to exercising my ego politically in public led me into drama. Then at Ohio State, I studied physics and chemistry, and dabbled in the theater when all the new French drama was coming out—Camus, Sartre, Ionesco, Beckett—I directed their works and did some original translations. Then I spent two years in Columbia Medical School, but two years was enough to intuit what a lifetime would be like. That was the middle sixties. Everybody was getting a little bit nervous about what they were committed to and what they were doing—Kennedy was getting killed—all kinds of things were happening politically and socially, and it really seemed time to come out of the labs and look at the world. I began spending a lot of time in the Thalia and the New Yorker movie houses because, having lived in Ohio for twenty years, I really hadn't seen good films. I had seen contemporary Hollywood products, but I'd seen virtually no foreign films and not very much of Hollywood's history. Films seemed to have what the theater didn't—the theater was decayed because the writers were decayed. But in cinema, new, vital filmmakers were arriving on the scene. So I left Columbia Medical School, went down to NYU, and sort of talked my way into getting to teach cinematography, since I had a good science background. Then I got a job at NET TV as a motion picture cameraman, and I became committed right away. Pretty good job—$125 a day. I found out that good cameramen were a very scarce commodity, so producers paid them alimony in an effort to get a superior-looking product even if the subject was a piece of shit. Along with being interested in camera work and directing, of course, the idea of technology, the fact that literally two men made films—one doing camera work and the other sound work—really intrigued me.

The NET documentaries seemed very important. I made a lot of films for them—films with great generic titles like *Penguins, The Poor Pay More* and *The American Newspaper*. In two years' time, I traveled all over the country and got into all kinds of political and social issues and shot literally hundreds of thousands of feet of film. The camera became second nature. Jump ahead and add all that up to *Woodstock*.

Q: *You mentioned that your attitude toward what was going on in this country politically had a lot to do with your coming to a decision about your life. A more conventional, a more traditional career as a doctor no longer sufficed. Making films, then, became a way of working out your involvement in a radically changing social scene. It seems that more and more people with artistic ability, a certain sensibility, and some kind of concern and involvement in the world almost naturally turn to exploring through films. University students watch more and more films, and young artists who might have wanted to paint or write ten years ago are now much more interested in making a film.*

Wadleigh: You know, one of the first contacts I had with making movies was while I was in medical school, at Brookhaven National Laboratories. We had a research project which was concerned with the decay of the central nervous system of monkeys who had been radiated by gamma rays. We put these little Rhesus monkeys, with all sorts of radiation scars all over their bodies, on wooden crosses, like crucifixes, and then we'd go through tests to determine how their reflexes had degenerated, and then we'd trace it back to their neural responses. We had a little Bolex set up there, and we'd prod and torture these monkeys and watch them contract—literally watch them die on crosses. Very, very heavy. But, at any rate, that was the first thing I ever did with a motion picture camera.

You know, you go to medical school, and watch people die, and you're trying to contribute to some kind of legitimate research to improve life. What I'm trying to get around to is that when I turned to an art form like film, I really didn't have much of an interest in regular theatrical films; it seemed important to get right into documentaries, right into *cinéma vérité*. I felt one used the raw experiences to structure social documents that would move people to write legislation, or vote, or empathize with a cause.

I like to make *cinéma vérité* films mostly

because making them is a life experience for me. It's very much a kind of participation not in other people's lives but in my own life. The camera doesn't get in the way. It's coming into situations in a participatory manner. It's not a real voyeurism.

I've got a film, a CBS special, coming up called *Once Before I Die*. It's about fifty-year-olds and twenty-year-olds climbing a very high mountain, 21,000 feet in the Himalayas. Ironically enough, *Sports Illustrated* put up the money to make a sports film. Well, it's no more a sports film than *Woodstock*. It's a film about why people climb mountains. It's the reality of the bruises and the pain and the gripes and the interpersonal conflicts and the exhilaration of getting to the top. And in addition to that, I got to climb a mountain! And the camera made the experience of climbing the mountain much more sharply defined than if I'd had no camera and were not structuring a film as I went. That's perhaps the greatest thing about filmmaking for me. Here I've found an art form, a communications form that, in a selfish way, is fantastically self-rewarding.

The first wave of reporters who started talking to us about *Woodstock* kept asking why we'd made the film. The reason I gave over and over again was that I wanted a good seat. The making of that film made the experience infinitely more important, sharper, and more participatory than if we'd been merely "members of the audience." Making something for people means more than the bullshit of communicating to people. I'm afraid I'm much more selfishly oriented. And man, there's no other kind of filmmaking that can compare with it.

You've seen that piece on Sly. It tickles me every time to see Sly lean back at that piano, and it tickles me to watch my own shot swing around to the audience, and see that fantastic audience going berserk. And Jimi Hendrix' entire "Star-Spangled Banner" is one shot. To watch myself make the moves from his face to his hands to that crane shot—to go through the whole thing—is a gas. Those few minutes, focusing, putting all the reflexes together, with the intellectual perception, the empathetic ideas about how something should be shot, is really living life, for me. And it doesn't *have* to be seen by anyone.

Q: *In your first rough cut of* Woodstock, *there were some excellent sections, for instance the Canned Heat segment, which may have been the best in the whole film. Now it's not in the final version. Doesn't that constitute a major problem when you have to make editing decisions about your own work, particularly when it's of that quality?*

Wadleigh: Well, it does, it hurts me a little bit. I would like a few film critics to see that shot because it is a tour de force. There's an appreciation of long, developed shots now because of Godard. I knew what I'd done when I shot it, and literally filming it was as much reward as all the accolade and reviewing and having people say, "It's good." Maybe this comes out of my experience with French drama: It ain't the ruminating about the whole thing that matters, it's the reality of the moment. And editing is concerned with things past. And also, critical analysis is concerned with the past.

Q: *Take a circumstance—let's say some political event where you have very decided sympathies. You film it, and as a filmmaker, what you see and what you participate in while filming it, comes out reflecting something quite different than those sympathies. How could you reconcile this?*

Wadleigh: *Woodstock* provides a pretty good example. The film we could have done, when we came back with all our countless feet of film, could have been very leftist, very pro the kids, pro drugs and the music and social change and long hair and nudity and new morals, and all that. We might have felt, as many filmmakers do, that we simply can't give voice to the other side, because there's too much voice for the other side already. But I think our motive was a little more moderate than that. Because what we really are is biased towards entertainment.

Q: *In the interview segments of the film, were your requirements in terms of balance of attitudes and ideas, because those dialogues selected were representative, or simply because they worked in the context of the entire film?*

Wadleigh: I think you've hit it on the head there. I find them very easy to listen to.

Therefore, their "entertainment value" is very high. And I found that their situation, if not really typical, was very interesting within the context of *Woodstock*.

Q: *One of the reasons the film has impact as a social document, say, compared to* Monterey Pop *which simply uses reaction shots or crowd scenes, is that Woodstock, though one obviously has the sense of the size, the magnitude of it, somehow becomes personalized, individualized.*

Wadleigh: I must say, we self-consciously set out not to show four hundred thousand people, but to show individuals, profiles, and to generalize on that. We also set out to show the performers as real live people.

Maurice (holding up Warner's ad campaign): Do you know what they're doing? My God, this is what we've never intended for *Woodstock*. Even in their radio advertisements. Pretty fucking bad, man.

Wadleigh: We heard a radio spot. Bob, you do it, you do it better than I do.

Maurice: "*Shop with Woodstock stock. Go go go. Country Joe. Woodstock stop. Three days. Money. Come. Be there. Be there. Money, money, money, money.* [laughter] *Hippie, hippie. I'm a hippie, I'm a hippie, I'm sixteen years old, and before I went up, I thought Woodstock would be groovy. I thought Woodstock would be groovy. And you know something? It was groovy. It was groovy-er than I thought any groovy thing could be. In fact, it's psychedelicized my whole life. And I return to my work, psychedelicized, and I must say, with a new interest and vigor, and I am now the most successful fifty-year-old radio announcer, and I'm doing TV spots and radio spots for Warner Brothers impersonating a sixteen-year-old hippie. Groovy groovy Woodstock Stock Wood Country Joe.*"

They literally had a fifty-year-old guy imitate a sixteen-year-old kid saying things like, it's psychedelicized my life, whatever that means. And I, who was there, will never be the same. Really, really, it's unbelievable.

Q: *For a lot of filmmakers who've come along in the last few years, film is a very personal experience. But these are the filmmakers who operate the camera, or write and direct their own film. Your function, Bob, is quite different. You're on the other side—producing—with all the administrative problems that go with that, and you're also involved in the distribution of films.*

Maurice: I'm going to say very little about all that, because I am extremely undecided as to whether I like it or not. The nature of the work itself is not really satisfying, in a direct sense, as Michael's work is. Also, there's something positively objectionable about spending one's whole day in unending combat.

Wadleigh: Describe the combat. You get real shit. Bob, you know, is the head of a very talented group that had to deal with the whole circus of people, with Hollywood, Warner Bros., with all the fucking bullshit. The interesting thing, really, is that, in the past, producers have been like the Harry Cohns and all. You know, they've been show-business men with a sense of what the public wanted, with a sense of expectation.

Maurice: Now, every film has its own requirements which are a function of both the nature of the film, and the people who work on it. So, with some films, a producer will be, I suppose, nothing more than a bodyguard; with other films, he might make a creative contribution. And it's very obvious what that could be. He might be the person who finds the property, he might get the people together. He might even do more than that. I think the whole idea that the director has got to be top of the heap is nonsense, just incredibly dogmatic horseshit. Because it's quite conceivable that the director is an asshole. And it's quite conceivable, also, that a very good film could be made in which the contribution made by the director, in a very formal sense, is very, very small. And I think that this whole business about who is on top of the heap really should be a function of talent, and nothing else. You see, the writer might conceivably be the guiding spirit and the one who controls, because of his talent and personality, everyone else. Or it may be the producer. I can think of a film in which it was the cameraman. So it's not really roles, it's individuals. And the individuals can step

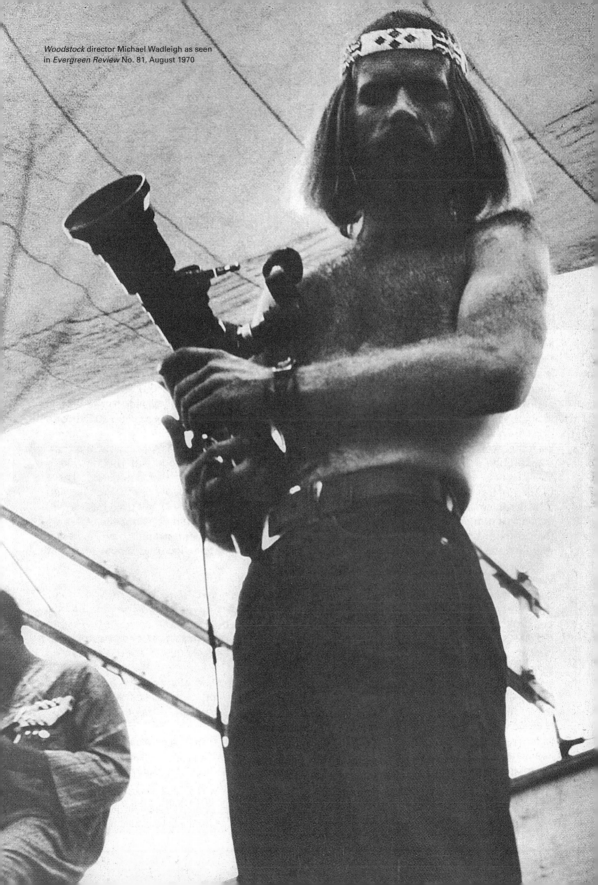

into whatever roles they choose.

Wadleigh: Since I've run a company for a couple of years, I'm not unfamiliar with the tasks of producing, so I'm not about to knock whatever the producer contributes, or his importance to the effort. But I think, as Bob says, you adjust to personalities. Whatever your personal scope is, whatever the balance is, that's the formula for any particular film. One must separate the people who are directly responsible for the product, and the people who are responsible for its distribution. And one must analyze how the two are serving their roles. Bob is very interested in really becoming active in distribution; I'm interested in it myself. There's a real necessity when you see what's being done with your product, when you know its potential.

Maurice: You need the kind of producer that I am, because there are other producers out there against whom genuine filmmakers have to be protected. I'm talking about the people at Warners who have the producer's instinct for creative involvement, but who don't have enough professional restraint to keep themselves from doing something they shouldn't do.

Wadleigh: If you want to shorten the film out of esthetic considerations, out of an interest in giving a product to a community of people, then you don't simply cut the acts in half, like Warners wanted to do.

One of the unfortunate things about *Woodstock* was that it was so big from the beginning, and it's my fault and to my discredit that the whole artificial division between your role as producer and mine as director did exist. This was an abnormal project partly because of the demands on your time, and your battles. I remember at Woodstock, God, you were barely able to be there! You know? Barely able to be there. And that makes so much difference.

Maurice: Yeah. Of course. In my own mind, I've defined a good producer's function as being, first of all, bodyguard, [laughter] right? Secondly, when no one else will empty the garbage, the producer empties the garbage. Really, that's what it is.

Q: *Do you see yourself continuing to function as a producer of films?*

Maurice: To be quite honest, I'm really undecided. Producing *Woodstock* has satisfied certain needs I've had, but I think I've got to satisfy other needs, too.

At this point in America, a producer's function, if he's going to be a good producer, really *is* as a bodyguard. The whole industry is just so incredibly fucked up in the United States that a good film simply cannot get made, and survive, unless someone is there constantly, day and night, beating off all the potentially destructive people and situations.

Q: *Is that really always true? Let's say you know some small distribution company which has a reputation for not interfering with filmmakers. Can't you go to them with an idea and get, say, $200,000 and go ahead and make a film?*

Maurice: Obviously, that would be ideal, but, then again, we're getting back to the classic problem in American production. The one you're referring to specifically is that of money. Now it just happens you picked the right number. We really needed about $400,000 to spend on creating the film *Woodstock*. There was a very nice independent producer and financer who offered, who would have loved to do the film, but didn't have $400,000, only $200,000, and he just didn't have a penny more. I'd like to believe he would have left us alone.

Q: *Now, because of the success of Woodstock, you shouldn't have any difficulty in going to someone and saying, "We've got this film that we want to make, and it can be made for $100,000," or $200,000 or $250,000. Getting that kind of money to make your own film, and getting the kind of creative freedom and control that you deem necessary, I suspect, will no longer present a major difficulty.*

Maurice: No, it's not going to be a problem, because now, just given the two of us, and with nothing more than our own personal involvement, we can, I think, simply bypass the studio or distributor, and borrow the money ourselves from the banks, which is where the studios get it anyway. They just go down to

the bank and sign for the money. We can do that. We can be a studio. We don't even need an office.

Q: *How about your involvement with each other in the future?*

Maurice: We have a promise between us that on our next project, Mike will produce, and I will direct! That should, once and for all, destroy this whole notion of conventional roles.

Wadleigh: Right, and something else is coming. We have largely unformulated plans, but something else is going to happen for us. Bob and, obviously, I have been able to see how outmoded the studios are, even in terms of providing filmmakers with the kind of technology they need to mix their films, to shoot their films, to edit them. One area Bob and I are particularly going to get involved in is production facilities. Warner Brothers had nothing on their lot. It was ironic that we couldn't find anything we really needed. Bob and I share an interest in trying to get the motion picture technology to a really free creative state. And I don't know whether that's one of the roles of a producer, but I do think people will form companies or associations where their interests are allied, and where their ideals are allied.

Q: *Well, what real role can a producer play? Not something in name only, but a real area in which he can be creative. Can it be a satisfying role for somebody who has the same kind of motive, artistic intent, and interest that the filmmaker has, but is not himself a filmmaker because he doesn't use a camera or actually direct a film?*

Maurice: What's happened in the last few years is that there really aren't any formal roles any longer. And the roles vary from film to film, depending on the personalities and talents of the people involved. Michael is very fully the filmmaker of *Woodstock* and has had literally everything to do with making the film. I have made no contribution whatsoever, esthetically, or in any other way that bears directly upon the film. My job really has been that of administrator, organizer, and very much, as I said, that of bodyguard, because the tremendous commercial value

of *Woodstock* has really made it necessary to be a strong bodyguard.

They were really after us. There was money here and Warners smelled it. They wanted to come in every single day for six months, and somehow or other, wrest it from our control so they could do whatever they had in mind. They also wanted, because of their own ego needs, to put themselves into the project. I wasn't about to let *them* do that, when I was refraining from doing it. I took my own personality out of the project entirely. And so, in a film like *Woodstock*, the producer's function is really to create a fucking stockade within which the person who has the talent can go ahead and do what he wants to do. It's impossible for any human being to take the position I've taken unless you really trust the person you're working with, and feel he has the talent.

Of course, Warner Brothers didn't have that trust because they never even asked themselves whether Michael was capable of doing the job or not capable of doing the job. They didn't give a shit!

What's really disappointing about Warner Bros. is not that they are pigs in their attempt to take over the esthetic end of the project, because one knows that's inevitable with the studios, and has been for a long time. We expect it, and are reconciled to it, and can defend ourselves against it. What's really disappointing is not that they want to do *our* job, but that they're incapable of doing *their* job. They really don't know how to distribute the film.

I was at the theater the other night, the Trans-Lux East, the second night of the run of the film, and Ted Ashley and Fred Weintraub were both there in the theater, right? The Chairman of the Board, the chief operating executive of the company, and his right-hand man. You know something? Even though they were present, and even though the manager of the theater was present, and the technical advisor for Warner Bros., and a couple of other vice-presidents, they still couldn't get the projector to run!

And the advertising campaign! My sense of shame alone would prevent me from releasing that kind of advertising! I would just simply admit to the world that I can't do advertising and I would do no advertising on the Woodstock film. But Warners doesn't

have that sense of shame. In fact, they proba-
bly think what they did was pretty good.

I've been in contact with a lot of rock
performers. As you know, a lot of them have
started their own labels in an effort to pro-
duce their own records, control the advertis-
ing and distribution of their product, and to
give themselves time to produce something
they're proud of. With a product like a film,
of course, you're dealing with an enormous
entity. I mean, the cost. God, they said they
were sinking hundreds of thousands of dol-
lars into the advertising. I'm sure that at least
tens of thousands of dollars of that went into
things like ... on Sunset Strip they literally
bought a fake boutique and they're peddling
Woodstock buttons and headbands, if you
can imagine that, with *Woodstock* written on
them.

I don't think the kids know that this film
was made by long-hairs. I mean, they haven't
even capitalized on the obvious, that a couple
of "your own"—a couple of freaks, genuine
freaks—have actually made this film. Which
would be a positive advertising bag, you see.
On the contrary, they've tried to push it off
as a product of a corporate enterprise, of a
parking lot agency.

Q: *Is that inherent in a studio setup? Perhaps
Zabriskie Point is a pertinent example. Just
the fact that Antonioni was involved with
MGM, and getting six million dollars to make
a movie, regardless of the creative control he
had, may have been corrupting in terms of
who he is as a filmmaker. Yet, in a different
sense, Kubrick was able to use Metro. He
spent ten million dollars of their money. I
have reservations about 2001. But I think, in
Kubrick's terms, it's a much more successful
film than Zabriskie is in Antonioni's terms.
Does it strike you that there's an inherent
problem involved in becoming part of that
studio matrix, no matter how much the cre-
ative control?*

Maurice: The very act of taking money from
someone, to some degree or another, makes
you want to do something he will like. And,
no matter how strong-willed or independent
you are, when someone gives you a million
dollars, or six million, or ten million, unless
you are a complete fucking nut: you do feel
a bit of gratitude. And that bit of gratitude

becomes transformed immediately into a
desire somehow or other to reciprocate. And
you do it by responding to their personalities
and their interests and their orientations. It's
very hard to resist that. I think everyone real-
ly does want to be nice, and everybody likes
to get along. But when you take that money,
you're putting yourself in a very difficult po-
sition. The studios are aware of this because
they've been in that position for a long, long
time. And they're on the reverse side of it.
They're also tempted to be nice and to re-
ciprocate and to come over to your side, you
see. Especially if they really like the film and
appreciate it. They're human beings, so they
want to respond. But they've become very
aware of this failing in themselves. So what
they do—what Warners did—is set up situ-
ations which cause arguments, which cause
a falling-out. Then they can say, fuck you,
we're not going to give you tickets to your
own show because you did such and such.
This happens. They create a lot of bad feel-
ings so that they can destroy in themselves
whatever sense of obligation and good feel-
ing they have for the filmmaker.

Q: *It strikes me that the industry—the major
companies—measures success only in terms
of box office. Conventional reaction would
be, or should be, look, we've got two guys
who've made a film which is going to make
us a lot of money. And these are two people
who, hopefully, can make us a lot of money
again in the future.*

Maurice: Unfortunately, the real structure of
Hollywood isn't commercially aware. That's
my complaint. They always say to us, well,
you're the filmmakers, you're the artists, and
we understand your orientations and we
know that the only thing you care about is
making a good film, but you've got to under-
stand that our needs are equal to yours, be-
cause we're putting up the money. And they
fall back on that again and again. The film's
got to make money. You've got to recognize
that there are commercial needs here that
have got to be met. We just say, of course,
we accept that, we understand that. We know
why you're in it and we're going to try and
satisfy your needs while we satisfy our own.
But, it doesn't work out. Somehow, the story
doesn't have a happy ending because they're

not really interested in the commercial success of the film.

So you see, our problem is going to be: If *Woodstock* makes a lot of money, nobody's going to want to give us another project! Their feelings will be: These fucking kids came in here and spent $600,000, and made a film that grossed fifty million dollars. Who the fuck do they think they are? But if we had gone in and spent twenty million, and grossed $600,000 they would have said, gee, they have a terrific production team there! Fantastic the way you handled that! That was an enormous project! Listen, we've got something here that requires a twenty million dollar expenditure. You know how to do it. You've done one of these. We don't know what the fuck we're doing, and we're very comfortable with someone else who doesn't know what they're doing, so come on in!

I don't like to talk about my life because I can't pull it together in analysis, or in reflection, but, among other things, I've spent a lot of time reading books, an awful lot of time. And I also spent a lot of time in building construction as a laborer in New York City in the midst of the Mafia, literally the toughest, roughest fucking business that I imagine exists: digging ditches, and working on high-risers, and being a shop steward and foreman and super. And you know, I always wondered, well, shit, construction is really a very valuable experience in its own way, and being a book reader and intellectual is, also, I would imagine, a preparation for something or other. And I always wondered how these two experiences would affect the rest of my life. So, when I walked into Warner Bros. that first day, as I was walking down this very, very long, seemingly endless, corridor which finally sets you in the office of a vice-president, I thought, well, I'm really glad I read all those books, you know, because I've got this enormous backlog of insight and information and acuity and practice. So I opened the door, and I thought, O God, I don't need that! All I need here is my construction background! Because these people are ... I really don't know how to put it! In the whole course of producing this film, I've never once drawn on any of the bookreading, just the construction stuff. Because I was dealing with exactly the same kind of people who dig ditches and who run construction unions—musclemen

and money-guys. And quite truthfully, I succeeded. It was really a production triumph. Nobody has ever kept the studio at bay, nobody's ever fucked them around quite as much as I have. I mean, we really had total freedom. They didn't have any leverage over us at all. And the reason for that is very simple: I was not an intelligent, well-read, literate person who had civilized reflexes to things. I was a fucking gangster like they were! [laughter]

Q: *If Warners decides to cut the film, or go to optical sound, is there anything you can do?*

Maurice: Yeah, there are some legal things we can do that are kind of amusing and funny which will drive them out of their fucking minds. You know, we really should do them, just to demonstrate to Warners that when they enter into a contract that has a specific intent, they have got to honor the intent as well as the letter of the contract. And, at this point, they are neither honoring the letter nor the intent. But I think our satisfaction will come from a lawsuit that is as creative, possibly, as the film is! It will just drive them up the fucking wall.

Wadleigh: I've got to emphasize our two principal considerations. *Woodstock* must be kept at its present length, which causes the structure and the content to happen the way it does now, and the stereophonic version should be kept in. At least, then, I feel that rock music is served. You know, some people told me that they were from some place like Illinois, and they never even heard a major rock group perform, all they really heard were those little, local dance bands. They came to New York, saw the film at the theater here, and were astounded that the rock bands were so loud, and that Woodstock was what they had always imagined a legitimate rock concert to be. It's like bringing television to the natives. So those two considerations— length and sound—became really important. Despite what critics say about the film: Keep it in its original state for audiences!

Somehow, all rock concerts almost seem like endurance contests. Jimi Hendrix is a good example. Hendrix came on Monday morning; he had a two-hour set, and the end of the film is the last fifteen minutes of that

set. We literally stood there falling asleep on our feet, trying to wait it out with him, watching him work his group up, and work himself up to those last fifteen minutes, to that fantastic thing he does. In the same way, you see the kids wait as the rock performers really get with it, turn on, and get working properly. So that last set, that last fifteen or twenty minutes, *really* makes sense to them. In the same way, I think that the film, even though it builds a series of good moments, has that kind of wholeness. You know what the entire three-day experience must have been like. When Ashley and Weintraub ask me: Why include Jimi Hendrix? Why put that "raving awful music" (in their words), at the end of the movie, why put something that has to be endured? The only reason I can give, is, you *have* to do it. Nobody appreciates anything unless they have to live through it, unless they endure over five thousand decibels of volume. It seemed to make sense that one of the aspects of rock, one of the aspects of these concerts, of this whole generation of people, was this property of endurance. And they want to take it away and make it easy. That, I think, is a definite arithmetic progression in the diminuation of the effectiveness of the film. Cutting it down to a conventional length and a conventional format, as rock has been cut down before, is really like undercutting the whole generation. As Pauline Kael said, she's never been at a rock concert, but she did have a sense, as a middle-aged woman, that she was seeing, for good or for bad, what it's really about, and what the performances are all about.

Q: *Well, on the other hand, why the concern? Obviously, the more money the film makes, at some given point, the more money you'll make. And the reviews certainly must have been satisfying.*

Wadleigh: I'll tell you one thing. It's embarrassing if the product that is in monophonic sound is a butchered version of a three-hour film that we produced. It's fucking around with my own ego and my own personal interest in the film. It has nothing to do, really, with providing America with a great piece of art. It's just that I didn't work six months for that film to be cut up and whittled down and dismembered. It really seems worth the time

and effort, and the trouble, to see that it remains as it is. There have been so few films, if any, that have not been an embarrassment to the people who support and who create the art form called rock. I think enough of the film to feel that it really does belong, not just to me or to Bob, but to the people who were at Woodstock. It pretends to be nothing more than an adequate representation of what was there, and we're proud, really proud, and superstitious of the honesty of the film. And there's not, as far as I am concerned, any dishonesty in that film, in terms of its representation of the event, or the people who were there, or the towns which surrounded it, or the rock performers themselves. And feeling that so strongly, it really destroys me to think of the product being ruined.

There are so many kids who've never gotten to see, for good or bad, what Jimi Hendrix is all about. They hear his music, but they don't see him perform. They don't even see people like Richie Havens or Joan Baez. I think there are a lot of kids hung up on being a rock star. As Mick Jagger says, what else can a poor boy do but play in a rock band? I think that honesty, or exactitude, or whatever you want to call it, realism, in dealing with the all-time great rock concert, is important to where America is at today. Somehow, I think of *Woodstock* as source material more than anything else. "The Ed Sullivan Show" is not source material. The Beatles on "Ed Sullivan" are not the Beatles. But the people in *Woodstock* are real.

Maurice: I agree with that. That's the one sure thing we have accomplished.

Wadleigh: Another thing I feel strongly about is the opening of the film showing a bunch of long-hairs constructing a stage in the middle of a daydream meadow. A lot of people's heads are at the whole idea of communes, the whole idea of working with wood, grass, getting back to nature. I'd hate to see a whole lot of glossiness and a whole lot of disclaiming placed on the event, and on the music, and on the audience, the people.

You're going to fall asleep, eh?

MUCKING WITH THE REAL

L.M. Kit Carson

No. 82, September 1970

1. ΔE times $\Delta t \approx h$

 —Werner Heisenberg, *The Principle of Indeterminacy*, 1927

In other words, starting from the core of what is Real (the Basic Fact: ΔE or position, and Δt or momentum), scientifically there is no Truth, only Half-Certainty—the wormy sign (\approx) in this equation means "approximately" equal: That undoes it, and It.

2. 1960 Godard, *Le Petit Soldat*: "Photography is Truth. And cinema is Truth-24-times-a-second."

3. About 3 years ago, late Winter 1967, Jim McBride and I went into a coffee shop on West 45th Street off Broadway.

4. About 3 years ago, late Winter 1967, Jim McBride and I sat in a coffee shop on West 45th Street off Broadway. Jim was eating, as usual, a cheeseburger.

 At that time we were researching a book on *cinéma-vérité* for the New York Museum of Modern Art: *The Truth on Film*. We had just taped 3- and 6-hour interviews with Richard Leacock, the Maysles Brothers, Andy Warhol, D.A. Pennebaker, Andrew Noren, other *cinéma-véritistes*—all of them stumbling around the endless basic question in *c-v*, or filming-the-Real: *Can* you get It, the Real, the Truth, on film?

 (From this question fell all the others: What is the Real once you get it on film? Still Real? Your Responsibility to Integrity of Real before Camera—i.e. how close can you frame into subject without violating? etc. Responsibility to Integrity of Camera before Real—i.e. how much can you rip off subject to get the unmasking you need within the 3-minute, 10-minute load of film? etc.)

 Andrew Noren's interview cut deepest for us into the bullshit about *cinéma-vérité*: there's only one truthmovie, *cinéma-vérité*, a man can make, he said, and that's the movie of himself—just turn the camera directly on his own life: "Me." (And Noren made movies just like this, confronting himself at random hours: the camera squatting on its tripod coldly grinding along watching Andrew and his girl friend drink coffee, fucking, etc.—and in one remarkable shot when the screws on the camera-base are loose, the camera at last seems to be unable to watch any more and

very slowly turns away from Andrew and his girl friend in a bathtub: V-e-r-y s-l-o-w-l-y t-u-r-n-s to look at the sunshiney paisley curtain flapping in and out a window—until Noren notices, grabs the camera and jerks it around to face him again.)

This un-camera-shy Noren—in America, where most filmmakers either fear or worship the camera—this Noren, who unscrewed the lens from the camera and pushed his fingers into the guts of the camera while it was running—he was onto something. We went back to argue with him and interview him twice more. McBride especially wanted to redo the tapes (you see, the year before, Jim had shot an uncompleted fictional movie about an obsessive moviemaker, like Noren, who keeps a film-diary). And when Jim talked to Noren now, Noren kept kicking Jim's imagination in the ass.

5. About 3 years ago, late Winter 1967: McBride, eating his usual cheeseburger, handed me an outline he'd written for a movie about a filmmaker named David (no last name), a sane man and loser like most, who'd finally lost his life. "My life ... haunts me," Jim wrote David as saying; "My life ... haunts me." To stop This, David starts filming and taping the days and nights of his existence—he figures to get his life down on plastic, then It can't get away anymore.

David assumed here: you get The Real, The Fact, The Truth on film. Film, after all, started 1877 with Muybridge trotting that horse past the row of cameras to get on-film-proof that the fulltrotting horse lifts all 4 feet off the ground at once—proof! Gov. Leland Stanford of California won his bet about the horse's hoofs using the Muybridge photo-series as proof, The Real, no doubt about it. Film is Real Light/ Real Time/ Real Space/ Real Motion/ Real Sound/ Bad Color but—that's The Real stuff, Film is Real; yes.

McBride finished his cheeseburger, said he'd now enough money to try the film-diary movie again. "Be a great movie," I said, starting to suggest some actors for David. McBride suggested me.

6. "I want the facts, ma'am. Just the Facts. That's all."
—Jack Webb, age 32–49 on TV "Dragnet," 1952–59 & '67–'70

7. "The Facts are nothing, sir!"
—Norman Mailer, age 47, Defense Witness in the Chicago-7 Conspiracy Trial, 1970

8. As John Kennedy's brains explode in the millisecond between frames 312 and 313, Porky Pig as Jack Ruby pops out of the bull's eye—stuttering like a fool—and (sweeping his white-gloved, 3-fingered gun across the TV screen) he points to the "Real" Paul-McCartney in Us: Richard M. Nixon (who flashes Porky a last uncomprehending glare of recognition). It's all there, the Facts right on frames 312 through 316 of Mr. Abraham Zapruder's 8mm *cinéma-vérité* truthmovie. Have you seen It all?

9. Q. *Most of the people who see* David Holzman's Diary *are fooled into believing it. In fact, at the San Francisco Film Festival, when the credits appeared at the end of the movie, the disappointed audience booed because what they thought Real turned out to be just a movie. Do you want* DHD *esthetically to fake people out?*

A. Someone asks this question every time. There are several answers.

FIRST.

All art's a decoy. Not Real. Not Fact. Not The Truth; but pulls you to The Real, The Truth. Obvious: You don't sit in a painting of a chair (not Real); you keep your distance, and maybe think about (The Real) Mr. Chair.

But a movie, motion-pictures-with-sound, apparently is Real: the little kangaroo you see hopping across in front of Robert Mitchum in *The Sundowners*—that's Kangaroo in person, Real—no statue, no word; but a kangaroo. The movie medium holds The Real for decoy: A real tree for a Real tree—it's a Real-decoy, yes. But still every movie ever made's a fake-out.

SECOND.

However, from the beginning, The Real and *David Holzman's Diary* began to rush together, mix, twist, join more than usual for a movie.

Here: We had to shoot the movie in 5 days around Easter 1967 (no money for more footage: $2,500 was the budget; and I had to return to school in Texas after the Easter weekend). So time pressure and the need to make every 28¢-foot of film good, drove McBride, Mike Wadleigh, the cinematographer, and

me like maniacs—we had to *become* David Holzman and never slip out of David or we'd lose the movie. For example, while interviewing the Thunderbird-Lady, I choked and couldn't say a word (altogether stunned by the woman—and she was driving off), but Wadleigh took over the questions, and he improvised perfectly as David—the switch from me to Wadleigh off-camera goes unnoticed by audiences. For example, I began to live like David Holzman: Sleeping alone in the apartment with the camera equipment, not eating—after a few days I lost a girl friend of 2 years (like David did) because she began to hate the movie-making (like David's movie-girl, she exited on a subway late one night, her last line: "You're crazy").

Then: This was intense concentration; but not closed concentration, so The Real could break into what we were doing very easily. This wasn't a tight tiny fiction movie-world we tried to hold together inside the frame, cutting off the real-world. (We didn't chase pigs, out of the barnyard because they were too piggy for a movie, as they did in Cuernavaca on *Butch Cassidy*). "For me, the idea in filming is just to keep looking," Richard Leacock said in his interview, "Don't go after what you've set up and that's all. Because if you don't keep open, you'll miss something every time. And you'll never see it again." (And we replayed these interview tapes over and over during that time, studying and editing them.) So we kept looking, as in *cinéma-vérité*, to whatever the moment might turn up, to grab the chance, the unrepeatable: Wadleigh buys a new fish-eye lens, we tape it on the camera and invent a scene for it; McBride wants a sequence where an old man collapses on the sidewalk—before we can stage this, some kids mug a bum and we shoot that instead. We kept open: All of a sudden we were mucking with The Real; and The Real mucked right along with us.

THIRD.

"Truth and Life merge," Jim McBride always steps up to the microphone and says in answer to this question. And smiles. And that's all.

10. *A year later, walking out, after a* Diary *screening, Pennebaker said to me (funny smile): "You've killed* cinéma-vérité. *No more truthmovies."* No. Truthmovies are just beginning.

Eclipse Day
March 7, 1970
Irving, Texas

No. 83, October 1970

FİLM AND REVOLUTİON: AN İNTERVİEW WİTH JEAN-LUC GODARD

Kent Carroll

The "comrades" of the Dziga-Vertov group, in the words of Jean-Pierre Gorin, consist, "for the moment, of just what you see before you—we two—but sometimes we are only one." The other, sometimes solitary member, is Jean-Luc Godard, who, through twenty-eight films (eighteen features) in the past thirteen years, has established a hard claim to being the most "important" filmmaker of the past decade.

In this writer's opinion, Godard, in the company of D.W. Griffith, Sergei Eisenstein, and Orson Welles, is one of the four principal creators of film as an art form. He has quite literally changed not only the manner in which films are made, but the very way in which we look at the world.

This interview was conducted on Sunday evening, April 26, before Kent State, and after returning from Austin, Texas, the last stop on an eight-day tour of six major American universities. The tour was undertaken by Godard as a means to earn money for the completion of Till Victory, a film on the Al Fatah. That film has since been completed and Godard is now editing the first of a new series of four films entitled Vladimir and Rosa, the exact content of which not even his French producer can speak of with much detailed accuracy.

In the last two and a half years, working with a changing assortment of "comrades," Godard has completed six films of varying length. Besides See You at Mao (1969) and Pravda (1969), he has finished A Movie Like the Others (1968), East Wind (1969), Struggle in Italy (1969), and Till Victory (1970).

Given the heavy political content of the interview, it seems important to note that twenty-seven-year-old Gorin was able to handle the contradiction of paying for the airfare from Boston to San Francisco of a girl we met in Cambridge, and that Godard, when prevented from taking an afternoon nap by the strange voices in an adjoining hotel room ("Listen, it sounds just like a Hitchcock movie"), reacted by slipping a piece of paper reading "Revolution till Victory" under the offending door.
—Kent Carroll

Question: *Why did you decide to call yourselves the Dziga-Vertov group?*

Godard: There are two reasons. One is the

name Dziga Vertov itself, and one is the group Dziga-Vertov. The group name is to indicate a program, to raise a flag, not to just emphasize one person. Why Dziga-Vertov? Because at the beginning of the century, he was really a Marxist moviemaker. He was a revolutionary working for the Russian revolution through the movies. He wasn't just an artist. He was a progressive artist who joined the revolution and became a revolutionary artist through struggle. He said that the task of the Kinoki was not moviemaking—Kinoki does not mean moviemaker, it means film workers—but to produce films in the name of the World Proletarian Revolution. In that way, there was a big difference between him and those fellows Eisenstein and Pudovkin, who were not revolutionary.

Gorin: He was quite aware that movies were used by the ruling class which invented them for the rest of us; that the movie was the ideological expression of the bourgeois.

Q: *Is he more than an historical example? Can those same principles be applied today? And if so, how can you apply them to the very different circumstances that exist?*

Godard: First we have to realize that we are French militants dealing with the movies, working in France, and involved in the class struggle. We are in 1970 and the movies, the tool we are working with, are still in 1917.

The group Dziga-Vertov means that we are trying, even if we are only two or three, to work as a group. Not to just work together as fellows, but as a political group. Which means fighting, struggling in France. Being involved in the struggle means we must struggle through the movies. To make a film as a political group is very difficult for the moment, because we are more in the position politically of just individuals trying to go on the same road. A group means not only individuals walking side by side on the same road, but walking together politically.

Q: *Is it necessary to work as a group? Could an individual, independent filmmaker make films politically?*

Godard: It depends. First you have to try and be independent from the ruling class

economy. You have to realize what it means to be independent. It doesn't mean just to be a hippie on a campus. They think a place like Berkeley is a so-called liberated area, but when they go to the border of this liberated area they see that the bars on the prison remain, only they're more invisible. You have to be independent first from the bourgeois ideology, and then you can move toward a revolutionary ideology. That means you have to try to work as a group, as an organization, to organize in order to unite. The movies are simply a way to help build unity. Making movies is just a little screw in building a new concept of politics.

Gorin: What we are trying to make are revolutionary movies that will promote revolutionary change. You will have to break all the old chains. The first notion to disappear is certainly the notion of the *auteur*.

Godard: The notion of an author, of independent imagination, is just a fake. But this bourgeois idea has not yet been replaced. A first step might be to simply gather people. At least then you can have a free discussion. But if you don't go on and organize on a political basis, you have nothing more than a free discussion. Then collective creation is really no more than collective eating in a restaurant.

Q: *Does it demand certain talents or certain kinds of knowledge?*

Godard: Yes, but you can't speak of kinds of knowledge or talent, only of social use of knowledge and social use of talents. Of course, to handle a gun you need a certain capacity, a certain ability. To run fast, you need to have good legs and good training. Not to be out of focus when you photograph something, you need a certain capacity. But then there is the social use of that certain capacity. That technique or that capacity does not just exist in the air like the clouds.

Q: *You imply that your purpose is to break down not only an esthetic, but also the whole history of film. Then, is it more advantageous to be first a radical before becoming a filmmaker and attempting to make revolutionary films, or the other way around?*

Godard: We're an example. Both of us. I was a bourgeois filmmaker and then a progressive filmmaker and then no longer a filmmaker, but just a worker in the movies. Jean-Pierre was a student and then a militant, and then he thought he had to go to the movies for a moment, just because it was an important part of the ideological struggle which is the primary aspect of the class struggle today in France. So we joined. And he had to learn techniques a little more than I, and I had to learn political work as a duty, not as a hobby.

Q: *Is it possible to take advantage of expertise? Could you, working among yourselves and knowing what kind of film you wanted to make, use someone like Raoul Coutard?*

Godard: Why not? For example, at the moment we still need an editing girl or boy, not because we can't do it, or we don't know how to do it, but because we want someone better trained. That way it goes faster, and we have to go as fast as possible. I mean, Lenin can take a taxi because he has to go fast from one place to another and he doesn't necessarily care if the taxi driver is a fascist. The same is true with editing. We are hesitating for the picture we have done for Al Fatah between two girls who are politically involved in a different way. They are at different stages of the revolutionary process, and we have to choose which one is best for the movie from a political point of view. One of the girls belongs to a group which has a very precise political program we agree with for the moment. The other one is much less militant, but it might be that to work on this movie could be progress for her and, because of this progress, we might have a more productive political relationship together.

Gorin: As Jean-Luc said, because there is no such thing as technique, but only a social use of technique, it is very hard to find a cameraman or an editing girl who is not overeducated, overtrained. First they must go backwards to have the possibility to criticize things.

Godard: We made a step forward when we tried to reduce all those so-called technical problems to their utmost simplicity. When you read a book on photography, whether by Hollywood photographers, whether by Kodak, it looks like building an atomic bomb, when it is not. It's really rather simple. So we are trying to make only a few images, work with no more than two tracks, so the mixing is simple.

Gorin: In fact, ours is a very dialectic movement. In a certain way, we are going backward, but backward means that we are going against the traditional way films are made. It means fighting Hollywood films. By going backwards, we are actually progressing because we're trying to be able to build something new.

Godard: And when we speak of Hollywood, we understand Hollywood as everybody, whether it be Newsreel, whether the Cubans, whether the Yugoslavians, whether the New York Film Festival, whether the Cannes Film Festival, whether the Cinémathèque française, whether *Cahiers du cinéma*. Hollywood means everything connected with films. So every time we say Hollywood, it means the imperialism of this ideological product which is a movie.

Q: *Is* See You at Mao *the first film you attempted to make by the kind of revolutionary political process you've described?*

Godard: The first one was called *A Movie Like the Others*. It was done just after the 1968 May–June events in France. But it was a complete failure. So the real first attempt, with a bit of thinking, is *See You at Mao*, which is still kind of bourgeois, but progressive in many aspects of its making. Like the technical simplicity of it.

For example, in *Mao*, the shot of the nude women can generate a real progressive discussion. Just yesterday evening in Austin, a student said there was no difference between *Zabriskie Point* and *Mao*. I said, "Okay, but after seeing *Zabriskie Point*, what do you do?" "Oh well," he said, "I'm thinking more." I said, "Okay, what are you thinking more of?" He said, "Well, I don't know." Conversely from *Mao*, he asked why instead of a woman's body we didn't use a man's body? And I said, "Because we were actually discussing how to try and build an image for women's liberation." And then we had a real political

and progressive discussion which you absolutely do not have the capacity of having with *Zabriskie Point*. That's what we mean by saying that simple techniques generate progressive political ideas.

Q: *Is that how you determine if another step has been taken? Is the success of each succeeding film based on the reaction from the people who view the film, on your own attitudes about the film, or on a combination of the two?*

Godard: Mostly our own attitudes determine progress because, until now, there have been mainly negative aspects in our films. But the fact that those negative aspects can be transformed into positive aspects in succeeding films is because they were nevertheless achieved in a progressive way.

Gorin: Our own possibility of self-criticism was the result of producing the films. I couldn't say anything, or only very abstract things, about films like *One Plus One*. *La Chinoise* was of no use to Jean-Luc, and of less use for me. But with *See You at Mao*, we had the possibility to really criticize ourselves and to say more precisely where we must go.

Q: *Is* Pravda *a step beyond* Mao?

Godard: Yes, but only because *Pravda* differs in the negative aspect; we made the effort to finish it, and not to quit and say it's just garbage. But having made that psychological effort, we must also put a notice on it. This is a garbage Marxist/Leninist movie, which is a good way of titling it. At least now we know what not to do anymore. We've visited a house in which we'll never go again. We thought it was a step forward but we realized, how do you say, a jump into emptiness. It was a learning process. And the first thing we learned was that it was not done by group work, but by two individuals.

Q: *You continue to use the metaphor "step forward." Does that imply that at some point there is a final step, a full-blown revolutionary film with no negative aspects?*

Godard: No. Only revolution again. People think we are aiming at a model, and this model you can print and then sell as a revolutionary model. That is shit. That is what Picasso has done and it is still bourgeois.

Gorin: Precisely. What is the difference between the two conceptions? One is saying, finally, art is art, which means things are things, and they hope to stay the way they are. We are saying that art is revolutionary art, art is a sensation of movement, and movement doesn't exist with a Greek urn. Only specific movements can exist with specific situations. That means that revolutionary art is a very wide open country, and there is not one form, but hundreds and thousands of them that, like political revolution itself, will never stop.

Q: *At the very beginning it's likely that it will be easy to gauge steps forward but, after the initial departure, how will you measure progression?*

Godard: At a certain point you go from quantity to quality. Until *A Movie Like the Others* I was a moviemaker and an author. I was only progressing from a quantity point of view. Then I saw the job to be done, and that I had the possibility of doing this job only with the help of the masses. For me this was a major advancement. You can't do it as an individual. You can't do it alone, even if you are an advanced element of the good militant. Because being a good militant means being related, one way or another, with the masses.

Q: *Does it then follow that other revolutionary filmmakers, or would-be revolutionary filmmakers, have very little to learn from your own experience and that, secondly, at a certain point, each separate film can only be judged in its own specific context? That it can't even be related to the film that went before or the films that come afterward?*

Gorin: No, I think that all revolutionary filmmakers have to meet at a certain point. They must confront the same problem we did. First they will be engaged, in their own way, in a war that will be quite similar to our struggle. But you have to work on general principles because each step of the revolution is trying to produce a parallel approach. There should be different types of revolutionary

moviemakers, and sometimes we have to fight with them ideologically because that is one way we analyze our principles.

Godard: For example, the Newsreel people are fighting the Underground moviemakers, and both Underground and Newsreel are fighting Hollywood. This is a contradiction within the imperialistic system. And then there is Dziga-Vertov. We are fighting Hollywood, Newsreel, and the Underground. But sometimes we work on a united front with the people of Newsreel because it is important at a certain point to work with them to fight both Underground and Hollywood. For example, we took a movie made in Laos (we think it is a revisionist picture, even if they call it a Marxist picture), and brought it to the Palestinian fighters just for them to see others in another part of the world fighting against imperialism. So at that moment we were working on a united front. It is like when you make a demonstration in the street. Sometimes you must coordinate it with a group you are fighting ideologically. You do this to concentrate on the main enemy at the moment.

Q: Is one of the contradictions the distribution of the film?

Godard: Yes, one of the contradictions is between the distribution and the production. This contradiction has been established by imperialists who put distribution in command, who say, "since we have to distribute movies, we have to produce them in such a way that they can be distributed." So we, Dziga-Vertov, have to do the exact opposite. First we have to know how to produce, how to build a picture, and, after that, we will learn how to distribute it. It means that with the very few films we have, the very little money, we must try not to distribute always the same way. The old way was to make it to sell it. To make another one to sell it. To make another one and to sell it. Now, this is over. It might mean that we will be obliged to stop making movies for economic reasons or maybe from political decisions. At a certain historical point we will know if it's more important not to make a movie.

Q: Are there any examples of people making genuine revolutionary films, political films by political means?

Godard: Maybe, but if there are, they must be unknown, and they have to be. Maybe there are one or two in Asia, and one or two in Africa, I don't know. In China they are probably working like that, but related to the Chinese situation. It's easier for the Chinese because there have been twenty years of dictatorship of the masses, and now the masses are taking over the ideological superstructure. This means that they have the capacity to really begin to work on art and literature in a true, revolutionary Chinese way.

Q: How do you evaluate films like Battle of Algiers and Z?

Godard: A revolutionary film must come from class struggle or from liberation movements. These are films which only record, they are not part of the struggle. They are just films on politics, filmed with politicians. They are completely outside the activity they record; in no sense are they a product of that activity. At best, they are liberal movies.

They claim they attack when they're just what the Chinese call a bullet wrapped in sugar. These sugar bullets are the most dangerous ones.

They advance a solution before analyzing the problem. So they put the solution before the problem. At the same moment they confuse reality with reflections. A movie is not reality, it is only a reflection. Bourgeois filmmakers focus on the reflections of reality. We are concerned with the reality of that reflection. But, at the moment, we must deal and work with only a few resources. This is a real situation. This is a ghetto situation. Our commissioned movies have been rejected by British, Italian, and French television because they were fiercely attacking them. And they feel us out the same way as the FBI. And we have not a possibility of having an Oscar or selling to CBS. We absolutely have not.

Gorin: Movies were invented about the time that the old bourgeois arts were declining. Movies were used to reinforce all the implications of the other arts. In fact, Hollywood movies are really from the same

GODARD

SEE YOU AT MAO / PRAVDA

2 Films by Jean-Luc Godard and comrades of the Dziga-Vertov Group

"Dziga-Vertov was the only truly Marxist moviemaker. He was a revolutionary
working for the Russian Revolution through the movies. We took his name for our group,
not to emphasize one person, but to indicate a program, to raise a flag."
—Jean-Luc Godard—April 1970

GODARD IN AMERICA

A film by Ralph Thanhauser

GROVE PRESS/EVERGREEN FILMS
53 East 11th Street, New York, N.Y. 10003 (212) 677-2400

old psychopolitical form as the novel.

Godard: You have a very good example with Émile Zola. He began as a progressive writer, dealing with mine workers and the working-class situation. Then he sold more and more copies of his books. He became a real bourgeois, and then photography was invented. Then as an artist, he began to make photographs. But what kind of photographs was he making by the end of his life? Just pictures of his wife and children in the garden. In the beginning, his books were dealing with a coal workers' strike. You see the difference? He could have at least begun again to photograph strikers. But he did not. He was shooting his lady in a garden. Just like the Impressionist painters were doing. Manet was making pictures of the railroad station. But he was absolutely not aware that there was a big strike in the station. So one thing that can really be proved is that the development of movies and the invention of the camera did not mean progress, but only different kinds of tricks to convey the same stuff already in the novel. That's why the relationship between novels and movie-making, the way a script is written and the way the director casts the film, why all those things are really a reinforcement of the same ruling-class ideology. The narrative line has brought the novel to death. Novelists became incapable of transforming progress into a revolutionary movement because they never analyzed where the narrative line was coming from. By whom was it invented? For whom and against whom? In a movie, there is no pure technique, there is nothing like a neutral camera or zoom. There is just social use of the zoom. The social use of the camera. There could be a social use of the 16mm camera. But when it was invented, there was no analysis of the social use of this light, portable camera. So the social use was controlled by Hollywood.

Q: *Do all art forms have as much possibility as film as ideological elements in revolutionary struggle?*

Godard: I think it is much more difficult for painters and sculptors, much more difficult for arts like theater and music, because there is no science of music, and absolutely no social use of music except by imperialists. Look at the Rolling Stones. A year ago they were considered the leading hippies since the Beatles. Look what happened. Those Rolling Stones did a show at Altamont and allowed a situation where people were killed. There is nothing more to say.

We think that the music in China is, for the moment, less revolutionary than theater, just because the Chinese tradition of theater is more Chinese than music. For example, the blacks here have a problem with their music because it has been stolen by the whites. So first they must recover it, and afterwards they must transform it, because now the whites have black sounds in their music. And this process is really very difficult.

Q: *Is it possible in a country like the United States to work toward a revolutionary art form without having it co-opted by our sponge-like culture?*

Godard: It doesn't mean that black militants haven't the right to play rock and roll, but when and how that music is played becomes a political decision they have to make, because of the fact that whites are using rock and roll.

Gorin: The fact that there is a main form of art doesn't mean that the other forms of art must disappear. In fact, they can fight one against the other in a dialectical process.

Q: *In this country, certain kinds of music, drugs, new life-styles and values have formed what some people want to call an alternate culture. Even if you disagree with what that alternate culture is, even if you decide that there is really very little in it that is revolutionary, can it have some political importance?*

Godard: It can, but you have to determine how and when. The alternative is no more than the one I faced when I was leaving my bourgeois family. That was an alternative—to stay with the family or to leave it—so I left it. But that isn't just an alternative, it's another concrete situation. I became a member of another bourgeois family called show business.

Gorin: Those people, even if they don't think of themselves politically at some point, have to act politically even if it is not clear to them in strict political terms how they are different from the ruling class which is opposing them. Those people are in a process in which they might be radicalized, they might be politicized. Eventually these so-called liberated people gathering in university areas will face the repressive structure of this society which will politicize them. Right now they are dreaming, they are walking on the edge, but this walk, for the moment, is a progressive walk. Why? Because they're going to clash with the ruling structure. And they'll have to face it. And they'll have to change.

Q: *But isn't that only true for some, like the middle-class students who come out of a suburb, go to a university, and get hit by a policeman for the first time?*

Godard: Yes, but when you are hit, two things can happen—either you think better after, or you become more dumb than you were. The kind of response is important. Most want to go into a street march, when to analyze and organize may be much more essential.

Gorin: And then there is always the risk of being killed—that's an important problem. That's why there is a great difference between us and the American universities. We have seen what can happen. Soon the same thing will happen here.

Q: *How much do you think you were able to learn about the student situation in this country by touring some of the major universities, by speaking with students, especially after they had seen* See You at Mao?

Godard: We have gathered a little information, but not enough to make a picture out of it. We have seen the difference between Yale, where there is a concrete problem, the Bobby Seale trial, and Austin, where there is not. And the difference between Minnesota and Madison, and comparisons like that. Some schools are more advanced for the moment because the clash is happening more often. Berkeley was the place where we got the worst reception, and this is absolutely correct. Throwing tomatoes in Berkeley was absolutely normal because they are more involved in the mass struggle than Harvard. So it was in the more progressive areas that we got a violent response.

Gorin: For instance, in Berkeley, because their situation is more advanced, two days was not enough time. In Austin, things were rather clear in only one day.

Godard: To have a real discussion with the audience would take three or four days in Berkeley.

Gorin: What I mean about Austin, eighty percent or ninety percent of the people were listening to us, but were interested in a very wrong way. They were interested in Jean-Luc. They were interested out of respect for an ex-great moviemaker. [laughter]

Godard: We saw different situations. People in Austin or in Minnesota did not say, "We have people in jail so give us the money you are making," like the people in Berkeley. And then you have the Panthers who say, "We have people in jail," but who don't ask for money.

Q: *Can students have a separate political identification? Do you believe they are a political class with revolutionary potential?*

Godard: Let's not speak of the students. First we must speak of the university, and what the university is in this society, and the possibility that the university may be a weak point. Is the university more unbearable than a factory or another place? This is the question that should be raised. And if the university is the prime target, this is the task and the aim for the students, because they are in the university. But you have to know whether, at a certain time, to weaken the ruling structure, you should attack on that point—attack the university as a weak point—instead of another one.

Q: *Some radicals find a Marxian analysis of the American working class very difficult, because a great part of what has traditionally been identified as the working class has, in this country, been co-opted into the middle class. A factory worker here can often make*

enough money to live in the suburbs, to have a car and a color television set. And very often these workers are politically reactionary. Many are anti-black, most are chauvinistic about America's involvement in Southeast Asia. As a group, they demonstrate few progressive tendencies. At one point, SDS wanted to align themselves in some fashion with the workers, but they seem to have found it virtually impossible.

Godard: Yes, but they made the same mistakes as in France. They were speaking of the working class before speaking of themselves.

In every article in the militant papers here, there are two things that puzzle me. First, they are saying, support North Vietnam, but they speak very little of what's happening elsewhere. The articles mainly deal with inside America. If a paper is ten pages, there are nine and a half pages of America, and not even one-half page on outside—on Laos, or South America or Palestine, on France or Italy or Germany. Secondly, they are just speaking of themselves. And when they are speaking of themselves, there is no attempt to look at the economic grounds which permit them to be themselves. So when they try to make an analysis of their concrete situation, it is very difficult because it means a new kind of struggle.

Q: *Could there come a point when you decide that there is no point in making more films? Might you decide to devote your energies entirely to a different kind of revolutionary activity which would not allow you to make films?*

Godard: Some look to Che Guevara because he died fighting, and think they must do the same, but that is a very romantic notion.

Q: *What about the problem of financing films? As more and more distribution outlets become aware, like the television stations, of the kind of films you want to make, and the reasons you want to make them, won't most of the regular sources for finance be entirely unavailable?*

Godard: This is why we may have to work just in a suburb or in a certain factory with the video tape. The only possibility might be to ask two hundred people for ten cents every week in order to deliver to them their information. Information *from* them *to* them. And this will be political work. But still we have the four pictures we are going to do for Grove Press. Grove Press has already bought two pictures in advance. What does it mean for us? It means we can control the picture except inside the States. It means, since it is more money than we have had in the last two years, that we have a capacity to think and work on the picture for six or seven months. It means we have no bread and butter problem for six months, and we have more creative possibilities. It means to pay people on the same basis that we are paid. But still we know what Grove Press is, more or less, and we know, more or less, what we are. So the first picture, *Vladimir and Rosa*, will deal with sexuality. We know Grove Press is interested in erotic things as well as politics and avant-garde art. And since Barney Rosset is interested in that, we have tried to work within that, and to deliver the best picture we can. But at the same time, militants will be able to learn something from the movie. And if they are angry that it's handled by Grove Press, which is a contradiction, at least it is progressive to deliver a picture that will upset people. So if they're really angry, that may lead to political action. That a contradiction exists is obvious, but the answer is quite clear: we are far more realistic in our approach than those who act as if the revolution had already occurred.

Q: *These two films,* Vladimir and Rosa *and* 18th Brumaire, *will they be fictional films? Is your one specific goal to make a revolutionary fictional film?*

Godard: With *Vladimir and Rosa* we'll try to begin again with fiction, but it will be very difficult. The road leading to fiction is not yet clear—it's still bushes and trees. We think that movies are fiction, and reality is reality. We don't think documentaries are reality. Fiction is fiction, reality is reality, and movies are fiction. The only problem is to try to make revolutionary fiction. To have made bourgeois fiction, and to go into revolutionary fiction means a long march through many dark countries.

Q: *So the film can only be a function of your own involvement as you relate to a specific political situation?*

Godard: It's like between man and woman. You can only work together when each one is the outside and the inside of the other one. If not, it's just a bourgeois marriage. Our contract with Grove Press is a bourgeois marriage. But it is correct because this is the way people are married today.

Q: *You mentioned an interesting story about proposing a film to the Greek government.*

Godard: Yes, we said it was just to make people aware that *Z* was produced, more or less, by the CIA. Now that it has won an Oscar, no one need doubt that.

Gorin: When the Greek fascists came into power, all the French moviemakers refused to go to Greece to shoot movies when the Greek government extended invitations.

Godard: Someone told me in London that there was a possibility of getting money in Greece. So I wrote a treatment, a script, but probably it stopped at CIA's headquarters. It was a fantastic story about a Chinese James Bond who steals the Olympic flame in order to transport it into China, to help the Chinese launch an atomic satellite. [laughter]

Q: *What kind of film would you have made had you been able to go to Greece, had they given you money?*

Godard: We would have asked for a million dollars, and made two or three shots of olive groves and said: "There is a spy behind the trees; if you look hard within one hour you will see him." But they were afraid.

Q: *How do you now consider your older films, especially those like* La Chinoise, *which are pointedly political?*

Godard: They are just Hollywood films because I was a bourgeois artist. They are my dead corpses.

Q: *At what exact point in time did the break from bourgeois to revolutionary filmmaking occur?*

Godard: During the May–June events in France in 1968.

Q: *Are there any of these earlier films that you now consider to contain any positive merit?*

Godard: Perhaps *Weekend* and *Pierrot le Fou*. There are some things in *Two or Three Things*. Some positive things in those films. *One Plus One* was my last bourgeois film. I was very arrogant to make that, to think I could talk about revolution just like that—just to make images, thinking I knew what they meant.

Q: *What about* One A.M., One American Movie, *that you shot two years ago during your last trip to this country? Will you ever complete it?*

Godard: No, it is dead now. It is two years old and completely of a different period. When we shot that, I was thinking, like a bourgeois artist, that I could just go and do interviews with people like Eldridge Cleaver and Tom Hayden. But I was wrong. And Tom Hayden was wrong to allow me to do that because it was just moviemaking, not political action. When we were in Berkeley, I talked to Tom and apologized, and told him I thought he was wrong. But Cleaver was correct. We paid him a thousand dollars, and for him to take that money was correct. His was a political decision—he needed the money to escape America.

Q: *Do you still maintain any relationship with people from the bourgeois days, people like Truffaut or Coutard?*

Godard: No, not really. We no longer have anything to talk about. We are not fighting one another, not as persons, but they are making bourgeois garbage and I have been making revolutionary garbage.

No. 83, October 1970

We:
A Manifesto

Dziga Vertov

Dziga Vertov (1896–1954) was the foremost film experimentor of the Soviet Union whose major work included Three Songs about Lenin *(1934) and* The Man with the Camera *(1929). During the Stalin period, Vertov encountered both official censorship and bureaucratic harassment. The films he managed to complete were performed, if at all, only before small audiences, and a number of them remained uncopied in the archives where they finally disintegrated. But during the Lenin Year celebrations, Vertov's* Three Songs about Lenin, *a film made up of documentary footage depicting the building of socialism in the Soviet Union, and sequences of the funeral of Lenin, was publicly performed in Moscow. Vertov's work has recently been shown at a number of Vertov festivals in Paris, Vienna, Brussels, Stockholm, and other major cities.—Eds.*

We call ourselves the "Kinoks" in order to differentiate ourselves from "filmmakers," a group of rag-pickers who are quite good at foisting off old stuff onto the public.

We see no relationship between the swindling and the calculation of profiteers and true *Kinok cinema*.

The Russo-German cinedrama, with its heavy load of visions and memories of childhood, seems inept to us.

Kinok thanks American adventure films, those films full of spectacular movement, and thanks American direction à la Pinkerton for their quick-moving images and their close-ups. They are good films, but disordered ones, and are not based on a precise study of movement. They are a cut above psychological drama which, despite everything, lacks any kind of theoretical basis. This drama is stereotyped—the copy of a copy.

WE declare that old novelized, theatricalized films and others have leprosy.

—Don't go near them!
—Don't touch them with your eyes!
—They're a mortal danger!
—Contagious!

WE claim that the future of cinematographic art is to be found by denying its present.

The death of "cinematography" is indispensable if cinematographic art is to live. *We*

call upon people to hasten its death.

We protest against the mixture of the arts that many people call "a synthesis." A mixture of the wrong colors, no matter how closely they resemble the pure colors of the spectrum, will never produce white, but instead a dirty gray.

We will attain synthesis at the peak of accomplishment in each art, and not before.

WE are purifying Kinok cinema of elements that intrude: music, literature, and theater. We are seeking our own particular rhythm that will not have been stolen from somewhere else, and we are finding it in the movements of things.

WE call upon people to escape from:

—the sickly-sweet snares of romance
—the poison of the psychological novel
—the embrace of the drama of lovers
—and turn their backs upon music.

Let us go out into the wide open spaces, the space of four dimensions (the usual three plus time), searching for materials, a beat, a rhythm, that are our very own.

The "psychological" prevents man from being as precise as a chronometer, and prevents the fulfillment of his desire to be like a machine.

We have no reason to devote most of our attention to today's man in this art of movement.

The fact that men, unlike machines, do not know how to behave makes us feel ashamed—how can we help but be ashamed if the infallible behavior of electricity touches us more than the disordered pushing and shoving of active men and the corrupting flabbiness of passive men?

The joy we feel on seeing the dance of saws in a sawmill is more comprehensible and closer to us that those we see in dancehalls.

WE do not want to film man for the time being, because he doesn't know how to control his movements.

We want to move, by way of the poetry of the machine, from the shambling citizen to the perfect electric man.

By baring the soul of the machine, by making the worker fond of his factory, the peasant girl fond of her tractor, the machinist fond of his locomotive, we are bringing creative joy to each mechanical task, we are making men more like machines, and we are educating new men.

The *new man*, freed of his clumsiness and awkwardness, and possessed of the effortless, precise movements of the machine, will be the noble subject of our films.

WE are marching, faces bared, toward the recognition of the rhythm of the machine, of the wonder of mechanical work, toward the sight of the beauty of chemical processes; we sing of earthquakes; we compose cine-poems with flames and electric generating plants; we admire the movements of the comets and meteors, and the sweep of spotlights that dazzle the stars.

All those who love their art seek for the profound basic principles of their technique.

Cinematography, which is nervous and irritable, needs a rigorous system of precise movement.

The beat, the rhythm, the nature of movement, its exact disposition in relation to the coordinate axes of the image, and perhaps to the axes of coordinates of the real world (three dimensions, plus the fourth, time), must be inventoried and studied by all filmmakers.

Necessity, precision, and speed: these are the three factors we require of every movement worthy of being filmed and projected on the screen.

We require that montage be a geometric extract of movement by means of a captivating alternation of images.

Kinok cinema is the art of organizing the necessary movements of things in space, thanks to the use of an artistic rhythmic whole that corresponds to the physical properties and the inner rhythm of each individual object.

The *intervals* (that is, the passage from one movement to another), rather than the movements themselves, constitute the material (the elements of the art of movement). It is these intervals which bring the action to a kinetic conclusion. The organization of movement is the organization of its elements, that is to say, of its intervals, in the phrase. In each phrase there is a beginning, an attainment, and a falling off of movement (each manifesting itself to this or that degree). A work is made up of phrases, just as a phrase is made up of intervals of movement.

Once having conceived a cine-poem or a fragment, Kinok must know how to note it down precisely, in order to give it life on the screen when technical conditions are favorable.

The most perfect scenario, obviously, cannot replace these notes, just as a text does not replace an actor's pantomime, and just as literary commentaries on the works of Scriabin give one no idea of his music.

In order to be able to represent a dynamic study on paper, we must have a system of graphic signs to represent movement.

WE are in search of a cine-scale.

WE rise and fall with the rhythm of movement as it speeds up and slows down proceeding far away from us, near us, on top of us, in a circle, in a straight line, in an ellipse, to the right and to the left, with plus signs or minus signs, movements curve, take a straight line, join together, break into fragments, multiply by themselves, silently transfixing space.

Cinema also is *the art of imagining movements* of things in space, answering the imperatives of science; it is the incarnation of the dream of the inventor, whether that inventor be a scientist, an artist, an engineer, or a carpenter; thanks to the Kinoks, he is the realizer of what is unrealizable in life.

Patterns in movement. Designs in movement. Projects for an immediate future. The theory of relativity on the screen.

WE salute the fantastic regularity of movement. Borne by the wings of hypotheses, our eyes driven by propellers move out into the future.

WE believe the moment is approaching in which we will be able to launch hurricanes of motion in space, held in control by the lassos of our tactics.

Long live *dynamic geometry*, the movement of points, lines, surfaces, volumes.

Long live the poetry of the machine that is moved and moving, the poetry of steel levers, wheels and wings, the iron cry of movements, the blinding grimaces of incandescent gasjets.

(Text of the Kinok manifesto as published in the magazine *Kinophot*, no. 1, 1922. The first program published in the press by the Kinok group of documentary filmmakers, founded by Vertov in 1919.)

PAPATAKIS: TIGER IN A THINK-TANK

Parker Tyler

Previously, I have written but a single interview without relying on the taped version. But interviewing the Greek-Ethiop film director Nico Papatakis amid the camp décor of the Charles French Restaurant (where I lunched with him and his actress-wife, known professionally as Olga Karlatos), I have found my second experience fertile and reassuring. Papatakis is—in one valid and still useful word—chic, and besides that, talented and very serious. I tend to be soothed by spacious restaurants and can smile at overt camp. But our environs were just not in it for the more than two hours we spent at table; nor, except casually, were the dishes (that we more or less ate) in it. Papatakis has a large dash of charisma that makes all else secondary. At first glance, he looks like a lionized Italian movie star in declining years, and yet, at second glance (to the expert), he could be nothing but Greek; primarily.

Born in Ethiopia of an Ethiopian mother and a Greek colonist father, he fought, when seventeen, against the Italians in the Italo-Ethiopian war, and went into exile on Italy's victory, going to live first in Athens, then in Paris. It was a period of hard times and odd jobs till he had the notion of starting a night club that would cater to the smart set. It was the famous La Rose rouge. Before long, its success palled and provoked a disillusionment. Wryly, he asks of that distant time: "What could I hope for? the Légion d'Honneur?" Always—his skin is a kind of quicksilver-pink—his racial origin posed certain problems. Instinctively, on the national crises of Vietnam and Algeria, he sided with their peoples as underdogs. Yet to be, as he recalls, "a little adopted African"? No and again. No!

Result: today, at fifty-two, Papatakis is well launched on a filmmaking career in which he writes, directs, and produces (like a model *auteur*-director) his own films. He looks much younger than he is, and his ideas strike me as so young, vital, and challenging that I have risked the epithet at the head of this interview. Something about Papatakis challenges your own daring.

Early on, he pronounced—a tiny bit wearily as if he has said it much of late—"I cannot go back to Greece." A slight shrug gave the sentence both italics and suspense. Papatakis has a delicate way of, what he

237

terms in an English neologism, "ironizing"—calling the fatal turn of events, one might say, with tongue in cheek. He has an excellent English, up to points where his anxiety, to make something clear, precipitates him into French—at hand was our charming interpreter, Margie Goldsmith, who translated at such points. Papatakis, I was informed, is a marked man, even in Paris, which he has made, to date, his home of exile; ironically enough, France, unique among European nations in this respect, is a friend of the present Greek regime.

It was while he was shooting his latest feature, *Thanos and Despina*, that the coup d'état of the army officers took place in Greece. He had to finish up in fifteen days, packaging his film miraculously under the very eyes of the Greek censors. Well might its original French title, *Les Pâtres du désordre*, mean *shepherds of disorder*. Before the final shots were completed, the false uniformed policemen, who have a role in the closing sequence, had some trouble being distinguished from the genuine uniformed policemen who suddenly sprouted on the mountainous scene. The film ends on a wild mountaintop after a struggle and chase up the adjacent mountainsides. A strange personal drama with significant social overtones is reaching its climax. Thanos, a former shepherd—brilliantly incarnated by a real Greek gypsy—is technically eloping with a native Greek girl whom he has morally, if not physically, seduced, or rather, subjugated; for his temperament is gay, cynical, and cruelly autocratic despite his occupation. One doesn't know how ironic Thanos' way of seducing the girl has been; it seems to be, at least partly, revenge on the community for having tricked, insulted, and cast him out. The whole village (except the girl, Despina, who follows him, hypnotized, like a slave) has been organized against him. The engineer of this plot is a young man of the district—a former chum of Thanos' in the army—who nurses a physical yen for him, and has plotted, begged, and otherwise pressured him into getting away from it all and living together; unfortunately, just what the two men's past relationship was is left undefined.

Now, anyway, the shepherd just won't have his suitor. Thus has Thanos' exit come to running away and being pursued by the whole village as well as by Yankos, his male lover, and the police. In a perverse turn of mind, the thwarted suitor seems to have decided to settle for the maiden, his "intended," whom he tries to capture from Thanos. So the plot, after all, takes the classic form of a fight over a girl. After a brave and debonair show (during which he makes a toreador's move of confronting, outfighting, and sparing his suitor's life), Thanos is cornered on the mountaintop with the faithful girl at his heels—suddenly he takes her hand: they jump over the cliff and die.

In the same breath that I told Papatakis how thrilling and beautiful I thought this filmic sequence, I objected that it was spoiled a bit by the young man acting Thanos' lover: he just didn't, physically attractive though he was, project an image of passion; since the homosexual passion was an axis of the plot, the young actor's negative mediocrity was a serious blemish. It took special courage to say this because next to me (between Papatakis and myself) sat the Despina of the film, Mme. Papatakis, looking fabulously like her screen image; that is, smooth, lovely, immaculate of feature, all black-and-white linear harmony. A fragile, slight-shouldered, dreamish young woman, she is the opposite of the busty, intense, showy film star. Gazing into her pure black eyes, I hastened to add that, despite said blemish, the movie had not for an instant bored me.

Promptly, Papatakis admitted, after considering a moment, that maybe, as I believed, the thwarted ex-soldier (in the habit of wearing his old paratrooper's uniform) had not "projected." Yet the admission seemed not to make Papatakis at all unhappy. I think I guessed why. People inspired by ideas tend grandly to look to the ideas, beyond their spoiled realization, and particularly to *an* idea. For his ideas, this Ethiopian Greek obviously has a very positive—even a *tigerish*—affection. What ideas or idea? I quickly took measures to identify them, and the answer was ready enough: anti-fascist, anti-imperialist, anti-establishment; in a word, "revolution." If I hadn't already sensed Papatakis' seriousness, and the tigerish glint in it, I might have mistaken him for a man dealing dubiously in radical clichés. My ploy was to cleave to his work and its plans.

The presence of a moral and political

sensibility in *Thanos and Despina* is crystal clear—but not so its ideas. Nothing could be dumber, on the other hand, than to take the facile view of a Vincent Canby that the film is a "mock-folk epic." One might as well call one of the old English morality plays mock-folk. As in Glauber Rocha's *Antonio das Mortes*, it is the ritual pattern that matters in *Thanos and Despina*, and (in both films) the political overtones inherent symbolically in the assertion and composition of such rituals at this time. I sought for a key to the past in Papatakis' future. So I asked him what he was working on now. Was it another updated "folk" theme?

Not exactly. He has completed, he said, a film script about the student uprisings in May 1968 in France. "You mean you haven't started to film it?" A flicker of trouble shot through his expression. Yet he smiled that ironizing smile. "I have some backers that are interested in it but I do not know ... I really don't like to live in France because the police harass me. I have no feeling of freedom. They are always *there*. I answered my phone once and what did I hear when I asked who was speaking? 'The police,' they politely answered! They want to remind me I am under surveillance all the time." There was a "that's all" in these words and their intonation.

For a split second, I reviewed what I knew about Papatakis' past work. Terribly radical? Terribly "political"? On the surface, hardly. I had to mention my regrets that I had somehow missed *Les Abysses*, his first film, which brought him general attention in Europe with its controversial success. Gaining a signal award at the 1963 Cannes Festival, it was considered a breakthrough for the "violent cinema," a trend then not so impressively topical as now. The history of *Les Abysses* attests to the fierce, deep-going unconventionality of this decidedly *auteur*-director, with his mixed race, adventurous career, and revolutionary motivation. The film is not an adaptation of Jean Genet's *Les Bonnes* (*The Maids*), which provided only the take-off point for a story about another offbeat sex triangle. Having himself been, when a child, a servant, Papatakis must have had an affinity with the basic social situation in *The Maids*. Remember that Thanos, the humble shepherd, has a passive detachment till pricked and persecuted. Then, like the humble hero

of legend, the canonic Fool, he rises up and asserts the true power of his ego.

Papatakis' film has been called "anarchistic." That is a vague label nowadays, spanning a wide range of actions and motives. Did something, aside from politics, in Papatakis' personality explain, perhaps, his obsession with the idea of opposite sexes at war over one sex? I had to get deeper. So I went on to his association with his friend Jean Genet. Genet's unique temperamental perversity is reflected in the fact that originally he wanted the roles of the two maids in his play acted by young men. Incidentally, this idea has been executed, with success, I think, in Eliot Feld's recent ballet based on *The Maids*. Now, startled yet not really surprised, I learned that Papatakis' original film venture was the production of Genet's famous film *Un Chant d'amour*, set in a prison and full of its author's peculiar homosexual esthetics—tender, violent, poetic at once. Genet has inherited the French erotic tradition (offbeat-Baudelairean) of violence, death, crime, and perversity. Self-evidently, a profound rapport with this complex as a life situation—and specifically a *political* situation—has helped to mould Papatakis the creative filmmaker. Yet this Greek-Ethiop is no more "another Genet" than he is "another Baudelaire."

Les Abysses was rejected outright by French distributors, and only at the behest of André Malraux himself—prompted by such prestigious individuals of French culture as Sartre, André Breton, and Genet—was the film entered at the Cannes Festival where it caused its furor. Papatakis kept referring to Genet, and suddenly he confessed—now I had the clue!—that his interest focused on "evil" as represented by all forms of revolutionary action, sexual, political, or economic. Thus, apparently, Genet's sublime criminal inverts, hero-worshipped by their author, have crystallized Papatakis' belief in evil as a necessary vital force, a force greater even than the lives of criminal inverts as conceived by Genet.

The theme of Papatakis' new, unrealized film script, he said, expresses his transformation of Genet's viewpoint and its highly personal esthetic. He has concentrated on the role of "the delinquents" (his term) in the May 1968 disorders that began with the Paris

student demonstrations. Criminal waifs, all sorts of undergrounders, quickly joined the action. But when the shouting and the heaving were over, the wounds bandaged, when, in short, accounts had to be settled with the authorities, the students proceeded to repudiate their emergent allies, the delinquents, taking no responsibility for them. Why? Because, technically, most were criminals; many (some of Genet's friends, doubtless) already had police records. The arrested students, having hired lawyers, decidedly did not wish their defense tainted by association with the underground rebels who had joined them in the battle … "I see," I murmured to Papatakis. We found ourselves just sipping and eating.

It had been strange to hear this film director, so poised and—yes!—chic, so conversationally casual, come out for evil in its specifically "delinquent" form; especially as his wife, pure, tranquil, lovely, sat next to me as we faced each other. Here was a fascinating wrinkle. Brushing to one side the unworthy thought of Papatakis as a fashion-follower, I silently reflected: Well, that's *art* for you! Only in the safe, pure, tender environs of art can an idea such as Papatakis'—at once so abstract and yet so real as a daily happening—persist and define itself with liberty and ease. Assisted by our interpreter, Papatakis had started to explain his conception of good and evil. Good seems to him a static principle, a sort of embodiment of the Establishment in terms of civilized progress. Yet this same good represents the past as rigid, undynamic, played-out, with the result that evil is automatically called upon as the force that will energize society over again by destroying its barren, rigidified traditions. Papatakis' evil is the very principle of true energy: health itself! Anarchism? Perhaps. But surely a very personal brand: a chain reaction of good and evil, an existential paradox.

On one hand, it sounded like Marxist logic, and yet the naming of Evil as if with a capital letter brought up the function of opposites in classical dialectics. This suggested, of course, Hegel's concept of opposed forces that perpetually transcend violence by reaching a peaceful plane of resolution which becomes a higher form, a forward stage in society's predetermined drive toward perfection. I said as much to Papatakis. Scouting

the problem of perfection, he would have neither the Hegelian philosophy of ultimate reconciliation between the opposites of good and evil, nor (when I brought it up) anything like a perpetually suspended contest between good and evil, like that of God and the Devil in the so-called Manichean heresy of Christian theology. I suspected all that was too "academic" for Papatakis, who conceded, however, that his idea was basically materialist.

"Marx's conversion of Hegel?" I queried. I got an "ironistic" shrug of faint impatience and he shook his trim, handsome head in the negative. He seemed to smile with a shadow of despondence that I could not see his idea in the clear. He started to ejaculate in French and I saw that I had to put to him the decisive question. "Wait," I said. "Let me ask you just this: Do you believe in evil as an eternal force—not as something that will wither away after the true revolution comes and achieves its aim?" Our interpreter, turning to Papatakis, carefully phrased my sentence in French. Unhesitantly, in French, Papatakis answered: "Yes, that is what I mean: evil *is* an eternal force."

"Ah!" I exclaimed. "Now I understand *Thanos and Despina* better!" We smiled, then, all around the table. Papatakis' eyes, I thought, had sparked with a gleam of relief and satisfaction. More seriously, at last, we got down to our meal. In my mind's eye I was recalling that rocky mountaintop against the sky and the gypsyish shepherd—lean and handsome as a swift revolutionary act—hoping to go scot-free (though now encumbered by the village beauty in love with him) and yet inevitably trapped by his pursuers. I recalled that Papatakis had expressed a profound anger with the classic idea of Greece as "the cradle of civilization" and as an "eternal culture." To him—taking him at his present word—only evil seems "eternal." The very beauty of the wild countryside where he filmed the last scenes of *Thanos and Despina* provided what he termed "traps for myself." The filming of the action could not but emphasize the landscape's great photogenic qualities. Yet beneath the surface, "all that beauty," Papatakis had said that he sensed "the color of oppression and the tragic presence of man."

"Now *that*," I thought (as I went on

pretending interest in my filet of sole in cream sauce with tomatoes), "is surely a classic conception of man: the conception of the great antique tragedies!" Yet Thanos, the picturesque shepherd, debonair and dandied-up for his flight, is no Orestes or Oedipus; he is pressured, as it were, by eternal forces, into his odd, ironic, if self-destroying gesture—full of its own force, Byronically vainglorious. The double suicide—his and Despina's—suggests the emergent pseudo-lesbian incest of Genet's suicidal "maids." But ... what, I quickly reminded myself, of the new Papatakis film, the one whose hero is to be the delinquent collective as of Paris, May 1968?

I put aside all interest in my sole—Papatakis was showing only faint interest in his curried shrimp—because at that moment a million-dollar-movie question had flared up in me (I don't mean that Papatakis' movie is expected to cost that much: the less spent on a well-produced movie, nowadays, the better it is apt to be. No, I speak only figuratively). "Tell me," I said, catching Papatakis' elusively tigerish glance amid the subtle quicksilver of his face, "tell me! Do you plan on making your hero as *individualized* as Thanos in your new film about revolutionary evil?"

"Oh, yes!" he replied, as if the prospect were a foregone conclusion. And twice he nodded, emphatically. FULL STOP. A new Thanos, I inferred, a more fully charged symbol, because now he'll be collectivized.

What can be expected of this as yet untitled film?—it is, so Papatakis admitted with boyish embarrassment, still untitled. With what there is to go on, one can speculate. Could there be in Papatakis' mind a "dandy" of anarchistic evil—tragically climaxed evil—a kind of gay martyr; a *man who laughs* in the environmental trap of our times? Yet a man who *acts*, too, with daring and grace and authority, in the very midst of knowing he is the elected scapegoat, the Fall Guy of modern history? Is this what, in fact, the Abbie Hoffmans, Jerry Rubins, and Bobby Seales of our day predicate? Papatakis' sensibility and his revolutionary urge, his feeling for fate mingled with his feeling for style—a *personal* style as seen in his shepherd-hero—might ... just *might* ... issue in a Daring Young Delinquent on the Flying Trapeze of the World Revolution. That, unexpectedly,

could be very nice! If, of course, it were done with taste, true emotion, and penetration of the depths.

Perhaps (such are my afterthoughts) something inherently Don Juanish exists in Papatakis' delinquent-hero. For Don Juan (as we see vividly in *Don Giovanni*, Mozart's opera) gears up very well with Papatakis' stated concept of evil as a perpetual, ever renewed and renewing force. With his thousand-and-three seductions, and still going strong, the Don Juan type would seem to incarnate the same "anarchy" of moral action Papatakis has in mind when he lauds evil as the essential energizer. The many ladies loved and left by the fabulous Don were unhappy. But happiness—especially any particular person's happiness—is not the relevant issue; it wasn't in Don Giovanni's time, and presumably it isn't now. Don Giovanni himself is "happy" only in being conscious of his own person as a force transcending all morality of conduct. His only happiness is the transcendent freedom to *seduce*. He is out to lay the world, and all that stops his illustrious career is the intervention of the supernatural powers supposed of the Christian religion. These powers remain a valid theatrical device, a "classic" device. And yet very few people today believe in the ability of *anything* to halt the growing revolutionary temper of our restless society ... except tentatively and temporarily.

In this tentativeness and temporariness, we are, all of us, trapped as the earthbound race of man. No Apollo mission to the moon, successful or merely heroic, can extricate us from this trap whose dilemmas we have to work out down here during this and all other "earth days." I was really sorry not to have been able to pursue such thoughts with Nico Papatakis. He and his wife, when we had our coffee, were quickly wafted away to another rendezvous with the agents of publicity.

I did have the chance, however, to ask him if he would go back to France in order to film his new work in the actual setting where its action took place: Paris and its hoary groves of Academe. "As you know," said Papatakis, "I don't like the prospect of working in Paris. They are trying"—the slight, ironizing smile again—"to get me to live and work *here*."

"Really?" I broke out. "That's marvelous!"

Yet the "they" was vague enough to make it tactless of me to inquire just who

"they" might be, and what inducement they were offering. Besides, time had really run out.

I can add, personally, I hope they—that is, we—*do* keep Papatakis over here. Everything else being even, he might add up to something wonderful. Think tanks *need* tigers—preferably with a flair. And flair, indubitably, Papatakis has.

Our interpreter, long hair floating in the wind on Sixth Avenue, was out in the street frantically hailing a cab. On the curb, I shook the dreamish hand of Olga Karlatos. I was thinking: "Add a *sex*, add a *problem*!" Our day is one of piling-up problems, and there's nothing piling-up problems need so much as one real good hero ... That word "good" is merely colloquial. Papatakis: take it from here!

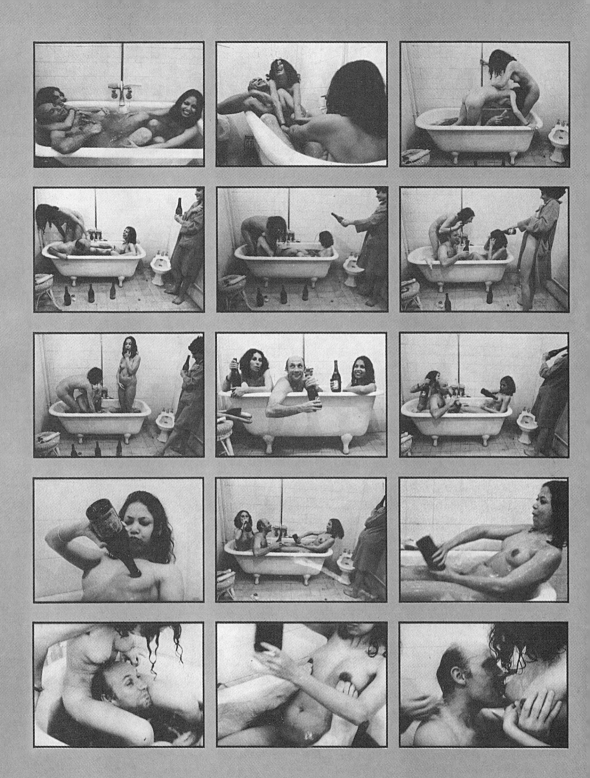

One page from a feature devoted to the release of Jens Jørgen Thorsen's *Quiet Days in Clichy*, which included numerous publicity stills, excerpts from Henry Miller's novel, and the lyrics of Country Joe McDonald's theme song for the film, from *Evergreen Review* No. 85, December 1970

Hollywood's Last Stand

Tom Seligson

I spent this last July traveling across America with an Indian friend of mine; stopping off in Chicago to see the Uptown slums in which the Indians who have left the reservations now live, their hopes of a healthier, more secure life in the cities squashed by the rotting tenements and dead-end day-labor jobs available to people of all colors. And the reservations themselves—my friend a Sioux, we visited Standing Rock in North Dakota—were even more depressing, the Indians living in tiny clapboard homes with sometimes ten in two rooms, few of the homes having running water or toilets, and the roads, unpaved, the pavement ending where the reservation begins, Even though there was a Pow-Wow going on when we were there—a tribal celebration with Indian dances and a traditionally joyous time—the utter despair of the Indians was apparent. The heavy drinking and the commonplace violence—one of the young Indians we were staying with attacked a BIA (Bureau of Indian Affairs) cop with a knife—both reflected the unchanging degradation of the Indians in America. Eighty years after the Wounded Knee Massacre (one of the last major Indian battles), the Indians are still oppressed, perhaps even more than the blacks. Clustered on what little land that still belongs to them, they face two alternative means of destruction. They may stay on the reservation, which is their traditional home, their *land*, the land being of seminal importance to the maintenance of their culture, and continue to have to contend with present conditions of poverty and disease. (Some seventy percent of the Indians on Standing Rock are unemployed. The yearly family income is around $190. The life expectancy of Indians there and at other reservations is one half that of whites.) Or they may move to the cities where there are more "job opportunities." But Indians, like the "street Indians" I saw in Chicago, feel displaced, isolated, and lonely in the white man's culture. They often take out their anguish in booze and frequent suicide.

If anyone is going to change America's traditional mistreatment of its natives, it will be the young Indians now coming of age. Like George, the young Indian from New York whom I traveled with, they are angry, tough, and resolved to begin fighting back. George was one of the leaders of the attempted Ellis

Island takeover, and, as we drove through the North Dakota hills, he talked about the oppression he has felt, the pressures, both blatant and subtle, that have been used to try to keep him down. He told me that the BIA schools he attended are white-staffed schools located off the reservation which work to discourage the Indian from thinking *as* an Indian, to Anglicize him. He told me he received beatings for doing Indian dances, and that he was forced to pick up bottle tops on his knees, and was once tied by his wrists to a boiler, all for speaking his native Sioux language. But he could stand the physical punishment, he said. It was the attempt to destroy his culture that outraged him most. The lies in the history books he was made to read. The racist things his teachers taught him. Out of school, worst of all was the hatchet job Hollywood had done on his people, the distortions of their customs, and the misrepresentations of historic fact that film-goers, both Indian and white, have accepted as true. George is proud of his ancestors. He is proud of the sophisticated life-style the Indians developed, the truly representative forms of government they perfected, and the communal and equitable tribes that seem so humane compared with the greed and the hate of white American culture. He is also proud of the resistance his forefathers put up against the advancing cavalry so set on destroying them. He talked enthusiastically about how Geronimo and his small band of Chiricahuas eluded the army for years, per-forming such a brilliant guerrilla campaign that Che Guevara is supposed to have stud-ied the Indian leader. And when we passed the fort in North Dakota which is on the site of the Little Bighorn, he smiled as he talked about how Custer got his ass whipped. "They never show what really happened," George said, shaking his head, referring once again to the filmmakers' distortion of the Indians. "What we were *really* like. And so many peo-ple believe what they see."

The American Indian. Think about him for a minute and what comes to mind? Rampaging hordes of painted red warriors hooting and howling as they terrorized settlers heading west. Barbaric tortures of cavalrymen or trappers, usually involving knives, or rawhide and horses (you know the one—arms and legs each tied to a horse, the four horses galloping in different direc-tions, the bloody remains never shown). And of course *scalping*. Have you ever seen an Indian movie in which a blood-thirsty savage, a Jack Palance sneer on his lips, didn't take the scalp of an innocent white man? Or in which a beautiful Indian maiden doesn't fall in love with a Gary Cooper or a John Wayne? Hollywood has created an Indian in America, not the real one, mind you, but one thought to be real by whites and, even more unfor-tunately, Indians alike. Hollywood's Indian has changed over the years, one stereotype replacing another. The Indians were barbar-ians in the films of the '30s and '40s (Errol Flynn dying as Custer), or misunderstood in the more sympathetic '50s, the proud "noble savage" out of place in the new world, a fa-tality of the white man's expansion and prog-ress. The misrepresentation continues on the screen and the oppression continues off it, for the suffering I saw on the Chicago streets and in the barren western reservations is di-rectly related to Hollywood's crude portrayal of the Indian. George and the other red men in America need their past. They need their past honest and whole if they are to salvage their future.

The Hollywood films of the '50s and '60s effectively buried the Indian as far as white America was concerned. The poverty and despair which I found so appalling has hence been allowed to remain. Most whites don't know that there are over 600,000 Indians in America today, many of them living under conditions worse than those I saw. We are oblivious to their lives, callous to their pain; for who, after all, are the mod-ern-day Indians? They are the descendants of the butchers and renegades the films have taught so much about. We are inured to their present suffering, possibly even thinking it in a way deserved.

On the reservation, I saw Indian children, brought up on the films of the '60s—the John Wayne and Cowboys and Indians shoot-em-ups—playing Cowboys and Indians them-selves. I saw them actually fight over who has to play the Indian because, as one little boy put it, "The Indians always lose." And at the dances, I saw Indian men wear beaded headbands. Never a part of traditional Indian dress, the headband is a Hollywood creation, and one now so associated with Indians in

the popular imagination that the modern-day red man, struggling hard to retain his cultural identity, is obliged to wear them. Like a broken-down actor performing in a role he once would have scorned, the Indian plays the part he has been given, even though he knows it is false. Watching the men dance, I was struck by their impotency, and despite their enthusiasm for the dance, their sense of loss.

I went on to California with George, to Alcatraz, where young Indians like himself are now making their stand, beginning to take back part of the America they lost. I was impressed by the Indians I met on Alcatraz, the determination they showed working on the island, knowing that the Coast Guard could invade any minute. They were proud of what they were doing, proud because they saw it as the modern equivalent to the nineteenth century Indian wars. With pictures of Geronimo and Chief Joseph in the landing station, they had no doubts about their past. Hollywood's influence had not blinded these militant young Indians. "It's the other Indians I'm worried about," George told me while we were out there. "The ones who aren't involved in the struggle as yet. They've got to learn the truth about the past if they're gonna get angry too. They've got to learn it."

I remembered those words when I came back to New York, and had heard about a new Indian film. Called *Soldier Blue,* it was touted as a film for the '70s, an Indian film which was supposed to be honest. I didn't really expect Hollywood to change, and certainly not Joseph E. Levine and company, among whose last films was *The Carpetbaggers.* But I decided to go, so I called up George and the two of us went.

At the beginning, I thought it was just more of the same, you know, with the Indians raiding a cavalry wagon train, massacring the cavalry, and the film showing us close-ups of severed limbs and scalped heads, all we've come to expect in Hollywood's films about the brutal savages. But after that opening scene, *Soldier Blue* parts company with all the other Indian films ever made.

Candice Bergen plays a tough-talking Easterner who has been living with the Indians and, along with one of the cavalrymen (whom she calls Soldier Blue), she is the only survivor of the Indian raid. Bergen can't quite bring off the bitchy Weatherwoman

role—I couldn't help contrasting her with the tough-sounding and -acting young Indian women I'd met on Standing Rock, one of whom is now in jail for beating up a white guy—however it is through her that the disbelieving Soldier Blue (he's played very well by Peter Strauss), and the equally skeptical audience, learn that the Indian raid is justified and indeed should be applauded. Remember how you used to cheer when the cavalry charged, when you heard the bugle sound, and saw the line of blue dashing in to rescue someone from the red men? By the end of *Soldier Blue,* most members of the audience were yelling for the Indians.

Soldier Blue is an extremely important American film because, for the first time in Hollywood history, we get the Indian's story honestly presented. How the raids on cavalry and settlers were defensive attempts to stem the theft of their land. And, more importantly, how the cruelty and barbarism attributed to the Indian more accurately should be laid to the white man. In explaining her lack of sympathy for the slain cavalrymen, Bergen gives modern America a badly needed lesson in history. In response to Soldier Blue's laments for his fallen comrades, she talks about the inhuman tortures practiced, not by the Indians, but by the cavalry. The castration of Indian men and the dismemberment of Indian women. After destroying an Indian village, cavalrymen traditionally cut off the breasts and parts of the vagina from the dead and dying women for use as tobacco pouches and trophies. When Soldier Blue, appalled by Bergen's apparent disloyalty, sputters, *"And what about the scalps?"* she answers him. "And just where do you think they picked up that little trick?" Scalping was largely unheard of in America before the arrival of white Europeans. It is a practice that was performed on poachers in "civilized" England, and later encouraged by bounties (rewards for Indian scalps were given in some states) in America.

In the last scene of *Soldier Blue* the cavalry surrounds a Cheyenne village, and the Indians are hopelessly outnumbered. The Cheyenne chief, Spotted Wolf, rides out, not to attack, but to ask for peace. Like the Sioux tribesmen—George's great-grandparents—who were mercilessly destroyed in the winter of 1890, the Cheyenne's gesture for peace is

ignored, and the massacre takes place.

The massacre, which is one of the bloodiest on film,—children's heads are lopped off, women, resisting gang rape, are dismembered, Spotted Wolf is castrated alive by the laughing cavalrymen—is based on the Sand Creek massacre of November 29, 1864, when Colonel J.M. Chivington and a force of Colorado Militia killed nearly three hundred Indian men, women, and children. A statement at the end of *Soldier Blue* relates the movie massacre to the historical event, which it calls "the most atrocious in the annals of history." I found it hard to watch the massacre. I found it hard, not because of the blood, but because I kept thinking of the little children I played with on Standing Rock, the girls I'd met on Alcatraz, and the young Indian sitting next to me, and knowing that their people had actually died that way, that the scene was true. I felt ashamed because of what America had done, not only to the Cheyenne, but to the Sioux, the Comanche, and all the other tribes, and how the destruction was still going on, no longer with guns and swords, but with teachers and books and films. It's a small comfort, but hopefully *Soldier Blue* marks an end to Hollywood's contribution to Indian destruction. I thought the film told the truth. So did George. The next day he took his younger brother.

FONDA, MY BUDDY

Seymour Krim

Iowa City, Iowa—When Jane Fonda was recently bounced around by customs lugs and police patriots at the Cleveland Airport on a phony pill-smuggling charge, the local *Daily Iowan* referred to her in its story as simply "Fonda." Not Miss Fonda, not Jane Fonda after the first sentence, but basic, rugged Fonda in the same way that you're Hoffman or Jordan and I'm Krim. This is deliberate policy on the part of (Leona) Durham, who edits this college daily out here, a 23- or 24-year-old Kansas person who deals some strong piss and fire at groaning American traditions, and if it is a practice that took root in the college and underground press during my seventeen months abroad I never heard about it. But in my questioning of people— and reading a headline like *"Fonda Pleads Innocent of Smuggling, Assault"* really got to my male-conditioned, Pavlovianized eyes— no one seems sure whether this practice of using a woman's last name as flatly as men's names are customarily used is something started here or not. Apparently the *Guardian* in NY is now doing it too.

Let me just say that it was brand-new for me and it had its intended effect. "Fonda" was suddenly an equal, a mate, a full person I could identify with much more closely than if she had been kept apart by the usual meaningless delicacies which require a Miss or a Mrs. in front of the essence: which in our society is that crucial last name. *"Fonda, 32, is scheduled to return here Monday for a preliminary hearing on federal charges of smuggling pills into ... Police and federal officials contend Fonda became abusive and violent when ..."*

Quite simply, these sentences made me think of Fonda as I would a man. Don't misunderstand. Not that I wouldn't be delighted given the opportunity to fuck her, kiss, dive, seek softness—no lessening of her womanly attributes and their ability to rouse desire— but the sudden realization on my part that beyond looking female (producing ova, bearing offspring) she was as separate and individual a human as I might flatter myself as being and above all did not deserve programming by the push-button curseword, Miss.

Again, to make it clear, I'm not a professional Women's Lib propagandist, I read this piece in the *DI* with no preconceptions—Fonda's marriage to putative French

cocksman Roger Vadim would, if anything, tend to make it all confusingly comic if you have my grisly humor—but just by Editor Durham's dropping the "Miss" and a couple of "Janes" from the AP dispatch she turned the whole thing around for most of the men who read the piece out here. Keep in mind that it didn't have to be Fonda. It could have been Streisand, Joplin, (Angela) Davis, etc., etc. In a way, I think it was fitting that I first saw this last-name way of identifying a woman applied to Fonda, certainly she has become "Fonda" even more than her father these days, more really THERE, but any woman would have been revealed just as suddenly by this stroke of justice on Durham's part.

Why have the young editor and staff of a midwest college paper introduced this change of newspaper manners? What went through their minds before pulling a switch which I believe will pick up acceptance in all of the print media in this country just as "blacks" did? Well, it isn't hard to see, again suddenly, the kind of contempt some women (like some Negroes, chicanos, Jewish boys, Italian-Americans, so forth) must have had for themselves just because of all the loaded symbolism of that preening little word, Miss. It meant, and means still to the new female consciousness, something artificial and removed from the real world of battle and ideas. And for "real world" read male world. It means a paternalistic condescension and narcissistic gallantry on the part of men which is paid for by the segregation of women to the nonserious side of life. But most of all it means that, in a world dominated by men you're a side issue, a decoration, an ornament, a "fucking machine" in business primarily to please men in some fashion or else humiliate yourself internally for not being acceptable.

All the millions of miles of crap that went with being either on a pedestal or on the floor, never simply standing straight.

But all I really know about this, viscerally, is that these notions are undone in a flash when you see the name "Fonda" on the page without any preliminary curtsy. It's quite an amazing experience, especially in this day when the printed word is supposed to be not half so effective as it used to. Take it from me that in this case, at least, such easy McLuhanism is dead wrong and misleading.

Pound once said "it can all be put into the language," meaning everything can be said, and while I agree with him (and have to disagree with Sontag who said she wanted to make film because words were inadequate) the beautiful thing about "Fonda Pleads Innocent ..." is that it achieved an opening in my and other men's heads by eliminating a piece of language instead of adding. That, too, is part of the literary genius, skillful editing, and so it fascinates me that the expert and acute handling of words can have such a powerful effect on the inner life. Frankly I love it: always hoping against hope that words are still the most potent agents of communication going, identifying with them and their role, somehow fighting each and every day for their status against detractors because, let's face it, my own rather scarred mortality is wrapped into them and when they go I might as well—

But returning to thinking of Fonda as a man. I said earlier that this didn't mean one smothered one's erotic feelings. I still believe that, but would like to hazard something else: if Fonda is like a man in essence, or if a man is like Fonda, then love between myself and a Fonda becomes closer to homosexual love than what we've previously been accustomed to. Heterosexual love emphasized basic differences; homosexual love emphasizes basic sameness. Can that be tolerated by a majority of men? That when we finally SEE women as separate, proud, deep, individualistic entities like ourselves—at least the selves we imagine we are—we will make love to them as we do to our own kind, whether in sublimated straight-guy fashion or right-out-front faggotry? Complete equals? I feel that something along this line must inevitably follow the stripping of the gingerbread from our conception of women and the ranking of them in exactly the same way that we're lined up in the world.

When this happens, increasingly, I think the relations between men and women will become easier in this country; or, if not exactly easier, because "there is always conflict when there are more than two wills on the planet at the same time" (William Burroughs), at least more grownup than the present nervous, cryptic, exasperating psychodrama that has ripped the guts out of practically all of us. In other words, I think all our love lives will

be the better for seeing men and women as part of the same exact species because they can't get any worse. Think of Fonda, think of Krim, getting together as self-respecting people in just the same way that Krim and a male friend of his might hang out together or Fonda and a female friend. I think practicing homosexuals have broken the path of what will happen between heterosexuals once women are thought of as every bit standup people BEFORE THE UNIVERSE just as men have always conceived of themselves.

Homosexuals assume a dignity, a relaxation (when there's no harassment), a sameness, a likeness, in the people they want to communicate with sexually whatever their other difficulties and hangups. And it is this sameness, this mutual understanding, that I've always felt was lacking in the frantic dating-game between men and women over here. We're so different we're scared of each other. It's tense, artificial, nonhumane, perverted in some slave-master game of power and neurosis, and yet one kicks oneself because this was supposed to be the grand thing, the marvelous time that everyone had been waiting to grow up to find. Most of us of both sexes know it isn't so—it's been almost a ghastly fraud on both sides.

So for what it's worth I say let the Fondas, Firestones, Steinems, Oates's, Streisands, Davis's, (Tess) Schwartzes, all the slit people, insist that the male-controlled media refer to them as bluntly as it does to men. Dropping of the "Miss" and even the "Mrs." may seem a small thing, just doing away with outmoded etiquette, but it indicates a much larger idea to the reading public and will make its effect, never doubt it. And once this formal newspaper equality is accepted by the mind, the senses, when it undermines old habits, it will lead—should, and as I see it, must— to a different contract between the sexes in our country. Which means a new contract between people. Something that men now have only with their drinking or kibitzing pals, something that women normally have only with sisters or that casual homo they feel easy with. Instead of being enemies, superior-inferiors, coy cunts, and brutal pricks, I'm the man and you're the chick, let every Krim see every Fonda as a replica of himself (in this case doubtless a better and more effective one), and we'll be on the road to being more human, no matter where it leads, than we ever have. Certainly there's trouble ahead with this concept, but think of all the horror behind. Do you want a repeat of that?

P.S. A smartass in the Writer's Workshop here where I teach asks when Durham is going to start running "he" for "she" in the follow-up stories on Fonda. Ha ha. This guy misses the point, but you can expect gags of this type while feminist radicals wage war with words which can shock the best of men out of their lack of imagination.

Eros and the Muses

Jerome Tarshis

The ad in the *San Francisco Chronicle* was basically truthful. "Nothing like this has ever happened before. Not, as in Denmark, a pornographic display, but an artistically free festival ... where filmmakers publicly project their visions of human behavior, including in that range the sensual and the sexual."

The advertised event was the First International Erotic Film Festival, which took place in San Francisco on December 1–6, 1970. Its sponsors spent about twenty thousand dollars and took in about fifteen thousand, but aside from losing money, which they expected, they considered the Festival a success. They had wanted to encourage serious filmmakers to work on films that would be in some sense erotic and also artistic, and to provide a setting in which dirty movies could be considered as works of art. Most of the filmmakers who entered last year's Festival seemed to be inhibited in various ways about sexual subject matter, but an institution has been created and this year's films may be quite different.

The promoters and the filmmakers had a qualified success, but I am sure most of the audience went away disappointed.

What they expected, I believe, after talking with a number of them, was an amalgam of pornography and art. They hoped for erotically arousing films that would also be edifying experiences. What they got was mostly standard underground ("New American Cinema") films.

Because the sponsors had chosen not to define "erotic film," anything the filmmakers submitted was considered. There was some nudity and some sex, often presented with a full range of visual razzledazzle—superimposed images, split screen and other optical printing effects, color solarization. There were several primarily humorous films, and several in which no human body appeared. And there were a few commercial sex films.

The audience had reason to expect a combination of art and porno. Leo Productions and the Sutter Cinema, the sponsors of the Festival, were just names to many of the filmmakers who entered. But in the Bay Area they are well known for hard-core pornography with artistic pretensions. Leo makes them, and the Sutter Cinema shows them. One Leo film exhibited at the Festival showed a girl masturbating while sitting on an American

"Pickett: tonight's guest in a Procrustean bed."
From *Evergreen Review* No. 88, April 1971.

flag. If she had been sitting on a bed in a standard porno motel-room setting, that would have been mere pornography, but if she sits on an American flag, we may choose to believe that the filmmaker, whatever else he was doing, was Making A Statement.

Leo is headed by Lowell Pickett, thirty-six, and the Sutter Cinema by Arlene Elster, twenty-nine, who are business associates, close friends, and prominent members of the Sexual Freedom League. Their commitment to sexual liberation goes beyond the fact that they make a living by selling sexual images: when I first met them, more than a year ago, Pickett was holding Sexual Freedom League orgies in his home on Friday nights, and Elster was conducting a Wednesday-night discussion group on outstanding pornographic books.

Aside from the personal reputations of the sponsors, there is the San Francisco scene in general. At this writing there are more than twenty theaters in San Francisco that show hard-core pornographic films, and several public places where live sex shows are put on. *Variety* recently reported that San Francisco is the hardcore capital of the world. That may be exaggerated, but an erotic film festival in San Francisco might produce very hot stuff indeed.

The advertising also mentioned four thousand dollars in prize money, with two thousand going to the best film in the Festival, and the three judges could hardly have been better chosen to support the audience's hope for a marriage of art and porno. Arthur Knight, film critic for the *Saturday Review*, is coauthor of a long-running series of *Playboy*

articles on sex in cinema. Maurice Girodias, of Olympia Press, publishes exactly that combination of hard-core pornography and mostly half-baked artiness that the Festival's sponsors strive for in their own films. Bruce Conner, artist and filmmaker, is not especially associated with sex in film, although his *Cosmic Ray*, which showed a naked woman with clearly visible pubic hair, was pretty daring for 1962.

Last, there was the theater. The Festival was held at the Presidio, a well-kept art house in an expensive residential neighborhood. For some time it has specialized in films of sexual interest that are at least a cut above grind-house cheapies. It is too far away from downtown to attract the usual porno crowd: businessmen taking a long lunch hour, salesmen killing time, tourists who don't know where to go, servicemen on leave. When the *I Am Curious* films played in San Francisco, they played at the Presidio, and it was an ideal choice for the Erotic Film Festival.

Opening night was crushingly well attended. There were some of the middle class and middle-aged, and some of San Francisco's nobility and gentry in search of titillation provided under respectable auspices, but it was mostly a young, long-haired,

"A Cockette. 'The only authentic exhibitionist.'"
From *Evergreen Review* No. 88, April 1971

"Festival Audience. 'It applauded, booed, hissed, yelled "Right on!" and "Bullshit"'" From *Evergreen Review* No. 88, April 1971

marijuana-smoking audience, with almost as many women as men. The underground press turned out en masse, to report and to freeload. Sitting behind me were two people who said they were from *Zap Comix*. When I asked if *Zap* reviews films, they said it might in the future. The aboveground press was also there. Film people came. Almost the only thoroughgoing exhibitionists in the crowd were the Cockettes, a troupe of female impersonators who do satirical material.

The Festival audience was extraordinarily responsive; it applauded, booed, hissed, and yelled, "Right on!" and "Bullshit!" On opening night the last film was a commercial sexploitation number, *The Zodiac Couples,* that ran for an agonizing sixty minutes. The audience engaged the film's narrator in a sprightly dialogue, and those who did not walk out—there was a lot of voting with the feet—had a good time laughing at the film and applauding their own wit.

Partly because of the diverse nature of the entries, and the lack of a definition of "erotic film," the judges decided that no one film was so far ahead of all the others as to deserve the two thousand dollar prize, and so they divided the money equally among four films. Dead-heat first prizes went to Scott Bartlett of San Francisco for *Lovemaking*; to James Broughton of Mill Valley, Cal. for *The Golden Positions*; to Karen Johnson of Northridge, Cal. for *Orange*; and to Michael T. Zuckerman of New York for *Secks*. According to a statement issued by the judges, these decisions were unanimous.

It was more difficult to agree on the second prizes, five awards of two hundred dollars each. Two judges voted for each film; the third disagreed, often violently. Second prizes went to John Dole of San Francisco for *The Miller's Tale*; to Victor Faccinto of Sacramento, Cal. for *Where Did It All Come From? Where Is It All Going?*; to David Kallaher of Cincinnati for *Verge*; to Dirk Kortz of San Francisco for *A Quickie*; and to Carl Linder of Los Angeles for *Vampira*.

There was too much disagreement to award third prizes to particular films. The rest of the prize money, one thousand dollars, went to Canyon Cinema, a West Coast cooperative that distributes films by many of the entrants, "to encourage the production of more—and better—erotic films in the Bay Area."

The four first-prize films were a various lot. The judges stated that Scott Bartlett's *Lovemaking* "most closely approximated their idea of what an erotic film could be—an imaginative, suggestive, nonclinical evocation of the sexual act." (What kind of fascist nonsense is this—*the* sexual act? Gentlemen, there are an awful lot of sexual acts.) The film began with a few squiggles of light moving on a dark screen, and I wondered if I was going to see a wholly abstract work. But then the screen was filled with what I took to be the skin of a naked woman—a small part of a naked woman—standing under a shower. From the sound track we heard a rushing of water.

Later—I am describing a few of the more identifiable pictures Bartlett has made for us—we see what I took to be a woman's vulva, photographed upside down, with fingers stroking it. Still later the lower half of a woman's torso, with the head of a man apparently kissing her vulva. The whole film ran to abstraction and partial views of the body. For me the most direct and least fragmented suggestion of "the sexual act" came from the sound track, which seemed to consist largely of cries by an excited woman. I found *Lovemaking* visually and aurally agreeable, but it is neither a turn-on film nor a statement about sexual passion. Bartlett avoids things, which is perfectly all right in a single film, but disturbing to me if that film is presented as the judges' ideal of what an erotic film could be.

Karen Johnson's *Orange*, which ran for only three minutes, began with a lovingly photographed closeup of the skin of an

orange. The camera's gaze moved around the orange and settled on its navel. A thumb tip appeared and pushed into the navel. Other fingers joined it and tore open the orange, broke it into sections, and put them into a full-screen mouth which ate the orange. At the end of the film the audience burst into explosive applause.

That was all. The use of extreme close-ups in sharp focus produced a sensual if not sexual feeling that was quite compelling, and it is possible to think of eating an orange as symbolic of a sexual act. I liked it myself. Bruce Conner said he thought it was the best film in the Festival, and it was warmly received, but I would still rather not think of this year's Festival as being dominated by a magnificent film of the opening of a champagne bottle.

The Golden Positions, by James Broughton, did not purport to be an "evocation of the sexual act" or a statement about Eros. As Broughton quotes Confucius, the golden positions are standing, sitting, and lying, and the film explores the visual possibilities of posing and moving the human body. Among the credited performers were several dancers, including Ann Halprin, who did a charming and funny vaudeville bit.

At the beginning, we see a man's naked midsection, with the navel at the center of the screen, and we hear a narrator's voice saying, "Let us contemplate." Contemplate—navel—get it? The camera backs off, the man's whole body appears, and the narrator says, approximately, "The subject of our lesson for today is the human body, which is the proper study of man and the measure of all things." I may have garbled the words, but I have retained the tone, which is deliberately banal and sententious.

Broughton presents a series of poses and brief intervals of dance movement, sometimes humorous, sometimes humbly admiring of the body, and sometimes hard to figure out. The narrator gives us a parody of a religious service, and the musical accompaniment gives us parody hymns to the body. For me that sound track was unpleasantly distracting; sophomoric jokes can be very funny, but they pall after a time.

That is also my feeling about the film as a whole. *The Golden Positions* would have been a stunning job at seven minutes and impressive in a stately way at twenty minutes. At its actual length, thirty-two minutes, it is a laudable failure. Its virtues and faults are those of Pacifica Radio and educational television, and its appeal will be to much the same audience, which seems to prefer having its esthetic experiences certified by great expanses of dignified boredom.

The remaining first-prize film, *Secks*, by Michael T. Zuckerman, was described by the judges as "abounding with humor and fertile with suggested points of departure for at least half a dozen more pictures." In the first of several enjoyable though hardly unified bits, a naked girl walks out of an apartment building and into an open convertible. She is driven around New York City by a chauffeur, and the other drivers don't notice. The sky doesn't fall, traffic doesn't jam, New York doesn't pause in its unseeing busyness.

Among the cast credits I noticed the names of Donna Kerness and Bob Cowan, two superstars from the stable of filmmaker George Kuchar, and in its tone *Secks* often reminded me of Kuchar's work. But there is much more visual trickery in this film, and Zuckerman seems to have set out to show everything he could do with the medium in a single film. I hope the next Zuckerman film I see is less fertile with suggested points of departure and rather more pulled together, but *Secks* had some very nice moments.

Some other films deserve mention. I had a good time watching *Andromeda* by George Paul Csicsery of Berkeley, which suggested the world of classical mythology. *Stamen*, a male homosexual film by P. Lane Rapère of San Francisco, was full of superimposed and color negative images, but maintained a warm emotional tone in spite of its visual bravura. Jerrold A. Peil, also of San Francisco, gave us *How To Make*, a "satirical guide to the making of pornographic movies." YOU NEED SYMBOLISM, says one title, and we see three people fondling a cat; YOU NEED SUSPENSE, says another, and the screen goes blank for a while.

Two films I found hateful but nevertheless respectable were *Cybele*, made in Japan by Donald Richie of the film department of the Museum of Modern Art, and *The Christ of the Rooftops*, by Herbert Jean deGrasse, of Comptonville, Cal. Richie's film, whose performers appeared to be dancers or

dance-trained actors, has the obtrusive visual beauty provided by its Japanese setting. The action, presumably based on ancient myth, and described in the titles as a pastoral ritual in five parts, runs to a comically portrayed sadomasochism. A very odd job. *The Christ of the Rooftops* is, among other things, a crude effort to illustrate that familiar piece of barroom wisdom, "If Christ came back today, they'd crucify him again." DeGrasse handles this theme less well than Dostoyevsky, but his film is often boisterously funny in spite of what it is trying to say.

On the whole, the quality of the films was respectable, and the sponsors of the Festival are to be thanked for putting on a good show of underground films even if they disappointed the lay audience. It would have been better if more films had been entered. The sponsors expected at least five hundred films and were prepared for a thousand or more; in fact there were about eighty. Conner said that about ten percent were worth looking at as films, which he considers a normal percentage for an underground film festival. Perhaps unfortunately for the audience, fifty percent of the entries were shown at the Festival, rather than Conner's ten percent or less.

Entries had been solicited from filmmakers' coops, university film departments, and other likely sources, but the invitations went out about a month and a half before the judging, and that turned out to be not enough time. Films were still being received after the Festival began. As for the international aspect, although films were received from Australia, Brazil, and Canada—one film from each country—I would hope for more foreign films next time. Post mortem discussions suggested that simply transporting a film from one country to another often required more time than was available, not to mention the possibility that Customs might delay some films.

This year's Festival is scheduled for November, and the call for entries will go out six months before the deadline, a period intended not only to make international participation easier, but also to allow films to be made especially for the Festival. Already more than fifty filmmakers have called up the sponsors to ask about the 1971 Festival, and a satisfyingly larger number of entries seems likely.

Before the 1971 Festival takes place, I'd like to express a few general observations about this year's films and some hopes for the future. Many of the observations are concurred with by Bruce Conner, with whom I discussed the Festival at length; my preferences and hopes are my own.

The invitations specified that entries might be in 8mm, 16mm, or 35mm format, and, if 35mm films are wanted, I'd like to see entries of the caliber of Bergman's *Smiles of a Summer Night*, or the Japanese masterpiece *Thousand Cranes*. This year there were no feature-length theatrical films from major producers.

One reason why Lowell Pickett and Arlene Elster sponsored the Festival is that they cannot find many dirty movies that are any good at all artistically. They commission independent filmmakers, some of whom have done nice films on nonsexual subjects, in hope of getting something better than routine porno. They want to occupy a position like that of Maurice Girodias in Paris in the 1950s; much of what he published was garbage, but he also published books of real literary merit. Most of what Arlene Elster shows at the Sutter Cinema is garbage, but she is quite eager to find the cinematic equivalents of Beckett, Burroughs, and Nabokov. After much disappointment, she feels that filmmakers are ashamed of sexual subject matter and do not really believe it can be treated artistically. The Festival is an attempt to break down that mental resistance.

In Oriental cultures there is a tradition that allows direct sexual representations to be considered high art, and in Japanese prints the artist is allowed not only to show the sexual organs plainly, but to exaggerate their size. The films shown at the Festival suggested to me that many filmmakers believe that hiding or blurring the outward appearances of the genital organs is art, while showing them clearly is porno. Undoubtedly some of this runs parallel with the tendency toward abstraction in twentieth-century painting and sculpture, but I think a lot of the abstraction I saw was modesty—or shame— disguised as an art.

Another reason for the prevalence of visual dazzlement is that many filmmakers seem to identify themselves with a bag of tricks. *I know how to do superimposed images*, runs

the reasoning; *I like superimposed images; therefore any film I make is going to be full of supers.* In any erotic film made by some of these people, Venus would be merely tonight's guest in a visual Procrustean bed.

Which leads me to some of the limitations of the underground film. People who dislike pornography complain that the characters have no depth and no history, and do not exist in any seriously developed psychological or social context. They are bodies, and they perform sexual acts in an unidentified bed. The same complaint can be lodged against most of the films in this festival, although their creators might be insulted at being compared to pornographers.

To mention the most brutal limitation, character development seems to call for dialogue, which requires synchronized sound, which requires equipment most underground filmmakers cannot afford. Another limitation is that while Ingmar Bergman is a writer, most underground filmmakers are not. They generally do not have trained actors at their disposal. One way around this limitation is to use dancers and dance movement, as Broughton did quite successfully in *The Golden Positions*. Another way to achieve sustained action without creating a story out of nothing is to use a ready-made story, as in the film made from Chaucer's *The Miller's Tale*. (But that film had a written narration and used professional and semi-professional actors.) Still another way to organize sustained action is to suggest myth or ritual, as in several other films.

When I discussed this point with Conner, he said filmmakers like to do what they think they do well, and most underground filmmakers think of themselves as photographers and film editors. Not playwrights, directors, or choreographers. We are going to have the visual razzle-dazzle for a long time, and some of it is marvelous.

But, if I may address myself to Santa Claus, in this year's festival I should like to see less embarrassment about sex on the part of the filmmakers. An orange can indeed be a symbol, friends, but so can a cunt. And I'd like to see more interest in what the performers are doing and why, not just in their possibilities as visual elements. And evidence of a broader spectrum of talents than those of photographer and editor. As for superimposed images used as substitutes for thinking about Eros, and as cheap approaches to the sublime, we had enough the first time around.

The First Annual Congress of the High Church of Hard Core

No. 89, May 1971

Robert Coover

Amsterdam is a religious city, unlike any other. Not a mecca or an apostolic see, but a city of refuge and fomentation, a city of heresies and holy outrage, literally underground, below sea level, with an historic view up the ass-end of orthodoxy, and so an inspired setting for *Suck* magazine's "First Annual Wet Dream Festival," held there last November.

For if there was one common response among the pilgrims to four days and nights of fuck-films strung end-to-end—beyond deadened buttocks and early boredom—it was the sense of being engulfed in some kind of moral and iconic ceremony. It was like being back in Sunday School again—right down to the hard seats, the self absorption of the priests, the collection plate clink, and the proselytizing fervor of the official creed: "When we are unafraid and free from possessiveness it will make little difference what kind of social organization we choose to live under, because we will be open, kind, and generous. It is sexual frustration, sexual envy, sexual fear, which permeates all our human relationships and which perverts them. The sexually liberated, the sexually tolerant and the sexually generous individuals are open,

tolerant, and generous in all their activities. Therefore S.E.L.F. (Sexual Egalitarian & Libertarian Fraternity) wishes to encourage sexual freedom, sexual tolerance and sexual generosity." (All communicants had to sign this creed to see the films.)

That is to say, the films themselves, with few exceptions, were either pallid home movies or slick sex-shop merchandise, lacking the efficacy of professionalism and holy humility, the projected celebrants for the most part self-conscious charlatans given to fraudulent orgasms; and the *Suck* organizers were ceremonial bumpkins, clumsy at the arts of ritual fervor, and for all their evident good will, even benevolence, there was a pervading stink of hucksterism and peacocksmanship in the air. And so the prophesied *extasis* did not descend upon the gathered faithful, nor was Amsterdam suddenly invigorated by a flood of liberating sperm (it was the end of November, and the year continued to sink impotently toward its dark demise). And yet, nevertheless, one was left with the feeling that behind the ingenuous artifices lay a primitive mystery worth a Sunday morning's contemplation, a mystery that perhaps had

less to do with erotic titillation than with one's consciousness of himself—in short, that pornography, especially in large doses, was good for the soul.

There was some exhibitionist onstage fucking and sucking, programmed efforts at excitation, and one filmmaker (a German, need one add) took a public shit, but the general ambience was one of withdrawal and becalmed emotions. Orgy seemed somehow inappropriate. Watching simultaneous multiscreen projections of a number of indistinguishable pricks thumping away in their anonymous cunts is something like watching clouds pass or leaves fall or waves lap a shore. It was entirely fit that the final night of films was held in "Cosmos," one of those barren white centers for Eastern mystery cultists, vegetarian, opposed to all drugs including alcohol, skeptical of pleasure, and given to meditative self-abnegation.

The very nature of film, of course, is counterorgiastic. Orgy is communal, and film by itself is voyeuristic, masturbatory, private. It can be used ceremonially, but iconic paradigms and larger-than-life spectacle are after all only minor elements in any total religious festival, especially one that might aspire to "become the annual sexual highlight of Europe and of your life ... a four-day get-together ... where we can really cum [sic] to know one another."

But orgy aside, film is extraordinarily relevant to the religious experience, and the Wet Dream Festival partook unavoidably of its sacramental nature. Film—especially silent film, which most of this festival's entries were (the liturgical chant was taped rock)—is pure gesture, prior to all perception and understanding, profoundly ambiguous, irreducible; yet at the same time it is selective, exemplary, repeatable and yet mutable, illuminative. "Focus" is as religious a word as "revelation." Editing is as holy an office as administering the Eucharist. And paying one's tithe at the gates before entering the holy place, whether to watch there a cocksucking, a sacrifice, or a pratfall, does not diminish the implied commitment to transcendence.

Not all the films in Amsterdam were simply about commonplace fucking and sucking, there were a few variations. There was an intensely communicative film, for example, of a girl's face as she smoked and masturbated: the one undeniably genuine orgasm in the entire parade. A great cartoon of Snow White and the Seven Dwarfs, in which the cottage, during orgy, expanded and contracted like a toilet plunger, a prick popping out of the chimney with every plunge, shooting jism. Anamorphic fuckscenes shot with a wide-angle lens: alas! the receding head, the fattening ass! Some ultimately wearisome experiments with montage, magic markers, bad lighting, and the like. A giggly clutch of what looked like suburban housewives peeing in a beer stein, then (after a clumsy cut) guzzling the contents. A terrific sequence in one film involving the caressing, puncturing, and eating of glossy green peppers, cucumbers, sausages. In another, a bald man grinning sheepishly at the camera while someone above shat on his head. Later, these turds, now lying in the grass, gathered a swarm of flies, and another man (the filmmaker, if I am not mistaken) crept up on them, raised his hand, hesitated dramatically, then slapped his hand in the shit, no doubt the festival's most memorable single image.

The prizewinning film was, not surprisingly, a barnyard spectacular, a mystical and muddy return to Mother Earth and all her well-hung progeny, in which a vestal virgin fucked or was fucked by every piece of meat on the farm, most unforgettably (because it is so humanoid) by a pig.

But the majority were simple pornoracket fuck-films, and most of the time it was like having to listen, over and over again, to some illiterate preacher hung up on the Tenth Commandment or the parable of the mustard seed. There may be more glory in Christ's cock or Mary's cunt than in their bleeding hearts, but even holy unadulterated motherfucking loses its efficacy in time, if unalleviated by subtlety and surprise. These films were mostly adolescent male masturbatory fantasies (the eager, talented, many-orificed slave of whatever sex), governed by the potential of the zoom lens, which all too often burrowed in on sad, soft pricks and dry cunts.

(The zoom lens, extension of the Victorian keyhole, is in fact altering the sex act, since positions that block the camera's inspection of the copulative organs or throw shadows over them are taboo, and new positions, not very comfortable, are being discovered that

allow the most open shots. E.g., the girl lies on her back, heels doubled under her rump, thighs spread as wide as possible; the man lies on his side, below her ass and perpendicular to her, bow-sprung by the press of her thighs; and the camera and lights hover overhead with a perfect zoom shot of the fucking organs, not to mention the stretched muscles and grimacing faces. Arms and legs must be kept out of the way—group fucking is often a necessary expedient to help hold the limbs in awkward positions: has anyone ever thought of using basketcases?—and the actors are often obliged to reach around and spread their own cheeks so the camera can see their assholes.)

But, of course, "adolescent," "masturbatory," and "fantasy" are not necessarily and in all contexts pejorative. One may relate to initiations, for example, the others to self-inquiry and to imagination. If these films and these entrepreneurs somehow debased the sacraments as newscasters debase our social life or bureaucrats our communal purpose, that's not to say there's anything intrinsically dull or sinister about films or fucking (or even politics, for that matter). The church, as they say, is not to be judged by its sinners. And one should not too harshly judge Jim Haynes and his *Suck*-mates—first-annuals are always fraught with calamity and misrepresentation, and overshadowed by the threat of repression or disinterest. They seemed to be in love with what they were doing, and as porno becomes the established orthodoxy, the Mafia-priests to come will no doubt make them seem like innocent saints and martyrs.

Perhaps all this high-church talk is too weighty for porno, even in irony. Certainly, a blue movie has more to say to us than Billy Graham or the Pope, White House transients or Rowan and Martin, but then who or what does not? In fact, there's probably even more to be said for hardcore porno than for, say, Antonioni or Brakhage, or such films as *Easy Rider, Chelsea Girls,* or *M*A*S*H.* Still, by itself, there's not much in the stuff, ten or fifteen minutes of it is a very long time indeed. If porno festivals are to thrive and take over the world, they'll probably have to learn something—in both individual films and overall festival programming—about pace and timing, honesty and awe, complexity and self-criticism. They will have to be taken out of the hands of bagmen and randy innocents, and given over to filmmakers, environmental artmakers, metaphysicians, and musicians. Rites of passage will have to be distinguished from holy farce, credos subjected to ecumenical debate, clergy and congregation alike led away from the temptation of the simplistic and the regressive. In sum, the second and successive congresses of the High Church of Hard Core will have to be invaded by the sanctifying grace of art and truth, which is not necessarily just another new position.

News from Phyllis and Eberhard Kronhausen

Sara Davidson

Pornography may make you throw up, but it hasn't killed anyone.
—Phyllis and Eberhard Kronhausen

It comes down to sitting in a screening room at nine in the morning, being bombarded with images of girls into girls, pigs into girls, girls into men, and so on, until either the possible combinations or one's stomach gives out. On the day I arrive in Copenhagen, Doctors Phyllis and Eberhard Kronhausen, "certified psychologists" (as their personal stationery states), authors, filmmakers, and sexual crusaders, are away for the day. They have sent me, as a prelude to meeting them, to Palladium Studios to look at rushes of their new film, *Why?* I've missed a night's sleep, and my system is suffering from time-change shock. But nine A.M.—three A.M. by my body clock—is the only time the screening room is free.

The lights go off, and on come pictures of two young women performing acrobatics with their mouths glued to each other's genitals. I turn to John Hilbard, the Danish producer of *Why?*, who is a fastidiously groomed man with an air of gentle urbanity. What's the film about? I ask. He says, "It's a documentary about people in the pornography business." Why are they doing it? What is their background? Are they normal people or what? "The two girls are really lovers," he says. Most of the lesbian acts in porno clubs and films are faked, "but this is not." The girls are dressed now, walking arm in arm through the zoo, kissing, and posing for an interview. Effie, a mulatto girl of twenty who plays the man in the relationship, says she wishes she had a penis, even though her girlfriend, Marianne, assures her she can "fuck as well as a man" without it.

Suddenly there is a pudgy girl in a barn, naked except for white boots caked with cow dung, preparing to have intercourse with a bull. "This girl makes pornography with animals," Hilbard says. "She loves animals more than people. Around her neck, can you see? She wears a locket with a picture of her first dog." The bull kicks at her, as she massages its nether regions. Does the bull like it? I ask. Hilbard says, "Not much. Probably the

dogs do enjoy it."

Waves of nausea are getting to me. Do they think they'll be able to show this movie in American theaters? "Why not?" Hilbard says. "People are wondering how these things are done." In Denmark, since July 1969, when the government lifted all restrictions on pornography, except that it can't be displayed in shop windows or sold to children, literally anything can be seen on the screen, in magazines, or in person at a "live show." The bulk of the porno is consumed by tourists, Hilbard says. "But normal Danish people are acting more freely now. It's accepted here that young people live together from fourteen, fifteen, on, and that girls as well as boys have the right to make experiences."

The lesbians flicker back onscreen, making love on a platform bathed in pink light. "They're so beautiful in their movements," he says. "Just like one body." I think I've seen enough now to get the idea. I take a cab back to my hotel, try, unsuccessfully, to buy Alka-Seltzer, and go to sleep.

The phone jars me awake at five P.M. with this message from Eberhard Kronhausen, who speaks with a thick German accent: "We are back now. We can see you for dinner, if you like." An hour later, I find them on the sidewalk, looking much smaller in life than in their photographs. Eberhard's clothes hang loosely on his thin body, and deep creases cut like scars down his face. Phyllis is small, full-breasted, with a healthy, blonde-blue-eyed Nordic radiance. She asks what I thought of the rushes. I admit I was unhinged by the bull. Phyllis smiles. "The way the girl moved with the animal made it beautiful to me." Eberhard adds, "It was a beautiful bull." We walk to a Polynesian restaurant, but I don't feel up to eating. Phyllis puts her hand on my shoulder. "What can we do for her, Ebe?" He suggests I drink mineral water.

The Kronhausens began their public career by fighting censorship of erotic realism by authors such as Henry Miller and D.H. Lawrence. They went on to attack censorship of all the arts and laws interfering with private sexual acts. By 1970, they had come to stand full-out for the legalization of pornography, claiming it needs no "socially redeeming value" apart from its own existence. The Kronhausens have been saying for more than twelve years that there is no

evidence pornography leads to crime or antisocial behavior. They feel it may serve therapeutic functions, in sex education and as a safety valve for release of tensions. The US Commission on Obscenity and Pornography, appointed by President Johnson, recently concurred with the Kronhausens, and recommended that all restrictions on sale of pornography to adults be eliminated.

Phyllis Kronhausen has little patience to even argue about censorship anymore. "It's irrelevant," she says. "Starvation, over-population, war—these are important social issues, not pornography. It's not even worth discussing. It's of no concern to anyone that this woman is fucking a bull."

Then why make a film of it? I ask.

"To show people. Look—this is what you're so terrified of. This is why we're clogging the courts. There are seventeen thousand pornography cases in the US courts now, thirteen cases before the Supreme Court. It costs thousands of dollars. It's such a waste, it's humiliating!" She bangs her hand on the table. "Governments are not at all shocked by violence—they have all kinds of rationalizations for wiping out whole tribes, but pornography gets them."

Eberhard says they decided to make *Why?* because "the public who sees pornography may think these are strange people, or circus freaks. They are not. In many respects they are more normal than others in this crazy world." The Kronhausens tried to find three sets of people in Copenhagen's porno subculture who would lend themselves to a psychological study. They found the two lesbians performing in a live show, and, at another club, found a married couple who went into porno to make a better living. The man had been an ironmonger. On an impulse, he answered an ad for models in the live shows, tried to perform with several girls, but found he couldn't respond, six times a night, to anyone but his wife. He persuaded her to try it with him. At first, this shy, red-haired housewife was terrified, but she came to take a sense of pride in putting on a good show.

Bodil, the girl with animals, attracted the Kronhausens' attention because she was featured in many magazines. Phyllis arranged to meet her, and Bodil, like the others in the film, was signed to a contract and given a fee. "I was struck by Bodil," Phyllis says, "because

Grove Press Films On Sexual Behavior

Cover of a specialized Grove distribution catalog, circa 1970;
the photo is a still from the Kronhausens' *Freedom to Love*

she seems happy and well-adjusted to her life. All three of our examples are happy, though fairly poor people, much happier than three-quarters of the others we know. They are all in love, and very involved with what they're doing." Eberhard says, "Bodil is a perfect example of the way human–animal relationships can be more tender than relationships between people."

They finish dinner, and we walk down the Amagertorv, a long street of shops, cafes, and theaters that is closed to cars. Young people are sitting at outdoor tables having coffee and pastries, or bunched on the ground playing guitars. The Kronhausens' first movie, *Freedom to Love*, is playing at one of the theaters and has been sold out almost every performance. Eberhard, walking with hands stuffed in his black leather jacket, says, "We have a pretty good life, I think. But in the last several years we've gotten very pessimistic about whether we, as a civilization, will come through." Phyllis nods her head. "Things look so bleak, I wouldn't want to be a young person today. I really wouldn't. The younger generation isn't as much ahead of its parents as we'd hoped. They're still dropping babies without thinking about it. We've got to learn to enjoy sex and stop breeding." I ask if the Kronhausens ever wanted to have children. They are silent a moment. "Ebe's sterile," Phyllis says, and adds, quickly, "but we would have chosen not to have children anyway, because of overpopulation." Eberhard says, "The kids may be dropping babies, but at least they're not getting married. Marriage drives people crazy." Phyllis says, "It's the relationship that counts. Marriage is irrelevant."

The Kronhausens decided to marry in 1954, when they were studying for their doctorates at Columbia Teachers College. "If we hadn't gotten married we never would have received our degrees or been licensed to practice," Phyllis says. "We were living with schizophrenics and writing our theses on living therapy. It was bad enough in the school's eyes that we didn't have wall-to-wall carpeting and were sleeping on the floor. If we had been living in sin, we would have been expelled."

After 1954, the resumes for Phyllis and Eberhard are nearly identical. They have moved, developed, published, testified, and experimented as a single unit. But before that year, their lives progressed along strikingly different tracks. Eberhard was born in 1915, the only son of a well-to-do family in Berlin. He was a Hitler youth at sixteen, and wore the golden emblem when the Nazi party was still illegal. "I thought they were a socialist party, and when I learned they were not, I wrote a political protest book that was banned by the Nazis when they came to power. They resented me all the more because I became a traitor to the cause." He was arrested twice by the Gestapo, he says, sent to a concentration camp, where he was kicked in the genitals, and, in 1939, smuggled out of the country by a sympathetic secret police agent. He found his way to South America and joined a fundamentalist Christian group who were living communally in Venezuela and Colombia. After several years he grew disillusioned and came to the United States. He married his first wife and enrolled at the University of Minnesota to study psychology and sociology.

Phyllis, who is fourteen years younger than Eberhard, grew up in a poor Minnesota farming community. No one in her family had ever gone to college, but Phyllis wanted to be a doctor. After a grueling stretch of studying days and working nights in a hospital to earn her tuition, she gave up the idea of medical school. With a hard eye toward economic realities, she majored in business administration. After graduating, she went to India for two years, drifted back to New York, and met Eberhard at a party in Greenwich Village for University of Minnesota alumni. Eberhard was already divorced from his first wife. He and Phyllis began living together and went to Columbia to do graduate work in marriage and family-life education. They also underwent psychoanalytic training with Dr. Theodor Reik, and took schizophrenics into their home. "The therapy we developed happens in the life situation," Eberhard says. "Our patients have total access to us—they can walk in on us in the shower, swim nude with us." Phyllis says one twenty-year-old boy used to go to classes with her because he couldn't be left alone, and would climb in her lap on the bus. "The best work comes about when you become emotionally involved with the person," Eberhard says. "Change takes place unobtrusively, as a natural process."

From schizophrenia, they shifted their attention to sexology. And it is at this point in their biography that the details, the statements, the psycho-historical fragments, fail to present a satisfying explanation of why these two people became zealots for sexual liberation. When asked about their messianic commitment, they offer replies such as: "We ourselves had such a terrible sexual upbringing that we decided to study the subject"; or, "Sex is one area in which our culture seems to be the sickest and most disturbed. Very few people even work in the field because it's so taboo." But many, perhaps most, people have what they consider a "terrible" sexual upbringing, and do little more than try to work out some personal resolution. The Kronhausens found they could be a self-sustaining team in the face of wide opposition and public hostility. They immersed themselves in sexual literature, art, pornography, psychiatric studies, and research in sexual response. In the process, they say, they never developed immunity to the aphrodisiac effects of their subject matter.

In 1959, they published their first and most influential book, *Pornography and the Law*. While the Supreme Court was laboring over the relative obscenity of works such as *Lady Chatterley's Lover*, the Kronhausens pointed out what should have been obvious to anyone who had ever read a brown-wrapped number like *The New Ladies' Tickler*: there are unmistakable differences between "hard-core pornography" and erotic realism in literature. Erotic realism attempts to portray life as it appears to the author, but "obscene" books are erotic fairy tales that distort reality to provide nonstop titillation. "An obscene book must constantly keep before the reader's mind a succession of erotic scenes," the Kronhausens wrote. "It must not tire him with superfluous, nonerotic descriptions of scenery, character portrayals or philosophical expositions." In obscene books there are never references to contraceptives, pregnancy, abortion, disease, emotional problems, or unrequited feelings. There is usually a seduction in which the "victim" is a willing collaborator, some kind of incest, permissive parent figures, supersexed men with enormous organs and limitless potency, and passionate, insatiable women, "who like nothing better than almost continuous intercourse."

Pornography and the Law was a boon to many people who were too inhibited or too lazy to seek out erotic writing because the book contained long excerpts from ten obscene books, and samples of erotic literature from Samuel Pepys to Edmund Wilson. The Kronhausens became lightning rods for people with sexual hang-ups, and others who were interested in experimentation. For two years, Phyllis taught sex education to undergraduate men at Columbia. She ran the class like a therapy group, and each student was asked to write or present in class a detailed account of his sex life. On the basis of this material, the Kronhausens published in 1960 the book *Sex Histories of American College Men*. They went on to write *The Sexually Responsive Woman, Walter, the English Casanova*, and, most recently, *Erotic Fantasies*, a study of sexual folklore and erotic underground literature.

While studying verbal erotica, the Kronhausens also explored visual evocations of sex. They used much of their income from royalties to purchase erotic art, and, with Grove Press, put together two volumes of erotic art which are selling handily for twenty-five dollars each. The books contain works from almost every country, with heavy representation from China, Japan, India, Western Europe, and America. The artists include: Rembrandt, Picasso, Chagall, Dalí, Warhol, Oldenburg, Rodin, Edvard Munch, André Masson, George Grosz, Jasper Johns, Larry Rivers, Jean Dubuffet, Max Ernst, Utamaro, Matta, Paul Delvaux, and Tomi Ungerer. Interestingly, certain sexual fixations seem to transcend time and culture. Running through the samples, from pre-Columbian pottery to pop art, are fantasies about people making love with deer, bears, cows, and other animals; multiple coupling; pleasure machines; garters and black stockings; and everywhere, detached phalluses that fly, float, sprout from the ground, pop out of cans, and whirl in perpetual motion. The oriental works traditionally were used for the guidance of brides and grooms. In China, as far back as the second century BC, couples would roll out beautiful painted scrolls by their pillow and study drawings of positions given poetic titles such as "Posture of the Butterfly Exploring a Flower" and "Posture of the Gobbling Fishes." The

Kronhausens presented an international exhibition of erotic art at museums in Denmark, Sweden, and Germany, and are trying to bring the show to this country. To see if there would be censorship problems, they shipped ten paintings to themselves at a New York address. The works were confiscated by US Customs, and the case is awaiting trial. But Eberhard Kronhausen says, "We are used to trials." Court battles have been a leitmotif in their lives. They have testified as expert witnesses in countless censorship cases, and almost all their own projects have involved litigation.

In 1960, the Kronhausens gave up their psychiatric practice in New York and moved to Paris, living on the streets and, Phyllis says, "absolutely starving for three years. We couldn't even get money out of publishers. People treated us miserably. We lived with Michel Simon in a slum. We paid a price deliberately, in order to grow, to experience, to learn to live. When you see how we've aged in fifteen years …" Eberhard smiles wistfully. "We could have had a very comfortable life—teaching and seeing patients. We could be as wealthy as Hugh Hefner. We could have made a lot of money on sex. But we've spent our lives not compromising."

In 1964, a severely disturbed young man with a large income of his own was referred to the Kronhausens, and they became his family. The youth, whom I shall call David, was a paranoid schizophrenic who had received shock treatment in hospitals and was considered a hopeless case. He was afraid to go out of his house, and could not get through a day without hash and an assortment of stimulants and barbiturates. Eberhard says, "We treated him twenty-four hours a day, seven days a week. It was a constant struggle, but we wanted to convince him that travel, meeting people, opening up to life, was more consciousness-expanding than dope." David gave the Kronhausens a monthly salary, and the three of them left Paris for a round-the-world trip. "It was cheaper than if he had been in a hospital," Eberhard says. "It's just as easy to travel around the world as to live in New York, if you know how." At first, the Kronhausens had to buy kilos of hash for David, and watch him constantly. "He took fifty sleeping pills in Kenya, and in the Fiji Islands, he flipped out again, yelling and hallucinating on the plane." It took three trips around the world, Eberhard says, to show him that life was better than drugs. "He's in Paris now and spends his winters in India. He can cope, travel on his own. He has people living with him from time to time. But we convinced him he should not marry or have children. He couldn't take the strain of that relationship."

In every country, the Kronhausens would seek out erotic art and pornography, and try to get a sense of the strengths and sicknesses of the culture. Eberhard says, "We've found that after three months of living in an area, you develop blind spots about its problems and insanities. For example, the drafts and poor heating in England, the noise and dirt of New York—after a time you begin to think it's normal. We don't. We differ from anthropologists, because we can set up extraneous standards for judging if aspects of a culture are healthy and functional." The Kronhausens think Sweden is the closest to a sane culture they have experienced, "except for the ungodly climate," Phyllis says. "Ingmar Bergman is right—you get depressed in November, and have to drink. If they closed up Sweden for four months a year, everyone would be happy." She adds, "There's no reason, either, to have the goddamn Swedish language, except for reading poetry. They should teach English as a primary language and Swedish as a tribal language."

The Kronhausens found that every culture fosters sexual inhibitions, and that most people live "in a more or less constant state of sexual frustration." Sexual repression leads, they feel, to illness, alcoholism, violence, bad moods, surliness, and general misery. "We just want to try and free people from this," Phyllis says. "People need sex, mentally and physically. More sex will make the world better."

Since the Kronhausens don't believe in presenting one face to the world and wearing another in private, they have, themselves, lived at the frontiers of sexual experimentation. They made an erotic film using themselves as actors, with industrial noises and animals on the soundtrack. "At the moment of orgasm, you hear a lion attacking," Eberhard says. "This was seven years ago, and the Danish censor banned it." They've participated in group sex parties, orgiastic

rites, and free love communities. "We've watched each other fuck with other people," Phyllis says. "Neither of us is possessive or jealous in the traditional sense, partly, I think, because we have so much going together on the work level. I'm more withdrawn than Ebe. I tend to feel more lonely and abandoned if we're separated for a time. He gets terribly involved with other people, and it bothers me, because if he gets sidetracked, it interferes with our work." She doesn't worry about his leaving her because "if our relationship breaks up, I feel there's no relationship anyway. And I don't think it would happen that I would become more interested in another person."

The Kronhausens advocate group sex to bolster marriages. Few people can concentrate their sexual interest on one person for a lifetime, Eberhard says, and group sex, because it is shared, is better for the couple than secret affairs. "Group sex offers a maximum of sexual experience with a minimum of jealousy. Partners attend together and know they will leave together. In ten years of group experience, I've only seen one case where the pair-bond was hurt."

Group sex is, for the Kronhausens, a means to transcendental ecstasy. "We've tried opium, hash, and LSD, and wouldn't have missed that experience, but we cannot see taking acid habitually," Eberhard says. "Sex is the greatest consciousness-expander. You can get fantastically high on sex, but it's easier in a group than in a one-to-one relationship. In the group, you're not encumbered by a lot of ego hang-ups. You can experience sensuality in a pure form, abandon yourself more fully to your senses than if you're involved emotionally and on other levels." Phyllis says, "We believe there are many roads to ecstasy. Each person should get ecstasy, orgasm, in his own way. Group sex is a good trip, but it can work one night and not the next. It's like going to a Chinese restaurant twice."

We are sitting at an outdoor table at Oskar Davidsen's restaurant, overlooking a lake. The Kronhausens are alternately sipping Schnapps and beer; I'm still drinking mineral water. Eberhard says, "I don't think we've had a chance to get across to the world who we really are. We're known as propagandists of sexual freedom, but we're really liberal social philosophers. We don't think you can have sexual freedom unless you have a free society. The next documentary we make will deal only marginally with sex and primarily with social conditions. We're also thinking of making a film on America."

The crew for *Why?* meets in the morning at Palladium Studios in Hellerup, a suburb of Copenhagen. Vibeke Gad, the Kronhausens' production assistant, shows up first, wearing jeans, a pink t-shirt, and leather vest. She has large blue eyes that seem perfectly round, short brown hair, and a lithe, bountiful figure that recalls the women in Renoir paintings. Vibeke is twenty-seven, has two children, and has worked for some time on television productions. Before she met the Kronhausens, she says, "I was completely innocent and naïve." The day she met Bodil, Vibeke says, "I could hardly look at her. I kept saying, we'll have to get some social workers out here, this person is so disturbed. But I came to respect her, you know, because she is sensible and practical, and she does seem contented." When they filmed the sequence with the bull, Vibeke says, "I got so sick, I went home and cleaned my house from top to bottom. I changed the sheets, scrubbed the floors, and kicked out my dog. I couldn't look at the poor thing for two days. And I haven't been able to have intercourse with my husband since then. The whole crew got sick from the bull. If the Kronhausens hadn't taken it so naturally, we all would have quit the film. We were in shit this high …"

She points to her knee, and Phyllis, who has just arrived with Eberhard, calls over, "Pornography may make you throw up, but it hasn't killed anyone." Phyllis is wearing a black sweater and no bra, black slacks, and black lace-up support shoes that she and Eberhard had specially molded to their feet in New York. With the rest of the crew, they drive to the apartment of Effie and Marianne. "We're going to film their personal life, their lovemaking at home," Phyllis says. I hope we can get them to have an orgasm."

The girls are dressed in matching suede shirts and western hats. Their tiny, three-room apartment is filled with wigs, jewelry, plants, birds, and ceramic knickknacks. "All the clothes are Marianne's," Effie says, nudging Eberhard. "We men don't care about clothes." She takes a long black dress with

slits and sequins from the closet. "This is the only dress I have, but Marianne will never let me wear it. She'll get crazy, because she thinks I look better than her." Everyone laughs. Phyllis says to me, "This is how they start emerging as human beings in the film, not sex machines, animals." She rubs Effie's cheek affectionately.

The girls are in the process of moving to a larger apartment downstairs, and their new bed hasn't been assembled yet. The Kronhausens decide to shoot the lovemaking later in the week, and set up cameras and tape recorders for interviews. Vibeke conducts the first one with Marianne, who doesn't speak English. Michael Salomon, the cameraman, says, "Her Danish isn't so good either. She has something like a lisp—it's characteristic of some people who haven't had much education." Marianne is nineteen, and left her husband and baby daughter to move in with Effie less than a year ago. She had had several affairs with women before that, and named her daughter after one of them. She is exquisitely photogenic—a china-doll face, with a cleft chin, dimples, and upswept green eyes—but her responses to questions are shallow and unimaginative.

Effie is more animated, and startlingly candid. She is twenty, with an easygoing humor that masks the turbulence of her life. She was adopted at age five by a Danish couple after being shuttled through more than thirty foster homes in Germany. Her father was a black soldier from Louisiana, she was told, and her mother was a Polish housemaid. Effie was always attracted to girls, she says, and wanted to be a man. "In school, I was the strongest in the whole class. I liked to wear trousers and fight with all the boys." She began to make love with men when she was fourteen, "because I thought there must be something to it, if everyone says men and women have to be together. But I didn't enjoy it. I was never excited. All I got was the feeling that they just go in and out of you." She tried more than fifty men, she says, "and I thought I had an orgasm once, but when I found girls, then I found out it wasn't the real thing with men." During her childhood, she was molested by older men several times, and when she was fifteen, three boys raped her in a club basement. "I think I would have been a lesbian even if I had not had these bad experiences, because I think it comes from inside your head. You have that feeling before you really know what is happening. When I was fifteen and my parents found out I was going with girls, they told me I would grow away from it. But I didn't. As I got older, the feeling became stronger inside me."

The Kronhausens feel Effie is right—that sexual preference is established early in life, as a matter of imprinting. "We don't think homosexuality is a sickness that should be cured. It's just a different sexual preference." Eberhard says most people are bisexual, and can respond to a variety of stimulation. But it is impossible to "convert" someone with a homosexual or heterosexual preference to the other taste, he says.

"Many psychologists and doctors have told Effie that she needs a man to make her a person," she says. "I tell them to stop talking nonsense, and tell me how to satisfy Marianne, because I love her and want to make my life with her." Effie hopes it will be possible someday for her and Marianne to marry and have a child, "to make me feel like a husband and a father. Perhaps if we find a nice man who's a little bit brown—so I would feel like the baby was mine—I would like to see them make love, and have Marianne get pregnant. Then I could watch her stomach grow for nine months and think, it's my baby that's coming. I don't think the child would think anything about having two mothers. It's only if other people talked and made the child feel bad."

Phyllis says later, "Effie's frightened that Marianne will leave her. Marianne is much more conflicted than Effie—she's an individual who's never really happy or satisfied." Eberhard says, "But she's much more compatible with Effie than she was with her husband. They had nothing going for them, sexually or otherwise. At least Marianne found out early in life that she prefers women. Some people don't until they're forty." Phyllis agrees. "With a little therapy, they could be helped tremendously to settle down and feel more secure. This has started to happen through making the film, because they've talked about things they never dared ask each other before."

The next day, the Kronhausens want to shoot a flashback of Effie being raped at age fifteen. They ask Vibeke to hire three young

Cover of a specialized Grove distribution catalog, late 1960s

actors. She says, "I must know, how much do you want them to do?" Phyllis says, "They have to take down their pants, but they don't need hard cocks." Eberhard says, "The rape will be the only faked sex scene in our movie. We have to, because Effie couldn't take it."

There is some trouble booking the actors and the scene is put off until afternoon. In the morning, they shoot footage of Effie and Marianne shopping. Marianne is in a pouty mood, but the minute the cameras are on, she snuggles up to Effie, who pinches her on the bottom. Effie walks stiff-legged, with long strides; Marianne is all wiggly. The Kronhausens buy Effie a men's camel-hair jacket to wear in a later scene. As she is being fitted, Phyllis takes Marianne to a women's store, and comes running back a few minutes later and grabs Effie. "Your wife found a beautiful dress! It's beige, so you'll match."

Next stop is the Østerport Restaurant, where elderly couples are picking their way around the midday smorgasbord. With the cameras rolling, Effie escorts Marianne to a table, orders drinks, and the waiter says to her, "Yes, sir." Effie lights Marianne's cigarette. "You look beautiful today." Marianne smiles. "I always do."

It is over in three takes, and they sit down at a long table for lunch: t-bone steaks on planks, vegetables, salads, and red wine. Michael, the soft-spoken young cameraman, is explaining why he and his wife got divorced, but are continuing to live together. "There's less pressure from society, and we get along better than when we were married. My wife wanted to prove that she could be independent, but she couldn't." Eberhard says, "Give her two weeks' vacation with me in Paris." Michael: "She'll come back a lesbian or something."

A tall man with powdery skin and gouged eyes walks into the dining room and waves at Effie and Marianne. They excuse themselves to go talk to him. Phyllis says, "That's the guy who worked at the Mermaid Club with them; he had a sadistic act where he would put Effie on a cross, wrap a whip around her neck, and pretend to beat her. He wants to take both the girls to Paris and be their manager. He thinks they could make a great act." The two return and Marianne raises her wine glass demurely. "Skål." Eberhard lifts his with a toothy smile. "To all better orgasms."

When they return to the studio, the three young actors are waiting in the cafeteria. Vibeke says, "They're eating to build up strength. They're very disappointed it's not a real rape scene." In the dressing room, Effie puts on a short pink dress and a fluffy wig that makes her look much younger. Marianne watches, sulking, as the makeup lady combs the wig. Effie says, "The wig belongs to Marianne." Effie walks outside and Eberhard throws out his arms. "Beautiful. You look like you want to be raped." He shows her to the boiler room, where the three extras are standing, shy and awkward, against the wall. Eberhard says, "The three guys pull you in here, throw you on the floor, two hold you, and the third guy fucks you." Effie points to her waist. "You only see to here, right?" Eberhard: "You see a little more, but they won't do anything." Michael says, "We hope." Effie lifts up her dress. "See my underpants? I wanted to have some protection." She is wearing thick, old-fashioned cotton drawers. Eberhard laughs. Phyllis asks Marianne to wait upstairs, and whispers to me, "Effie doesn't want Marianne to see this, to see her being fucked by three men, because that makes her not a man."

Effie, speaking Danish, begins telling the actors how the rape should go, what they should say. Eberhard nods approval. "This is the way I like it best—if they work it out themselves. Because it is real." He tells them, "Try to get it on the first take, because her dress will be ruined from the floor. Ready now?" The boys knock Effie down, and struggle to hold her spread-eagled on the ground. She is kicking and fighting with all her strength. Her screams are bloodcurdling. Vibeke's eyes grow round with fright, and she chews on her fingers. The makeup lady, a tight-faced little creature, shudders in horror. Effie continues to shriek until Michael stops the camera. There is a moment of awful silence. "Give me back my pants," Effie says, with a choked giggle. The three actors get up, short of breath. One stammers, "It was rather tiring." Eberhard says, "I think that will do. We'll just get it once more for the sound." While they are waiting, Effie fakes kicks at the actors, and gives one a karate chop in the stomach. Phyllis comments, "Effie gets into these situations because she's attracted to violence—she's eroticized by it."

After the rape, we go to the screening room to see the complete rushes of Bodil with the bull. She appears first riding a gray horse across a field. "The stallion is her favorite animal," Phyllis says. "Before she makes love with her boyfriend, she'll go to the barn to excite herself with the horse." Abruptly, she appears in a blue dress with her hair in a messy ponytail above her forehead. She drags two goats to a fence post, and milks them with a cigarette dangling from her mouth. The camera pans across her bedroom: over the bed is a large photograph of two horses mating; at the foot are eight live puppies. Lacy porno underwear is spilling from all her drawers. There are three rabbits living in a box papered with nudie photographs, and a movie projector, "so she can see herself in porno films," Phyllis says. Inside a glass cabinet is an elaborate microscope and a gigantic red glass phallus. "Doctor Schmutz," Eberhard says with a laugh. While Bodil sits for an interview, flies land on her head and walk down her face. She doesn't flick them off.

In the final sequence, two porno film-makers arrive to photograph her with the bull. She tries to excite the animal by stroking it, but after a time has to bring in a cow. Her boyfriend, wearing a felt hat and a cretinous smile, holds the cow while Bodil guides the bull onto it. Then Bodil pulls the bull away, drops under it and guides its member inside her. "I wouldn't have believed it myself," Eberhard says. "I was completely amazed." Bodil repeats the procedure many times, and at the end, the bull's member is fully extended. "There, now you got something," Eberhard says. "Look at that—that is something." Vibeke moans. "Ughhhh! I'm going to be sick again." Michael covers his face. Eberhard says, "Some girls do worse things for money." Like what? I ask. He shrugs. "Marry men that they can't stand."

Pornography is just another business, he says. "And most of the businessmen are amateurs—they don't know anything about sexuality. They think they know what the trade wants." To illustrate this point, the Kronhausens take me to the porno sector of Copenhagen by the central railway station. It is a maze of storefronts and garish signs: "Intime Sex," "Animal Orgy," "Climax Club," "Love Power Show." The shops sell dirty magazines, photographs, color slides, 8mm film, obscene books in four languages, pills, creams, and battery-operated pleasure tools. But what draws tourists to the area are the private clubs and their live shows. Each day, an entire page in the *Ekstra Bladet*, one of the city's large newspapers, is filled with ads: "Enjoy an exciting blue evening in Copenhagen. We offer lesbians, strippers, massage, and a real live FUCK, with complete bar and restaurant." All the clubs have lesbian acts, but there is no male homosexuality, except at places which cater exclusively to homosexuals. The Kronhausens believe male homosexuality is too threatening to men to be erotic. "Lesbianism is not as taboo. It's exciting to both men and women. The male spectator can project himself into the lesbian situation. At sex parties that swing, you can have all the lesbian contacts you want, but you seldom see male homosexuality."

At the Venus Club, where the Kronhausens found the married couple they are using in their film, an eighteen-year-old girl named Becky has just finished a lesbian act. She has met the Kronhausens before, and invites them into the dressing room, where she is sitting on the floor, wearing jeans and an Indian shirt, knitting a sweater for the man she lives with. The cubicle is steamy and cramped. Phyllis fans herself. "This is awful. They should have some ventilation." Becky laughs. "It's worse out there with the lights." She offers us a warm beer and some cookies. "I'm going to take off soon for a month in Ibiza," she says, pushing her long hair behind her ears. "I really need the rest—I've been working every single day." When the live shows started, Becky says, performers were paid about five hundred dollars a week. As the novelty wore off, fewer customers came, and the fees went down to one hundred and fifty dollars a week. Many of the clubs had to close. To make more money, Becky started working in two at the same time, doing six shows a night, zigzagging from place to place. Eberhard says, "I think if they lowered their prices, they'd get more people here, especially more Danes." The clubs charge the equivalent of fifteen dollars for membership, and about four dollars for admission.

Money is taken at the door of the Venus Club by two sour-faced, burly men. Inside, there is a small stage with a foam-rubber mattress covered by a white bear rug. The

backdrop is red velvet with some dim blue lightbulbs. On the walls are blowups of a fat black girl, spreading wide her various orifices. About a dozen middle-aged men are sitting at little tables. The expressions on their faces suggest they are all suffering from gas pains. As a jazz record begins, accompanied by much static, a blonde in a tight, sequined gown wiggles her way among the tables. Trailing behind her is a ridiculous black net cape which catches on the chairs and in some of the customers' faces. One man with a cigar says disgustedly, as she tries to tickle his neck, "Not again!" The girl strips on the bear rug, masturbates, then opens a blanket which Becky calls "the sperm blanket" and offers to massage, or masturbate, anyone in the audience. A paunchy man with glasses comes forward.

The show is declared over and the audience hustles out. The manager flicks on the overhead lights, and all the performers and staff come out to have dinner. The blonde girl has changed to a tiny white minidress, and looks infinitely more appealing than she did in tile sequin and net costume. "That's what I mean," Eberhard says. "They have no taste for true sexuality." As we walk out, they are being served a stew of lamb and potatoes. Phyllis says, "These people are healthy, mentally, compared to the vice squads and government censors. That's where we get the sick people—they're the perverts, the creeps."

I say goodbye to the Kronhausens, and spend my last night alone, walking through the Tivoli Gardens, watching a ballet company do *Swan Lake* on a twinkling gingerbread stage. I talk to people in the cafes, and sit with students on the Amagertorv, listening to James Taylor on a portable record player. None of the people I've met in Copenhagen, apart from the Kronhausens, has ever been to a live show. A girl who is studying to be a doctor tells me, "We are all free to experiment, so why should we pay to look at others?" Finn Neugebauer, a young artist with a wonderful head of white-gold hair, explains in a patient tone, "There is an absence of feeling in pornography. I have no interest to see it. It is much more satisfying to experience sensuality in a natural setting with people one cares about." Slowly, I begin to feel my appetite returning, and sense that, at some point, I may even be interested in sex again.

As time passes I come to think of the Kronhausens as sexual gadflies, buzzing, circling, delivering small stings to that uptight, middle-aged consciousness which publicly condemns sexual freedom and privately seeks out pornography. I have an image of the Kronhausens—from a story Eberhard told me—that seems to pinpoint their place in the revolutionary whirlpool of our times:

Phyllis and Eberhard are in Washington for one of the mass marches against the war in Vietnam. Wearing their black support shoes, they take their place in the celebrity line, with actors, professors, millionaires, rock stars, and radical heroes. They find themselves behind Dr. Benjamin Spock, expert on baby care, and author of a political book called *Decent and Indecent*. Dr. Spock is exceptionally tall, and as they begin walking, chanting, and waving their signs, Eberhard cranes his neck back and calls to Spock, "Don't forget, sexual freedom and political freedom go together!" Dr. Spock turns around, looks at the Kronhausens, and says: "What?"

No. 91, July 1971

Those Homophile *Husbands*

Parker Tyler

If *Husbands* is a homosexual mystery story, it is not in any sense either homosexual or mysterious by the conscious intent of John Cassavetes, who conceived it and is principally responsible for its execution. I put it this way because *Husbands* has the air of being a working collaboration among its chief actors, the three who play the husbands of the title, Cassavetes himself (Gus), Peter Falk (Archie), and Ben Gazzara (Harry). Their collaboration was confirmed by the chummy atmosphere of a television interview with the three actors conducted by Virginia Graham after the film got an excellent press and seemed a hit. What *Husbands* undeniably asserts is a very unconventional—and what some might call a very cynical—view toward plain heterosexual romance, here in the form of at least three marriages which, judging by the film's action, have hit the rocks; positively so in one case, Harry's; quite possibly so in the cases of Gus and Archie.

If one wished to be unsympathetic to what Cassavetes has done with *Husbands*, it would be easy and obvious to attach to it the current tag of male chauvinism. For *Husbands* is a "stag" movie—about audiences rather than

performers and with virtually all its clothes on. An exception is when Archie takes off his clothes as a gag; socially, that is. This is an antediluvian stunt staged by drunks (Archie is very drunk), and I have not yet been informed that it means anything but exhibitionism induced by sexual frustration. However, the sex scenes themselves have very little undress. Their naked climaxes (two of which we must politely assume did take place) are invisible, and lovemaking has been confined to first stages, in which Gus practically has to assault the bargirl he has picked up in a London gambling casino, and Archie has to coax a mute, shy, slender, lovely Chinese girl to so much as give him the first kiss. When she does, she gets hot very quickly and sticks her tongue in his mouth. Even as a whore's routine, it shouldn't be out of order. But Archie has a reaction which is either stupidly puritanical or compulsively homosexual: he pushes her away and declares he thinks soul-kissing—it isn't so named but they used to call it that—indecent.

This response of Archie's is but one item of passing evidence to prove how oddly square these revolutionary husbands are,

or at least seem. And why should they seem "revolutionary"? Throughout, in deliberate and multitudinous ways, it is made clear that they consider their nonsexual affection for each other much worthier, more tangibly enjoyable, than their sexual affection for their respective wives, which at least Harry (for he says so) confines to action in bed. Here one must draw as fine a line between the physical and the sexual as the esthetic philosophers of old Athens were tempted to do when it came to love between men. With disarming candor, Harry gets drunk enough to hug Gus and Archie to him and give the latter a smacky kiss on the cheek. "Fairy Harry!" he then jovially brands himself. "Except for sex, and my wife's very good at sex," he adds, "I like you guys better." Archie and Gus appear to reciprocate. Yet just to keep the record straight, one of them puts in, rather solemnly, "Fairy Harry, you're out of line." Touché, Eros! That's one on Homeros.[1] Or—wait now … Is it?

As for the legitimacy of the film's representation of how off and onbeat our husbands are, I can't say I any longer have any direct contact with the middle-class, white-collar, neighborhood society of suburbia, where Gus, Harry, and Archie maintain themselves and families and presumably originate. While it is casually revealed that Gus is a dentist and Harry has a desk in what looks like the production department of an advertising agency, it is hard to say just what average income prevails among them. A key to their cultural status is provided by their boss-cat airs in taking over a neighborhood bar (proletarian-cum-lush in tone) for a sort of wake in honor of the fourth member of their private stag club: the poor guy, as we learn at the flick-on, has just been wafted from this vale of tears.

The opening funeral scene establishes how statutorily thick with normalcy and conventionality these husbands and fathers are, for they reminisce of the fourth male, loved and lost, in terms of family-album snapshots: everybody and his neighbors inhabit them. On the other hand, Pete Hamill has suggested that the whole reason for the

wildly out-of-line behavior of the three survivors, who follow Harry's desperate lead and fly to London with him for a Jet-Set spree, is that all are in love with the fourth, now gone; he was a hardier specimen, it seems, with blond crew cut and perhaps other, less exposable, charms. The question, if not the mystery, of homosexuality is bound to occur to every judicious viewer of the film, and I daresay to some injudicious viewers. Its sex hatred, present enough to be morally uncomfortable, is standard if seen from the viewpoint of the family quarrel as a symptom of the continuing War between the Men and the Women. Usually the esthetic forms of this war, nowadays, are comic—all the way from the sphere of romantic comedy to the sphere of the comic strip and the dirty joke. In a propaganda article for Women's Lib,[2] Betty Friedan finds reason in *Husbands* to proclaim that today in America the mere term, "my wife", has the status of a dirty joke.

Mrs. Friedan exaggerates, of course, but her partisan resentment is not totally without grounds. Surely the action at Harry's home the morning after the barroom wake is *dirty* if not in the least a *joke*. If it's a joke because it suggests a tabloid news story ("Near Knifing in Queens Domestic Spat") it doesn't mean to be joking. It is so drearily, savagely documentary in style that heterosexual Eros might well weep tears of blood for it. Evidently suburban wife and suburban husband have a statutory quarrel that has reached the breaking point. The heterosexes are shown as common brutes with a grudge against each other as great as it is old and subterranean. Since the lady's accomplishments in bed have already been extolled (and written off) by her husband, this scene of maddened, shameless violence offers a glittering object lesson for moralists of the classic War between the Men and the Women.

The very fundaments of this war are prime causes, speaking technically, for the sexual neurosis, which may be either homosexual or heterosexual. The main point of *Husbands*, Cassavetes's own particular stress on his theme, is that these three pals, while they love *each other*, are heterosexually in great trouble. What, superficially, the strident action and conclusion amount to is

1 From the Greek: (h)omo = the same + Eros = the love god; author's contraction for homosexual Eros as opposed to heterosexual Eros. Not to be confused with (H)omeros = Homer the Greek poet.

2 *The New York Times*, January 31, 1971.

that Gus, Harry, and Archie become exiles from heterosexual love; or rather, they are like losers in an unexpected state of heterosexual bankruptcy. It isn't their fault as investors, perhaps it's not even their wives' fault (Mrs. Friedan thinks it is!). It may be, to take it frivolously, just a maneuver of Eros on the sexual stock market. To be sure, it's *serious*. Because of the demands of physical nature (all three males are in their youngish prime), their psychic situation, sparked by the trauma of losing their fourth pal, now endures a maximum strain at its most vulnerable point: the obvious homosexual alternative. If they weren't such bosom pals, of course, they'd be vowing a new sex life instead of drowning their all-male sorrows together.

Cassavetes could not be literate and avoid not merely naming, but also exercising, the temptation for his heroes to turn homosexual. Suppose, in fact, Pete Hamill was right, and the three men are secret and suppressed (perhaps unconscious) homosexuals who have formed an adoring private circle about the "blond god" who incontinently dies? This would make them a quasi-homosexual clique with the departed god having played, and perhaps been, "straight man." I can't see that there is a single factor or wrinkle in the film to contradict, as sheer speculation, this assumption. One could hazard that neither Archie, Gus, nor Harry understands his homosexual role except, perhaps, unconsciously. But granting the foregoing possibilities, every bit of character revelation in *Husbands* would neatly fit such a hypothesis. And there is yet another possibility that would leave undisturbed the film's statistical surface. The *departed* husband could have been a secret homosexual—one of those unspoken but recognizable elements that frequently determines a form of group behavior. Here the hetero survivors' problem might well be: "is there anyone to *replace* him?" And even: "Should it be *one of us*?" A great deal of ambivalent emotion might be worked up over such a strange possibility.

One sees how difficult the situation might become. The peculiar anguish of our hero-husbands would seem to exploit the difficulty, though if any of the above hypotheses be true, it is kept behind a veil. Not only do the threesome feel that, having lost the precious fourth member, the surviving solidarity is mysteriously threatened, but precipitately, as well, they feel called on to make postponed moral decisions. Harry's is the most radical decision to be made: Will he split finally from wife, family, home? He will. And apparently, at the end, he *does*. The in-crisis episode, when the three realize the depth and perhaps the intractable nature of their post-mortem problem, is the men's room vomiting scene. This follows the longish, dolefully vulgar barroom wake when it is the royal whim of three boss cats to compel the bar crowd to make asses of themselves by competing in a "talent contest." This has been extremely painful for a mere witness (speaking for myself) while perhaps it was infinitely touching to connoisseurs of the folksy illiterate, those thinking it funky rather than, as I do, fatuous. To me, the vomiting scene, brutally realistic as it is, comes as a welcome purge of the preceding visions and sounds, consuming minutes and minutes as annuated barflies of both sexes, bribed by liquor, sing annuated songs, and Gus, Archie, and Harry drunkenly run the proceedings.

The tune changes with the trio's urgent retreat to the men's room, where they come face to face with the nemesis of the toilet bowl, into which human gastronomic errors are disgorged the wrong way. Note exactly what happens. For here Cassavetes's script is the most original, the performances the most scrupulously realistic. I don't refer to the acrobatics of vomiting, though these are (in sound anyway) horrendous, or to homosexual contacts, absent here although often made the function of such quarters. Harry, riding high on the wave of drunkenness, could call himself a fairy because he could make the aspersion a real guy's tipsy put-on. *Now* the real guys are faced with ugly hangovers and the ugly immediacies of nauseated organisms. Nausea, remember, may be a sign of heterosexual disgust at involvement (willing or unwilling) with homosexuality. So what do we witness? Harry, stern with the other two because he's holding his liquor better, goes in and out of the dinky men's room while his pals suffer. He's ironically grim, even bitter, and, furthermore, he's jealous of the incidental chumminess formed by the others' sickness: Gus and Archie vomit, revomit, and, in laconic torpor, sink squatting to the floor so that the camera sees their heads at

toilet-bowl level.

Because they seem to wish to stay put, Harry gets annoyed, mocking them for wanting, as he says, "to be alone"—alone, that is, *as a pair*. This trifling casualty, to Harry, jolts the unity of the trio. Meanwhile, for this privy scene, Harry has appeared wearing a red plaid tam o' shanter borrowed from one of the female barflies. Is there any significance to this gratuitous hint of transvestism? It must remain ambiguous and yet the ambiguity could hardly be unintended. I think it calls something into question. What it calls into question is lodged in a general abiding state of question by the whole film: heterosexuality itself. For so deliberately heterosexual a film, *Husbands* is flagrant with homosexual innuendo. How committed are these characters?—how committed their creator and mover? One *can't* go "stag" the way Cassavetes has done here without letting in homosexuality by the back door, and once in, it's sure—in this cultural milieu anyway—to make straight for the men's room. A note of no little interest is that when, later, the three engage adjoining hotel rooms in London, the first thing they do, merely to rest, is to sit together on a bathroom floor in cozy proximity with the trite toilet bowl and the novel *bidet*. One might well ask: How stealthily anal can you get and still be staunchly hetero?

What is morally put in question, overtly and beyond doubt, is the marital, family, and community fate of Harry, Gus, and Archie as well as their special friendship pact, their private little clique. The latter is what principally concerns them as the film's action gets them deeper into the throes of their spree. Precisely, we have the paradox of *an intermale love problem among men who are heterosexuals in bed*. That should ring a famous mental bell: what traditionally is the platonic homosexuality of ancient Athens. One feature of the film's mystery becomes: How could this tradition show its nose in the citadel of modern, puritanic, aggressively hetero suburbia? But Cassavetes has caught on to that "nose" in just this region with all the intent purpose of a faggot casing something prodigious in the men's room.

Certainly I don't mean to brand *Husbands* as a homo charade. Quite the contrary! Cassavetes and the other two seem conscientiously heterosexual, both privately and in terms of the roles enacted here. But that's just it. Exactly the fictional terms chosen for these roles place heterosexuality in great danger, even in sore suspicion, of being a failed institution. That is why it's hard to understand a Betty Friedan's evangelical optimism over *Husbands*. Here we behold no toiling intellectuals or artists; no closet queens leading a double life; no fixtures on an analyst's couch suspended in puzzled bisexuality. In fact, it is just because Gazzara, Falk, and Cassavetes are convincing as real guys, not gay guys, that the film got through so penetratingly to the Women's Lib leader, Mrs. Friedan, who started her previously mentioned article by granting that *Husbands* "is a movie made by men about men's love for other men." Her whole thesis is disarmingly simple: the anguishing dilemma of Gus, Harry, and Archie exists not because *they* have failed as men, but because their *wives*, as women, have not risen to their gaping opportunity. Women, Mrs. Friedan explains, have not yet bridged the intersex gap by equalizing themselves with men.

Mrs. Friedan is not one who noticeably ponders; she does noticeably propagandize. But I am much more interested in the realities of the film than in Mrs. Friedan's highflown Lib rhetoric, which is sociologically motivated and oversimplified. It gives "husbands" all the credit and makes "wives" into reactionary backsliders who have no fem-lib intuitions, therefore no proper conception of sexual behavior. Yet why assume that Harry, Archie, and Gus have a proper conception of sexual behavior? Such is far from being self-evident. Their manners when they bed the bargirls in London are, to say the least, goofy and gaffish. The denizens of the worldly establishment where they land, the gambling casino, obviously peg them as the kookier type of American lout: a set of real gentlemen-goof balls. To be sure, a vast malady of modern marital life is indicated, however ambiguously, by *Husbands*. But ... just what is this malady? What do its actual symptoms convey? The Women's Lib viewpoint is neither a diagnosis nor a prognosis of it; it's only a pep talk about it. In utterly discounting homosexuality as a relevant factor among the Archies, Guses, and Harrys of real life, Women's Lib is writing off not only one common sense, perhaps plausible, solution

to drastic intermale love problems, but flouting psychoanalysis as a tested platform of personal help leading to either stable homosexuality or stable heterosexuality.

One guesses the nature of the Friedan strategy. To align the Lib viewpoint with an analyst's couch, or an equivalent, would be to grant the concrete possibility of unconscious homosexuality in the world's Guses, Archies, and Harrys, a concession which cannot be oriented to the heterosexual phase of the Women's Lib movement. Of course, this movement has a lesbian phase too, and in *Husbands*, so far as factual speculation goes, the fault in marital structures may be that the *wives* have unconscious homosexual tendencies. *Husbands* is much, and deliberately, devoted to appearances, surface phenomena. Mrs. Friedan, for one fem-lib exponent, overlooks that the three wives in the film are given very little show. Why is this? Their images do appear in snapshots, the widow of the dead man does act up at his funeral, and Harry's wife looks very commonly shrewdish, honestly hateful, and goes after him with a kitchen knife. This stinginess of script doesn't seem quite fair to the girls' side in this inherent War between the Men and the Women.

In *Husbands* we have a decided pro-male emotional commitment, whatever its terms. To me, the doggedness of Cassavetes and his colleagues in this regard verges on the morbidly sentimental. Perhaps, despite all the genuine warmheartedness, the genuine enough good-guyness, *Husbands* proves for Gazzara, Falk, and Cassavetes too much an occasion of condescension. Morbid sentimentality is one symptomatic superstructure of the restless unconscious, of deliberately suppressed impulses. I wouldn't say that Gus, Harry, and Archie, as conceived, are necessarily suppressing homosexual yearnings; no; but I would say that they are suppressing *something*. Could it be just plain, old, undenominated "sexuality"?—what Freud calls the polymorphous perverse as characteristic of the earliest stages of growth? The trio's behavior in London, where they climax their binge by bedding pickups from the gambling casino, displays not only symptoms of naïve American-guy boorishness, but also clear-cut puritan inhibitions and a kind of ingrained infantilism. Archie, as was noted,

is elected to illustrate the latter: he shrinks from tongue kissing as if it meant sexual dishonor. Is all this an account of *male* sexual maladroitness? Scene by scene, action by action, a prevalent atmosphere of built-in frustration is created as evidence against the sexual normalcy, adequacy, and adulthood of these three husbands. Their very squareness becomes, as identifiable sexual mores, the sign and proof of their own lack of erotic style—alas! their poor-dope ineligibility. Cassavetes's earnest emotion has ultrasentimentalized itself. Neither the framework of life nor the film's inner statistics give support, shape, and conviction to the moral empathy so obviously required of the spectator.

What has really happened to our heroes? Their trauma, bringing their basic dilemma nakedly into the open, has made them regress to gawky boyishness, artless adolescent emotiveness. Altogether, I should say, the three actors, through good will toward the husbands they play, endow them with a little too much natural dignity for their characters as written into the script and duly performed. These grown guys hit out at each other sometimes, like schoolboys on a drunken rampage—loving one moment, loathing the next. An *abiding* truth of it? They're still the old gang, they hope—they hope, they *hope*! This is what provides the film's tag line, which is meant, one supposes, to be the coup de grâce of pathos. It comes when the sobered-up, submissive Gus and Archie decide to leave the stubborn Harry—who has completely split—in London and go back to their homes in America as repentant, gift-bearing prodigals.

"What's he going to do without us?" they repeat to each other when about to enter their adjacent homes. This going back is an "act of separation" for them, too. It's the superclimax of the film's deep-planted sentimentality, What *can* Harry do without them? An excellent question: the inevitable question. But, man! Can I think of a lot of things—and all of them, whatever their sex, good! Betty Friedan would think only of one thing: Harry could become a manly adherent of Women's Lib. Indeed he could. But why not, I ask, a *gay* adherent? Or why not *both*? Or, to be quite thorough, neither? There are such things as manly gays, you know, as I trust I have sufficiently indicated elsewhere.

In this film, the Manly Gay, or Groovy Guy, remains a mystery because only a chimera— one of the possibilities living in the purely speculative realm. That's fiction for you! Even when interesting and valid, it may leave ends dangling. But the world ... the world ... the world is where ends are caught up, tied, untied, used and used till time itself is up. There's a mystery about that. But it isn't necessarily sexual. Only, sometimes, it *is* sexual. Definitely.

No. 92, September 1971

PASOLINI'S DECAMERON

Photographs by David Hamilton

The photographs on this and the following pages were taken by photographer David Hamilton during the shooting of Pier Paolo Pasolini's new film, *The Decameron*, based on Boccaccio's famous Renaissance classic. Pasolini, the Italian director of *Teorema* (1968) and *The Gospel According to St. Matthew* (1964), is especially noted for his strong visual sense; he has said that in many ways modern Italian cinema has picked up where Italian painting left off. For *The Gospel According to St. Matthew*, Pasolini himself has acknowledged Piero della Francesca as the visual inspiration. For his new film, the inspiration was the painter Giotto, a contemporary of Boccaccio's (therefore a reliable source for authentic costumes and props) who actually appears in one of his stories.

Written by Boccaccio between 1348 and 1358, *The Decameron* consists of one hundred prose tales adapted from traditional sources, but stunningly original in their ribald humor and earthy realism. For his film, Pasolini chose more than half a dozen of *The Decameron*'s Neapolitan tales, plus two others and a segment about the painter Giotto (acted by Pasolini himself), who becomes the director's chief means of imposing a unifying view on the teeming fourteenth-century world he portrays. Pasolini wrote his own screenplay in such a way that the individual stories flow into one another, and some of the characters reappear constantly in a stream of action. In the final scene, Giotto is hard at work on his great fresco cycle in the church of Santa Chiara; the faces on his paintings are those of the characters who appeared in earlier scenes. Pasolini has said that the figure of Giotto bears the same relationship to the characters (whom Giotto arranges into a balanced fresco) as he, Pasolini, himself does to the whole composition of the film, thus creating, in effect, a stage-within-a-stage technique.

In casting *The Decameron*, Pasolini avoided the use of professional actors as much as possible. Aside from three actors and himself, none of the people he chose for *The Decameron* had ever before appeared on the screen. The vast majority of the fifty-four actors seen in the film are ordinary people cast from the streets of Naples. Most of the scenes were shot on location in Naples, the only Italian city which Pasolini feels has remained relatively unaffected by modern civilization.

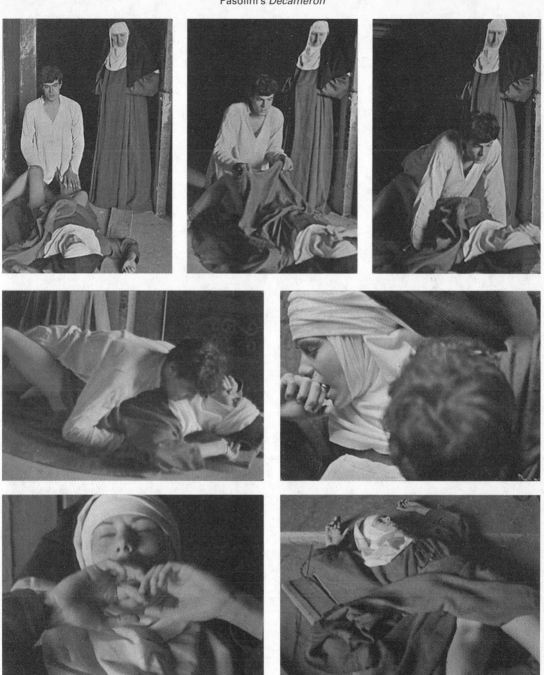

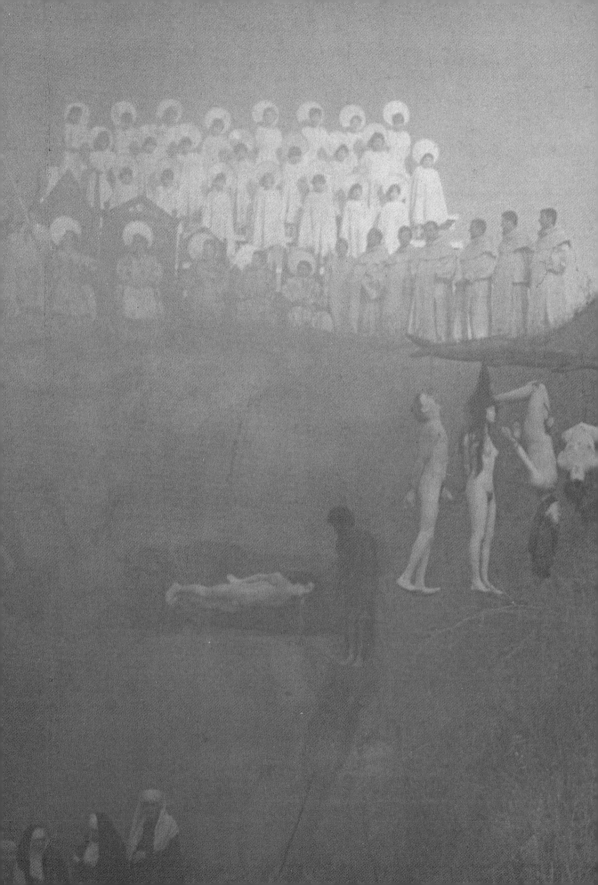

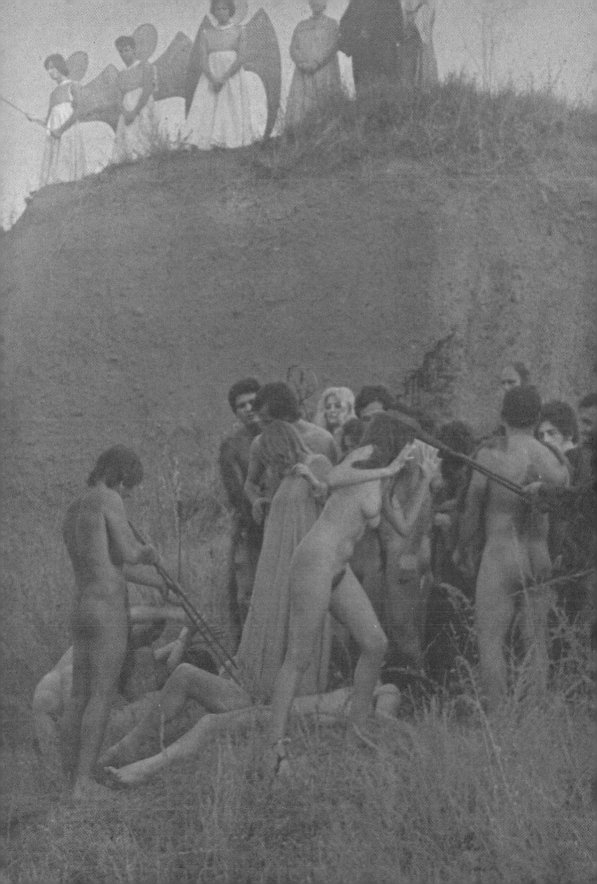

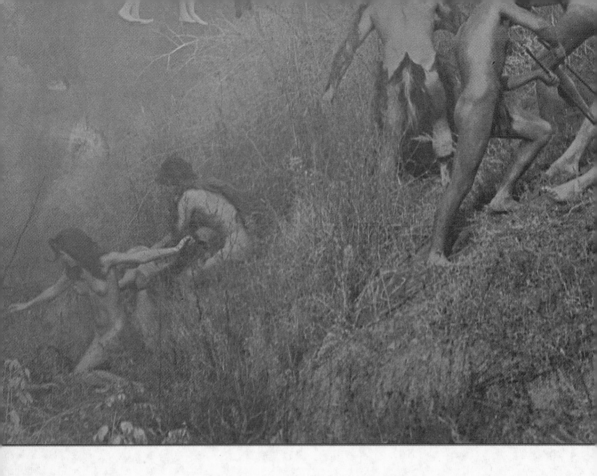

No. 91, July 1971

Film: *Freaks* and Fellini

Nat Hentoff

Finally, I've seen Tod Browning's 1932 movie, *Freaks*. Certain cultist critics had led me to expect art rather than an occasion for voyeurism; but the film's only interest is its accidents of nature. (Have you any idea how poignant a covey of gentle spirits with pointed heads can be? Or how menacing the speed of a dwarf? Or how disturbingly puzzling the sangfroid of a cigar-smoking man with a moustache and not much else—no legs, no arms, only a fraction of a trunk. How does he do certain things?)

The epilogue of *Freaks*, according to a French cinema dictionary, "is the most horrifying scene in the history of film." Hardly. We see cases like that coming home from Vietnam on the late news. Actually, nothing in the movie is deeply frightening, not even the freaks' pitiless hunting down, in darkness and rain, of a straight lady who had done them wrong and so would never, to say the least, be straight again. And yet the maker of *Freaks* also filmed *Dracula*, which, the first couple of times I saw it, did make me quite apprehensive of open windows at night.

I'd appreciate hearing from readers with knowledge of what went on during the filming of *Freaks*. My guess is that Browning thought the grotesque cast—and his story of vengeance—would be frightening enough. Or perhaps he was moralizing at us. (Andrew Sarris writes that "*Freaks* may be one of the most compassionate movies ever made." They, too, bleed even as you, I, and Shylock.) Since *Freaks* is back on the art house and college circuit, you can decide for yourself.

Unscared, and unfulfilled as a voyeur, I thought again of *Freaks* when I saw Fellini's *The Clowns*. (Made for Italian television, this eighty-eight-minute "diary of notes, profiles and sketches," as Fellini describes it, should be available for American theater bookings soon, perhaps by the time you read this.) Partly a journey back into Fellini's boyhood, and partly a documentary on what is left of the true clowns (with Fellini bumping in and out of that part of the film as himself), *The Clowns* is at least a half hour too long. But just as no evening with Duke Ellington's band is ever wasted, so any period of time with Fellini has its singular satisfactions. (Before *The Clowns* began to roll at New York's Museum of Modern Art, a solemn young man behind me said to an equally solemn

286

cineaste: "My impressions are still more literary than visual and that bothers me." Fellini is *so* visual, while also being mockingly literary, that perhaps the young man had a less difficult afternoon than usual. Anyway, whatever else happens in his films, Fellini does indeed exercise the visual imagination.)

When he was a boy, Fellini tells us in the movie, the clowns did not make him laugh—"those chalky faces with indecipherable expressions." But clowns remind him, now, of certain natural freaks from his hometown when he was a boy. And in a much too brief, utterly arresting section of the film, a series of extraordinarily distinctive faces and bodies reappear—a dwarf nun, always in a hurry ("She had to do *everything* because the saints trusted only her"); a fascist who has turned into human stone; a merry old retardate, who is primarily his private parts. Nothing that follows—including much more than I ever wanted to know about the history of circus clowns—is as evocative as the freak show. And its attraction is beyond voyeurism, although it starts with that.

Fellini, as in previous pictures, has transformed freaks into figures in fables. He likes to talk about films in terms of fable. ("I am profoundly attracted by anything," he told Pierre Kast in *Cahiers du cinéma*, "that tends to restore man to a stature that is more vast, more mysterious even, and more anguished, but in any case neither pacifying nor consoling. I prefer a dimension whose contours are lost in obscurity … to a little well-lighted construction that is a prisoner of very rigid walls.")

And that is where Tod Browning failed. He should have destroyed the rigid walls of his plot and let us find out more about the freaks themselves. In the fun-house mirror of what they might have chosen to let us see of their lives, each viewer might have seen something of himself—something mysterious perhaps, or anguished, or frightening. *Mon semblable, mon freak.*

The freaks—Browning's, Fellini's—will not get out of my head, and I'm beginning to think I know why. In his recent nonfiction horror story, "Friendly Fascism: A Model for America," Professor Bertram Gross, building on Ellul and Orwell, among others, details how we are moving toward a managed society which "rules by a faceless and widely dispersed complex of warfare-welfare-industrial-communications-police bureaucracies caught up in developing a new-style empire based on a technocratic ideology, a culture of alienation, multiple scapegoats, and competing control networks."

I saw a branch of that society in *Gimme Shelter*, the movie David and Albert Maysles and Charlotte Zwerin have made of the Rolling Stones at Altamont. There, the culture of alienation was so pronounced it was like watching a screen split into many parts. But the screen was not split. A girl strangles on her shock at the violence in front of her, while a young man, next to her, laughs. Standing beside Mick Jagger on stage, a bearded bad-tripper convulsively turns into The Werewolf of London (much more convincingly than Henry Hull did); and for too long a time, *nobody* pays any attention to him. Fat, naked women emerge from the seething mass, and submerge again. But unlike Fellini's freaks, they are past the age of fable. *They have no idea where they are.* And no one around them cares.

Certainly, with regard to both Altamont and the movie, *Gimme Shelter*, itself, there are multiple scapegoats. (A number of critics have accused the Maysles of a degree of exploitation only somewhat less than that of slave traders. A number of critics, this again proves, are unable to get outside their own very rigid walls even when the advance men from Armageddon come knocking at the door.)

As for competing control networks, again look at *Gimme Shelter*—Mick Jagger, the pleading Lucifer: ("Stop hurting each other; you don't have to"). The Stones' own security police, the Hell's Angels ("I'm no peace freak in any sense of the word!"). Lean, tough Grace Slick with her long, tapering fingers, suddenly not so tough and coolly patrician ("Pl-e-a-se be kind! Let's not keep fucking up! You got to keep your bodies off each other unless you're going to make love"). And the money men, the promoters, the lawyers, the hawkers of the counterculture ("Look at them, those kids, they're like lemmings!").

The new freaks (the word used in celebration, not as in old-time circuses), having been sanctified at Woodstock, turn to the devil, in sympathy and in need of satisfaction, at Altamont. But the devil cannot hold

them. ("Why are we fighting?" Jagger asks the air. "Why are we fighting? We don't want to fight. We need doctors down here now.")

The end of the movie: Jagger, in the film, looking at the film. Grimacing in disgust. At the freaks? At himself? And behind him, a Maysles, grinning. He knew what a hell of a good film he had.

Now, about those other freaks—the ones in Tod Browning's movie, the ones who keep circling and changing shape in Fellini's imagination. I wonder about them more and more. They can't lose themselves in a faceless, managed society, even if they wanted to. Of the traditional clowns, Fellini rightly says that only "vague, heartrending traces" of them remain in today's circuses. But the freaks, the true freaks, are still around. Somewhere. They're nature's freaks so they keep appearing from time to time. There are very few carnival sideshows anymore in which they can work. Where are they?

A student of mine at New York University says she knows where a sizable number of them lives. She's raising money to film a documentary about them. "They're very together people," she tells me. "I mean, they keep together, but most of them are very together inside their own heads. They have to be to keep on."

I hope she does make that picture. I have an imprecise but nonetheless strong feeling that the freaks—the true freaks—may have something to tell us.

Perverse Chic

Tom Seligson

Things fall apart, the centre cannot hold;
Mere anarchy is loosed upon the world,
The blood-dimmed tide is loosed, and
* everywhere*
The ceremony of innocence is drowned
 W.B. Yeats, *The Second Coming*

When I arrived at the premiere of Charles Henri Ford's new film, *Johnny Minotaur*, Paul Morrissey, the director of *Trash*, came running over to the cab. "You can't get in," he said. "They're already too crowded." I was surprised by the number of people who had come to see the film, but even more by who they were. Waiting in the congested lobby of the Bleecker Street Cinema, hoping to crowd into one of the few remaining seats, were Robert Gorham Davis and other academic critics I recognized from Columbia; Richard Lorber, Sol Yurick, and other radical writers; as well as Holly Woodlawn, the now short-haired Jackie Curtis, and other representatives of the Andy Warhol Theater of the Ridiculous Underground. There didn't seem to be any outward consistency to the crowd, either in appearance or position: German Prince Egon von und zu Fürstenberg

standing in tailor-made sport jacket at the head of the line talking with the radical Sid Bernard. I couldn't imagine what we all had in common, why the similar interest in the film. I knew Charles Henri Ford to be an early symbolist poet and long-time friend of Gertrude Stein, and I had come to the film because it was supposed to be colorfully erotic and perverse. The film and the party given afterwards were revealing about all who were there. And, more importantly, they showed what has happened to underground culture in America, how sated, jaded, and corrupted it has become.

Johnny Minotaur was preceded by Jean Genet's short but legendary *Chant d'amour*, and I, along with Fürstenberg and others, managed to get in and sprawl out on the theater floor just before the film was to begin.

Johnny Minotaur is a celebration of decadence, an indulgent personal fantasy of sex, spiritual death, and physical dissolution. Shot entirely in Crete where Ford spends his summer months, it consists ostensibly of a rambling montage about the making of a film, an ongoing examination into the "whys" and "hows" of its own creation. Even on this level

the fatigue and narcissism of the film are evident, its self-consciousness not appearing contrived, but merely acquiescent. As if to say, "What else is important?"—"What else is there to do?" *Johnny Minotaur*, like an old man masturbating, intent on himself, looks only within itself. And the vision itself is not new, the obsession with sex and the body that of a jaded voyeur. We see Nikos, a seventeen-year-old Greek boy whose dark eyebrows run across his face like a caterpillar. We see him playing like a child with some boys of his own age, then later, his tan, tightly muscled body brought closely into view, watch him simulate masturbation with a curved rubber cock and tell of his visits to local whorehouses, an enticing smile on his face. Ford, interviewed in the film about his interest in Nikos, claims he wants to adopt him, says he would "expose him to things" and "see about his education." He admits under questioning that he is also interested in Nikos sexually. Nikos is not the only body explored. Two teenage boys wrestle naked—one of them repulsively obese, the loose flesh around his stomach hanging over his cock—and give one another a soap shower afterwards. We see two boys fucking on a bed, a crowd of bronzed sun-worshipers on the beach, and in the scenes I found to be most erotic, two dancing sailors with hustler-smiles and tight baskets, their starch-white uniforms heightened by the dull light, and Ford's beautiful niece Shelley Scott (she's Ruth Ford's daughter by Zachary Scott) swinging nude in a hammock, her white breasts and triangle at her crotch set off by her dark-oiled tan. "It is tempting to be promiscuous in this part of the world," one of the film's many voices says. Again, it seems nothing else matters. Not the totalitarian dictatorship existing at that very moment in Greece. Not the world removed from beaches, beds, and still-sandy bodies. Nothing but self-absorption and the perpetual pursuit of pleasure.

There's a quiet desperation to *Johnny Minotaur*, apparent not only in its hedonism and indiscriminate search for satisfaction—in one scene a boy humps a pin-up of Jayne Mansfield and then fucks a melon he has carved a hole in—but also in its flirting concern with death. The whole Minotaur theme, introduced late in the film as if to give it some general meaning, only reinforces the sense of personal dissipation. The mythical significance of the Minotaur is related in stilted, academic tones, but Allen Ginsberg (he, along with Salvador Dalí, is among the narrating voices) explains its particular relevance to the film when he associates it with a kind of spiritual death and more precisely the dissolution of the body. "In killing the Minotaur," he says, "one kills oneself." Death is the ultimate stage of decadence in Ford's fantasy, and we see it when Johnny (a good-looking artist) paints a skeleton on the body of a naked boy, and even more vividly when one of Ford's young men symbolically castrates himself. Perhaps castration represents the fear of women in the homosexual vision—the Minotaur is a beast hiding in the cunt-like labyrinth—but it also may signify the total satiation and release of sexual need. A mask of the Minotaur is burned at

"At the JOHNNY MINOTAUR opening. Photographs left to right: Taylor Mead and Charles Henri Ford; Candy Darling; Mrs. William Buckley and Dotson Rader. 'I couldn't imagine what we all had in common, why the similar interest in the film. How ... corrupted our underground has become.'" From *Evergreen Review* No. 92, September 1971.

the end of the film, and in the same way that it approaches destruction do the characters in the film verge on the loss of themselves. *Johnny Minotaur* is about the abandonment of standards, the giving up of self to luxury, pleasure, and physical desire. It is revealing as a study in corruption.

The party given in Ford's honor after the film was most fitting. Held in a loft studio down in Soho, it was crowded with over a hundred guests, both the filmgoers and others. While a long line formed waiting for the beer and wine, young writers and filmmakers smoked grass and danced, and Charles Ford's friends huddled around to congratulate him. His actress-sister Ruth Ford and Mart Crowley, author of *The Boys in the Band.* A bubbling Sylvia Miles from *Midnight Cowboy*, and Hortense Calisher, the writer. Ronald Tavel, who has written some of the best underground theatrical drama, was standing next to a worn-looking Tennessee Williams, and Sid Bernard, whose gray hair was all madness, spoke to Williams about the film. "I only go to dirty films," Williams said smirking, "and I liked *Johnny Minotaur.*" But Williams was obviously pissed by Bernard's interruption because he was working at nagging out of Dotson Rader a hustler's price—forgetting a moment that he, Williams, had recently very publicly converted to Catholicism and turned his back on the things of the flesh, and forgetting, too, that he had a weak alcoholic heart—and Rader laughed because Tennessee had taken his novel (*Gov't Inspected Meat*) as fact. Holly Woodlawn, star of Warhol's *Trash*, kissed everyone hello, Prince Egon Fürstenberg smoked a drug called Angel Dust along with several pretty models, and Candy Darling danced wildly in her silver hot pants. It wasn't the mood or the action that made the party an appropriate aftermath for the film. Rather it was the combination of people. Curiously mixed to begin with, it became even more strangely diverse when Peter Glenville, the upper-class English director, arrived with Mrs. William F. Buckley, wearing a full-length dress. The underground, rebelling for the last fifteen years against the sterility and hypocrisy of straight culture, suddenly seemed terribly weak and flaccid. And, like one of the interviewers in Ford's film who yawned while watching a love scene between two boys, it seemed cynical and bored.

Mrs. Buckley talked to many of the radical writers there. Knowing that she was somehow not out of place at the party, that the underground had more in common with her class than with any other, and wanting to make a point out of it, she turned to Rader before walking away. Smiling, her eyes shining not unlike her husband's, she said, "Darling, there's one thing you should realize. When the Revolution comes, after they get me they'll be coming for you." *Après moi le deluge!*

No. 97, Summer 1973

A Transit to Narcissus

Norman Mailer

To pay one's $5.00 and join the full house at the Trans-Lux for the evening show of *Last Tango in Paris* is to be reminded once again that the planet is in a state of pullulation. The seasons accelerate. The snow which was falling in November had left by the first of March. Would our summer arrive at Easter and end with July? It is all that nuclear radiation, says every aficionado of the occult. And we pullulate. Like an ant hive beginning to feel the heat.

We know that Spengler's thousand-year metamorphosis from Culture to Civilization is gone, way gone, and the century required for a minor art to move from commencement to decadence is off the board. Whole fashions in film are born, thrive, and die in twenty-four months. Still! It is not that long since Pauline Kael declared to the readers of *The New Yorker* that the presentation of *Last Tango in Paris* at the New York Film Festival on October 14, 1972 was a date which "should become a landmark in movie history—comparable to May 29, 1913—the night *Le Sacre du printemps* was first performed—in music history," and then went on to explain that the newer work had "the same kind of hypnotic

excitement as the *Sacre*, the same primitive force, and the same jabbing, thrusting eroticism … Bertolucci and Brando have altered the face of an art form." Whatever could have been shown on screen to make Kael pop open for a film? "This must be the most powerfully erotic movie ever made, and it may turn out to be the most liberating movie ever made …" Could this be our own Lady Vinegar, our quintessential cruet? The first frigid of the film critics was treating us to her first public reception. Prophets of Baal, praise Kael! We had obviously no ordinary hour of cinema to contemplate.

Now, a half-year later, the movie is history, has all the palpability of the historic. Something just discernible has already happened to humankind as a result of it, or at least to that audience who are coming in to the Trans-Lux to see it. They are a crew. They have unexpected homogeneity for a movie audience, compose, indeed, so thin a sociological slice of New York and suburban sausage that you cannot be sure your own ticket isn't what was left for the toothpick, while the rest of the house has been bought at a bite. At the least, there is the same sense

of esthetic oppression one feels at a play when the house is filled with a theater party. So, too, is the audience at *Tango* an infarct of middle-class anal majesties—if Freud hadn't given us the clue, a reader of faces could decide all on his own that there had to be some social connection between sex, shit, power, violence, and money. But these middle-class faces have advanced their historical inch from the last time one has seen them. They are this much closer now to late Romans.

Whether matrons or young matrons, men or boys, they are *swingers*. The males have wife-swapper mustaches, the women are department-store boutique. It is as if everything recently and incongruously idealistic in the middle class has been used up in the years of resistance to the Vietnamese War—now, bring on the Caribbean! Amazing! In America, even the Jews have come to look like the French middle class, which is to say that the egocentricity of the Fascist mouth is on the national face. Perhaps it is the five-dollar admission, but this audience has an obvious obsession with sex as the confirmed core of a wealthy life. It is enough to make one ashamed of one's own obsession (although where would one delineate the difference?). Maybe it is that this audience, still in March, is suntanned, or at the least made up to look suntanned. The red and orange of their skins will match the famous "all uterine" colors—so termed by the set designer—of the interiors in *Last Tango*.

In the minute before the theater lights are down, what a tension is in the house. One might as well be in the crowd just before an important fight commences. It is years since one has watched a movie begin with such anticipation. And the tension holds as the projection starts. We see Brando and Schneider pass each other in the street. Since we have all been informed—by *Time* no less—we know they are going to take carnal occupation of each other, and very soon. The audience watches with anxiety as if it is also going to be in the act with someone new, and the heart (and, for some, the bowels) is in tremors between earthquake and expectation. Maria Schneider is so sexual a presence. None of the photographs has prepared anybody for this. Rare actresses, just a few, have flesh appeal. You feel as if you can touch them on the screen. Schneider

has nose appeal—you can smell her. She is every eighteen-year-old in a miniskirt and a maxi-coat who ever promenaded down Fifth Avenue in that inner arrogance which proclaims, "My cunt is my chariot."

We have no more than a few minutes to wait. She goes to look at an apartment for rent, Brando is already there. They have passed in the street, and by a telephone booth; now they are in an empty room. Abruptly Brando cashes the check Stanley Kowalski wrote for us twenty-five years ago—he fucks the heroine standing up. It solves the old snicker of how do you do it in a telephone booth?—he rips her panties open. In our new line of *New Yorker*-approved superlatives, it can be said that the cry of the fabric is the most thrilling sound to be heard in World Culture since the four opening notes of Beethoven's Fifth.[1] It is, in fact, a hell of a sound, small, but as precise as the flash of a match above a pile of combustibles, a way for the director to say, "As you may already have guessed from the way I established my opening, I am very good at movie-making, and I have a superb pair, Brando and Schneider—they are sexual heavyweights. Now I place my director's promise upon the material: you are going to be in for a grave and wondrous experience. We are going to get to the bottom of a man and a woman."

So intimates Bertolucci across the silence of that room, as Brando and Schneider, fully dressed, lurch, grab, connect, hump, scream, and are done in less than a minute, their orgasms coming on top of one another like trash cans tumbling down a hill. They fall to the floor, and fall apart. It is as if a hand grenade had gone off in their entrails. A marvelous scene, good as a passionate kiss in real life, then not so good because there has been no shot of Brando going up Schneider, and, since the audience has been watching in all the somber awe one would bring to the first row of a medical theater, it is like seeing an operation without the entrance of the surgeon's knife.

1 John Simon, as predictable in his critical reactions as a headwaiter, naturally thought "Last Tango" was part of the riffraff. Since it is Simon's temper to ignore details, he not only does not hear the panties tearing (some ears reside in the music of the spheres) but announces that Schneider, beasty abomination, is wearing none.

EVERGREEN REVIEW No. 97 VOLUME 17/SUMMER 1973

evergreen

SPECIAL CLOSEUP

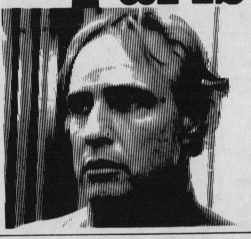

Last Tango in Paris

ALBERTO MORAVIA /ARRABAL
IRIS OWENS/DOTSON RADER
PARKER TYLER/NAT HENTOFF
NORMAN MAILER

ILLUSTRATED

Cover of special newsprint edition of *Evergreen Review* No. 97, Summer 1973.

One can go to any hardcore film and see fifty phalluses going in and out of as many vaginas in four hours (if anyone can be found who stayed four hours). There is a monumental abstractedness about hardcore. It is as if the more a player can function sexually before a camera, the less he is capable of offering any other expression. Finally, the sexual organs show more character than the actors' faces. One can read something of the working conditions of a life in some young girl's old and irritated cunt, one can even see triumphs of the human spirit—old and badly burned labia which still come to glisten with new life, capital! There are phalluses in porno whose distended veins speak of the integrity of the hardworking heart, but there is so little specific content in the faces! Hardcore lulls after it excites, and finally it puts the brain to sleep.

But Brando's real cock up Schneider's real vagina would have brought the history of film one huge march closer to the ultimate experience it has promised since its inception (which is to re-embody life). One can even see how, on opening night at the Film Festival, it did not matter so much. Not fully prepared for what was to come, the simulated sex must have quivered like real sex the first time out. Since then, we have been told the movie is great, so we are prepared to resist greatness, and have read in *Time* that Schneider said, "'We were never screwing onstage, I never felt any sexual attraction for him ... he's almost fifty, you know, and'—she runs her hand from her torso to her midriff, 'he's only beautiful to here!'"

So one watches differently. Yes, they *are* simulating. Yes, there is something slightly unnatural in the way they come and fall apart. It is too stylized, as if paying a few subtle respects to Kabuki. The real need for the real cock of Brando into the depths of the real actress might have been for those less exceptional times which would follow the film long after it opened and the reaction had set in.

Since *Tango* is, however, the first major film with a respectable budget, a superbly skilled young director, an altogether accomplished cameraman, and a great actor that is ready to do more than dabble in improvisation, indeed will enter heavily into such near-to-untried movie science, so the laws of improvisation are before us, and the first law

to recognize is that it is next to impossible to build on too false a base. The real problem in movie improvisation is to find some ending which is true to what has gone before and yet is sufficiently untrue to enable the actors to get out alive.

We will come back to that. It is, however, hardly time to let go of our synopsis. Real or simulated, opening night or months later, we know after five minutes that, at the least, we are in for a thoroughgoing study of a man and a woman, and the examination will be close. Brando rents the empty apartment; they will visit each other there every day. His name is Paul, hers is Jeanne, but they are not to learn each other's names yet. They are not to tell one another such things, he informs her. "We don't need names here ... we're going to forget everything we knew ... Everything outside this place is bullshit."

They are going to search for pleasure. We are back in the existential confrontation of the century. Two people are going to fuck in a room until they arrive at a transcendent recognition or some death of themselves. We are dealing not with a plot but with a theme that is open range for a hundred films. Indeed, we are face to face with the fundamental structure of porno—the difference is that we have a director who, by the measure of porno, is Eisenstein, and actors who are as gods. So the film takes up the simplest and richest of structures. To make love in an empty apartment, then return to a separate life. It is like every clandestine affair the audience has ever had, only more so—no names! Every personal demon will be scourged and the sex will obliterate the past! That is the huge sanction of anonymity. It is equal to a new life.

What powerful biographical details we learn, however, the instant they part. Paul's wife is a suicide. Just the night before, she has killed herself with a razor in a bathtub; the bathroom is before us, red as an abattoir. A sobbing chambermaid cleans it while she speaks in fear to Paul. It is not even certain whether the wife is a suicide or he has led her—that is almost not the point. It is the bloody death suspended above his life like a bleeding amputated existence—it is with that crimson torso between his eyes that he will make love on the following days.

Jeanne, in her turn, is about to be

married to a young TV director. She is the star in a videofilm he is making about French youth. She pouts, torments her fiancé, delights in herself, delights in the special idiocy of men. She can cuckold her young director to the roots of his eyes. She also delights in the violation she will make of her own bourgeois roots. In this TV film she makes within the movie she presents her biography to her fiancé's camera: she is the daughter of a dead army officer who was sufficiently racist to teach his dog to detect Arabs by smell. So she is well brought up—there are glimpses of a suburban villa on a small walled estate—it is nothing less than the concentrated family honor of the French army she will surrender when Brando proceeds a little later to bugger her.

These separate backgrounds divide the film as neatly between biography and fornication as those trick highball glasses which present a drawing of a man or a woman wearing clothes on the outside of the tumbler and nude on the inside. Each time Brando and Schneider leave the room, we learn more of their lives beyond the room; each time they come together, we are ready to go further. In addition, as if to enrich his theme for students of film, Bertolucci offers touches from the history of French cinema. The life preserver in *L'Atalante* appears by way of homage to Vigo, and Jean-Pierre Léaud of *The 400 Blows* is the TV director, the boy now fully grown. Something of the brooding echo of *Le Jour se Lève* and Arletty is also with us, that somber memory of Jean Gabin wandering along the wet docks in the dawn, waiting for the police to pick him up after he has murdered his beloved. It is as if we are to think not only of this film but of other sexual tragedies French cinema has brought us, until the sight of each gray and silent Paris street is ready to evoke the lost sound of the *Bal-musette* and the sad near-silent wash of the Seine. Nowhere as in Paris can doomed lovers succeed in passing sorrow, drop by drop, through the blood of the audience's heart.

Yet, as the film progresses with every skill in evidence, while Brando gives a performance which is unforgettable (and Schneider shows every promise of becoming a major star), as the historic buggeries and reamings are delivered, and the language breaks

through barriers not even yet erected—no general of censorship could know the armies of obscenity were so near!—as these shocks multiply, and lust goes up the steps to love, something bizarre happens to the film. It fails to explode. It is a warehouse of dynamite and yet something goes wrong with the blowup.

One leaves the theater bewildered. A fuse was never ignited. But where was it located? One looks to retrace the line of the story.

So we return to Paul trying to rise out of the bloody horizon of his wife's death. We even have some instinctive comprehension of how he must degrade his beautiful closet fuck; indeed, we are even given the precise detail that he will grease her ass with butter before he buggers her family pride. A scene or two later, he tricks forth her fear of him by dangling a dead rat which he offers to eat. "I'll save the asshole for you," he tells her. "Rat's asshole with mayonnaise."[2] (The audience roars—Brando knows audiences.) She is standing before him in a white wedding gown—she has run away from a TV camera crew which was getting ready to film her pop wedding. She has rushed to the apartment in the rain. Now shivering, but recovered from her fear, she tells him she has fallen in love with somebody. He tells her to take a hot bath, or she'll catch pneumonia, die, and all he'll get is "to fuck the dead rat."

No, she protests, she's in love.

"In ten years," says Brando, looking at her big breasts, "you're going to be playing soccer with your tits." But the thought of the other lover is grinding away at him. "Is he a good fucker?"

"Magnificent."

"You know, you're a jerk. 'Cause the best fucking you're going to get is right here in this apartment."

No, no, she tells him, the lover is wonderful, a mystery … different.

"A local pimp?"

"He could be. He looks it."

2 Dialogue quoted from Bernardo Bertolucci's "Last Tango in Paris." The final screenplay by Bernardo Bertolucci and Franco Arcalli (published by Delacorte Press and Delta Books in association with Quicksilver Books, Inc. Copyright © by United Artists Corporation MCMLXXII) was of course not entirely written in advance but was in part suggested to the actors, and in other places is a transcription after the fact of the full improvisation. In other words, a small but important part of the screenplay has in effect been written by Brando and Schneider.

She will never, he tells her, be able to find love until she goes "right up into the ass of death." He is one lover who is not afraid of metaphor. "Right up his ass—till you find a womb of fear. And then maybe you'll be able to find him."

"But I've found this man," says Jeanne. Metaphor has continued long enough for her. "He's you. You're that man."

In the old scripted films, such a phrase was plucked with a movie composer's chord. But this is improvisation. Brando's instant response is to tell her to get a scissors and cut the fingernails on her right hand. Two fingers will do. Put those fingers up his ass.

"*Quoi?*"

"Put your fingers up my ass, are you deaf? Go on."

No, he is not too sentimental. Love is never flowers, but farts and flowers. Plus every superlative test. So we see Brando's face before us—it is that tragic angelic mask of incommunicable anguish which has spoken to us across the years of his uncharted heroic depths. Now he is entering that gladiator's fundament again, and before us and before millions of faces yet to come she will be his surrogate bugger, real or simulated. What an entrance into the final images of history! He speaks to us with her body behind him, and her fingers just conceivably up him. "I'm going to get a pig," are the words which come out of his tragic face, "and I'm going to have a pig fuck you,"—yes, the touch on his hole has broken open one gorgon of a fantasy—"and I want the pig to vomit in your face. And I want you to swallow the vomit. You going to do that for me?"

"Yeah."

"Huh?"

"Yeah!"

"And I want the pig to die while,"—a profound pause—"while you're fucking him. And then you have to go behind, and I want you to smell the dying farts of the pig. Are you going to do that for me?"

"Yes, and more than that. And worse than before."

He has plighted a troth. In our year of the twentieth century how could we ever contract for love with less than five hundred pounds of pig shit? With his courage to give himself away, we finally can recognize the tragedy of his expression across these twenty-five years. That expression has been locked into the impossibility of ever communicating such a set of private thoughts through his beggar's art as an actor. Yet he has just done it. He is probably the only actor in the world who could have done it, but then nothing less than *The Godfather* would have enabled him to be in such a position. His metaphor is not filled with shit for too little. He has been living in it. Pus, poop, and Puzo. Now, Brando is scourging himself. He is taking the shit that is in him and leaving it on us. How the audience loves it. They have come to be covered. The world is not polluted for nothing. There is some profound twentieth-century malfunction in the elimination of waste. And Brando is on to it. A stroke of genius to have made a speech like that. Over and over, he is saying in this film that one only arrives at love by springing out of the shit in oneself.

So he seeks to void his eternal waste over the wife's suicide. He sits by her laid-out corpse in a grim hotel room, weeps, proceeds to wipe off the undertaker's lipstick, broods on her lover (who lives upstairs in the hotel), and going through some bend of the obscure, for now, offstage, he proceeds to remove his furniture from the new apartment. We realize this as we see Jeanne in the empty rooms. Paul has disappeared. He has ordered her to march into the farts of the pig for nothing. So she calls her TV director to look at the empty apartment—should they rent it? The profound practicality of the French bourgeoisie is squatting upon us. She appreciates the value of a few memories to offer sauce for her lean marriage. But the TV director must smell this old cooking for he takes off abruptly after telling her he will look for a better apartment.

Suddenly Brando is before her again on the street. Has he been waiting for her to appear? He looks rejuvenated. "It's over," she tells him. "It's over," he replies. "Then it begins again." He is in love with her. He reveals his biography, his dead wife, his unromantic details. "I've got a prostate like an Idaho potato but I'm still a good stick man ... I suppose if I hadn't met you I'd probably settle for a hard chair and a hemorrhoid." They move on to a hall, some near-mythical species of tango palace where a dance contest is taking place. They get drunk and go to the floor. Brando goes in for a squalid parody of the

tango. When they're removed by the judges, he flashes his bare ass. He is still mooning on *The Godfather*.

Now they sit down again and abruptly the love affair is terminated. Like that! She is bored with him. Something has happened. We do not know what. Is she a bourgeoise repelled by his flophouse? Or did his defacement of the tango injure some final nerve of upper French deportment! Too small a motive. Must we decide that sex without a mask is no longer love, or conclude upon reflection that no mask is more congenial to passion than to be without a name in the bed of a strange lover?

There are ten reasons why her love could end, but we know none of them. She merely wants to be rid of him. Deliver me from a fifty-year-old, may even be her only cry.

She tries to flee. He follows. He follows her on the Métro and all the way to her home. He climbs the spiraling stairs as she mounts in the slow elevator, he rams into her mother's apartment with her, breathless, chewing gum, leering. Now he is all cock. He is the memory of every good fuck he has given her. "This is the title shot, baby. We're going all the way."

She takes out her father's army pistol and shoots him. He murmurs, "Our children, our children, our children will remember ..." and staggers out to the balcony, looks at the Paris morning, takes out his chewing gum, fixes it carefully to the underside of the iron railing in a move which is pure broth of Brando— culture is a goat turd on the bust of Goethe— and dies. The angel with the tragic face slips off the screen. And proud Maria Schneider is suddenly and most unbelievably reduced to a twat copping a plea. "I don't know who he is," she mutters in her mind to the oncoming *flics*, "he followed me in the street, he tried to rape me, he is insane. I do not know his name. I do not know who he is. He wanted to rape me."

The film ends. The questions begin. We have been treated to more cinematic breakthrough than any film—at the least—since *I Am Curious (Yellow)*. In fact, we have gone much further. It is hard to think of any film which has taken a larger step. Yet if this is "the most powerful erotic film ever made" then sex is as Ex-Lax to the lady. For we have been given a bath in shit with no reward. The film, for all its power, has turned inside out by the end. We have been asked to follow two serious and more or less desperate lovers as they go through the locks of lust and defecation, through some modern species of homegrown cancer cure, if you will, and have put up with their modern depths—shit on the face of the beloved and find love!—only to discover a peculiar extortion in the esthetic. We have been taken on this tour down to the prostate big as an Idaho potato only to recognize that we never did get into an exploration of the catacombs of love, passion, infancy, sodomy, tenderness, and the breaking of emotional ice, instead only wandered from one onanist's oasis to another.

It is, however, a movie that has declared itself, by the power of its opening, as equal in experience to a great fuck, and so the measure of its success or failure is by the same sexual esthetic. Rarely has a film's value depended so much on the power or lack of power of its ending, even as a fuck which is full of promise is ready to be pinched by a poor end. So, in *Tango*, there is no gathering of forces for the conclusion, no whirling of sexual destinies (in this case, the audience and the actors) into the same funnel of becoming, no flying—out of the senses in pursuit of a new vision, no, just the full charge into a blank wall, a masturbator's spasm— came for the wrong reason and on the wrong thought—and one is thrown back, shattered, too ubiquitously electrified, and full of criticism for the immediate past. Now the recollected flaws of the film eat at the pleasure, even as the failed orgasm of a passionate act will call the character of the passion into question.

So the walk out of the theater is with anger. The film has been in reach of the greatness Kael has been talking about, but the achievement has only been partial. Like all executions less divine than their conception, *Tango* will give rise to mutations which are obliged to explore into dead ends. More esthetic pollution to come! The performance by Brando has been unique, historic, without compare—it is just possible, however, that it has gone entirely in the wrong direction. He has been like a lover who keeps telling consummate dirty jokes until the ravaged dawn when the girl will say, "Did you come to sing or to screw?" He has come with great honor

and dignity and exceptional courage to bare his soul. But in a solo. We are being given a fuck film without the fuck. It is like a Western without the horses.

Now the subtle sense of displacement which has hung over the movie is clear. There has been no particular high passion loose. Brando is so magnetic an actor, Schneider is so attractive, and the scenes are so intimate that we assume there is sexual glue between their parts, but it is our libido which has been boiling that glue and not the holy vibration of the actors on the screen. If Kael has had a sexual liberation with *Tango*, her libido is not alone—the audience is also getting their kicks by digging the snots of the celebrated. (Liberation for the Silent Majority may be not to attend a fuck but hear dirty jokes.) So the real thrill of *Tango* for $5.00 audiences becomes the peephole Brando offers us on Brando. They are there to hear a world-famous actor say in reply to "What strong arms you have,"

"The better to squeeze a fart out of you."
"What long nails you have."
"The better to scratch your ass with."
"Oh, what a lot of fur you have."
"The better to let your crabs hide in."
"Oh, what a long tongue you have."
"The better to stick in your rear, my dear."
"What's this for?"
"That's your happiness and my ha-penis."

Pandemonium of pleasure in the house. Who wants to watch an act of love when the ghost of Lenny Bruce is back? The crowd's joy is that a national celebrity is being obscene on screen. To measure the media magnetism of such an act, ask yourself how many hundreds of miles you'd night drive to hear Richard Nixon speak a line like: "We're just taking a flying fuck at a rolling doughnut," or "I went to the University of the Congo; studied whale fucking." Only liberal unregenerates would be so progressive as to say they would not drive a mile. No, one could start mass migrations if Nixon were to give Brando's pig-and-vomit address to the test of love.

Let us recognize the phenomenon. It would be so surrealistic an act, we could not pass Nixon by. Surrealism has become our objective correlative. A private glimpse of the great becomes the alchemy of the media, the fool's gold of the century of communication. In the age of television we know everything about the great but how they fart—the ass wind is, ergo, our trade wind. It is part of Brando's genius to recognize that the real interest of audiences is not in having him portray the tender passages and murderous storms of an unruly passion between a man and a woman, it is rather to be given a glimpse of his kinks. His kinks offer sympathetic vibration to their kinks. The affirmation of passion is that we rise from the swamps of our diapers—by whatever torturous route—to the cock and the cunt; it is the acme of the decadent to go from the first explosive bout of love in *Tango* down to the trimmed fingernails up his rectum.

Then follows the murder. Except it does not follow. It has been placed there from the beginning as the required ending in Bertolucci's mind; it has already been written into the screenplay first prepared with Trintignant and Dominique Sanda in mind. But complications and cast changes occurred. Sanda was pregnant, et cetera. Brando appeared, and Schneider was found. Yet the old ending is there. Since it did not grow convincingly out of the material in the original script, it appears, after Brando's improvisation, to be fortuitous altogether.

In the original screenplay, the dialogue is so general and the characters so vague that one has to assume Trintignant, Sanda, and Bertolucci planned to give us something extraordinary precisely by overcoming their pedestrian script. It is as if Bertolucci purposely left out whole trunklines of plot in order to discover them in the film. Only it was Brando who came along rather than Trintignant to make a particular character out of a general role, to "superimpose"—in accordance with Bertolucci's desire—his own character as Marlon Brando, as well as something of his life, and a good bit of his private obsessions. As he did that, however, the film moved away from whatever logic the script had originally possessed. For example, in the pre-Brando treatment, we would have been obliged to listen to the following:

Leon (alias Paul): *I make you die, you make me die, we're two murderers, each other's. But who succeeds in realizing this is twice the murderer. And that's the biggest pleasure: watching you die, watching you come out of yourself white-eyed, writhing, gasping, screaming so loud that it seems like*

the last time.

Oo la la! We are listening to a French intellectual. It is for good cause that Bertolucci wants to superimpose Brando's personality. Anything is preferable to Leon. And Brando most certainly obliterates this mouthy analysis, creates instead a character who is half noble and half a lout, an overlay drawn on transparent paper over his own image. Paul is an American, ex-boxer, ex-actor, ex-foreign correspondent, ex-adventurer, and now, with the death of his wife, ex-gigolo. He is that character and yet he is Brando even more. He is indeed so much like Brando that he does not quite fit the part of Paul—he talks just a little too much, and is a hint too distinguished to be the proprietor of a cheap flophouse at the age of fifty—let us say that at the least Paul is close enough to the magnetic field of Marlon for an audience to be unable to comprehend why Jeanne would be repelled if he has a flophouse. Who cares, if it is Marlon who invites you to live in a flophouse? On the other hand, he is also being Marlon the Difficult, Marlon the Indian from the Underworld, Marlon the shade of the alienated, Marlon the young star who when asked on his first trip to Hollywood what he would like in the way of personal attention and private creature comfort points to the nerve-jangled pet he has brought with him and says, "Get my monkey fucked."

Yes, he is studying whale-pronging in the Congo. He is the raucous out-of-phase voice of the prairie. Afterwards, contemplating the failure, we realize he has been shutting Schneider off. Like a master boxer with a hundred tricks, he has been out-acting her (with all his miser's hoard of actor's lore), has been stealing scenes from her while she is nude and he is fully dressed. What virtuosity! But it is unfair. She is brimming to let go. She wants to give the young performance of her life and he is tapping her out of position here, tricking her there—long after it is over we realize he does not want the fight of the century, but a hometown decision. He did not come to fuck but to shit. To defecate into the open-mouthed wonders of his audience and take his cancer cure in public. It is the fastest way! Grease up the kinks and bring in the pigs. We'd take a stockyard of pigs if he would get into what the movie is about, but he is off on the greatest solo of his life and

artists as young as Schneider and Bertolucci are hardly going to be able to stop him.

So he is our greatest actor, our noblest actor, and he is also our national lout. Could it be otherwise in America? Yet a huge rage stirs. He is so great. Can he not be even greater and go to the bottom of every fine actor's terror—which is to let go of the tricks which ring the person and enter the true arena of improvisation? It is there that the future of the film may exist, but we won't find out until a great actor makes the all-out effort.

But now we are back to the core of the failure in *Last Tango*. It is down in the difficulty of improvisation, in the recognition that improvisation which is anything less than the whole of a film is next to no improvisation. It has diminished from the dish to a spice which has been added to the dish (usually incorrectly). Bertolucci is a superb young director, adventurous, steeped in film culture, blessed with cinematic grace. He gives us a movie with high ambition, considerable risk, and a sense of the past. Yet he plows into the worst trap of improvisation—it is the simple refusal of filmmakers to come to grips with the implacable logic of the problem. One does not add improvisation to a script which is already written and with an ending that is locked up. No matter how agreeable the particular results be, it is still the entrance of tokenism into esthetics: "You blacks may work in this corporation, and are free to express yourselves provided you don't do anything a responsible white employee won't do." Stay true to the script. It reduces improvisation to a free play period in the middle of a strict curriculum.

The fundamental demand upon improvisation is that it begin with the film itself, which is to say that the idea for the film and the style of improvisation ought to come out of the same thought. From the beginning, improvisation must live in the premise rather than be added to it. The notion is not easy to grasp, and in fact is elusive. It may even be helpful to step away from *Tango* long enough to look at another example of possible improvisation. An indulgence is asked of the reader—to think about another kind of film altogether, a distracting hitch to the argument, but it may not be possible to bring focus to improvisation until we have other models before us.

So the following and imaginary film is offered: Orson Welles to play Churchill while Burton or Olivier does Beaverbrook in the week of Dunkirk. Let us assume we have the great good fortune to find these actors at the height of their powers, and have for *auteur* a filmmaker who is also a brilliant historian. To these beginnings, he adds a company of intelligent English actors and gives them the same historical material to study in order to provide a common denominator to everyone's knowledge. At this point the auteur and the company agree upon a few premises of plot. The auteur will offer specific situations. It will help if the episodes are sufficiently charged for the actors to lose their first fear of improvisation—which is that they must make up their lines.

Then a narrative action can begin to emerge out of the interplay of the characters, in much the way a good party turns out differently from the expectations of the hostess, and yet will develop out of her original conception. With a script, actors try to convince the writer, if he is present, to improve their lines—with improvisation they must work upon their wits. Why assume that the wits of this company of intelligent English actors will have less knowledge of manner and history than an overextended script writer trying to work up his remote conception of what Churchill and Beaverbrook might have been like? Why not assume Welles and Burton have a better idea? Are they not more likely to contain instinctive knowledge in their ambulating meat? Isn't the company, in its steeping as good British actors into their own history, able to reveal to us more of what such a week might have been like than any but the most inspired effort by a screenwriter?

We all contain the culture of our country in our unused acting skills. While Clark Gable could probably not have done an improvisation to save himself, since he had no working habits for that whatsoever, the suspicion still exists that Gable, if he had been able to permit himself, could have offered a few revelations on the life of Dwight D. Eisenhower, especially since Ike seems to have spent a good part of his life imitating Gable's voice. If violence can release love, improvisation can loose the unused culture of a film artist.

The argument is conceivably splendid, but we are talking about *historical* improvisation where the end is still known, and it is the details that are paramount. How simple (and intense) by comparison become the problems of doing a full improvisation for *Tango*. There we are given a fundamental situation, a spoiled girl about to be married, a distraught man whose wife is a suicide. The man and the girl are in the room to make love. We are back at the same beginning. But we can no longer project ahead! If the actors feel nothing for one another sexually, as Schneider has indicated in several interviews was the case for Brando and herself—she may even have been telling the truth—then no exciting improvisation is possible on sexual lines. (The improvisation would have to work on the consequences of a lack of attraction.) Actors do not have to feel great passion for one another in order to give a *frisson* to the audience, but enough attraction must exist to provide a live coal for improvisation to blow upon. Without some kernel of reality to an improvisation only a monster can continue to offer interesting lines. Once some little attraction is present, there is nothing exceptional about the continuation of the process. Most of us, given the umbilical relation of sex and drama, pump our psychic bellows on many a sensual spark, but then most affairs are, to one degree or another, improvisations, which is to say genuine in some part of their feeling and nicely acted for the rest. What separates professional actors from all of us amateur masses with our animal instinct for dissembling, our everyday acting, is the ability of the professional to take a small emotion in improvisation and go a long distance with it. In a scripted piece of work, some professionals need no relation to the other actor at all—they can, as Monroe once said, "wipe them out" and substitute another face. But improvisation depends on a continuing life since it exists in the no man's land between acting and uncalculated response; it is a *special* psychic state, at its best more real than the life to which one afterward returns, and so a special form of insanity. All acting is a corollary of insanity, but working from a script offers a highly controlled means of departing from one's own personality in order to enter another. (As well as the formal power to return.)

What makes improvisation fertile, luminous, frightening, and finally *wiggy* enough

for a professional like Gable to shun its practice is that the actor is doing two things at once—playing a fictitious role, while using real feelings, which then begin to serve (rather than the safety of the script) to stimulate him into successive new feelings and responses, until he is in danger of pushing into emotional terrain which is too far out of his control.

If we now examine *Tango* against this perspective, the risks (once there is real sexual attraction between the man and the woman) have to multiply. They are after all not simply playing themselves, but have rather inserted themselves into highly charged creatures, a violent man with a blood-filled horizon and a spoiled middle-class girl with buried tyrannies. How, as they continue this improvisation, can they avoid falling in love, or coming to hate one another? With good film actors, there is even every real danger that the presence of the camera crew will inflame them further since in every thespian is an orgiast screaming to get out.

So murder is the first dramatic reality between two such lovers in a continuing film of improvisation. They progress toward an end which is frighteningly open. The man may kill the woman, or the woman the man. For, as actors, they have also to face the shame of walking quietly away from one another, a small disaster when one is trying to build intensity, for such a quiet ending is equal to a lack of inspiration, a cowardice before the potential violence of the other. Improvisation is profoundly wicked when it works, it ups the ante, charges all dramatic potential, looks for collision. Yet what a dimension of dramatic exploration is also offered. For the actors can even fall in love, can truly fall in love, can go through a rite of passage together and so reach some locked crypt of the heart precisely because they have been photographed fucking together from every angle, and still—perhaps it is thereby—have found some private reserve of intimacy no one else can touch. Let the world watch. It is not near.

So the true improvisation which *Tango* called for should have moved forward each day on the actors' experience of the day before; it would thereby have offered more esthetic excitement. Because of its danger! There is a very small line in the last recognitions of the psyche between real bullets in a

gun, and blanks. The madness of improvisation is such, the intensities of the will become such, that one hardly dares to fire a blank at the other actor. What if he or she is so carried away by excitement that they will refuse to fall? Bring on the real bullet, then. Bite on it.

Of course, literal murder is hardly the inevitable denouement in improvisation. But it is in the private design of each actor's paranoia. Pushed further together in improvisation than actors have gone before, who knows what literal risks might finally have been taken. That is probably why Brando chose to play a buffoon at a very high level and thereby also choose to put Schneider down. Finally we laugh at those full and lovely tits which will be good only for playing soccer (and she will choose to lose thirty pounds after the film is done—a whole loss of thirty pounds of pulchritude). Brando with his immense paranoia (it is hardly unjustified) may have concluded like many an adventurous artist before him that he was adventuring far enough. No need for more.

Still he lost an opportunity for his immense talent. If he has been our first actor for decades, it is because he has given us, from the season he arrived in *Streetcar*, a greater sense of improvisation than any other professional actor. Sometimes he seemed the only player alive who knew how to suggest that he was about to say something more valuable than what he did say. It gave him force. The lines other people had written for him came out of his mouth like the final compromise life had offered for five better thoughts. He seemed to have a charged subtext. It was as if, whenever requested in other films to say script lines so bad as "I make you die, you make me die, we're two murderers, each other's," the subtext—the emotion of the words he was using behind the words—became "I want the pig to vomit in your face." That was what gave an unruly, all but uncontrolled, and smoldering air of menace to all he did.

Now, in *Tango*, he had nothing beneath the script, for his previous subtext was the script. So he appeared to us as a man orating, not improvising. But then a long speech can hardly be an improvisation if its line of action is able to go nowhere but back into the prearranged structures of the plot. It is like the aside of a politician before he returns to that prepared text of which the press already

has got copies. So our interest moved away from the possibilities of the film and was spent on the man himself, his nobility, and his loutishness. But his nature was finally a less interesting question than it should have been, and weeks would go by before one could forgive Bertolucci for the esthetic cacophony of the end.

Still, one could forgive. For, finally, Bertolucci has given us a failure worth a hundred films like *The Godfather*. Regardless of all its solos, failed majesties, and off-the-mark horrors, even as a highly imperfect adventure, it is still the best adventure in film to be seen in this pullulating year. And it will open an abyss for Bertolucci. The rest of his life must now be an improvisation. Doubtless he is bold enough to live with that. For he begins *Last Tango* with Brando muttering two words one can hardly hear. They are: Fuck God.

The unmanageable in oneself must now offer advice. If Bertolucci is going to fuck God, let him really give the fuck. Then we may all know a little more of what God is willing or unwilling to forgive. That is, unless God is old and has indeed forgot, and we are merely out on a sea of human anality, a collective Faust deprived of Mephisto and turning to shit. The choice, of course, is small. Willy-nilly, we push on in every art and every technology toward the re-embodiment of the creation. It is doubtless a venture more demented than coupling with the pig, but it is our venture, our white whale, and by it or with it shall we be seduced. On to the Congo with sex, technology, and the inflamed lividities of human will.

Sex and Politics

That's what great filmmaking is all about today. And Grove Press has 12 great films to prove it.

A sexy Yugoslav revolutionary, a blonde Czech model, a dazzling French double-agent, an exquisite Greek turned rebel. All yours and more at the Grove Press International Film Festival, beginning March 16th.

Twelve films by the new, revolutionary filmmakers from Europe, Africa, Asia, and South America. The filmmakers who are smashing old traditions and taboos to create a cinema spawned by a new era of political ferment and sexual honesty. These are the filmmakers who won acclaim at Cannes, Venice, and Berlin.

For as little as $1.15 per ticket you can fight the Greek junta, ride with the Brazilian "cangaceiros," help the beautiful French spy make Mister Freedom's "big one" fizzle, join the Hungarian anarchists, see the reality of Japan, step into a Czech art class, see the end of a priest. And lots more. Twelve films that passionately search for new answers to the old questions of the good life. Some with humor, irony or eroticism, others with mystery, poetry, and allegory.

WINTER WIND
HUNGARY-FRANCE

a film by Miklos Jancso
Produced by Marquise Film (Paris) and Mafilm Studio No. 1 (Budapest)

1969 Venice Film Festival.

"An admirable, audacious, beautiful film."
—Le Nouvel Observateur

"A balletic look at dialectics in violence...Jancso is one of the more remarkable filmmakers."—Variety

Eastmancolor,
Cinemascope.
Beginning March 15th.

THE MOST BEAUTIFUL AGE
CZECHOSLOVAKIA

a film by Jaroslav Papousek
Produced by Barrandov Film Studio, Prague

1969 Cannes Film Festival and 1969 Sorrento Film Encounter.

"Beautiful, full of human understanding, very funny. Full of gags and moments of virile and robust humor."
—Jeune Cinéma

Beginning March 22nd.

MANDABI
SENEGAL—FRANCE

a film by Ousmane Sembene
Produced by Domireve (Dakar) and C.F.F.P. (Paris)

1968 Venice Film Festival, 1969 New York Film Festival, 1969 San Francisco International Film Festival, and 1969 London Film Festival.

"A wonderful, real comedy with fine master and a new kind of film. A masterpiece that could justify any film festival!"—Kino

Eastmancolor.
Beginning March 26th.

MISTER FREEDOM
FRANCE

a film by William Klein
Produced by O.P.E.R.A., Paris

1968 Avignon Film Festival.

"A wild farce, it crackles, roars, gushes...A madness that will amuse many, disturb others. The farce is savage, the parody virulent."—France-Soir

"A masterpiece."
—Le Monde

Color.
Beginning March 30th.

Antonio Das Mortes
BRAZIL

a film by Glauber Rocha
Produced by Claude-Antoine, Mapa, Glauber Rocha

Best Director, 1969 Cannes Film Festival. Prix Luis Buñuel, International Critics Award, and Prix de l'Association Internationale des Cinemas d'Art et Essai.

"An astonishing, inspired, free, rich, lyrical film. Restores to cinema its grandeur and its magic."
—Le Monde

Eastmancolor.
Beginning April 2nd.

DESTROY, SHE SAID?
FRANCE

a film by Marguerite Duras
Produced by Ancinex/Madeleine Films, Paris.

1969 New York Film Festival and 1969 London Film Festival.

"Explodes into life. One is hypnotically captive until the end...Dramatic, haunting."—The Guardian (Manchester)

Beginning April 6th.

"BOY"
JAPAN

a film by Nagise Oshima
Produced by Sozosha–A.T.G., Tokyo

1969 Cannes Film Festival, 1969 New York Film Festival, 1969 San Francisco International Film Festival, 1969 Venice Film Festival, and 1969 London Film Festival.

"Extraordinary. Weird, beautiful, and terrifying."
—The Observer (London)

Eastmancolor,
Cinemascope.
Beginning April 9th.

THE MAN WHO LIES
FRANCE—CZECHOSLOVAKIA

a film by Alain Robbe-Grillet
Produced by Como Films-Lux C.C.F. (Paris), Ceskoslovensky Film (Bratislava)

1969 Berlin Film Festival. Jean-Louis Trintignant, the Best Actor award, Berlin Film Festival.

"Robbe-Grillet loves to keep us from seeing some things. Not to blind us. But so we may see better. Into ourselves."—L'Express

Beginning April 13th.

END OF A PRIEST
CZECHOSLOVAKIA

a film by Evald Schorm
Produced by Barrandov Film Studio, Prague

1969 Cannes Film Festival and the 1969 Sorrento Film Encounter.

"A sinister farce in which the seemingly comic elements shock and disturb."
—Le Monde

Beginning April 16th.

THANOS & DESPINA
GREECE

a film by Nico Papatakis
Produced by Lenox Films, Paris

1968 Cannes Film Festival.

"A truly anarchistic film such as one finds only once in a decade...stupefying."
—Le Nouvel Observateur

"A violent and passionate tableau. A great film!"
—L'Humanité

Beginning April 20th.

EARLY WORKS
YUGOSLAVIA

a film by Zelimir Zilnik
Produced by Avala Film (Belgrade) and Neoplanta Film (Novi Sad)

"Golden Bear" of the 1969 Berlin Film Festival. New Yugoslav Cinema program of the Museum of Modern Art, New York City.

"Gives us the revolutionary flame that the young Western cinema is incapable of giving."—Combat

Beginning April 23rd.

THE JOKE
CZECHOSLOVAKIA

a film by Jaromil Jires
Produced by Barrandov Film Studio, Prague

International Critics Award at the 1969 New Delhi International Film Festival, 1969 Cannes Film Festival, 1969 New York Film Festival, 1969 Sorrento Film Encounter, and 1969 London Film Festival.

"A chilling, scouring film... Transcends boundaries of nations and time."
—Nat Hentoff

Beginning April 27th.

Subscribe now to the Grove Press International Film Festival and reserve your seat for each of these twelve great films at their American Premiere and pay only half the regular ticket price (you'd have to pay $2.50 if you bought the ticket at the box office). You pay $17.50 for one subscription of 12 tickets or $30.00 for two—a saving of $30.00 over the regular box office prices. And you get these other benefits.

Plus a thirteenth ticket to a "special event" with each subscription. A premiere of a major feature film to be announced.

Plus a free 96-page Festival Book crammed with articles, interviews with the directors, and photographs.

Plus the privilege given only to subscribers to reserve seats in advance by calling the box office the day before you wish to attend.

Plus total flexibility! You can attend any film in the Festival at any of these three participating theatres at any time: The Bleecker Street Evergreen Cinema (144 Bleecker Street), the Evergreen 11th Street Theatre (53 East 11th Street) and the Cinema Village (22 East 12th Street).

Plus the right to use the tickets in any way you see fit. Bring eleven friends to one showing; see all twelve yourself; bring one friend to six performances. Consider the possibilities!

Grove Press International Film Festival

Grove Press
International Film Festival
214 Mercer Street
N.Y., N.Y. 10012

Gentlemen:

Please send me □ one subscription $17.50
□ two subscriptions $30.00
(check one)

total $_____

NAME_____

ADDRESS_____

CITY_____ STATE_____ ZIP_____

PLEASE ENCLOSE CHECK OR MONEY ORDER.
NYT 3/1

APPENDIX

The Evergreen Theaters Selected Screenings

Compiled and annotated by Matt Peterson

The Evergreen Theater*
53 East 11th Street

1968

17 January	*Passages from Finnegans Wake* (Mary Ellen Bute)
1 April	The Films of Peter Weiss†
8 April	Now Cinema!‡
1 May	*A Woman is a Woman* & *Alphaville* (Jean-Luc Godard)
3 May	*Woman in the Dunes* (Hiroshi Teshigahara) & *Bandits of Orgosolo* (Vittorio De Seta)
6 May	*Variety Lights* (Federico Fellini) & *Volpone* (Maurice Tourneur)
8 May	*The White Sheik* (Federico Fellini) & *The Love Game* (Philippe de Broca)
10 May	*Sweet and Sour* (Jacques Baratier) & *Italian Straw Hat* (René Clair)
13 May	*Bay of Angels* (Jacques Demy) & *Banana Peel* (Marcel Ophüls)
21 May	*I, a Man* (Andy Warhol) & Underground Newsreel
8 July	[RENOVATION]
16 September	*Warrendale* (Allan King)
18 November	*Beyond the Law* (Norman Mailer) & *End of a Revolution* (Brian Moser)
27 December	*Weekend* (Jean-Luc Godard) & *Zuckerkandl!* (John Hubley)

1969

10 March	*I Am Curious (Yellow)* (Vilgot Sjöman)
14 November	*Terry Whitmore, for Example* (Bill Brodie) & *Thank You Mask Man* (Jeff Hale)
28 November	*I Am Curious (Yellow)*

1970

16 March	*Winter Wind* (Miklós Jancsó) & *Naughty Nurse* (Paul Bartel)
6 April	*Destroy, She Said* (Marguerite Duras)
13 April	*The Man Who Lies* (Alain Robbe-Grillet)
20 April	*End of a Priest* (Evald Schorm)
30 April	*Mandabi* (Ousmane Sembène)
7 May	*The Man Who Lies* & *L'Immortelle* (Alain Robbe-Grillet)
15 May	*The Joke* (Jaromil Jireš) & *The Most Beautiful Age* (Jaroslav Papoušek)
20 May	*I Am Curious (Blue)* (Vilgot Sjöman)
16 June	*Censorship in Denmark: A New Approach* (Alex de Renzy)
21 August	*Freedom to Love* (Eberhard and Phyllis Kronhausen)
15 September	*Quiet Days in Clichy* (Jens Jørgen Thorsen)
20 December	*Be Glad for the Song Has No Ending* (Peter Neal) & *Blues Accordin' to Lightnin' Hopkins* (Les Blank & Skip Gerson)

1972[§]

14 February *Pete Seeger: A Song and a Stone* (Robert Elfstrom)

The Evergreen Bleecker Street Cinema[¶]
144 Bleecker Street

1969

31 October *L'Immortelle* & *Film* (Alan Schneider)
21 November *Float Like a Butterfly, Sting Like a Bee* (William Klein)
28 November *Duet for Cannibals* (Susan Sontag) & *The Bed* (James Broughton)
17 December *The Funniest Man in the World* (Vernon P. Becker)

1970

3 January *The Queen* (Frank Simon) & *Weekend*
7 January *Passages from Finnegans Wake* & *Film*
14 January *Warrendale* & *Moonbird* (John and Faith Hubley)
21 January *L'Immortelle* & *Duet for Cannibals*
28 January *Will the Real Norman Mailer Please Stand Up?* (Dick Fontaine)
 & *Float Like a Butterfly, Sting Like a Bee*
4 February *Cat and Mouse* (Hansjürgen Pohland)
18 February *I Am Curious (Yellow)*
16 March *Winter Wind*
26 March *Mandabi* & *Minitaurus* (Peter Schneider)
6 April *Antonio das Mortes* (Glauber Rocha) & *Paint* (Norman Gollin)
23 April *Early Works* (Želimir Žilnik)
7 May *Antonio das Mortes* & *Mister Freedom* (William Klein)
21 May *See You at Mao* & *Pravda* (Jean-Luc Godard)
6 June *Monterey Pop* & *Don't Look Back* (D.A. Pennebaker)
1 July *Belle de jour* (Luis Buñuel) & *Dear John* (Lars-Magnus Lindgren)
9 July *Animal Farm* (Joy Batchelor and John Halas) & *The War Game*
 (Peter Watkins)

[*] Alternately known as the Evergreen Eleventh Street Theater and the Evergreen Cinema.

[†] The listing doesn't specify which of Peter Weiss' films were screened, but Grove Press distributed his *Faces in the Shadows*, *Hallucinations*, *Interplay*, *The Mirage*, *Relief*, and *The Studio of Dr. Faust*.

[‡] A program of short films which included Eberhard and Phyllis Kronhausen's *Psychomontage*, Roberta Hodes' *The Game*, Alan Schneider's *Film*, Bruce Torbet's *Super Artist*, Andy Warhol, John Taylor and Lebert Bethune's *Malcolm X: Struggle for Freedom*, and Yukio Mishima's *Rite of Love and Death*.

[§] In the Spring and Summer of 1971 Evergreen leased the theater to an outfit which operated as the Soho Theatre, a showcase for all-male pornographic films. I have been unable to determine if there were additional Evergreen programs between 20 December 1970 and the Evergreen Cinema revival on 14 February 1972.

[¶] Evergreen leased the Bleecker Street Cinema from its founder and owner, filmmaker Lionel Rogosin (1924–2000). The theater returned to Rogosin's control after the 9 July 1970 program.

The Grove Press Film Division

Research and annotations by Matt Peterson

Feature Films

Antonio das Mortes (Glauber Rocha)
Beginning to End (Lewis Freedman)
Beyond the Law (Norman Mailer)
Boy (Nagisa Oshima)
Cat and Mouse (Hansjürgen Pohland)
Chafed Elbows (Robert Downey)
China! (Felix Greene)
Come Back, Africa (Lionel Rogosin)
Danish Blue (Gabriel Axel)
Death by Hanging (Nagisa Oshima)
Delusion of the Fury (Madeline Tourtelot)
Destroy, She Said (Marguerite Duras)
Diamonds of the Night (Jan Němec)
Diary of a Shinjuku Burglar (Nagisa Oshima)
Duet for Cannibals (Susan Sontag)
Early Works (Želimir Žilnik)
End of a Priest (Evald Schorm)
Events (Fred Baker)
Float Like a Butterfly, Sting Like a Bee
 (William Klein)
Freedom to Love (Eberhard & Phyllis
 Kronhausen)
Funeral Parade of Roses (Toshio Matsumoto)
The Funniest Man in the World
(Vernon P. Becker)
The General (Clyde Bruckman & Buster
 Keaton)
Good Times, Wonderful Times (Lionel
 Rogosin)
The Great Wall of China (Joel Tuber)
I Am Curious (Blue) (Vilgot Sjöman)
I Am Curious (Yellow) (Vilgot Sjöman)
Image, Flesh and Voice (Ed Emshwiller)
L'Immortelle (Alain Robbe-Grillet)
Inner Revolution (Gil W. Toff)
Innocence Unprotected (Dušan Makavejev)
Inside North Vietnam (Felix Greene)
The Joke (Jaromil Jireš)
Keeping Things Whole (Walter Ungerer)
Lenny Bruce Performance Film (John
 Magnuson)
The Lesson (Glenn Jordan)

M (Fritz Lang)
Man is Not a Bird (Dušan Makavejev)
The Man Who Lies (Alain Robbe-Grillet)
Mandabi (Ousmane Sembène)
Mingus (Thomas Reichman)
The Mirage (Peter Weiss)
Mister Freedom (William Klein)
The Most Beautiful Age (Jaroslav Papoušek)
Narcissus (Willard Maas & Ben Moore)
No More Excuses (Robert Downey)
No More Fleeing (Herbert Vesely)
On the Bowery (Lionel Rogosin)
Passages from Finnegans Wake
 (Mary Ellen Bute)
The Picture (Lucian Pintilie)
Pinter People (Gerald Potterton)
The Police (Fielder Cook)
Pravda (Jean-Luc Godard)
The Queen (Frank Simon)
Quiet Days in Clichy (Jens Jørgen Thorsen)
The Rise and Fall of the CIA
 (Mike Beckham, Gavin MacFayden,
 Allan Segal)
See You at Mao (Jean-Luc Godard)
Something Different (Věra Chytilová)
Thanos and Despina (Nico Papatakis)
Titicut Follies (Frederick Wiseman)
Tonight for Sure (Francis Ford Coppola)
Transport from Paradise (Zbyněk Brynych)
Troublemakers (Norman Fruchter & Robert
 Machover)
Vladimir and Rosa (Jean-Luc Godard)
Waiting for Godot (Alan Schneider)
Warrendale (Allan King)
Weekend (Jean-Luc Godard)
*Will the Real Norman Mailer Please Stand
 Up?* (Dick Fontaine)
Winter Wind (Miklós Jancsó)
You're Lying (Vilgot Sjöman)

Selected Short Films

A Trip to the Moon (George Méliès)
A Well Spent Life (Les Blank & Skip Gerson)
An Award Winning Film (Timothy Sheehan)
Andy Warhol (Marie Menken)
The Bed (James Broughton)
Black Panthers: A Report (Agnès Varda)
The Blood of the Beasts (Georges Franju)
The Blues Accordin' to Lightnin' Hopkins (Les Blank & Skip Gerson)
Children in Conflict (Allan King)
The Cry of Jazz (Edward Bland)
Eh Joe (Alan Schneider)
End of a Revolution (Brian Moser)
The Fall of Byzantium (Maurice Pialat)
Film (Alan Schneider)
Flaming Creatures (Jack Smith)
For Life, Against the War (Week of the Angry Arts)
Fugs (Ed English)
The Funeral of Jan Palach (Anonymous)
Fuses (Carolee Schneemann)
The Game (Roberta Hodes)
The Goad (Paul Joyce)
Godard in America (Ralph Thanhauser)
The Great Train Robbery (Edwin S. Porter)
Guernica (Alain Resnais and Robert Hessens)
Interviews with My Lai Veterans (Joseph Strick)
Life and Death of 9413, a Hollywood Extra (Robert Florey & Slavko Vorkapich)
Malcolm X: Struggle for Freedom (Lebert Bethune & John Taylor)

Malcolm X Speaks (Charles Hobson & Gil Noble)
Minitaurus (Peter Schneider)
Moonbird (John and Faith Hubley)
N.U. (Michelangelo Antonioni)
Naughty Nurse (Paul Bartel)
O Dreamland (Lindsay Anderson)
L'Opéra-mouffe (Agnès Varda)
Operation Abolition (HUAC)
Operation Correction (ACLU)
Pacific 231 (Jean Mitry)
Paint (Norman Gollin)
Peepshow (Ken Russell)
The Private Life of a Cat (Alexander Hammid and Maya Deren)
Psychomontage (Eberhard & Phyllis Kronhausen)
Rite of Love and Death (Yukio Mishima)
Shipyard (Paul Rotha)
Some Won't Go (Gil W. Toff)
Spend It All (Les Blank & Skip Gerson)
Student Demonstrations (Želimir Žilnik)
Sunlight (Melvin Van Peebles)
Super Artist, Andy Warhol (Bruce Torbet)
Thank You Mask Man (Jeff Hale)
Three Pickup Men for Herrick (Melvin Van Peebles)
Un Chant d'amour (Jean Genet)
Wavelength (Michael Snow)
Weegee's New York (Weegee)
The World of Paul Delvaux (Henri Storck)
Zuckerkandl! (John Hubley)

*The Grove Press film catalog also included the Cinema 16 Film Library, featuring the films of Stan Brakhage, Robert Breer, James Broughton, Bruce Conner, Carmen D'Avino, Maya Deren, Ed Emshwiller, Peter Kubelka, Willard Maas, Norman McLaren, Marie Menken, Sidney Peterson, Aldo Tambellini, Madeline Tourtelot, Stan VanDerBeek, and Peter Weiss.

Notes on the Contributors

Sidney Bernard

Editor of the *Literary Times* from 1963 to 1967, Bernard penned numerous left-wing articles for the *New York Herald Tribune*, the *National Observer*, the *Nation*, and other publications. A collection of his writing was published as *This Way to the Apocalypse: The 1960's* (1969).

Helen & Tom Bishop

Helen Gary Bishop was an actress, documentary producer, author, and translator; for Grove Press, she translated Eugène Ionesco's *Killing Game* (1974) and *A Hell of a Mess* (1975) and, with her husband Tom, Fernando Arrabal's *Garden of Delights* (1974). A wartime émigré from Vienna via Paris, Tom Bishop has taught at New York University since 1956, where he is currently Florence Gould Professor of French Literature and Director of the Center for French Civilization and Culture. His published works include *Pirandello and the French Theater* (1960) and *From the Left Bank: Reflections on the Modern French Theater and the Novel* (1997).

Stefan S. Brecht

Son of playwright Bertolt Brecht, German-born poet and critic Stefan Brecht moved to New York in 1966, where he began writing on the city's alternative theater scene. His publications include *The Theatre of Visions: Robert Wilson* (1972) and *Queer Theatre* (1978).

Kent Carroll

Kent Carroll joined Grove Press in 1969, and served as Editorial Director from 1973 to 1980, in addition to working extensively on Grove's film concerns; at Grove, Carroll acquired and published the illustrated script of George Lucas's film *American Graffiti*, Gilbert Sorrentino's *Mulligan Stew*, John Kennedy Toole's *A Confederacy of Dunces*, and other titles. In 1981 he founded Carroll & Graf Publishers, which he ran until 2001. He is currently Publisher-at-Large for Europa Editions.

L.M. Kit Carson

L.M. Kit Carson is best known as a screenwriter; his credits include the scripts for the American remake of *Breathless* (1983) and *Paris, Texas* (1984). He also appears in Jim McBride's seminal mock-documentary *David Holzman's Diary* (1967), and directed, with Lawrence Schiller, a film about Dennis Hopper's production of *The Last Movie* entitled *The American Dreamer* (1971).

Robert Coover

Robert Coover is the award-winning author of over twenty books of fiction and plays, beginning with the Grove-published collection *Pricksongs and Descants* (1969). Notably, his fiction has often drawn inspiration from cinema, as in his short story collection *A Night at the Movies, or, You Must Remember This* (1987) and his novel *The Adventures of Lucky Pierre: Directors' Cut* (2002). At Brown University, he has taught writing workshops in immersive virtual reality and in other electronic and mixed media, and founded the International Writers Project for writers who face personal danger and threats to their livelihood in nations throughout the world.

Sara Davidson

A journalist, author, screenwriter, and television producer, Sara Davidson is perhaps best known for writing the best-selling nonfiction novel *Loose Change: Three Women of the Sixties* (1977) and *Joan: Forty Years of Life, Loss, and Friendship with Joan Didion* (2011).

Michel Delahaye

Writer and actor Michel Delahaye worked for *Cahiers du cinéma* from 1959 to 1969. He appeared in numerous films, including Jean-Luc Godard's *Alphaville* (1965), Jacques Demy's *Donkey Skin* (1970), and Jacques Rivette and Suzanne Schiffman's *Out 1, noli me tangere* (1971).

Lita Eliscu

In addition to writing on film and drama, Lita Eliscu was one of the few women rock critics of her time. She published extensively in *Billboard*, *Crawdaddy*, the *East Village Other*, *Phonograph Record*, and elsewhere.

Wallace Fowlie

A prominent American literary scholar, Wallace Fowlie published more than twenty books on French literary figures of the 19th and 20th centuries, including Baudelaire, Mallarmé, Proust, and Verlaine, and his prose translations for *Rimbaud: Complete Works, Selected Letters* (1966) greatly influenced the reception of Rimbaud's writing in the 1960s.

Frieda Grafe

A major German film critic and translator during her lifetime, Frieda Grafe has had little of her writing translated into English; an exception is her brief study of Joseph L. Mankiewicz's *The Ghost and Mrs. Muir* (1995) for the BFI Film Classics series. In German, her selected writings have been published by Brinkmann & Bose in twelve volumes.

David Hamilton

A British photographer and film director, David Hamilton was known internationally for his sometimes controversial collections of erotic female nudes, including *Dreams of a Young Girl* (1971), *Sisters* (1972), and *The Age of Innocence* (1992).

Nat Hentoff

An influential American journalist and critic with a long and productive career, Nat Hentoff was best known for his political commentary and writings on jazz for *Down Beat*, the *Village Voice*, *JazzTimes*, the *New Yorker*, and other publications, as well as numerous nonfiction books and novels.

Seymour Krim

American writer Seymour Krim is remembered as one of the more pivotal if undersung voices of both the Beat Generation and the New Journalism. He edited the collection *The Beats* (1960), and his selected writings were published as *Views of a Nearsighted Cannoneer* (1961), *Shake It for the World, Smartass* (1970), and *You and Me* (1974).

André S. Labarthe

French actor, critic, and filmmaker André Labarthe began publishing in the 1950s at *Cahiers du cinéma*. As an actor, he appears in Jean-Luc Godard's *Vivre sa vie* (1962) and twenty other titles; in addition, his work as producer and director for the television series *Cinéastes de notre temps* (1964–1972) and *Cinéma, de notre temps* (1988–present) has made a significant contribution to film culture.

John Lahr

Since 1992 John Lahr has been a regular contributor to the *New Yorker*, where for twenty-one years he was the magazine's senior drama critic. His writings on theater have been collected in numerous volumes, and he has published biographies of Joe Orton, Frank Sinatra, Elaine Stritch, Noel Coward, and his father, actor Bert Lahr.

Julius Lester

A noted writer on African American history and politics, Julius Lester has had several books published by Grove, including *Look Out, Whitey! Black Power Gon' Get Your Mama* (1968) and *Revolutionary Notes* (1969). Beginning with the award-winning *To Be a Slave* (1968), Lester has also distinguished himself as a prolific writer of children's literature, including a number of retellings of folktales.

Norman Mailer

One of the most influential American writers of the 20th century, Norman Mailer also directed several films, including *Beyond the Law* (1968), *Wild 90* (1968), *Maidstone* (1970), and *Tough Guys Don't Dance* (1987), an adaptation of his own novel of the same title.

Louis Marcorelles

Journalist Louis Marcorelles was a frequent contributor to *Cahiers du cinéma* and other publications from the late 1950s onward. *Living Cinema: New Directions in Contemporary Film-Making* (1973), his only book translated into English, profiles new documentary movements like direct cinema and Free Cinema of the 1960s.

Gregory J. Markopoulos

A major American experimental filmmaker, Gregory Markopoulos directed nearly 30 films, including *Twice a Man* (1963), *Galaxie* (1966), and *The Illiac Passion* (1964–1967). His collected writings were published in the volume *Film as Film* (2014).

Jonas Mekas

Lithuanian-American poet, journalist, and filmmaker Jonas Mekas has often been called the godfather of American avant-garde cinema. The first film critic for the *Village Voice*, he was a founder of the Film-Maker's Cooperative, Anthology Film Archives, and *Film Culture* magazine; his films include *Walden (Diaries, Notes, and Sketches)* (1969), *Reminiscences of a Journey to Lithuania* (1971–1972), *Lost, Lost, Lost* (1976), and *As I Was Moving Ahead Occasionally I Saw Brief Glimpses of Beauty* (2000).

Annette Michelson

Critic and scholar Annette Michelson is Professor Emeritus in the Department of Cinema Studies at New York University and a founding editor of the journal *October*. Prior to *October*, she served as a film critic for *Artforum*. As actor, she appears in Noël Burch's *Noviciat* (1964), Michael Snow's *'Rameau's Nephew' by Diderot (Thanx to Dennis Young) by Wilma Schoen* (1974), and Yvonne Rainer's *Journeys from Berlin/1971* (1980). She recently published the first volume of her collected criticism, *On the Eve of the Future: Selected Writings on Film* (2017).

Jean Narboni

A French journalist, film historian, and film theorist, Jean Narboni served as editor of *Cahiers du cinéma* in the 1960s and '70s, where he oversaw a move toward a more politicized understanding of film, signaled by his influential editorial "Cinema/Ideology/Criticism" (1969), co-written with Jean-Louis Comolli.

Michael O'Donoghue

Best known for his work in comedy, Michael O'Donoghue was a founding writer and editor for *National Lampoon* magazine and the first head writer of *Saturday Night Live*. For *Evergreen Review* he wrote the comic-book serial *The Adventures of Phoebe Zeit-Geist*, with illustrations by Frank Springer, published in book form by Grove in 1968.

Dotson Rader

A frequent contributor to *Evergreen Review* and noted figure of the New Journalism, Dotson Rader has published the novels *Gov't Inspected Meat and Other Fun Summer Things* (1970), *The Dream's On Me* (1974), *Miracle* (1977), and *Beau Monde* (1981), and nonfiction works *I Ain't Marchin' Anymore!* (1969), *Blood Dues* (1976), and *Tennessee Williams: Cry of the Heart* (1985). His journalism has been widely published in the US and abroad.

Jacques Rivette

A critic for *Cahiers du cinéma* beginning in the early '50s, Jacques Rivette was one of France's most prominent directors; his expansive filmography includes *Paris Belongs to Us* (1960), *Out 1, noli me tangere* (1971), *Celine and Julie Go Boating* (1974), *Le Pont du Nord* (1981), and *La belle noiseuse* (1991).

Richard Schickel

Richard Schickel was a film critic for *Time* from 1965 to 2010. He published books on Walt Disney, Harold Lloyd, Gary Cooper, Marlon Brando, Woody Allen, Steven Spielberg, and many other Hollywood figures.

Abraham Segal

In addition to writing essays and reviews for film journals *Cahiers du cinéma*, *CinémAction*, *Image et son*, and *L'Avant-scène cinéma*, Abraham Segal has directed documentary films since the 1970s, including *You've Only Got One Life* (1977), *Investigation of Abraham* (1997), *The Mystery of Paul* (2000), and *When Sisyphus Rebels* (2013).

Tom Seligson

After publishing in *Evergreen Review*, Tom Seligson became an Emmy Award–winning director and producer of series and documentaries for CBS News, A&E, Discovery, and many other networks. He is also the author of six books, two of which have been sold to Hollywood.

Lawrence Shainberg

Lawrence Shainberg's books include *Brain Surgeon: An Intimate View of His World* (1979) and *Ambivalent Zen: One Man's Adventures on the Dharma Path* (1995), as well as the novels *One on One* (1970) and *Memories of Amnesia* (1988). He has had numerous essays published in the *New York Times Magazine*, *Harper's*, the *Village Voice*, and a Pushcart Prize–winning monograph on Samuel Beckett published by the *Paris Review*.

Daniel Talbot

Film exhibitor Daniel Talbot founded the legendary New Yorker Films in 1965, which would distribute work by Chantal Akerman, Jean-Luc Godard, Rainer Werner Fassbinder, Abbas Kiarostami, Ousmane Sembène, Straub–Huillet, and many others to American audiences. Talbot edited the collection *Film: An Anthology* (1959) and operated, with his wife Toby Talbot, the New Yorker Theater, one of New York City's great art-house cinemas, from 1960 to 1973, as chronicled in Toby Talbot's *The New Yorker Theater and Other Scenes from a Life at the Movies* (2009). The Talbots have run the art-house multiplex Lincoln Plaza Cinemas since 1981.

Jerry Tallmer

One of the founders, with Norman Mailer, of the *Village Voice*, editor and journalist Jerry Tallmer left that publication seven years later to pen arts and drama criticism at the *New York Post*. After three decades at the *Post*, he spent another two decades writing and editing regular columns in the *Villager*, *Thrive*, *Gay City News*, and other independent journals.

Jerome Tarshis

Jerome Tarshis wrote biographies of physiologist Claude Bernard (1968) and anatomist Andreas Vesalius (1969), as well as interviews and art criticism in *Art in America*, *Artforum*, the *Atlantic*, *San Francisco Magazine*, *Studio International*, the *Village Voice*, *Vogue*, and elsewhere.

Parker Tyler

Poet and critic Parker Tyler became known for his influential writings on film, collected in *The Hollywood Hallucination* (1944), *Magic and Myth of the Movies* (1947), *The Three Faces of the Film: The Art, the Dream, the Cult* (1960), and other volumes. With Charles Henri Ford he wrote the experimental novel *The Young and Evil* (1933) and co-edited the Surrealist journal *View* (1940–1947). A frequent contributor to *Evergreen Review*, Tyler published his groundbreaking *Underground Film: A Critical History* (1969) with Grove; he also wrote the first study of homosexuality in cinema, *Screening the Sexes* (1972).

Amos Vogel

Viennese-born Amos Vogel came to New York as a refugee in the 1930s. With his wife Marcia, Vogel operated the film society Cinema 16 from 1947 to 1963, after which he helped found the New York Film Festival and published his landmark study *Film as a Subversive Art* (1974). His writings have been collected in *Cinema 16: Documents Toward a History of the Film Society* (2002) and *Be Sand, Not Oil: The Life and Work of Amos Vogel* (2014).

INDEX